From Pigalle to Préault

From Pigalle to Préault is the first comprehensive study of sculpture produced in France between 1760 and 1840. Examining the momentous changes in form and meaning that occurred in this genre during this period, Alison West situates these developments within the context of the social upheavals leading to and following the French Revolution and Napoleonic Wars. She traces important developments, such as the rise and fall of the neoclassical style, as well as establishes new topics such as "neo-Goujonism" while applying new methodologies to the study of this subject. Richly illustrated with over 300 halftones and 8 color plates, this work makes accessible an important body of sculpture that has been neglected in the literature of art history.

From Pigalle to Préault

Neoclassicism and the Sublime in French Sculpture, 1760–1840

ALISON WEST

CAMBRIDGE
UNIVERSITY PRESS

PUBLISHED BY THE PRESS SYNDICATE OF THE UNIVERSITY OF CAMBRIDGE
The Pitt Building, Trumpington Street, Cambridge, United Kingdom

CAMBRIDGE UNIVERSITY PRESS
The Edinburgh Building, Cambridge, CB2 2RU, United Kingdom
40 West 20th Street, New York, NY 10011–4211, USA
10 Stamford Road, Oakleigh, Melbourne 3166, Australia

First published 1998

Printed in the United States of America

Typeset in Sabon 10 /13 on QuarkXPress

*A catalog record for this book is available from
the British Library*

Library of Congress Cataloging-in-Publication data
West, Alison, 1953-
From Pigalle to Préault : neoclassicism and the sublime in French
sculpture, 1760–1840 / Alison West.
p. cm.
Includes bibliographical references and index.
ISBN 0-521-44326-1 (hb)
1. Neoclassicism (Art) – France. 2. Sculpture, French.
3. Sculpture, Modern – 19th century – France. 4. Sculpture,
Modern – 20th century – France. 5. Mythology, Classical, in art.
I. Title.
NB547.5.N35W48 1998 97-87
730'.944"09033 – dc21 CIP

ISBN 0 521 44326 1 hardback

In memory of:

Dorothy Jacobson,

H. W. Janson,

and Frank West.

Contents

Acknowledgments

As with any book that evolves out of earlier work (in this case, a dissertation), the author's debt of gratitude encompasses those who helped with the first incarnation of the work as well as those directly involved in the new version. First and foremost among the latter is the Christian Humann Foundation without whose generous support the book might not have appeared.

I also welcome this opportunity to salute H. W. Janson who encouraged me as an undergraduate to pursue the study of the history of art and became my graduate advisor until his death in 1982. In addition, my warm thanks go to the many persons who extended their help in one way or another in the course of my research: Countess Anna Maria Cicogna, Antoine Debré and Brigitte Delattre, Hans W. Elschenbroich, Bernard Gabioud (Hospice du Grand St. Bernard), Françoise Soultier- François (Besançon), François Guillot de Rode, Norman Hinton, Terence Hodgkinson, Simone Hoog (Versailles), Dominique Jardillier (Paris, Senate), Nancy LaNasa, Isabelle Lemaistre (Louvre), Philippe Martial (Paris, Senate), Charles Millard (Ackland Museum of Art), Antoinette Le Normand-Romain (Musée d'Orsay), Anne Pingeot (Musée d'Orsay), Robert Provansal (Paris, Senate), Olga Raggio (Metropolitan Museum of Art), Michel Richard (Paris, Senate), Filippo Romano (Quirinale Palace), Annie Scottez de Wambrechies (Lille), Sarah Staccioli (Borghese Gallery), Margaret Szmurak, Michelle Théry (Paris, Assemblée Nationale), Claus Virch, the staffs of the Institute of Fine Arts and Metropolitan Museum of Art Libraries, of the Bibliothèque Nationale, of the Cabinet des Dessins of the Louvre, as well as to those who answered my many letters of enquiry and read the manuscript, and to those friends who have encouraged me throughout.

To Beatrice Rehl at Cambridge University Press for engaging to see this project through, and to Camilla Knapp and Pat Woodruff for their indispensable contributions to the manuscript my heartfelt thanks.

Finally, I should like to express loving gratitude to my father, James West.

*Unless otherwise indicated, all photographs are courtesy of the author.

Abbreviations

PERIODICALS

AB	*Art Bulletin*
AQ	*Art Quarterly*
BM	*Burlington Magazine*
BSHAF	*Bulletin de la Société de l'Histoire de l'Art*
GBA	*Gazette des Beaux-Arts*
JWCI	*Journal of the Warburg and Courtauld Institutes*
ZfK	*Zeitschrift für Kunstgeschichte*

REFERENCE WORKS

Deloynes	Collection de Pièces sur les Beaux-Arts, imprimées et manuscrites, recueillies par Pierre-Jean Mariette, Charles Nicholas Cochin, et M. Deloynes. 63 volumes. Bibliothèque Nationale, Paris.
Lami	Eugène Lami, *Dictionnaire de la sculpture du 18ᵉ siècle* (Paris, 1914) and *Dictionnaire de la sculpture du 19ᵉ siècle* (Paris, 1918), Kraus reprints, Neideln/Liechtenstein, 1970.
Salons	*Les Salons de Diderot*, eds. Jean Seznec and Jean Adhémar, Oxford, 1957.

Unless otherwise specified, the spelling in the quotations respects the original, and all translations of original source material are by the author.

Introduction

IN NOTRE DAME, Pigalle's *Tombeau d'Harcourt* stands covered in dust. At the church of Saint Roch, the meager remains of Falconet's once famous *Calvary* linger in oblivion behind a heavy curtain while freezing winter weather is causing Duseigneur's plaster *Crucifixion* (1850–62) to flake. The church would like to remedy these problems, but it can find no money. Meanwhile, Doyen and Vien's far more famous canvases have enjoyed a complete cleaning. Nearby at the Louvre, Michelangelo's *Slaves* stood until recently in the basement of the Pavilion de Flore, often closed off to the public at the lunch hour for staffing reasons.[1] The *Mona Lisa*, on the other hand, has never known a moment's peace. Even when sculpture is permanently accessible, as in the central halls of the National Gallery's West Wing in Washington, D.C., its handsome but arid display has so anesthetized the works that most visitors tend to ignore the statues on their way to the paintings galleries. In this respect, the Musée d'Orsay has done more than any other museum in recent history to focus attention on sculpture, whether one agrees or not with the choices or the display.[2] And good or bad, all museum pieces stand identified.

In many ways the bane of aesthetic enjoyment, labels nonetheless subliminally help to affirm a work's stature. But countless sculptures in the great if dimly perceived outdoor museum of public places present the blank face of anonymity to even the curious passerby. Discreetly recessed in a shady corner of the Luxembourg Gardens, for example, Dalou's exuberant *Monument to Delacroix* (1890) yields little clue as to its author's identity. In turn, that absence of information tends to ensure a continued indifference to the work.

The plight of sculpture, repeatedly satirized by Daumier, is an old one. Vivant-Denon wrote to Napoleon: "I must warn your Majesty that the taste of the nation inclines markedly towards painting rather than sculpture. I believe this is due to the vivacity of the national temperament, . . . its love for all sorts of sensations and its passionate character."[3] Added to this, large-scale sculpture is unwieldy, few want to buy it for their small apartments. The market for sculpture is less sensational than that for painting and university curricula reflect this. Consider the number of books or courses entitled "The *art* of such-and-such a century" which turn out to be about the *painting* of that period.[4] And to how many does the Place Pigalle simply mean the red-light district? Is it surprising then that so little attention is paid to sculpture of the eighteenth and nineteenth centuries? Furthermore, in spite of the eminently social and economic dependency and programmatic role of public sculpture, most publications delving into the textuality of art, strategies of representation, reception and so forth, have centered almost exclusively on painting. Indeed, in the last forty years, one of the chief arenas for revisionist art history has been eighteenth- and nineteenth-century French painting, in particular from David to Delacroix. From *Pigalle to Préault*, while shifting the emphasis somewhat (in that Pigalle represents an older tradition than David), draws upon that scholarship to reshape our view of the history of sculpture of that period.[5]

One of the problems in treating French sculpture between 1760 and 1840 rests with the absence of a true French *chef d'école*. While Jacques-Louis David stood in the international vanguard of painting, two foreigners came to dominate sculpture: Antonio Canova and, later, Bertel Thorvaldsen. Canova's fame (such as it is today) tends to obscure the early devel-

opment of neoclassicism in France and its evolution during and after the Napoleonic era. At the same time, the neoclassical reaction to the rococo and baroque overshadows the lasting contributions of the great sculptors who worked in the earlier styles. Furthermore, in comparison to painting, far fewer works survive, making the task of re-creating the period in question more difficult. Falconet's dismantled Chapels at Saint Roch, for example, can no longer impress the public, though they were and should have remained a unique Parisian accomplishment. What the Revolution and subsequent changes of government did not destroy, indifference and time would. Innumerable plasters and terra-cottas have been allowed to perish for want of sympathy.

A reason for undertaking this study, then, was simply to take a closer look at French sculpture from the time of the ancien régime to the age of Louis-Philippe. Former scholars and critics of the years between 1760 and 1840 have of course viewed it with some frequency as a hiatus in the proper evolution of French painting and sculpture, which purportedly found its true character in a measured naturalism free from excessive dogma or foreign influence.[6] Where sculpture is concerned, this point of view has taken longer to change, a new direction being roughly charted in the brief essay on "La Tradition classique" in the hefty catalogue *La Sculpture au XIXème siècle* (Paris, 1986). What I proposed when undertaking this book was to generate a study of this still obscure period from Pigalle to Préault that did justice, among other things, to the influence of the baroque and the rococo, or to the international style developed in Rome and the nationalistic reaction to it.

The categories, contradictions and directions defined in such trail-blazing works as Robert Rosenblum's *Transformations in Late Eighteenth-Century Art* or the 1974 *David to Delacroix* exhibition catalogue find their counterparts in sculpture with, inevitably, some modifications. And at times, it will be found that sculptors rather than painters led the way. Later, academic dogma, with its surer grip on sculpture, would slow the development of sculpture more effectively than that of painting. For David's Roman style, one has Houdon's earlier *Morpheus* or Moitte's *Cassini*, for his "Greek" phase, Chaudet's or Chinard's work. Eventually Gros' "baroque" manner would find an echo in the reliefs and figures for the Arc de Triomphe du Carrousel or David d'Angers' *Grand Condé*. The interchangeability of modes that

one notes in painting occurs in sculpture too, the "real" (or exact) and the "ideal" living side by side. Houdon and Barye both kept alive a tradition of scientific exactitude at the service of their alternately idealized or passionately realistic works. It would take longer, however, for the deep psychological empathy of a Géricault to penetrate the domain of French sculpture, David d'Angers' busts and Préault's *Pariahs* being a first inkling. Sculpture would be much slower too in taking to oriental subjects.

The chief area in which sculpture has no counterpart in painting, namely funerary monuments, is a subject so broad that it requires separate treatment.[7] Therefore, only those monuments which help elucidate thematic developments are mentioned. Portraiture has also remained subsidiary to the main arguments for the same reason of its excessive scope.[8] These and many other areas are in great need of further exploration, as are the careers of individual artists, although work has begun in that area yielding valuable documentary information.

The critical reception and influence of Michelangelo and Puget, first addressed by Eugène Dörken and Theodore Reff,[9] still cries for attention. Almost nothing exists on the social standing of sculptors or their role in the art world and the entire question of the *Paragone* from the Renaissance through the nineteenth century invites exploration.[10] It was very much a living issue which rankled with sculptors in particular.[11] Patterns of iconography[12] and the problems of patronage remain open to investigation too, as does the shaping of the audience for sculpture in the eighteenth and nineteenth centuries.[13] An exhaustive study of contemporary sculpture theory would be an invaluable tool, as would a synthesis of issues in French sculpture from the founding of the Academy in 1648 on.[14] Finally, an in-depth look at the women sculptors of the period would be interesting, although it is true that few were as active or successful as their counterparts in painting.[15]

Some of these issues had a long life. The question of how to be *French* seems to crop up perennially, from Girardon's shunning of Bernini's flamboyance to a general suspicion of neoclassicism as un-French. The problem of the nature of portraiture and of how to resolve the public, ideal persona with the animated, private individual arose early with Coysevox's busts of artists and reached a summit in eighteenth-century French sculpture with Houdon's exquisite likenesses. In royal portraiture, the challenge would be to recon-

cile absolute might with the new humanism of the Enlightenment.[16]

For all the grand public works produced during the middle of the century, countless more small-scale private sculptures came into being. It might even be claimed that the latter more fully expressed the ethos of the rococo, the true concern of both patron and artist, than the full-scale public monuments of the time. Terra-cottas, models and statuettes were collected with zeal by connoisseurs. The proliferation of small pieces did reflect a new mode of life, of comfortable apartments and intimate spaces: the liveliness and erotic overtones of many of these works owe their existence to this *intimisme*. More elaborate or fanciful compositions might be attempted, more personal invention allowed. Yet almost every sculptor of ambition coveted the opportunity to create on a grander scale and to challenge the character of public statuary as well.

In a sense, two new issues dominated "political" public sculpture after 1760: secular morality and the call for inspiring role models, and democracy or the introduction of nonroyal figures in the public place, to embody this secular morality. Neoclassicism as such became a useful if not wholeheartedly endorsed stylistic counterpart to these changes.

Pigalle's *Citizen* (Fig. 6) for his *Monument to Louis XV* (1756–65) at Reims has survived as one of the greatest accomplishments of the century for its brilliant resolution of so many of the issues facing the sculptor. Naked yet comfortably clad in personal dignity, neither victorious athlete nor god, the Citizen was Pigalle's own invention. Having read Voltaire, he left aside slaves in favor of free men[17] and created one of the most memorable and compelling thinkers – or musers – until the advent of Rodin. To the female figure was left the more traditional role of allegorical mediator, but what an allegory!: "Gentle Government" guiding a willing French lion.

The individualization of the Citizen's thoughtful face (Pigalle himself)[18] still allows for the recognition of Everyman, while the composition, a marvel of effortless diagonals and gentle torsion, yields what the Hindus might call a variation on the pose of "Regal Ease." This informal tone at the foot of such a lofty monument introduces to the public domain the intimacy of private musings (Pigalle's *Voltaire*, on the other hand, would bring heroism to the private domain). It is a tribute to Pigalle's sensibility that despite the several attacks on the effigy of the king

(destroyed August 15, 1792), the Citizen and his female counterpart remained unscathed[19] and still grace the city of Reims.

Neoclassicism and the Sublime

Something more might be said concerning the scope of this study which pairs the neoclassical, the paradigm of romantic longing expressed through style and subject, with the sublime, the spirit of exaltation associated with those longings yet giving birth to shapes and forms far removed from the measured beauty of antiquity. Henry Fuseli's *Artist Moved by the Grandeur of Ancient Ruins* (Fig. 77) gave eloquent form to this restless tandem of style and sentiment.

As the title suggests, the main chronological parameters of this book encompass the height of the rococo through the advent of high romanticism, Pigalle and Préault serving as bookends. Where Pigalle's work is concerned, as well as Falconet's, I chose to place the emphasis on the representations of male achievement from Pigalle's *Voltaire* and the *Maréchal de Saxe* to Falconet's *Peter the Great* and his dramatic Chapel of the Calvary of 1760, although the more intimate aspects of their creation appear as well. Their images of quiet heroism together with Augustin Pajou's early classicizing manner constitute the point of departure for what follows. Two books, divided by the Revolution, might have allowed for more detailed discussion of the individual artists. Yet that would have been to sacrifice the broader whole, the full extension of certain developments through those eighty years and beyond which so captivated my attention and indeed gave birth to this study. The Goujon revival, for example, spanned a century. In short, some of the major themes would have lost their force by being severed half way. The period as a whole held out the fascination of unexpected reversals and continuities, of remarkable quality and variety, and of a compelling quest for sculptural validity in the face of considerable odds – the *Apollo Belvedere*, Canova, the Elgin Marbles.

In limiting myself to pursuing the rise and fall of neoclassicism (or pseudo-, neo- and postclassicism) and the sublime (as opposed to the broadest "romanticism"), I had to leave a great deal out. The rococo, for example, is but tangentially touched upon, while the troubadour style, the Renaissance revival and the resurgence of Christian art barely make an appearance. Neither have I attempted to systematically fit the

artistic developments of this period into their political or social context, although inevitably the pressures of social change must be accounted for at various crucial points. The very nature of certain public monuments compels discussion of their political meaning, but the overall purpose here is to gain insight into the *artistic* climate of French sculpture during this time of upheaval. There are instances, indeed, when to force the issue of political contextualism is to squeeze blood from a stone. (A monument as famous as Nelson's in Trafalgar Square came about largely as a "practical consideration for town planning.")[20] Everything can be said to be in some way politically derived, even the diametric rejection of the prevailing scheme of things, call it negative influence, reception by refusal. Clodion's apolitical prerevolutionary works might speak of the elitism of the rich, able to afford his delicious eroticism for their new, cozy, private apartments. Or his output of small terra-cottas might seem untainted by the political and economic situation, an idyll carved out of his personal taste which then found a market. Nicola Chiaromonte, for example, in *The Paradox of History* (University of Pennsylvania Press, 1985), analyzes "the tradition which, in opposition to that of Hegel and Marx, constantly juxtaposes individual experience against historical abstraction, and, whether ironically or tragically, stresses the eternal disparity between the two,"[21] beginning with Fabrice del Dongo's dislocating experience of the battle of Waterloo in Stendhal's *Charterhouse of Parma*. In a medium so dominated by political pressure, might it not also be interesting to see where sculptors have evaded it, made the best of a perhaps bad situation, gone against the fashion, or turned the potential handicaps of propaganda to their advantage as David d'Angers did? Great art can make the political interesting, but defining the political situation will not necessarily explain great art.

The chapters tend to move forward in a broadly chronological way, but thematic concerns interfere with such a simple schema. As a result, the overall structure of this study depends on an alternation between those two approaches, slowly knitting together the various strands which lead to the eruption of a radical and dominant French school in the 1830s.

Finally, a further word about the "sublime." As is well known, the eighteenth century and Burke in particular recast Longinus' *On the Sublime* in modern terms and gave new impetus to the interest in and acceptance of the raw, uneven, awesome side of nature and art. This is the primary sense of "sublime" as it is used here. The grandiose, the spectacular, the impressive, the fear-provoking, the suprahuman and the inhuman constitute its ground, rather than the sublime of superhuman perfection as it was also understood in the eighteenth century, although this too is relevant.[22]

Like romanticism with which it is so intimately bound, the sublime is elusive in its chronological parameters. It began to gather its energies with Falconet and Pigalle and reached a peak in the middle of the nineteenth century, thus extending beyond the height of neoclassicism with which it merged along the way.

Neoclassicism continues to present fewer problems of interpretation than the all-embracing word "romanticism," though even it has shades of meaning that can be cause for confusion.[23] It is used here to denote the movement toward a conscious, methodical re-creation of the principles of ancient statuary and the quest for a purity of line resulting in the international style of 1800 analyzed by Robert Rosenblum. Broadly speaking, it developed from the pseudoclassicism of a Pajou with its tentative promise of a more programmatic endorsement of the "true style," as it was then known,[24] through the high neoclassicism of the international style, to recede again into the more individual classicisms of a Pradier or Barye.

As Canova (and, later, Bertel Thorvaldsen) embodied more completely than any other sculptor the theoretical considerations dominating sculpture, he must serve as the point of departure for a study of the French neoclassicists. At the same time, though Canova and Thorvaldsen stamped the international movement with their characters, the French evolved their own classicisms – a warmer, republican classicism, initiated by Jean-Guillaume Moitte and his contemporaries, and a revival of Jean Goujon's style.

Antiquity and the Present

The great return to the precepts of classicism presented a special problem for sculptors, since the largest surviving body of work from antiquity was sculpture. This naturally put contemporary sculpture both at a singular disadvantage, because it was held to be, a priori, inferior to its predecessors, and also at a singular advantage, since, by virtue of its medium, it was the natural perpetuator of the classical style. To Winckelmann, Schlegel, Hegel, Reynolds, Quatremère de Quincy, Gautier, Baudelaire and others, as well as to a good many artists, sculpture had achieved the summit

of its perfection several millennia before, never to be equaled again. Unlike painters, sculptors would suffer from the singular burden imposed upon them by their Greek ancestors. For example, painters translating ancient reliefs and statues into appropriate settings did so without enduring direct comparison to the model. At the very outset then, from the rise to the flourishing of high neoclassicism, a keener competition with the past underlay the production of sculpture.

No consensus on the best path to the "true style" existed. Yet, if theoretical tracts devoted to sculpture differed in their details, they never varied in their fundamental agreement on the principal subject and form of sculpture: the ideal, male nude. The general ideas propounded by the various theoreticians favoring classicism are familiar enough, but a brief sketch of some of the contradictions in the reinterpretation of the past and of the internal logical inconsistencies illumines the nature of the sculptor's struggle to steer an even course through the high waters of fervid antiquomania.[25]

Foremost among the influential French theoreticians of the late eighteenth century ranks Antoine-Chrysostome Quatremère de Quincy (1755–1849)[26] whose training as a sculptor added considerable weight to his theoretical pronouncements and allowed him to enter into a virtual artistic partnership – as advisor – with Canova whom he befriended in Rome. The number and compass of his publications[27] bear witness to the breadth of his interests and to his unquestionable erudition, but these works are often afflicted by the inevitable pitfalls of extreme dogma, a dogma at times exaggerated with an eye to contemporary problems.[28] Quatremère's acceptance of Winckelmann's sociological and environmental explanation for the excellence of Greek art brought on the first major breakdown in his logic.

It was held that a variety of benefits depended upon the outstanding geographic position of Greece, including nudity in the gymnasium and a concomitant study of anatomy. A perfect social order was also thought to have occasioned the artistic excellence of the best Greek art which necessarily reflected the underlying moral good in its beauty of form. If the greatness of Greek art reflected its social order and climate, art as the mirror of contemporary French society would inevitably be a flawed one.

Seconding the view that the climate of Greece provided the optimum breeding ground for sculptural perfection because of the customs it engendered, Quatremère proceeded, in the *Considérations sur les arts du dessin en France* (1791), to counsel the study of the nude, even if this scarcely mirrored a contemporary way of life. He went so far as to agree that "the sight of a nude statue might even provoke a disagreeable sensation in an inhabitant of Siberia."[29] Quatremère impressed his reader with the need for academies in the north to achieve the same results as those of ancient Greece, much as one might use *orangeries* to grow oranges out of their natural environment.[30] In short, he hoped, through reforms in the Academy and a more stringent education, to bring sculpture back to a golden age. (A shift to the importance of liberty over climate as the dominant requirement for great art would help the theoretical condition of sculpture after the Revolution.)[31]

The contradictions assumed considerable proportions when submitted to the scrutiny of those modernists who, agreeing with the basic premise that the excellency of Greek art could only be of Greece and of ancient times, proceeded to the obvious conclusion that northern art must be of the north and of modern times – the ineluctable zeitgeist. Hegel, Herder, Schlegel, Madame de Staël, the French exegete of contemporary German thought, and many others, all guided their arguments in this direction. Rather than wish upon modern times the compromise of an inevitably inferior contemporary sculpture, they concluded that the era of sculpture had passed and that of painting come with the dawn of the Christian age. And thus it was that Baudelaire would inquire why sculpture was boring and Gautier would deny it the possibility of being romantic – "Every sculptor is by necessity classical."[32] By championing the Middle Ages, Chateaubriand's *Génie du Christianisme* (1802) helped undermine antiquity as well.

The democratic flavor of Quatremère's writing after the Revolution betrays his profoundly felt civic view of art with some startling results. Believing liberty and equality to have been fundamental to Greek art, he felt that democracy would ensure the proliferation of statues, unhindered by royalty and its self-serving patronage. He even envisioned a statue to the inventor of a new kind of tile.[33] If his many rigid pronouncements on sculpture and austere personality failed to endear Quatremère to his contemporaries, his concern for the moral and democratic role of sculpture was deep and genuine, as was his concern with the promulgation of the arts in general. Holding the view that genius would flourish only where talent abounded, like the summit of a pyramid rising from a broad base, he encouraged

the arts at all levels. Quatremère's chief rival, on the other hand, Emeric-David, felt there were too many artists and advocated an elite.[34]

T. B. Emeric-David (1755–1839), a member of the Academy, differed from Quatremère in several other, more important respects. Like Winckelmann, Quatremère considered sculpture to rest upon an ideal vision sustained by a study of the most beautiful elements in nature, although he granted the individual mind greater conceptual liberty.[35] In his famous *Recherches sur l'art statuaire* crowned at the Academy in 1801 and published in 1805, Emeric-David inverted this order of things, positing the primacy of the imitation of nature without, however, abandoning the ideal as the ultimate goal. The phrase "imitations perfectionnées" crops up, after all, to explain works inspired by but not subservient to ancient models. This important theoretical work did more than simply invert Quatremère's abstract-idealist stance: it offered an apology for sculpture in a troubled climate, both politically and geographically, and an appeal to Napoleon as legislator for help.

To justify his appeal, Emeric-David pursued a line of argument that attributed the successful emergence of Greek sculpture to the encouragement of government, or to its institutions, and demonstrated the fallacy of believing that either climate or social stability and liberty had anything to do with the generation of genius in Greek art.[36] Thus the importance of dismissing climate as an essential factor, to get rid of the inconsistencies contingent upon having a northern sculptural tradition. Certainly, Thorvaldsen came to Rome intent on being more Greek than the Greeks or more Catholic than the Pope – Canova, the titular head of neoclassicism. In any event, the climate of Rome held a special appeal and appeared to favor artistic maturation. Sergel had even written: "The air of Rome is unique, the breath of life to the artist's soul. . . . Happy and a hundred times happy the artists who consider Rome their native soil, there to live and there to die. All the nordic countries are graves to artistic genius."[37] Later, no doubt tired of Winckelmann and Quatremère's insistence upon the benefits of a southern climate, Humbert de Superville wrote not only in praise of the north, but of its sculpture-engendering virtues as well.[38]

Emeric-David's chief preoccupation lay, nevertheless, in showing that, out of love of nature and one another, the Greeks began by copying what they saw rather than idealizing. Opposing trifling subject matter

and low genre as much as Quatremère, he nonetheless refused to relinquish a first place for the imitation of nature which, in his opinion, was the foundation of greatness. By "nature" was meant the *belle nature* of French eighteenth-century theory, or the finding of the most beautiful models in nature, also a concept of collective qualities.[39] At least this perfection was to be found in the observation not of plaster casts but of the actual thing, that "nature" from which sprang a just appreciation of form and function, and an understanding of the good inherent in the beautiful.

Emeric-David was much influenced by his discussions with the wealthy collector and sculptor Jean-Baptiste Giraud, who later came to epistolary blows with him, the former having purportedly slighted his contribution to the *Recherches*.[40] His sculpture and that of Pierre-François-Grégoire Giraud (or Giraud de Luc) is to some degree the illustration of Emeric-David's text. With this work and his other writings (largely posthumous publications), he stemmed the tide of criticism against French seventeenth- and eighteenth-century sculpture, commending Puget, admiring Pigalle (though he failed to endorse his art wholeheartedly) and adding his encomium to Houdon's generally admired *Écorché*.[41] But science still remained the handmaiden of the ideal.

Emeric-David's views gained ground rapidly. A critic at the Salon of 1801 remonstrated with those young artists who "imagined that with thought alone one could do without the help of the model," by telling an anecdote about Puget's use of his own foot for the *Milo*.[42] Chaussard, who favored looking to the Revolution rather than antiquity for subject matter, most particularly manifested his sympathy for Emeric-David's position in his life of the eminent sculptor Pajou included in the *Pausanias français* (1806).[43]

In spite of Emeric-David's attempts to counter Quatremère, it would prove far more difficult for sculptors than for painters to relinquish the strict tenets of academicism, especially in official commissions.[44] Landon summed the situation up with these intransigent words: "All innovation is dangerous in an art . . . whose principles have been irrevocably established."[45] Inevitably, sculptors found themselves more tightly bound to the wheel of government than painters and even a petulant iconoclast like Auguste Préault would temper his ways for a badly needed commission here and there. On the other hand, one of the remarkable developments of the 1830s was a particularly visible subversion of the

official line in a number of works including the *Marseillaise* and David d'Angers' highly personal and controversial Pantheon pediment. Ironically, it had been as hard for some sculptors to convince patrons of the merits of radical neoclassicism when it was at its height.[46] By and large, however, Greek sculpture remained the gauge of excellence throughout the nineteenth century, as may be judged from these two comments:

> Chantrey said if by any trick the Creugas of Canova could be buried and dug up again in fragments as an ancient statue, it would produce a great sensation.[47]

What insipid fragments most of the really eminent Institute statues would make were their heads knocked off by some band of modern invaders. Would anything survive mutilation with the serene confidence in its fragmentary but everywhere penetrating interest which seems to pervade the most fractured portion of a Greek relief on the Athenian Acropolis? Yes, there would be the débris of Auguste Rodin's sculpture.[48]

But the question would become, "Which Greek sculpture?" For in 1816, the Elgin Marbles abetted a significant reappraisal of the masterpieces of antiquity. They were to prove themselves powerful and ambivalent ground for theoretical disputes, serving both the academicists and the modernists in turn. And they would supplant both Canova and Thorvaldsen as universal models, helping to lead the way into a new sculptural language.

CHAPTER ONE

Of Moral Instruction

SCULPTURE HAS LONG BEEN considered the vehicle par excellence of moral instruction and, as such, the eighteenth century might have had little new to offer. But the dramatic iconographic and stylistic changes emerging around 1760 gave a new inflection to the moral tenor of public sculpture especially. Spurred by antiquity, scenes of sacrifice, depictions of virtuous mourning, and representations of enlightened rulers made their appearance along with a more democratic celebration of virtue. From simple commemorative busts and statues, the honoring of national heroes broadened to include the most telling moment, symbolic nudity, and death itself. Some of the historical themes familiar to painting, beginning with the work of Gavin Hamilton and Benjamin West and finding ill-fated expression in Greuze's *Septimius Severus* (1769), would also swell the sculptural repertory. But the originality of the period lay in transposing these models onto national and increasingly contemporary public figures.

In pursuing the goal of exemplary moral art, France clearly owed something to her own artistic past as well as to that of other European countries, and England in particular.[1] The *Worthies of Stowe* (1733), Roubiliac's lofty *Sir Isaac Newton* (1755; Fig. 205) and his *Handel* (1738; Victoria and Albert Museum, London) are among the best-known antecedents. In 1767, a Frenchman admiringly referred to the English tradition of honoring men of talent as an emulation of the Greeks and Romans, citing Westminster Abbey in particular as "the sanctuary of national glory."[2] After the Revolution, Quatremère also invoked the tombs in Westminster and St. Paul's to justify the transformation of Ste. Geneviève into the Pantheon.[3] In Italy, Andrea Memmo's ambitious gathering of sculpted notables surrounding the Paduan market came into existence between 1775 and 1792. On home soil, Segrain had hoped, in the late seventeenth century, to honor the great poet Malherbe with a statue on the facade of his *hotel* in Caen.[4] Titon du Tillet's far better known *Parnasse français (French Parnassus)* was to have been a monumental homage to the great men of France.

Titon du Tillet

Putting both size and nature at his service, Titon du Tillet (1677–1762), a well-established Parisian of some repute, had planned as early as 1708 to build a Parnassus incorporating ninety of the great writers and musicians of France in the form of statues, medallions and names listed on scrolls.[5] The lengthy mutations of the generally ill-fated project are of less concern than the very fact of its inception and eventual, if often subliminal, assimilation into later transient projects and dreams.[6]

Louis Garnier executed the model in 1708 (Fig. 1),[7] but Titon du Tillet nursed the ambition of erecting "a colossal Mount Parnassus in the middle of Paris or Versailles. The full-scale monument was to be about sixty feet high, with a base one hundred and sixty feet in circumference and with figures eight to ten feet tall. Only these figures, Titon suggested, in an attempt to keep down the costs would be in bronze. The mountain proper would be of stone."[8] Eventually the Arc de Triomphe (1806–36) became the focal point of the patriotic interest anticipated by Titon du Tillet.[9] He did not live to see his grandiose scheme realized, but during the course of his life he repeatedly sought backers and published various *Descriptions* of the monu-

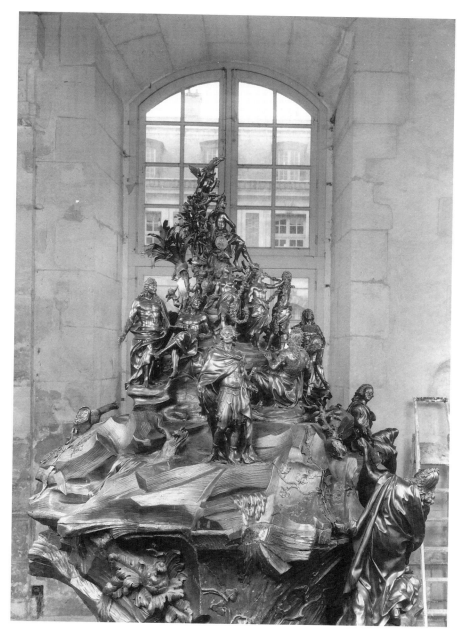

Figure 1. Titon du Tillet and Louis Garnier. *French Parnassus*, 1708–18. Bronze. Versailles, Musée National du Château de Versailles. Photo: R. M. N.

ment, the first in 1727 followed by two more in 1732 and 1760.[10] And, most importantly, from 1723 until Titon's death, the *Parnasse* never ceased to draw attention and praise from his contemporaries.[11]

The monument owed its renown to Titon's dissemination not only of his *Descriptions* but also of engravings after the group and after various paintings of the *Parnasse* which, over time, underwent several changes.

By 1757, for example, it had become a large fountain. The fame of the project was such that as late as the 1760s, Augustin Pajou himself contributed several handsome bronze statuettes to the ensemble. The incorporation of additional figures led to the broadening of the base which thereby became an even more imposing piece of artificial nature.[12] There, in splendid disarray, held aloft by a quaint Mount Parnassus, sits,

stands and debates the flower of French intellectual life. The small scale of the work deprived it, unfortunately, of the immediate visual impact of the larger and eventually more famous works of Falconet and Pigalle.

Falconet

Until Etienne-Maurice Falconet (1716–91)[13] received the commission for the *Peter the Great* (1766–78; Fig. 2), and in spite of his protestations of indifference to posterity, he felt he had created nothing worthy of his name.[14] Besides the Chapel of the Calvary at Saint Roch, the bulk of his work until that time had consisted of charming intimate statues and groups, on which his early fame rested.

Born in Paris in 1716, he began his studies in the studio of J. B. Lemoyne, becoming *agrée* in 1744 and an academician in 1754. A few years later, in 1757, he received his appointment to the Manufacture de Sèvres where he remained until his departure for Russia in 1766 and which did so much to encourage the sensuous vocabulary of his art.

Falconet shared the generally held view that a sculptor's principal object lay in commemorating great men,[15] although he was by no means the first to air this opinion. In following the history of Titon's *Parnassus*, one also follows the history of the genesis of the sculptor as commemorator not only of monarchs but of great men as well.

The equestrian, commissioned by Catherine the Great, was destined to legitimize her reign by linking her to Peter the Great whom she cleverly honored rather than herself. She was so successful in this that people often think of her today as his granddaughter instead of the German-born princess that she was. Alive to the empress's taste for Voltaire, Diderot and Enlightenment thought, Falconet shaped the image of a benevolent, tunic-clad Russian hero, friend to the nation, and magical protector.

The sought-after commission enabled Falconet to concentrate his loftiest thoughts and aspirations into a single monument fulfilling the goals of exemplary moral art in its nobility of attitude and intent. An earlier project for an equestrian *Monument to Peter the Great* of 1716 by Carlo Rastrelli[16] had retained the traditional slaves of such monuments, for which Bouchardon substituted *Virtues* in his most famous work, the equestrian *Louis XV* (commissioned in 1749).[17] There can be no doubt that this choice moved Falconet toward his own pared-down vision. Shorn of any allegorical paraphernalia, with the exception of the unobtrusive serpent of evil beneath the stallion's rear right hoof, the self-possessed czar embodies the image of great leadership, an image of enlightenment holding sway over Nature's wilder strains through the force of his inner, divinely ordained authority.

More than a decade earlier, Jean-Baptiste Pigalle (1714–85), Falconet's contemporary and great rival, had already begun to formulate such a vocabulary, generating a new breed of stoics in French commemorative sculpture.[18] The consummate expressions of this new trend took form in his *Monument to the Maréchal de Saxe* (1753–70; Figs. 3 and 4), reaping generous if qualified praise from Diderot in the process.[19]

Pigalle

Pigalle, also born in Paris (1714), showed a temperament far simpler than Falconet's and more likable, yet fully alive to the intellectual issues of the day. After eight years of apprenticeship with Robert Le Lorrain and further study with J. B. Lemoyne, he struggled to Rome on his own account in 1736. Academician by 1744, he quickly soared to success, becoming one of Madame de Pompadour's favorite sculptors. Bouchardon's choice of him over his own student, Vassé, to complete his equestrian of Louis XV (completed in 1763) sealed his fate as one of the most illustrious artists of his time. Thus it fell to him to emblazon the annals of French history with a vibrant monument to one of its most glorious generals.

A hero mourned by all France,[20] the *Maréchal de Saxe* impresses the viewer with the valor of a great soldier whose fearless forward march and proud disdain of death confer an Olympian stature upon the mortal man. Deaf to the tears and supplications of Love and France, the Maréchal de Saxe descends dauntless to his end. And he alone rises like a pillar of strength in the midst of an emotional and visual turmoil, of victorious flags and banners, and the thrashing of wings. This conflation of the *Apollo Belvedere* and the resurrected Christ set a new standard for personal grandeur. To mention the *resurrected* Christ though, is to draw attention to the very absence of that luminous possibility. The gaping tomb waits with grim finality.

The rich and unusually three-dimensional monument stands in the Protestant church of St. Thomas in

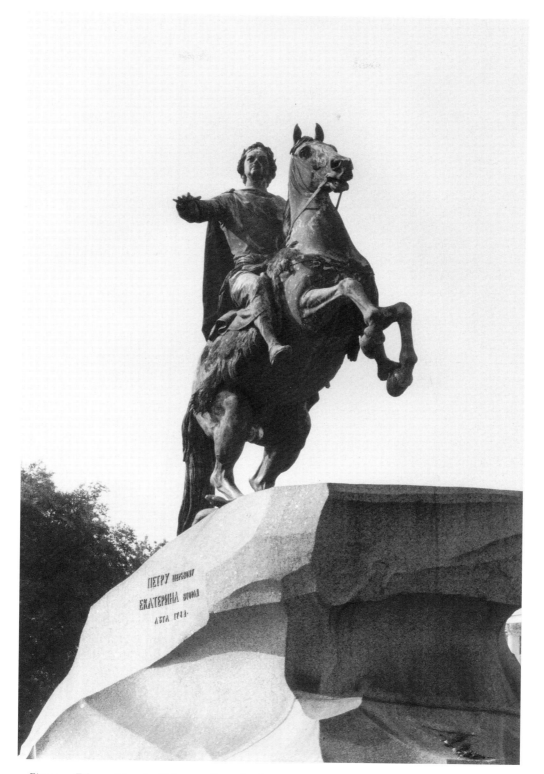

Figure 2. Etienne-Maurice Falconet. *Peter the Great*, 1766–78. Bronze equestrian. St. Petersburg.

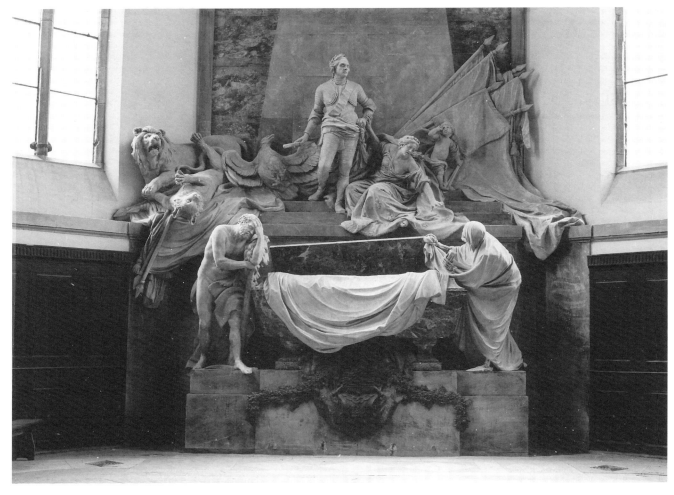

Figure 3. Jean-Baptiste Pigalle. *Monument to the Maréchal de Saxe*, 1753–70. Marble. Strasbourg, Church of St. Thomas. Photo: Courtauld Institute.

Strasbourg, a mesmerizing amalgam of movement and stasis, loftiness and loving detail, animal, man and allegory. If the unity of the whole suffers from the strain of too many vying parts, the brilliance of the central figure alone makes up for this. The Maréchal bears the full weight of his destiny – a Protestant without the benefit of absolution. He enters death free of mediation, amplifying the emotional resonance of the work: for of all man's enemies, death casts the darkest shadow.

Taking a step back into the annals of French military history, one finds that a superhuman aura hung about the brave soldier, notably in a poem by the seventeenth-century writer Grégoire Huret. As frightening as thunder and bold as Mars, the soldier fears neither death nor fate.[21] Finally, in the next century,

when a woman supposedly cried out upon seeing David d'Angers' *Grand Condé* (1817–27; Fig. 43), "'Pon my soul, it's like thunder!," she was echoing a long tradition which cast the national hero in sublime terms, the terms evoked by Falconet and Pigalle.

Radiance of intellectual achievement and moral rigor found their expression to differing degrees both in Pigalle's engagingly pensive *Citizen* for the *Monument to Louis XV* (Figs. 5 and 6) for Reims, completed in 1765,[22] and in his apotheosis of Voltaire (1766; Fig. 7).[23] The *Citizen*, a sort of "hero of the common man," embodied the intelligence and health of those fortunate enough to live under the aegis of a benevolent ruler. His nakedness speaks both to his condition as "natural" man and as a timeless ideal. The sinewy, dehydrated nakedness of the *Voltaire*, on

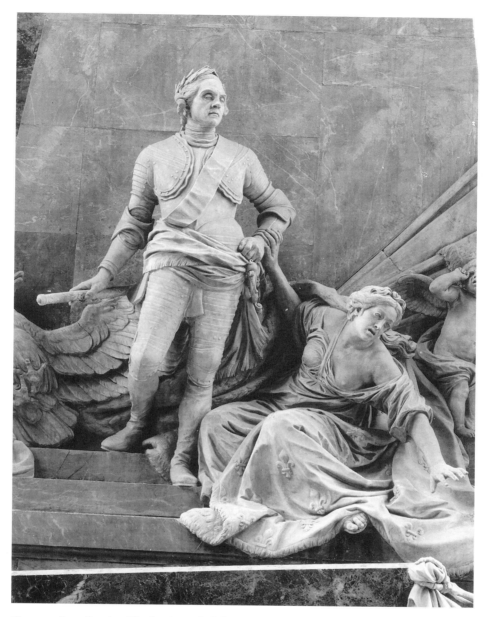

Figure 4. Jean-Baptiste Pigalle, *Maréchal de Saxe*, detail from *Monument to the Maréchal de Saxe*, 1753–70. Marble. Strasbourg, Church of St. Thomas. Photo: Courtauld Institute.

the other hand, was to have called to mind the famous, misidentified *Dying Seneca* (Fig. 8) (though few actually grasped the reference)[24] and suggested, through this visual parallel, Voltaire's readiness to die for his ideas. His state of undress might also have recalled the familiar symbol for truth.

Born at Mme Necker's famous dinner party of April 17, 1770, Pigalle's bold if disconcerting *Voltaire* aimed for an ascetic grandeur sustained by exquisite surface detailing. But the arresting brutality of the

truth and the flawed composition, giving too much importance to the flimsy scroll at the body's core, interfere with a wholehearted embrace of the sculptor's idea. Such "vérisme" repelled the critics (and Voltaire too) whose sensibilities were still attuned to the pleasant aura of moderation in everything. This was amply demonstrated by the popularity of Antoine Houdon's (1741–1828) own benevolent, clothed version (1779–83; model at the Salon, 1781; Fig. 9) of the philosopher, removed from Pigalle's virtuous tree

Figure 5. Jean-Baptiste Pigalle. *Monument to Louis XV*, 1765. Bronze. Reims.

stump to a comfortable "Louis XVI" armchair.[25] The compact form and abstract robe chasten the expressive freedom of Pigalle's conception, though the mood is lighter and the portrait a "speaking" one.

These two *Voltaire*'s, both privately commissioned homages and the first to celebrate a living, bourgeois intellectual, went hand in hand with d'Angiviller's steadily growing interest in a morally regenerative art, although neither was added to his series of "Grands Hommes." Indeed, Voltaire was considered dangerous to the crown. Given the crown's displeasure with Voltaire in his later life, and the latter's incessant flow of mordant commentary, Pigalle's concept might be said to reflect Voltaire's courage better than Houdon's work, while the latter better reflects his wit. As June Hargrove writes, "The rivalry was complete when Houdon's *Voltaire* went to the Comédie Française, which had rebuffed Pigalle's, while the latter went to the Académie Française where the former was declined!"[26]

To these two private commissions may be added

that for the Ecole Militaire and the handsome statue of the great naturalist *Buffon* (Fig. 10) by Augustin Pajou, favorite sculptor of Louis XVI. Louis XV had handed Buffon's job over to the Comte d'Angiviller in 1771 while the naturalist was thought to be ill beyond hope. When he recovered, Louis XV hit upon the idea for the statue as a means of reparation. Completed in 1776, the toga-clad figure stood in the Jardin du Roi where it could be seen by anyone walking through. Buffon, incidentally, was no more pleased than Voltaire had been with Pigalle's work.[27] Meanwhile, in 1773, the commission for four statues (now lost) for the Ecole Militaire yielded another *Maréchal de Saxe* by Huez, a *Grand Condé* by F. Lecomte, a *Maréchal du Luxembourg* by Mouchy and Pajou's first *Maréchal de Turenne*. Like the two *Voltaire*'s and Pigalle's *Maréchal de Saxe*, these works became part of the groundswell building toward the appearance on the public stage of nonroyal figures.

The statues of Voltaire and Buffon provided ammunition for the dispute (summarized in the following chapter) that opposed contemporary to classical dress or nudity and that lasted well into the nineteenth century. Even Rodin's *Balzac* (commissioned in 1891; Fig. 206) fell heir to the tedious arguments. It should also be noted that those sculptors choosing to do so gave the attribute of classical nudity only to the intellectuals among the "Grands Hommes" until Napoleon's rise to power. Meanwhile, Pigalle's *Voltaire* or Titon's choice of Mount Parnassus and of Roman costumes lead to the consideration of a grandeur and stoicism predicated upon the specific attributes of classical clothing or absolute nudity and of their function as a metaphor for morality.

The *Voltaire* ought to have satisfied everyone on the last count but for the important fact that the sitter had been literally rather than metaphorically translated into stone, his feeble nudity failing to enlist admiration for his intellectual power. As Quatremère insisted, "There is no metaphor without metamorphosis."[28] Embarrassment may have greeted the nudity of the octogenarian philosopher, but Pigalle's *Voltaire*, together with his *Maréchal de Saxe*, Falconet's *Peter the Great*, Pajou's *Buffon* and Titon du Tillet's *French Parnassus* still paved the way for d'Angiviller's famous series of "Grands Hommes" begun in 1776.[29] Yet neither Falconet's nor Pigalle's adumbration of the fully fledged "neoclassic stoic," nor the deliberately moralizing character of the "Grands Hommes" was sufficient to spare these works the jibes of the ultra-

Figure 6. Jean-Baptiste Pigalle. *Citizen* from the *Monument to Louis XV*, 1765. Bronze statue. Reims.

neoclassicists. After the Revolution, the condition of these works as exemplary moral art suffered in direct proportion to the scathing criticism levied at their "decadent" style.[30] Jacques-Louis David, in his famous diatribe against the Academy delivered on August 8, 1793, singled out Falconet with especial venom:

> This Falconet is the person who wrote six fat volumes to prove that the horse of Marcus Aurelius in Rome (a recognized masterpiece of antiquity) is not equal to the one he made in Russia, and which will soon be so buried under the snows of the Neva that no one will talk about it anymore.[31]

Without referring directly to the "Grands Hommes," these words illumine the disrepute into which works failing to attain the "true style" fell, regardless of their inspiring character.

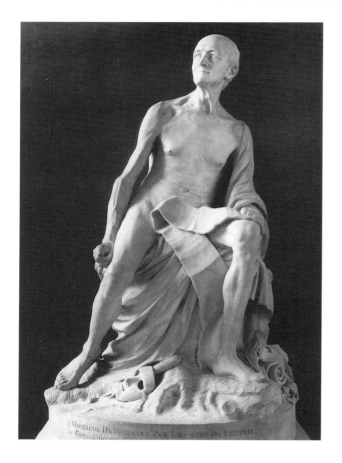

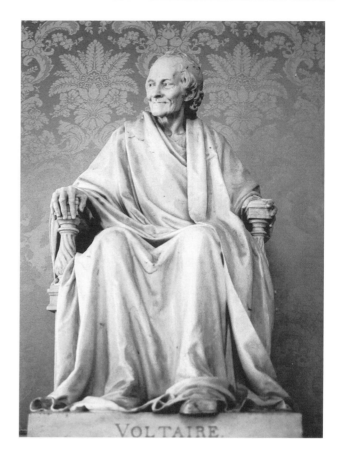

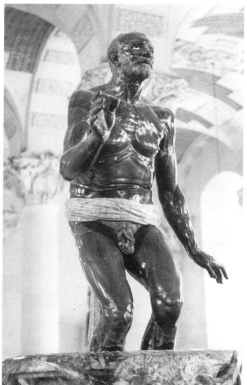

The "Grands Hommes"

These manifestations of national pride, the "Grands Hommes," owe their existence not only to the many precedents mentioned above but also, of course, to the general cry for exemplary moral art to which J.-J. Rousseau had added his own voice in 1750.[32] Fueled by a passion for Plutarch, it was a persistent theme. Critics continued to publish their hackneyed views for decades.[33] Pierre Patte's *Monumens érigés en France à la gloire de Louis XV*, a serious plagiarism of Titon's *Descriptions*,[34] added impetus to the trend further accelerated by repeated injunctions in the various Salon criticisms. La Font de Saint-Yenne, in his well-known *Sentimens sur quelques ouvrages de peinture, sculpture et gravure ecrits à un particulier de province*

Figure 7 (above left). Jean-Baptiste Pigalle. *Voltaire*, 1766. Marble statue. Paris, Louvre. Photo: R. M. N.

Figure 8 (left). Dying Seneca. (Fisherman), Paris, Louvre.

Figure 9 (above right). Antoine Houdon. *Voltaire*, 1779–83. Marble statue. Paris, Comédie Française.

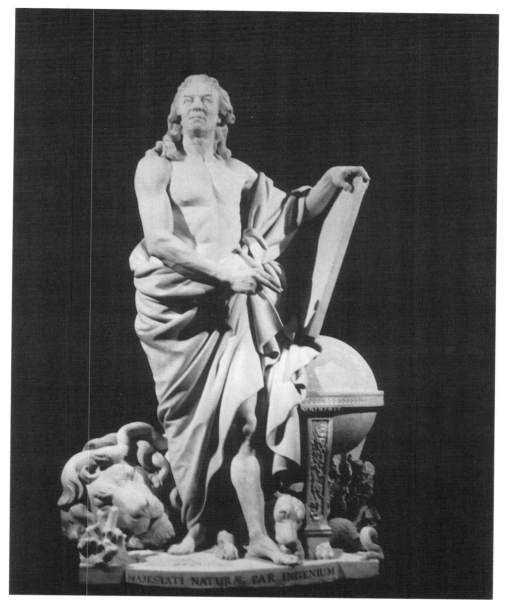

Figure 10. Augustin Pajou. *Buffon,* 1773–76. Marble statue. Paris, Muséum d'Histoire Naturelle.

(1754), dwelled at some length on the inspiring character of works celebrating the virtues of famous Frenchmen and of great kings and queens. In the year of its publication, Louis-Claude Vassé (1716–72) sculpted the first of five busts of French notables commissioned by Pierre-Jean Grosley for the Hotel de Ville of Troyes.[35] Between 1754 and 1763 appeared *Mignard, Girardon,* the jurisconsult *Pierre Pithou, Père le Cointe* and the poet *Jean Passerat.* Mathon de la Cour duly noted their appearance and ennobling effect.[36] When Jean-Jacques Caffiéri (1725–92)[37]

exhibited his busts of *Jean-Philippe Rameau* (1765) and *Jean-Baptiste Lulli* (1771), they received enthusiastic support from the author of *A l'ombre de Raphael.*[38] The year 1768 saw the publication of Octavien de Guasco's important *De l'usage des statues chez les anciens,* which endorsed the erection of civic monuments, followed by Charles Henri Watelet's "Essai sur les jardins" (1774) favoring statues of great men.[39] Finally, the *Mercure de France* carried a notice on the great men to be placed in the école Royale Militaire in 1773, introducing the group of soldiers with

the line, "If one considers sculpture from a moral point of view, its most noble goal is to perpetuate the memory of famous men,"[40] a leitmotif in the criticism of sculpture. Innumerable examples could be offered as proof of the generally recognized if not fully documented trend leading to d'Angiviller's actually belated "Grands Hommes" commission.[41]

St. Germain's *Ordonnance du roi* of 1776, a document concerned with military reform, almost certainly lent additional weight to this commission. The army was in turmoil, plagued with disorderliness, insubordination, luxury and discrimination.[42] The entire series of "Grands Hommes" was clearly a propagandistic enterprise, but the military heroes in particular had a more than passing relevance to a very real problem. Destined for the public museum being planned for the Louvre, these works were intended to influence the young military aristocracy in the direction of absolute obedience and discipline, and physical readiness too. The biscuit de Sèvres reductions would also have done this, but they were so expensive and rare, that in no way can they be considered a democratic dissemination of the full-size works.[43]

Indeed, one might question whether the commission was a democratic one at all. By choosing figures with whom the impressionable might identify, the crown could be seen as attempting to fine-tune the manipulation of its subjects and particularly its young officers. Still, the nationalistic, democratizing and inspirational character of the series serves as a watershed in the iconography of public sculpture.

Of the actual moral effect upon the salon public little is known. The matter crops up briefly in Montaiglon's *Judgment of a Young Girl on the Salon of 1777*, which gives one pause when imagining how a little boy might have reacted:

> I went there one day recently with my little American, who was suddenly transfixed and who, without being conscious of it, became an interesting spectacle. On entering the court, she was pleasantly surprised to see, at each corner, the statues of four of our great men: those of Fénélon by M. le Comte; of Sully by M. Mouchy; of Descartes by M. Pajou; and of the Chancellier de l'Hopital by M. Gois. She admired these four benefactors of the nation brought to life by the marble. They impressed her as greatly as if they had been there in the living flesh. The Chancellor especially, shown at the moment he offered himself up to his murderers, stirred her emotions: she blushed, made a quick,

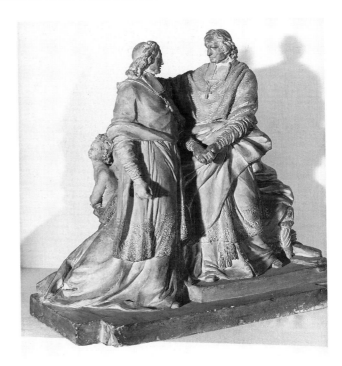

Figure 11. Jean-Guillaume Moitte. *Bossuet and Fénélon*, 1780s. Terra-cotta sketch. Montpellier, Musée Fabre. Photo: Claude O'Sughrue.

involuntary curtsy and flew off like a bird up the grand staircase.[44]

The primitive eye (a young American!), the innocent beholder, Rousseau's Emile duly educated. If little exists beyond this by way of a general commentary on the public reception of these statues, which were relegated to storage after the salon, one knows at least that the celebration of greatness enjoyed a private or domestic vogue as well. Mlle Clairon, for example, crowned a bust of Voltaire during one of her Tuesday evening dinners.[45] Others kept little altars to the memory of great men in their gardens.[46] Finally, the introduction to the Official Catalogue for the Salon of 1793 advised its readers that the public, like the ancient Athenians, was turning to the tombs of its heroes for inspiration in the fight against tyranny.[47] One is then treated to the "fact," in footnote, that "in our own day we have seen soldiers sharpening their sabers on the tomb of Marshal Saxe." If this is to be believed, even metaphorically, the popularity and propagandistic usefulness of Pigalle's work as a moral exemplar outweighed the current artistic theories and prejudices of the Academy, spearheaded by Quatremère de Quincy, Pigalle's own pupil.

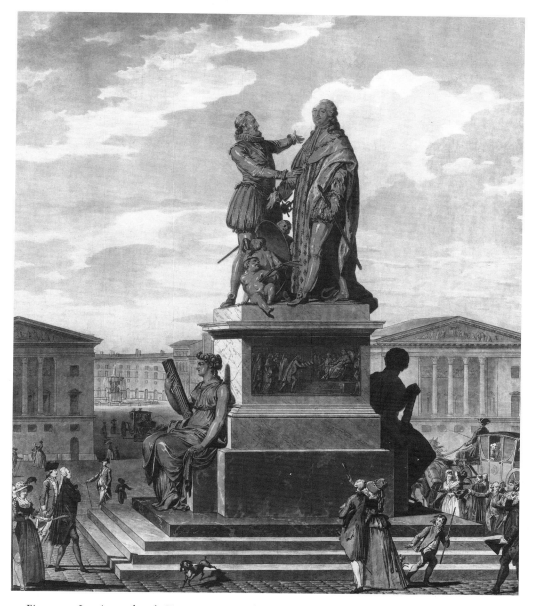

Figure 12. Janninet, after de Varenne. *Project for a Monument to Louis XVI and Henry IV, 1790.*
Color engraving. Paris, Bibliothèque Nationale, Cabinet des Estampes (de Vinck, vol. II, no. 460).
Photo: © cliché Bibliothèque Nationale de France, Paris.

Titon du Tillet had initiated a long French sequence reaching a climax of official patronage in d'Angiviller's commission,[48] a trend which continued unabated during the entire nineteenth century. In 1727, he had even projected a "Temple of Victory" for Louis XIV's military heroes as a pendant to the intellectually and artistically oriented *Parnassus.* This set the example for the Place Royale du Peyrou commission in Montpellier which never materialized.

The Baron de Faugères submitted his project for the Place Royale du Peyrou in 1771, proposing to decorate the corner pedestals of the square with groups of Louis XIV's great heroes and distinguished civil servants.[49] Pigalle himself voiced an active interest in the undertaking though nothing came of his enthusiasm since he was not selected to participate.[50] Instead, Clodion (*Condé and Turenne*), Moitte (*Bossuet and Fénélon;* Fig. 11), Pajou (*Colbert and Duquesne*) and Julien (*Président Lamoignon and Chancellier d'Aguesseau*), all prominent sculptors, erratically presented

Figure 13. Joseph Wilton. *Monument to General Wolfe*, 1772. Marble relief. London, Westminster Abbey.

Figure 14. Antoine Houdon. *Project for a Tomb for Prince Alexander Mikhailowich Galitzin*, 1777. Terra-cotta sketch. Paris, Louvre.

models and drawings for their groups, the execution of which was so long delayed that the Revolution finally put an end to the project.

Their chief difference from other such honorific monuments lay in the almost anecdotal grouping of two figures caught in the midst of a discussion, like the famed *Papirius Group* in the Museo delle Terme, Rome.[51] In this respect, they might have just stepped off Titon's *Parnassus* into the Place du Peyrou.[52] It may have been this commission which precipitated the project for an equally conversational *Monument to Louis XVI and Henry IV* (1790; Fig. 12) which depends so

Figure 15. Clodion. *Tomb for the Comtesse d'Orsay,* 1772–89. Terracotta sketch. Paris, Louvre.

clearly on Pigalle's enlightened *Monument to Louis XV* for its overall composition.

A Hero's Death

Though stoicism attained its utmost meaning in the confrontation with death, the active heroism of the early "Grands Hommes" rarely accommodated its immediate presence. Sculpture remained the province of victory. Examples of dying heroes destined for the public square or building appeared, therefore, far more slowly than they did in painting.[53] In principle, death had its foreordained place in the churches and, after the Revolution, in the cemeteries of France (although considerable change would take place there too).

Yet a number of noble deathbed scenes did make an early appearance. Relief especially lent itself to the new vogue in its first appearance off hallowed ground, Luc Breton's vanished *Death of General Wolfe* (1771) being a case in point.[54] Breton (1731–1800), an artist from Besançon, spent his entire life there after a prolonged Roman visit (1758–71) during which he earned his living by, among other things, carving reliefs for various foreigners, including an English architect.[55] This last detail may shed light on what was, after all, a curious choice of subject for a Frenchman. Breton carved his relief in the same year Benjamin West exhibited his famous painting, but no record of its appearance survives to reveal whether it approached the idealized local color of West's revolutionary his-

toricism or whether it followed the model for another relief, his *Testament of Eudamidas* (Fig. 33) after Poussin, for which dates between 1755–65 or 1767–71 have been advanced.[56]

Even the latest date would make the *Testament* one of the earliest reflections of Poussin's deathbed scenes in French eighteenth-century art, which proliferated in tombs and monuments destined for a church location.[57] Joseph Wilton's *Monument to General Wolfe* (1772; Fig. 13) in Westminster Abbey is the most significant full-scale counterpart, a lavish re-creation of Wolfe's last moments in his tent. Shifting the death scene from the battlefield to an interior, Wilton cast the feverish, wounded general as a naked martyr in the arms of an attendant officer.[58] Houdon later tried his hand at this type in his maquettes for a *Tomb for Prince Alexander Mikhailowich Galitzin* (1777; Fig. 14). The vice-chancellor of Russia, the Prince, half-naked in a shroud, calmly yields to death upon a simple couch, attended by Virtue and Friendship whose presence compels Evil in various forms to flee.[59] Not long before, Houdon's friend Clodion had also executed the model for a relief (1772–73; Fig. 15) for the *Tomb for the Comtesse d'Orsay* (1772–89, destroyed 1793) in which the young wife, as she bravely dies, shows her husband the son she is leaving him. If Gavin Hamilton's famous Roman works inspired the composition, the exquisitely modulated surfaces and the figure of death belong to an older school.[60]

By the time Barthélemy-François Chardigny (1757–1813) executed his *Saint Louis on the Verge of Death Giving Instructions to His Son* (1784–6)[61] and

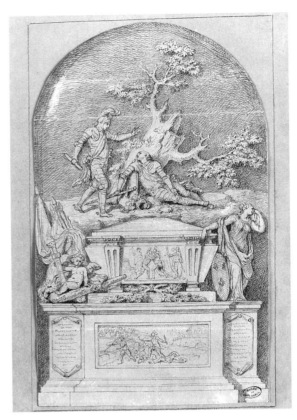

Figure 16. Augustin Pajou. *Project for a Monument to Bayard*, 1789. Drawing. Grenoble, Musée de la Peinture et de la Sculpture. Photo: Musée de Grenoble.

Pajou prepared his project for a *Monument to Bayard* (1789; Fig. 16) the genre had become a staple of salon submissions.[62] With regard to Pajou's sketch, a rich reserve of images of the popular hero's death existed, all of which share the basic elements of medieval armor and a natural, sylvan setting (e.g., A. Beaufort's *Bayard*, 1781; Musée des Beaux-Arts, Marseilles), to which the sculptor conformed.[63] For Pajou, as for many artists (or their patrons), classicism and national historicism presented viable, alternative modes. In fact, he had already tried his hand at historicizing costumes with his vigorous terra-cotta model (1769–73; Musée des Beaux-Arts, Besançon) for the *Statue of Henri IV* which was to have been part of yet another group of inspirational men ordered by Gabriel for the entrance to the Cathedral of Sainte Croix in Orléans.

Of the post-revolutionary death scenes, one of the most interesting developments was the introduction of the unknown hero. Both Denis-Antoine Chaudet and

François Masson executed respectively a relief of *Devotion to the Fatherland* (1792–93; Fig. 17) and a large group of a *Warrior Dying in the Arms of France* (1792–93; lost) for the Pantheon (admittedly a quasi-religious place of commemoration) in which the hero takes the form of a generic young man. If it was politically astute to avoid portraying any one contemporary hero, a hero's stock rising and falling with alarming swiftness, it was equally clever to invite any Frenchman to substitute himself for the anonymous hero. As the century progressed, this genre would come to dominate war memorials, especially after the Franco-Prussian War. The unknown warrior was *the* democratic memorial par excellence.

Other than in these works, however, few heroic deaths appeared in sculpture, the great funerary celebrations having preempted that function. Later, the Napoleonic Wars provided fresh heroes whom it seemed safe once again to commemorate in both painting and sculpture, Général Desaix († 1800) being by far the most celebrated. Thus Joseph Chinard modeled his eccentric *Dying Desaix* (c. 1800–04; Fig. 18).[64] Destined for the Place des Vosges, the work was never finished. Rather than victory, Chinard sought to convey the elegy of passing glory which he emphasized with languid lines flowing down from the horse's head through the rest of the composition.[65] The same configuration appeared in Jean-Baptiste Regnault's painting of *Desaix* (1806; Musée de Versailles), in which Desaix is seen falling from his horse, and Jean-François Peyron's *Death of Général Valhubert* (1808; Fig. 19), both redolent of Christian imagery. Jean-Guillaume Moitte's marble relief of *Death of Desaix* (1805; Fig. 165) for the hero's tomb carries over the idea with clear echoes of West's *Wolfe*.[66]

Subsequently, Napoleon vigorously opposed Claude Dejoux's wish to sculpt a colossal figure of the same Desaix dying, insisting instead upon a living, victorious form (1805–07; Fig. 162).[67] The same thing had happened when Pigalle presented Louis XV with the option of an expiring Saxe or the heroic model ultimately chosen,[68] although in this case the figure was destined for a church. Both Pradier and David d'Angers eventually exploited the pathos of noble demise in similar settings, the former in the *Monument to the Duc de Berry* (1821; Fig. 303), the latter in his heroic *Monument to Bonchamps* (1819–25; Fig. 301). Both men meet their end in classical nudity. An equally nude statue by Barthélémy Corneille (c. 1760–1812), the *Adjutant Dalton Killed at the Crossing of the Min-*

cio (1812) for the staircase of the Senate, was one of the first to commemorate a dying hero in freestanding sculpture without the context of a chapel or church.[69] Of Dalton's appearance, however, nothing is known. Niccolò Bernardo Raggi (1790–1862),[70] an Italian working in France, followed this up later with his *Bayard* (1820) for Grenoble. The hero is seen faltering but still standing against a tree trunk in his last moments in an unfortunate transposition of Géricault's dashing *Wounded Cuirassier* (1814). More interesting and bizarre would have been David d'Angers' statue of Beaurepaire (1740–92) committing suicide. In the sketch (1838; private collection), Beaurepaire stands fully attired in military costume, a pistol to his forehead.[71]

The supreme urgency of impending death emerges fully in David d'Angers' *Général Gobert* (1847; Fig. 20), which shows us Gobert falling from his horse, cut down by guerillas at Baylen, Spain, in 1808. The patron commissioned this work for the cemetery of Père Lachaise, a location somewhere between the public square and the church chapel, and insisted that the moment chosen be that of death.[72] While David drew upon any number of models all the way back to antiquity, in particular the *Dying Amazon* in Naples, there can be no doubt that Sir Richard Westmacott's *Mon-*

ument to General Sir Ralph Abercromby (1802–05; Fig. 21), which shows Abercromby falling from his horse into the arms of an aide, precipitated David's compositional decisions. The life-size, marble group was visible to all in St. Paul's Cathedral, which had become something of a "public place" for the dead by that point, a museum of heroic virtues. David infuses his group with a wild energy through explosive directional changes: the horse's head turns one way, Gobert's body falls to the other side, and the "maquisard" below juts away at yet another angle. David may also have taken his cue from the work of his beloved teacher, Philippe Laurent Roland, whose *Death of Cato* (1783–85; Fig. 22) produced such a shock upon its exhibition in 1785. Passion is the driving force of David d'Angers' work, and such an impassioned language radically heightened the tone of funerary art. Unlike Chinard's strangely languid composition for the Place des Vosges, David d'Angers' monument could pass muster in the middle of a city square. These secular descents from the Cross marked the apogee of this particular genre of national "exempla virtutis," which had a small but significant counterpart in subjects derived from antiquity, including Roland's *Cato*.

In treating the death of ancient heroes, sculptors on occasion gave freer rein to a more violent vocabulary,

Figure 17. Denis-Antoine Chaudet. *Devotion to the Homeland*, 1792–93. Paris, Pantheon.

Figure 18. Joseph Chinard. *Dying Desaix*, c. 1800–04. Terra-cotta sketch. Paris, Louvre.

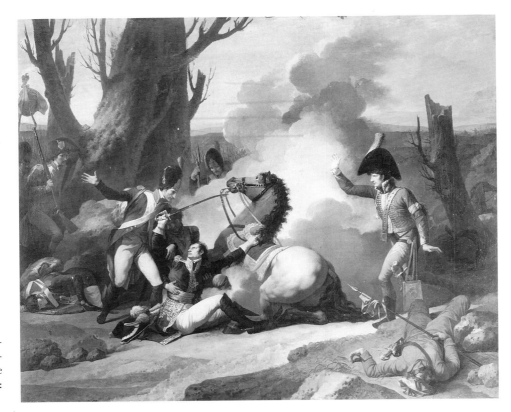

Figure 19. Jean-François Peyron. *Death of Général Valhubert*, 1808. Versailles, Musée de Chateau de Versailles. Photo: R. M. N.

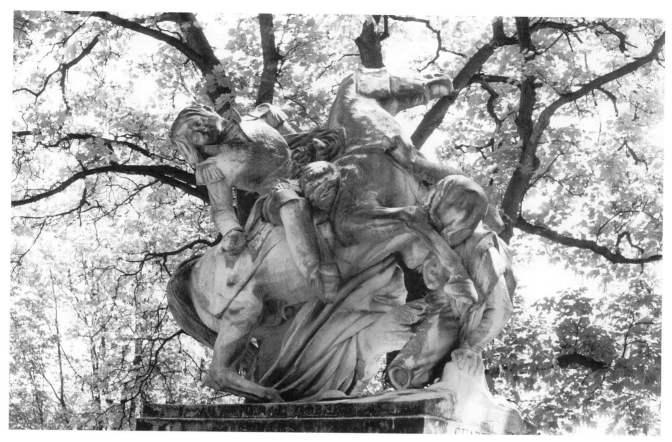

Figure 20 (above). Pierre-Jean David d'Angers. *Death of Général Gobert*, 1847. Bronze equestrian. Paris, Cemetery of Père Lachaise.

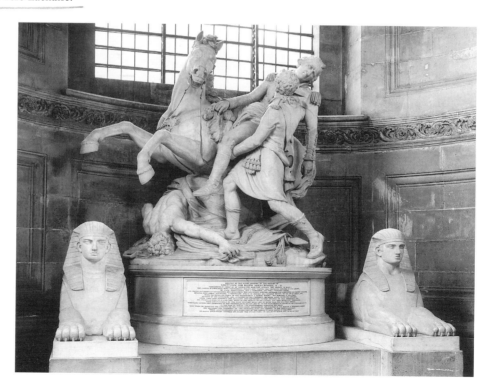

Figure 21. Sir Richard Westmacott. *Monument to General Sir Ralph Abercromby*, 1802–05. Marble group. London, St. Paul's Cathedral.

Figure 22 (above). Philippe Laurent Roland. *The Death of Cato*, 1783–85. Terra-cotta sketch. Paris, Louvre.

Figure 23. François Dumont. *Titan Foudroyé*, 1712. Marble figure. Paris, Louvre.

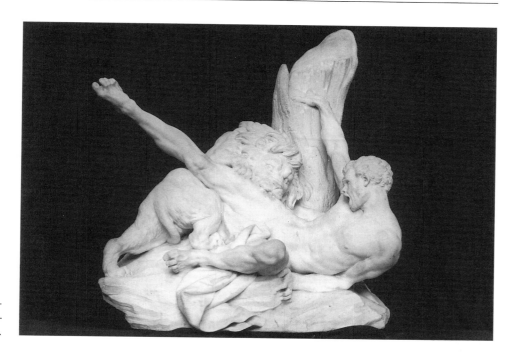

Figure 24. Etienne-Maurice Falconet, *Milo of Crotona*, 1744–54. Marble group. Paris, Louvre.

a fine line separating the heroic from the horrific. Claude Dejoux's statue of *Philopoemen Drinking the Hemlock* (1785; lost) and René Milot's *Death of Socrates* (1785; lost), for example, have as their tumultuous counterpart Roland's Academy reception piece, his *Cato*. The terra-cotta model in the Louvre is small but vigorously expressive. Half recumbent upon a disordered bed, Cato tears open his self-inflicted wound to pull out his own entrails. Repugnance at the explicit details surfaced predictably in contemporary criticism,[73] although Diderot used revulsion at just such details to deride the pusillanimity of his contemporaries.[74]

A long history of sculpture depicting violent death lay behind Roland's *Cato*, for example, François Dumont's *Titan Foudroyé* (1712; Fig. 23) or both Puget's and Falconet's *Milo of Crotona* (1671–82 and 1744–54; Figs. 24 and 25). Roland approached the grim sublimity of death with a new force and studied graphism, while the bed and the sword bear the telltale traces of a more insistent classical vocabulary. Perhaps Roland also found ancient justification for his conceit in the Roman *Dying Gaul* (Fig. 120) or *Gaul Killing Himself and His Wife*, but he far exceeded the pain or violence in them, moving toward the passionate extremities of certain works by Henry Fuseli and Nicolai Abildgaard, for example.

From the "neoclassic horrific" to the purely horrific

Figure 25. Pierre Puget. *Milo of Crotona*, 1671–82. Marble group. Paris, Louvre.

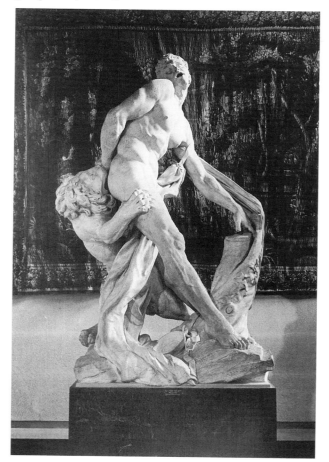

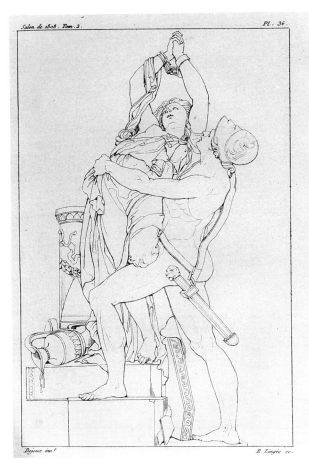

Figure 26. After Claude Dejoux. *Rape of Cassandra*, 1787. Engraving, London, *Salon de 1808*, vol. II, pl. 36.

the distance was small, but few works in this genre survive.[75] Of the few large-scale classical subjects presented at the salon, almost nothing survives. Claude Dejoux's eight-foot plaster *Rape of Cassandra* (1787; Fig. 26), for example, has been lost, although it was a government commission.[76] Neither precisely an "exempla virtutis" nor an entirely horrific or erotic subject, this large group stood somewhere between the virtuous widow type and the delicate rape scenes of the rococo. Nonetheless, Cassandra's decorous, heavenward plea sets the overall tone of noble endurance of an ignoble fate. While surely owing something to Puget's *Perseus and Andromeda* (1678–84; Fig. 27) and other such groups, Dejoux used these as a foil, it would seem, for his more compact grouping, classical details and rigorously centered composition.

The relative scarcity, in comparison to painting, of sculpted "exempla virtutis" drawn from antiquity might suggest a lack of interest on the part of sculptors (and particularly of patrons), but the titles of a number of sample drawings in the Salon catalogues dispel that assumption. Take, for example, Pajou's *An Episode in the Life of Lycurgus* (1763 Salon; Fig. 28),[77] which appeared in the same salon as Vien's *Marchande d'Amour* and in which the Spartan king is showing his people their future king, his brother's son. The drawing is noteworthy for its depiction of a sturdy doric order in the background. Like so many, Pajou turned to Poussin's classicism for inspiration in a grave and stately mode.[78]

The Prix de Rome remained a haven for such themes which Claude Dejoux, anointed member of the Academy in 1795, tried unsuccessfully to enrich with subjects like "Duguesclin's Battle against the English" or "Clorinda and Medoro."[79] The list of Prix de Rome competition titles for sculpture yields, for example, "The Death of Germanicus" (1762), "Mucius

Figure 27. Pierre Puget. *Perseus and Andromeda*, 1678–84. Marble group. Paris, Louvre.

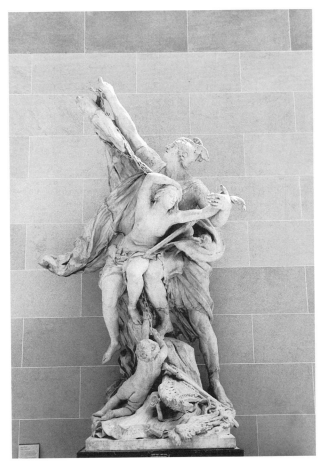

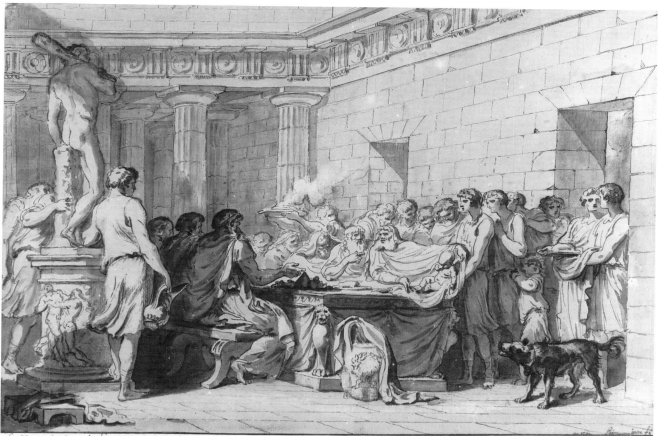

Figure 28. Augustin Pajou. *An Episode in the Life of Lycurgus*, 1762. Drawing. Rouen, Musée des Beaux-Arts. Photo: Musée des Beaux Arts.

Scaevola Confronting Porsenna" (bas-relief, 1769), "Brutus Condemning His Sons to Death" (1787) or "The Death of Tarquin" (1788), clearly the sort of subject with possible counterparts among the military "Grands Hommes," with the exception, naturally, of Tarquin. If the drawings especially signal an interest in the classical "exemplum virtutis," the "Grands Hommes," beginning with Pigalle's *Voltaire* and *Maréchal de Saxe*, remained the principal vehicle of noble sentiment until the Revolution.

CHAPTER TWO

Toward Classicism and Nudity in French Sculpture

IF CANOVA rather than a Frenchman was responsible for the first major programmatic statement of rigorous neoclassicism in sculpture, this in no way alters the fact that the French helped to prepare the ground. As in painting, only gradually did the momentum build toward the unity of style and subject of Canova's *Theseus and the Dead Minotaur* (1783; Fig. 221) and the *Monument to Pope Clement XIV* (1787; Fig. 99). But the constituent elements appeared individually in sculpture at about the same time, the fearless grandeur of Falconet's *Peter the Great* and Pigalle's *Maréchal de Saxe* finding its counterpart in the well-tempered classicism of Augustin Pajou. Even before the latter had begun to explore the possibilities of a mild pseudoclassical style, others had scrutin-ized ancient sculpture with considerable attention. Prominent among these was, of course, Edmé Bou-chardon.

Bouchardon

Edmé Bouchardon (1698–1762)[1] early exemplified that inherent feeling for the normative which periodically appeared in French art as a natural corollary of its exemplary academic foundations, and which, in his case, was abetted by his friendship with the antiquarian Comte de Caylus. First training with his father in the Haute Marne before going to Paris in 1721, Bouchardon was singular in the amount of time he chose to spend in the Eternal City, remaining there for nine years (1723–32) until the Duc d'Antin recalled him to Paris. Few other sculptors succeeded in finding as much remunerative work to sustain them as he did, work which enabled him to remain in Rome.

He had been the first French sculptor of his age to apply the lessons of antiquity there in more than a routine academic way, but he failed to become a *chef d'école* as Jacques-Louis David was to be, due in part, perhaps, to his proud and unaccommodating character. Though he took to heart the lessons he learned and translated some of them into his sculpture, his work remained romanizing rather than classicizing in its later programmatic sense. The senatorial *Baron Philipp Stosch* (1727; Fig. 29 cf. Fig. 30 and pp. 36–37) – another antiquarian – for example, loses none of his individuality to the exigencies of severe idealism. Even after his return to Paris, Bouchardon shed little of his innate classicizing reserve – witness the handsome *Fontaine de Grenelle* (1739–45), perhaps too small and unfountain-like, but composed of exquisitely modeled figures (and delightful "asides" such as the duck flying out of the tall grass). Most famous of all was Bouchardon's equestrian to *Louis XV* with its Roman costuming and four classically draped and classicizing *Virtues* as caryatides on the base. These figures mark an important intellectual shift, as noted above (Chap.1, "Falconet"), away from the monarch as victor to the monarch as father of all the virtues. However, the *Cupid Carving a Bow from Hercules' Club* (first sketch, 1739; marble, 1750; Fig. 104), with its animation and implied cunning, set a tone shocking to Bouchardon's critics and supporters alike. Where Pigalle had managed to elegantly humanize *Mercury* in the simple act of tying on his sandle, Bouchardon seemed to vulgarize Cupid as a gamin. Despite this and despite his usually classical penchant, his popularity grew, which was no mean accomplishment in light of the well-known later jibes of both French critics and Academy directors directed at

Figure 29. Edmé Bouchardon. *Baron Philipp Stosch*, 1727. Marble bust. Berlin (Dahlem), Staatliche Museen Preussischer Kulturbesitz. Photo: Staatliche Museen.

Figure 30. Luc Breton. *Jean-Melchior Wyrsch*, 1771. Tinted plaster bust. Besançon, Musée des Beaux-Arts. Photo: Bulloz.

the cool manner of classicism. Bouchardon was indeed remarkable in having garnered almost universal praise as the greatest sculptor of his time.[2]

Pigalle

Before dying, Bouchardon named Jean-Baptiste Pigalle to succeed him in completing the equestrian *Louis XV* for what is now the Place de la Concorde, despite the latter's less pronounced penchant for antiquity. All the same, having failed to win the Prix de Rome, Pigalle walked there in 1736, fired by a determination to avail himself of every advantage he might in the pursuit of his career. He remained in Rome three years with the financial assistance of the older sculptor Guillaume II Coustou and was given permission to study at the French Academy. While there, he executed several copies after the antique, including the *Knucklebone Player* (1739; G. Wildenstein, Paris).[3] In the last year of his life, he also sculpted an unfinished, classicizing statue of a female *Thorn-puller* (1785; Musée Jacque-

mart-André, Paris).[4] Why Pigalle executed this work is not known, but the deliberate classicism of every detail speaks of a sudden, renewed preoccupation with the interests of his Roman days and, perhaps, a desire to explore contemporary stylistic evolutions. Where his indubitably classicizing *Voltaire* had offended, this little work could only charm.

On the whole, Pigalle leaned toward a fresh, elegant naturalism which sprang in part from his study of ancient art. His *Child with a Birdcage* (1750; Fig. 31),[5] for example, became a pendant to an antique statue of the same type, showing, along with his *Voltaire*, his particular sensitivity to the qualities of realism in Late Hellenistic and Roman sculpture. As anyone looking to the varied styles of antiquity might, Pigalle found inspiration to suit his temperament. None of his work, however, aimed for the deliberate programmatic classicism of the next generation, nor was it a polemical vehicle in the same sense that the sculpture of his great rival Falconet was. Indeed, Falconet stands out among prerevolutionary French sculptors not only for his for-

Figure 31. Jean-Baptiste Pigalle. *Child with a Birdcage*, 1750. Marble figure. Paris, Louvre.

mulation of an epic style and for his early exploration of the sublime, but for his preoccupation with, if not devotion to, the style of antiquity as well.[6]

Falconet

Although Falconet, a sculptor of singular intellectual achievement, if acid temperament, was noticeably absent from France (1766–83) during a good part of its initial period of artistic reform – or quest for the "true style" – his was a substantial legacy both to the revolutionary and postrevolutionary periods. Like a number of his contemporaries, Falconet demonstrated considerable versatility passing from the boudoir genre in which he excelled to the unexpected heroicism of his *Peter the Great*. If the latter is Falconet's epic manifesto, the *Apelles and Kampaspe* (1765; Fig. 32),[7] a boudoir piece, presents, nonetheless, an important aspect of his ardently defended artistic theories. The

relief anticipates the popularity of such classical themes to be treated eventually in a style consonant with the historical period depicted.[8] In this instance, Falconet's intentions were deliberately polemical and opposed to ancient methods.

In spite of its classical accoutrements, the *Apelles and Kampaspe* still confronts one with the delicate attitudinizing, erotically suggestive subject and diagonal, illusionistic composition of the rococo which Falconet considered to be one of the most tangible modern improvements over the airless void and flat backgrounds of ancient reliefs.[9] Dandré-Bardon (1700–83), a contemporary painter, composer, poet and theoretician, concurred with Falconet in his high opinion of the modern relief, seeing it as the possibility of a union between sculpture and painting which would result in a production superior to both (it being understood that sculpture meant statuary).[10] Yet Falconet, in his *Réflexions sur la sculpture* (read at the French Academy in 1760 and published the following year) had also enjoined his fellow sculptors to model after Poussin to demonstrate the proximity of the two media,[11] a personal "Ut pictura scultura" which might well entail a diminution of perspectival effects. And, indeed, flatness constituted one of the very qualities Luc Breton perhaps inadvertently achieved in his relief after Poussin (Fig. 33) by virtue of its source. He may well have known Falconet's *Réflexions*, but others who did not were also drawn to copying Poussin in relief. Thus, Breton's version can be measured against that (c. 1730; Fig. 34) of the English sculptor Michael Rysbrack (1693–1770) after the same painting.[12] While in both the solemnity of Poussin's painting gives way to an overall busyness of surface texture, in the latter a homely dog, a dramatic curtain and an insistently rococo table break with the original completely.

Compared to Breton's, Falconet's own reliefs were less visibly progressive from a reformer's point of view. They naturally suffered at the hands of programmatic classicists in search of the very void and flat background shunned theoretically by the cantankerous sculptor.[13]

Falconet permeated his writings with pro-modernist views, rejecting the ever-growing antiquomania (if not antiquity itself) around him. His most prominent text in this respect is his *Observations sur la statue de Marc-Aurèle* (1771), in which he specifically noted Winckelmann's wavering attitude from an initially negative to a positive appraisal of the equestrian – Falconet himself holding a largely negative opinion.[14] He

Figure 32. Etienne-Maurice Falconet. *Apelles and Kampaspe*, 1765. Marble relief. Private collection.

Figure 33. Luc Breton. *The Testament of Eudamidas*, c. 1760. Terra-cotta relief. Besançon, Musée des Beaux-Arts et d'Archéologie. Photo: C. Choffet, Besançon.

Figure 34. Michael Rysbrack, *The Testament of Eudamidas*, c. 1730. Bronze relief. Hoare Collection, Stourhead (National Trust), Wilts. Photo: Courtauld Institute.

questioned Winckelmann on a variety of technical points in his notes to his own translation of books 34 through 36 of Pliny (1772)[15] without, however, forgoing a genuine acknowledgment of Winckelmann's achievement.[16] Falconet uttered his flattering encomium despite a feeling of exasperation at Winckelmann's Francophobia, a feeling to which he gave vent in 1776 in his brief exchange of letters with Mengs over the *Observations*.[17] As Piranesi's love of Rome had spurred him to oppose Winckelmann's exclusive Grecophilia,[18] so Falconet's love of Puget spurred him to contest Winckelmann's position in a characteristic bout of nationalism.

Falconet's *Apelles and Kampaspe* illustrates his theories on perspective and the treatment of the flesh for which Puget remained his unshakable ideal: "In what Greek sculpture does one find folds of skin, softness of flesh or the coursing of blood as capitally rendered as in the works of this famous modern artist?"[19] Of course, the Elgin Marbles remained to be fully discovered by European sculptors.

Falconet's dominantly rococo Sèvres productions do tend to veil his classical bent. On closer examination of the relief *Apelles and Kampaspe*, for example, one finds a sturdy architectural framework whose chief effect is to flatten rather than to deepen the background regardless of the diagonals established by the easel and the left pilaster. In fact, Falconet, despite his veneration of Puget and venomous attacks on antiquomaniacs, harbored an interest in a gentle classicism which he delicately expressed in the small statue *Sweet Melancholy* (model, 1761; marble, 1763; Fig. 35) with its reflections of the ancient *Polyhymnia* type (Fig. 36), and in the allegorical statue *Winter* (model, 1765; marble, 1771; Fig. 37), and to which he gave voice in his writings.[20] If Falconet saw no contradiction in his espousal of a more naturalistic idiom and the "beau idéal" he advocated, it may indeed be attributed to his "considering Greek and Roman art as only one in a variety of historic possibilites and not as an antipode to Bernini."[21] This historical consciousness manifests itself differently in his readiness to criticize those works of antiquity, such as the *Marcus Aurelius*, which fell below his standard of excellence. On the other hand, he shared with almost everyone the view that those works of antiquity most fit to convey the principles of nude statuary included the *Laocoon*, the *Farnese Hercules*, the *Torso Belvedere*, the *Dying Gaul*, the *Apollo Belvedere*, the *Antinous*, the *Castor and Pollux*, the *Hermaphrodite* and the *Medici Venus*.[22]

That Falconet created *Sweet Melancholy* for Lalive de Jully may have had something to do with its style, since the collector and patron had earlier commissioned what has come to be considered the first piece of neoclassical furniture, a writing table and filing cabinet designed by L. J. Lorraine around 1756 (Musée Condé, Chantilly).[23] Falconet's work marks a definite change in style from the earlier *Bather* (Fig. 44) of 1757, though even to that he applied an original linear strength. Thus one must suppose a conscious effort on the sculptor's part. And, in view of Falconet's many exchanges with Diderot, an exchange with Lalive de Jully seems all the more probable. The figure, clothed in Grecian simplicity, is filled with contemplative grace, blending the new "sensibilité" with the growing antiquarianism of the time.[24] On quite a different scale, Falconet's *Winter* offers an enticing example of his sculptural gifts in every respect.

Begun in France for the Marquise de Pompadour, the allegory of *Winter* (Fig. 37) was completed in 1771 in Leningrad where Falconet sold it to Catherine the Great. He exhibited the model at the Salon of 1765 indicating that it was intended to be placed "in the midst of a bed of winter flowering plants."[25] Falconet particularly liked this work; Diderot and Jean-Baptiste Claude Robin admired it especially for its classicism.[26] In fact, the pose may have been derived from a work like the Palazzo dei Conservatori *Tyche* (Fig. 38). The technical accomplishment of the carving makes this one of Falconet's most satisfying achievements in his pseudoclassicizing manner, even if the delicate features and expression bear the obvious trace of their time.

The monumental equestrian of *Peter the Great* presents a more complex instance of Falconet's approach to antiquity. The meticulous studies involved in preparing for the modeling of the horse remind one of an Encyclopédiste searching for the truth. "An equerry was asked to ride a horse at full gallop, again and again, on the top of an artificial hillock . . . where he suddenly stopped to cause the rearing of the animal."[27] If Falconet did not carry out Bouchardon-like anatomical studies, he pursued a unique, almost Muybridge-like research into movement. The didactic point behind this lengthy and rewarding exercise lay in proving the shortcomings and anatomical inaccuracies of

less. In this, Falconet showed himself to be an artful compromiser who avoided both the excesses of contemporary clothing and the historical anachronism of ancient military dress. (But perhaps he was dictated to in this matter.) Others felt, however, that a choice had to be made, thus generating the debate of modern versus ancient dress (meaning the toga or complete nudity) which evolved into the more subtle problem of

Figure 36. Polyhymnia. Marble statue. Rome, Musei Capitolini. Photo: Archivio Fotografico dei Musei Capitolini (inv. 2135).

Figure 35. Etienne-Maurice Falconet. *Sweet Melancholy,* 1763. Marble figure. St. Petersburg, Hermitage.

the *Marcus Aurelius*[28] by providing an unquestionably correct horse for a monument to which Falconet added his own visual élan and personal, radically simplified allegory. Indeed, while he updated the ancient statue, so to speak, with his anatomical perfections and by causing the horse to rear at the summit of an artificial hillock in a characteristically modern, baroque way, he nonetheless returned to the dramatic simplicity of the older work by avoiding an elaborate allegorical statement. Falconet also chose the simplest Russian raiment possible for his rather wooden monarch, an outfit that is both nationalistic and time-

Figure 37. Etienne-Maurice Falconet. *Winter*, 1765–71. Marble statue. St. Petersburg, Hermitage.

Figure 38. Tyche. Rome, Palazzo dei Conservatori.

stylistic purity within a classicizing idiom (the subject of later chapters).

Nudity

By virtue of their prominence and numbers, the heated debate centered about the "Grands Hommes":

These four statues [Descartes, Sully, Fénélon, Chancellier de l'Hôpital] are draped or clothed according to their period and condition which adds to the veracity of the resemblance. Messrs. Pigal [*sic*] and Pajou felt that they could dispense with such veracity, the former in his statue of Voltaire and the latter in that of M. le comte de Buffon visible in the King's chambers. It is true that these statues are less portraits than allegorical figures which, in a way, offer us the physiognomy and expression of the genius of illustrious men.[29]

The last sentence points to a grudging understanding of nudity as the assimilation of the sitter to a symbolic or quasi-divine state. But Monsieur de Villeneuve, the author of a "Letter to the *Journal de Paris*" (about the statue of Voltaire clothed "à la Romaine") of 1781, expressed the general feeling of the French as regards Houdon's *Voltaire* in stating that, as the crowning intellect of France, he should be shown in characteristic dress and attitude.[30]

Houdon's *Voltaire* (Fig. 9) is far less Roman than implied by the title of M. de Villeneuve's letter, but it was a convenient pretext for an exposé of the arguments opposing classicism to modernism, essentially favoring the latter. A few years earlier the absence of wigs in certain portrait busts had already triggered adverse commentary in a salon critic who could not bring himself to accept the new fashion "of not endowing such heads with wigs; they think they have

given them the air of Philosphers and I think they merely look like beggars" (e.g., Luc Breton's bust of the painter, *Jean-Melchior Wyrsch*, 1771; Fig. 30).[31] This removal of the very artificial wig to restore the sitter to a more natural condition also carried him one step in the direction of classicism, illuminating in a small way the ties between naturalism and classicism in the rejection of the rococo.[32]

The opposition to contemporary dress grew in strength from the mild "M. Pajou outdoes himself. His portraits are as well realized as contemporary costume allows" (1779; cf. Fig. 42)[33] to the far more insistent opinion that "the artist's inspiration must dry up at the sight of the bizarre shape of our clothing" (1783).[34]

Inevitably, neoclassicism offered the perfect fusion of style and content by virtue of its principal view that the single, male, nude figure constituted the highest metaphor for moral worth and hence the superfluity of precise, historic iconography to convey a moral lesson. Around this notion centered the arguments for idealized nude portraiture to which Canova responded with his *Napoleon* (1801–06; Fig. 158). But the emperor, upon receiving the statue in 1812, quietly ordered it removed to the basement of the Louvre whence it finally emerged as a gift to Wellington from the English nation. The situation was constantly reversing itself, however, as one learns from yet another "littérateur" in 1790 for whom classical attire was simply not democratic enough.

The author of the pamphlet in question repudiated classical dress as a form of elitism inappropriate to a new republic.[35] Thus one finds oneself in the perplexing situation of juggling those opinions favoring classicism during the Revolution as a reminder of the democracy of the ancient Republic and those favoring modern dress as true and democratic (interesting also in dispelling the notion of an exiguous bond between neoclassicism and the rise of the bourgeoisie).[36] In general though, there was a shift toward the consideration of the "Grands Hommes" in terms of a classical aesthetic rather than merely in terms of iconographic properties, a situation obviously favored by Winckelmann's writings and Quatremère's lobbying.

Although Pigalle's *Voltaire* remains the most famous French antecedent, his *Citizen* (Fig. 6) for the *Monument to Louis XV* (1765) can also be invoked in this context as a "hero of the common man." This perfectly composed, full-length statue permanently installed at the base of a royal monument in a public place was the first of its kind in France. In different, more conventional ways, both Bouchardon and Simon Challes (1719–65) had anticipated these developments as well. Due to the death of his patron, Bouchardon never realized his projected statue to the Prince de Waldeck, a commission he received in Rome. But a drawing of 1730 in the Louvre represents the prince on a pedestal, strategically draped around the hips, with his Roman armor at his feet – an exception to military dress due perhaps to the artistic climate of the Eternal City.[37] Some thirty years later, Challes had sent a naked *Christopher Columbus* (1763) to the Salon, which subsequently vanished. The figure lifting some drapery off a globe to reveal America[38] was not well received,[39] and almost nothing was said about the choice of subject which was striking to say the least. What these statues indicate is a sporadic movement toward ideal nudity which in a way was impeded by the *type* of person allowed in the public place. After all, the king would hardly submit to a public state of undress in sculpture. Consequently, one would have to wait for a climate more accommodating to both nudity and nonroyal personages as well (garden sculpture excluded).

In the wake of these came several major works furthering the exploration of the nude portrait. Both Pajou's portrait of the great naturalist *Buffon* (1773–76; Fig. 10) spiritually if not technically part of d'Angiviller's commission,[40] and Clodion's (1738–1814) magnificent *Montesquieu* (plaster, 1779; marble, 1783; Fig. 39)[41] originally had in common the toga. In the face of severe criticism, however, Pajou's son-in-law had had to renounce the toga in favor of the robes worn by Montesquieu in his capacity as "Président à Mortier." Oddly enough, d'Angiviller had agreed to the quasi nudity of Pajou's statue at the time of its commission in 1773. Possibly the profession upon which Buffon's fame rested, that of naturalist, accounted for the surintendant's leniency.

At no time, however, even at the height of neoclassicism, did the French public easily welcome a nude portrait statue. The obstacles strewn upon the path to heroic nudity led certain artists to resort to casuistical arguments in the hope of winning acceptance, which, by 1789, the government more readily accorded. It is well-known, for example, that Pierre Julien still felt obliged to justify his loosely robed *Poussin* (plaster, 1789; marble, 1804; Plate 1; cf. Fig. 40) a figure of superbly athletic form, on the grounds of a sudden noc-

Figure 39. Clodion. *Baron de Montesquieu*, 1779–83. Marble statue. Paris, Louvre.

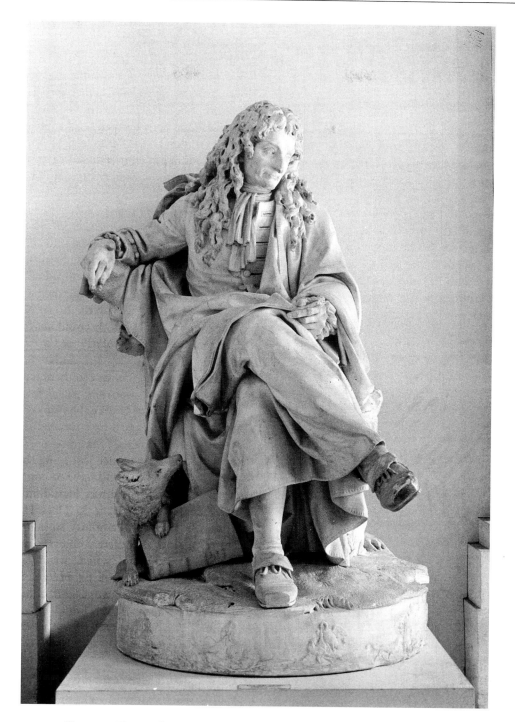

Figure 40. Pierre Julien. *La Fontaine*, 1783–85. Marble statue. Paris, Louvre.

turnal vision during the hot, Roman summer.[42] At least the togalike night clothes reflect the subject's own stylistic inclinations as well as, perhaps, the famous painting of the nocturnal, startled *Marius at Minturnae* (1786; Louvre) by the prematurely deceased Jean Germain Drouais (1763–88), who exhibited the large work in Rome to universal acclaim. Perhaps the least known of these unclothed men, Jean-Baptiste Stouf's (1742–1826) *Montaigne* (commissioned, 1792; Salon, 1800; Fig. 41) most readily justifies his condition.[43] Famous for his enjoyment of walking about naked (noted in the Salon catalogue), Montaigne is remembered here in a peculiarly theatrical pose and state of undress – a Saint Jerome in the desert of the worldly world – with the words "Que sais-je" carved on the base. Stouf studied with Pajou and seems to have quietly co-opted the fainting pose of his teacher's grieving *Psyche* sinking back onto her cushion.

Figure 41. Jean-Baptiste Stouf. *Montaigne*, 1792–1800. Marble statue. Paris, Louvre.

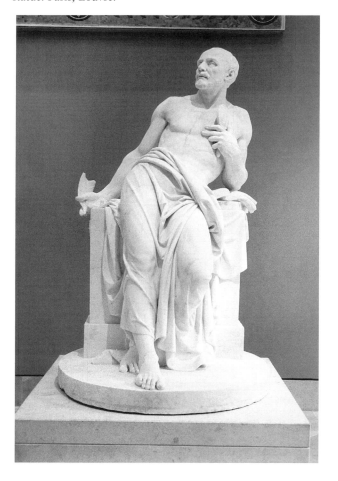

Even Pigalle had projected for an earlier, unrealized monument to Joan of Arc (1760) that she appear "dressed as Pallas, having a leopard [the English] at her feet."[44] While not as radical as the *Voltaire* or the *Citizen*, the figure's intended classical dress shows a remarkable consistency of vision. Furthermore, it would have been the only eighteenth-century homage to a "Grande Dame," one who happened to have been one of France's great military heroes. But did anyone seriously want women to emulate Joan of Arc?

Of the male military heroes, none sports a toga, the question of nudity being entirely ruled out for the present, with the exception of both Bouchardon's project and Challes' almost naked *Young Turenne Asleep on a Canon* (1761 Salon), and he would hardly count as a "Grand Homme" yet.[45] But why exactly should this apply only to the military figures? To the prudish society of the Louis XVI period nudity was cause for concern. It could also be interpreted as vulnerability, a particularly undesirable quality in the sphere of military propaganda. Beyond this, one could simply agree with Luc Benoist's statement that sculpture wanted not only to celebrate a man but an anecdote as well.[46] Unlike the thinkers or artists, these men of action had to be captured in the heat of the "significant moment," that moment of supreme inner struggle and lofty choice justifying their commemoration. Every detail would have to conform to that very particular instant in time, including a plumed hat if need be (cf. Fig. 42, 43). Thus Houdon's famous *Tourville* (1781; Versailles) stands prepared to do battle against completely uneven odds, pointing to the royal command which would send him to his defeat at the battle of La Hogue like Leonidas at Thermopylae. Windswept and proud, he faces his destiny as a hero should, but clothed in the details of history. As far as Diderot was concerned it was "painting, a handsome Van Dyck."[47]

Generally speaking, military figures retained their specific characteristics. Only in death, timeless by all standards, did nudity appear more readily and this within the context of reclining tomb figures and reliefs – witness Pigalle's *Tombeau d'Harcourt* (1771–77; Fig. 99), David d'Angers' *Général Bonchamps* (1819–25; Fig. 301) or Pradier's *Duc de Berry* (1821; Fig. 301). The significance of these considerations lies in underlining the radical change under Napoleon when suddenly, in sculpture, generals and admirals shed their uniforms for the toga or for absolute nudity,

Figure 42. Augustin Pajou. *Maréchal Turenne, Protecting the Crown at the Battle of Dunes (1658),* 1783. Marble statue. Versailles, Musée National du Château de Versailles.

After his many years in Russia and two years in Holland, Falconet returned to France in 1781 embittered by the jealousies and intrigues of the Russian court.[48] In 1783 he suffered a stroke, shattering his hopes of ever seeing Italy on the very eve of his departure.[49] However much Falconet derided the obsequious deference to antiquity already prevalent, and however much he might have thought Puget to have surpassed the ancients, he must surely have shared Diderot's view that no artist could attain true breadth of vision or perfection until directly exposed to the greatness of antiquity, meaning Rome. In the *Observations sur Marc-Auréle,* he touchingly complained, "I have not seen Rome and that vexes me greatly."[50] And if he is to be believed, the sight of a cast of the *Apollo Belvedere* in Russia moved him to tears.[51] In view of his intellectual and artistic aspirations, the temptation to speculate about Rome's possible influence upon him is

Figure 43. Pierre Jean David d'Angers. *Grand Condé,* 1817–19. Plaster statue. Angers, Galerie David d'Angers.

signaling the ascendance of artistic and political ideals over decorum and historical subservience.

While Falconet had not actually attempted to present a nude hero, as had Bouchardon, he had reached for a certain timelessness in his *Peter the Great.* Its historical prominence, however, resides less in its premonitions of classical reductionism than in the suggested heroism of the czar and in its manifestation of a new sublime sentiment which will come under discussion at a later point. The work reveals more vividly than any other Falconet's enduring dialogue with antiquity and the presence of a highly conscious pursuit of style, whether for or against antiquity. He offered a deliberately modern answer to the past, which furthered the cause of naturalism and scientific exploration in opposition to blind admiration and abject imitation of ancient works.

great. Gavin Hamilton and the "International Circle" were in full sway and Canova was by then on the path to international fame. Instead, Falconet died eight years later, paralytic and neglected, while an artistic revolution appeared to pass him by. Yet not only did Falconet exhibit a lasting if quarrelsome interest in antiquity, he also showed a precocious although passing taste for the art of Jean Goujon whose style was so eminently suited to a revival during the period of "high" neoclassicism.

CHAPTER THREE

The Goujon "Revival" in France

O F THE MANY nationalistic and stylistic revivals of the eighteenth century, the Goujon "revival" seems to have escaped notice. Naturally, those commenting on the work of assorted sculptors of the second half of the century have perceived the influence of the great master. But a prolonged look at the period reveals attention to Goujon and the sixteenth century so sustained that it can indeed be called a movement. For the sake of coherence, this chapter traces the history of neo-Goujonism from its incipience to its end in the second half of the nineteenth century as a corollary to the development of neoclassicism.

Goujon's name never achieved the same currency as Poussin's, yet a number of works and critical texts from the period spanning the years from around 1760 to 1840 and beyond attest to a growing consensus of admiration for the sixteenth-century sculptor. Famed for his reliefs rather than for his freestanding sculpture, Goujon's impact remained largely decorative, which may account in part for his not achieving a position comparable to Poussin's in the pantheon of revivals.

This renewal of interest in Goujon coincided with the early stages of neoclassicism, linearity being of the essence in both cases. To draw too intimate a parallel between the mannered contours of Goujon's elongated figures and the radical simplicity typifying the international style around 1800, however, would be a mistake. Goujon flattened and twisted his figures like coiled springs into their shallow, confining spaces. The neoclassicists aimed at a clarity and ease of silhouette more or less free of such contortions until the arrival of Ingres. Still, it was during the postrevolutionary period and the Empire that "Goujonism" reached its

zenith. It took root much earlier, though, in unexpected quarters.

Falconet

Falconet was among the first to show an interest in Goujon with his statuette of the *Bather with a Sponge* (1762; Fig. 45) In his first *Bather* (1757; Fig. 44) for which the later one was a pendant, he had already inclined toward a delicately mannered attenuation, introducing a generation of small-headed figures with sixteenth-century proportions, like Houdon's *Diana* or Pajou's *Ceres*.[1] In the case of the *Bather with a Sponge*, the pose itself rather than the proportions betray Goujon's influence. The young girl, almost entirely divested of the latter's masterful draperies, is cast along the lines of one of the *Nymphs* from the *Fountain of the Innocents* (c. 1547–59; Figs. 56–58), although Falconet reversed the head.[2] Needless to say, he was not aspiring to Goujon's monumentality in either this delicate, articulate statuette for Sèvres or in the earlier *Bather*. Rather, the sixteenth-century master provided him with an enviable model of linear precision to which Falconet brought the inflections of a more gentle naturalism, thereby altering Goujon's greater formal concerns. This foray into the style of Goujon corresponds to Falconet's other classicizing explorations of the time and occurs in the work of his contemporaries as well.

Vassé

Louis-Claude Vassé (1716–72), a disagreeable protégé of the Comte de Caylus whom Bouchardon disowned in favor of Pigalle, stated his affiliation more boldly in

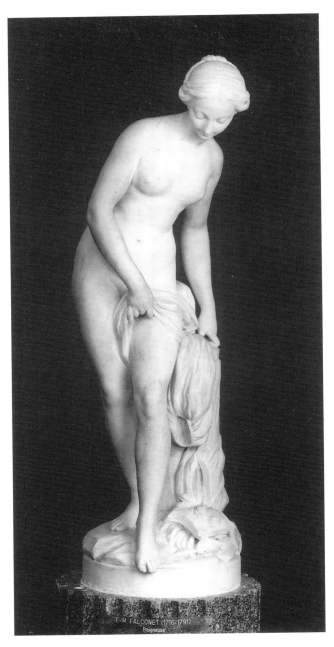

Figure 44. Etienne-Maurice Falconet. *Bather,* 1757. Marble statuette. Paris, Louvre. Photo: R. M. N.

his delicate *Nymph Carrying Water and Wringing Water from Her Hair* (1761, Fig. 46).[3] Like Falconet's *Bather with a Sponge,* the *Nymph* echoes the pose of Goujon's own *Nymphs* (Figs. 56–57). The turn of the head, the positioning of the arms and the urn reflect the sixteenth-century work even more literally than Falconet's figure. The mood was catching: Christophe-Gabriel Allegrain's pleasing if somewhat phlegmatic

Venus at Her Bath (commissioned 1756; 1767 Salon; Fig. 47) recasts in French terms a general feeling for Gianbologna's figural composition echoed in Goujon's own sharp contrapostos.

Without borrowing quite as specifically, other sculptors also gave a Goujonesque flavor to their reliefs, for example, a *Naiad* (1765; Fig. 51) by Pierre-Philippe Mignot (1715–70). It was characterized by Diderot as having a "liquid and flowing character; [a] pure, simple and uncomplicated design."[4] Mathon de la Cour, on the other hand, found the figure to be a little cold (and therefore less rococo and more progressive).[5]

Figure 45. Etienne-Maurice Falconet. *Bather with a Sponge,* 1762. Plaster model. Paris, Louvre. Photo: R. M. N.

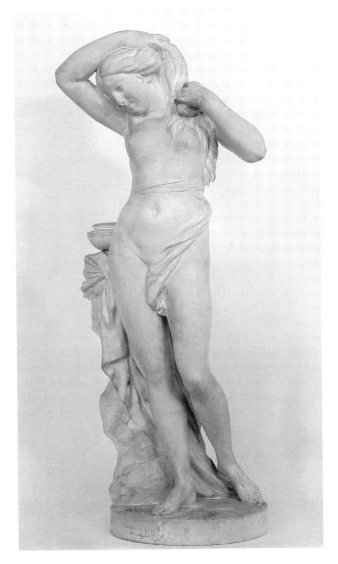

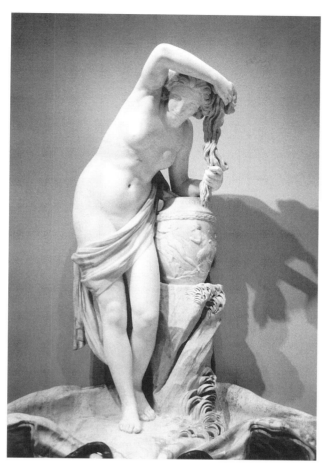

Figure 46. Louis-Claude Vassé. *Nymph Carrying Water and Wringing Water from Her Hair,* 1761. Marble figure. New York, Metropolitan Museum of Art.

Houdon

In a mild-mannered way, Antoine Houdon, whose early sculpture especially bears the imprint of a fine classical sensibility, also expressed an inclination toward the proportions and clear silhouettes of Goujon's work, most notably in his *Diana* (1776–95; Fig. 48). First conceived as a freestanding garden sculpture and often compared to Goujon's sculpture,[6] the *Diana* carried forward Falconet's early exploration of a new figural style. The proportions of the small, proud head to the long-limbed body approach the mannerist canon, although Houdon shunned the extreme tapering of the *Diana of Anet* (Louvre), thought then to be by Goujon, and his powerful contrapostos. A fountain project of Houdon's, quickly sketched by Gabriel de Saint-Aubin (1777; Fig. 49), also bears the telltale traces of Goujon's *Nymphs* for the *Fountain of the Innocents.* Still, Houdon, like others, sacrificed some

of Goujon's most characteristic qualities in favor of prettiness.

The *Diana* would later be derided for her all too French female form,[7] but at the time, the elegant fluidity and strength of line on such a scale signaled a shift in taste. (Her nudity remained a cause for concern in a time of revived moralism.) Beyond these examples, Houdon had either little opportunity or desire to work in this vein. His contemporary, Augustin Pajou (1730–1809), was to play a far more significant role in establishing the sixteenth-century artist as a master worthy of emulation.

Figure 47. Chrisophe-Gabriel Allegrain. *Venus at Her Bath,* 1756–67. Paris, Louvre.

Figure 48. Antoine Houdon. *Diana*, 1776–95. Terra-cotta statue. New York, The Frick Collection. Copyright, The Frick Collection, New York.

Pajou

Pajou, born to a sculptor-craftsman and grandson of a "master sculptor," learned his first lessons from them before going on to study with the great portraitist J.B. Lemoyne. In 1748, at the age of eighteen, he won the *grand prix*, eventually reaching Rome in 1752. By the 1770s he had become the leading court sculptor, an able salesman for his talents and a popular teacher.

At the beginning of his career, Pajou modeled himself upon Goujon intuitively rather than consciously or devotedly. Thus he instinctively drew upon his national artistic heritage for his first major commis-

sion, the beautiful mythological figures of wood, plaster and gilding for the Opera at Versailles. Using a figural style comparable both to Joseph-Marie Vien's chill bathers (e.g., *Greek Woman at Her Bath*, 1767; Fig. 51) and to Goujon's elongated forms, and with the help of some eighteen assistants, including his favorite pupil, Roland, Pajou completed the reliefs in three years (1768–70; Figs. 52 and 53). While less pointedly Goujonesque than Vassé's *Nymph* (Fig. 50) for example, this series illustrates the natural confluence of the emerging neoclassical movement and the Goujon revival – shallowness of carving, classical decorum and smooth forms.[8]

Meanwhile, Pajou's famous son-in-law, Claude Michel or Clodion, had begun to work in close collaboration with the architect Aléxandre Théodore Brongniart (1739–1813) for whom he executed some of his most compelling works. These include the four reliefs of the Liberal Arts at the Musée Thomas Henry at Cherbourg, recently paired with the *Triumph of Galatea* as part of the same commission for Brongniart's *hôtel* for Jacques Louis Bouret de Vézelay, completed in 1775.[9] The hair styles, delicate pleating of the draperies and poses have been likened to Goujon's work as well as that of Primaticcio and the school of Fontainebleau.[10] The relief of *Painting and Sculpture* (Fig. 54), a particularly complex grouping, has the added interest of presenting four figures (one, the back of the *Torso Belvedere*), each from a different point of view. It recapitulates one of the merits of painting – and by extension relief sculpture – as elaborated in the *Paragone*: the human form can be seen at all angles at once in a painting.

Clodion's father-in-law, Pajou, as well as Roland, Pajou's student, both carried out more of this kind of architectural sculpture with growing precision. Pajou followed up his own first rather vague adaptation of Goujon's manner with several works more closely attuned to Goujon and his contemporaries: the reliefs and two freestanding niche figures (1777–82; Fig. 55) for the Hotel d'Argenson (demolished) in Paris.[11] In these, he demonstrated a more expert grasp of Goujon's draperies and compositional principles, largely due to an exact copying of the originals (Figs. 56 and 57), tempered by an eighteenth-century sense of proportion and a more playful grace. Several years later, Pajou turned to Goujon once again with a clearly archaeological eye, when he was invited to provide a fourth side for Goujon's displaced *Fontaine des Innocents*.

Figure 49. Gabriel de Saint-Aubin. Drawing (lost) after Antoine Houdon's *Fountain Project with Naïad*, 1777 Salon.

Since the sixteenth century, Goujon's fountain had ranked as one of the principal sights of Paris.[12] Its impending destruction drew a vigorous protest from Quatremère de Quincy whose published objections (January 1787) and intervention brought about the work's preservation.[13] Something of its popularity may be further gleaned from the fact that Pajou's friend and neighbor Charles de Wailly possessed casts of the fountain in his home on rue de la Pépinière.[14]

The fountain was moved from its original, architecturally dependent site to a freestanding position in the center of the open square, where it still stands today. The move required the creation of a fourth side for the fountain for which the government turned to Pajou who created three new *Nymphs* (Fig. 58) and several bas-reliefs for the south and west sides. To carry out this task with a deeper feeling for Goujon's manner, Pajou requested permission to take a cast of Goujon's *Peace* from one of the oeils-de-boeuf in the Cour du

Louvre.[15] Despite these precautions, Pajou's figures never quite assimilate the weighted elegance and majestic grandeur of Goujon's style. All the same, as a result of his work, and thanks to an archclassicist, Paris saw the deliberate revival of Goujon's manner, generating a special aura of prestige about the sculptor, "preserved" as he was by government order.

Even before this official accolade, Roland had executed a number of caryatids for the facade of the Théâtre Feydeau in Paris in 1786.[16] David d'Angers (Roland's pupil), who saw them before their destruction, remarked that they were a "free and vigorous imitation" of Jean Goujon's *Caryatids*,[17] to which Jacques-Louis David subsequently paid homage in his *Paris and Helen* (1788; Paris, Louvre).

Pajou's *Psyche Abandoned* (plaster, 1785; marble, 1791; Fig. 105), immediately preceding the Goujon restorations, embodies few of the characteristics binding his relief style to that of the sixteenth-century master's. Her classical attributes fail to conceal the essential (and technically brilliant) naturalism of the

Figure 50. Joseph-Marie Vien. *Greek Woman at Her Bath*, 1767. Oil painting. Ponce Museum. Photo: Ponce Museum.

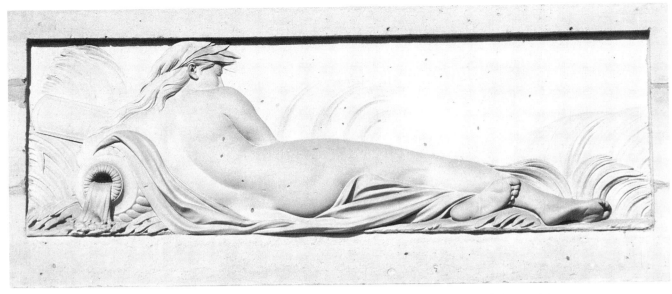

Figure 51. Pierre-Philippe Mignot. *Naïad*, 1765. Stone relief. Paris, Fountain of the Haudriettes.

whole, lacking either the mannerist canon or that sense of linear tautness governing the work of programmatic classicists and already more evident elsewhere. He revised his work with another, however, a terra-cotta statuette of *Ariadne* (1796; Fig. 106) executed after the onset of the Revolution, in which he elongated the limbs in a way reminiscent of Clodion's work of the period[18] and devised a more severely calculated pose. The basic configuration is identical, but the figure is more standing than collapsing and altogether more compact, as though Pajou were belatedly applying some of the lessons he had learned while

working on the *Fountain of the Innocents*. If Pajou nurtured the Goujon revival largely because of the nature of his commissions, rather than from deep artistic conviction, he nonetheless gave a sustained impulse to it.

Boichot

A less familiar figure on the Parisian scene, and hence less influential, the obscure but greatly gifted Guillaume Boichot[19] (1735–1814) pronounced himself far more dramatically a disciple of Goujon and the six-

Figure 52. Augustin Pajou. *A Goddess*, 1768–70. Gilded wood and plaster relief. Versailles, Opera House of the Chateau de Versailles.

teenth century than most of his contemporaries. A student of Challes, whose vanished nude *Christopher Columbus* (1763) revealed an early interest in classical idealization, Boichot was in a good position to absorb his teacher's precocious inclinations. He failed to win the Prix de Rome in 1765, but he managed nonetheless to travel to the Eternal City. There, he studied antiquity and the mannerists, whose style he continued to absorb upon his return to France in 1770. At that time he paid a number of visits to Fontainebleau to study the art of Niccolò dell'Abate, Primaticcio and Il Rosso.[20] Before settling in France in 1771, he visited Rome once again where he earned his living by making reductions of "the most beautiful statues of antiquity for a few Englishmen, true lovers of art."[21]

Boichot's numerous drawings show this able draftsman to have been immersed in the sixteenth century,[22] as does a terra-cotta vase in the Louvre, with its superbly modeled funerary gathering of nudes (1791 Salon; Plate 2).[23] Some of his most successful creations in this style survive in the form of terracotta medallions at the Musée de Chalon-sur-Saône, his hometown. He produced an entire decorative scheme for the château of the Marquis Louis-Henri de Pons between 1770 and 1773, including the four medallions of *Water Divinities*.[24] The sharp contortions and anatomical proportions of one in particular, a female figure (Fig. 59), abundantly illustrate Boichot's careful study of Goujon's work (as well as that of the Fontainebleau mannerists). One finds the same cramping of the figure into an awkwardly small space, resulting in a sense of bursting energy particularly evident in this early medallion.

Figure 54. Clodion. *Painting and Sculpture*, 1775. Terra-cotta relief. Paris, Louvre. Photo: R. M. N.

In spite of his long friendship with Vivant-Denon, whose bust he sculpted in 1804, and J.-L. David's encouragements, Boichot never became a full-fledged success, his death putting an end to whatever small reputation he had. His interests however were premonitory of the nationalistic stylistic developments which followed hard upon the outburst of the Revolution and to which he would have a more public occasion to contribute.

Charles Percier provided the drawings for the reliefs of the Arc du Triomphe du Carrousel, to be executed in strict accordance not only with their design but also within a specified depth.[25] A marked tendency toward flatness pervaded relief carving throughout this period, which David d'Angers would come to exalt as the only manner appropriate to this mode, speaking repeatedly of "grands méplats" in his *Notes*.

Figure 53. Augustin Pajou. *A God*, 1768–70. Gilded wood and plaster relief. Versailles Opera House of the Chateau de Versailles.

Figure 55. Augustin Pajou. *Nymph,* 1777–82. Plaster statue for the Hotel d'Argenson (demolished, 1923). Paris, Banque de France. Photo: Atelier de l'Image et la Reprographie.

Figure 56. Jean Goujon. *Nymph,* 1547–59. Marble relief. Paris, Fountain of the Innocents.

Figure 57. Jean Goujon. *Nymph,* 1547–59. Marble relief. Paris, Fountain of the Innocents.

Figure 58. Augustin Pajou. *Nymph,* 1789. Marble relief. Paris, Fountain of the Innocents.

The academician and theoretician, T. B. Emeric-David, who favored the adoption of Goujon's style in the work of other sculptors, showed a surprising lack of sympathy for Guillaume Boichot's reliefs of *River Gods* (1807–09; Fig. 60) for the Arc de Triomphe du Carrousel. Oddly thinking that Boichot had been striving after a Praxitelean grace, he dismissed the "Florentine mannerism" as a poor second.[26] In executing the

River Gods, Boichot merely followed a pattern consistent with his innate taste.[27]

Neo-Goujonism appeared well before the Revolution and thus cannot be claimed as a revolutionary by-product. The new verbal honors conferred upon Goujon after 1789, however, and the far more pointed sculptural references to him, imposed in part by the commissions, transform what had been a fairly ran-

dom taste into a more pronounced alternative to the international style, principally in decorative, architectural sculpture. In fact, while reflecting a neoclassical preoccupation with line and contour, the revival may have even represented a rejection of the international style in favor of the nationally acclaimed classicism of Goujon's reliefs on public monuments. After the Revolution, and during the Empire, the French eagerly turned to their own grand master, holding him up like a shield against the Canovian tide.

Moitte

Jean-Guillaume Moitte's (1746–1810) relief of *The Aristocracy Buried under the Ruins of the Bastille and the Triumph of Liberty* (Fig. 61) for the enormous temporary Triumphal Arch for the Fête de la Fédération, July 14, 1790, at the Champs de la Fédération,[28] enriches the revival with its flamboyance. Moitte, it should be said, since time has greatly obscured his rep-

Figure 59. Guillaume Boichot. *Water Divinity*, 1770–73. Terracotta relief. Chalon-sur-Saône, Musée Denon.

utation, came to great prominence in revolutionary Paris, working hand in hand with both Quatremère de Quincy and Jacques-Louis David and sharing the latter's political convictions.[29]

The subjects of the reliefs for the Triumphal Arch gave him the opportunity to depict unusual scenes: here, the monstrous and symbolic Hydra of aristocratic evils slowly subsides, vanquished by Liberty.[30] Several "relief" drawings made after his return from Rome (1773) astonished other artists and set the course for what would follow.[31] Moitte threw caution to the winds in depicting these events, paying scant attention to classical decorum except in the two hieratic profiled figures of the triumphant female allegories. If anything, Roman rather than Greek reliefs constituted their formal premise, the figures to the right exuding an appropriately Gallic quality. And again, Goujon's ghost lurks behind the Genius furiously striding to the left. The relief of *Renown* (attributed to Goujon at the time; Fig. 62; cf. further discussion of Figs. 62 and 63 on page 55) over the chimney of the Salle d'Honneur at the Château d'Ecouen lay somewhere in the back of Moitte's mind along with Roman images. As to the elongated proportions, these were again appropriated from the work of Goujon and the school of Fontainebleau, and they appear in many of his drawings, particularly those of decorative objects which he sketched for the jeweller Auguste.[32] The overwrought composition of the *Aristocracy Buried* eventually gave way to a more lucid relief style, readily legible at a distance. But Moitte's greatest originality lay in this highly charged, impassioned language.

Moitte paired the relief mentioned above for the Triumphal Arch for the Fête de la Fédération with another, *The Arrival of the King in Paris and Order Established by the Parisian Militia* (Fig. 64) celebrating the universal Federation. Louis XVI, Marie-Antoinette and their children advance in a friendly and respectful fashion to the left, followed by toga'ed French citizens whose passage is cleared by active, visibly elongated, mannered soldiers. (Mme Moitte even figured in the procession at the head of the group of women who donated their jewels to the cause.) To the event, Moitte applied not only the style of Goujon combined with antique reminiscences but also the palliating, auspicious ambiance of a popular period in French history implied by the Henry IV costumes worn by the monarch and his family.[33] The project for an unreal-

Figure 60. Guillaume Boichot. *River Gods*, 1807–09. Stone relief. Paris, Arc de Triomphe du Carrousel.

Figure 61. Jean-Guillaume Moitte. *The Aristocracy Buried under the Ruins of the Bastille and the Triumph of Liberty*, 1790. Engraving by Massard. Paris, Bibliothèque Nationale. Photo: © cliché Bibliothèque Nationale de France, Paris.

ized *Monument to Louis XVI and Henry IV* (1790, Fig. 12) magnifies the same political message.

Few noted Moitte's penchant for mannerism in clear terms, the theoretician Quatremère hailing him broadly for his "true style." A comment of Delécluze's, published in 1828, gives a clue to the reason for this absence of distinction: "During the last few years, in France, one dubs 'classical' any painter devoid of imagination who professes to mechanically imitate the sculpture of antiquity *or of the masters of the sixteenth century.*"[34]

Moitte, J.-L. David and Quatremère were intimately involved after the Revolution. Quatremère, who was in charge of the renovation of the Pantheon, handpicked Moitte for the execution of the pediment,

Figure 62 (right). School of Jean Goujon. *Renown*, c. 1550. Plaster after the original relief over the Chimney of the Salle d'Honneur, Château d'Ecouen. Photo: R. M. N.

Figure 63 (below). Pierre Baltard. Moitte's *Genius of Liberty*, 1793. Drawing after Moitte's plaster model, 1817. Bibliothèque Historique de la Ville de Paris. Photo: Lauros-Giraudon.

while David selected him to execute the reliefs on the arch for the Fête de la Fédération. A more ringing endorsement of his style would be hard to imagine (although it was not uncontested). Like David, Moitte worked extensively in the service of the Revolution, shaping his artistic language to meet its needs, particularly in the many reliefs he projected and executed.

The Pantheon[35] gave Quatremère, who assumed responsibility for the transformation of Ste. Geneviève into the nation's repository of fame in 1791, the opportunity of giving free rein to his classical doctrines. He avoided sculptors like Houdon (who had executed reliefs for Ste. Geneviève) and Pajou whose classicism failed to satisfy his exigencies, turning rather to those in whose dogmatism he felt confident. Fontaine, who knew Quatremère's plans, reported that he wanted to call on those "young sculptors who, having completed their studies in Italy, were returning to France and bringing with them . . . the principles of taste founded on the admiration of ancient works."[36] In spite of this, he gave a particularly French stamp to the whole. The Pantheon became a vast sculptural enterprise in which Lucas, Lorta, Cartellier, Petitot, Masson, Chardin, Boichot, Boquet, Ramey, Blaise,

Figure 64 (top). Jean-Guillaume Moitte. *The Arrival of the King in Paris and Order Established by the Parisian Militia,* 1790. Engraving by J. B. Luciend. Paris, Musée Carnavalet. Photo: Andréani, for the Photothèque des Musées de la Ville de Paris by SPADEM.

Figure 65. Jean-Guillaume Moitte. *"Nous sommes tous des soldats,"* c. 1792. Drawing. Paris, Musée Carnavalet. Photo: Habouzit, for Photothèque des Musées de la Ville de Paris by SPADEM.

Dupasquier, Beauvallet, Anger, Stouf, Baccarie, Suzanne (J.-L. David's traveling companion on his crucial student trip to Naples), Foucou and Delaistre participated for the interior reliefs.[37] Moitte, Chaudet, Roland, Boichot, Lucas and Lorta contributed on a grander scale with statues for the peristyle and entrance.[38]

Quatremère ensured what he considered to be the proper dependence of sculpture on architecture in tandem with Moitte, who shared equally in the conceptual responsibilities:[39] every group and relief expressed its relation to the whole clearly and purposefully without betraying the laws of artistic decorum.[40] This was most tellingly displayed in the interior reliefs with their blank backgrounds and explicit emphasis on the underlying planarity of the architecture. Quatremère had even foreseen a frieze of funerary ceremonies, the "French Panathenaians," [41] an early call upon the program of the Parthenon. Little remains of the secular ensemble dismantled at the onset of the nouveau régime. A few prints and drawings, a terra-cotta model, these are the few remnants which nonetheless convey something of the dominant tone. Goujon's presence could be felt particularly in the reliefs.

Moitte's pedimental relief *La Patrie couronnant les Vertus civiles et héroïques* (1793) presented a complex allegory through a simple, heraldic grouping at odds with the earlier Federation reliefs.[42] In this, one can be sure that Quatremère had his say. Strong vertical and horizontal axes dominate the whole.[43] In certain respects the iconography still resembles that for the Federation reliefs with their symbolic beasts, victories, despots and ruins. A detail of a drawing for the pediment (Fig. 63) showing the Genius of Liberty bearing the *palladium* of France and leading two lions drawing the chariot filled with the attributes of Virtue preserves Moitte's characteristic manner, though the movement of the figures is punctuated by a hieratic stillness at the very center of the composition. In the contorted figure of Moitte's Genius of Liberty especially, those Goujonesque characteristics of his other works emerges. The head and arms are neatly modeled on Goujon's nymphs and other female figures by him or thought to be by him (e.g., Fig. 62), turning and twisting themselves into two-dimensional patterns.

Four drawings for spandrel reliefs (c. 1792; Fig. 65) capture the same mixture of movement and stasis.[44] The drawings give no indication of the eventual relief depth, but it is safe to assume that whatever was executed would have been as flat as Claude Ramey's *Music and Architecture* (c. 1793; Fig. 66) for which the terra-cotta model survives at the Musée Carnavalet.[45] In the spandrel, Ramey fused the neoclassical ideal with the grace of Goujon to produce an elegant, decorative work more lucid, graceful and traditional than Moitte's designs. If these few examples hardly convey a complete picture of the Pantheon's decoration, their relative stylistic consistency points to a national brand

Figure 66. Claude Ramey. *Music and Architecture* (c. 1793). Terra-cotta relief. Paris, Musée Carnavalet. Photo: Photothèque des Musées de la Ville de Paris by SPADEM.

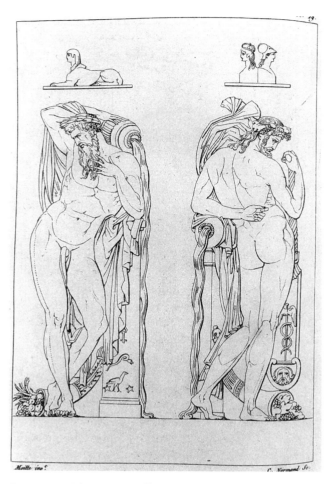

Figure 67. After Jean-Guillaume Moitte. *The Nile and the Rhine,* 1805. Engraving, Landon, *Annales,* 1833, vol. II, pl. 36.

of classicism partly inspired by Goujon. The same, however, cannot be claimed for the two remaining peristyle reliefs by Chaudet and Lesueur, which the artists elaborated from more individual perspectives.[46]

Moitte's proclivity to Goujon cropped up again in the male river gods, the *Nile* and the *Rhine* (Fig. 67), flanking the *Death of Desaix* on his monument to the popular hero (1805). They and the female Genii on the end of the sarcophagus gave Moitte another opportunity to measure himself against his artistic forebear with great elegance.

The persistence of this trend is all the more interesting in that nothing compelled Moitte to adopt this national style, a situation which Napoleon's renovation of the Louvre (1805–10) would impose. Politically, this would also be an occasion for France to show the world the strength of her own classical cultural heritage in no need of a boost from Rome.

The Louvre

Roland, Denis-Antoine Chaudet (1763–1810) and Moitte together executed reliefs for the attic of the west facade of the Cour du Louvre between 1805 and 1810. Emeric-David pointedly savoured their Goujonesque flavour:

> In 1805, a sort of contest drew together three of the greatest masters of their period, Moitte, Roland and Chaudet. They sculpted three bas-reliefs on the interior facade of the Louvre, next to, and to the North of, the Pavillon Sarazin. The first to the left is by Moitte; the one in the center is by Roland; the third by Chaudet. They had to imitate Jean Goujon and his disciples to preserve the harmony of the monument: as a result the struggle was difficult and glorious. Perhaps Chaudet was too polished where he should have shown himself more audacious and energetic. Moitte, gathering his energies, dared to take on Michelangelo; better yet, Roland brought Goujon back to life, and appears to have surpassed his competitors.[47]

Of the four female allegories, Chaudet's *Victory* (Fig. 68) exhibits the most serenely mannered pose and the least massive proportions. In this, he remained true to himself, opting for a greater overall delicacy and tranquility. His *Homer* and *Virgil* also retain the air of his personal, Anacreontic style.[48] This lyrical sense surfaces in the roundels of *The Three Arts of Drawing* (Fig. 249) and the *Genius of Sculpture* executed during the same period for the vestibule of the Louvre. In these he demonstrated an able synthesis of Canovian and mannerist elements (rendered all the easier by Canova's own mannerism). Moitte's contorted, Michelangelesque *Moses* (Fig. 70) owes a general debt to the relief by Goujon and his assistants dominated by the figure of Mercury (Fig. 69). Roland's *Victory and Peace* with *Hercules, Minerva,* the *Nile* and the *Danube* (Fig. 72) derive their general appearance from Goujon's relief of Genii over *Mars and Bellona* (Fig. 71).

All three sets of reliefs display relatively shallow carving and a generic similarity due to the subjects and an undoubtedly clear agreement between the three sculptors and Percier and Fontaine, in charge of the renovations. Yet, the closer the sculptor was to international neoclassicism, the more distant he was from Goujon. Chaudet and Moitte exaggerated the two-dimensional patterns, emphasizing hieratic profiles or

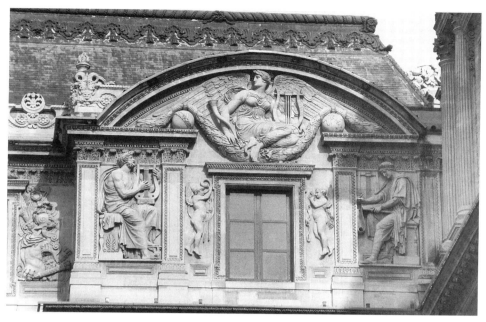

Figure 68. Denis-Antoine Chaudet. *Victory, Homer and Virgil*, 1810. Stone relief. Paris, Louvre, Cour Carrée.

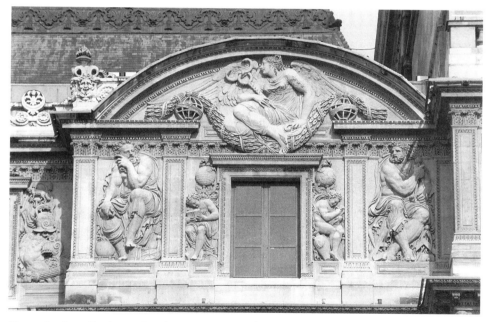

Figure 69. Jean Goujon and assistants. *Mercury above Archimedes, Reading and Writing Genii, and Euclides*, c. 1552–55. Stone relief. Paris, Louvre, Cour Carrée.

strict frontality at the expense of Goujon's freer contortions. In this respect, Emeric-David's encomium to Roland for mastering Goujon's style better than the others rings true, inasmuch as he kept the latter's livelier spatial sense. None of the imitators, however, had the courage (or the desire) to fully imitate the claustrophobic effect of cramped space generated by Goujon's figures. On the other hand, the fidelity of their renderings takes on a new strength when compared to the insipid imitations produced by an Augustin Dumont for the Pavillon Lesdiguière between 1854 and 1857. These reliefs have entirely lost the taut linear quality of the earlier works, pointing to the obvious importance of neoclassicism in understanding and emulating Goujon.

The earlier reliefs saw the day at about the same

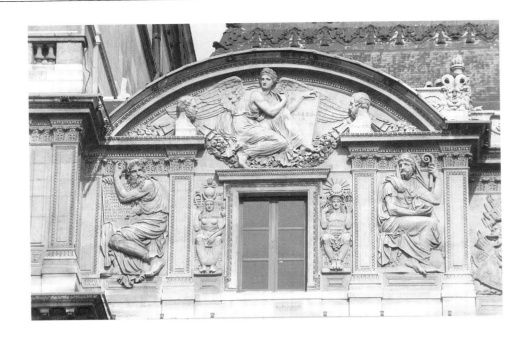

time that Chaussard, in *Le Pausanias français* (1806), commended the surpassing achievements of Fontainebleau and the sixteenth century. In rapturous terms, he linked the names of the French and Italian schools in a sweeping panegyric which ends in praise of Goujon's unrivaled mastery.[49] Alexandre Lenoir had anticipated this admiration in his words of dedication for two freestanding monuments to Goujon and Cousin erected around 1800 in the Musée des Monuments Français. Saluting them as founders of the French school, he too paid homage to their talent.[50] As an extension of this newly endorsed approval of the sixteenth-century master, François Lemot, who along with Claude Michallon was commissioned to restore the Salle des Caryatides at the Louvre in 1794, also executed a replica of the caryatids for the Salle des Maréchaux at the Tuileries in 1806 under Percier's direction.[51] By 1810, Landon's

Figure 70 (opposite, top). Jean-Guillaume Moitte. *Legislation, Moses and Numa,* 1810. Stone relief. Paris, Louvre, Cour Carrée.

Figure 71 (opposite, middle). Philippe-Laurent Roland. *Victory and Peace over Hercules, the Danube, the Nile and Minerva,* 1810. stone relief. Paris, Louvre, Cour Carrée.

Figure 72 (right). Jean Goujon and assistants. *Genii and Coat of Arms above Mars, Captives and Bellona,* 1552–55. Stone relief. Paris, Louvre, Cour Carrée.

simple explanation of the style of Achille Valois' youthful work, the relief of *Leda and the Swan* (1807; Fig. 73) for a fountain on the rue du Regard, lent an almost commonplace tone to the sculptor's use of Goujon.[52] As in the previous examples, the Goujonesque cadenced curves and sinuous draperies derive additional visual significance from the shallow carving which stresses line over volume. It was no coincidence that when the relief was moved, it was moved to the back of the old Fontaine de Médicis (in the Luxembourg Gardens), harmonizing effortlessly with its style.

The Nineteenth Century

Goujon's popularity continued unabated during the nineteenth century. The opening, in 1824, of five galleries in the Louvre to house the collections of mod-

Figure 73. Achille Valois. *Leda and the Swan,* 1807. Marble relief. Paris, Luxembourg Gardens, Fontaine de Médicis.

ern French sculpture put the final official seal on his reputation,[53] while critics and writers cemented the situation with their praise.[54] As might be expected, the younger generation of sculptors, especially during their student years, reflected this fashion in their work. For example, along with John Flaxman and Sir Francis Chantrey, Goujon acted as a guide in the formulation of David d'Angers' (1788–1856) "méplats," or broad, flat surfaces. While a student at the French Academy in Rome, he compounded his exploration of Flaxman and Canova with the influence of Ingres and his taste for Goujon (cf. Fig. 75) in a singular plaster, the *Nereid Bringing Back the Helmet of Achilles* (1815; Fig. 74), for which there was a projected pendant, *Nereid Bringing Back the Shield of Achilles*.[55] The sculptor sealed his *Nereid* into one long, mannered curve, from the extreme, tantalizing preciosity of the helmet-holding hand to the tiny, outstretched foot. Draperies gush about her like the stylized waters of a fountain. Through Ingres' example, David achieved a higher erotic pitch and complexity than that found in Goujon's figures. Few of David's later works betray such a direct response to either Ingres or Goujon, although his relief of *Innocence Imploring Justice* (1820–25) for the Louvre still retains, not surprisingly, a feeling for the contrasts of pleated draperies and naked flesh typical of Goujon's work.[56] Indeed, after this date, the new forces of anti-academicism would begin to erode the primacy of contour and line in favor of a freer, more luxuriant plasticity. Still, in the midst of these new developments, both David's coeval, James Pradier (1790–1852), and his pupil, the dramatic iconoclast Auguste Préault (1809–79), would find the opportunity to meditate, however fleetingly, upon the sixteenth-century master's style.

Pradier's *Psyche* (1824; Fig. 265), completed in Rome at the time of the opening of the Louvre galleries, may have been carefully calculated to capitalize on that publicity as well as the recent arrival of the *Venus de Milo* in Paris (1821).[57] Even at the time of its exhibition, Emeric-David noted a parallel between the columnar figure, with her mannered (indeed Canovian) gesture, elaborate hairdo and heavily pleated draperies, and the art of Goujon.[58] Later, David d'Angers also detected Goujonesque elements in Pradier's work, notable also in the spandrel figures of

Fame (1829–34) for the Arc de Triomphe.[59] But the Goujonesque traits were far less pronounced than in David's own earlier work or that of the artists of the First Empire. Pradier subsequently laid aside this eclectic neo-Goujonism. Some twenty years later, Préault tried his hand at it in a more searching way.

Préault, who said "I am a connoisseur of Michelangelo, of Jean Goujon, of Germain Pilon,"[60] lent substance to his admiration in his *Ophelia* (plaster, 1843; bronze, 1876; Fig. 76).[61] The virgin floating in the water derives her grace in part from the mellifluous flow of lines in the draperies which hark back to Goujon and sixteenth-century sculpture.[62] While shunning direct quotations from Goujon's work, Préault did homage to his art. Every part of the body is made to conform to the expressive quality of the long, liquid curve, just as David d'Angers had based his *Nereid* upon one arching line. But the medium, the literary source (Shakespeare) and the deeper subject of madness and death, were characteristic of the fevered rebellion against academicism. What Delacroix achieved through "flochetage," Préault tried to realize through his creation of a state of material flux in bronze. Plastic form melds with plastic form, the ebb and flow of lines gently obscuring the contours of Ophelia's body as she slowly sinks to her death. The sorry maiden and the water are one.

Préault's relief marks the end of the Goujon revival on a monumental scale. Already the end of the Empire and of building programs likely to encourage an emulation of his manner had signaled a decline of that particular trend. The style, fashions and subjects of the sixteenth century, however, remained in vogue well into the 1860s when Albert Carrier-Belleuse and Antoine Dalou both produced magnificent, Goujonesque kneeling caryatids for the Hotel de Païva in Paris.

It is but a short step from the Goujon revival to full-fledged neoclassicism. Most of the sculptors interested in the sixteenth-century artist were equally attuned to the advent of the "true style" and most of them also had a chance to broaden and sometimes deepen their acquaintance with antiquity under the auspices of the French Academy in Rome. A glance at the activities of the international group of artists gathered there will serve as a final preamble to the study of the advent of neoclassicism in France.

Figure 74. Pierre-Jean David d'Angers. *Nereid Bringing Back the Helmet of Achilles,* 1815. Plaster relief. Angers, Galerie David d'Angers.

Figure 75. Jean Goujon. *Naïad* from the stylobate of the Fontaine des Innocents, 1647–59. Marble relief. Paris, Louvre.

Figure 76. Auguste Préault. *Ophelia,* 1843–76. Bronze relief. Paris, Musée d'Orsay.

Rome

ROME! – the ultimate destination of not only every French art student aspiring to official success, but of most northern (meaning non-Latin) artists as well. The city provided antiquity at firsthand, harbored the first museums and lay at the center of excavations under way throughout southern Europe. From the 1760s on, it offered a rich international panoply of artistic figures fired with enthusiasm for antiquity and the re-creation of its principles. Henry Fuseli (1741–1825) gave succinct visual expression to the profound importance of Rome for the artists of his generation in *The Artist Moved by the Grandeur of Ancient Ruins* (1778–80; Fig. 77). This record of despair in the face of inspiring if irretrievable glory speaks not only of the city's past glories and surviving treasures, but also of the artist as a "superior feeler of things,"[1] of a new subjectivity, of the responsibilities of programmatic reform, and of the measure of these burdens communicated through Piranesian scale. The French, however, appeared to be free for a time of the more acute symptoms of this nostalgia, even though one of the most notable obligations of the sculpture students at the French Academy was the copying of an ancient statue. What may easily be misconstrued as a sign of neoclassical intentions was often merely a perfunctory and, at times, even an unbearable duty.[2] Thus it was one of the paradoxes of the French Academy in Rome, that in spite of its exemplary curriculum, which included the compulsory copying of antiquities,[3] it failed to generate the intense programmatic neoclassicism that would culminate in the work of Antonio Canova and Bertel Thorvaldsen, both of whom shunned copying as a demeaning activity.[4] Did their long academic tradition inure the French to the vividness of a renewed classical language? If in

the security of their academic stronghold they appeared to be immune to the feverish intensity with which both the Roman restorers and the northern artists pursued antiquity in these early stages of neo-classicism, a number of the young sculptors at the academy proved to be more sensitive to the call for artistic reform and to the activities of other foreigners in the city than has been allowed. A glance at the contemporary artistic climate in the domain of sculpture will help to set their endeavors in perspective.

Before the French Revolution, Rome's position as the sine qua non[5] of art was absolute, the city drawing to itself both a familiar and a less well-known group of artists which included, during the 1760s and 1770s, the sculptors Luc Breton (in Rome from 1758 to 1771), Clodion (1762–71), Antoine Houdon (1764–68), Pierre Julien (1768–73), Claude Dejoux (1768–74), Jean-Guillaume Moitte (1771–73), Philippe Laurent Roland (1772–77), Antoine Dupasquier (1776–79), Christopher Hewetson (1756–98), Joseph Nollekens (1760–70), Thomas Banks (1772–76), Johann Gottfried Schadow (1775–85), Johan Tobias Sergel (1767–78), Alexander Trippel of Schaffhausen (1774–93); the Romans, Vincenzo Pacetti (1746-1820), Bartolommeo Cavaceppi (1716? – 99) and Antonio Canova (winter 1779–80); as well as the painters Jacques-Louis David (1775–79), Fuseli (1770–78), George Romney (1773–75), Gavin Hamilton (1723–98) – a permanent resident from 1748 on – Anton Raphael Mengs (1728–79), who came and went (1754–61, 1769–73, 1777–79), and Nicolai Abildgaard (1772–77); and, in his own category, Piranesi (1720–78).

Among the sculptors mentioned, two in particular elicit interest for their successful careers as restorers of

Figure 77. Henry Fuseli. *Artist Moved by the Grandeur of Ancient Ruins,* 1778–80. Drawing. Zurich, Kunsthaus. Photo: 1995, Copyright by Kunsthaus Zurich. All rights reserved.

ancient works, namely Bartolommeo Cavaceppi and Vincenzo Pacetti. In fact, the history of restoration offers a telling parallel to the development of programmatic neoclassicism in sculpture. A growing respect for the intrinsic worth of fragments gradually superseded the rather cavalier attitude toward antiquities characterized by such radical alterations as Pierre Cartellier's conversion of an antique torso into a statue of Napoleon under the direction of Vivant-Denon.[6] In his "Tenth Discourse," Sir Joshua Reynolds, after adducing Michelangelo's work as proof that beauty of form alone was sufficient to create great art, used the *Torso Belvedere* to emphasize his point, concluding that its great attraction rested in the "perfection of [the] science of abstract form" which everyone might enjoy "if they could but divest themselves of the expectations of *deception,* and look only for what it really is, a *partial* representation of nature."[7] By 1816, Canova, Flaxman

and Benjamin West were actively opposing any attempts whatsoever to "improve" the Elgin Marbles along the lines of Thorvaldsen's Aegina restorations for Ludwig I of Bavaria in 1816.[8] This was not only a matter of archaeological purity but also of aesthetic maturity and artistic respect, for who would be so bold as to restore the unrivaled Phidias? This appreciation of the intrinsic value of fragments would eventually have far-reaching consequences, culminating in Rodin's truncated forms.[9]

Cavaceppi

Among those distinguishing themselves for their energetic commercial activities were Joseph Nollekens, Vincenzo Pacetti and, above all, Bartolommeo Cavaceppi, who was a close friend of Winckelmann and the single most important restorer of antiquities in

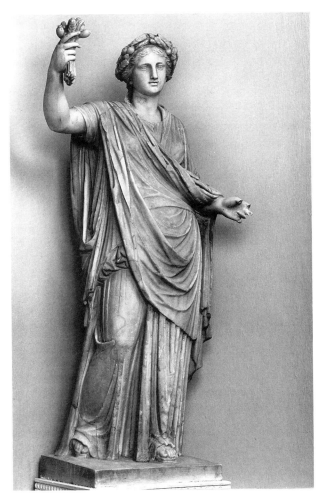

draped and posed with little feeling for the stronger lines and firm contraposto of ancient models – a solid but workmanlike creation. His restorations and copies, on the other hand, are particularly noteworthy for their precision and consistency, betraying the touch not only of a fine craftsman but of a true amateur as well. Indeed, Cavaceppi's success allowed him to amass a considerable collection which he could study at leisure. He was known to all and many were known to him, so that his discoveries and observations about ancient sculpture circulated freely, giving a boost to the increasingly sophisticated practice of archaeology.

Pacetti

Vincenzo Pacetti (1746–1820) followed in Cavaceppi's steps even to his belated baroque style, though

Figure 79. Bartolommeo Cavaceppi. *Ceres,* 1760s. Marble statue. Middlesex, Syon House. Reproduced by kind permission of His Grace the Duke of Northumerland.

Figure 78. Bartolommeo Cavaceppi. *Hygieia Restored as Ceres,* before 1768. Marble statue. Hampshire Broadlands. Reproduced by gracious permission of The Right Honourable Lord Romsey. Photo: Forschungsarchiv für römische Plastik, Köln (#1689/4).

Rome.[10] The fervor with which English patrons especially had begun collecting antiquities spurred sculptors like Cavaceppi to undertake restoration as a full-time career, leading inevitably to a study of classicism and through it to his own mitigated neoclassicism. Cavaceppi never fully overcame his education in the baroque-rococo school though his restorations were carried out in the spirit of the work at hand, meaning with a new stylistic integrity which had a lasting succession among later sculptors.[11] An example of his own invention (Fig. 79) and an example of his restoration (Fig. 78) elucidate both his competence and his shortcomings when it came to inventiveness and charm of execution. His figure is heavy, and

for the redecoration of the Villa Borghese between 1776 and 1778 he executed a number of mildly neoclassical reliefs for which Gavin Hamilton may have provided the designs.[12] His 1773 prize-winning group of *Achilles and Penthesilea* (Fig. 80) drew the attention and praise of the Romans and tempted Sergel to model his own intense *Mars and Venus* (terra-cotta, 1775; marble, 1804), dependent upon both Pacetti's work[13] and its source, the *Menelaus and Patroclus* (Loggia dei'Lanzi, Florence) of which the Pasquino in Rome preserves the ruined likeness.[14] Pacetti visibly strove after nobility and severity, but like Cavaceppi, he lacked the artistic means to achieve them. This lends credibility to Count Leopoldo Cicognara's recollection, in his important *Storia della Scultura* (1813–17), of Vien and Sergel's view that Italian sculptors were incapable of executing anything but copies and restorations.[15]

Nollekens

Among the foreigners in Rome, Joseph Nollekens (1737–1823)[16] engaged in an early, tempered classicism also precipitated by the English passion for antiquities. Nollekens, a winner of the gold medal at the Academy of St. Luke in 1768, developed the artful vocabulary of a simulated classicism amounting almost to a spirit of forgery. His *Venus Tying Her Sandal* (1773; Fig. 81) is a case in point. The expression, the hairstyle and general form show a good understanding of ancient models[17] but no real attempt to formulate a modern classical language. Why indeed should he if – money being his principal object – his patrons were satisfied with his pastiches?[18]

Nollekens' reputation rested chiefly on his bust portraits for which he was famous, "the Emperor of bust chisellers,"[19] which distinguishes him from those

Figure 80. Vincenzo Pacetti. *Achilles and Penthesilea,* 1773. Terra-cotta group. Rome, Accademia di San Lucca.

Figure 81. Joseph Nollekens. *Venus Tying Her Sandal,* 1774. Marble statue. Yorkshire, Wentworth Woodhouse. Photo: Courtauld Institute.

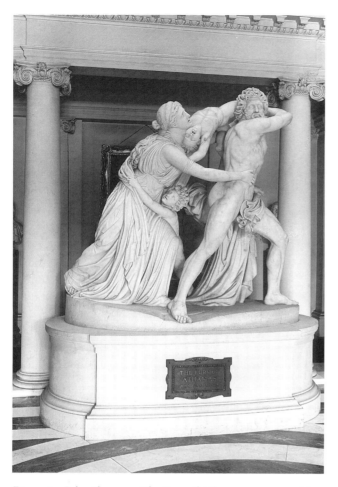

Figure 82. John Flaxman. *The Fury of Athamas*, 1790–94. Marble group. Suffolk, Ickworth, The National Trust. Photo: A. F. Kersting.

sculptors like Thomas Banks, John Flaxman, Falconet and Canova, who, in their pursuit of the "grand style," shunned portraiture to the best of their abilities (although Canova produced such remarkable life-size, full-length portraits that his reputation could rest on those alone). At this point it should be said that in spite of the mania for antiquities, the market for an original, modern, classicizing work was small. Banks' devotion to his art remains all the more remarkable in view of the difficulties and prejudices besetting all sculptors sharing his tastes and ambitions:

Phidias still boasts contemporary praise![20]

Considered against this background, Flaxman's joyful surprise at receiving the commission for his life-size, four-figured group of the *Fury of Athamas* (Fig. 82) rings true: "Who would have employed me in England

to make a group seven feet high of a man and a woman, an infant and a larger child? I have never yet heard of an English sculptor being employed on such work."[21] In spite of their growing archaeological knowledge, the restorers and copiers who executed excellent replicas and performed tastefully in repairing ancient broken parts more often than not failed to demonstrate a profoundly classical spirit in their personal creations.

It fell to the well-known group of English and Scandinavian artists gathered around Fuseli and Hamilton to set the tone for an increasingly radical and dramatic approach to antiquity.[22] A brief step back in time to the person of Johannes Wiedewelt will underscore the degree to which sculptors were as deeply involved as painters in the questions raised by Winckelmann.

Wiedewelt

The progressive if moderately skilled Danish sculptor, Johannes Wiedewelt (1731–1802),[23] in fact left Rome in 1758 for Copenhagen after several years of sharing an apartment with Winckelmann, his friend and correspondent until the latter's death in 1768. This association with Winckelmann had a lasting effect, which Wiedewelt transferred to his pupils, the Swiss Alexander Trippel, who opened a popular studio for northerners in Rome in 1776, and the far more celebrated Dane, Bertel Thorvaldsen (1770–1848), who arrived in Rome in 1797 for a stay of some forty years.[24]

Wiedewelt practiced a heartfelt if ponderous classicism, his garden sculptures (e.g., *Paris and Helen*, 1764, Schlosspark-Fredensurg) being a provincial amalgam of late rococo or baroque elements and heavy-handed classicizing motifs. Still, his unusual *Tomb of Frederick V* at Roskilde (erected 1769; Fig. 83), composed of a raised classical sarcophagus topped by a column and flanked by two isolated mourning figures, made a radical statement in stark black and white.

To some degree, Alexander Trippel (1744–93) may be seen as his most obvious heir, a man, as H.W. Janson said, of great ambition but uneven talent.[25] While his main work, the *Tomb to Count Sachar Tschernyschew* (1787–88) survives in fragments only, a vanished drawing of it captures the essential ingredients of calm lucidity and symmetry.[26] But even his best works lack the grace and refinement of, say, Bertel Thorvaldsen's, although it may be that he sought no such qualities, preferring a blunt "conceptual" classi-

cism instead. His early death of malaria, common in those days in Rome, curtailed an influential career.

With a busy and well-attended studio, Trippel surely familiarized other sculptors in Rome with Wiedewelt's distant creations through discussions or even sketches. Undoubtedly they knew Wiedewelt's starkest creations from a French translation of C.C. Hirschfeld's *Théorie de l'art du jardin* which appeared in Leipzig in 1781 with a number of illustrations of Wiedewelt's original monuments for the gardens of Jägerpriss (1777 on; Fig. 84). They are all to a greater or lesser degree characterized by the geometric simplicity and abstraction usually associated with Goethe's sculptures at Weimar, such as the sphere of the *Altar of Good Fortune* (1777). In one way or another, knowledge of Wiedewelt's work circulated in Rome and formed the backdrop for northern radicalism most impressively and passionately expressed first

by Johan Tobias Sergel, who was to deploy a far greater if less pedagogic talent, and then by Thorvaldsen.

Sergel

An intimate of the English circle in Rome,[27] a friend of Clodion[28] as well as of Julien and Houdon (with whom he did anatomical studies),[29] and a frequenter of the model-drawing sessions at the French Academy, Johan Tobias Sergel (1740–1814) became one of the dominant personalities in Rome where he remained from 1767 to 1778. Again, Cicognara referred to him as one of the best sculptors of his day.[30] His passionate reworking of the classical canon yielded in rapid succession his *Diomedes* (1771–72), *Mars and Venus* (1771–72), *Drunken Faun* (1770–74), *Rage of Achilles* (c. 1775) and *Dying Othryades* (1778), all character-

Figure 83. Johannes Wiedewelt. *Tomb of Frederick V*, 1769. Marble. Church of Roskilde. Photo: Courtauld Institute.

Figure 84. Johannes Wiedewelt. *Monument*, 1777 or later. Norwegian marble. Jägerpriss Park, Denmark.

dierly figure of dynamic vigor. He exaggerated the contraposto in the shoulders for greater visual thrust as the hero steals away with the image of Athena on which the safety of Troy depended.[32] Gavin Hamilton's comparably flamboyant classicism in *Achilles Dragging Hector's Body around the Walls of Troy* (engraved by Cunego in 1766), may have encouraged Sergel's propensity for sustained dynamism.

A versatile artist, he displayed a more lyrical temperament in his *Cupid and Psyche* (c. 1770–74; Fig. 87), originally created for Madame du Barry.[33] The mellifluous circling of arms anticipates the same quality in numerous other works of "high neoclassicism," most notably Canova's *Venus and Adonis* (1789). What distinguishes this group from earlier pairs is the self-contained clarity of the silhouette and the purity of the classical physiognomies, although Psyche's imploring gesture, to be rendered so much more archly by Ingres in his *Jupiter and Thetis* (1811) and Cupid's gentle withdrawal retain a delicate naturalism.

The essentially heroic tone permeating Sergel's art, especially during his Roman and second Parisian stay (1778), contributed to the formulation of the "sublime," Michelangelesque vocabulary employed by the English artists grouped in Rome. The repressed energy of the *Diomedes*, for example, surges forth from the *Rage of Achilles* (c. 1774–75; Fig. 88). Although he turned to a style no more remote than the second century B.C.,[34] Sergel achieved a degree of raw intensity evocative of times more ancient still, and comparable in quality to that found in a number of Flaxman's later line drawings.

The *Dyonisiac Scene* in the Uffizi,[35] Giulio Romano's crushing mass of Titans in the Palazzo del Te at Mantua, these and other Michelangelesque creations lent their weight to the new muscular frenzy and contractions of this period. And if Clodion made his *River Scamander Dried Up by Vulcan's Fire* (Fig. 89) after his arrival in Rome in 1762,[36] then he too shared in forging the drama of this new heroic mode, more particularly since Sergel was greatly influenced by his modeling style.[37] The circles grow and the links multiply if one also considers that Clodion lived near Piranesi in 1770–71 and was most likely a friend of his.[38]

Upon his return to Sweden at the end of 1778, Sergel tempered his originality to suit the requirements of court portraiture (although his standing *Gustavus III* is clearly a clothed, portly *Apollo Belvedere*), caus-

ized by a singular verve free from sycophantic subservience to antiquity.

Sergel's early career brought him to Paris in 1758 while studying with Jean-Pierre Larchevèque, a French sculptor established at the Swedish court. He entered the milieu of the Comte de Caylus and Bouchardon during his seven-month stay, initiating himself into the classical world through these contacts. The fruit of the intervening years ripened in Rome where he found even greater stimulation for his classical leanings.

This exposure to Rome's riches resulted in one of the earliest, freestanding, full-scale, neoclassical statues, the *Diomedes Stealing the Palladium* (Fig. 85), "voted better than anything by Michelangelo, as good as anything by the Greeks."[31] Into this figure, Sergel compressed his knowledge of the *Apollo Belvedere*'s slender, striding form and the universally admired *Horse Tamer* (Fig. 86) of the Quirinale to create a sol-

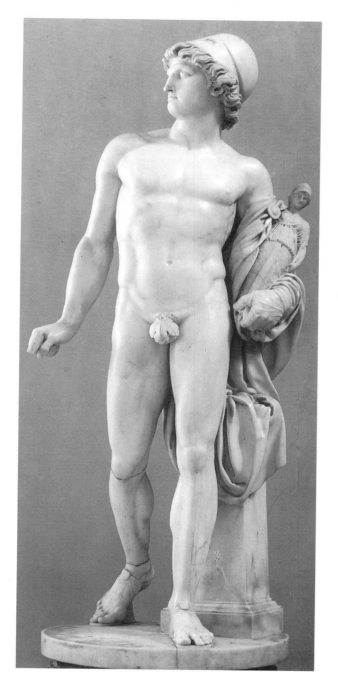

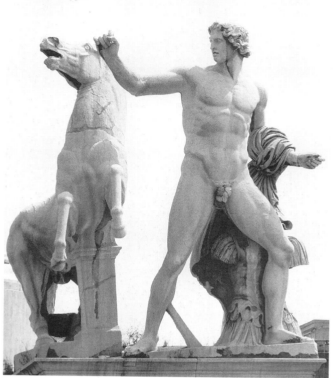

Figure 85 (above, left) Johan Tobias Sergel. *Diomedes Stealing the Palladium*, 1771–74. Marble figure. Stockholm, National Museum. Photo: National Museum.

Figure 86 (above, right). *Horse Tamer*. Marble. Rome, Quirinale.

Figure 87 (right). Johan Tobias Sergel. *Cupid and Psyche*, c. 1770–74. Marble group. Stockholm, National Museum. Photo: National Museum.

Figure 88 (opposite, top). Johan Tobias Sergel. *The Rage of Achilles*, c. 1774–75. Terra-cotta figure. Stockholm, National Museum. Photo: National Museum.

Figure 89 (opposite, bottom). Clodion. *The River Scamander Dried Up by Vulcan's Fire*, c. 1762. Semur-en-Auxois (France), Musée. Photo: © Inventaire Général SPADEM.

Figure 90 (above). John Tobias Sergel. *Dying Othryades*, 1778. Terra-cotta figure. Paris, Louvre.

Figure 91 (below). Jean-Baptiste Giraud. *Dying Achilles*, 1789. Marble figure. Aix, Musée des Beaux-Arts. Photo: Bernard Terlay.

Figure 92. Thomas Banks. *The Death of Germanicus*, 1774. Marble relief. The Earl of Leicester
and the Trustees of the Holkham Estate. Photo: Courtauld Institute.

ing him to look back upon his Roman days as a time of irretrievable happiness and artistic freedom.[39] One of the last works to leave his hands in the final glow of those days, when he was already on his way back north, earned him a gold medal at the Paris Salon of 1778. There were no reactions to the *Dying Othryades* comparable to those that Canova's later *Theseus and the Dead Minotaur* would elicit, but the heroism of Sergel's style still produced quite a reaction.

A French critic unchauvinistically proclaimed the *Dying Othryades* (Fig. 90) the masterpiece of the salon,[40] further commending Sergel's able fusion of "nature and antiquity." Sergel himself spoke of Nature as the source of art, a nature, however, which he looked for in the realm of bodily perfection found, for example, in the fencing halls of Rome.[41] His Nature was the *belle nature* of the handsome model which was also available to him every evening for four years (1768–72) at the French Academy.[42] He studied antiquity by day to achieve a balanced program and felt himself to have been "the first young sculptor to have dared follow nature with the principles of the ancient."[43]

While in Rome, in addition to the sculptors mentioned, Sergel had developed close ties with, among others, the painters François-André Vincent, then director of the French Academy, and Julien de Parme, J. Berthélémy, Joseph Barthélémy, Le Bouteux, Dominique Lefèvre, Carle Van Loo and Joseph-Benoît Suvée, who overlapped with the sculptor Jean-Guillaume Moitte in Rome in 1773.[44] Sergel played an almost unique role as a link between the alienated groups of French and English artists in Rome. One can hardly overestimate the importance of casual conversation among artists communicating new ideas to each other with the help of sketchy illustrations on a stray piece of paper.[45] These ideas must have circulated about Rome like snatches of a melody heard at random, and Sergel – "Bonhomie Sergel"[46] – a most gregarious if moody man, must surely have assisted in their dissemination (cf. Fig. 91).

Banks

The English group of artists which gathered at the English Coffee House in the Piazza di Spagna included

Figure 93 (right). Thomas Banks. *Thetis and Her Nymphs Rising from the Sea to Console Achilles for the Loss of Patroclus,* 1778. Marble relief. London, Victoria and Albert Museum. Photo: Courtauld Institute.

Figure 94. Henry Fuseli. *Samuel Appears to Saul at the Witch of Endor's,* 1777. Drawing. Zurich, Kunsthaus. Photo: 1995, © Copyright by Kunsthaus Zurich. All rights reserved.

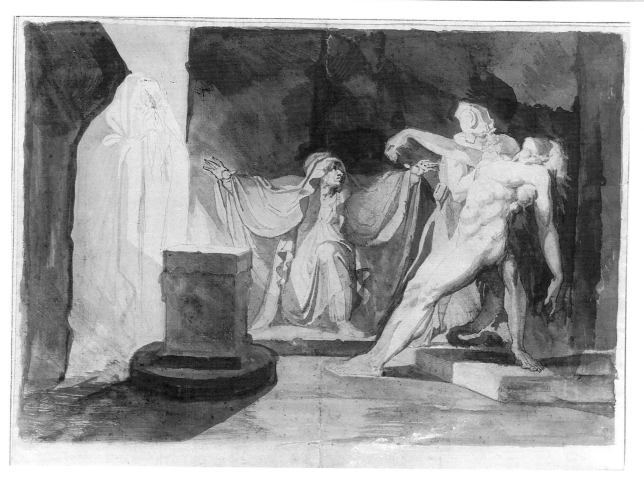

the sculptor Thomas Banks (1735–1805),⁴⁷ who arrived in Rome in 1772, the year of Sergel's first major critical success with the *Diomedes*. He immediately fell in with Sergel's English friends, joining Hamilton, Fuseli and Romney in their insatiable study of antiquity. He gave birth almost immediately to the deliberately neoclassical style of the *Death of Germanicus* (1774; Fig. 92),⁴⁸ to be followed by the *Thetis and Her Nymphs Rising from the Sea to Console Achilles* (1778; Fig. 93) in a progression toward a more shallow carving which stressed the importance of line over volume. With these reliefs, Banks took a firm step in the direction of an original, radical classicism surpassing any contemporary endeavor except, in certain respects, Sergel's. The essential linear strength of the reliefs endows the first with a quality of passionate mourning and womblike protection about the dying man, the second with both an elegiac grace and disturbing, furious anguish heightened by the contrast of the eerie, floating arabesque of nymphs and Achilles' painfully braced body.

The figure of a *Dying Bacchante* (?) from a *Dyonisiac Scene* in the Uffizi,⁴⁹ admired already by J.-L. David (drawing, Louvre) and Fuseli (Fig. 94),⁵⁰ no doubt contributed to Banks' conception of *Achilles*. Banks' *Achilles* also recalls both Clodion's *Scamander* and Sergel's drastic, graceless *Rage of Achilles* (Fig. 88). The agonized yearning animating the latter, however, speaks more of a Hellenistic or baroque expansiveness which Banks transmuted into a violent inner emotion expressed through convincing muscular contractions. The vehemence and the delicacy evident in the refined illusion of submerged aquatic forms were in fact without precedent, although one might look to Donatello's schiacciato reliefs for the textural subtleties and raw emotions. In this Banks showed himself to be in the forefront of the exploration of the Renaissance as well.

Banks harbored within himself a disposition for both an unclassical mood and form, expressed in the twisted pose and irregular silhouette of his later, Michelangelesque *Falling Titan* (1786) and a supremely linear if essentially passionate classicism in his reliefs.⁵¹ Flaxman's engravings developed these modern expressive qualities to their fullest through the minimal means of pure outline, the ramifications of which are by now familiar at least in painting. They lead to a comparable aspect of the will to linear abstraction in sculpture, related to but not identical with the other, specifically archaeological, primitive bent of the time espoused by the Danes. To Canova one owes the most vivid expression of the linear ideal in sculpture to which the French would fully respond only after the Revolution. Meanwhile, they shared in what Rome had to offer and showed that, far from being insensitive to the strivings of the other foreigners there, they were very much alive to the new language of classicism and the sublime so briefly sketched above.

CHAPTER FIVE

Early Neoclassicism in France

ROME HELD THE PROMISE of artistic accomplishment for those who traveled there, but what the students at the French Academy made of their Prix de Rome years varied according to their own temperament and ambition, as well as to the character of the academy director. Houdon, for example, began his career in Rome, while Pajou created little of consequence there. Yet Pajou, along with his younger colleagues Houdon, Moitte and Julien, was to bring French sculpture to the threshold of an ideological neoclassicism. What Bouchardon, Pigalle and Falconet had begun, these sculptors would further without quite ratifying their stylistic forays into a credo. The course of French painting followed a similar pattern, beginning with Vien's paintings of the 1760s and Greuze's moralizing family dramas. Yet French painters were slow to produce a work as radical as Pigalle's *Citizen* or as heroic as his *Maréchal de Saxe*. Try as it might, Greuze's *Septimius Severus* (1769) never overcame its flawed characterizations.

Pajou

Pajou spent his Prix de Rome days (1752–56) in Italy well before most of the group influenced by Gavin Hamilton arrived, meaning that he was there too early to behold their passionate embracing of Winckelmann's lessons. While he never espoused the more determined, even extravagant, neoclassicism of a Sergel or Banks, nor fully grasped the boldness of Goujon's manner, his was nevertheless a temperament dominated by a consistent, classicizing reserve, especially visible when his busts, for example, are compared to those of Houdon. A certain grand

impenetrability and taut surfaces characterize most of his formal portraits. Still, Pajou has left behind more personal portraits of friends and of his teacher J. B. Lemoyne, for example, which show a marvelous vigor. Yet Houdon's more subtle touch leaves one with a sense of the porous softness of skin and a great depth or warmth in the gaze. If Pajou's reserve was a matter of temperament, it was also deliberate, witness his heroic statue of *Buffon*, the important drawing of *Lycurgus* mentioned above or the very early relief of the endlessly titled *Princess of Hesse-Homburg As Minerva Consecrating the Cordon of the Order of St. Catherine on the Altar of Immortality* (1759–61; Fig. 95). Pajou, drawn to the ancient stele type, undermined it to a degree through a soft plumpness of form and chattiness of detail. Still, the overall concept represented a bold move.

Several unexecuted tomb projects shed further light on Pajou's alignment with the burgeoning historicism characterizing this entire period. The first of these, an ink drawing enlivened with watercolors and white gouache of the *Tomb of the Maréchal Charles Louis Auguste Fouquet, Duke of Belle Isle* (1761; Fig. 96), shows the deceased, romanized duke actually within the gloomy precincts of the family mausoleum, "containing the tombs of his wife and his son, the Count of Gisons, who both predeceased him. Their spirits have left their tombs in order to greet him; the Angel of Death is shutting the door of the sepulchral chamber in order to indicate that the Maréchal was the last of his family."[1] The Maréchal Fouquet completes the Maréchal de Saxe's impending act in a moment of Greuzian pathos, locked-in for good by the Allegory of Time. In fact, the drawing even anticipates something

Figure 95. Augustin Pajou. *The Princess of Hesse-Homburg as Minerva Consecrating the Cordon of the Order of St. Catherine on the Altar of Immortality,* 1759–61. Marble relief. St. Petersburg, Hermitage.

of the niggling classical manner of Greuze's *Emperor Septimius Severus Accusing His Son Caracalla of Trying to Assassinate Him* (1769; Fig. 97). While somewhat awkward, the unusual scheme depicting the end of a dynasty shows a more inventive side of Pajou's imagination. Both wife and son welcome the long lost paterfamilias in a unique "homecoming" scene, a sort of lugubrious version of the Fragonardian "Happy Family." Pigalle's grand and eccentric *Tomb of Comte Henri-Claude d'Harcourt* (1771–76; Fig. 98), begun some ten years later, capitalized upon and publicized similar family sentiments.[2] The countess stands ready to join her husband in death as he emerges in his shroud from the coffin. Above stands a beautiful, classicizing Genius of Death extinguishing the flame of life.

This genre lent itself to any number of variations (cf. Fig. 99), which Pajou would again explore in the second of his two classicizing tomb projects executed in the same year as his project for a *Monument to Bayard.*

The drawing of a *Tomb for Peter Borissovitch Tscheremytchew and His Wife, Princess Czerkasky* (1789; Fig. 100) finds its inspiration in a variety of works, the most recent and obvious, perhaps, being David's *Hector and Andromaque* (1783; Fig. 101) with its juxtaposition of weeping mourners and the supine deceased. Pajou's two recumbent figures united on a single classical bed are attended by their son who stands to the left, unveiling his departed parents. Also in attendance, Hymenaios, or the Genius of Marriage,

Figure 96. Augustin Pajou. *Project for a Tomb of the Maréchal Charles Louis Auguste Fouquet, Duke of Belle Isle,* 1761. Drawing. Cooper-Hewitt National Design Museum, New York. Photo: Art Resources, N.Y.

Figure 97. Jean Baptiste Greuze. *Emperor Septimius Serverus Accusing His Son Caracalla of Trying to Assassinate Him,* 1769. Paris, Louvre.

Figure 98. Jean-Baptiste Pigalle. *Tomb of Comte Henri-Claude d'Harcourt,* 1771–76. Marble. Paris, Cathedral of Notre Dame.

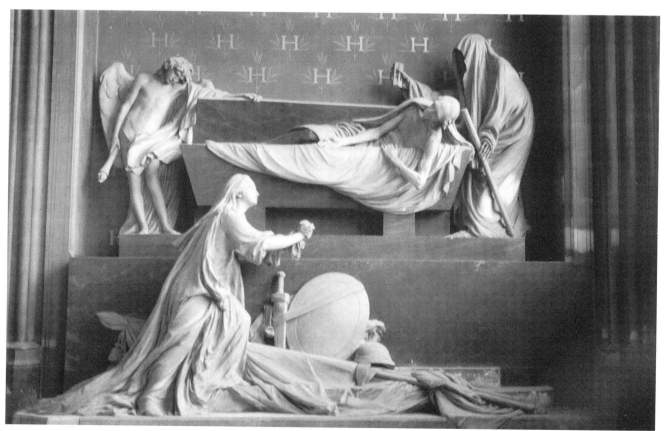

Figure 99. Antonio Canova. *Monument to Pope Clement XIV,* 1783–87. Rome, Santi Apostoli.

weeps to the right, a sorrowing figure derived from the Genius of Death on Canova's *Monument to Clement XIII* (1783–92; Rome, St. Peter's).

By this date, Canova had risen to international prominence. His works were engraved and widely publicized, resulting in the rapid absorption of his style all over Europe. Not to be forgotten either, Pajou's own student, L.-P. Deseine, had seen and commented upon the *Clement XIV* (Fig. 99) at the time of its creation during his Prix de Rome stay (1783–87). But Pajou shunned two significant characteristics of Canova's early tombs – their more moderate color schemes and their juxtapositional ordering, which is to say, the gathering of self-absorbed, noncommunicative participants into one group.

In France, the emphasis remained narrative and theatrical in the tradition of Pigalle's influential *Tombeau d'Harcourt.* Pajou also brought a more vivid chro-

matic variation to his *Tomb for Peter Borissovitch Tscheremytchew,* with blue and yellow variegated marbles for the bases and blue turquin for the urns which are enlivened by gilding, as are the sword and helmet, the various orders littered on the base, the palette and other artists' tools and the stork. The figures alone emerge in ghostly white against the opulence of the rest. The urns and high, flaming torches belong to the general classical props of the time even if the lifted drapery harks back to rococo unveilings of sleeping Ariadnes. Finally, the exhibition of the half-naked bodies inevitably conjures up the royal *gisants* of St. Denis. For physical decay and death, however, Pajou substituted eternal youth and gentle sleep, classical notions par excellence.

This tomb project came at the end of several decades of classicizing "lamentatios," two particularly significant relief examples having been produced for

Figure 100. Augustin Pajou. *Tomb for Peter Borissovitch Tscerenytchew and His Wife, Princess Czerkasky,* 1789. Drawing with gouache. Kunstbibliothek mit Museum fúr Architecktur, Modebild und Grafik-Design, Staatliche Museen Preussischer Kulturbesitz, Berlin. Photo: Kunstbibliothek.

Sens in 1775. The works in question represent the *Death of the Dauphin* (Fig. 102) and the *Death of the Dauphine* by the precocious and all-but-forgotten Antoine Dupasquier (1748–1831).[3]

In 1775 the architect Guillaumont invited the fledgling sculptor, before he had even won the Prix de Rome, to prepare the plaster models for the reliefs. They were destined to decorate a portal at the entrance of Sens whose cathedral housed the dauphin and dauphine's tomb. The sculptor, who tried unsuccessfully to postpone his departure for Rome in 1776 to complete the scenes in marble, never finished them.[4] But one can readily accept the suggestion that Dupasquier discussed this exceptional commission with his friends and colleagues, including David, at the French Academy and so disseminated his particular vision of the "lamentatio" before being expelled for misconduct.[5] Dupasquier's reliefs do not aspire to the intense rhythmic linearity suffusing Thomas Banks' *Death of Germanicus* (1774; Fig. 91), but the shallow carving, the classical furnishings, the costumes, the

Figure 101. Jacques-Louis David. *Hector and Andromaque*, 1783. Oil painting. Paris, Ecole des Beaux-Arts. Photo: Ecole Nationale Supérieure des Beaux-Arts.

shrouded nudity and the figures carefully positioned to emphasize the relief's flatness lie at the core of neoclassical deathbed scenes.

As far as the style is concerned, Dupasquier may well have taken into consideration Guillaume II Coustou's (1716–77) tomb for the dauphin and dauphine in the cathedral proper. The latter had begun his *Tomb of the Dauphin and Dauphine* (1766–77; Fig. 103) for the cathedral of Sens in 1766 with Julien as one of his assistants. Though by no means comparable to the consummately restrained programs of Canova's later tombs, the inclusion of classical urns for the commemoration of the deceased dauphin (1765) and, eventually, his wife (1767) bears the stamp of classical funerary rites devoid of blatant religious imagery (Religion and Immortality appear as mourners rather than as prophesiers of the next life). Both it and Pigalle's *Saxe* provided France with early statements of burial rituals more secular than Christian. The figures, however, twist in space and still display artfully graceful gestures (e.g. Conjugal Love's outstretched hand) at odds with the later neoclassical gravity of public monuments.[6]

The works by Pajou mentioned within the context of the Goujon revival might be recalled here to flesh out the picture. His varied and elegant Versailles reliefs, architectural figures and restorations form an important group. Added to these, the vigorous portraits of the classically draped *Buffon* and the flamboyant *Maréchal Turenne Protecting the Crown at the Battle of Dunes (1658)* (1783; Fig. 39)[7] two other figures for D'Angiviller's "Grands Hommes," as well as his statues for the Ecole Militaire and the extraordinarily well-received *Psyche Abandoned* remind one of Pajou's commanding presence in the Paris of the seventies and eighties.

The cleaning of Pajou's *Buffon* (Fig. 10) has magically resurrected the liveliness of the detailing, and it gained much during its postcleaning exhibition when it stood in a black room, glistening in the trained light like a potent apparition. Carefully sidestepping the humiliating feebleness with which Pigalle had endowed his *Voltaire*, Pajou seems to have turned to Buffon himself for guidance. His trail-blazing treatise *Histoire naturelle* (1749), in the section entitled "L'âge virile," carries this particularly clear definition: "The body of a well formed man should be square in shape, the muscles should be severely expressed, the contour of the limbs sharply drawn, the features of the face sharply defined."[8]

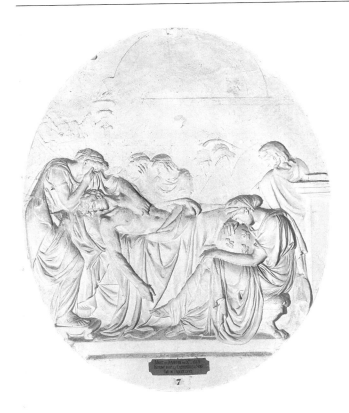

A whole bestiary rests at Buffon's feet. From this animated base his togaed form rises, crowned by a heroic torso and leonine, intelligent head. This commingling of charm and bombast establishes a new genre – the intellectual hero on his own battlefield as conqueror of the natural world.

The one work which brought Pajou notoriety thanks to the prudery of the church, his *Psyche Abandoned* (Fig. 105), was also commissioned by the crown in 1782 as a pendant for Bouchardon's *Cupid* (Fig. 104).[9] Tremendously popular among critics and public alike, the *Psyche* drew crowds to Pajou's studio where it went on view after its removal from the Salon of 1785 (plaster). Drapery much like a sheet still trails over the richly cushioned stool, suggesting that behind Psyche's lassitude and nudity lies the warmth of a conjugal bed. Bedroom intimacy, sexual longing and grief commingle, which is why, with few exceptions, she delighted so many. The composition, based on a delicate serpentine, with one foot lifted on a convenient support, characterizes many of Pajou's mythological female figures.

The heroine embodies a heartfelt resignation. She has lost Cupid through her foolishness (the symbol of her undoing, the oil lamp, lies at her feet) and now languishes alone. Mechtild Schneider speaks of a new suffering and desire, a love less idealized and more real, of a pathos absent from baroque art, and of the modern treatment of the Cupid and Psyche theme which came into existence with such force in this period.[10] In addition, Psyche's loss and subsequent travails, as described by Apuleius, acted as a metaphor for Plato's idea of the soul's longing for true union. But was the sculptor really thinking of that?

Pajou has daringly transformed the grief of Hellenistic suffering into an eighteenth-century, feminine language without distorting Psyche's beauty. It would be possible even to imagine Pajou's viewing of David's *Hector and Andromaque* (1783 Salon) at the time he was choosing his subject, with an eye to interpreting longing and sorrow. And indeed, David's own work was hailed as a new interpretation of grief, solidly supported by credible body language.[11] Psyche's own ges-

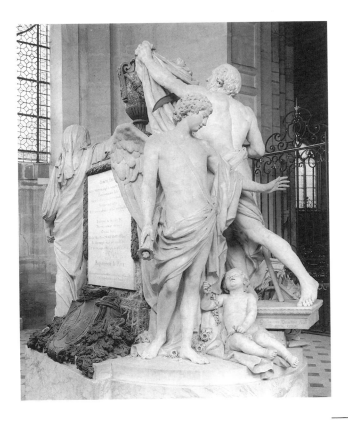

Figure 102 (top). Antoine Dupasquier. *Death of the Dauphin*, 1775. Plaster relief. Sens, Musée de la Ville de Sens. Photo: Musée de la Ville de Sens.

Figure 103 (left). Guillaume II Coustou. *Tomb of the Dauphin and Dauphine*, 1766–77. Marble. Sens, Cathedral. Photo: Courtauld Institute.

Figure 104 (above, left). Edmé Bouchardon. *Cupid Carving a Bow from Hercules' Club*, c. 1750. Marble statue. Paris, Louvre. Photo: R. M. N.

Figure 105 (above, right). Augustin Pajou. *Psyche Abandoned*, 1785. Marble statue. Paris, Louvre. Photo: R. M. N.

Figure 106. Augustin Pajou. *Ariadne*, 1796. Terra-cotta statuette. Paris, Louvre.

tures, pose and expression all play upon each other to suggest a convincingly lovelorn maiden, which may also explain her popularity. For all the oddness of the arm holding her side as if for heartburn, as one critic sniped, she brought a new *sensibilité* to sculpture. It is almost impossible to visualize the *Psyche*, however, as a pendant to Bouchardon's boyish *Cupid*. In fact, older and of a different character entirely, she was never exhibited next to the *Cupid* after her completion in marble in 1791. (The Louvre continues this tradition.) And by then, she had lost her popularity for perhaps emotional as well as stylistic reasons – her temporary heartache surely seemed a superficial thing in those dire times. This was no Andromaque or Agrippina. Even today, Psyche's somewhat self-indulgent grief fails to deeply move the viewer who might be more inclined to admire the technical mastery if the work were more emotionally compelling. Yet along with Pajou's delightful *Bacchante* (Louvre) and serenely self-composed, beautiful statuette of *Ceres* (c. 1768–70),[12] it remains one of his chief works. Perhaps alive to the reasons for the failure of the marble *Psyche* at the 1791 Salon, Pajou produced for the Salon of 1792 the elegant portrait statue of a classically draped and delicate Mme de Noailles (eventually duchesse de Mouchy). Still at the Château de Mouchy, it is signed by Pajou, "Citoyen de Paris, 1792."

Unruffled by the deeper longings for or greater visions of antiquity characterizing the work of the English in Rome, Pajou permeated his art with the moderate classicism of fashionable good taste which ensured that he would quickly fall from favor after 1789. Even artists of greater classical eloquence who failed to grasp the temper of the day found themselves shorn of glory. Such was to be the case for Houdon, at least until the rise of Napoleon.

Houdon

Antoine Houdon's (1741–1828)[13] art was both more brilliantly rococo (the busts in particular) and more profoundly classical than Pajou's. Yet he never availed himself to the same extent of all the classical furniture or Roman costumes (especially the crested helmets) that one finds in Pajou's projects and reliefs. He left almost no drawings from which to judge the direction of his thoughts outside the sphere of his commissions,[14] and, unlike Falconet, Canova or David d'Angers, he left virtually no record of his opinions on the role of sculpture, save the few standard ones agree-

Figure 107. Antoine Houdon. *St. John the Baptist*, 1767. Plaster statue. Rome, Villa Borghese.

ing to nudity as the condition of statuary and the obligation of sculpture to commemorate greatness.[15] He claimed even, in a letter to his friend Bachelier, that his busts of famous men were executed "pour la gloire" and sold only later.[16] But he saw himself first as a craftsman, his modest character standing in vivid

Figure 108. Antoine Houdon. *St. Bruno*, 1766–67. Marble statue. Rome. Sta Maria degli Angeli.

contrast to Falconet's – the intellectual first and craftsman second.

As a Prix de Rome winner, Houdon turned his academy residency (1764–68) to unusual profit, not only gleaning what he could from the ancient art about him but also creating two masterpieces for

Santa Maria degli Angeli, the *St. John the Baptist* (1767; Fig. 107) and the *St. Bruno* (1766–67; Fig. 108) which, transcending the formulaic gesturings of the rococo, brought him early fame well before Sergel produced his *Diomedes* (1771).

In a manner reminiscent of Bouchardon's countless studies for his Louis XV equestrian, Houdon executed his celebrated *écorché* (Fig. 110) in preparation for the colossal *St. John* (the original plaster measured about ten feet) whose powerful anatomy and outstretched hand plumb the ancient world from Polyclitus' as yet unidentified *Doryphoros* (Fig. 109) to the *Augustus of Prima Porta*.[17] The loose draping of the Baptist's sheepskin, falling away as it does from the right hip, suggests even that Houdon wished to clearly display his mastery of the classically inspired musculature of the abdomen with its emphatic division of parts. The firmly extended arm, however, while deriving its general idea from works like the *Augustus*, or even the *Marcus Aurelius*, is in fact an entirely original and

Figure 109. Doryphoros. Marble statue. Naples, Museo Nazionale.

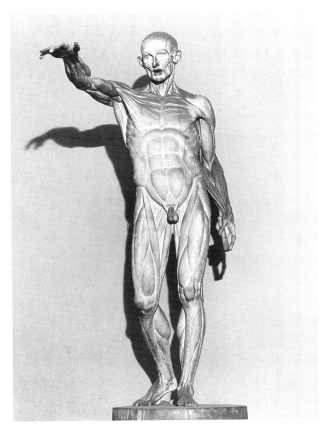

Figure 110. Antoine Houdon. *Ecorché*, 1766–67. Bronze statue. Paris, Ecole des Beaux-Arts. Photo: Ecole Nationale Supérieure des Beaux-Arts.

Figure 111. Henry Fuseli. *Houdon's Ecorché*, 1770–78. Drawing. Weimar, Nationale Forschungsund Gedenkstätten der Klassischen deutschen Literatur. Photo: Stiftung Weimer Klasik.

masterful expression of the "laying on" of hands: the hand is not merely extended in the ritual of baptism but is slightly cupped with the fingers spread to suggest the streaming down not only of water but of the Holy Spirit as well. (Houdon altered the arm position of the ten-foot plaster statue for the church itself so that it stretches high overhead instead. But the hand remains the same.) Whatever baroque elements may have lingered in the juxtaposition of the figures of Saint Bruno and Saint John in Santa Maria degli Angeli, creating a contrast of introspective and dynamic personalities animating the worshipper's space, the emphasis on broad planes, facial impassivity and classical anatomy and contraposto all point to Houdon's awareness of both Rome's ancient treasures and of the art of those gathered around Gavin Hamilton.

Accidentally destroyed in 1894 and largely over-

shadowed by the *St. Bruno*, the *St. John*, which had only been executed in plaster and of which a reduced, life-size plaster cast (Fig. 107) survives in the Villa Borghese, exemplifies Houdon's natural feeling for a classical, gravity-bound, athletic form. Yet he successfully escaped a purely "pagan" look due to the naturalistic accents in the physical descriptions, whether in the treatment of the long hair or the delicately modeled knees, for example, and so created a credible Christian figure.[18] Canova liked the determined gesture which recurs in his *Clement XIV* (Fig. 99) and even drew the *écorché*, further testifying to his admiration.[19] Before him, Fuseli had also sketched the famous model (1770–78; Fig. 111), indicating that its popularity extended well beyond the walls of the French Academy.

An engraving after Domenico Banti's *Napoleon* (1808–11; Fig. 112), as it stood in Venice, suggests

that the quality of the arm gesture and the general pose made a deep impression on everyone. This seven-and-a-half-foot statue by Banti has been called a pastiche of Canova's *Napoleon*,[20] but it is quite obviously a paraphrase of Houdon's *St. John*, giving Banti's *Napoleon* a French heritage appropriate to its nationalistic mood.

Since its unveiling, Houdon's marble *St. Bruno*, the far better known pendant to the *St. John*, has elicited admiration for its formal restraint achieved through large areas of undisturbed draperies and deep, mystical absorption. It seemed more original than the *St. John* which struck its thoughtless critics as a pastiche of the *écorché*, even though the latter was known to have been a study for it.[21] With hindsight, it is clear that Houdon's *St. John* was as original and daring as its counterpart. Sergel's *Diomedes* later overshadowed it, partly because of its greater drama and partly because it was a fully nude figure drawn from classical antiquity with no destination in mind. In short, it was a conscious manifesto of new things, whereas Houdon practiced his classicism at a more intuitive and less didactic level.

The young *Vestal* (Fig. 113) of ca. 1768–69, which reappeared in bronze as a lamp base in 1777, constitutes the pagan counterpart to these religious works, pointing again to Houdon's genuine feeling for a calm, lyrical classicism which he gladly applied to Christian and classical subjects alike.[22] Clodion, with whom Houdon shared an apartment in Rome from 1765 to 1768,[23] tried his hand at vestals too, though he opted for a livelier silhouette and a greater monumentality. His *Vestal Sacrificing* (1768; Fig. 114), the only large marble of Clodion's Roman period, falls into the same category of garlanded vestals in painting of the time, such as Vien's *Virtuous Athenian* (1763)[24] which had been preceded iconographically, for example, by the sculptor Jean-Jacques Caffiéri's *Vestal Maintaining the Sacred Flame* (1757).

But, to continue the digression, Clodion produced a number of graceful reliefs during his Roman stay very much in the spirit of the times. Among these may be counted several vases, and, most tellingly, his terracotta relief of the *Vendor of Cupids* (1773 Salon; Boston, private collection),[25] a subject made famous by Vien's painting (1763) and G. Nolli's engraving (1762). A simple gravity characterizes the figures in all these reliefs, as well as the handsome plaster statuette of *Hercules Resting* (c. 1762; Fig. 192).[26] A superbly integrated figure largely defined through its front and

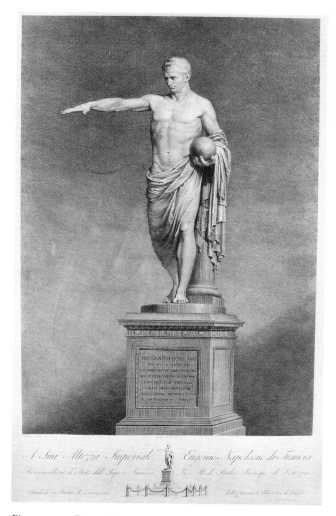

Figure 112. Domenico Banti. *Napoleon*, 1808–11. Engraving after the statue in the Piazzetta di San Marco, Venice, by Metteini and Zulian. Venice, Museo Correr. Photo: Museo Correr.

back views, it remains one of Clodion's most monumental, weighted, virile males. Clearly he came to Rome primed to see with understanding eyes.

Houdon, in turn, set his sights on a male god. He presented at the Salon of 1771 a plaster (1769), life-size model of *Morpheus* (*morceau de réception* 1777; Fig. 115) composed in a gentle spiral. More of a winged sleeping soldier than a somnolent deity,[27] it bears the stamp of a young artistic mind toying with the legacy of works like the *Dying Gaul* and *Barberini Faun*, as well as Paul-Ambroise Slodtz's handsome *Dead Icarus* (1743; Louvre). Pierre Julien might even have shared the same living model for his later *Dying Gladiator* (1779; Fig. 119).

The multifaceted nature of Houdon's art allowed him to express himself in a spirited classicism typified

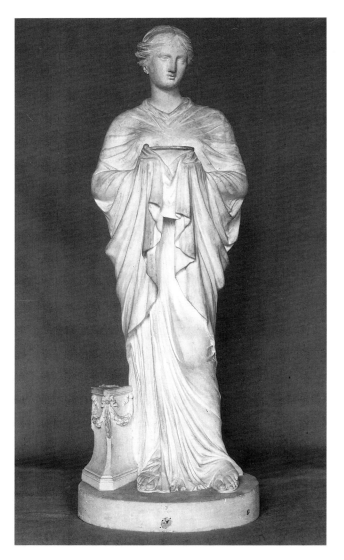

Figure 113. Antoine Houdon, *Vestal*, 1768–69. Terra-cotta statuette. Perrot-Houdon Collection. Photo: Bulloz.

Figure 114. Clodion. *Vestal Sacrificing*, 1768. Marble statuette. Washington, D. C., National Gallery of Art, Samuel Kress Collection.

by the *Diana* (1776–95; Fig. 48) and *Apollo* (1790). Like Falconet, Houdon took pride in surpassing the ancients, in this instance by creating figures fleeter of foot and lighter of tone. The technical virtuosity of resting the figures only upon the ball of one foot lends them a divine weightlessness that recurs brilliantly in Canova's *Dancing Figures* and *Hebe*. But this very virtuosity or lightness also deprived the works of the seriousness associated theoretically with the classical revival and present in the *St. John the Baptist*. Houdon struck the more sonorous notes of the "true style" in the *Tomb of Victor Charpentier, Comte d'Ennery* (1781; Fig. 116), which capitalized on both the new

stylistic trend and surge in the iconography of virtuous widowhood. Gathered about a commemorative pedestal upon which sits a small square chest with the ashes of the former soldier and colonial administrator, the widowed countess, her daughter and the count's sister to the left stand plunged in sorrow. While the Comtesse de Blot (modeled on the *Polyhymnia* in the Louvre; cf. Fig. 36) gives way to desperate grief, the Comtesse d'Ennery gently urges her young daughter forward to pay homage to her father's memory. This particular grouping conveys the impression of the child's initiation into some undefined stoic lesson at the hands of an Agrippina or Andromaque. The deeply carved fig-

ures against the blue turquin marble have both the quality of a classical relief and the richness of three-dimensionality emphasized by the thickly folded draperies for which more deliberately neoclassical sculptors would substitute the transparencies of the Attic style.

In addition to the various reliefs, paintings and tombs already mentioned which might have served as a point of departure for Houdon's *Tombeau d' Ennery*, the Louvre houses another significant example: Louis-Claude Vassé's *Grief* (1767–70; Fig. 117), for the tomb of the Garde des Sceaux, Paul-Esprit Feydeau de Brou.[28] The classical details of the hair and drapery and the sorrowing resignation spoke directly to the sensibility of the next generation, including Jacques-Louis David whose seated figure of Camilla to the far right in the *Oath of the Horatii* (1784; Fig.

118) bears a more than passing resemblance to Vassé's figure. What Houdon brought to his grouping, however, was a greater solemnity and monumentality exceeding the purely *larmoyant* flavor of so many of the female mourners of the time.

The "goût à l'antique" occasionally flowed into Houdon's portraiture as well, witness the fashionably classicizing bust of *Frederika Louisa of Saxe-Gotha* (1773) who was reading Winckelmann at the time.[29] But the most famous instance of a mitigated classicism in his portraiture is, of course, the *Voltaire* (Fig. 9). Commissioned by Madame Denis, the writer's niece, the statue stands somewhere between his vestals and his hallmark, the lively, *mouvementé* portrait.[30] The severe, heavy chair, the wreath and togalike robe add their symbolic message to the whole, without dissimulating Voltaire's identity or meager frame clad in a

Figure 115. Antoine Houdon. *Morpheus*, 1777. Marble statuette. Paris, Louvre.

Figure 116. Antoine Houdon. *Tomb of Victor Charpentier, Conte d'Ennery,* 1781. Marble. Paris, Louvre.

contemporary if almost invisible costume. In light of the various elegant attitudes of the seated "Grands Hommes" (such as Julien's *La Fontaine* or Clodion's *Montesquieu*), the sedate pose with uncrossed legs of Houdon's *Voltaire* appears all the more restrained.

Though Grimm compared Houdon to Phidias,[31] the sculptor was never able to accommodate the severity of style called for by the more ideological neoclassicists, nor was his sense of the heroic infallible. Even in the bust of the famous actor, *Larive as Brutus* (1784, Paris, Comédie Française), Houdon translated the fundamental energy of the frowning *Caracalla* (Naples,

Museo Nazionale) and Michelangelo's *Brutus* into a more superficial, theatrical show of "terribilità," the polished surface and facial details diminishing the ferociousness of its predecessors.[32] His life-size *Cicero* (1804; Fig. 149), commissioned for the series of great men for the Chambre des Députés, lacks conviction too. The gesture is weak, the orator mute, the drapery a shower of busy folds. Its failure can be measured against Clodion's recently rediscovered and more compelling *Cato* (Fig. 150)[33] for the same series. The political climate dictated an heroic severity for which, as it turns out, Clodion's gifts were better suited,

despite errors of iconography and perhaps a slightly
underscaled torso and head.[34]

Quatremère, in his eulogy of Houdon in 1829,
wrote: "The ancient style did not manifest itself in his
work in all its imposing severity; but he knew that,
were he to imitate it too faithfully, he would have been
ridiculed at the time by most of his colleagues and
their admirers who were competely indifferent to the
masterpieces of antiquity."[35] Those few polemical
words sum up the problem of artistic vision vis-à-vis
contemporary taste, although Houdon actually
appears to have been perfectly content with a less
severe style, while his contemporaries were not quite
as indifferent to antiquity as implied. In any event,
Quatremère was being as kind as he could. Others
would reap higher praise elsewhere, Joachim Le Bre-
ton and the Abbé Pascal both lavishing blandishments
on Pierre Julien for striving more valiantly than most
in the cause of the true style.[36]

Julien

Pierre Julien's (1731–1801) *Dying Gladiator* (1779;
Fig. 119; cf. Fig. 120) lies at the root of his reputation
as one of the first to set France back on the true and
narrow path of classicism. And indeed this refined,

Figure 117. Louis-Claude Vassé. *Grief*, 1767–70. Marble relief
from the tomb of Paul-Espirit Feydeau de Brou. Paris. Louvre.

Figure 118. Jacques-Louis David. *Oath of the Horatii*, detail, 1784. Oil on canvas. Paris,
Louvre.

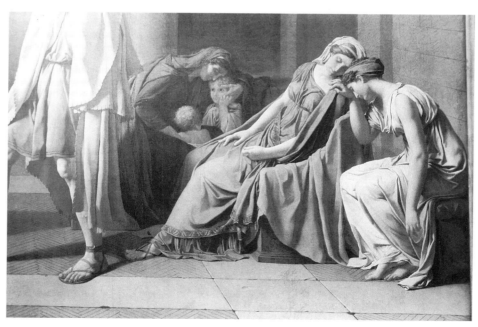

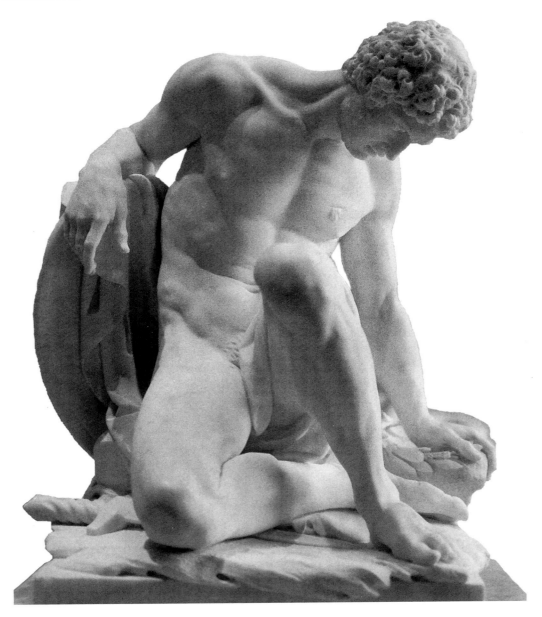

Figure 119. Pierre Julien. *Dying Gladiator*, 1779. Marble figure. Paris, Louvre.

sensitive *morceau de réception* set a new tone: compact and still touched with the cubic simplicity of the block from which it was carved, the marvelously handsome, naked warrior enters death quietly, elegantly.[37] The *Gladiator*, the stunning, virile *Poussin* (plaster, 1789; marble, 1804), the richly detailed *La Fontaine* (plaster, 1783; marble, 1785) and the seductive, classicizing yet animated group of *Young Woman with a Goat* (1785 Salon; Rambouillet, 1787) – his most famous works – exhibit a sustained mastery of

composition, technical expertise and dramatic or poetic sense.

A kind man, excellent teacher and lifelong friend of the sculptor Dejoux, Julien (1731–1801) began his career with one of those legendary twists so popular in the nineteenth century: a Jesuit spotted him modeling little figures while watching his herd in the Haute Loire.[38] He was put to study at the age of fourteen with a master-sculptor in Puy before going to Lyon and eventually to Paris. There began his important appren-

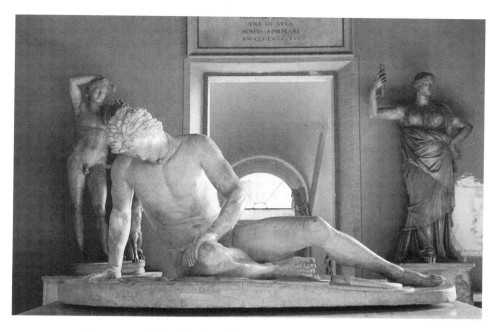

Figure 120. Dying Gaul. Marble statue. Rome, Museo Capitolino.

ticeship with Guillaume II Coustou and his work on the *Tomb of the Dauphin and Dauphine* in Sens Cathedral. In 1765, a year after Houdon, he won the Prix de Rome, spending five years there (1768–1773). But, less prolific than Clodion and not the versatile portraitist that Houdon was, he never achieved quite the same success. Yet he belongs to the group that included Clodion, Houdon and the older Pajou, the group that shaped a new, French classicism.

Julien excelled in bringing to life the fundamental intelligence and force of his male characters, even at their lowest ebb. For all their difference of attire and pose, both the *Poussin* (Plate 1) and the *La Fontaine* (Fig. 41) display a splendid physique and exhibit a fully engaged mind through both the attitude of the body and the expression of the face. *Poussin*'s nudity and more sober pose befit his artistic convictions, while *La Fontaine*, a teller of tales par excellence, sits cross-legged in the company of one of his delightful creations, the clever little fox inching his way around the feet of the master. With Pajou's *Buffon*, it seems, began this inclusion of charming animal companions (long seen, of course, in funerary sculpture), used also to good effect by Chaudet, Canova and Carpeaux.

The group of *Young Woman with a Goat* (Fig. 121; cf. also Fig. 200) for the Laiterie of Rambouillet combines the animal kingdom and anecdotal mood of the poet and the nudity and classicism of the painter with

a discreet look at the *Capitoline Venus*, hovering in a web of old and new directions.

It was left to artists of Jean Guillaume Moitte's convictions to further the development of the grandiose and radical in France, especially after the onset of the Revolution. At that point, Clodion, Julien, Pajou, Houdon and Roland all took a back seat to this moody friend of Quatremère and Jacques-Louis David.

Moitte

In the eyes of Quatremère, Moitte's was the most serious bid for recognition as the restorer of the true style in France. The archaeologist singled the sculptor out especially for what he considered to be the inspiring loftiness of his manner.[39] A pupil of Pigalle (like Quatremère) and of Jean-Baptiste Lemoyne (like Pajou), Moitte (1746–1810) traveled to Rome in the summer of 1771, his poor health compelling him to cut short his stay in May of 1773. His taciturn character earned him the dislike of his fellow students in Paris,[40] though this did little to interfere with a successful career. This may be attributed, in part, to his friendships with David[41] and Quatremère, who, overseeing the transformations of the Pantheon, handpicked Moitte for the execution of the pediment. Conversely, his friend-

Figure 121. Pierre Julien. *Young Woman with a Goat*, 1785–86. Marble group. Rambouillet, Grotto of the Queen's Dairy.

ship with these two may have been due to a didactic nature in keeping with their own.

Moitte had been invited to participate in the Place du Peyrou project, modeling the *Fénélon and Bossuet* (Fig. 11) for which he requested payment in 1789.[42] The terra-cotta would hardly arouse suspicion of a strong classical affiliation, but for Moitte's likely awareness of the *Papirius Group*.[43] Its abundance of historical accessories set it neatly within the by-then well-established tradition of d'Angiviller's nationally costumed "Grands Hommes." In his statue of *Jean-Dominique Cassini* (plaster, 1789; posthumous marble, 1810; Fig. 122), on the other hand, Moitte sought to temper the overtly contemporary poses and cos-

tume of some of the seated "Grands Hommes," as Houdon had in his *Voltaire*. The seventeenth-century astronomer almost vanishes under a quasi-Augustan appearance – save for his long nose in profile.[44] Further obliterating a precise historical record, Moitte draped Cassini in a toga. The figure's studied physical heroism recalls both Michelangelo's *Medici Tombs* and J.-L. David's epic style in painting. Moitte also drew upon works like the *Seated Philosopher* in the Pallazzo Spada, Rome. Pigalle's *Citizen* lingers not far behind for the general conception of the musing pose. The mood, however, Moitte altered to express a new degree of active intellectual power. The frowning face bears no resemblance to the easy, smiling intelligence

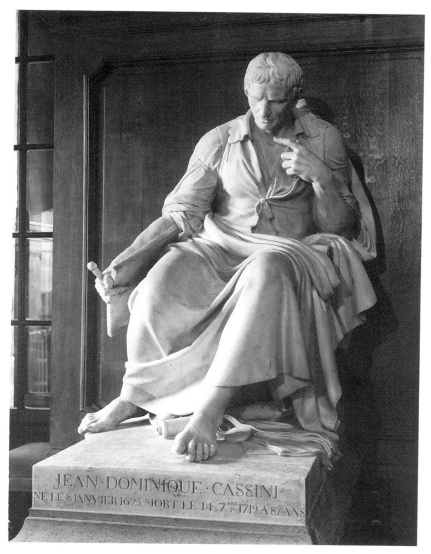

Figure 122. Jean-Guillaume Moitte. *Jean-Dominique Cassini*, 1789–1810. Marble. Paris, Observatory. Photo: Observatoire de Paris.

of Pigalle's *Citizen* or Houdon's philosopher, for example. Johan Tobias Sergel's deeply pessimistic drawings of melancholic figures come to mind instead.

In addition to the *Cassini*, Moitte's statues and relief (1784) for the Hôtel de Salm (Palais de la Légion d'Honneur) and Ledoux's *barrières*, the grisaille frieze for the Arc de Triomphe of the Fête de le Fédération of 1790, the Pantheon pediment (1793; Fig. 140), the large relief for the Palais du Luxembourg (1795–1802, installed 1806), the *Death of Général Desaix* (1805; Fig. 165) and the cumbersome statue of *Custine* (1810) constitute the major part of his realized public works.

The earliest of these, the six figures crowning the Hôtel de Salm and a relief for the portico at the rear of the innercourt (*Fêtes à Palès*), were his first important commissions.[45] Moitte did not execute the statues himself, letting a sculptor by the name of Bertolini work them up from his terra-cotta models instead.[46] Three of these models, representing Mars, Diana (Figs. 123 and 124) and Ceres,[47] and the terra-cotta for the relief (Museum of Fine Arts, Philadelphia) communicate a lively sense of movement and a strong feeling for plastic values, while the physical prowess of *Mars* especially anticipates that of the *Cassini*.[48] Roland, who shared the commission with Moitte and several other

Figure 123. Jean-Guillaume Moitte. *Mars,* 1784. Terra-cotta sketch. Paris, Musée de Palais de la Légion d'Honneur. Photo: Musée du Palais de la Légion d'Honneur.

Figure 124. Jean-Guillaume Moitte. *Diana,* 1784. Terra-cotta sketch. Paris, Musée du Palais de la Légion d'Honneur. Photo: Musée du Palais de la Légion d'Honneur.

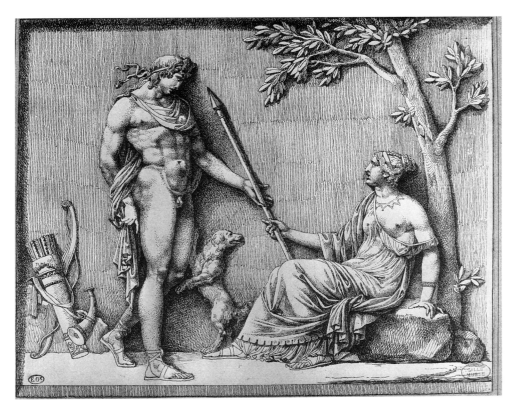

Figure 125 (opposite, below).
Philippe-Laurent Roland. *Roman Sacrifice* and *Triumph of Tatius*, 1783. Marble reliefs. Paris, façade of the Palais de la Légion d'Honneur. Photo: Musée du Palais de la Légion d'Honneur.

Figure 126 (right). Jean-Guillaume Moitte, *Cephalus and Procris*, c. 1771–73. Drawing. Lille, Musée des Beaux-Arts. Photo: Musée des Beaux-Arts.

Figure 127. Jacques-Louis David. *Frieze "à l'antique,"* 1780. Drawing. Grenoble, Musée de la Peinture et de la Sculpture. Photo: Musée de la Peinture et de la Sculpture.

sculptors or stonecutters, pursued a more pronounced Roman classicism in his two reliefs *Roman Sacrifice* and *Triumph of Tatius* (1783; Fig. 125) than Moitte did in his *Fêtes à Palès.* Even if its full severity has yet to be realized, all the reliefs carry forward the idea of a monumental, ancient planar style. This is especially true of Roland's sober *Triumph of Tatius* (Fig. 125).

Moitte's own characteristically bold temperament is seen to even greater advantage in his numerous drawings whose subjects demonstrate Moitte's full participation in the concerns of his day, from neo-Goujonism, to a heroic neoclassicism and even to the horrific.

That some of Moitte's earlier drawings have occa-

Figure 128. Jean-Guillaume Moitte. Mother Killing Herself after Having Killed Her Child, c. 1785–90. Drawing. Besançon, Musée des Beaux-Arts.

Figure 129. Léopold Boilly. *The Heroine of Saint Milhier*, c. 1794. Oil sketch. Private collection.

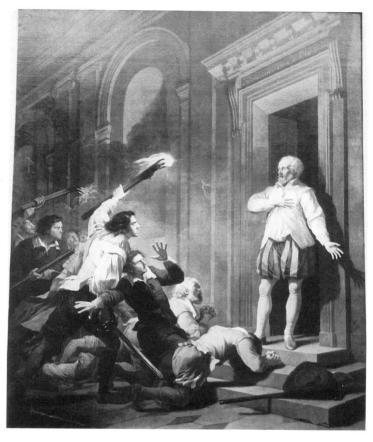

Figure 130. Joseph-Benoît Suvée. *The Death of Admiral Coligny,* 1787. Oil painting. Dijon, Musée des Beaux-Arts.

sionally been attributed to David points to the proximity of their youthful artistic paths. The latter's *Frieze "à l'antique"* (1780; Fig. 127) and Moitte's *Cephalus and Procris* (c. 1771–73; Fig. 126) attributed by Gonse to David,[49] share a broad assimilation of classical forms in relief. Vestiges of the recent past clung to other works in which a light rococo touch may still be discerned. In a signed and dated drawing of 1780, *Jupiter Greeting Venus in Olympus* (Musée Fabre, Montpellier)[50] from his illustrations of Fénelon's *Telemachus*, the crowded, nebulous atmosphere harks back to the recently chastened rococo, but the figures themselves are possessed of a new massiveness characteristic of Moitte's style. Looking a little more closely at Moitte's drawings of a *Mother Killing Herself after Having Killed Her Child* (ca. 1785–90; Fig. 128; cf. also Figs. 129 and 130), and *Achilles and Tros, Son of Alastor* (ca. 1785–90, Fig. 131),[51] one is entitled to speculate further about the new force therein and its

source. An answer comes in the form of the Swedish sculptor Sergel.

One may assume that Moitte and Sergel knew each other even if there is no evidence of a firm friendship, as they both followed the same modeling class at the French Academy.[52] Moitte's dour temperament and Sergel's gregariousness might have kept them apart, but a glance at Sergel's massive figural style in the terra-cotta groups of *Venus and Anchises* (1769–70) or *Mars and Venus* (1771–72; Fig. 132) is enough to suggest a stylistic exchange at least between the two artists. Even Moitte's drawing of *Achilles and Tros* (Fig. 131) combines both Sergel's sculptural and graphic manner in a burst of frenzied, energetic movement.

A *Mother Killing Herself* (Fig. 128), more tenebrous yet in both style and deed, shares the frenetic manner of the *Achilles and Tros.* Based upon a gruesome passage toward the end of Voltaire's *Henriade,* it

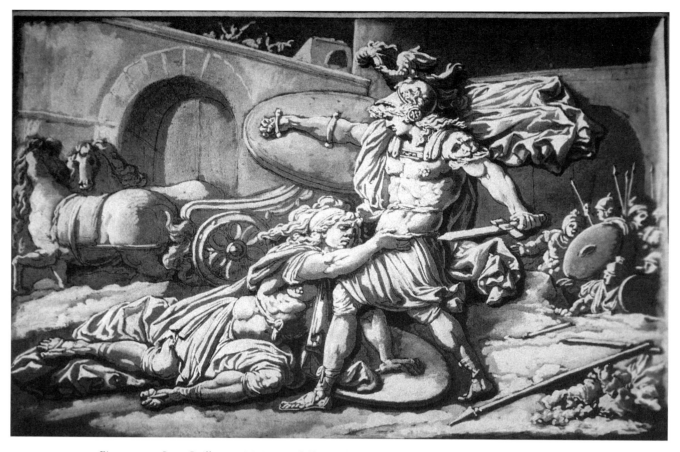

Figure 131. Jean-Guillaume Moitte. *Achilles and Tros, Son of Alastor,* c. 1785–90. Besançon, Musée des Beaux-Arts.

illustrates an episode in the siege and famine of Paris.[53] The histrionic drawing corresponds in several ways to Suvée's *Death of Admiral Coligny* of 1787 (Fig. 130), also taken from the *Henriade*,[54] both in the torchlit drama of the moment and the heroization of the figures.[55] Moitte may even have responded to the painting during its genesis with this drawing. The highly charged atmosphere of Léopold Boilly's sketch of a scene entitled *The Heroine of Saint-Milhier* (c. 1794; Fig. 129) appears also to be directly linked to Suvée's and particularly to Moitte's work. In an unusual departure from his usual manner, Boilly depicted a horde of looters rushing into the hovel of impoverished Parisians during the famine which crippled Paris after the Revolution.[56]

The dating of Moitte's two drawings is still in question, Serullaz placing the *Achilles* early in his career,[57] Gramaccini around 1794.[58] The deep chiaroscuro of the settings dominated by diagonal perspectives, and the flamboyance of line are indeed those of Moitte's

earlier career and are readily found in such sketches as *Fortitude and Justice* (ca. 1783)[59] as well as in the single sketches of *Fortitude, Justice, Prudence* and *Temperance* (ca. 1785), all in the Musée des Arts Décoratifs, Paris. They are also more apparent in Moitte's *Mars* and *Diana* than in the *Project for the Cupola of the Pantheon* of 1794 to which Gramaccini compares the drawings.[60] Bearing in mind Suvée's work as well, it would seem reasonable to date the drawings between 1785 and 1790.[61] These cross-influences shed light upon a community of artistic ideas far less evident when one consults the final sculptural products of the period in France. Terra-cotta statuettes act, in this sense, as an intermediary stage between drawings and finished works, preserving some of the freedom of drawing, while moving to the greater solemnity of the marble or bronze.

From a small group such as *Love and Friendship* (c. 1780–85; Fig. 133)[62] can be gauged the degree to which Moitte, still animated by Clodion's spirit (cf.

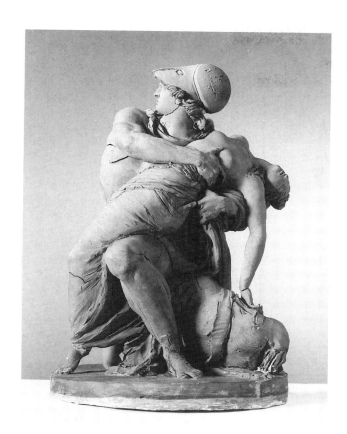

Figure 132 (left). Johan Tobias Sergel. *Venus and Mars*, 1771–72. Terra-cotta group. Stockholm, National Museum. Photo: Stockholm, National Museum.

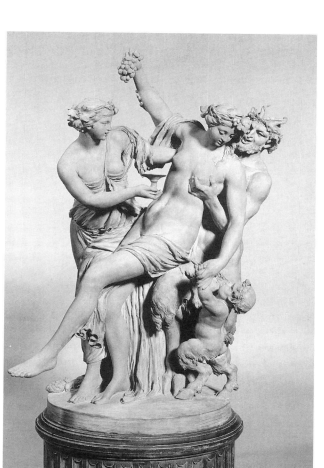

Figure 133. Jean-Guillaume Moitte. *Love and Friendship*, c. 1780–85. Terra-cotta group. Besançon, Musée des Beaux Arts.

Figure 134 (left). Clodion. *Satyr and Bacchantes*, 1766. Terra-cotta group. New York, The Frick Collection. Copyright, The Frick Collection, New York.

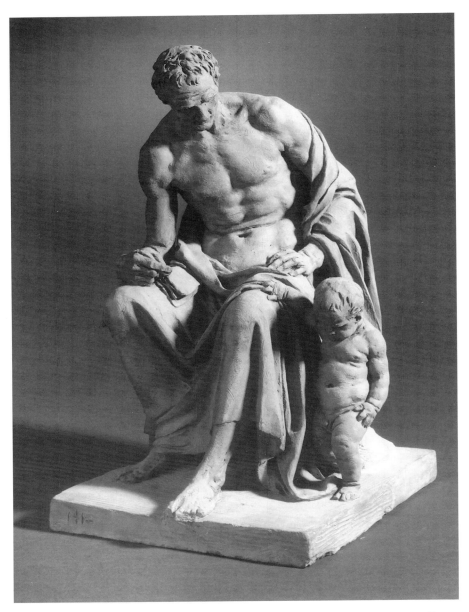

Figure 135. Jean-Guillaume Moitte. *Monument to Jean-Jacques Rousseau*, 1795. Terra-cotta group. Paris, Musée Carnavalet. Photo: Photothèque des Musées de la Ville de Paris by SPADEM

Fig. 134), distanced himself from the latter in the muscular treatment of the figures. His terra-cotta comes closer in fact to the *Jupiter and Juno* (1769–70) by Sergel, who learned about terra-cotta modeling at Clodion's side.[63] Both Sergel and Moitte forsake Clodion's lissom and lighthearted eroticism for something more viscerally compeling. This similarity points further to Moitte's undocumented but likely acquaintance with Sergel's work.

Moitte's *Cassini* stands as one of the earliest full-

scale examples of the translations of Sergel's moody epic mode into an acceptable public monument. His talent for this sort of thing reappears in his competition model (1795; Fig. 135) for the *Monument to Jean-Jacques Rousseau* (*Jean-Jacques Rousseau méditant sur le plan de l'Emile et examinant les premiers pas de l'enfance*) with its Christ-like emphasis upon a tender regard for children. Moitte won the competition in which every important sculptor (except for Houdon)[64] participated, although his entry – alas –

never materialized in stone.[65] Changes in the political situation occasioned reversals in educational policies which jettisoned Rousseau's gentler methods in favor of socializing the child through work and punishment, not the least bit evident in Moitte's companionable grouping.[66]

In spite of the model's thirty-four centimeters, the large scale of the principal figure is striking and bears considerable resemblance to the earlier *Cassini*.[67] Rousseau is remarkably free of posturing, his arm resting heavily on his thigh in an elegant gesture of ease. For the child, Moitte enlarged upon Pigalle's earlier, brilliant observations of children as well as the exquisitely sensitive mood of Houdon's busts of children. The terra-cotta speaks in general of an uninterrupted feeling for rich modeling and the figural style of earlier works at times obscured by Moitte's most public revolutionary works and the inevitable transformations of marble.

Sergel's Legacy

Moitte was not alone in admiring Sergel's talent. His boldness evidently appealed to a number of the new generation of sculptors seeking alternatives to the rococo.[68] Roland, for example, Moitte's collaborator on the Hôtel de Salm commission, brought a new, vigorous gruesomeness to his *Cato*, in keeping with the spirit of Fuseli, Banks and Sergel who were in Rome during his Prix de Rome days. He was back in France in time also for Sergel's remarkable Salon success. The circumstantial nature of the evidence is strong enough to suggest a broad current of inspiration extending to Roland and to others before and after him. Indeed, Jean-Baptiste Giraud (1752–1830),[69] the advisor and erstwhile friend of Emeric-David, executed his only known work, the *Dying Achilles* (1789; Fig. 91), very much in the spirit of Sergel's *Dying Othryades* (so much so that, for a long time, Sergel's work was attributed to him).[70] Giraud's composition, however, in spite of its technical excellence, is literally and figuratively cramped because of the strained leg and foot posture. Yet the wounded hero's broad, muscular form echoes Sergel's own style even to the warm natural inflections. These would have meshed easily with Giraud's and Emeric-David's own taste for a more balanced study of nature and Greek antiquity than that recommended by Quatremère.

Indeed, when J.-B. Giraud went to Rome in 1779, he did so with the intention of learning the true lesson of antiquity and "unlearning academic routine"[71] or drawing by rote after dead, white plaster casts. To learn the lesson of antiquity was also to learn the secrets of nature and to this end he studied anatomy at the hospital of Santo Spirito. In this he resembled Houdon whose *St. John the Baptist* was the fruit of a remarkable marriage uniting science and idealism.

The only extant testimony to Giraud's studies is the *Dying Achilles*, of which J.-L. David wrote in 1789: "He was instantly accepted on the basis of this work although of a style which still has not caught

Figure 136. Louis-Pierre Deseine. *Mucius Scaevola*, 1790. Marble figure. Paris, Louvre.

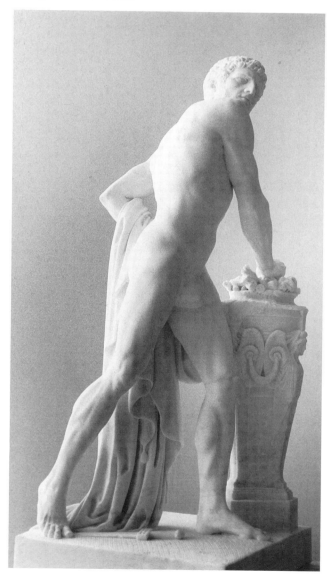

on much at the Academy which does not yet like the antique much. He is certainly our . . . foremost sculptor; he is the only one who really follows the ancients . . . and is truly gifted."[72] These few words recapitulate once again the oft told tale of the Academy's slow concession to neoclassicism noted earlier in Quatremère's eulogy of Houdon. They also shed light on David's taste. For all his friendship with Moitte, he gives preeminence to Giraud, the theoretician, the wealthy, independent art lover and artist free to follow his inclination toward a moderate, Hellenistic classicism.

As a final example of Sergel's belated influence upon French sculpture a tentative finger might be pointed at Louis-Pierre Deseine's *Mucius Scaevola* (1790; Fig. 136). This work captures not so much the liberal plasticity as the pose and thrust of Sergel's still famous *Diomedes*. Deseine, Pajou's pupil, had been abreast of developments in Rome, and, while not a vigorously original talent, knew how to make use of the originality of others.

The full extent of Sergel's influence upon the French remains to be measured. While Houdon actually led the way toward a new classicism with his *St. John* and his *Morpheus*, Sergel's heightened drama, broad sensuality and exclusively ancient subject matter thrust him into a leading role in Rome and even in Paris on his return to Sweden in 1778. His fame and popularity, if nothing else, served as a sanction for students to apply the lessons of antiquity more forcibly than hitherto tolerated. After Sergel, the two major forces of change would be Canova, whose stellar rise to fame in the 1780s eclipsed everyone else, and the French Revolution.

French Sculpture after 1789

THE WELL-KNOWN PROLOGUE to the salon catalogue of 1793 began with a postrevolutionary evangelical call to arms, that is, a call for art at the service of the state and of morality. In sheer numbers, almost twice as many sculpture entries appeared at the Salon of 1793 (182) as at that of 1789 (about 93), followed by a precipitous decline to fifty or so works at each salon thereafter. The importance of the submissions, however, decreased proportionately to the increase in numbers, and their overall moral tenor, save for the occasional Liberty, hero or other relevant public figure, failed to rise significantly. Any number of Bacchantes engaged in one activity or another continued to appear steadily throughout the interregnum. Yet, in the opinion of some, the Revolution ideally suited the goals of sculpture, the generation of "Beauvallet, Michallon, Ramey, Cartellier, Espercieux, Lesueur, Chaudet, Dumont, Bridan fils, Chinard and Lemot" creating its first work during this period.[1] And indeed, in spite of the instability of the political situation, the government did commission a number of considerable projects reflecting the ambitions of those in power, particularly from the Directoire on. The Pantheon reliefs and statues, the Louvre reliefs, the Arc de Triomphe du Carrousel and, eventually, of the Etoile (1806–33), the doomed Temple to Glory (later the Madeleine, 1806–42), and the Vendôme column constituted the chief Parisian monuments along with the various commemorations of the popular hero Général Desaix, the new "Grands Hommes" for the Pont de la Concorde[2] and the Salle du Sénat, the 1802 commission for a series of busts of "grands hommes" for the Galerie des Consuls,[3] and a colossal elephant for the Place de la Bastille (1810 commission), which perished like so many of the other commissions.[4] Despite these projects, however, contemporaries still deplored the lack of government support and private patronage.[5] Furthermore, painters, architects and theoreticians rather than sculptors oversaw the major sculptural undertakings with Jacques-Louis David as guiding spirit during the height of revolutionary unrest,[6] followed by Percier and Fontaine with Napoleon's rise to power.

Ranking as Europe's foremost exponent of the "true style" in painting, J.-L. David satisfied French preeminence at the international level. In sculpture, however, since Canova occupied that position, the French had to contend grudgingly with a foreigner as the dominant sculptural personality of the time.[7] Rising French nationalism and scholarly interest provoked a heightened defense of France's sculptural as well as pictorial heritage aided by Alexandre Lenoir's activities at the Musée des Monuments Français, although it would be some time before the neorococo movement and a changed political situation would vitiate the art of the eighteenth century. At the time, neo-Goujonism continued to offer the most nationalistic alternative to the international style, while simultaneously giving the French a sense of being legitimate heirs to a radical classicism. The official consulate and empire style remained, nonetheless, that of the "Canovians," Chinard, Chaudet and Bosio, to be discussed in a later chapter.

As no artist of Canova's stature or, in any event, reputation appeared in France to take the lead, part of the artistic prestige of the consulate had to reside in the spoils of war. The treasures of the Vatican and the other Italian plunder gathered by Napoleon were triumphantly paraded through Paris during the Fête de la Paix in 1798.[8] The Louvre, which had become a

national museum in 1794, prepared to receive the *Apollo Belvedere* and the *Laocoon* in the Galerie des Antiques inaugurated in 1800, while the Prix de Rome subject for sculpture, "Marcellus orders the monuments of Syracuse to be transported onto his ships," gave ancient precedence to Napoleon's activities. Contemporaries observed that the presence of the Greek and Roman masterpieces had stimulated a more zealous interest in ancient statuary among Parisian artists.[9] Their impact upon contemporary sculpture actually remains hard to pinpoint because of the already prevailing antiquomania, although nudity in portrait statues increased, much to the dismay of Parisians. The antiquities may have also given French sculptors the confidence to continue to pursue their own classicisms, including a "Republican classicism," independently of Canova who was indebted, after all, to the same monuments for his particular style. Quatremère even attributed the lack of attention given to Canova's plaster *Creugas* (1803 Salon) to the presence of the antiquities,[10] conveniently brushing over the fact that the *Creugas* remains one of Canova's least appealing works. These spoils of foreign campaigns, together with the demands of propaganda and the political situation in general, the changing condition of the artist and the theoretical conflicts within the Academy pitting Emeric-David against Quatremère de Quincy, all left their stamp upon the sculpture of those uneasy years. Leaving the international style and its French ramifications to later discussion, this chapter concerns itself more specifically with elements of style more local in flavor (republican and imperial classicism) and with an iconography and mood endemic to the postrevolutionary situation.

Republican and Imperial Classicism

Moitte, Houdon, Julien, Roland, and J.-B. Giraud had already set the tone for a warmly inflected, richly modeled classicism before the Revolution. While Giraud produced little after 1789 and a number of both Moitte's and Roland's major postrevolutionary works have vanished, these five sculptors nonetheless helped shape the expressive vocabulary of this period. Their classicism (excluding the neo-Goujonism treated separately) belonged to the figural type of David's *Horatii* or *Brutus*, a type more suited to the demagoguery of the Revolution than Canova's initially cooler, silent forms of the 1780s.

Moitte's winning competition model for the monu-

ment to Jean-Jacques Rousseau (1795) reflected the qualities of his Augustan *Cassini* and provided an eloquent, athletic image of the guiding philosophical light behind the momentous changes in progress. Even when Moitte chose to adopt the sixteenth-century canon of elongated proportions for his frieze of the *Aristocracy Buried under the Ruins of the Bastille and the Triumph of Liberty* (Fig. 61), he cast the figures in a setting notable for the absence of Greek clarity. He drew instead upon Roman historical friezes and reliefs. Furthermore, part of the second relief of *The Arrival of the King in Paris* also incorporated his wife's donation of jewels to the state in emulation of the worthy Roman women who had done the same to help Camillus,[11] drawing together style and historic reference.

The Roman (republican and imperial) rather than Greek basis for a considerable portion of the sculpture produced during this period rested upon obvious political parallels discussed at length elsewhere in the literature on painting and architecture. Questions of rivalry already alluded to in the discussion of neo-Goujonism and of Canova's dominant role also played a part in determining stylistic decisions, reflected even in Boichot's *River Gods* for the imperial Arc de Triomphe du Carrousel.

Percier and Fontaine's jewel-like creation, begun in 1806, ranks first as a small monument of architecture which, like the Fête de la Fédération arch of 1790, had some impact on the style of the reliefs devoted to Napoleonic victories.[12] The figures in historical costume in more or less stylized attitudes stand against backgrounds which minimize illusionistic effects yet shun the blankness of Greek reliefs.[13] They represent an educated mixture of classical restraint, historic precision, airlessness and high polish typical of imperial splendor and achieved by J.-L. David, for example, in his *Consecration of the Emperor Napoleon I* (1805–07).

Imperial ornateness reached a high point in Denis-Antoine Chaudet's earlier, seated figure of *Peace* (1803–05, cast in 1806; Fig. 137) whose existence grew out of one of the many temporary statues erected during the interregnum. On the 27 Thermidor, An IX, the government, with fireworks and fanfare, had set up a forty-foot statue of *Peace* on the Pont Neuf.[14] At the end of the year, Count Chaptal ordered that a permanent life-size replacement be made, the silver angels from the reliquaries for the hearts of Louis XIII and Louis XIV in St. Paul du Marais being melted down

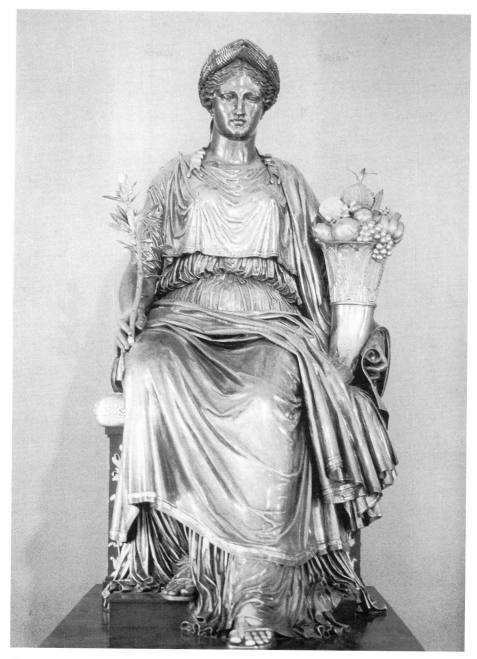

Figure 137. Denis-Antoine Chaudet. *Peace* (1803–05, cast in 1806). Silver statue with gold chasing. Paris, Louvre.

for the occasion. This work transformed the material opulence and privilege of the defunct monarchy into the rewards of revolution and, especially, empire. The silver and gold alone embody the abundance suggested by the cornucopia held in the left arm of the graceful, matronly figure of Peace. Cast by Cherest, the magnificent chasing of the precious metals corresponds to Chaudet's own incisive clarity of detail and silhouette even in his marble works, to which there will be occasion to return, and whose more precise classicism distinguish him from sculptors like Moitte. The other most obviously imperial monument (in terms of both inspiration and contemporary actuality), the column of the Grande Armée (1806–10) in the Place

Figure 138. Column of the Grande Armé (Vendôme column), 1806–10. Paris, Place Vendôme.

Figure 139. Trajan's Column. Rome, Fori Imperiali.

Vendôme, became the catalogue par excellence of Napoleon's Austerlitz campaign, unfolding in time like a silent film. Beyond merely adapting the conception of Trajan's column, the reliefs themselves have some of the unusual, primitive flavor of the Roman originals (Figs. 138 and 139) with their architectural inconsistencies and vertical arrangements of figures, for example. The painter and medal designer Pierre-Nolasque Bergeret (1782–1863) provided the one thousand drawings of relief sections for the legion of sculptors working on the eight hundred and forty-five feet of frieze.[15] Individuality of hand counts for little, therefore, in this extensive project.

These later imperial monuments formalized what had been a more intuitive approach to Roman monuments and sculpture in the preceding decade, which abounded in programs of a Roman kind. Among these, the single most important early revolutionary commission, the Pantheon, was to have been the home

of France's great men and a temple to intellectual greatness and courage. Quatremère de Quincy, who had shared with David the artistic responsibilities of revolutionary Paris,[16] had argued in favor of art as propaganda in his *Considérations sur les arts du dessin*[17] and gave life to his convictions in his program for the former church of Ste. Geneviève.

The transformation of the Pantheon (Fig. 140), Titon du Tillet's dream indirectly realized and to be complemented by the Invalides (dedicated to military heroes),[18] involved sculptors alone. Quatremère's pointed iconographic program extended not only to the interior and exterior reliefs, but also to the larger than life-size sculptures commissioned for the peristyle and projected for the interior, most of which disappeared along with Moitte's pedimental relief. His report on the monument's program serves as a substitute for the lost or unexecuted works and re-creates, in a few preliminary words, the enthusiastic climate in

which the whole was undertaken.[19] The commissions for the peristyle and entrance consisted of a group in stone by Chaudet representing *Philosophy Instructing a Young Man and Showing Him the Path to Glory and Virtue*, Roland's *Law*, Boichot's *Force* and Masson's *Warrior Dying in the Arms of France*. Lorta's *Liberty* and Lucas' *Equality* stood inside to the left and right of the entrance. The extensive relief decoration also included, significantly, two scenes mentioned earlier of *Devotion to the Fatherland* by Masson and Chaudet for, respectively, one of the great pendentives and the facade, as well as Boquet's pendentive *Love of Country*, underlining the importance of that particular virtue.

Roland's *Law* had formerly served as a processional figure of plaster and cloth in the Fête de la Loi of June 3, 1792, when twelve "slaves" bore it aloft to convey the urgent need for law and order after the assassination of the mayor of étampes.[20] The festival generated none of the enthusiasm that had characterized that of the Fête de le Fédération in 1790, largely, it seems, because its purpose was repressive and devoid of popular participation. Looking like a "frieze in motion,"[21] the procession remained remote and Roland's figure ineffectual. Quatremère, who had been in charge of this particular festival, admitted himself that his neoclassical images produced little "moral effect on the minds of the public."[22] The tiny image of the statue of the *Law* that survives in Berthault's engraving after Prieur's drawing (Carnavalet, Paris) reveals a static, seated, possibly female figure holding what looks like a tablet of the law, although a scepter

Figure 140. View of the Pantheon with Moitte's pediment. Paris, Carnavalet. Photo: Desgraces, for © Photothèque des Musées de la Ville de Paris by SPADEM.

VUE DE L'EGLISE STE GÉNEVIEVE, PANTHÉON FRANÇAIS.
Sépulture destinée aux mânes des Grands Hommes et des Dignitaires de l'Empire.

Figure 141. Guillaume Boichot. *Force As Hercules*, c. 1795. Bronze figure. Los Angeles County Museum of Art. Photo: © Museum Associates, LACMA.

Figure 142. Pierre Puget. *Hercules Gaulois*, 1663–68. Marble statue. Paris, Louvre.

has been suggested.[23] Under the best of circumstances, a symbolic figure of this kind rarely moves beyond the pedantic or formulaic. The figure finally disintegrated leaving little trace of its appearance behind, a fate which met all the statues of the peristyle with one, modified exception.

Boichot's fifteen-foot *Force As Hercules*[24] survives in the form of Landon's line engraving and a bronze statuette (Fig. 141) from which something of its monumental aspect may be gleaned. Viewed from the front, the legs and torso suggest an adaptation of the *Torso Belvedere* (Fig. 143) combined, in the profile view, with Puget's *Hercules Gaulois* (Fig. 142). Boichot harnessed both expressive traditions to his needs, substituting a more rigorously classical head and alert pose for the puffy-cheeked face and slouch of Puget's figure. This very obvious borrowing from Puget, while going against neoclassical dogma, speaks of the strength of nationalism in this period of crisis. The fine bronze statuette reveals Boichot's grasp of Florentine sculpture as well and his own considerable gifts as a modeler. It is fair to assume that the other figures and groups shared this heroic type, with allowances for gender, inasmuch as the artists were cooperating closely with Quatremère and Moitte.

Quatremère had intended to augment the cumulative effect of the six massive figures for the peristyle and entrance of the Pantheon with a colossal, chryselephantine figure of *La Patrie* (Fig. 144) of his own devising[25] and an equally gigantic *Renown* or *Fame* crowning the dome, neither of which was ever fully realized.[26] Every virtue and quality associated with the Revolution was to have found form in the Pantheon program, culminating in *La Patrie*. Under the guise of celebrating great men,[27] this carefully orchestrated ensemble of permanent propaganda was ultimately geared to nurturing among the lower and even the middle classes not only the concept of unity within the state, or nationalism, but sacrificial devotion to it as well. Each man might aspire to fame and to the glory of burial and commemoration in the Pantheon (whereas no one but the dauphin might aspire to Versailles), just as each American boy (the time may come for girls) may aspire to the presidency. This appeal to his ambitions might encourage the *citoyen* to cherish the new "equality" and "liberty" and to wish to preserve and protect them from both local and foreign royalists. And to preserve those new personal liberties meant preserving the new state, worshiped no longer in the form of the king, but in the form of countless *Fra-*

Figure 143. *Torso Belvedere*. Marble. Rome, Vatican Museum.

ternités, *Egalités* and especially *Libertés* and then, by 1792, in the form of *La Patrie* or *La République* which subsumed all three.[28] At the same time, *La République* assumed the lower-class name of *Marianne*, which she has retained to this day, rendering her more accessible to the people than a mere, chilly personification of government.[29] Again, by skillfully avoiding direct references to revolutionary episodes, Quatremère achieved an adaptable iconographic program lending itself more readily to assimilation by the subsequent governments of the interregnum, but not by the nouveau régime (cf. further discussion of Fig. 145 on page 110).

The same was true of Moitte's then-famous relief of *The Motherland Calling upon Her Children to Fight* (1795–1802, destroyed; Fig. 146) for Chalgrin's skillful renovations of the Senate (Luxembourg Palace). After seeing it in 1802, Benjamin West said it was the best contemporary relief in France.[30] A teeming accumulation of figures, including a trio of Horatii-like

REPUBLIQUE FRANÇAISE

Projet de Groupe a executer au fond du Pantheon Français

men and a group of Flaxmanesque supplicants at the foot of an archaic statue of Liberty, the relief legitimizes the government's perpetual need for soldiers. Justice, Prudence and Fortitude stand behind the State, or France, to the left. Rude's *Marseillaise,* or *Departure of the Volunteers,* later dramatized the same theme of course, but with the intention of binding Napoleon's glorious past to the July monarchy.

The political program of the Pantheon recurred in the various *fêtes révolutionnaires* as well as in a number of Salon entries which repeatedly played upon the need for individual action, beginning with Jean-Joseph Espercieux's plaster model of *Liberty* exhibited in 1797 and the result of a national competition. The artist inscribed on the base the words: "Liberty holds in her hand public Felicity. One acquires and preserves Liberty through philosophy *and through arms.*"[31] A work presented by Lorta at the Salon of 1802, *An Allegorical Figure Representing Unity Who Leads the French People to Victory* again presses the point.[32] It is equally telling that, when Edmé-étienne Gois, fils (1765–1836) exhibited his life-size, government-commissioned *Joan of Arc* (Fig. 197) at the same salon, the catalogue, ignoring the famous voices (for anticlerical reasons too, no doubt), presented her willingness to sacrifice herself as entirely self-motivated: "This young girl, animated by the desire to be useful to her country, *conceived the notion* of going to fight the enemies of France."[33] This timely propaganda urging French citizens to fight the Napoleonic Wars made rare use of a female historical figure and initiated a long line of Joan of Arcs in the nineteenth century.

An earlier project by Carlo-Luca Pozzi (1735–1805), *Concord Tightening the Bonds of the State Alliance* (c. 1795; Fig. 145) allows a glimpse of the sort of group allegory created for the public forum. This ensemble was meant to have taken the place of Lemot's temporary *Liberty* created for the Fête de l'Unité of August 10, 1793. Again, France in the guise of a rather small Hercules makes an appearance, supporting the fasces which Concord binds under the

Figure 144 (top). A. C. Quatremère de Quincy. *La Patrie,* c. 1793–95. Drawing. Paris, Bibliothèque Nationale. Photo: © cliché Bibliothèque Nationale de France, Paris.

Figure 145. Carlo-Luca Pozzi. *Concord Tightening the Bonds of the State Alliance,* c. 1795. Drawing. Paris, Musée Carnavalet. Photo: Degraces, for Photothèque des Musées de la Ville de Paris by SPADEM.

Figure 146. After Jean-Guillaume Moitte. *The Motherland Calling Upon Her Children to Fight,* 1795–1802. Engraving by Chataigner, c. 1800–01. Paris, Bibliothèque Nationale. Photo: © cliché Bibliothèque Nationale de France, Paris.

Figure 147. Jean-Guillaume Moitte. *Monument to the French People,* 1794. Drawing. Paris, Bibliothèque Nationale, Cabinet des Estampes. Photo: © cliché Bibliothèque Nationale de France, Paris.

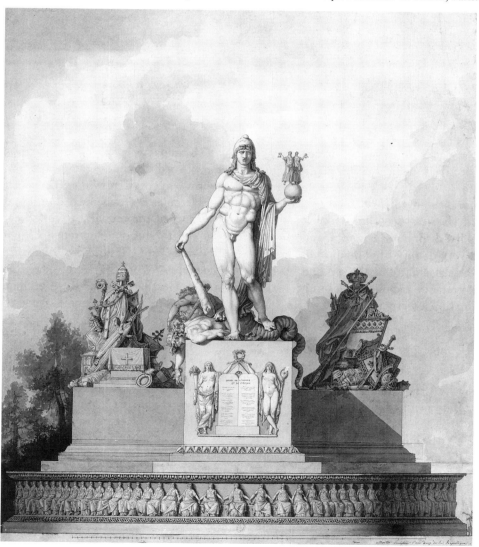

Figure 148. Jean-Baptiste Regnault. *Presentation to the Senate of the Captured Austrian Flags,* 1812 Salon. Oil on canvas. Versailles, Musée de Château de Versailles. Photo: R. M. N.

observing eye of a seated Minerva. Unfortunately, the latter's shield effectively truncates the central figure instead of spreading like a protective wing about the group. Furthermore, the need for didactic storytelling has overwhelmed classical decorum, lending an animated, even mildly disorganized appearance to the whole.[34] But this very quality of animation or "enactment" upholds the sense of a "mythic present" prevalent during those years, or a spontaneous and constant reliving and validation of crucial events which took place at the festivals, political gatherings, and public funerals, and no doubt gave rise as well to the declamatory style in representations of orators both ancient and modern.[35]

The alternation between Liberty or Marianne and Hercules as an embodiment of France, filling the vacuum created by the absence of a king, eventually yielded in favor of Marianne, up to a point.[36] Each allegory fulfilled different roles favored by moderate or more radical factions and for which models already existed in Pigalle's *Monument to Louis XV.* When the King's statue fell in 1792, *Gentle Government* and the *Citizen* remained, or motherly education and a resting, thinking athlete.

The didactic needs of propaganda were such that the "word" would come even to overwhelm the "form" on occasion, witness David's idea for the colossal Hercules he envisioned standing upon the heaped-up ruins of the monarchy (first idea, Nov. 7, 1793). On the forehead he stamped "Light," on the chest "Nature" and "Truth," on the arms "Force," and on the hands "Work."[37]

The Herculeses of the Revolution served as the male counterpart to the female personifications of the motherland and the Republic and gave the French a sense of themselves as colossal and heroic, indeed as a machine of war.[38] While David's idea failed to materialize, others prepared sketches for the competition for the proposed colossus, which by 1794 had become the *French People Crushing Fanaticism, Royalism and Federalism.* The project died for want of an apparently winning submission. Moitte, whose name does not even appear on the list of entrants, transformed the rubble of statues David had envisioned for the base into two neat piles of trophies on top of the base on either side of a gigantic Hercules crushing the Hydra (the monarchy) underfoot (Fig. 147).[39] This graceless, pneumatic Hercules dominates a jarringly original

Figure 149. Antoine Houdon. *Cicero*, 1804. Painted plaster statue. Paris, Bibliothèque Nationale.

Figure 150. Clodion. *Cato*, 1804. Plaster statue. Paris, Senate, Luxembourg Palace.

composition by ignoring all baroque ideals of integration in favor of an almost Canovian one of juxtaposition of parts. The varied elements are brought together into one narrative by the stunning circular plinth with its hundred larger-than-life, seated, hand-holding maidens. Hercules towers like a mountain, two minute figures to the lower right setting the scale for the monument's hypertrophic size.

Jean-Baptiste Regnault's painting of the *Presentation to the Senate of the Captured Austrian Flags* (1812 Salon; Fig. 148) affords a rare glimpse of the kind of sculptural program that appealed to the government. The original Senate commission of 1798 called for six full-scale figures culled from d'Angiviller's "Grands Hommes." Temporarily stored in the Salle des Caryatides pending their relocation in the Louvre, they represented a throwback to the ancien régime and as such were eventually dropped. During the Consulate, however, in keeping with d'Angiviller's example, twenty-two more statues were commissioned, including figures from French history and "Napoleonic" heroes. In 1808, the government even voted a statue of Napoleon himself to be placed in the Senate.[40] Thus some twenty-eight famous men in all, situated in the Salle des Séances or along the grand staircase of the Luxembourg, shed the light of their legendary courage upon the proceedings.[41]

The enlarged program still restricted the chief focal point to ancient heroes (now dispersed), establishing a timeless yet politically apt gathering at the core of the Salle des Séances. Facing the senators on either side of a small hemicycle stood Cato, Brutus and Cicero to the left, and Solon, Lycurgus and Demosthenes to the right. Houdon's delicate and badly received *Cicero* (1804; Fig. 149), the defender of the Roman republic against tyranny, cut a poor figure in those lofty surroundings for which Clodion's more vigorous *Cato* (1804; Fig. 150) seemed better suited.[42] In addition to these, four other statues destined for the Salle des Séances appeared at the 1804 salon: Ramey's *Scipio Africanus* (Luxembourg Palace), Delaistre's *Phocion*, Chaudet's *Cincinnatus* and Cartellier's *Aristides*. The figures visible at the front left of the hemicycle in Landon's line engravings of *Cincinnatus, Scipio,* and *Aristides*[43] convey the impression of a sober group heavily dependent upon ancient emperors and philosopher types. Yet, other statues for comparable commissions reveal a subtle shift away from this decorous severity toward a more dramatic emphasis.

Draped in an unusual and complex pattern of diagonals, François Lemot's mysterious *Lycurgus* (Fig. 151) intrigues the viewer by concealing more than it reveals of the hero. His *Brutus* (1798; Fig. 153), also for the temporary Chambre des Députés at the Palais Bourbon, in its unabashed plagiarization of the Capitoline *Brutus* (Fig. 154), more obviously displays the fierce demeanor that had instantly become one of the most popular visual staples of the Revolution.[44] Claude Michallon (1751–99) in particular hit upon an especially umbrageous "terribilità" for his *Cato* (Fig. 152) for the same Chambre des Députés, the brandished sword foretelling his grisly end. A cap of heavy hair and deep furrows above the eyes enhance the unsmiling determination of the face.[45] This new mood was to reach far into the nineteenth century.

The demagoguery of the Convention and the Tribune was slowly infiltrating the vocabulary of sculpture, Lesueur's *Demosthenes* (1806; Fig. 155) for the Palais Bourbon evincing a new, movemented character unusual in official sculpture and so tellingly captured in a small terra-cotta *Brutus* at the Carnavalet (Fig. 156). The "mythic present" and the "telling moment" of the Grands Hommes collide as Demosthenes raises his arm threateningly above his head to dramatize his point. The supremacy of the spoken over the written word during the pre-Consulate days especially[46] finds a new outlet here, again a kind of permanent spontaneity capturing the essence of political haranguing. Like the *Brutus*, Cartellier's *Vergniaud* (plaster, 1804–05; Fig. 157), also for the Senate staircase, stretches out his arm to an imaginary audience. He is, like so many others, draped only in a togalike robe on the strength of a sudden nocturnal impulse – in this case, to rehearse his speech for the Tribune on the following day (even though he was famous for his brilliant, extemporaneous speeches).[47]

It may even be that these raised arms carry a political significance beyond their obvious subject and action, namely that they defy ancien régime decorum.[48] Like the *Tyrannicides*, these figures speak to the heart through the vigor of their gesturing. This oratorical, communicative genre finally fed into the full-blown drama of the *Marseillaise*.

Classical Nudity

The question of nudity raised in relation to Pigalle's *Voltaire* and the "Grands Hommes" came to a head in

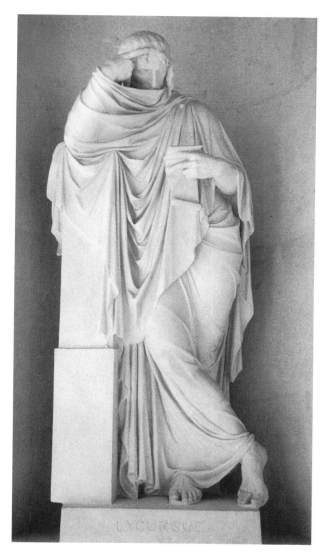 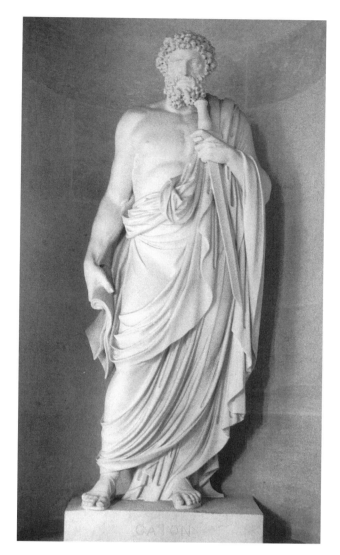

Figure 151. François Lemot. *Lycurgus*, 1799. Plaster statue. Paris, Assemblée Nationale.

Figure 152. Claude Michallon. *Cato*, 1799. Plaster statue. Paris, Assemblée Nationale.

these years. During the Revolution, of course, dress codes became so politically charged that death might result from wearing the wrong pants.[49] In terms of art, the clean sweep of the Revolution meant to some the rejection of contemporary dress in favor of that of Greece or Rome as a means both to eradicate the royalist past and to espouse a democratic Republic. The sculptor Espercieux even favored a complete return to the toga for his living contemporaries.[50] Those like the philosopher and mathematician Condorcet, on the other hand, who shared his faith in a progress that went beyond the ancients, objected to anything but contemporary costume. In a time of constant change,

however, all this would inevitably yield problems for as time-consuming a medium as sculpture. By and large, however, the critics and public continued to consider nudity a product of the extreme artistic dogma practiced in Rome and fundamentally alien to the "reasonable" traditions of France,[51] a few works in particular polarizing the camps.

A foreign work, Canova's statue of *Napoleon as Mars the Pacificator* (1803–06; Fig. 158), remains the paradigmatic, neoclassical male nude figure and image of fearless authority, a new, unclad *Augustus of Prima Porta*.[52] Napoleon commissioned the work in 1801 leaving the details to the Italian artist. Sketched by

Figure 154. *Capitoline Brutus*, Rome, Museo Capitolino.

Figure 153. François Lemot. *Brutus*, 1798. Plaster statue. Paris, Assemblée Nationale.

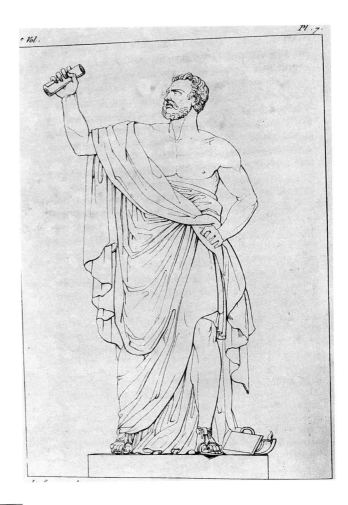

Figure 155. After Jacques Lesueur. *Demosthenes*, 1806. Engraving, Landon, *Annales*, 1806, vol. XI, pl. 7.

Figure 156 (left). Anonymous. *Brutus*, c. 1800. Terra-cotta statuette. Paris, Musée Carnavalet. Photo: Degraces, for Photothèque des Musées de la Ville de Paris by SPADEM.

Figure 157. Pierre Cartellier. *Vergniaud*, 1804–05. Plaster. Versailles, Musée du Chateau de Versailles.

Figure 158. Antonio Canova. *Napoleon as Mars the Pacificator*, 1803–06. Marble statue. Apsley House, London. Photo: Victoria and Albert Museum.

1802 and little altered in the actual execution, Canova's purposeful god comes striding to a halt, extending a Victory in his right hand. Its ignominious positioning without pedestal in the cramped stairwell of Apsley House, London, where complacency has left it, precludes a proper appreciation of the stance and proportions.[53] These show themselves to greater advantage in the handsome bronze (1812; installed only in 1859) in the Cortile of the Brera, Milan. The head (Fig. 172) ranks also as one of Canova's finest achievements in heroic portraiture. Indeed, it struck Fernow, his most unsympathetic critic, as an irresistible configuration, setting the standard for all other Napoleons.[54] With its larger-than-life scale and what can only be called Byronic idealization, Canova made of Napoleon a legend.[55] This image prefigures more than any other the all-American comic-book hero Superman. The godlike features exhibit a passionate intensity that reaches far beyond the atmospheric romanticism of J.-L. David's flamboyant *Napoleon at the Col du Mont Saint Bernard* or, for that matter, any of the other sculpted or painted portraits of the consul or emperor. Along with Roman imperial portraiture, modern inspiration lay within easy reach. Canova would undoubtedly have been invited to see Moitte's *Cassini* while in Paris in October 1802, since he was on friendly terms with him as well as Giraud and Houdon.[56] If nothing else, Moitte's own handsome and heroically scaled and brooding intellectual would have heightened Canova's sense of possibility.

Considering the date of the commission for this colossal, indeed imperial, statue, it would seem that Bonaparte intended to pave the way for public acceptance of his eventual coronation as emperor. Admittedly, Canova only completed the statue in 1806, but he had modeled the colossal bust by 1802, after posing sessions with Napoleon in Paris,[57] and had readied the plaster to great acclaim by 1803. With images such as these in existence, Napoleon's coronation might seem like an afterthought to a fait accompli.

Unfortunately, the statue embarrassed Napoleon who found it too "athletic,"[58] but it marks a significant point in Canova's oeuvre as a masterful portraitist, if one is willing to overlook the transfiguration of a short, stout man into Mars. It also marks the introduction of nudity, previously reserved on the whole for thinkers, into the sphere of contemporary military portraiture. On its exhibition in Canova's studio in 1806, it found high favor with the Roman pub-

lic, whose opinion the *Mercure de France* of September 1806 immediately echoed, terming it a masterpiece of modern sculpture.[59] Yet, Napoleon had Canova's statue safely hidden away upon its belated arrival in France (1812),[60] (the same fate that met the sculptor's statue of Napoleon's mother, Letizia).[61] As a result, controversy surrounded *Napoleon* far less than it did those works in the same vein which found their way to the Salon or other public display. Nonetheless, Canova's statue constitutes the background for this particularly radical group of nude or seminude contemporary French heroes whose authors could also rely on the more moderate French essays in the genre, like Pajou's *Buffon*, Julien's *Poussin* or even Moitte's *Rousseau*.

The fact is, everyone seemed to want to do a nude Napoleon. Moitte himself had projected a *Monument to Napoleon* (1801–02; Paris, Bibliothèque Thiers), in which Napoleon appeared as an almost naked Roman general.[62] In 1804, the Corps Législatif voted a marble statue to Napoleon for its Salle des Séances to be executed by Chaudet who courageously modeled a seminude *Napoleon As Legislator* (1805), with Napoleon draped in a toga. The controversy was so acute that Vivant-Denon took up the sculptor's cause for which he was warmly thanked by not one or two but by a legion of artists who added their collective letter to the debate.[63] Regardless of the opposition to classical dress, however, no full-length statue of Napoleon in modern uniform was erected during his lifetime. At best he was seen in his coronation robes in Ramey's statue (1810; Fig. 159) for the Assembly Hall of the Institute which inevitably retain a certain transcendent aura.

Again and again, sculptors were brought up hard against this paradox: in spite of the fashionableness of neoclassicism, to reach for the highest goal of sculpture required courage. Thus, however contradictory it might seem, news of Canova's *Napoleon* had conveyed a message of artistic freedom far beyond the norm. Chaudet went on to portray Napoleon once again in simple Roman apparel for the Vendôme column (1810; Fig. 160), although without the same spirit as Canova. For the latter's spear and victoriously pacific gesture, Chaudet substituted a mere sword and a cramped arm position. Napoleon himself had hoped originally to see a statue of Charlemagne, with whom he so clearly identified, crown the column.[64] But he was prevailed upon to accept his own image.[65]

On another occasion, Chaudet, who participated

Figure 159. Claude Ramey. *Napoleon in Coronation Robes*, 1810. Marble statue. Paris, Louvre.

Figure 160. Denis-Antoine Chaudet. *Napoleon*, 1810. Paris, Musée Carnavalet. Photo: Degraces, for Photothèque des Musées de la Ville de Paris by SPADEM.

with a number of other sculptors in honoring Napoleon's generals, evolved an impressive effect for his statue of *Général Dugommier* (c. 1808–10; Fig. 161), related admittedly to the question of timelessness rather than to that of classical nudity. The general's voluminous cloak all but hides the Napoleonic costume, while the helmet sufficiently resembles those worn by the Romans to establish a generic similarity without forgoing the precision of contemporary history. The other generals in the series fail to wear their heavy cloaks to the same effect.

In the hierarchy of genres, Chaudet's solution was the more appropriate, leaving quasi deification to the emperor. David d'Angers, in his essay on Thorvaldsen, neatly recapitulated the problem, allowing a certain idealization of historical costume for men of outstanding quality, nudity being reserved for men of quasi-divine grandeur alone.[66] And by way of example he gave Napoleon.[67]

Indifferent to such niceties of rank, Dejoux (a friend of Quatremère's) brought the heroic nude to a climax in France in his ill-fated statue *Général Desaix* (1805–07; plaster, 1808; bronze, 1810; Fig. 162).[68] Moitte's overheated imagination had originally given birth to an astonishing monument to *two* naked generals, Desaix and Kléber (1800–01; Ecole des Beaux Arts, Paris) for the same Place des Victoires. It was to have incorporated the four horses of San Marco later diverted to the Arc de Triomphe du Carrousel (but not used there either).[69] While adapting to Napoleon's preference for clothed figures in the second project (Fig. 163), he still retained shock value by setting the heroes in a full-scale chariot dominated, in one version, by a Victory crowning them. Alas, Moitte and his collaborator, the architect Raymond, lost the project, but still in the works was the *Death of Général Desaix* for which Moitte's first idea (1801; Fig. 164) was of a *naked* dying Desaix. The animated relief bears all the telltale signs of his revolutionary work from the Federation frieze (1790; Figs. 61 and 63) to the Senate relief of the *Motherland Calling Upon Her Children* (1795–1802) and shows again Moitte's passionate, personal, and almost idiosyncratic pursuit of a hyped-up classicism. The final relief (Fig. 165), completely dominated by the hero's horse, shows a death tamed by contemporary costumes and a naturalistic setting. Dejoux, meanwhile, tried to keep the flame burning high.

Napoleon had overridden Dejoux's desire to represent Desaix dying, insisting upon a living hero instead.

the grandiloquent figure recorded in any number of contemporary engravings (see Fig. 162). The eighteen-foot bronze, one of the few colossi of the period translated into "durable" material, was erected in the Place des Victoires in 1810 with a strategically placed loin-cloth concealing what would offend the bourgeoisie. In time it was dismantled and, with Chaudet's Vendôme *Napoleon* and Houdon's Boulogne *Napoleon*, it was melted down for Lemot's equestrian *Henry IV* on the Pont Neuf.

There is nothing to match the scale of Dejoux's *Desaix*, not even Charles Antoine Callamard's plaster *Napoleon As Achilles* of which the first model measured some ten feet.[70] One has to look rather to the

Figure 161. Denis-Antoine Chaudet. *Général Dugommier,* c. 1808–10. Marble statue. Versailles, Musée du Château de Versailles. Photo: R. M. N.

Figure 162. After Claude Dejoux. *Général Desaix,* 1805–07. Engraving, Landon, *Salon de 1808,* vol. II, pl. 21.

At least the hoary old artist, over seventy by then, stuck to his principles where nudity was concerned. Remembering that Julien, author of the almost naked *Poussin,* was his good friend, one gets the feeling that a core group of artists sustained each other in their most difficult choices. In any event, Dejoux produced

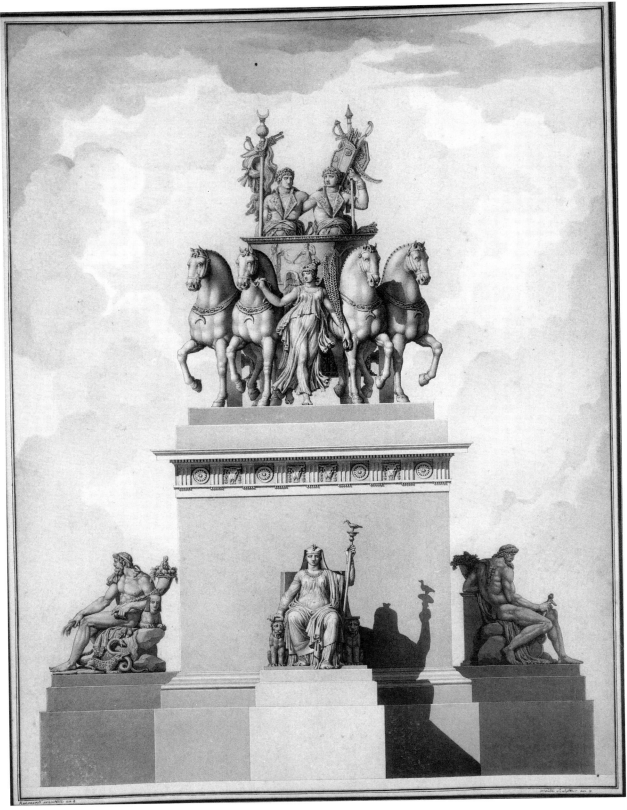

Figure 163. Jean-Guillaume Moitte. *Project for a Monument to the Generals Desaix and Kléber,* 1800–01. Drawing. Paris, Ecole Nationale des Beaux-Arts. Photo: Ecole Nationale Supérieure des Beaux-Arts.

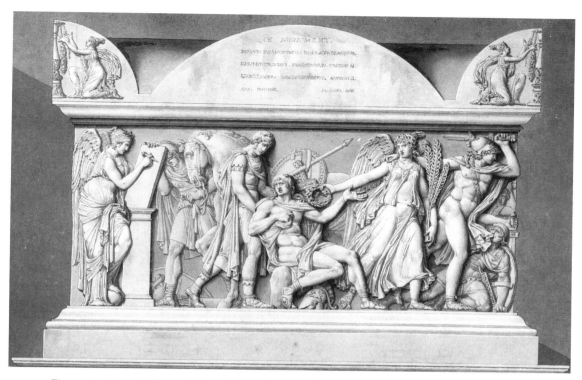

Figure 164. Jean-Guillaume Moitte. *Project for a Tomb for Général Desaix*. Drawing. Paris, Ecole Nationale des Beaux-Arts. Photo: Ecole Nationale Supérieure des Beaux-Arts.

Figure 165. Jean-Guillaume Moitte. *Death of Général Desaix*, flanked by reliefs of the *Nile* and the *Rhine*, 1805. Marble relief. Hospice du Grand Saint Bernard. Photo: Hospice du Grand Saint Bernard.

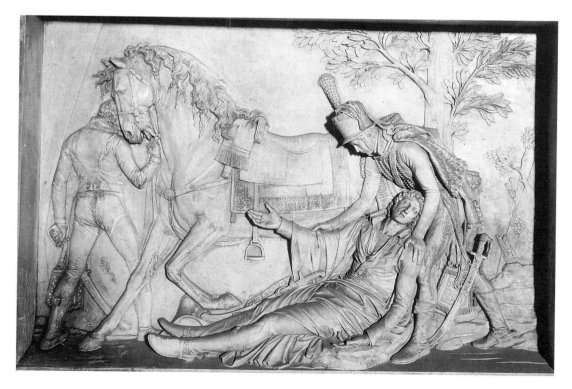

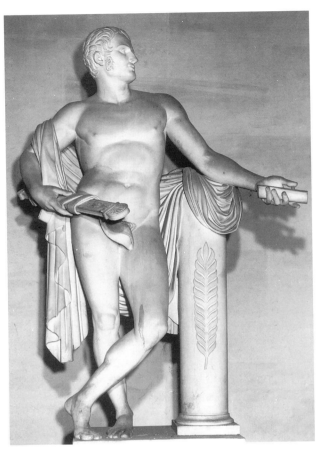

Figure 166. Charles Dupaty. *Général Leclerc*, 1812. Marble statue. Versailles, Musée du Château de Versailles. Photo: R. M. N.

great Herculeses of the *fêtes révolutionnaires* and to Moitte's imposing project (Fig. 163) for the background to such an idea.

Charles Dupaty's (1771–1825) *Général Leclerc* (1812; Fig. 166) met with a little less opprobrium for its nudity. The life-size marble figure recalls David's sketches for the *Oath of the Jeu de Paume* (1791–92; Fig. 167), with its many nude participants awaiting historic costume. The same can be said of Cartellier's *Vergniaud* (Fig. 157) for the Senate staircase. In the case of the former, Dupaty had received careful instructions from Denon (as had Milhomme for his statue of the quasi-nude *Général Hoche* of the same year, now at Versailles) that the "cloak of the ancients" cover the essentials so that Napoleon might place the statue in a Catholic church if he so chose![71]

Ultimately, these nude figures led the critic Dumont to complain that without labels the subjects remained unidentifiable. He offered as an example a naked figure by Corneille which he supposed to be some classical hero until he read the label and discovered it to be the *Adjutant Dalton Killed at the Crossing of the Mincio*, one of the figures for the Senate staircase.[72] But how many could identify the clothed generals (or intellectuals) except, perhaps, for the very famous Turenne, Condé and Bayard?

These statues represented an influx of contemporary heroes in Paris, which marked a significant departure from the former "Grands Hommes" code and took their cue from works like the privately commissioned *Voltaire*s. D'Angiviller's commission had left no room for the recently deceased. The later program

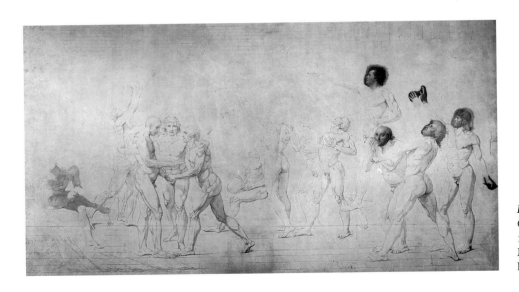

Figure 167. Jacques-Louis David. *Oath of the Jeu de Paume*, 1791–92. Oil sketch. Versailles, Musée du Château de Versailles. Photo: R. M. N.

reflects a new awareness of history in the making along with the need to provide the public with a different set of heroes both to offset the largely royalist group of earlier times and shape the view of the present. Napoleon has already made his appearance among these within the context of the problems of nudity in sculpture, but that fails to exhaust the importance or variety of the busts and statues which began to apppear as early as 1797, after Napoleon's astounding Italian victories.[73]

Napoleonic Imagery

For a while, the Revolution had given the impression that the government *was* the people, and new images were sought to play out this fantasy in the form of *The French People, Liberty*, and the new *Marianne*. The ascendence of Napoleonic imagery openly signals the return to the business-as-usual propaganda machine of autocratic rule. And, indeed, far more works celebrating Napoleon came into existence than his fabled protests would warrant. His command to remove Baron François Lemot's (1772–1827) handsome, gilded statue of him from the quadriga (also by Lemot) on top of the Arc de Triomphe du Carrousel may have been sincere.[74] But the numbers of reliefs, busts and statues commissioned by him or voted to him by men in power both before his ascension to the imperial throne and after (not to mention his profile on the coin of the realm) confirm his grasp of their political utility. Why otherwise commission a statue from Canova, the most famous sculptor of his time?

The disappearance of a large number of these works has favored the myth of Napoleon's modesty, but, as all of Gros' sanctifying portraits so clearly spell out, the reality was different.[75] One particular category of commemorative sculpture, however, never fully surfaced during his time, namely, equestrian portraits. A number were projected; Canova's horse for a Naples equestrian reached the stage of a full-scale plaster model (1806–10) known through engravings.[76] In France, Moitte (1803–04)[77] and Gois fils (1808) sent models to the salons, but no commission resulted from these essays, possibly for lack of funds. At the same time, Napoleon and his advisors carefully steered attention away from works that might lessen his prestige, as the police reaction to the so-called public response to the reliefs for the Corps Législatif demonstrates.[78]

The unveiling of these works, including Chaudet's now destroyed *The Emperor Presenting the Flags Conquered at the Battle of Austerlitz to the Deputation from the Corps Législatif* (1810) for the pediment, led the police to report upon the unfavorable reception produced not by an excess but a *lack* of grandeur in showing Napoleon on horseback accompanied by a mere handful of infantrymen bearing the flags. As a result, on the orders of minister of the interior, the chief of police enjoined the newspapers to refrain from discussing the reliefs. Such small failures notwithstanding, Napoleon was willing to take full credit for his extensive artistic patronage by allowing his bust to occupy the center of Lemot's relief for the east pediment of the Louvre: *The Muses, Invited by Minerva, Pay Homage to the Sovereign on His Completion of the Louvre* (1808–10). Again, "like a signboard . . . switched with every change of proprietor,"[79] a bust of Louis XIV (still there) took the place of Napoleon's.

In the same year that Canova received the commission for the statue *Napoleon as Mars the Pacificator*, two larger-than-life statues were begun in Rome, one by Giovanni Battista Comolli (1755–1830), the other, at the instigation of the French minister Cacault, by François Maximilien Laboureur who availed himself of Canova's bust for his togaed figure (1803–06; now in Ajaccio).[80] Not much later, Charles Antoine Callamard (1769–1821), a student at the French Academy who also used Canova's bust, undertook his colossal statue of *Napoleon as Achilles* (1803–05), encouraged by Murat and above all by Cacault.[81] In spite of the latter's valiant efforts to obtain the translation of Callamard's three-meter model into marble, he failed, the plaster eventually crumbling in quiet oblivion.[82] Banti's statue (Fig. 112) in Venice, indebted to Houdon's *St. John*, was soon to be erected as were many others which have since disappeared, including several copies of Chaudet's *Napoleon as Legislator*[83] and a *Saint Napoleon* for the facade of the Milan cathedral![84] Surprisingly enough, in view of Houdon's relative unpopularity after the Revolution, even he received commissions for three busts and, in 1806, for a colossal bronze statue of Napoleon to top the Boulogne column destroyed at the Restoration.[85] But if his bust of Napoleon (Fig. 168) is any measure of the full-scale statue, it fell short of the heroic type established by Canova.

Figure 168. Antoine Houdon. *Napoleon,* 1806. Terra-cotta bust. Dijon, Musée des Beaux Arts.

Within the domain of bust portraiture, Charles-Louis Corbet's (1758–1808) famous *Bonaparte* (1799; modeled 1797; Fig. 169) broke most radically with the mold of by then traditional classicizing formulae to seize the fleeting expression, lank hair and mobile features of the rising general in a moment of arrested attention. To some, his features bore the imprint of a man of destiny,[86] but certainly without the Byronic cast of Canova's bust, executed only a few years later, or the fire of Gros' painted portrait of *Napoleon at the Pont d'Arcole* (1796; cf. Fig. 173) which Corbet's work most resembles and which Chaudet admired enough to copy. This is the vivid record of a modern hero satisfying those who failed to see the necessity of shrouding the present in the past. It bears witness to the ongoing tradition of French eighteenth-century portraiture already touched by the greater intensity of high romantic feeling so quickly absorbed and expressed by Lemot in his astonishing bust of the great

Louis XIV hero, the sea-faring, storm-tossed *Jean Bart* (1804; Fig. 174).[87]

The variety of solutions (cf. Figs. 170, 171, and 172) in Napoleonic portraiture is quickly judged if one juxtaposes Corbet's bust with Houdon's deeply sensitive, exquisite classical herm (1806; Fig. 168 and Plate 3), one of Chaudet's strong, "Canovian" busts (1798; Fig. 171) which became the official imperial portrait, Chinard's troubled idealization (1801; Fig. 170) and Canova's overpowering hero (Fig. 172). Houdon, who received the rare privilege of modeling both Napoleon and Josephine from life,[88] remained true to his innate delicacy, sparing his work the fierce or icy grandeur favored by others, and lending the emperor an air of thoughtful consideration.[89] Chaudet remained true to himself (cf. Fig. 173) as well in favoring a chiseled grandeur for his own compelling version (derived from *his* statue of *Napoleon As Legislator*) of which some twelve thousand copies found their way to the four

Figure 169. Charles-Louis Corbet. *Bonaparte,* 1799 (replica of the bust at the 1797 Salon). Plaster bust. Paris, Musée Carnavalet.

Figure 170. Joseph Chinard. *Napoleon*, 1801. Plaster bust. Reuil-Malmaison, Musée Napoléon.

(1848–52) for the crypt of the Invalides, wrote that, "had [he] been free, . . . [he] should have liked to show this noble figure, this heroic figure tormented by his lofty thoughts, by the greatness of his unrealised dream . . . to stamp upon his august brow all the drama of his superhuman existence."[92] The overwhelming hold that the memory of Napoleon had upon the imagination of subsequent generations comes to life through these words which happen to describe the very qualities Canova succeeded in capturing in his own remarkable bust.

Sublime Demagoguery

The passion in Canova's portrait and the grimness of many of the statues for the Salle des Séances of both the Corps Législatif and of the Senate recurred in the mythological figures and groups which appeared at the salons. A quality of darkening events flowed into

Figure 171. Denis-Antoine Chaudet. *Napoleon*, 1798. Bronze bust. Paris, Louvre.

corners of the empire.[90] Yet, both his drawing after Gros and a *Bust of Sébastien Bourdon* (1810 Salon; Fig. 175) reveal a searching, experimental mind attuned to the passions of the time. Chinard, for whom Bonaparte did not pose, combined the various possibilities, retaining Corbet's mobile features within the more formal bounds of a rigid, frontal format, embellished with the ornamentally refined hair characterizing Chaudet's style, and a decorative, metallic richness in the costume.[91]

Later, the artistically repressed Simart, having executed the full-length, academically conservative (yet ornately gilded) draped figure of the emperor

Figure 172. Antonio Canova. *Napoleon*, 1802–06. Marble bust. Florence, Galleria d'Arte Moderna. Photo: Scala/Art Resource, N.Y.

Figure 173 (left). Denis Antoine Chaudet, after Gros. *Napoleon at the Pont d'Arcole*, after 1798. Drawing. Bayonne, Musée Bonnat. Photo: Photothèque des Musées de la Ville de Paris by SPADEM.

Figure 174. François Lemot. *Jean Bart*, 1804. Marble bust. Dunkerque, Musée des Beaux-Arts. Photo: Courtauld Institute.

Figure 175. Denis-Antoine Chaudet. *Sébastien Bourdon*, 1810 Salon. Marble bust. Paris, Louvre. Photo: R. M. N.

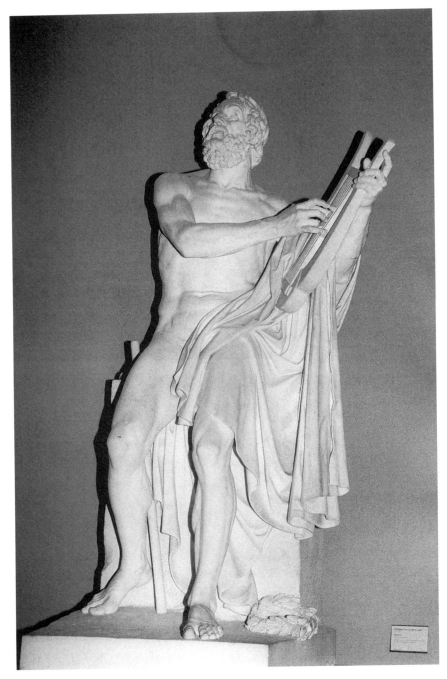

Figure 176. Philippe Laurent Roland. *Homer*, 1801–10. Marble statue. Paris, Louvre.

the iconography of painting and sculpture alike. As early as 1785, Roland had exhibited Cato's violent end, indicating an early interest in themes which knew a burst of popularity especially after 1789. He pursued his earlier inclination, if not for violence, at least for gloomy grandeur in his figure of *Homer* (plaster, 1801; marble, 1810; Fig. 176), the blind exile, the mythic poet of mythic stature, declaiming his cantos to the sound of the lyre.[93] Transposing his tale to the present, he might be intoning the great deeds of Bonaparte's own armies received elsewhere in the arms of Ossian, in Girodet's famous painting of the *Apotheosis of the French Heroes* (1802).

Homer shared with the blind Belisarius and the

blind Oedipus the symbolism of revolutionary exile, in addition to which he came to exemplify the artist's plight,[94] which it may not have been Roland's intention to portray but which had become an accepted convention by 1789.[95] Later, in the wake of the Revolution, the artist's role would assume a biblical, prophetic grandeur, aided perhaps by such images as Roland's pagan poet.[96]

Roland availed himself of the recently spoliated Capitoline herm bust of *Homer* exhibited in the Louvre from 1797 on, accentuating the traits to heighten the sense of overpowering genius: with his beetling brow and newly parted lips, he sings to the wind and the sky.[97] But if the spirit of Hellenistic sculpture enlivens this statue, so perhaps does the ghost of Pajou's *Buffon* and especially of Bernini's *St. Longinus* (1629–38; Fig. 177) in St. Peter's. The martyr radiates ecstatic sentiment from the beatified face to the outthrown arms. St. Longinus' ecstasy, however, is drawn forth from him by the divine presence above to which he yields. Roland's poet, while directing his intensely blind gaze to the heavens, reaps his gifts from within. It was during this period that the centrality of God gave way to man's will.

The fervent expression, heavenward glance and restlessness of Roland's *Homer* mark a high point in the evolution of a particularly passionate style rooted in Roland's earlier work. And just as his *Cato* drew criticism for its graphism so would this figure for its purported lack of idealization, all of which helps us to understand David d'Angers' outspoken devotion to his teacher.[98] Yet it is precisely in the accentuation of convincing detail (of a nonetheless very athletic, noble body) that Roland achieves a degree of credibility for the legendary figure rapt in song.

The suggestion of convincingly emitted sound in Roland's *Homer* became a standard means for dramatic expression from Préault's *Crucifixion* and Rude's *Marseillaise* to his flamboyant *Maréchal Ney*. The statue's presence is thereby extended into the viewer's space, achieving greater psychological immediacy.

In sculpture, the seat of expression tends to reside in the body rather than the face, although from Falconet's *Milo* to these later works an unbroken line of expressive faces can be found. But during the neoclassical period in particular the tension between the ideal and the facially expressive grew. At the same time, the drama of David's *Oath of the Horatii* (1784) had sparked a tremendous new interest in the

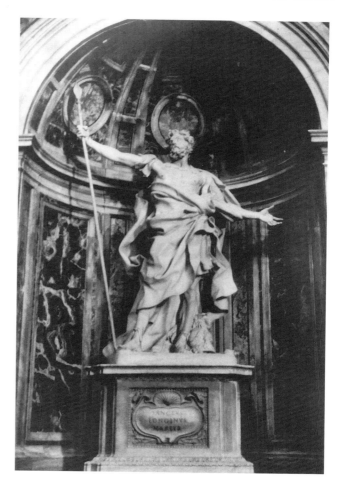

Figure 177. Gian Lorenzo Bernini. *St. Longinus*, 1629–38. Marble statue. Rome, St. Peter's.

expressive capacity of the body alone.[99] It is this pantomimic energy, already noted above, that erupts in sculpture.

The salon catalogue of 1814 (no. 1064), for example, notes that Gois' *Philoctetes* is begging the gods to end his suffering, just as an *Achilles* (1814) by Petitot seems, in Landon's words, to be accusing the gods of his premature death with fists to the sky,[100] while the title of Dupaty's *Ajax Defying the Gods* (1812–17) speaks for itself. Having escaped the sinking of his fleet for the rape of Cassandra, he is about to be engulfed by the waters for his insolent defiance. As in Canova's electrifying *Hercules and Lichas* (1795–1815; Fig. 178), a broad movement of the legs, spread in wide embrace of the ground, signals the character's energy and purpose. This type of dynamic body language characterizes the brilliance of David d'Angers' *Grand Condé* (Fig. 43) in his sweeping arm

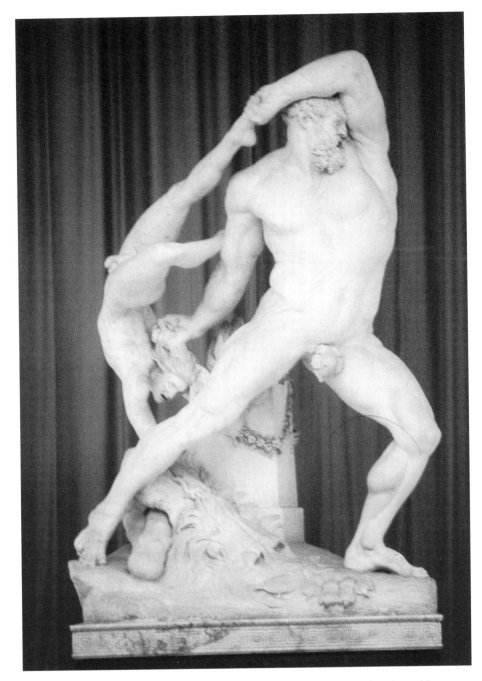

Figure 178. Antonio Canova. *Hercules and Lichas,* 1795–1815. Colossal marble group. Rome, Galeria d'Arte Moderna.

and deep, backward motion of the body, as though the sculptor had convulsed Pajou's *Turenne.*

Later, Rude carried these extremes to their highest pitch with the *Marseillaise* (Fig. 179), the single most ardent manifestation of his profound republicanism with all the characteristics of sublimity in the thunder-ous call to arms, the flamboyant movement and the unrepentent ugliness.[101] Rude effected a shift away from what might be called the "Male Sublime" to a new paradigm of the "Female Sublime" with a power-ful *and* ugly woman at the summit of a public monu-ment: Joan of Arc and the Messiah rolled into one.[102]

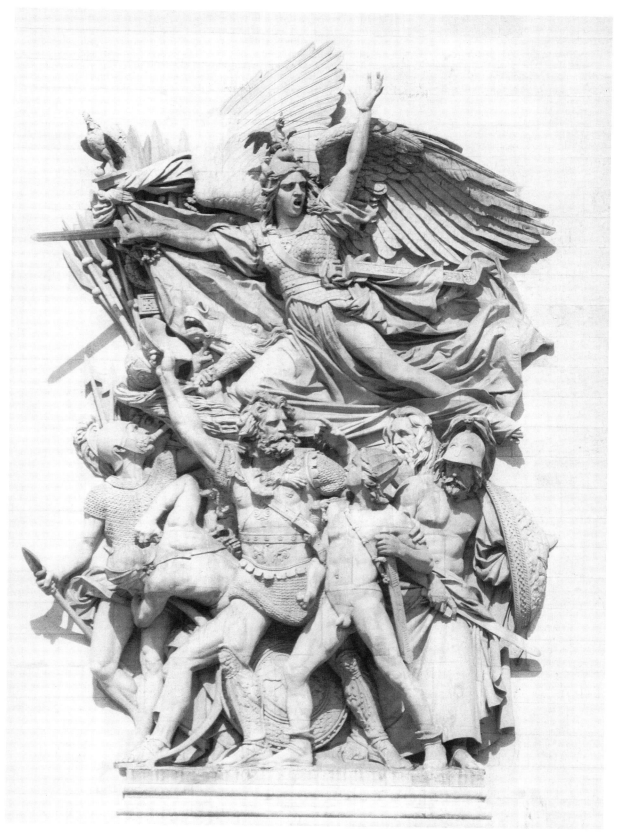

Figure 179. François Rude. *Marseillaise*, or *The Departure of the Volunteers of 1792*, 1833–36. Stone relief. Paris, Arc de Triomphe de l'Etoile.

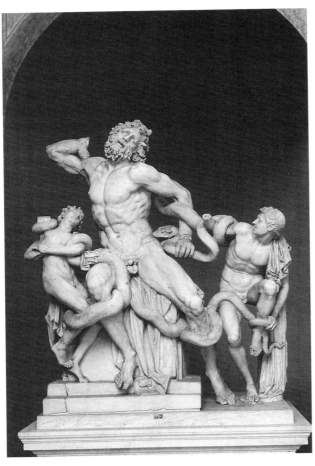

Figure 180. Lacoon. Marble group. Rome, Vatican Museum.

His first sketch (c. 1833, Louvre) tells a far more sedate tale of a trumpeting call to arms dominating a modified group of the *Horse Tamers.* Energetic enough, the drawing underwent radical change to become the *Marseillaise* (or *The Departure of the Volunteers of 1792*), an overpowering, rabble-rousing Marianne above a willing group of valiant men and boys marching off to war with eloquent, clearly expressed gestures. The projecting and laterally expanding energies of the lower part of the relief find themselves forcefully redirected by the vertical accent of the relief toward Marianne, the emotional focus of the whole. As to her face, nothing prepares one for it in French sculpture. Rude took a quantum leap out of the world of the *Laocoon* (Fig. 180) to find the expressive medium for his vision. Even Duret's larger than life-size head of *Orestes* (1833; Fig. 181), criticized for its delicate distortions, pales beside Rude's Marianne.[103] Three works may have paved the way: Niccolò

dell'Arca's *Magdalen* from the *Lamentation* (1462–63) in Sta Maria della Vita, Bologna, *Lichas* from Canova's violent group, and Flaxman's *Odysseus Fighting with Scylla* (Fig. 182).[104] Did Rude know them? Even in its own day, the life-size terracotta group in Bologna was called "phantasticus et barbarus."[105] By virtue of the sweep of motion accompanying the Magdalen's passionately grief-stricken response to Christ's death, she becomes the most immediate focus of attention with a searing immediacy of the kind one associates with photojournalism. Although the face of Canova's *Lichas* receives less direct exposure and retains a slightly stylized configuration in the eyebrows and lines around the mouth, it too generates an emotional stridency at odds not only with Canova's usual composure but also with sculpture in general. Finally, Flaxman's head and torso of *Scylla* rising above the frenzied melee of diminutive

Figure 181. Francisque-Joseph Duret. *Orestes,* 1833. Marble bust. Avignon, Musée Calvet. Photo: Musée Calvet.

Figure 182. John Flaxman. *Odysseus Fighting with Scylla*, 1793. Engraving from the Iliad.

soldiers offers a hint of the ferociousness of the *Marseillaise* in the gaping, blood-thirsty mouth.

One of the chief texts in the history of aesthetics, Gotthold Ephraim Lessing's *Laocoon* (1766), reached a wider audience with its first French translation in 1802. The scream of Laocoon served as one of the pivotal points in defining the limits of the arts of painting (sculpture) and poetry. In the famous argument opposing the furious pain of Sophocles' Philoctetes to the handsomely controlled expression of the stone figure, Lessing offered several reasons for endorsing the sculptor's choice, none of which had anything to do with Winckelmann's notion of noble grandeur. Rather, Lessing saw in the famous group an attempt to preserve the most important ingredient of ancient art as he saw it: beauty, or the greatest beauty possible in keeping with the physical pain of the hero. He offered another explanation hinging on the viewer's participation: in order to preserve the pregnancy of the moment and the viewer's interest and compassion, the fullest paroxysm had to yield to a less complete, but more suggestive moment. A flat-out scream of despair would say it all and represent an immediate, frightening prelude to death. The moderate suggestion of pain, on the other hand, invites completion of the moment by the viewer who can witness with compassion the unfolding events. Duret's *Orestes* belongs to this tradition. Even if pain was not at issue, Rude's Marianne may be said to have broken with this tradition savagely and knowingly. The *Marseillaise* was instantly recognized as an icon of incendiary ugliness and urgency. It is the living, seering moment itself.

David d'Angers, for all his own originality,

responded to Rude's work with an attitude more typical of the conservatives, and perhaps with the resentment of an artist deprived of one of the most important commissions of the century.[106] Yet it was Rude who, along with Préault, belatedly established a language appropriate to the intensity of the Revolution as it continued to live in the collective memory of France.

The brilliance of Rude's solution has drowned out the earlier attempts of men like Roland and the sculptors of all the gesticulating demagogues for the Senate and Chamber of Deputies. But the impassioned language of the *Homer* was as original in 1801 as was Rude's work in its time.

Classical Themes for the Postrevolutionary Period

As a subject, Homer became popular especially in painting, although other sculptors besides Roland tried their hand at him on a smaller scale in groups or statuettes, for example, Corbet's *The Blind Homer Singing His Verses, Led by a Young Girl Carrying His Lyre and Listening with Admiration*, 1802, or Clodion's *The Blind Homer Chased by the Fishermen* (or *Bitten by Dogs*, 1810; Fig. 183).[107] Still others treated the theme of exile through the related subjects of Belisarius[108] and especially of Oedipus and Antigone – Lesueur (1793),[109] Louis Delaville (1805), Marin (c. 1805–07; Fig. 184) and Milhomme (1808, *Oedipus at Colonnus*). Even Chaudet's *Phorbas and Oedipus* (plaster, 1801 Salon; Fig. 253 and Plate 6) may have had more than sentimental charm. The powerful shepherd resuscitating the infant cast out into the wilderness might be likened to the tender welcoming home of France's exiles.

Joseph-Charles Marin (1759–1834), so often lost in the shadow of his friend Clodion, showed his more tragic group of *Oedipus and Antigone* along with a *Roman Charity* (c. 1805–07). He had already made a career for himself with terra-cotta groups and figures imitating Clodion's playful eroticism so successfully that they have at times been confused with the latter's work. The sketchiness of the two more sober terra-cottas would suggest that they represented private exercises (perhaps in the hope of obtaining a commission for something more durable) revealing his clear sense of the political climate.[110] In 1795, he had already conceived a small group of despondent *Canadian Indians at Their Child's Grave* (Fig. 185), an unusual subject

Figure 183. Clodion. *The Blind Homer Bitten by Dogs*, 1810. Terra-cotta group. Paris, Louvre. Photo: R. M. N.

derived from the painting (1781) by Jean-Jacques Le Barbier[111] and allied to the current romantic historicism of the time. Intended as a model for a clock case, the terra-cotta rises above its utilitarian function to remain one of Marin's most eloquent works.

Two individual terra-cotta statuettes of *Pleureuses* (c. 1805),[112] larger in scale if smaller in size, bear further witness to the sculptor's new emotional range. Their monumental despondency, perhaps reflecting knowledge of Canova's tombs, anticipates many such women in nineteenth-century sculpture, from Sapphos to dying Cleopatras. That these subjects were by no means foreign to his instincts may be gleaned from his terra-cotta competition relief for the Prix de Rome of 1801 which he won (jointly with Milhomme) at the unprecedented age of forty-two: *Caius Gracchus Taking Leave of His Wife, Licinia* (Fig. 186). The rich modeling and truly monumental grouping of mother and child leave the pedantic, academic performances so often encountered in these competition reliefs far behind. Marin received few commissions, however, beyond a *Tourville* (plaster,

1817 Salon; stone, 1827) for the Pont de la Concorde (Louis XVI), which might have called upon these talents on a larger scale. Yet the progressive broadening of his repertory earned him the acknowledgment of Landon who expressed admiration for his large marble *Bather* (Fig. 187) at the Salon of 1808.[113] Until then, Landon had thought of Marin as the Fragonard of sculpture, but Landon saw a new grandeur in this life-size nude which gave him hope.[114] Of course that was to have missed the potential of the smaller works which were very much in tune with devolopments in painting and the heightened emotional mood of the years around 1800.

Even more unexpected than Marin's salon submission were two groups, one by his teacher, Clodion, the other by E.-E. Gois fils. The latter's plaster, life-size *Departure of the Three Horatii for the Battle to Determine the Fate of Rome* (1800, now lost; Fig. 188), his first salon submission, brought Gois a measure of

Figure 184. Joseph-Charles Marin. *Oedipus and Antigone*, c. 1805–07. Terra-cotta sketch. Besançon, Musée des Beaux-Arts.

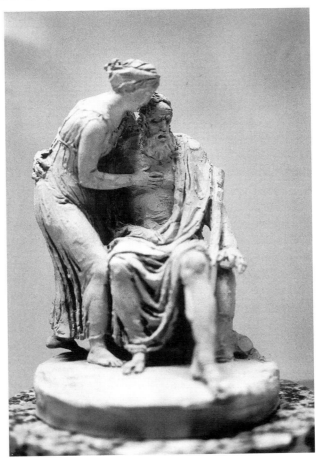

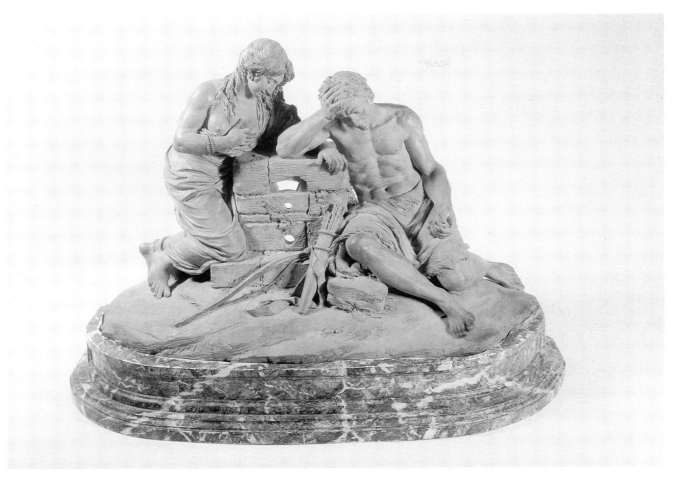

Figure 185. Joseph-Charles Marin. *Canadian Indians at Their Child's Grave*, 1795. Terra-cotta clock case. La Rochelle, Musées d'Art et d'Histoire. Photo: Musées d'Art et d'Histoire.

recognition in the form of a *prix d'encouragement* and generated considerable interest, although its suggestion of almost internecine or intranational bloodshed may have decided the government against commissioning it in marble.[115]

Indubitably, David's famous painting prompted the subject, but there the similarity ends. The disparate, anecdotic grouping substitutes for the rapt intensity of the oath the hesitancy of men lost in a forest – or at least Landon's line engraving conveys that impression, although Gois no doubt intended to suggest the alertness of men searching out their prey with watchful eyes. Nothing could be less classical than the diffuse focus and suggestions of a *promenade à trois*. Indeed motion permeates the group striding forward more visibly even than Canova's *Napoleon* and anticipating the lunging forward of his own, later *Joan of Arc*. These are hardly the light rococo running poses of a

Diana or *Roman Lupercalia*. As noted above, a different, purposefully striding figure was slowly finding its way into the sculptural vocabulary of the turn of the century, which would eventually multiply into a European legion of dynamic bards, preachers, and heroes like Vincenzo Vela's *Spartacus* (1847–79, Muso Vela, Lugano) furiously descending upon the spectator. This solution may even have represented Gois' one-upmanship over the famed *Tyrannicides*. Not two but three figures stand together on one base in a unique sculptural adaptation of a particularly neoclassical theme appearing here for the last time.

Equally spurred by the recent upheavals, Clodion sent his monumental uncommissioned group *The Deluge* (Fig. 189) to the Salon of 1801, the year after Gois' *Horatii*, and in the company of Roland's *Homer* and Chaudet's *Oedipus and Phorbas*.[116] He had ceased to exhibit his little groups since 1783. The decision to

137

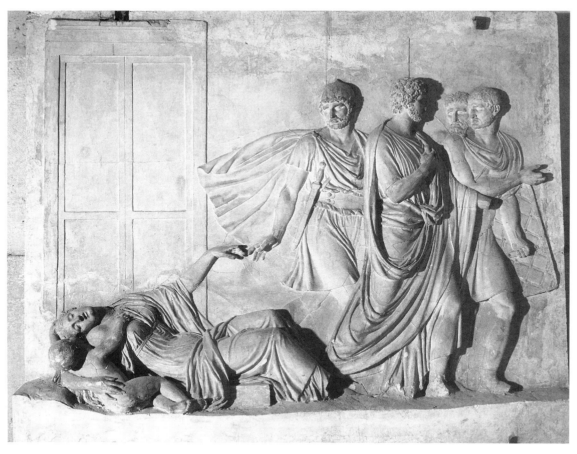

Figure 186. Joseph-Charles Marin. *Caius Gracchus Taking Leave of His Wife, Licinia*, 1801. Plaster relief. Ecole des Beaux-Arts. Photo: Ecole Nationale Supérieure des Beaux-Arts.

reenter the world of the salon with a dramatic, heroic statement was calculated to remind the audience of his gifts as the author of heroic, timely subjects, despite his age (he was sixty-three).

The Deluge, unique up till then in Clodion's oeuvre for its embodiment of a chastised classicism on a monumental scale and of a sublime or potentially horrific *sujet noir*, was also one of his most accomplished creations, as the surviving terra-cotta (Fig. 190) reveals. The life-size plaster, which has vanished, probably failed to carry the brilliant textural variations of the clay, but the composition and characterization of the protagonists could have passed smoothly from one medium to the other. Landon's line engraving does little justice to the group if indeed Clodion was successful in preserving some of the quality of the terra-cotta, which is far richer, plastically felt and subtle in its contrast of active and passive form. I would guess that Clodion retained the idealized, Lysippian sveltness for

the youth and the more rugged contours for the father, subtleties which Landon's uniform line obscures. Despite their differences, the drawing and the terra-cotta at least convey the originality of this independent contribution.

If Clodion looked at ancient works, such as the famous *Warrior and Youth* (then in Rome, now in Naples; Fig. 191) or the *Pasquino* (Loggia dei Lanzi, Florence), or even at more contemporary works such as Bernini's *Aeneas and Anchises* (1618–19),[117] Canova's *Hercules and Lichas* or Flaxman's *Fury of Athamas*, he did so as a master warming himself up to his own, personal vision. As in Marin's case, it helps to cast a glance at perhaps not Clodion's Prix de Rome, but at his handsome *Hercules Resting* (Fig. 192), already endowed with the lowering facial type of the postrevolutionary style and a similarly powerful anatomy which, in the *Montesquieu*, is so concealed by massive draperies.[118]

Clodion's choice of subject, possibly one of the many deluges of antiquity listed by Landon,[119] was not in itself unusual in contemporary art, witness especially Regnault's famous painting of 1789 (reexhibited, 1791; Fig. 193) which also groups two scenes of distress in one composition. In 1780, officials even chose the Deluge for the Prix de Rome competition for sculpture, but for a relief and not a three-dimensional work. In sculpture in the round, the subject was almost unique. Clodion thus initiated the series of freestanding "Deluges" of the nineteenth century, beginning with Etex's *Ship-Wrecked* and ending with Kessel's *Deluge* (1904; Musée Royal des Beaux-Arts, Brussels).

Did this *Deluge* have a particular meaning though? Is it possible that the year 1800, submerged under the revolutionary calendar though it was, had an impact on Clodion's subject? Chaussard had perceived in the Revolution a fervid atmosphere which might lend itself to subjects of this kind without being more specific;[120] the year 1800 might have seemed like a fresh start. The Deluge washed away the old, precipitated painful choices and brought in the new. Appearing at this juncture, the subject is telling. And did not Louis XV say "Après moi, le déluge."[121] If his "moi" can stand for the entire line of succession, the aristocracy, a way of life, then the Revolution was the cloudburst.

The catalogue gave an extended description of the events taking place in Clodion's work, referring first to the desperate father who believed his son to be dead. On discovering him to be alive, he lifts him into his arms to carry him to higher ground. Near him lies a woman who, after a long struggle, has succeeded in bringing herself and her child to safety. But exhausted by her effort, she loses her grip on the broken tree stump and is carried to her death.[122] The tragic and heroic events provoked astonishment among Clodion's critics, moving Landon to write, in terms similar to those he would reserve for Marin, that the work represented a remarkable departure from Clodion's small terra-cottas and numbered among the best that year.[123] But of course, for anyone with eyes to see and the courage to say so, Clodion's *Montesquieu* (Fig. 39) had been one of the grandest of the "Grands Hommes." Furthermore, it stood on view in what by then was the Salle des Séances of the Institute.

The critical reception was generally good – and bland. It was the few scathing reviews that unwittingly pinpointed the sculpture's originality. After announcing that the salon notice had prepared him for a relief

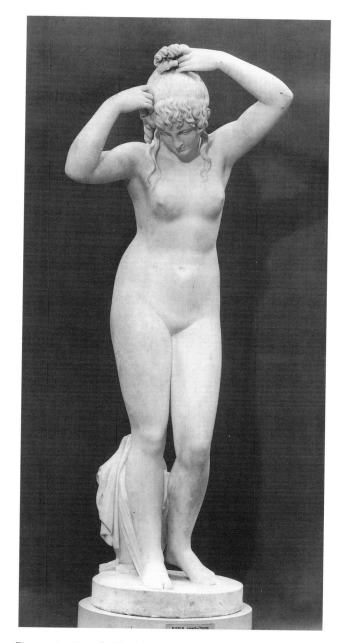

Figure 187. Joseph-Charles Marin. *Bather*, 1808 Salon. Marble statue. Paris, Louvre. Photo: R. M. N.

– the subject being "fit really for painting" – one critic expressed his surprise on beholding a freestanding group. He continued:

The woman and child, even in the description, have nothing to do with the man and the adolescent; two separate actions are taking place, contrary to the principles of all the arts, and perhaps without

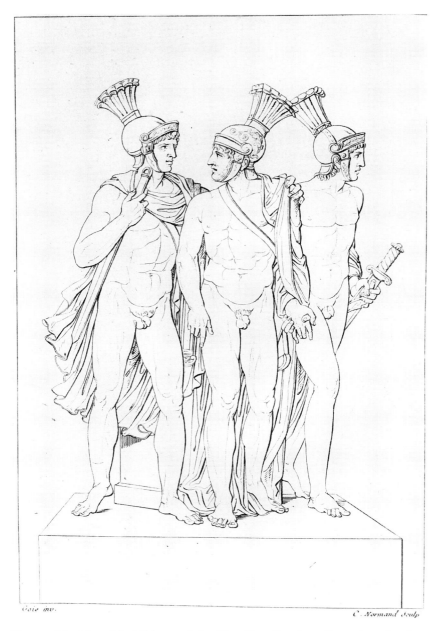

Gois inv. *C. Normand Sculp*

Figure 188. After Edmé-Etienne Gois. *The Horatii*, 1801. Engraving, Landon, *Annales*, 1803, vol. I, pl. 63.

precedent in sculpture; no one has ever placed two groups on the same base; this half-submerged woman, whose lower half must be inside the pedestal, has no place whatsoever in sculpture. A painter can cut off a tree, a structure, even a figure with the edge of his canvas, because the picture frame is the opening, large or small, through which the eye perceives a portion of a scene which the imagination can enlarge in any direction according to the subject; but sculpture cannot accommodate such fictions; a figure sunk in the pedestal can only appear to the mind as well as to the eye as the fragment of a figure; and I know of no sculptor before Clodion who has taken such license, though, of course, I am not speaking of what might have been done in bas-reliefs, which are paintings. In his pose and expression, the father, well modeled it must be said, looks like a Hercules Slaying the Hydra which I have seen somewhere and which Clodion may also have known. What is certain, what everyone

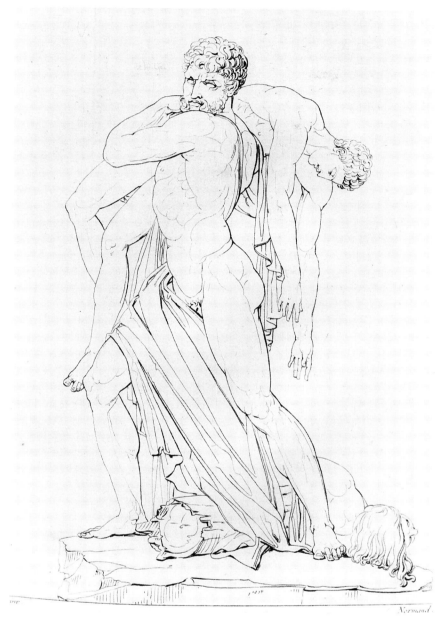

Figure 189. After Clodion. *Deluge,* 1801 Salon. Engraving, Landon, *Annales,* 1803, vol. I, pl. 48.

notices, is that this man . . . looks as though he wants to hurl his son into the water, rather than save him. . . . With regard to every aspect of its composition, therefore, one can consider this work, otherwise excellent in execution, as flawed.[124]

The half-vanished, drowned woman actually constitutes one of the remarkable effects of the group, an illusionistic creation of additional space for which Clodion found justification perhaps in the *Tyche of Antioch* (Vatican Museums), who has a figure swimming at her feet.[125] Knowledge of it may have reached Clodion verbally, or through a sketch. Furthermore, at Versailles, sinking in the quagmire, raged Gaspard Marsy's *Fallen Titan* (1675; Fig. 194) in the Fountain of the Enceladus. As one approaches the fountain, the struggling, vanquished Titan slowly appears in his heroic misery, surprising the spectator by his proportions and agony.

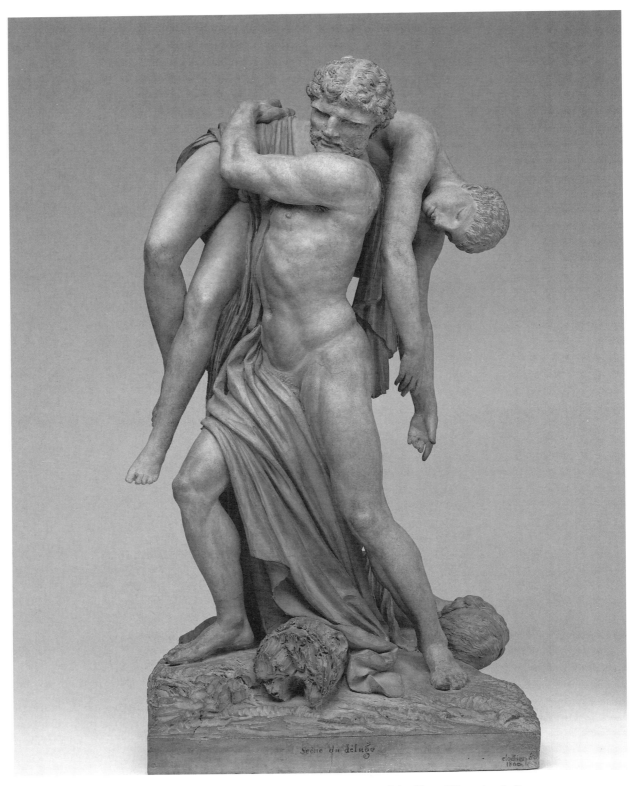

Figure 190. Clodion. *The Deluge,* 1801 Salon. Terra-cotta group. John H. and Ernestine A. Payne Fund, Courtesy Museum of Fine Arts, Boston.

Figure 191. *Warrior and Youth*. Marble group. Naples, Museo Nazionale.

Figure 192. Clodion. *Hercules Resting*, c. 1762. Plaster. Paris, Louvre. Photo: R. M. N.

To suggest that the father looks more like a villain on the point of hurling the lad into the water reflects a preoccupation with themes like Flaxman's *Fury of Athamas* or Canova's *Hercules and Lichas* more than a careful use of the critic's eye. The father's anatomy is simply not poised to throw.

The government subsequently invited Clodion to execute the *Cato* (1804) for the Palais du Luxembourg, and fifteen relief segments for the Vendôme column (1806–10). But *The Deluge* itself never took permanent form in stone.

Scenes of horror and tragedy on the scale of Clodion's group rarely occurred in sculpture, painting being the medium for extremity of this kind (witness Girodet's tremendously successful *Deluge*, 1806, Louvre, Paris). Individual victims did continue to appear, however, such as E.-E. Gois' *Philoctetes* (1812), "cette figure d'étude," as Landon called the seven-foot plaster (now lost) which, he informed his reader, could be seen to best advantage on a very low base in the center of a gallery, or better yet, in a grotto as decoration for a picturesque garden.[126] It came under attack, like Roland's *Cato*, for among other things, its undue veracity (clearly a matter of relativity), Delpech again

Figure 193 (left). Jean-Baptiste Regnault. *Deluge*, 1789. Oil on canvas. Paris, Louvre.

Figure 194 (below). Gaspard Marsy. *Fallen Titan*, 1675. Versailles, Château de Versailles Gardens.

wielding his pen and attacking the "disgusting wound" and ignoble pose of the hero, "rolling on the ground like a reptile."[127] More and more, the idealization of agony was giving way in fits and starts to the need for convincing pain and for a convincing reason for suffering, accompanied by the gradual introduction of the antiheroic in sculpture.

From the first *Belisarius* through the revolutionary images of exile to one of Rude's original ideas for the Arc de Triomphe the development is steady. Rude considered the possibility of a truly bleak *Retreat from Russia, 1812* (c. 1833; Fig. 195), composed of three soldiers in the remains of Roman uniforms, one blind and wounded, assisted by a comrade in arms over the fallen body of a horse. Two ferocious wolves prepare to devour the hapless prey surveyed with reserve by an allegorical figure (Winter?) above, fondling the long strands of his beard. In all probability, Rude knew Géricault's lithograph of the *Retreat from Russia* (1818; Fig. 196), which may have moved him to treat his subject with the same pathos. Rude's alternative to the *Triumph of 1810* eventually carved by Cortot would have been an exceptional exposition of the antiheroic in sculpture on a monumental scale.[128]

Figure 195 (above). François Rude. *Retreat from Russia, 1812,* c. 1833. Drawing. Paris, Louvre, Cabinet des Dessins. Photo: R. M. N.

Figure 196 (right). Théodore Géricault. *Retreat from Russia,* 1818. Lithograph. Paris, Bibliothèque Nationale, Cabinet des Estampes. Photo: © cliché Bibliothèque Nationale de France, Paris.

Paul and Virginia, both 1795), but purged of the floral charm of the eighteenth century. Painting dominated these genres, however, and little can be added to what has been said about them in this domain, especially in light of the relatively small number of surviving works. On the other hand, the execution in sculpture of subjects like Clodion's *Deluge*, because more unusual, made them more original.

In spite of long-standing prejudice, the postrevolutionary period yielded sculpture of both quality and originality which maintained a firm link with prerevolutionary modes of expression while paving the way for artists like David d'Angers and Rude. The destruction, however, of so many temporary works inevitably circumscribes one's appreciation of the overall achievement of the years between 1789 and 1814.

Most prominently absent are statues of the principal revolutionaries, Danton, Marat and Robespierre. Sculptors did offer busts of them to the Assemblé Nationale, and various statues and effigies of Marat are known to have existed, as well as of Mirabeau, but these have long since vanished.[129] No identifiable women from French history appeared at all save Gois' solitary *Joan of Arc* (Fig. 197). Women's virtues appeared on a distinctly lesser scale than men's, and usually in a maternal context, whether as a *Charity*, as in Fortin's handsome fountain for the rue Popincourt (Fig. 198) or Marin's *Roman Charity* or indeed as a simple disciplinary presence, as in Pajou's *Fidelity, the Mother of Constant Love* (1799, Metropolitan Museum of Art, New York), a small terra-cotta showing a woman restraining a small child from beating a dog. Coiffed *à la Titus*, she combines both antiquity and proper child-rearing in a vivid little scene.[130] But the scope and scale are indeed limited. No brave and simple men or women of the people found their way to commemoration either, in spite of the egalitarian propaganda, although an anonymous soldier did appear in both Masson's *Warrior Dying in the Arms of France* for the peristyle of the Pantheon and Chaudet's relief for the facade. The most vulnerable of all revolutionary manifestations took the form of the colossal figures for the various fêtes known today largely through engravings. The size of these and other figures leads into the consideration of the "sublime" addressed (in terms of form more than subject matter) in the following chapter.

Figure 197. Edmé-Etienne Gois. *Joan of Arc*, 1804. Marble statue. Orléans, Place Dauphine. Photo: Courtauld Institute.

The years between 1789 and 1814 also saw sculptors continuing to turn in a small way to purely horrific subjects like Chaudet's drawing of a *Mother and Child Attacked by a Tiger*, Stouf's *Frightened Woman* (1798) or Clodion's terra-cotta of a *Young Woman Fleeing from a Serpent* (1799–1805). A fashionable Gothicism began to appear as well (Deseine, *Eloise and Abelard*, 1806, or *Charles VIII*, 1800) and traits of primitive innocence (Boizot, *Adam and Eve, First Thoughts on Death*, 1793; Chaudet and Dumont,

Figure 198. Auguste-Félix Fortin. *Charity*, 1808 Salon. Marble relief. Paris, rue Sévignè.

The Sublime: Gigantism,
the Persistence of Illusion and the Ugly

THE *sujets noirs* of previous chapters, the grim deaths and gloomy themes of exile, all fed into the growing tide of romantically "sublime" iconography, but in sculpture especially, the Burkean sublime surfaced in effects at times unrelated to the iconography. These effects took different forms, wavering between two extremes: on the one hand, the obvious use of sheer size, on the other, the use of dramatic illusion. The first achieves its aims by generating a sense of such remoteness, such incommensurability that it sets the work beyond any possible identification with it on the part of the viewer. It remains entirely "other," oppressively awesome. The second achieves its aims through a theatrical manipulation of the subject (or of space) turning the viewer into a potential participant.

These extremes, with which the interregnum offered an unparalleled opportunity to experiment, had in fact already taken root and found expression in a number of important commissions and projects of the ancien régime.

Falconet

One figure especially stands out in prerevolutionary French sculpture for his early exploration of the sublime: Falconet. Even as small a work as Falconet's intended *morceau de réception*, the *Milo of Crotona* (1744–54; Fig. 24), belongs to that group of *sujets noirs* which gained increasing popularity from the 1760s on. The slow, agonizing, vividly enacted death of the vain athlete conformed perfectly to the horrific aspects of the sublime as they were to be tabulated by Burke and admired by Diderot.[1] Levesque, who wrote the introductory biography to the 1808 edition of Fal-

conet's *Oeuvres*, considered Falconet's *Milo* to be even more frightening, more "terrible," than Puget's,[2] echoing the praise of a critic in 1755 who perceived the work as a marvelous "spectacle of horror and astonishment."[3]

Falconet's early *sujet noir* (carrying on, it is true, a tradition of tormented mythological figures as reception pieces) coincided with a precocious, qualified interest in Michelangelo. Again, Levesque remembered an enthusiastic conversation with Falconet about the legendary sculptor.[4] Indeed, in spite of his criticism of the *Moses* and the *Bacchus* (known to him through engravings alone),[5] Falconet openly praised what he considered to be Michelangelo's greatest achievements, sharing in the enthusiasm of his contemporaries. The Comte de Caylus, for example, in a lecture in 1757, spoke of his "miracles of grandeur, proportion and awesome drawing."[6] These acknowledgments of Michelangelo's gifts coincided in turn with Burke's *A Philosophical Inquiry into the Origins of Our Ideas on the Sublime and the Beautiful* (1757) which provided a methodical appreciation of Michelangelo, without referring directly to him, and inspired renewed admiration for his genius. Reynolds' veneration, for example, is too well known to be discussed. Yet, like several subsequent theoreticians,[7] he was uneasy about his feelings, repressed as they were by notions of decorum. Thus he granted to Raphael the cool supremacy of tasteful perfection, all the while passionately favoring Michelangelo.[8] To Raphael went the prize, to Michelangelo the victory.

Falconet and Reynolds read each other's works[9] and exchanged gifts, the Frenchman sending the Englishman a plaster cast of his *Winter* and receiving in return an engraving after Reynolds' *Ugolino* (1773) whose

horror-inspiring character he appreciated as much as Diderot.[10] Furthermore, in 1766, his son, Pierre-Etienne, attended Reynolds' classes and later, in 1773, exhibited several paintings at the Royal Academy prior to joining his father in Russia.[11] To what degree Michelangelo constituted a common interest remains open to inquiry. What is certain, however, is that Falconet provides an early French counterpart to what is generally considered a predominantly English concern among artists – Michelangelo and the sublime. Moreover, Falconet read Burke's treatise critically as soon as it appeared in translation in 1766. Although he quibbled with and even mocked some of the Englishman's definitions, the important point remains that, like Burke, Falconet agreed to the existence and power of sublimity in nature.[12]

Dandré-Bardon also published his *Essai sur la peinture*, which included the *Essai sur la sculpture*, for artists in 1766. He cites Longinus rather than Burke in the footnotes, though he may have been familiar all the same with the English original of 1757 or with an idea of its contents. Nonetheless, his description of the sublime – "The wonderful, the extraordinary, the surprising which impress, ravish and thrill"[13] – recalls Boileau's translation of Longinus as much as anything by Burke, especially since the examples he chooses ravish for their delicacy and virtuosity as well.[14] While the scope seems less grand than Burke's vision of vastness and obscurity, silence and solitude, it nonetheless underlines the extent to which notions of the sublime had embedded themselves in current artistic theory in France.

Falconet even made a modest stab at a Michelangelesque style. On unjustifiably refusing his *Milo* on the grounds of plagiarism (after Puget), the Academy exacted a new work of him, the *Allegory of Sculpture* (c. 1754; Fig. 199).[15] With the change of subject, Falconet turned from Puget to Puget's mentor for inspiration. The firm structure, twisting pose and massive grouping of the *Allegory* show an altogether different concern from Falconet's earlier frantic *Milo* even if the alabaster-like translucence and general softness diminish the essential Michelangelesque "terribilità."[16] Yet, the later work also embodies Falconet's Renaissance-inspired views of the obligation of sculpture to present interesting aspects from every angle.[17] Falconet's grandest aspirations, however, would find tangible expression in the form of two great commissions: his *Peter the Great* and the earlier destroyed chapels of Saint Roch in which he first experimented with some of his ideas on a large scale.[18]

Figure 199. Etienne-Maurice Falconet. *Allegory of Sculpture*, c. 1754. Marble figure. London, Victoria and Albert Museum. Photo: © The Board of Trustees of the Victoria and Albert Museum.

In an unusual reversal of roles certainly gratifying to Falconet, he, a sculptor, was put in charge of the project rather than a painter, although he worked in a team with Jean-Baptiste-Marie Pierre (1712–89) and, eventually, Pierre-Antoine de Machy (1723–1807) and the architects Charles-Pierre Coustou (1721–97) and Etienne-Louis Boullée (1728–99).[19] Together they brought their work to term in 1760.

The three chapels of the Virgin, of the Communion and of the Calvary (Plate 4) were unveiled on December fourth to a mixed review, largely favorable from the general public, more critical from the "littérateurs."[20] Diderot especially found fault with every aspect of the commission which included a Berninesque glory, the destroyed Calvary and several sculpture groups (*Christ in Agony* opposite Coustou's *Saint Roch*, the *Virgin* and the *Angel of the Annunciation*, the prophets *David* and *Isaiah* and a *Magdalen* and two *Soldiers* at the foot of Michel Anguier's *Crucifix-*

ion). As always, Diderot gave free rein to the expression of his own fantasies and advice from which one derives a vivid sense of his theatrical propensities. In broad terms, he objected to a lack of unity, proportion and, where the Chapel of the Calvary was concerned, vision.[21] At a time of emerging megalomania, reflected in Boullée's later projects, Falconet's scheme appeared not grand enough. At least not by Diderot's standards. In addition to considering the soldiers to be like cardboard cutouts, he felt the space to be too small and too well lit. In criticizing the chapel for being too well lit, he was reflecting the growing taste for a certain "ténébrisme" which held a special place in the development of a romantic mood, found in its incipient stages in the paintings of Joseph Vernet, Philippe de Loutherbourg and Joseph Wright of Derby. Yet Falconet's Chapel of the Calvary belongs in part to this particular character of art. The Calvary certainly lies "somewhere between the picturesqueness of the baroque stage and the 'sublimity' of the romantic landscape," being in any event far more than a mere baroque pastiche.[22]

Unfortunately, only the sketchiest idea of the entire commission may be gleaned from C. Norry's drawing, *View of the Interior of Saint-Roch* (c. 1787, Cabinet des Estampes, Bibliothèque Nationale, Paris).[23] The sculpture was dispersed and lost, except for the *Christ in Agony*, during the Revolution, while the Chapel of the Calvary survived only to be dismantled in 1849, leaving nothing but part of the rocky promontory devised by Falconet and preserved in a painting by de Machy at the Musée Carnavalet. This chapel suffered further by being completely walled off from the rest of Saint Roch after having been the culminating focal point of a dramatic vista through the Chapel of the Virgin with its Glory and *Annunciation* and the Chapel of the Communion. Beyond these glowed the somber splendor of the Chapel of the Calvary. By an extraordinary stroke of luck, Nicolas-Bernard Lépicié (1735–84) chose to preserve the original appearance of the Chapel of the Calvary in a large painting on loan to the Musée Carnavalet from the Musée des Beaux-Arts, at Pau (Plate 4).[24] From this document one can begin to judge the effect of Falconet's ensemble, so dependent on Bernini. In fact the borrowings were deliberate.[25]

The Glory, a mass of gilded rays, of clouds and putti heads was a less sparkling version of Bernini's in St. Peter's. Furthermore, the *Christ in Agony* descends quite obviously from the *Ecstasy of Saint Theresa*[26] minus the ecstasy, while the general concept belongs to a baroque sense of theater and movement. But the extravagance of the Calvary extends beyond an admiration of Bernini. It was an exceptional foray into the mystery of Golgotha in sculpture which, because of its destruction, no longer forms part of our visual consciousness of the period.

The imaginary foreground figures, whether lost in admiration and awe or moved to humility, set the scale for the colossal massing of angular rock. Directly above Boullée's recessed, rectilinear altar and broken column with the instruments of the passion, appears the snake of evil casting a sinister spell on the event. Beyond, in an opening in the rocks, kneels the Magdalen gazing up to the crucified Christ while two common soldiers look on in curiosity mingled with reverence. Finally, in the background, the heavens appear to shed a transcendent ray upon the scene, enhancing the illusionistic effect of Lépicié's turbulent sky. Other naturalistic elements such as a tree stump and occasional tufts of grass complete the tableau.

If the painting is to be trusted, Falconet staged the Crucifixion in a bold chiaroscuro framed by massive boulders. Yet nothing of the dramatic arch of rock above the scene survives and, indeed, contemporary descriptions make no allusion to it, referring only to the rocky support. Can it be that the painting accomplished what the artist failed to do?[27] The original niche was (and still is) rather shallow and round-arched, allowing a fair amount of light to descend from the hidden window above, meaning that Lépicié may have acted upon Diderot's complaints in re-creating the chapel on canvas. But the visionary light cannot have been Lépicié's invention alone. Bernini's *Ecstasy of Saint Theresa*, with its concealed overhead source of illumination, would suggest that Falconet's own chapel shared something of its mystery-inducing atmosphere.

In spite of the theatricality of the work, it would never have occurred to Falconet to color his statues, a principle with which he entirely disagreed even though his teacher, J. B. Lemoyne, had resurrected the practice.[28] The Magdalen was of white marble, the soldiers of stone painted white. But for the rest, he freely applied color. "In addition to the blue marble altar, the gilded bronze column, and the blue-green and yellow-ocher of the painted sky, the visitor to the chapel saw a number of 'naturally' tinted details, such as the orange-gray tree stump, the bluish serpent, and the pale-green grass."[29]

Unusual as it might seem, the presence of such a rocky mass in a church was not without precedent. There was, for example, the Asam brothers' grouping of boulders at the base of the pilasters flanking the entrance to the church of St. Johannes Nepomuk (1733–46) in Munich. The high symbolism was appropriate, Falconet's scene taking place like a vision sustained above the altar by this "rock of faith." Louis François Roubiliac had not hesitated either to accumulate a towering pile of ruins about his *General Hargrave* (1757; Westminster Abbey, London) resurrected to the new life. But no one had gone as far as Falconet in thrusting so much naturalism or tenebrism into a French church.

In one respect, however, Falconet limited himself to traditional decorum, in part because of his use of Anguier's *Crucifixion*. The Crucifixion, a *sujet noir* if ever there was one, rarely entered the spine-chilling arena of the gloomy or terrifying with the exception of such idiosyncratic works as Grünwald's *Isenheim Altarpiece*. Falconet retained the more traditional tone of resignation and transcendence acceptable to the church. Only an iconoclast like Préault would try to break the barrier of decorum by carving a *Crucified Christ* (1840; Paris, Church of St. Gervais-St. Protais) in which the passion of Christ communicates itself through visceral, gruesome suffering. Predictably, the church of Saint-Germain-l'Auxerrois, which had commissioned it, refused the work. How many good citizens and parishioners wanted to be reminded, after all, that their salvation sprang from the hideous end of one tortured being?

The chapel rapidly acquired a certain fame, or notoriety, encouraging the Italian architect Gianantonio Selva to recommend the unusual sight to Canova before the latter's imminent visit to Paris in 1802, referring to it as a "slightly delirious fantasy."[30] Even Leopoldo Cicognara, who mentions their former popularity, spoke of Falconet's chapels in his *Storia* as "strange inventions, best suited to public festivals and theatrical displays."[31]

By attempting to lure the spectator into a state of willing credulity, or participation in the event, the artist could hope to add that much more to the impact of his sublime creation. Hence the value of heightened illusionism and shock effect. The Chapel of the Calvary serves to remind one of the enduring fascination with the illusionistic possibilities of sculpture, even during the height of the neoclassical reaction to overtly baroque means. Pierre Julien's Grotto for the Queen's

Dairy at Rambouillet and Canova's *Monument to Maria Christina* (Fig. 202) are cases in point.

Julien

A white marble group, *Young Woman with a Goat* (1785–86; Fig. 200), sits in an artificial grotto at the center of a craggy and unexpected vine-clad mountain of rock harboring a refreshing fountain. The goat cranes her neck to drink from the source, binding the delicate group to the setting, even if the unrealistic whiteness of the marble demarcates art from artificial nature.[32] The appealing suggestion of illusion, however, remains. Furthermore, the grotto, which fills only part of the interior space, is just as surprising as Falconet's chapel whose rocky ground protrudes from its architectural environment (though one might concede that a country dairy was the more logical place to house a return to Nature). While less gloomy than Falconet's *Calvary*, the Grotto with its boulders dramatically jutting into the purity of the neoclassical architecture strikes a note of grandeur that carries this idyll toward the sublime. In fact, the bold massing of rock first overwhelms the viewer before transforming itself into the seat of the charming, inviting tableau at its center. Should one be surprised then to find that, during the Revolution, the French erected a *Monument to Nature* in the Temple of Reason at Strasbourg (1791; Fig. 201), composed of a rocky mound with grass, shrubs, snake and all? And at the top – a many-breasted Diana of Ephesus standing for a nation's resurrection?[33]

The decision, in 1802, of a group of artists, which included David, Girodet, Lethière, Chaudet and Percier, to erect a monument to the solitary figure of Poussin constitutes another intriguing example of theatrical effects involving sculpture. Their plan to use a copy of Julien's *Poussin*, one of the few moderately classicizing *Grands Hommes*, conferred upon the statue an elite existence, unlike the other seated members of the series. Landon, who engraved the project (Fig. 203), gave a protracted description of the unrealized project in the *Annales* of 1803, conveying the sense of a dimly, dramatically lit temple in a landscape vividly suggestive of Poussin's own paintings.[34] Thus the environment would have re-created his art, the great genius himself occupying a central and solitary position in the dark precincts of the *sacellum*. The description reveals the author's desire to create a pic-

Figure 200. Pierre Julien. *Young Woman with a Goat*, 1785–86. Marble group. Rambouillet, Grotto of the Queen's Dairy.

turesque, highly evocative atmosphere inside the temple dominated by the ghostly marble *Poussin* plunged in his "night thoughts." The most striking effect was to have been achieved by dramatically focusing light through a skillfully orchestrated opening in the branches of the overhanging trees and a similarly calculated opening in the roof to illumine both the entrance and the figure of Poussin in the otherwise dark interior. Girodet's *Endymion* (1791; Louvre), itself so reminiscent of the *Ecstasy of Saint Theresa*

and her mysterious illumination, embodies these very effects.

This project reflected an active attempt to incorporate the mystery of creative genius into its actuality as Falconet, for religious reasons, had sought to incorporate the mystery of the passion at Saint Roch. But the entire concept expands the simple, confined illusionism of Saint Roch to make of the assembled scenic elements the symbol of Poussin's work, his subject, and his greatness. Like so many plans of the period, this

one lived only on paper, albeit centered around an existing sculpture. Even if the inspired tenor of the description and the enthusiasm of the inventors were insufficient to bring about the materialization of this singular idea, its very adumbration pointed both to the appeal of dramatic effects as well as to the artist's changing role in society.

Canova and the Mystery of Light

The subjective nature of such dramatic effects crops up repeatedly in various texts of the first decades of the nineteenth century, whether the effects had been intended or not. In the case of Canova's *Pauline Borghese* (1804–08; Fig. 204), the effects were calculated from the very start.

Napoleon's sister chose to be immortalized as the victorious goddess of love contemplating her trophy, the apple, but contemplating it in the seclusion of her apartments, well after the competition itself.[35] The arresting curves and rhythms of her silhouette, the delicate, Berninesque depressions in the flesh, pillows and mattress, and the illusionistic bed all translate into a work whose illusionistic properties establish a vivid tension with the aloofness of the sitter herself. That the work was destined for a palace housing a number of Bernini's signal achievements may have had some bearing upon the statue's ideation both as a polemical statement and a competition in technique.[36] In any event, a number of passages in Quatremère's monograph suggest a conscious attempt on Canova's part to seduce the viewer. While Canova paid lip service to the anti-Bernini liturgy, his heart and instinct carried him in the opposite direction.[37] In spite of everything, Canova was Bernini's rival as well as Phidias', even if critics hailed him at the former's expense.

Notwithstanding the rotating base (which has not been used for as long as can be remembered), the *Pauline Borghese* achieves its greatest perfection when viewed from the front and back. After the initial impact of the contour has passed, the modeling in all its variety and precision comes to the fore. Ingres' subverted sensuality arises from a comparable tension between a captivating linear contour and telling internal details.[38] Canova also covered the body with a slightly tinted wax to diminish the crudity of the white Carrara marble, as Thomas Banks had done earlier, using a "slight tint of coffee to stain it and give a softness to the lights and shades."[39]

The illusionistic properties of the couch, the statue's

Monument élevé à la Nature dans le Temple de la Raison à Strasbourg la 3me décade de Brumaire l'an 2 de la République.

Figure 201. Monument to Nature, Temple of Reason, Strasbourg, 1791. Engraving. Paris, Bibliothèque Nationale, Cabinet des Estampes. Photo: © cliché Bibliothèque Nationale de France, Paris.

base, have frequently been commented upon. Unlike the figure and mattress carved from a single marble block, the bed is of wood and plaster simulating marble and cloth. The gilding and textural subtleties lend an air of festivity and opulence to the whole while preserving Pauline's own sculptural purity. Her bracelet and the apple, for example, have remained white. Canova later applied gold jewelry and attributes to certain female statues such as the delicately fashioned *Hebe* alighting in youthful grace to pour wine from a gilded pitcher into a gilded chalice.

Figure 202. Antonio Canova. *Monument to Maria Christina* 1798–1805. Marble. Augustinenkirche, Vienna.

Because the couch sits upon a low marble platform, the viewer is invited to consider the whole as the work of art, but the platform notwithstanding, the essential disintegration of·the pedestal has already begun (as it had in baroque garden sculpture or in Falconet's *Peter the Great*). George Segal's *Lovers on a Bed* (1962) is the modern reworking of an old tradition, in which the intimacy of the subject accentuates the illusionistic proximity of the object. By standing in the center of the room, *Pauline Borghese* establishes her own context, free from the dictates of architecture. She is still the mistress of that house.

According to Canova's instructions, and he himself sometimes acted as guide, the statue was viewed by candlelight from which one may infer two things, the first being that Canova, putting the final touches to his works by candlelight,[40] wished it to be seen under ideal conditions.[41] Furthermore, it was the custom to view antique sculpture by torchlight, to which custom Canova may also have subscribed to meet the ancients in yet another way.[42] He had particularly admired the *Apollo Belvedere* under these circumstances during his first Roman sojourn.[43] The result in the case of the *Pauline Borghese* is startling: the statue's chill white

Figure 203. Collective project for a *Monument to Poussin.* Engraving. Landon, *Annales,* 1803, vol. II, pl. 14.

Figure 204. Antonio Canova. *Pauline Borghese,* 1804–08. Marble statue. Rome, Villa Borghese.

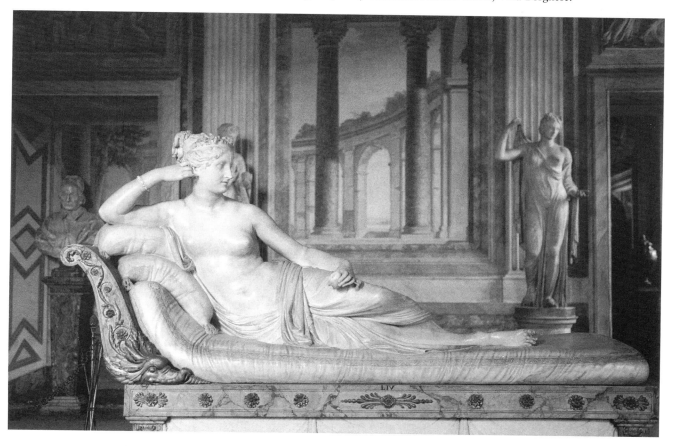

mobility comes to life under the flickering glow which lends its warmth to the stone.[44] By day, the waxen sheen diminishes; by torchlight, it appears to glisten richly on the surface still.

The Dutch consul to Rome, who organized a candlelit tour of the papal collections, later wrote that "successively illumined by the ambulant clarity of the torches, the marble appeared to come alive."[45] In *Corinne* one finds another such testimony touching Canova in particular, and which again places a certain emphasis on the lifelike qualities conferred by the illumination.[46]

In many respects, the implied eroticism of these viewing conditions, as much a viewer response as an intrinsic factor, parallels developments in painting of the period.[47] But, whereas sculpture depends precisely on external factors, painting could incorporate them and did, using the tenebrous, suggestive effects of chiaroscuro. The alternatives for sculpture were either the adoption of more openly erotic (or gloomy) subjects or a change of medium, namely the use of bronze which was to become a characteristic choice in the nineteenth century when technical advances made its use more economical.

A number of other instances echo the various subjective encounters with torchlit sculpture mentioned above with similar and telling results. For example, while a student at the French Academy in Rome, David d'Angers had the occasion to visit Canova's studio late in the day, giving rise to this lyrical record:

> One evening, I found myself in Canova's studio. The great artist had ceased to work; he was speaking about his art. A last ray of sun still touched the highest cornice; just below, in a warm shadow, stood the Three Graces, and a little further away, other barely clad figures of nymphs, goddesses and sensual courtesans. I contemplated these figures gradually being abandoned by the light and which soon found themselves shrouded in dusk. At one point, I thought I saw them move about like fantastic apparitions; it seemed to me that these poetic figures, delicately holding their draperies, were going to leave their pedestals and mingle in an aerial dance. At that moment everything seductive about those voluptuous forms spoke to my imagination; sculpture seemed to me to be the pure expression of exquisite beauty, the art of divinizing form by causing it to be adored. Never had I felt such a strong attraction to the sensualism of antiquity. I was enchanted, fascinated by the grace of the marble divinities to whom I was going to consecrate my admiration and my chisel.[48]

Figure 205. Louis François Roubilac. *Sir Isaac Newton*, 1755. Marble statue. Cambridge, Trinity College.

David d'Angers subsequently rejected the appeal of these sensual images, the moralist getting the better of the sensualist. But he continued to share Canova's practical grounds for viewing sculpture at night and by moonlight for the insight it gave into the massing and

Figure 203. Collective project for a *Monument to Poussin*. Engraving. Landon, *Annales*, 1803, vol. II, pl. 14.

Figure 204. Antonio Canova. *Pauline Borghese*, 1804–08. Marble statue. Rome, Villa Borghese.

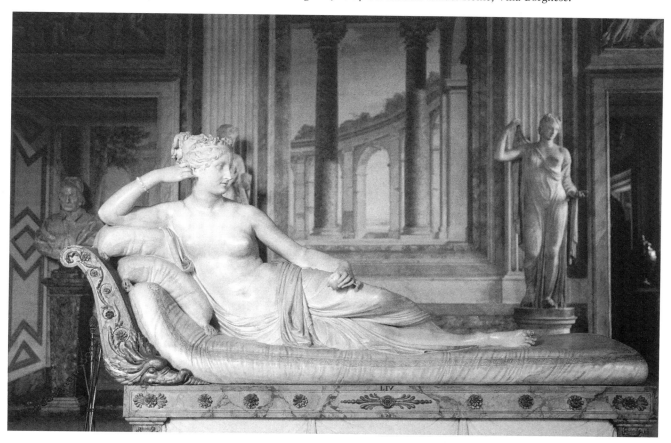

immobility comes to life under the flickering glow which lends its warmth to the stone.[44] By day, the waxen sheen diminishes; by torchlight, it appears to glisten richly on the surface still.

The Dutch consul to Rome, who organized a candlelit tour of the papal collections, later wrote that "successively illumined by the ambulant clarity of the torches, the marble appeared to come alive."[45] In *Corinne* one finds another such testimony touching Canova in particular, and which again places a certain emphasis on the lifelike qualities conferred by the illumination.[46]

In many respects, the implied eroticism of these viewing conditions, as much a viewer response as an intrinsic factor, parallels developments in painting of the period.[47] But, whereas sculpture depends precisely on external factors, painting could incorporate them and did, using the tenebrous, suggestive effects of chiaroscuro. The alternatives for sculpture were either the adoption of more openly erotic (or gloomy) subjects or a change of medium, namely the use of bronze which was to become a characteristic choice in the nineteenth century when technical advances made its use more economical.

A number of other instances echo the various subjective encounters with torchlit sculpture mentioned above with similar and telling results. For example, while a student at the French Academy in Rome, David d'Angers had the occasion to visit Canova's studio late in the day, giving rise to this lyrical record:

> One evening, I found myself in Canova's studio. The great artist had ceased to work; he was speaking about his art. A last ray of sun still touched the highest cornice; just below, in a warm shadow, stood the Three Graces, and a little further away, other barely clad figures of nymphs, goddesses and sensual courtesans. I contemplated these figures gradually being abandoned by the light and which soon found themselves shrouded in dusk. At one point, I thought I saw them move about like fantastic apparitions; it seemed to me that these poetic figures, delicately holding their draperies, were going to leave their pedestals and mingle in an aerial dance. At that moment everything seductive about those voluptuous forms spoke to my imagination; sculpture seemed to me to be the pure expression of exquisite beauty, the art of divinizing form by causing it to be adored. Never had I felt such a strong attraction to the sensualism of antiquity. I was enchanted, fascinated by the grace of the

Figure 205. Louis François Roubilac. *Sir Isaac Newton*, 1755. Marble statue. Cambridge, Trinity College.

marble divinities to whom I was going to consecrate my admiration and my chisel.[48]

David d'Angers subsequently rejected the appeal of these sensual images, the moralist getting the better of the sensualist. But he continued to share Canova's practical grounds for viewing sculpture at night and by moonlight for the insight it gave into the massing and

Figure 206. Edward Steichen. *Rodin's "Balzac" by Moonlight The Silhouette, 4 A.M.,* 1908. Pigment print. New York, Metropolitan Museum of Art, Alfred Stieglitz Collection, 1933. (33.43.36).

scale.[49] Elsewhere in his Notes, however, the irrational appeal of moonlight made its appearance again,[50] cast in the grandiose terms also employed by the painter Benjamin Robert Haydon. The latter was moved to describe his experience of the Elgin Marbles, which he visited by candlelight for the purpose of study, in tones as reverent as David's:

> The light streamed across the room and died away into obscurity. There was something solemn and aweful in the grand forms and heads and trunks and fragments of mighty temples and columns that lay scattered about in sublime insensibility – the remains, the only actual remains of a mighty people. The grand back of the Theseus would come towering close to my eye and his broad shadow spread over the place a depth of mystery and awe.[51]

Haydon is one with Fuseli's *Artist Moved by the Grandeur of Ancient Ruins.* The dramatic tenor of his vision recurs in turn in the writing of the French critic Théophile Thoré. In 1863, after describing the inability of the Parisian public to appreciate Préault's *Hecuba* or *Despair* (originally refused at the Salon of

1835), "that indescribable figure of a woman sinking into the ground, and who seems to be entering the chasm of death," he dramatically concluded with this vision: "And if in the evening, under the cypresses, one were to catch sight of that vague form in its agony, it would be terrible."[52]

Because of the moon, Wordsworth had also seen far more mystery in Roubiliac's proud *Sir Isaac Newton* (Fig. 205) than the sculptor had intended when portraying this embodiment of the ordering power of the human mind:

> And from my pillows, looking forth by light
> Of moon or favouring stars, I could behold
> The antechapel where the statue stood
> of Newton with the prism and silent face,
> The marble index of a mind for ever
> Voyaging through strange seas of thought alone.[53]

Finally, to this persistent refrain Edward Steichen lent substance with his photographs of Rodin's *Balzac* by moonlight – *The Silhouette, 4 A.M.* (1908; Fig. 206) – in which he recorded the inherent mystery of haptic art on a monumental scale.

The positioning too of a piece of sculpture imposed its own qualities upon a work, as when Canova's *Leopoldina Esterhazy-Liechtenstein* (1808; Eisenstadt, Esterhazy Castle), "seated on a rough-hewn rock," found her way into a Tempietto which her husband had built "on the edge of a craggy bluff overlooking his vast estate at Kismarton in Hungary."[54] With her sketchbook in front of her, she sat in meditation like so many of her living contemporaries given to the romanticism of solitary walks. Thus her location conferred an extrinsic poetry upon the lyric marble figure.

Similarly, one can be sure that Préault intended to serve tragedy the better by situating his relief of *Ophelia* (Fig. 76) level with the ground or Salon floor, like Clodion's drowning woman in the *Deluge*. The sunken relief, the fluid bronze technique and the subject constitute a perfect continuum of illusion in this more poetic version of his earlier *Despair*. Préault was nothing if not an enfant terrible stretching acceptable notions of decorum as far or farther than they could go. It can be hoped, in any event, that the Musée d'Orsay will move the *Ophelia* from the wall, where she looks like a sack of flour over a barrel, to a more compelling location – without any base at all – sunk at the visitor's feet like the *gisant* that she is.[55]

These are all variations on the same theme, the especially subjective nature of the perception of sculpture and its illusionistic possibilities which Falconet abetted with his deliberately dramatic illumination and setting. His Chapel of the Calvary constituted a radical essay in the sublime executed in the company of Boullée, whose own view of the sublime would take him directly to Burke's idea of a vast blank wall (specifically derided by Falconet) and away from the sculptor's more picturesque approach. For Falconet, this very approach proved to be excellent preparation for his major existing monument, the *Peter the Great* (Fig. 2, p. 11), which carried outdoors many of the ideas he had explored indoors and which allowed him to use St. Petersburg and the Neva as a stage for his work. It also gave him the opportunity to experiment with the heroic mode at odds with the pathos of his *Calvary*.[56]

Falconet's Peter the Great

The great surprise was that Falconet should have received the commission at all in view of the critical failure of Saint Roch, the almost total absence of por-traiture in his oeuvre and his general lack of experience with horses. His successful bid depended chiefly on his low estimate neatly corresponding to Catherine the Great's low offer.[57] Diderot immediately proffered his advice, describing another extravagant, even Berninesque program with a wide fountain and various personifications united in a "sublime whole" not unlike one of Titon du Tillet's variants for his *Parnassus*.[58] Falconet ignored the advice, but Diderot continued enthusiastically in his letters about grandeur, the sublime, the savage.[59]

As at Saint Roch, Falconet artificially re-created Nature to lend an air of immediacy to his subject. Though precedents exist for the general appearance of the rearing horse and rider, it nonetheless remains a unique conception.[60] In no other equestrian does one find such an unadorned, subtle melding of art with Nature from the galloping steed and its stern, benevolent rider, through the rocky promontory, to the actual ground in which the stone lies deeply buried. In a sense, the dissolution of the traditional pedestal for a public monument has begun. Falconet's *Peter the Great*, though a single figure, belongs to the lineage of Titon's project and, like it, combines the unlikely stylistic qualities of the rococo and the sublime.[61] The mountain and the figures, or base and figure, complement each other, enlivened by a pervasive energy flowing from the very bottom of the base to the summit of the composition.[62] Falconet distilled the essence of the idea into a single horse and rider surging into space on a dramatic crest of rock, the scale and location, the heroic spirit and energy elevating the whole into the domain of the sublime.

It must of course be said that both Falconet and Titon had a tradition of baroque garden sculpture to draw upon in which Nature and art come together in a theatrical way. Jean-Baptiste Tubi's *Chariot of Apollo* (1671) rising from the waters at Versailles or Marsy's *Fountain of Enceladus* set comparable conceits within the more formal space of clearly delineated basins. Even the ancient, classical *Niobids* (as engraved by François Perrier and reconstructed in the Villa Medici garden; Fig. 207) set the tone for life-size figures in a landscape.[63] François Perrier's engraving of 1638 had long since acquainted France with the *Niobids* as a hieratic tragedy unfolding in Nature. But each figure plays an individual, even disjunct role. This very quality inspired Dandré-Bardon to observe of the *Niobids* that they lacked the "beau désordre" that communicates the sublime.[64] Yet the popularity of the

Figure 207. François Perrier. Imaginary reconstruction of the *Niobids*. Engraving for the *Segmentum nobilium signorum et statuarii*, 1638.

Figure 208. François Girardon. *Apollo and the Nymphs of Thetis*, 1666. Marble group. Bosquet d'Appollon, Versailles.

Niobids' arrangement in such an illusionistic tableau prompted other experiments in the genre in a lighter, deliberately illusionistic manner.[65] In 1778, Hubert Robert responded to this fashion by removing Girardon's group of *Apollo and the Nymphs* (1666; Fig. 208) to their present grotto in the Bosquet des Bains d'Apollon, considerably altering Girardon's formal arrangement and creating out-of-doors an effect as surprising as Julien's Grotto for Rambouillet.[66] It is thus evident that Falconet both responded to and further stimulated these conventions stemming from the playful arena of baroque garden sculpture. Yet his *Peter the Great* so vividly embodies the concept of vigorous heroism that it rises above the merely playful to reach the level of exalted monumental art, just as Rude's disturbing *Awakening of Napoleon* (1845–47; Park of Fixin near Dijon) escapes the category of garden sculpture by evoking emotions of a more powerful kind. Placed within a sylvan setting upon a small, steep hill, the bronze produces the unnerving sensation of some ancient ritual unfolding on hallowed ground, as Napoleon removes his "shroud" to enter life eternal.

Even the dogma of programmatic classicism was hard put to restrain similar attempts and both Canova and Thorvaldsen would shed their classical compunctions in an attempt to emulate the rhetorical power of such illusionism in their own equestrians.[67] Later, in France, one sculptor came to grips with the matter at an increasingly fundamental level, preserving a high metaphoric quality in his figures while availing himself of the psychological effect of these illusionistic means. Auguste Rodin (1840–1917) buried the base of his *Eve* (1899) in the sands of the exhibition hall. She stood in shame in the very midst of the Victorian throng. By returning her to a primordial condition of pure shame, Rodin endowed her with depth and universality while, through her powerful nudity and visibly sculptural rather than anecdotal quality, he lent her a distancing monumentality.[68] Rodin would go one step further trying to bring heroism down to earth. That he carefully pondered the consequences of his experiment with the *Eve* is fully borne out by his continuous reworking of the *Bourgeois of Calais* (first shown in 1889) whom he wished ultimately to place one behind the other in front of the Town Hall, each an isolated, anguished entity, its base flush with the ground.[69] And what an experience of those tortured figures that would be!

An unbroken line stretches from Falconet's suggestive illusionistic essays in a "picturesque" sublime to

Rodin's more deliberately Michelangelesque works, pointing to the uncharted persistence of a trend and its transformation into great monumental art in the hands of a few outstanding sculptors whose aim it was to communicate the essential idea as directly and as dramatically as possible. One element in particular, however, distinguishes Falconet's undertaking from these other examples, namely, the importance attached to the base of *Peter the Great* and the size of the stone used for it.

The stone in question was the famous "Thunder-Stone," a three-million-pound monolith from the Karelian Swamp, from which Falconet carved out his desired support.[70] Its shape abets the overall appearance of forward motion, but one regrets what might have been a less tutored form had the "Thunder-Stone" suffered fewer changes. Nonetheless, Falconet achieved a unique effect. Furthermore, the very fact that he used the "Thunder-Stone" provoked considerable amazement and even hostility. A response to an attack on what was considered an extravagant waste of effort in moving the monolith focuses attention both on Falconet's historical awareness and on the sublime in terms of raw size.

In "Sur un article d'un certain journal,"[71] Falconet justified himself on several counts, citing Queen Semiramis' moving of an even larger stone, an example which he sarcastically followed with several others of a telling kind:

> The idea of the Macedonian sculptor, *who wanted to carve Mount Athos into a statue, with a town in one hand and a chalice in the other from which a river would flow into the sea*, may seem ridiculously gigantic to a modern journalist and only seemed large to the ancients. Michelangelo, who is something of an ancient now, and who liked mighty projects, was far from despising that of the Macedonian. As his biographer wrote, he wished to execute, in emulation of the ancient artist, a colossus on the mountains of Carrara which navigators could have seen from far away, and he always regretted not having been able to realize this project.[72]

To group Michelangelo's project with the fabled Mount Athos gives the measure of Falconet's regard for the Renaissance sculptor, while the examples adduced to justify his own activities seem almost ridiculously excessive when compared to the final result. Yet it tells one something about the nature of

his vision and the impact he wished to exercise upon the viewer gazing up at Peter the Great.

Mount Athos and the Gigantic

The legend of Mount Athos in particular had a wide appeal, entering the repertory of French painting in 1796 when Valenciennes produced his *Mount Athos Carved into the Shape of Alexander the Great*.[73] The relevance of Mount Athos was twofold: it applied both to the quest for gigantism or grandiose vision and to the employment of Nature to make art. The two combined yielded the formula for many of the revolutionnary festivals and a number of extravagant projects which never came to fruition, including Titon du Tillet's *French Parnassus* which he had hoped to erect on the Place de l'Etoile.

The logic of this choice was borne out by the many projects devised subsequently for the same location and which, significantly, grouped Falconet's *Peter the Great* with the earlier, fabled examples as a notable antecedent, while sedulously avoiding mention of Titon du Tillet's all too obvious influence. Few visionaries ever mentioned his name, least of all his plagiarists, Chaussard being no exception. In l'An VII (1798), for example, the latter submitted to a member of the Directoire a project for a permanent installation which later apparently received encouragement from David.[74] Composed at the time of Napoleon's first Italian victories, it proposed a succession of colossal, triumphal images particularly indebted to Titon's *Descriptions*.[75] What strikes one is the constant obsession with increasingly megalomaniac projects melding art with Nature on a gigantic scale. Falconet at least figures as a precedent in Chaussard's project as he does, anonymously, in the Chevalier de Mopinot de la Chapotte's *Project for a Monument To Be Erected in the Capital of France . . .*.[76] If this author balked at mentioning Falconet by name, he nonetheless saw merit in the work, which is more than can be said for David who heaped abuse upon Falconet's equestrian only a few years later.

The Revolution saw countless mountains rise and fall on the Champs de Mars and elsewhere and with them any number of gigantic Herculeses, inspired in part by J.-L. David's unrealized fifty-foot *Hercules Gaulois*.[77] But these mountains no longer boast the artistic unity of form evinced by Titon's *Parnasse* or Falconet's *Peter the Great*. As Claude Cochet le jeune's

Design for a Revolutionary Pageant at Lyons on May 30, 1790 reveals,[78] they are indeed simply mountains.

Of all the "progeny" of Titon's brainchild in particular, Auguste Préault's dream of transforming a volcanic peak into a monument to Vercingétorix is the most vivid. He saw ten-meter figures along the great spiraling highway leading to the summit and its mighty equestrian to the great French hero made of "dark materials . . . which would corrode."[79]

In 1845, *Le Magasin Pittoresque*, giving the patriotic Frenchman his due, had exhumed Titon's forgotten *Parnassus* and devoted an article to it.[80] Préault's darker fantasy carried him into a heroic domain far removed from the delicate eloquence of the *Parnassus* but still celebrating the greatness of France with time-weathered bronze. Other artists mined this powerful vein in different ways, stimulated more directly by the fabled Mount Athos. Thorvaldsen's *Lion of Lucerne* (1819–21; Fig. 209), for example, carved from the flank of a mountain, combines the idea of Mount Athos with a natural cave setting to commemorate the Swiss guards killed in the French Revolution.[81] In figurative sculpture, Mount Rushmore brings the series to its logical conclusion in the New World. Carved from the living rock by Gutzon Borglum (1927–39), the four presidents *are* America, the enduring incarnation of her history.

Nature stood at the service of art in all these enterprises, but landscape, except for a few notable exceptions, remained outside the grasp of three-dimensional sculpture other than in the most peripheral way as relief backgrounds. While painters turned landscape into art in unprecedented numbers in the eighteenth and nineteenth centuries, sculptors articulated it, or sublimated its wilder strains in animal sculpture. In the twentieth century, Christo's *Valley Curtain*, sublime in scale and poetic in inspiration, carried this marriage of art and Nature a little further, turning art into landscape for a while, an abstract merging of form with form.

The Legacy of the Revolution

Contrary to the view that "perishable works of art employed in [the] state festivals could have a lasting impact only when translated into permanent sculptural figures or historical paintings,"[82] revolutionary projects and large temporary monuments forged a link between the sculpture of the ancien and nouveau régimes and even provided the models for later pro-

Figure 209. Bertel Thorvaldsen. *Lion of Lucerne*, 1819–21. Stone. Switzerland, Lucerne. Photo: Margaret Szmurak.

jects. In certain instances, however, the presence of a drawing or engraving facilitated the transfer of imagery. Prieur's record of the *Festival in Honour of the Victims of Nancy* (1792; Fig. 210) is a case in point. The engraving shows an enormous circular platform supporting the equally vast square base of a monumental, classical sarcophagus dominating the whole. This generic type anticipates the very configuration chosen for Napoleon's tomb, an architectural rather than a sculptural project designed by Visconti and executed between 1843 and 1853 under the aegis of Louis-Philippe.[83] Napoleon's colossal porphyry sarcophagus stands in the center of the large, circular space opened in the floor below the cupola where Pradier's stately *Victories* (1843–52; Fig. 211) surround it, ornamenting each column.[84] These glacially impassive *Victories*, adapted also by Leo von Klenze to both the exterior and interior of the *Befreiungshalle* (1842–63), set up a majestic processional rhythm which owes its success to the imperturbable regularity and continuity of the circular configuration.[85] And,

indeed, Burke qualified the circle as sublime because of its intimations of eternity, the never-ending vastness of time and space.

The colossal white figures find a counterpart in Francisque-Joseph Duret's Gaulish giants of Florentine bronze (Fig. 212)[86] flanking the great bronze doors at the head of the flight of steps leading down into the tomb. Above the door the famous inscription reads, "I wish that my ashes may rest on the banks of the Seine / in the midst of the French people / whom I so loved," for which one could readily substitute a more Dantesque "Abandon all hope, ye who enter here."

Antoine Etex's 1839 tomb project of an equally gigantic equestrian Napoleon crossing the sphere of the world set upon a base in the center of a circular fountain articulated by twelve rearing hippocamps (Fig. 213)[87] inherits the same revolutionary traditions as does the fantastical idea of a Pont Napoléon pierced through the middle, the void straddled by a towering colossus of Rhodes in the guise of the emperor. These hypertrophic projects remained on paper, unlike the

famous elephant fountain for the Place de la Bastille (begun by Pierre-Charles Bridan in 1810, demolished 1846) which reached the halfway state of armature and plaster, but failed to become the twenty-four-meter bronze anticipated by its commissioners.[88]

The colossal in terms of the single figure gave rise to considerable academic squabbling. Although justifiable classically on the basis of Phidian precedent, the colossal is not an inherently classical dimension. That is, in shunning anthropomorphic scale, it moves from the domain of the harmoniously beautiful associated with a figure such as the *Apollo Belvedere* into the antithetical sphere of the sublime as defined by Burke. In 1795, the *Journal de la Décade* published an article on this very problem, "Some Reflections on a Statue of Fame Which Is To Be Placed on the Dome of the Pantheon," in which the author equated the colossal with man's vanity and pride, referring specifically to Deinokrates' megalomaniac project of Mount Athos.[89] Nonetheless, from Titon du Tillet on, as there has already been occasion to see, a plethora of sublime projects and a few actual monuments buried such criticism in a torrent of popularity.

Piranesi, Fuseli, whose *Artist Moved by the Grandeur of Ancient Ruins* speaks for itself, and any number of artists working in Rome fell under the spell of the sublime. Even Quatremère de Quincy, who had admired the Temple of the Giants at Agrigento, hoped to erect the huge, chryselephantine figure of *La Patrie* mentioned above under the cupola of the Pantheon. He justified himself through Phidias whose *Jupiter* he was to reconstruct in color in his famous publication *Le Jupiter Olympien* (1817; Plate 5). The impression made on the imagination of artists by this lost work was such that Flaxman found it to be "one of the seven wonders of the world."[90]

Figure 210. J. L. Prieur. *Festival in Honour of the Victims of Nancy*, 1792. Drawing. Paris, Musée Carnavalet.

Figure 211. James Pradier. *Victories*, 1843–52. Marble statues. Paris, Invalides, Tomb of Napoleon.

Figure 212. Francisque-Joseph Duret. *Gaulish Giants*, c. 1850. Colossal bronze caryatids. Paris, Invalides, Tomb of Napoleon.

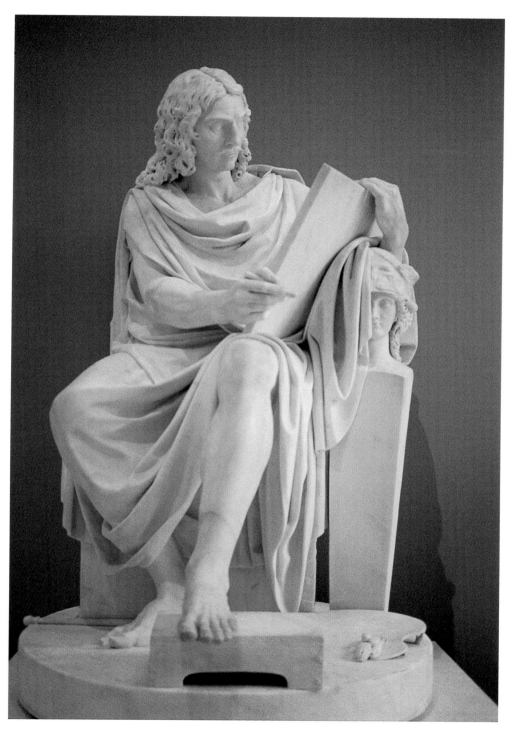

Plate I. Pierre Julien. *Nicolas Poussin*, 1789–1804. Marble statue. Paris, Louvre.

Plate II. Guillaume Boichot. *Funerary Vase*, 1791 Salon. Terra-cotta. Paris, Louvre.

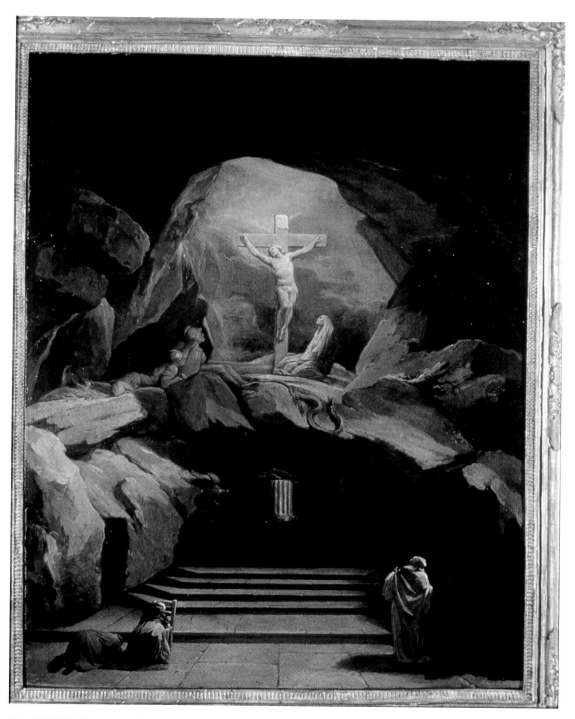

Plate III. Nicholas-Bernard Lépicié, *Chapel of the Calvary, St. Roch*, after 1760. Oil painting. Musée des Beaux-Arts, Pau (on loan to the Musée Carnavalet, Paris). Photo: Photothèque des Musées de la Ville de Paris by SPA-DEM.

Plate V. Antoine Houdon. *Napoleon*, 1806. Terra-cotta bust. Dijon. Musée des Beaux-Arts.

Plate VI. Denis-Antoine Chaudet. *Oedipus and Phorbas*, 1802–1818 (finished posthumously by Cartellier and Dupaty). Marble group. Paris, Louvre.

Plate VII. Antoine-Louis Barye. *River Gods*, 1854–62. Plaster model. Paris, Musée d'Orsay.

Plate VIII. Antoine-Louis Barye. *Tiger Devouring a Gavial*, detail. Bronze. Paris, Louvre.

Figure 213. Antoine Etex. *Project for Napoleon's Tomb*, 1839. Drawing. Paris, Musée Carnavalet. Photo: Photothèque des Musées de la Ville de Paris by SPADEM.

For the top of the Pantheon, Quatremère commissioned another colossus, the ill-calculated *Fame* (Fig. 214) just mentioned as the very object of attack in the article against colossi. Dejoux, who would at least realize his colossal *Desaix* in 1808, received the commission in 1793 and promptly produced the model in his studio. The twenty-seven-foot *Fame* struck its viewers with astonishment inasmuch as they saw it indoors and not upon the top of the cupola. It never ascended the cupola due to belated considerations of excessive weight. There it would inevitably have lost some of its awesome character by virtue of its perspectively diminished size.[91] Striding forward on a globe, Fame prepares to blow her trumpet in honor of the great men commemorated below.

An engraving of the *Anniversaire du 26 Messidor An IX. Feu d'artifice tiré à l'Etoile des Champs-Elysées sous le Consul Bonaparte Ier de la République française* (July 14, 1801; Fig. 215) provides a particularly striking example of the intimate relationship between sculpture and the propagandistic ephemera of the revolutionary festivals. From a sublime accretion of irregular rocks rises a gigantic Fame, striding across her globe in the attitude typifying her. The lights and deep shadows heighten the figure's size and effect, her message ringing forth like the bursting, dazzling fire-works in the night sky. And lest one think that the memory of these manifestations petered out with the fireworks, it is worth noting that, in 1833, Baron Hittorff toyed with the idea of reproducing Dejoux's *Fame* in hammered copper ("un procédé de moulage au marteau") for the top of the Arc de Triomphe.[92] Meanwhile, unused and unwanted, Dejoux's plaster eventually disintegrated.

Ephemeral as these colossi might have been, their legacy extended all the way to Bartholdi's *Statue of Liberty* in New York and engendered a lasting popularity among the sculptors and writers of the "romantic" generation. David d'Angers, for example, perceived the colossal as the only possible proportion for statues dedicated to great men. He argued that such commemorations represented "apotheoses," or the embodiments of divine spirits, who should give the impression of not being able to "enter a house."[93] He also strongly endorsed the pedestal to enhance the isolation of the figure as opposed to its dramatic psychological union with the viewer's space (that is, as opposed to Falconet and others).[94]

Victor Hugo responded to David d'Angers' feeling for the colossal, embodied in the *Grand Condé*, in his *Feuilles d'automne* (1828), a panegyric to "radiant colossi."[95]

The Colossal and the Ugly in Bust Portraiture

These preoccupations extended to bust portraiture, beginning indirectly with G. Polanzani's portrait of G. B. Piranesi (Fig. 216) for the 1750 edition of the *Opere Varie* (reused for *Le Antichità Romane*). The amputated arms and torso suggest not so much an ancient bust as the ruins of time and the haunting atmosphere of Piranesi's own work. Towering above the setting, Piranesi looks down like a troubled visionary from the cloudy vortex haloed about his head.[96] In this portrait, Piranesi underwent petrification for the sake of grandeur, stone lending the authority of its age and obduracy to the frailty of man's life. Its scale, however, is at issue here, the movement toward colossal portraiture taking root very quickly, beginning with Alexander Trippel's larger than life-size, classically inspired *Bust of Goethe* (1787).[97] The German sculptor Dannecker, planning his monument to Schiller (1810), is said to have exclaimed, "I will make Schiller living, but I cannot represent him otherwise than colossal."[98] In 1795, Romney depicted Flaxman in the process of modeling a colossal bust of William Hayley, although no record of the bust survives.[99] Clearly the size was not merely to impress but to give some sense of the quality of the sitter's intellect.

Figure 214 (above). After Claude Dejoux. *Fame,* 1793. Engraving, Landon, *Salon de 1808,* vol. II, pl. 35.

Figure 215. Anonymous. *Anniversaire du 26 Messidor An IX (July 14, 1801).* Engraving. Paris, Musée Carnavalet. Photo: Desgraces, for Phototèque des Musées de la Ville de Paris by SPADEM.

Figure 216. G. Polanzani. *G. B. Piranesi*, 1750. Frontispiece for the *Opere Varie* (reused for *Le Antichità Romane*). Engraving. Private collection, Venice.

Canova had chosen the same format for his expressive bust of *Napoleon* and for his remarkable *Self-Portrait* (1812). Not surprisingly, David d'Angers, inheriting both the emancipated position of artists from the Revolution and Canova's sense of the heroic, appointed himself celebrator of genius on a new scale. Availing himself of Gall's and Lavater's works on phrenology, he translated their physiognomic hypotheses, as well as the virile language of the Revolution, into the expressive hypertrophy of his many busts of famous men.[100]

The loquacious French sculptor again offered abundant reasons for his preference for the colossal, explaining, for example, that the life-size busts of Houdon appear smaller than life-size because they fail to give a sense of the passion or genius animating great men.[101] He condemned the colossal in busts of women or children (incapable of lofty thought or action),[102] and indeed, during the period in question, none

appeared, even though one might oppose a number of magnificent, ancient *Minervas* to this view.

In the consummate expression of his gifts as a portraitist, in the *Niccolo Paganini* (1831; Fig. 217), not only did David d'Angers create on a larger than life-size scale, but he also abandoned any attempt at physical idealization of a beautifying sort in favor of a psychological idealization expressed in the visible torments of genius and cranial distortions appreciated by his contemporaries.[103] In these works, he effects a union of size and quasi ugliness fully in accord with the distortions of the sublime characterized among other things as uneven, craggy, and dark (bronze, as opposed to marble).

It was but one small step from the *Paganini* to positive ugliness of which both Rude and Préault made a profession, the former in the screaming distortions of the *Marseillaise*, the latter more pervasively in a large number of refused works, including *Tuerie* (1834; Fig. 319).[104] On a heroic scale, Rude also twice sculpted busts of Jacques-Louis David without obscuring his disfiguring tumor. The earlier version (1831; Louvre, Paris) takes the form of an undraped bust truncated just beneath the neck and sculpted with Hellenistic flair. Rude allowed himself an even freer hand in the second version (1833–38; Fig. 218) of greater proportions. Animating the fierce and energetic appearance of the deceased painter, Rude drilled the eyes and wrapped David in a voluminous cloak the folds of which cut a dramatic diagonal across the front. In this detail and in its flamboyant character, the bust resembles Ingres' powerful portrait of the aristocratically ugly *Count Gouriev* (1825; Fig. 219) silhouetted against the skies of Italy.

This calculated veracity owed something to Houdon's example. The latter's pockmarked bust of *Willibald Gluck* (1775; Fig. 220), however, breathes with the humanistic bonhomie of the Enlightenment. Rude did not merely record honestly what he saw (and he may indeed have attenuated the deformity in the same way Ingres "improved" M. Bertin) but transformed David's blemish into a moral statement. This is less a case of "laideur intéressante" than a demonstration of republican morality. By preserving David's likeness in all its unpleasantness, Rude placed him beyond worldly vanity, a true republican like himself. He transformed the morality of high classical idealism into the morality of visual "truth" on a grand scale.[105]

Figure 217. Pierre-Jean David d'Angers. *Niccolo Paganini*, 1831. Bronze bust. Angers, Galerie David d'Angers.

Figure 218 (below). François Rude. *Jacques-Louis David*, 1833–38. Plaster bust. Dijon, Musée Rude.

Figure 219 (top right). Jean Auguste-Dominique Ingres. *Count Gouriev*, 1825. Oil on canvas. St. Petersburg, Hermitage. Photo: Scala/Art Resource, N.Y.

Figure 220 (right). Antoine Houdon. *Willibald Glück*, 1775. Terra-cotta bust. Paris, Louvre.

The Artist

The application of a hypertrophic vocabulary to the depiction of great men went hand in hand with the growing importance attached to the mystery of genius, or the mental sublime, with Michelangelo as its chief embodiment. Painters and sculptors alike struggled to present a new species to the world, the inspired, even tormented poet of creation in whom they mirrored themselves. Or, at least, through whom they exposed the subjectivity and independence of their own talent or discipline. Indeed sculptors, who are so often ignored in discussions of the artist's changing role, saw the immortalization of genius not only as their particular province (the permanence of stone) but also increasingly as the means to a better social standing. From Houdon's first self-commissioned series of busts of famous contemporaries, through Canova's sponsored commemorations for the Pantheon in Rome to David d'Angers' countless busts and medallions the progression is clear. The sculptor's quest for independence and social standing manifested itself in other ways as well: in the writings of Falconet and David d'Angers, in their self-portraits, in the founding of museums (Thorvaldsen and David d'Angers) or the commissioning of large monuments (Tempio Canoviano) and in the creation of "modern classics" (or uncommissioned, life-size, classicizing works) like Clodion's *Deluge* or Gois' *Horatii*.[106]

The Revolution commended the sculptor as a participant in the regeneration of the nation, theoretically ending the schizophrenic division between the moral worth of one of d'Angiviller's "Grands Hommes" and the relative insignificance of the executor. The "artiste engagé," the emancipated creator in the service of liberty took the place of the servant to kings and aristocrats – in the flamboyant speeches anyway.[107] For ardent republicans like David d'Angers and Rude, these developments would help them to take highly visible political stands, the one refusing to alter his Pantheon pediment (1833) to suit the government's political program,[108] the other commemorating without remuneration the deceased republican Godefroy Cavaignac in one of the simplest and most moving of nineteenth-century tomb effigies. Rude exhibited the unembellished, *gisant*-like figure in his studio in June 1847, as a gesture of political opposition to the July Monarchy.[109] And while contemplating this work, it seems appropriate to remember Godefroy Cavaignac's deep appreciation of the moral function of sculpture: "Sculpture alone can generate a monument; she is, so to speak, more democratic than painting, because she is more simple and grave, because she is better suited to the public place, to vast dimensions, to those emblematic figures which are engendered by the imagination" (1834).[110] David d'Angers merely called the effigy a "disfigured corpse,"[111] but it performed the same task of politico-artistic rebellion as had the earlier Pantheon pediment. For, indeed, the presence of the "ugly" or blunt was also part of this liberation which was both an anti-academic movement and a manifesto: to wit, the right of each artist to express himself as he saw fit, iconographically or formally.

David d'Angers viewed his right to create as the same right to make his own political, moral statement, a kind of philosophy in stone with real punch to it, like his Pantheon pediment. But this avenue of inquiry, while illuminating some of the choices made by the sculptors in question, is so broad as to require entirely separate treatment.[112] On the other hand, only by taking stock of the remarkable ascent to international fame achieved by Canova can one grasp both the power of his influence and the equal resistance to it by those who repudiated a foreigner as *chef d'école*.

Canova, Flaxman and the Vicissitudes of the International Style in France

My friend, the golden age is doubtless past
But good men will establish it anew.
And if I may state how I understand it:
The golden age with which the poet often
Beguiles us, that same golden age existed
It seems to me, as little then as now.
And if it did exist, it surely was
What may recur repeatedly for us,
For kindred hearts still chance on one another
And share enjoyment of the lovely world.

Goethe, *Tasso*, Act II

IN MANY WAYS, the Goujon revival in sculpture preempted the formal extremities of the international style as practiced by Flaxman, Canova, David in the *Intervention of the Sabines* (1799) and, mutatis mutandi, Ingres. The elongations, flatness and emphasis upon contour sprang up naturally in the classically conscious work of Goujon's imitators, from Ramey's *Music and Architecture* at the Pantheon to Moitte's reliefs for the Louvre. But French sculptors were hardly indifferent to the impressive artistic and financial success of Canova, nor could they have failed to acknowledge the stunning simplicity of Flaxman's engravings. However obvious this might be, little until recently has been said of the interest of French *sculptors* for Flaxman,[1] while Canova's role and theoretical interests continue to get second billing.

Flaxman's impact upon French sculptors shows itself, as might be expected, in their drawings and reliefs rather than in their three-dimensional works.[2] His influence passed to France both directly through his published works and, indirectly, principally through the figure of Jean-Auguste-Dominque Ingres to whom the sculptors Louis Petitot (1794–1862)[3] and

Jean-Pierre Cortot (1787–1843)[4] in particular owe so much. But one of the most salient and telling testimonies to Flaxman's relevance to French sculpture occurs in relation to the life of the obscure Berthélémy Corneille (c. 1760–1805).[5]

Corneille obtained the Prix de Rome in 1787 with *The Plague during the Reign of David*, traveling with François Xavier Fabre to Rome in December of the same year.[6] At the term of his Prix de Rome stay in 1791, he may have briefly returned to revolutionary France, only to reappear in Rome in 1792. Like a number of compatriots, he fled to Florence in 1793 to escape the reprisals of the Romans. Finally, around 1795, he moved to Volterra where Lorenzo Bartolini entered his studio, giving rise to this precious record of Flaxman's hold upon his contemporaries:

I did not know how to draw yet, but he gave me several tracings prepared for the most part by M. Fabre and, when he needed me to do something I did not want to, to get me going, he would show me the folders in which he kept the first works of the immortal Flaxman: the *Homer* and the

Tragedies. I liked them so much that all I could think of was those sublime compositions, so much so, that when Corneille was sculpting a large alabaster vase of the Medici type with a bas-relief of Polyxenes, I offered to do the ornaments if he would let me trace the works of Flaxman as my reward. My offer was accepted and I kept my part of the deal to the satisfaction of M. Corneille and the Cavaliero Falchi. My reserved and discreet character prevented me from brutally asking to trace what we had agreed upon; but I made my request several times with tact, each time turned down by Corneille who gave various excuses without ever flatly refusing. I was uncomfortable with not receiving what I deserved and desired with such ardour; I respected and liked my master, whom I did not want to annoy by further insistence. Finally, unable to live any longer in that place of exile, I ceased to nourish my affection for someone who showed himself to be so unjust at my expense. I availed myself of my earlier training to make copies of three keys, I prepared paper with mineral oil and proceeded to break the law by going to the studio at two every night. It was bitter cold, but my anxiety and joy at possessing those beautiful compositions was such that I felt nothing and worried about nothing. As I said, they were the Tragedies of Aeschylus, the Iliad and the Odysse. I gave many nights to achieving my goal, desiring to return home by Easter. I had all but finished, having only the Mercury as Psychopomp left to copy; I had been there for about a quarter of an hour and was about to begin when I heard a voice cry out, "Who goes there?"[7]

The rest of the story dwells upon his discovery by Corneille, their reconciliation and Bartolini's departure. This vivid if possibly distorted account sheds light both on Bartolini and Corneille's high esteem of Flaxman and on the latter's good fortune in having copies of his work at this early date. That Flaxman's drawings actually moved Corneille to transpose their style into his work is difficult to ascertain, however, little surviving to confirm or negate this possibility. But later sculptors, as there will be occasion to see, copied Flaxman's composition with care and even proceeded to some quite visible transpositions into sculpture.

Canova

If in the beginning Flaxman's works were hard to come by, Canova's presence on the international art

market of the late eighteenth century was so formidable that no artist could escape it.[8] The press documented every stage of his development from the creation of his *Theseus and the Dead Minotaur* (1781–83) to the end of his career,[9] his studio rapidly becoming one of the sights of Rome. Every collector aspired to own a work by his hand; monarchs strove to lure him to their courts. Napoleon in particular extended his protection to Canova in grandiose terms, writing: "Illustrious Artist, you have a particular right to the protection of the Army of Italy" (August 6, 1797).[10] His desire to bring the prestige of Rome to France encompassed her most famous sculptor. Canova was to have been the living jewel in Napoleon's crowning of Paris as the artistic capital of the world.[11] The century that was called the "Century of Napoleon" was also called the "Century of Canova,"[12] Stendhal acknowledging Napoleon, Byron and Canova as the three truly great men of his time.[13] His works were engraved and disseminated all over Europe during his lifetime and after.[14] His position as an artist was so exalted that it enabled him to transcend national and political barriers, this in a discipline heavily marked by political and nationalistic traits: while sculpting his statue of Napoleon, the Italian sculptor projected a monument to Wellington.[15] At his death, all of Europe honored Canova with a monument in the Church of the Frari, Venice. Sovereigns, writers such as Goethe, and artists of Thomas Lawrence's stature among others sent in their contributions.[16] As Cicognara wrote, "Canova did not belong to Venice alone but to all the world."[17] Obsequies were held for Canova in several places in Italy as if for royalty,[18] Quatremère noting that, since the death of Michelangelo, there had been nothing like it.[19]

The allegorical figures on Canova's monument represented, significantly, Sculpture, Architecture and Painting, Michelangelo's triumvirate. This evocation of Michelangelo is but one instance among many in which a parallel between the two artists was established, a matter of considerable interest in terms of the sculptor's role and his creative independence.

Cicognara, who addressed Canova as "Il Divino" in his correspondence,[20] charted the progress of Italian sculpture in three broad stages from Nicola Pisano through Donatello to its first apogee in Michelangelo. Following the latter's death, he, like almost every other scholar of the period, traced the decline of sculpture to its new nadir in the figure of Bernini, a situation reversed only by the advent of Canova. Memes, echo-

ing Cicognara, wrote, "and from this period [of his maturity] is to be dated the establishment of Canova on that throne, till then vacant since the death of Michael Angelo."[21]

Canova also painted, fired to a degree by the *Paragone*,[22] and eventually squeezed in the title of architect because of the Tempio Canoviano in Possagno, though he submitted his ideas to the scrutiny of his friend, the architect Gianantonio Selva.[23] If the grounds for his accession to Michelangelo's position as a practitioner of all three arts are shaky, the image nonetheless prevailed.

Of direct comparisons to Michelangelo's sculpture there are few instances,[24] the relationship between the work of the two artists being built upon the more abstract elements of role and artistic spirit. Thus Canova's *Hercules and Lichas* (1795–1815) falls within the category of works bound indirectly to Michelangelo through the sublime or a monstrous "terribilità."[25] When Canova conceived his freestand-

ing *Monument to Wellington* (1806–07), Michelangelo's projects for his *Tomb of Julius II* cast their long shadow over the modern work, a fact which did not escape Quatremère.[26] Thus, in spite of their countless differences, the significant fact remains that in the eyes of his contemporaries, the mantle of Michelangelo fell upon Canova's shoulders.[27]

Eventually, Canova was named inspector-general of all antiquities and works of art in Rome and the Pontifical States, the post once held by Raphael under Leo X. In this capacity Canova's impact transcended questions of style and nationality, giving sculpture itself a new luster and preeminence. He became the quintessential Vasarian artist-hero and, whether admired or not, his work became the standard by which sculpture was judged.

While Jacques-Louis David, as *chef d'école*, set the fashion in France for both painting and, to some degree, sculpture, Canova explored the significance of contour and transparency more consistently than any

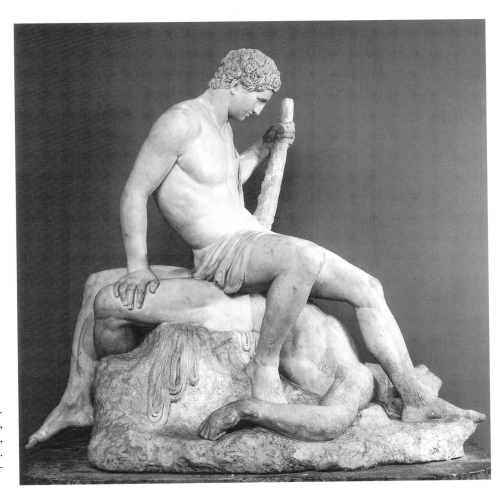

Figure 221. Antonio Canova. *Theseus and the Dead Minotaur*, 1782. Marble statue. London, Victoria and Albert Museum. Photo: Victoria and Albert Museum.

other European sculptor. As such, his work remains the starting point for any examination of the prevailing artistic concepts in relation to sculpture. While the complexity of his production, with its illusionistic qualities, astonishing violence (*Hercules and Lichas*) and unexpected, unclassical forays (e.g., the *Penitent Magdalen*), extended his reach beyond the sphere of academic neoclassicism alone, his probings into the nature of line and contour still had the advantage of consistency, quantity and high visibility in Rome at least. It is essential to take note of his evolution toward the intensely linear style which was to become his hallmark in order to gain a better perspective on the qualities of French sculpture in terms of the international style.

Canova's Triumphant Perseus

A striking auto-criticism within Canova's development gave rise to sharp alterations in style comparable to David's pictorial fluctuations. First Canova veered away from the early, extreme naturalism of the *Daedalus and Icarus* (1779)[28] to produce his *Theseus and the Dead Minotaur* (1782; Fig. 221). Subsequently he transformed the powerful and well-defined anatomy of the *Theseus* into the lyric and fluid grace of his Vatican *Perseus* (1801) which he further refined in the slightly later Tarnovska version (1804) in the Metropolitan Museum of Art. David had abandoned the rococo freedom of the *Battle of Diomedes* (1771) in favor of the sober classicism of the *Belisarius* (1781) and especially of the *Oath of the Horatii* (1784), to be questioned in turn, some fourteen years later, by his *Intervention of the Sabines* (1799) in which he forfeited the searching physical descriptions of the *Horatii* for a more abstract, purely linear rendition of form. Thus the stylistic progression from the *Theseus* to the *Perseus* echoes David's evolution toward the international style of 1800[29] and illumines the conscious nature of some of Canova's choices.

Canova's most deliberately programmatic work, *The Triumphant Perseus* (1801; Fig. 222), offers a clear lesson in the advent of the international style in sculpture and acts as a gauge of sorts for related developments in French sculpture. The svelte statue carried its author to the very pinnacle of fame,[30] but it is only with some difficulty that one can recapture the atmosphere of wonder and admiration that surrounded the birth of this ambitious creation, neglect having shrouded in oblivion the memory of Canova's stupendous success.

As soon as he had seen the *Perseus*, Canova's friend Gherardo de' Rossi published a panegyric to it. He actively encouraged the ladies of Rome to sell their jewels to buy the statue for the city bereft of the *Apollo Belvedere* (Fig. 223).[31] When news of its possible sale reached the papal government, it refused an export license.[32] Instead, the Papacy bought the *Perseus* which, summa of all honors, took the place of the spoliated *Apollo Belvedere*, then in Napoleonic France.[33]

Canova had always intended the *Perseus* as his ultimate statement on Greek art, as the distillation of his formal considerations and abilities in the highest genre, of which the *Apollo Belvedere* was thought then to be the embodiment.[34] When it was completed, the sculptor exhibited it in his studio next to a plaster cast of the famous Hellenistic work,[35] an unmistakable declaration of intent even if his mind's eye had also lingered on his favorite *Horse Tamers* of the Quirinale for the pose and Cellini's famous *Perseus* (1553) for additional conceptual stimulus.[36] Essentially, the *Perseus* aspired to be the modern *Apollo Belvedere* whose description by Winckelmann was of fundamental importance in preparing the ground for Canova's statue, with its emphasis upon the fragrant, elysian grace of the young god.

Winckelmann's assurance that the author of the Greek god "took only the necessary quantum of matter to make form visible" (to allow the form its greatest purity of expression impeded by the least matter possible),[37] though a totally poetic notion, is intrinsically bound up with his view of the hierarchy of styles. Style following rank, Winckelmann attributed to the gods the noblest manner and the most effortless appearance, subscribing to the "Epicurean notion that the bodies of the Gods were composed of the finest particles."[38] The sculptural realization of this higher vision necessitated a consonant refinement of the plastic body, the idea of whose effortless motion depended upon the absence of visible muscular propulsion. The more weightless a body, the more convincingly might its substance be rendered ethereal. Canova aspired, however incorrectly in a statue of a demigod, to capture in his hero the same ineffable grace and divine afflatus propelling the god of light.

Of another work, the *Niobids*, Winckelmann had written that, due to the unity of form and contour, she

appeared to have been "evoked like a thought rather than sculpted with effort."[39] This fundamental vision of the reification of the Idea through transcendent means superficially resembles Bernini's own spiritualization of substance through the visible annihilation of the physical, as in the *Lodovica Albertoni* (1674), whose garments both reveal and destroy the dying body. But this spiritualization is of an almost literal kind, effected through a more easily decipherable virtuosity. Canova sought both to express the intransigent nature of the stone and to transcend it. Hence the tensions in his art which hovers so precariously between the chaste ideals of transparency, the obduracy of cool, white marble and the seduction of warm flesh.[40]

Canova's views on the execution of a work, recorded by Missirini, incline toward a beauty of a transparent, ideal kind,[41] the fullness of his vision maturing only in the final carving, the "esecuzione sublime,"[42] when the form passed from the individuality of the bozzetto to the universality of the idealized marble.[43] In the delicacy and translucence of his surfaces as well as in the purity of the contour, Canova found a means of expressing the idea if not the actuality of transparency, or of insubstantiality in matter.[44]

Transparency and stone: More was longed for than could be realized. But from the longing one learns as much as from the stone turned to statue. Even in contemporary philosophical enquiry the notion of transparency played an important role. Taking the viewer's (perceiver's) desire for oneness with the perceived in the shortest delay possible as his point of departure, Hemsterhuis, in his *Lettre sur les désirs* (1770), which followed his *Lettre sur la sculpture* (1769), concluded that "the soul desired above all, among visible objects, a luminous point almost imperceptible in terms of its visible mass,"[45] which is to say, something of marked simplicity to void excessive material interference, or Winckelmann's "necessary quantum."[46]

Intimations of insubstantiality glimmered, therefore, not only in the quality of apparent physical effortlessness and surface translucence but also in the identification of the viewer with the immaterial ideal within the contemplated work, whose inner life was held by Winckelmann to express itself first in the contour. For a subliminal moment, the expressive strength of the silhouettes of the *Perseus* or of Canova's *Pauline Borghese*, for example, might annihilate the substance within to remain pure visual energy.[47] This ephemeral

transparency predicated upon contour illumines the evanescence of the "utopia of transparency" of which the *Perseus* remains the sculptural paradigm.[48]

If Canova wished to create a modern *Apollo*, he never lost his identity in the quest. It is true that like the ancient masterpiece which it equals in size and proportion, Canova's hero, Perseus, has conquered his opponent – Medusa, in this case – to reappear before Seriphus with the decapitated head. But, for the many similarities, there are as many telling differences.

For a moment, the viewer sustains the impression that Canova has merely reversed the *Apollo*'s position because of the change in supporting leg. Both figures nonetheless gaze to the left, Apollo into the distance, Perseus *at* the baleful head held aloft in his left hand (a deliberate pun no doubt). Canova consciously modified the contraposto, both left arm and leg now being engaged, to produce a greater dynamism, enhanced by the single, generous sweep of drapery from shoulder to ground. In point of fact, others had already effected this contraposto change, among them Houdon in his *Apollo* of 1790 without, however, conferring upon his swift god the streamlined rigors of Canova's contours. If one casts back to Sergel's *Diomedes* the evolution clarifies itself, leading from that robust, classically composed figure, whose movement dictates its contour, to Canova's Vatican *Perseus* bound within a significant visual pattern, within a lucid, dominant contour in accord with Hemsterhuis' prerequisite for rapid assimilation.[49] Temperamental differences in the pursuit of a particular style must naturally be allowed for. Sergel gave himself to voluptuous pleasures with joy (witness his delightful and passionate pornographic drawings) while suffering from gout all his life due to overeating, and periods of somber depression reflected in his series of melancholic sketches. Canova, a modest, delicate man, brought to his art his own refined sensuality. But it is hardly within the scope of this work to delve into the personalities of these principal figures whose art sheds its own light upon their inner lives.

The modification of the classical canon as well as the attribution of a divine appearance to a mortal hero revealed a daring inventiveness. Canova's contemporaries criticized his *Perseus* precisely for its Apollonian bearing and litheness of form. Fernow hastily seized upon this very error,[50] for as a mortal hero, Perseus had no right to an artistic divinization, calling rather for a muscle-bound anatomy on the lines of the *Pugilists*.

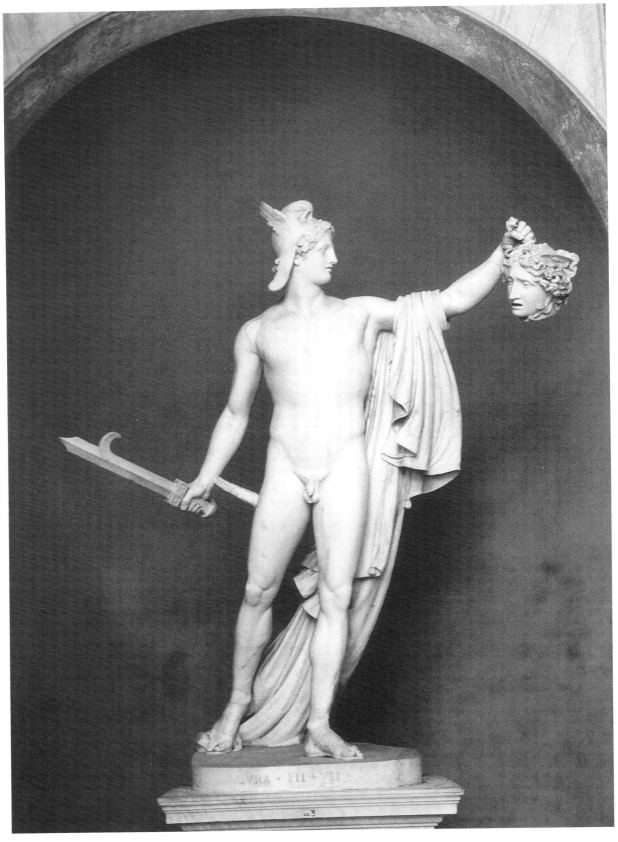

Figure 222. Antonio Canova. *The Triumphant Perseus*, 1801. Marble statue. Rome, Vatican Museum.

But Canova's main preoccupation lay in reinterpreting the canons of antiquity regardless of the subject.[51]

Canova's conscious violation of the rules resulted in what Pinelli describes as the conflation of a dynamic and psychological duality.[52] Unlike the Sun God, in a state of perpetual alightment and gliding forth, the *Perseus*, though also something of an "apparition," comes to a full halt, a specific moment pinpointed in time. The falling drapery, while visually active, is intrinsically static. Canova's admirer and biographer Isabella Teotochi Albrizzi even felt that, while invested with an Apollonian disdain for his victim, Perseus had fallen prey to the very human sentiment of a "nascente compiacenza."[53] It is doubtful, however, that Canova intended to deprive the *Perseus* of the aura of eternity. Nonetheless, Memes, shortly after Canova's death, by which time the statue had lost its glow, set down a tempered appreciation of the sculptor's abilities for that very reason:

> In absolute merit, then, Canova equals the masters of antiquity in fidelity of imitation, – in natural expression, – in accuracy and purity of execution; he falls beneath them in sublimity and vigour of conception, – the grandeur and vigour of his ideal, – and in that majesty of sustained character which lends to nature all the loftiness of blameless excellence in mind and form – yet leaves it nature still.[54]

Canova's visible departures from the model and his discreet inventions[55] confer upon the work the faint odor of modernity to which Stendhal was so sensitive, noting in his characteristically convinced manner that "Canova, having been romantic, that is having created sculptures that pleased his contemporaries (all the more so because the works were at their level), his works are understood and felt far more readily than those of Phidias."[56] In 1799, Goethe had already observed that "making the style of the ancients palatable in eighteenth-century terms constituted Flaxman's principal achievement on behalf of the dilettante."[57] Stendhal's sentiment was no doubt genuine, yet might there not be a touch of braggadocio in these words, and the many others like them, a defiance of the insurmountable past perhaps, or a deliberate iconoclasm tinged with recklessness?

Canova's work was proclaimed the peer of antiquity, indicating a certain satisfaction with things as they stood. This lends a positive aspect to the neoclassical revival belying the general inferiority complex that colored most contemporary thought and which so

Figure 223. Apollo Belvedere. Marble statue. Rome, Vatican Museum.

irritated any number of struggling or even successful sculptors. Canova himself moaned about the prejudice of contemporary critics in favor of antiquity.[58] A paradox arises from the consideration of nostalgia as a sine qua non of neoclassicism[59] in light of the eighteenth century's belief in man's perfectibility. Canova's *Perseus*, after all, filled the vacant pedestal of the *Apollo Belvedere* not as a niggardly stopgap but as its equal. The same can be said of the *Venus Italica* (1804–12) substituted for the *Medici Venus* which was also abroad.[60]

If the golden age could be revived, could its passing be lamented? The *Perseus* set up a knife-edge balance between past and present, the work's relevance being predicated upon an intimate knowledge of the *Apollo* which, it seemed, had carried through the corridors of time the very essence of ancient Greece. In his discussion of the *Perseus*, Pinelli refines the nature of the delicate balance of opposites, writing on the one hand of Canova's wish to render the past model relevant to the present "with all modern improvements" and, on the other, of his wish to infuse his work with an elusive evocation of nostalgia.[61] Of this "elusive evocation of nostalgia," however, its particularly subtle essence has evaporated with time, leaving one with the intrinsic worth of the *Perseus* divested of its dialectic, programmatic function. Nonetheless, one can reconstitute the reality not only of that nostalgia but also of the "utopia of transparency" in more precise visual terms through the comparison of the stylistic qualities in Canova's own work and in that of his predecessors and contemporaries. From these juxtapositions emerges the evidence of the deliberate search for an increasingly radical style, the sweep of the tabula rasa, which for a while, dominated the artistic strongholds of Europe.

Canova's Influence

In the first years of Canova's fame, Parisian acquaintance with his work was limited to engravings, or to secondhand reports through the news or via students in Rome to friends and teachers. Canova himself first visited Paris in 1802 to model his portrait of Napoleon.[62] During this trip he met with his friend Quatremère de Quincy on an almost daily basis and saw Houdon, Moitte and Jean-Baptiste Giraud among others.[63] But direct knowledge of his sculptures remained limited to those traveling to Rome or collecting privately until plaster casts of the *Creugas* (1795–1801; Vatican Museums) and the torso of the funerary Genius from the *Monument to Clement XIII* were exhibited in Paris in 1804.[64] The real revelation came in 1808 when his group of the standing *Cupid and Psyche* (1796–1800; Fig. 259),[65] the *Hebe* (1800–05),[66] the seated *Letizia Bonaparte* (1804–07)[67] and the kneeling *Penitent Magdalen* (first version, 1794–96; Fig. 224)[68] were exhibited at the salon. Several years later, in 1812, Canova's *Dancer*[69] and *Terpsichore*[70] also found their way into the Salon of 1812.

The critical reception of these works ranged from the occasionally tepid to the wildly enthusiastic, with, remarkably enough, especial warmth for the *Magdalen*, the least classical of the salon submissions. Indeed, of all Canova's Parisian works, none surpassed the *Magdalen* in fame.[71] The "Sommariva Magdalen," as she came to be known, enjoyed a prestige so great that at the time of the Sommariva sale in 1839 she went for 63,000 francs in comparison to a meager 15,450 francs for Prud'hon's *Psyche* and an even more wretched 2,300 francs for J.-L. David's *Cupid and Psyche*.[72]

Damaged upon arrival, Sommariva entrusted her to none other than Chaudet for repairs.[73] Sommariva, who had obtained the statue from the Frenchman Juliot, who in turn had taken it over from Monsignor Priuli, the original commissioner, then "built a little altar described for us by a contemporary as half-chapel, half-boudoir, furnished in violet and lit only by an alabaster lamp hanging from the cupola."[74] Although the manifestly erotic quality of Greuze's praying girls has dissipated in Canova's more subtle statement, these voyeuristic viewing conditions bring God and sex into lurid proximity.

The originality of the statue stunned the public which was expecting, no doubt, more of Canova's reputedly clear, cadenced silhouettes. The slumped form, bedraggled hair and religious subject made of her a veritable anomaly, the ancestor of innumerable dejected or mourning Eves and even of the mendicants and pariahs to step on stage.[75] With this work, Canova illustrated the changing relationship of art and religion, art becoming a means for the psychological investigation of a religious event divorced from its religious context. The *Magdalen* had no particular destination: she could just as well become the household Genius that Sommariva made of her, as the inhabitant of a gloomy church chapel or grotto.

Canova's new foray into such unclassical territory explains in part the work's appeal. Others followed in his tracks in a more classical idiom, Lorenzo Bartolini's *Faith in God* (1835, Poldi-Pezzoli, Milan) and Jean Jaley's *La Prière* (1831, Louvre, Paris) being the most obvious examples in sculpture of religion observed more than felt. Philippe Lemaire (1789–1863) boldly included her in the pedimental relief of *The Last Judgment* (model, 1830; stone, 1834; Figs. 225a and b) for the Madeleine in Paris, giving her a specific context while falling short of Canova's quality.

Many commented disapprovingly upon Canova's inclusion of a wooden staff and the figure's overall naturalism.[76] Bernini's presence shines through in the textural brilliance, for example, of the tears streaming down her cheeks. Yet Quatremère found room for approval in spite of this on the grounds of its radical independence from any previous work, ancient or modern.[77] While generally favorable, the critical reception accorded the work in later years was contradictory in a way worthy of note.

Chauvin gave an enthusiastic opinion of the *Magdalen* in his *Salon de 1824*, linking the work to the grand moral tradition of antiquity. To Chauvin's eyes, the simple, clear emotion of deep repentance precluded any bond with the "romantic" school which he scornfully rejected as "essentially cold, because radically false."[78] Another contemporary, De Latouche, however, came to the very opposite conclusion in his and Reveil's *Canova* (1825), seeing in the work a radical departure from the purely physical pain of the *Laocoon* or Niobe's impotent rage against the gods. Canova's *Magdalen* spoke the language of acceptance, a figure "resigned to the power of the heavens." In this, De Latouche perceived its "romanticism" and its powerful attraction.[79] The appeal of Canova's *Magdalen* transcended the blurred definitions of romanticism to attain universal admiration. Artaud, as late as 1836, when pointing out Lemaire's plagiarization of the *Magdalen* for his pedimental relief, reminisced about his first impressions of Canova's statue seen in the company of David d'Angers. It struck him as "portraying the essence of a forgiving and merciful Christianity, a point of view which David seemed to share entirely."[80] David d'Angers himself referred admiringly to the marble as one of Canova's masterpieces, one of the modern links to Greek sculpture for its *moral* sentiment. When describing the funeral of Cecilia Odeschalchi in Rome, he even used the imagined destruction of Canova's *Magdalen* to convey the magnitude of the human loss.[81]

To what degree then did the French care about Canova's art? In many respects he was nothing but a thorn in the side of the body of sculptors attempting to earn a living and forge a reputation in the shadow of his greatness. That sculptors fully felt the weight of Canova's position is born out by the young student Louis Dupaty's (1771–1825) pathetic lament over failing to obtain a good piece of marble: "M. Canova is fortunate to have found such good blocks, but who

should have beautiful horses if not the king?"[82] Even those sculptors who consciously emulated the style of his most classicizing works did so at an intuitive or purely imitative level. Others deliberately rejected Canova's light touch in favor of a more ponderous or fleshy classicism.

Already during the Revolution a number of sculptors had pointedly avoided too close an identification with Canova's style. And clearly, the popularity of the *Magdalen* notwithstanding, Canova's fortunes in a post-Napoleonic Paris could not hope to be as bright as during the Empire. Added to this, the shifting tides of opinion about the Elgin Marbles (discussed in the following chapter) would affect the reputation of the *Apollo Belvedere* and those works predicated upon its fluid grace. The anti-Canovian classicists found their champions in the likes of Fernow and Delpech, who bluntly stated his views in his criticism of the 1814 Salon:

> His faults [softness, lack of severity, etc. . . .], as I have said elsewhere, are the clear signs of the decadence of art. The French school must therefore resist *public opinion* which points to [Canova] as the model to be followed and, faithful to true principles, must walk in the path of the ancients: only there can she be sure not to lose herself.[83]

The French attributed Canova's prominence, which engendered both resentment and genuine admiration, to the commissions he was fortunate enough to secure. Another critic, reviewing the Salon of 1804, gave voice to this problem, referring to "the" monument to Louis XV (unspecified) and the Mausoleum of the Maréchal de Saxe as the last great commissions of substance in France to challenge the talents of sculptors.[84] Even David d'Angers shared this concern, venting his sense of retrospective, sympathetic frustration for his predecessors in his Notes.[85] But when the opportunity did arise for monumental ensembles, the results fell short of Canova's accomplishments. The three commissions awarded to Louis-Pierre Deseine (1749–1822) are a case in point.

Deseine

As a student in Rome (1783–87), it was Deseine who had written enthusiastically to his teacher Pajou about Canova's *Monument to Clement XIV* then under way.[86] After some years of neglect due to his royalist

Figure 224. Antonio Canova. *Penitent Magdalen*, 1794–96. Marble statue. St. Petersburg, Hermitage.

persuasions, Deseine was granted three important commissions, one directly linked to his position as restorer of Falconet's Chapel of the Calvary. He received this appointment in 1803 after the concordat and consequent partial restitution to the church of its spoliated belongings.[87] In addition to being instrumental in recovering Falconet's *Christ in Agony*, Deseine devised a lighting scheme in 1820 designed to magnify the chiaroscuro effects of Falconet's chapel,[88] juxtaposed by this point with his own *Entombment* (com-

pleted shortly before his death in 1820; Fig. 226). To the right, a painting of the *Crucifixion* by Abel de Pujol acted as pendant to it until Jehan du Seigneur's plaster group of the *Crucifixion* took its place after the destruction of the Calvary in 1850.[89]

In Deseine's *Entombment*, a black rocky background serves as a foil for the active groups of white plaster figures. These recall most vividly Emilian sixteenth-century *tableaux vivants*. But the group also bears the visible trace of Canova's impact upon Euro-

Figure 225 a and b. Philippe Lemaire. *The Last Judgment*, 1830–34. Stone relief. Paris, Church of the Madeleine, pediment.

Figure 226. Louis-Pierre Deseine. *Entombment,* completed 1819. Plaster. Paris, Church of Saint Roch.

pean sculpture even if the angularity of the drapery borders on the Gothic at times.[90] The work's destination dictated its illusionistic manner, tempered by the restraint of a classical form and the absence of such suggestive effects as painted sky, tree trunks and grass. While the reduction of means heightens the metaphoric quality of the group, it cannot dispel the sense of theatricality which Canova himself exhibited to a remarkable degree. His *Monument to Maria Christina* (1798–1805; Fig. 202) makes that clear.[91]

A monument to the idea of "juxtaposition" – as opposed to composition[92] – in which the figures exist in a community of independence also seen in his papal monuments, Maria Christina's funeral cortege nonetheless impresses the viewer with its rhythmic progression to and through the black doorway. The invitation to join them is made not through a baroque exhortation but through the insistence of the movement into the darkness beyond. The life-size figures pass over a loosely thrown rug hanging down over the marble base as does the leg of the mourning Genius to the right.

The illusionistic or "pictorial" qualities drew considerable attention at the time, turned to positive account by Quatremère – "a sort of conquest of painting by sculpture"[93] – and criticized by Carl Ludwig Fernow on the same grounds. Overcoming his own objections, Fernow nonetheless concluded that, "even we ourselves, when we overlook its inherent faults in

principle, and look at the work with the eyes – not of strict critics, but of lenient connoisseurs – are ready to confess that modern sculpture has produced no work of equal grandeur and excellence, and that in the details there is little we could wish to be omitted or even to be changed."[94] According to Quatremère, it was Canova's favorite work. Stendhal thought it to be one of the most beautiful monuments in the world.[95]

Neither obituary nor epitaph nor recondite allegory mars the simple elegy of this mourning scene. A gilded wreath in the hair, a gilded staff, these add a glimmer of life to the grieving figures harmoniously disposed upon the steps. Again, a contrast in stone, albeit extremely subtle, sets off the white marble mourners from the pyramid and serves also to enhance the illusion which may have been further accentuated by a carefully considered, crepuscular lighting.[96]

Deseine's own tableau borrows Canova's classicism, but where Canova achieves a high level of symbolism, Deseine, like Pajou, remains anecdotic. This distinction also characterizes his tombs for Cardinal de Belloy (1808–18) and for the Duke of Enghien (1817–19; Fig. 227).[97]

The remains of the Duke of Enghien, who was executed at Napoleon's command in 1804, were exhumed under Louis XVIII in 1816, requiring appropriate commemoration. Deseine exhibited his models at the following Salon of 1817 with a lengthy explanation of the action.[98] Religion sustains the prince above, while

Crime waits to strike, observed sadly by France.[99] The latter is suffused with Canovian melancholy while the figure of Crime draws upon J. - L. David's regicides in *Triumph of the French People* (1794; Fig. 228). The stark geometry and essential simplicity of the whole, however, fail to dissimulate the other equally important force at work in the conception (which one might guess from the description alone), namely the *Monument to the Maréchal de Saxe*. The energetic hero reappears in considerably diminished form as the Duke of Enghien defying his assassin below. At the time of the Restoration, when patrons and artists sought to revive the ancien régime in every possible way, such an admixture was to be expected.

A medley of styles persists in Deseine's *Tomb for Cardinal de Belloy* (Paris, Notre Dame), again dominated by a Canovian spareness of arrangement and a Flaxmanesque tenderness in the grouping of Charity with a young girl to the left. More human in scale and tone, these works lack both the grace and commanding eloquence of Canova's greatest accomplishments. Quatremère's championing of a foreigner, however galling to his compatriots, was understandable in the light of these particular works. Other sculptors like Chaudet or Clodion, who might have fared better, were not given the chance.

Figure 227. Louis-Pierre Deseine. Tomb of the Duke of Enghien (Château de Vincennes), 1817–19. Drawing. Location unknown.

Figure 228. Jacques-Louis David. *Triumph of the French People*, 1794. Drawing. Paris, Musée Carnavalet. Photo: Svartz for Photothèque des Musées de la Ville de Paris by SPADEM.

Sculptors of the Empire

In spite of the ambivalence of the French toward Canova noted earlier, his commanding presence proved to be irresistible, particularly after the onset of the Directoire. Every scholar interested in the period has offered a slightly modified list of the same names of sculptors affected in one way or another by Canova: Caloigne, Chinard, Chaudet, Beauvallet, Bosio, Pradier, Deseine, Dupaty, Callamard, Marin, Milhomme, Delaistre, Lemaire, Lemoyne, Lemot and Ruxthiel, most prominently.[100] Some of those listed, like Lemot, were in fact almost insensitive or opposed to Canova's style, their ability varied considerably, and they are by no means of equal interest. Others, like David d'Angers, are seldom mentioned. No French sculptor, however, remained as true to his own vision as did Canova who, to the best of his ability, shunned modern dress and portraiture – although two of his greatest works were full-length images of the imperial family. All his French followers succumbed to a greater or lesser degree to the exigencies of modern life, Chinard and David d'Angers founding their very careers upon portraiture (admittedly to very different ends).

Chinard

Joseph Chinard (1756–1813),[101] a sculptor of humble origins from Lyons, began his studies with Barthélémy Blaise in his home town. He worked in the baroque idiom of Blaise's school, but on acquiring sufficient funds, left for Rome (1784–87). There he absorbed both antiquity (copying the *Laocoon*, the *Ganymede*, the *Apollo*, and the *Dying Gladiator*)[102] and Canova's carefully calibrated arabesques, mannered eroticism and crisp detailing. Contrary to popular wisdom, however, Chinard failed to establish a friendship with Canova.[103] A disagreeable, opportunistic man apparently, he may indeed have recognized the commercial possibilities of emulating Canova's style. But to attribute Chinard's manner to this alone would be to ignore his innate sense for a coolly cultivated sensualism and a hard-edged precision, not to mention the transformative power of Rome. In any event, winning the coveted Balestra prize of the Academy of St. Luke in 1786 was enough to drag him from obscurity and set him on the road to success.

The immediate impact of Chinard's Roman stay and his incessant study of antiquities in the Borghese,

Vatican, Museo Pio Clemente and elsewhere can be seen in the four rediscovered statues of *Venus* (1790), *Apollo* (1790), *Ceres* (1789?) and *Mercury* (1791) created after his return to Lyons in 1787.[104] With elegance and ease, Chinard generated four pseudoantiques in an updated version of Nollekens' remaking of antiquity. All stem from ancient models touched by the freshness of a new age. Destined to ornament the estate of Pierre Dujast d'Ambérieux, the works fall into the category of excellent adaptations by a master craftsman whose greatest originality was yet to show itself.

Chinard plundered the erotic lessons of Canova's *Cupid and Psyche* (1787–93; Fig. 246) to richer effect and anticipated the greater conflict between the sexuality and chaste sculptural ideal of the *Pauline Borghese* and the *Venus Italica* in his famous bust of *Madame Récamier* (terra-cotta, 1801; marble, c. 1805; Fig. 229).[105] This portrait, more a portrait in the real sense than Canova's of a Pauline idealized almost beyond recognition, renders the eroticism more explicitly in the veiled glance and half-veiled bosom, the nigh-imperceptible intimation of a smile hovering about the lips and the insistent Canovian ringlets of hair leading an animated life entirely of their own. Her sphinxlike self-preoccupation is as mesmerizing as the chiseled sensuality of the marble which casts into grander terms the warmer inflections of the original terra-cotta. The best of Chinard's many other portraits combine a similarly marked realism with the stylizations of a precise, mannered classicism. A terra-cotta bust of an *Unknown Woman* (Fig. 230) is so striking and direct that, give or take a few carefully groomed locks, she could be a cool, chic denizen of today's downtown scene. She knows something.

The inclusion of the arms in the *Madame Récamier* and other busts, like that of *Madame de Verninac* (model, 1800; marble, 1808) for example,[106] – a free adaptation of ancient, Italian Renaissance and baroque traditions (already employed by Roland) – lends life and expression to the figures artfully truncated at the waist. Furthermore, viewed from the back, *Madame Récamier* on her pedestal gives the impression of a full standing presence, the inviting slope of her shoulders and the curve of her cheek seeming to beckon the viewer (more specifically a male) to an intimate dialogue. In this particular formula, Chinard deliberately escaped the greater solemnity of Canova's busts and of the models of antiquity. A few years earlier, Chaussard had approved Chinard's works with

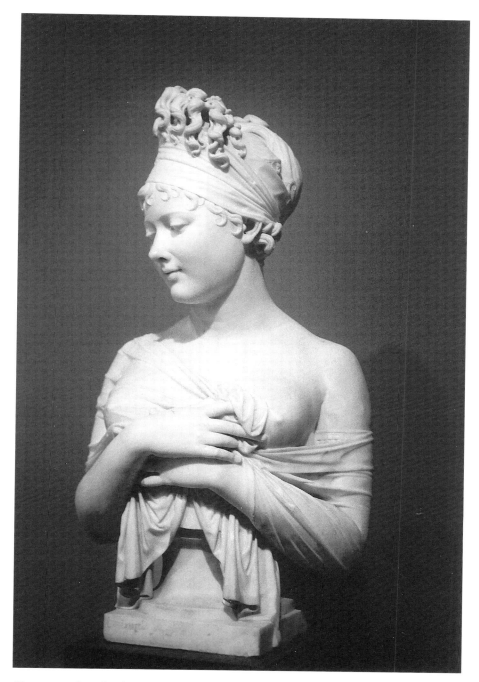

Figure 229. Joseph Chinard. *Madame Récamier*, c. 1805. Marble bust. Lyon, Musée des Beaux-Arts.

the commendation, "There is much spirit in the compositions of C[itoyen] Chinard. He is a poet."[107]

A variant of the portrait of *Madame Récamier* (Paris, Musée Cognacq-Jay),[108] veiled and more seriously pensive, adds another dimension to the sitter's personality or, in any event, to Chinard's emotional repertory. Her twin is to be found in Baron Gros' full-length portrait of the prematurely deceased *Christine Boyer* (1800; Fig. 231), first wife of Lucien Bonaparte.[109] Melancholic woods and a purling stream bearing off the rose of life set the stage for the young woman's reverie. To transform the upper part of the

Figure 230. Joseph Chinard. *Unknown Woman*, c. 1800–10?. Terra-cotta. Paris, Louvre.

figure into sculpture would yield a bust like Chinard's.

The elegiac constitutes a history of its own with roots most obviously in late-eighteenth century painting and sculpture. Johann Gottfried Schadow's (1764–1850) dazzling double portrait of the young *Princesses Luise and Friedericke of Prussia* (1795–97; Fig. 232) leaps to mind.[110] So devoted as to need no wordy exchange, each sister lives in her own realm with the lovely dreaminess of a *Diadoumenos*. Such lyricism touched by a cooler remoteness suffuses Dejoux's bust of *Marie-Christine de Brignolle,*

Princess of Monaco (1783; Fig. 233), an early, thoughtful essay in the genre by a developing classicist bold enough to shun the generally positivistic, cheerful side of so much rococo portraiture.[111] It also colors the more pathetic, emotionally wrought *tête d'expression* of *Andromaque* (c. 1800; Fig. 234) by Milhomme,[112] on the verge of winning the Prix de Rome. Hector, the object of her mourning, appears in relief below, stretched out like a *gisant* and foretelling Rude's own *Cavaignac.* Her despondency is matched only by the far more famous and idiosyncratic *Penitent Magdalen*

completed by Canova in 1796 (1808 Salon) and his own full-length *Psyche Abandoned* (Rome, 1806).

Chinard's independence from Parisian art circles may hold the clue to his pursuit of a less rigorous classicism in both his portraiture and small-scale works. In his case, as in Prud'hon's, it is significant that his trip to Rome was subsidized not by a prestigious Prix de Rome but by a private patron. His ties to the Academy were thus distant, as were Prud'hon's, a modest Dijonnais boarder, who turned to the benevolent Canova in part because the academy shunned him.[113] And like Chinard, Prud'hon became the master of a highly personal, moody classicism.

Chinard's Balestra prize entry had been a half-life-size group of *Perseus and Andromeda* (1786) which he later reworked in terra-cotta (1791; Fig. 235) and marble. In a more intimate version of the ancient *Perseus and Andromeda* (Fig. 236) in the Museo Capitolino, Rome, he transposed his rococo penchant into a

Figure 231. Antoine-Jean Gros. *Christine Boyer*, 1800. Oil on canvas. Paris, Louvre.

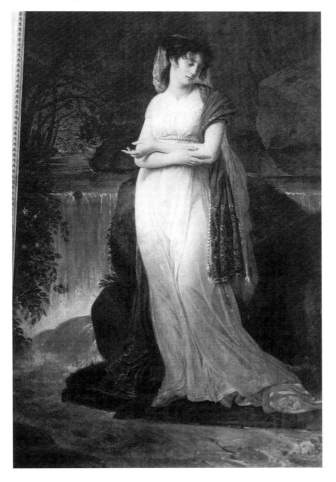

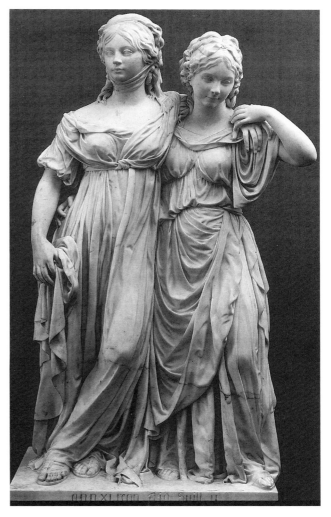

Figure 232. Johann Gottfried Schadow. *Princesses Luise and Fredericke of Prussia*, 1795–97. Marble group. Berlin, Staatliche Museen zu Berlin-Preussischer Kulturbesitz, Nationalgalerie. Photo: Staatliche Museen zu Berlin-Preussischer Kulturbesitz, Nationalgalerie.

domain pervaded with the ineffable touch of death.[114] Certain stylistic mannerisms, in the facial treatment for example, still evoke Canova's presence, but Chinard never relinquished a greater plastic freedom in the composition of his groups, Clodion's rich modeling leaving its mark upon the younger man.[115] The voluptuous, youthful fullness of Andromeda's breasts and belly in conjunction with her swooning demeanor speak more of sexual arousal than of relief at newfound freedom.[116]

Andromeda's fainting impassivity in Perseus' victorious arms recurs in the strange, resigned sadness of *Cillare and Hylonome* or *The Death of the Centaurs* (c. 1790?; Fig. 237),[117] engaged in the final throes of a

Figure 233. Claude Dejoux. *Marie-Christine de Brignolle, Princess of Monaco*, 1783. Terra-cotta bust. Paris, Louvre.

Figure 234. François Milhomme. *Andromaque*, c. 1800. Plaster bust. Paris, Louvre.

remarkable *Liebestod*. In these and similar works Chinard established a unique, morbid commingling of carnal desire, resistance and death.

Although Chinard's erotic explorations remained a private occupation, even the revolutionary works commissioned from him tend to lose their propagandistic vigor through their gentleness and pervasive lyricism. In the bas-relief *Honor and Country* (plaster, 1808; Fig. 238), for example, commissioned by the Municipal Council of Bordeaux in 1804 for a triumphal arch in honor of Napoleon, Athena's modest stance in the midst of unconvincingly active youths leaves something to be desired.

Like a sailor between Scylla and Charybdis, Chinard tried to steer clear of political troubles during his second trip to Italy in 1791–92 and upon his return to France. While in Rome, the Lyonnais van Risembourg had commissioned from him a *Reason in the Guise of Apollo Crushing Superstition* (1791; Fig. 240) and *Liberty in the Guise of Jupiter Crushing the Aristocracy* (1791) as candelabra bases. These terra-cottas, inspired variously by ancient works,[118] led to Chinard's imprisonment in the Castel Sant'Angelo for their anticlerical and subversive subjects. As soon as he was released he beat a hasty retreat to Lyons. There he was deemed insufficiently enthusiastic in support of the

Figure 235. Joseph Chinard. *Perseus and Andromeda,* 1791. Terra-cotta group. Lyon, Musée de Beaux-Arts.

Figure 236. Joseph Chinard. *Perseus and Andromeda.* Marble relief. Rome, Museo Capitolino.

cause, on the basis of a relief of *Liberty and Equality* that he had volunteered for the new pediment of the Hotel de Ville to replace the effigy of Louis XIV.[119] Jailed on October 6, 1793, largely for the equivocal gesture of Liberty, who appeared to be pushing over rather than supporting the symbol of the Revolution, he was only released on February 28, 1794.[120] The degree to which the municipality saw itself reflected in its art and its hypersensitivity during this period could have no clearer proof. It is remarkable, however, that no one reproached Chinard for the more graceful than virile tone of his political works. The style fails the urgent message. One looks rather to Moitte, or indeed to the grisaille inventions of Fragonard *fils* (1790–1850) for a more appropriate feeling. Alexandre-Evariste Fragonard's postrevolutionary drawing (engraved by Allais) of *The Genius of France Adopting Liberty and Equality* (Fig. 239) adapts an almost Blakean fierce symmetry to the group. It would easily have been one of the most striking monuments of its kind had it actually been intended for realization.

In the case of the *Apollo Crushing Superstition,*

(Fig. 240), a certain elegant flamboyance in the slender god energizes the group but also carries it to the brink of both the decorative and the erotic. As has been observed, "[it] is astonishing to see how fluently Chinard manages to hide the discrepancy between revolutionary content, implied by the militant subject of secularisation, and a hyper-refined classic style. The peculiar mixture of eroticism and moral 'message' is prophetic of the *fin de siècle*, especially Moreau."[121]

Thanks to his great gifts as a portraitist, Chinard became a leading sculptor of the imperial family and master of decorations for the republican celebrations in Lyons.[122] He executed, for example, a reclining Jean-Jacques Rousseau for the ceremonies in his honor (October 3, 1794) and a *Victory Giving the Crown* (1810) which was to have been executed in marble on the scale of some nine feet for the Place St. Louis at Marseilles. The work, engraved by Landon

Figure 237. Joseph Chinard. *Cillare and Hylonome*, c. 1790? Terracotta group. Location unknown.

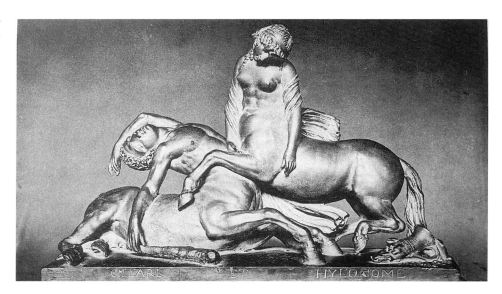

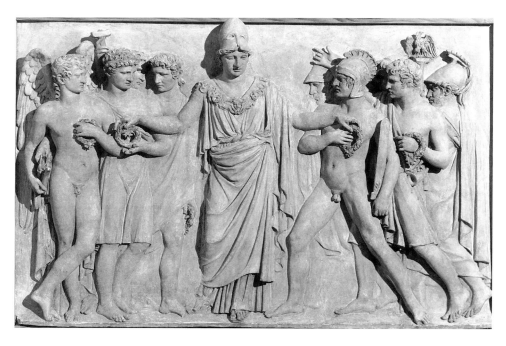

Figure 238. Joseph Chinard. *Honour and Country*, 1808. Plaster relief. Lyon, Bibliothèque Historique de la Ville. Photo: Studio Basset, Lyon.

(Salon de 1810; pl. 66) and similar to the *Apollo Crushing Superstition*, hardly escapes the standard mold of such rhetorical images. His *Général Cervoni* (1812), as recorded in another Landon engraving, expresses a more dominant, active tone through the decisive pose and an accretion of material details that enliven the entire surface. This and his more popular *Carabinier* (1806; Fig. 241), "du Gros sculpté,"[123] for the Arc du Carrousel show that, when confronted with the actualities of the authoritarian, military world, he was able to translate their direct stimulus into more vigorous images.

It was part of the novelty of the Arc du Carrousel to incorporate four fully uniformed soldiers from the Grande Armée into its iconographic program, arousing considerable critical opposition.[124] These soldiers were among the first anonymous heroes to be celebrated in the nineteenth century, with a vivid legacy in the art of Géricault. The idea originated not with Chinard or the other sculptors involved, however, but with the designers of the monument. As such, Chinard cannot take credit for it. On the other hand, another, small work does deserve a moment's notice for its originality, namely, his remarkable *Self-Portrait* (Fig. 242). No firm date exists for this statuette which some consider to have been executed between 1790 and 1795,[125] others around 1808.[126] Besides the remarkable

fact that it is a full-length, standing self-portrait of which exceedingly few exist, it shows Chinard in a togalike gown.

There were no "Barbus" among sculptors, or sculptors among the "Barbus," striking the attitudes and poses of a Maurice Quaï. This in itself constitutes an interesting ommission worthy of investigation in terms of the sculptor's social and intellectual standing.[127] Yet Chinard's *Self-Portrait* is one of the few examples of an artist recording himself in a costume like those of that radical sect. In 1806, Abel de Pujol had hit upon such a formula for his own youthful, self-conscious *Self-Portrait* (Fig. 243). In spite of the awkwardly bound arm, a paintbrush signals his craft, whereas Chinard's orator type gives no immediate clue to his occupation (he may be holding a chisel in his left hand).[128] The statuette avoids a severely classicizing aspect, the cloak draping the body in revealing, simple folds with one long sweep from the left shoulder to the right knee. As such, it falls short of the stylistic extremities advocated by the Barbus. But no sculptor had yet attempted a full-length self-portrait to communicate either his personal character or stylistic allegiances, profitable though the latter may have been.

In spite of his striving for success, Chinard's was a considerably less ambitious art than Canova's, although the lesser nature of his commissions may be

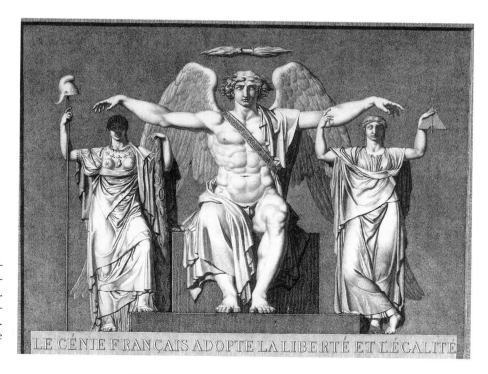

Figure 239. Alexandre-Evariste Fragonard. *The Genius of France Adopting Liberty and Equality*, 1794. Paris, Bibliothèque Nationale, Cabinet des Estampes (Hennin, no. 11978)., Photo: © cliché Bibliothèque Nationale de France, Paris.

LE GÉNIE FRANÇAIS ADOPTE LA LIBERTÉ ET L'ÉGALITÉ

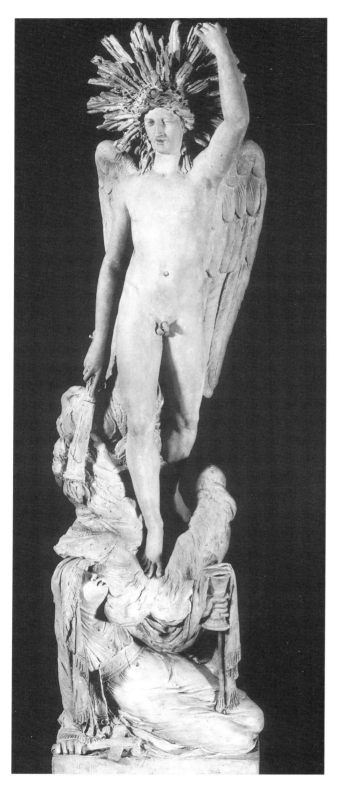

Figure 241. Joseph Chinard. *Carabinier*, 1806. Marble figure. Paris, Arc de Triomphe du Carrousel.

Figure 240. Joseph Chinard. *Reason in the Guise of Apollo Crushing Superstition*, 1791. Terra-cotta. Paris, Musée Carnavalet. Photo: Degraces, for Photothèque des Musées de la Ville de Paris by SPADEM.

partly responsible (and his ephemeral revolutionary works have vanished). He gave little new expression to the latter's attention to singing outlines and considerations of transparencies. Nor did he harbor the same ideological commitment to heroic nudity as Canova or, indeed, Chaudet. Furthermore, he had no theoretician like Quatremère to cajole or criticize him; he followed his personal inclinations, bowing occasionally to the exigencies of the government. Above all, he remained the most refined portraitist of his day. Ultimately, his portraits and the erotic possibilities of his smaller works were to be his most pregnant legacy, to be far more publicly exploited by Pradier.[129] The field, then, was left open to Chaudet to capitalize on the popularity of Canova's style on a more monumental scale.

Figure 243. Abel de Pujol. *Self-Portrait*, 1806. Oil on canvas. Valenciennes. Musée des Beaux-Arts Photo: Giraudon/ Art Resources, N.Y.

Chaudet

Denis-Antoine Chaudet (1763–1810),[130] who was also a painter, easily absorbed Canova's lesson, charmingly condensed in the *Cupid Playing with a Butterfly* (model, 1802; marble, posthumous, 1810; Fig. 244), a work of the Directoire. He had studied with Stouf and Gois père, first trying his hand at the Prix de Rome in 1781. His 1784 submission, *Joseph Recognized by His Brothers*, won him the coveted prize which would send him to Rome and to his real master. In both his prize-winning relief and a terra-cotta *Bust of Ména-geot* (Salon of 1789, French Academy, Rome), he clung to an idiom more animated and spontaneous than that of the works which were to become his hall-mark.

Chaudet's Roman stay overlapped with Chinard's, but they appear to have had little in common. Nonetheless, both found in Canova a font of inspira-tion even if Chaudet had little real feeling for the more subtle, erotic undertones of Canova's sculpture. In his compact and clearly defined crouching *Cupid,*

Figure 242. Joseph Chinard. *Self-Portrait*, 1795–1808. Terra-cotta figure. Montargis, Musée. Photo: Courtauld Institute.

Figure 244. Denis-Antoine Chaudet. *Cupid Playing with a Butterfly*, 1802–10 (finished posthumously). Paris, Louvre.

Chaudet retained the gingerly delicacy of gesture and "tubuluar" anatomy found in Canova's recumbent *Cupid and Psyche* (Fig. 246) not to mention Gérard's 1798 painting of the same subject (Fig. 245) and, in the profile views, the lucid silhouettes favored by Canova.

A remarkable affinity also exists between the drawings of the French and Italian masters, seen to good advantage in Chaudet's preparatory sketch (Fig. 248) for *The Three Arts of Drawing* (1810; Fig. 247) in the vestibule of the Louvre[131] and in Canova's *Dancing Figures* (Fig. 249). Chaudet's touch lacks the feathery lightness of Canova's, but he captures something of its fundamental energy, which survives in the beautiful if entirely overlooked relief.

On the other hand, Canova's lucid if highly mannered relief style had little effect on Chaudet's own much earlier *Devotion to the Fatherland* (1792–93;

Fig. 17) for the porch of the Pantheon, a work preceding Napoleon's political ascendancy. There, one of the few nude and anonymous dying heroes in French sculpture finds himself in an overwhelming press of commiserating or triumphant, allegorical female figures. The figure of Naked Truth to the left also introduces a note of marked voluptuousness into the proceedings, stemming from a physical vocabulary more generous in its proportions than that encountered in Canova's nudes.[132]

Along with Chinard, Chaudet came to embody the official Empire style, becoming one of Napoleon's favorite portraitists. Chaudet's commission for the statue of the emperor (1810; fig. 160) for the Vendôme Column (1806–10), ideological difficulties notwithstanding, capped a perfectly ascendant career truncated by illness alone. In addition to his pronounced official production, however, he made room for the elegiac and touching as well. In 1789 he sculpted *La Sensibilité* followed by *The Nest of Love*

Figure 245. François Gérard. *Cupid and Psyche*, 1798 Salon. Oil on canvas. Paris, Louvre.

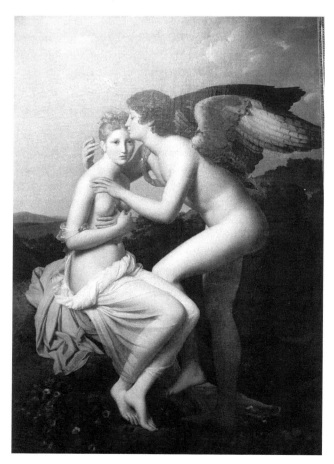

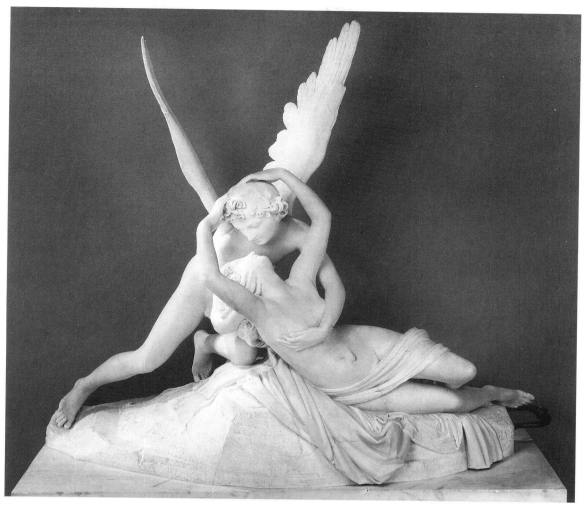

Figure 246. Antonio Canova. *Cupid and Psyche*, 1787–93. Marble group. Paris, Louvre. Photo: R. M. N.

in 1791, *Paul and Virginia* in 1795, and the life-size *Mourning Cyparissus* (1798; Fig. 250) which two Prix d'Encouragement funded (An II, An VII).[133] A Lysippian grace suffuses the ephebe's slender body as he clutches to his bosom the little stag he had befriended and accidentally killed. Chaudet carefully placed Cyparissus forward on the plinth so that the cloak falling from his shoulder in back might have a richer plastic effect when seen from the side. In other words, he was seeking a more columnar effect than the sweeping silhouette of Canova's *Perseus*, for example. In this genre, the public accorded particular favor to Charles-Antoine Callamard's (1769–1821) seriously damaged but still graceful *Wounded Hyacinth* (1811). This statue was famous until the end of the Third Republic, when it was still at the Louvre,[134] and reveals

the svelte proportions of the neo-Lysippian, and at times homoerotic, group of works in both painting and sculpture so popular during the Directoire and the Empire.

Chaudet's many drawings bear out his taste for idylls – and drama.[135] A disturbing sketch (Fig. 251), one of Apollo holding a minuscule Hyacinth in a moment of intense bereavement, again looks forward to the physical disparity and sexual intensity of Gustave Moreau's *Jupiter and Semele*, for example, while sharing with Jean Broc's *Death of Hyacinth* (1801) a pronounced homoerotic mood. It may indeed have been a first thought on the path to the less explicit *Cyparissus.*

In a certain sense, Henri Joseph Ruxthiel (1775–1837) vented the repressed eroticism of both

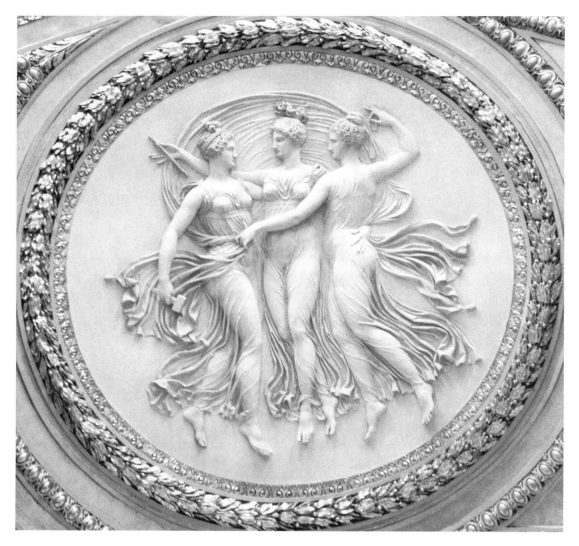

Figure 247. Denis-Antoine Chaudet. *The Three Arts of Drawing*, 1810. Plaster relief. Paris, Louvre vestibule.

Chinard and Chaudet's work when he burst upon the Parisian scene with his technically daunting *Zephyr and Psyche* (1814 Salon; Fig. 252) flying through space – an airborne *Apollo and Daphne*. Ruxthiel, a student of both J.-L. David and Houdon, and a Prix de Rome winner whose first salon submission this was, made no other work like it. But sometimes all an artist needs is one creation to gain a foothold in history. And this was his. It is an extravagant paean to Bernini, Houdon's fleet gods and goddesses, and Canova's *Dancing Figures* and floating *Hebe*'s while recalling the liquid passiveness of Chinard's Andromeda in the arms of Perseus. Ruxthiel pushed the Cupid and Psyche theme to a new level of sexual innuendo, Psyche

arching through the air with voluptuous languor. Only Pradier was daring enough to take up the challenge. In any event, it is clear that the "moral" revolution was over.

Far more down to earth, Chaudet's *Oedipus and Phorbas* (begun in 1802, finished posthumously in 1818 by Cartellier and Dupaty; Fig. 253 and Plate 6)[136] takes root within the same quiet ambience of the *Cyparissus*, displaying the sweet concern of a now virile man for a young victim, a theme made popular by the ancient and famous group *Silenus and the Infant Bacchus* (Fig. 254). The statue sets forth a less doctrinaire canon and composition than those established by Canova's early heroes. Older than Cyparis-

Figure 248. Denis-Antoine Chaudet. *The Three Arts of Drawing*, 1810. Drawing. Paris, Louvre, Cabinet des Dessins. Photo: R. M. N.

sus, athletically robust and stooped over the child at whom he gazes from beneath the round hat of a Greek shepherd, Phorbas arises from that particular conjuncture of postrevolutionary, poignant iconography of exile, and the more naturalistic approach detected in works like Roland's *Homer* or Boichot's *Force As Hercules*. And to underline the character of devotional tenderness, a curly-haired dog reaches up to lick the child's foot from under the shepherd's left leg. The masterful oppositions of large and small, strong and weak, highly textured and smooth, are brought together in a deeply personal expression of the classical tempered by a modern sense of childhood and tenderness.[137]

Like Chinard, Chaudet adapted Canova's style to his own ends without delving further into the theoretical nature of transparency and without seeking to rival antiquity as explicitly as the Italian in para-Apollos and para-Farnese Herculeses. And it could be that former students of the French Academy experienced a certain indifference to that sort of pursuit as belonging to one's student days. A different political

Figure 249 (below). Antonio Canova. *Dancing Figures*, 1790s. Drawing. Bassano, Museo Civico. Photo: Museo Civico di Bassano.

work also bears the mark of a sculptor striving after particularly "sculptural" effects – volume, density, three-dimensionality – so visible in the *Oedipus and Phorbas* as to suggest a deliberate attachment to a more natural expression of form – in other words, the French Tradition.[138]

What has come to be considered Chaudet's suave finish belongs in part, of course, to the hand of his friend Pierre Cartellier (1757–1831), executor of his unfinished works including the *Oedipus and Phorbas*. Cartellier never went to Rome, an important stepping-stone to success, yet managed to achieve a solid reputation as a committed classicist and fine, well-liked teacher to whom Rude was devoted.[139] But Cartellier's friendship with Chaudet did not quite embrace his Canovianism as well. His statue of *Modesty* (plaster, 1801; marble, 1808; Fig. 255), for example, which Josephine bought for Malmaison, demonstrates a firm, agreeable grasp of neoclassical principles without a hint of Canovian mannerism. On the other hand, the accentuation of the turn of the head and the ample

Figure 251. Denis-Antoine Chaudet. *Apollo and Hyacinth*, 1792–1810. Drawing. Paris, Louvre, Cabinet des Dessins. Photo: R. M. N.

Figure 250. Denis-Antoine Chaudet. *Mourning Cyparissus*, 1798. Plaster statue. Musée National des Châteaux de Malmaison et Bois-Préau. Photo: museum negative M.M.D.11.1.

climate, financial situation and short life span also put their limitations upon Chaudet's career, marked nonetheless by a staunch defense of heroic nudity. Thus Chaudet achieved a sufficiently linear, identifiably Canovian manner to become one of Napoleon's official artists – indeed, his chief portraitist – but failed to eclipse the Italian who survived him by twelve years. Yet Chaudet's elegant and masterful

Figure 252. Henri Joseph Ruxthiel. *Zephyr and Psyche,* 1814. Paris, Louvre. Photo: R. M. N.

drapery anticipate Canova's own *Venus Italica.* Inspired by the Capitoline *Venus* then in Paris, Cartellier (like Chaudet) proceeded to mold a figure whose columnar quality induces a sense of fully three-dimensional plasticity. The draperies accentuate the form with great elegance, while the overall impression is one of graceful gravity. Indeed, Canova's electric *Venus Italica* is all showy modesty in comparison to this chaste figure.[140]

Like Chinard, Chaudet and, later, Bosio, Cartellier could just as deftly translate all the details of modern historical dress into the marble precision of his portrait of *Louis Bonaparte, King of Holland* (1808; Fig. 256), a handsome concession to contemporary costume

which the need to eat rendered inevitable. Cartellier exhibited both the *Modesty* and the *King of Holland* at the Salon of 1808 at which Napoleon decorated the sculptor for his achievements. But his most original contribution takes the form of his relief for the east facade of the Louvre, directly below Lemot's fine if more conservative relief of the following year.

Glory Distributing Crowns on the Way through a Field of Trophies (1807; Fig. 257) unfolds in the hermetic world of heraldry. The relief's reminder of Hemsterhuis' basic premise of a clear, quickly assimilated image is perhaps not fortuitous as his works were reedited three times in Paris before 1809.[141] Nor do memories of Boichot's *River Gods* or the neo-Gou-

jonesque reliefs of the Cour Carrée linger far behind, although its most direct source of inspiration lay in the newly acquired *Great Carpegna Cameo* with its *Triumph of Bacchus*.[142] Critics excused the audacity of the relief on the grounds that it was most likely based upon the drawings of Percier (a good friend of Flaxman's) and Fontaine, who were in charge of the renovations of the Louvre, an interpretation against which Cartellier protested in one of several instances of a sculptor's outrage at being cast in a subsidiary role.[143] Inexact as the critics may have been, they were not entirely unfair in view of Cartellier's adherence to the flat, linear aesthetic of the decorations for both the Louvre and the Arc de Triomphe du Carrousel to which he himself had contributed a *Capitulation at Ulm* (1806–10). The four horses fan out in perfect symmetry above the archway, in a masterful display of his craftsmanship and daring. The bold design, the simple contours, the surging energy of the beasts held in check by both the cool central figure and the style

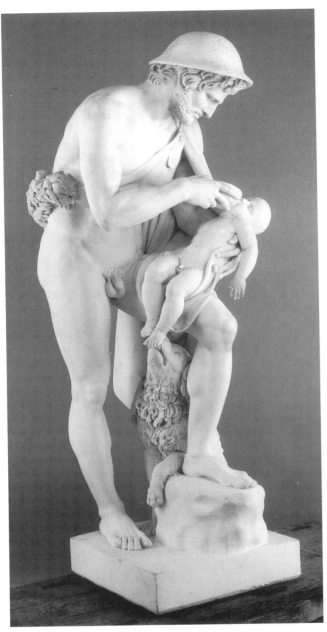

Figure 253. Denis-Antoine Chaudet. *Oedipus and Phorbas,* 1802–18 (finished posthumously by Cartellier and Dupaty). Marble group. Paris, Louvre. Photo: R. M. N.

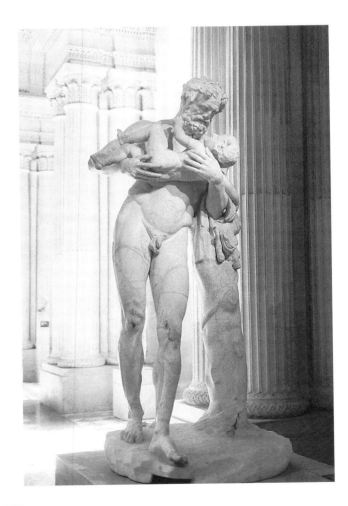

Figure 254. Silenus and Infant Bacchus. Marble group. Paris, Louvre.

Figure 255 (left). Pierre Cartellier. *Modesty*, 1801–08. Amsterdam Historical Museum. Photo: Amsterdam Historical Museum.

Figure 256 (below). Pierre Cartellier. *Louis Bonaparte, King of Holland*, 1808. Marble statue. Versailles. Musée du Château de Versailles.

Figure 257. Pierre Cartellier. *Glory Disturbing Crowns on the Way through a Field of Trophies,* 1807. Stone relief. Paris, Louvre, eastern entrance.

Figure 258. Pierre-Nolasque Bergeret. *Battle of Auserlitz,* 1806. Painting on porcelain. Paris, Louvre. Photo: R. M. N.

itself, all these made for a vigorous new language. This one work sets Cartellier far above Chinard in the domain of decorative political reliefs.

Landon's line drawing (Salon of 1810; pl. 10), because of its reduced scale, is even more revealing in the details, situating the relief in the company of Ingres' *Venus Wounded by Diomedes* (c. 1803; Basel, Kunsthaus) and Pierre-Nolasque Bergeret's *Battle of Austerlitz* (1806; Fig. 258).[144] These works all share the ornamental richness, the sumptuous ethic of the empire style while exhibiting their parentage to Flaxman's line engravings and Greek vase painting. Cartellier had no other opportunity to exercise his newfound style on public monuments, and Bosio would do little to further these innovations.

Bosio

The Baron François Joseph Bosio's (1768–1845)[145] Italian origins did nothing to bar him from high honors in France in a career which successfully spanned the Empire and the reigns of Louis XVIII, Charles X (who titled him) and Louis-Philippe.[146] Having first studied with Pajou until 1786, he then traveled to Rome to become Canova's pupil, eventually returning to Paris in 1807. Bosio, "the French Canova," felt no qualms about his manifest exploitation of Canova's style. His *Cupid Seducing Innocence* (1810), closely modeled upon Canova's standing *Cupid and Psyche* (first version, 1796; Fig. 265), and his *Hercules and Achelous* (1814; Fig. 259) boldly proclaim his affiliation. In the latter group, the hero and the victim, Achelous transformed into a serpent, are inexorably compressed between two invisible planes in an example of clear silhouetting more extreme even than anything attempted by Canova.

On the other hand, his *Apotheosis of Louis XVI* (1825; Fig. 260) for the Chapelle Expiatoire, calls

Figure 260. François-Joseph Bosio. *Apotheosis of Louis XVI*, 1825. Paris, Chapelle Expiatoire.

Figure 259. François-Joseph Bosio. *Hercules and Achelous*, 1814. Bronze statue. Paris, Louvre (formerly Tuileries Gardens).

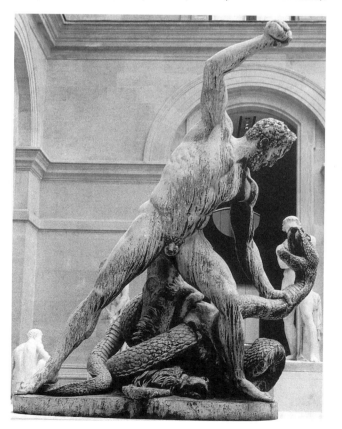

upon a prerevolutionary, baroque freedom of composition to convey something of the emotional significance of the scene as well as to revive the political associations of the style, heavy-handed though the group may be.[147]

Of all his works, the most charming is the small, silver *Henry IV as a Child* (Fig. 261) sculpted for Louis XVIII in 1824. The extreme refinement of the silverwork and the precision of detail conjure up a lost world of medieval craftsmanship. Nostalgia and historicism, troubadour genre and the craft of the silversmith all combine to make of this attractive figure a reliquary for the ancien régime. Again, classical linear precision, or indeed the exquisite perfection of fifteenth-century silverpoint, passed into the service of French national history and the interpretation of Jean Clouet in the third dimension. François Rude (1784–1853) would do the same with his silver *Louis XIII* (1840; stolen) for the Duke of Luynes at Dampierre.[148]

Bosio's lack of commitment to any one ruler, polit-

famous diatribe ("Why is sculpture boring?") against Pradier and his coevals, has had the effect of blinding following generations to his daring.

Having studied with Lemot in Paris where he had arrived in 1808,[150] Pradier joined David d'Angers as a Grand Prix winner in Rome in 1813, remaining there until 1818. His early, handsome *Son of Niobe* (1817–22, marble; Louvre, Paris; Fig. 262), like Bosio's *Hercules and Achelous*, shows off his academic and Canovian learning in the geometric simplicity of the silhouette which he would eventually abandon.[151] Pradier also seized upon the erotic possibilities of Canova's art, its seductive line and surface finish. As early as 1819, he exhibited a student work begun in Rome which fully anticipates the more flamboyantly erotic works of his later career: the reclining *Bacchante* (Musée des Beaux Arts, Rouen).[152]

In the *Bacchante*, Pradier still clung to the careful silhouetting of Canova's art, notably the *Pauline Borghese* whose cameo pose surfaces in exaggerated form here (as does the long, pointed nose). But a degree of vivacity and torsion have also found their way into being, elements to permeate his later nudes. Furthermore, his very own teacher Lemot had yielded to a voluptuous abandonment in his *Reclining Woman*

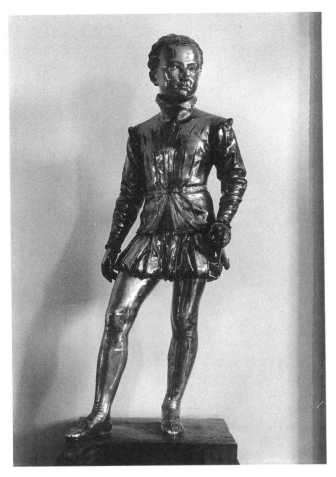

Figure 261. François-Joseph Bosio. *Henry IV as a Child*, 1824. Silver statue. Paris, Louvre.

ical order or style helped him to negotiate the shifting tides of revolution and governmental change unscathed. Extending this versatility to his art has had the effect of obscuring a clear individuality. Whereas Chinard may be remembered for his superb portraiture and eroticism, and Chaudet for both his icy, imperial portraiture and warm classicizing creations, Bosio leaves behind the lighter flavor of fine craftsmanship and opportunism artfully combined.

Pradier

Equally versatile, Jean-Jacques, called James, Pradier (1790–1852),[149] a sculptor of Swiss origins, inherited Bosio's mantle as the most successful official sculptor of his generation. And like Bosio, he spared his audience heavy artistic principles. This, along with Baudelaire's

Figure 262. James Pradier. *Son of Niobe*, 1817–22. Marble statue. Paris, Louvre.

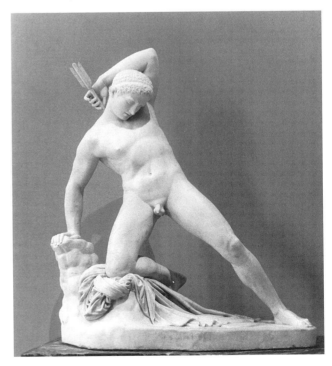

(1812; Fig. 263) or *Contemporaine* (in fact, Ida Saint-Elme) supine upon a Roman couch. The heavier, fleshier forms of this small, unmythologized nude may have constituted Lemot's own rebuke to the *Pauline Borghese*.[153] Thus Pradier had a wealth of material about him to stimulate his own penchant toward the sensual, including the titillation of Chinard's famous *Madame Récamier*. But where others had been coy, Pradier was blatant.

With each new female figure or group, Pradier introduced the telling details of his erotic preferences, such as the drapery of his *Psyche* (1824; Fig. 264) dropped to the hips below the pudenda like the *Venus de Milo* (and how *does* it stay up?, is the question one is forced to ask), or the luxuriant roundness and heaviness of form characterizing the *Three Graces* (1831; Louvre)[154] and so different from Canova (cf. Fig 265). Of course, these are works of the post–Elgin-Marble period emphasizing warmth of finish and fullness of form, discussed in the next chapter and so visible in his important and then-famous *Monument to the Duc de Berry* (1821–23; Fig. 303). It is one of the comparatively few works embodying a male nude that he has left behind and reveals the refined hand of an accomplished master.

Gustave Planche even saw the influence of Greek sculpture at work in Pradier's most controversial work, the *Satyr and Bacchante* (1834 Salon; Fig. 266).[155]

The *Satyr and Bacchante*, lost for many years, entered the Louvre as recently as 1980 and especially spells out a newfound freedom in the joyful abandon of the pose, the young woman's smiling face and the carefree sexuality.[156] The small plaster of the *First Step of Bacchus*, first conceived in 1824 but only exhibited in 1844, anticipated these developments to a remarkable degree and thrust Pradier into the forefront of the neo-baroque/rococo. To have sent the earlier work to the 1824 Salon, however, would possibly have jeopardized his election to the Academy and so he wisely refrained.[157] Both the early and the later group, however, exhibit carefully structured compositions based upon strong verticals and horizontals devoid of dramatic, space-piercing diagonals, but the extravagance of the women's poses especially break out of the academic mold. In the later group, the Bacchante's arching body reaches a climax in the left breast which juts upward full of sexual promise toward the Satyr's mouth. Her drunken smile and vine-wreathed hair add the final, explicit note of gay debauchery to the scene. A happy counterpart to the grim sensuality of Delacroix's *Death of Sardanapalus* (1827), the life-size *Satyr and Bacchante* scandalized Paris and the salon jury almost as much as Préault's *Tuerie* of the same year. (In fact, the work would no doubt have been refused had Pradier not by then been elected an academician.) In spite of this, or indeed because of it, Prince Demidoff bought the group which Pradier had

Figure 263. François Lemot. *Reclining Woman*, 1812. Engraving. Landon, *Salon de 1812*, vol. I, pl. 30.

executed in marble at his own expense for the salon, a new and bold *modus operandi* and a telling gauge of Pradier's self-confidence.

Pradier's originality extends even to the Maillol-like, monumental *Odalisque* (1841; Fig. 267). Apart from its derivations from Ingres, this carefully elaborated pyramid of interlocking forms shares with Rude's *Neapolitan Fisherboy* a concern for space enveloping form. Pradier adds to this a new sense of mass enlivened by the delicate torsion of the back and the full turn of the head. If not exactly a "figura serpentinata," the group at least harks back to sixteenth-

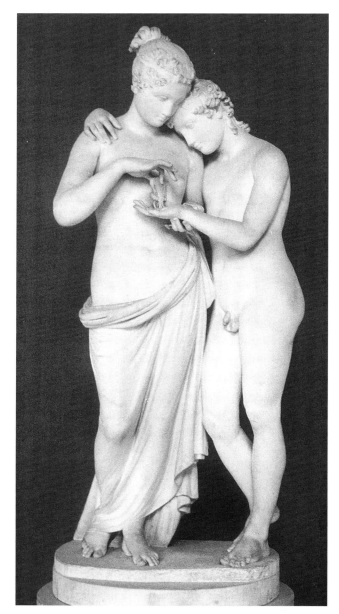

Figure 264. James Pradier. *Psyche,* 1824. Marble statue. Paris, Louvre.

Figure 265. Antonio Canova. *Cupid and Psyche,* 1796–1800. Marble group. Paris, Louvre.

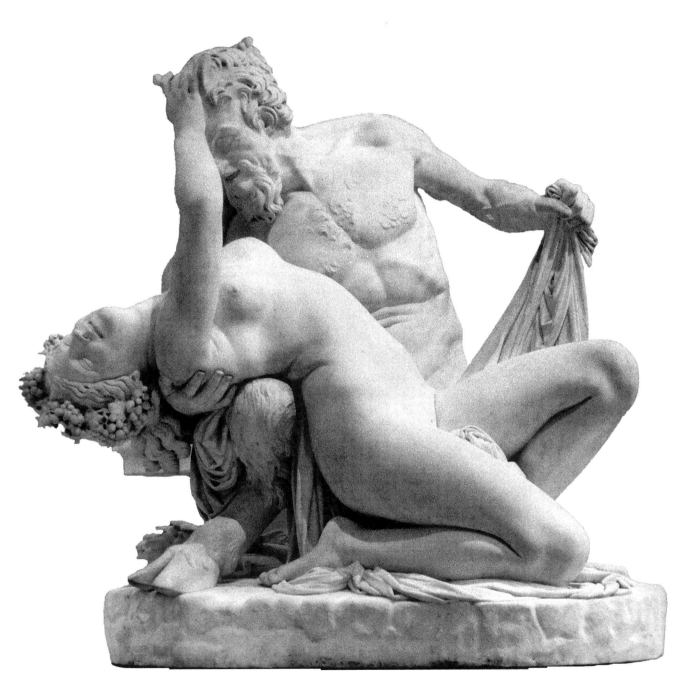

Figure 266. James Pradier. *Satyr and Bacchante*, 1834 Salon. Marble group. Paris, Louvre.

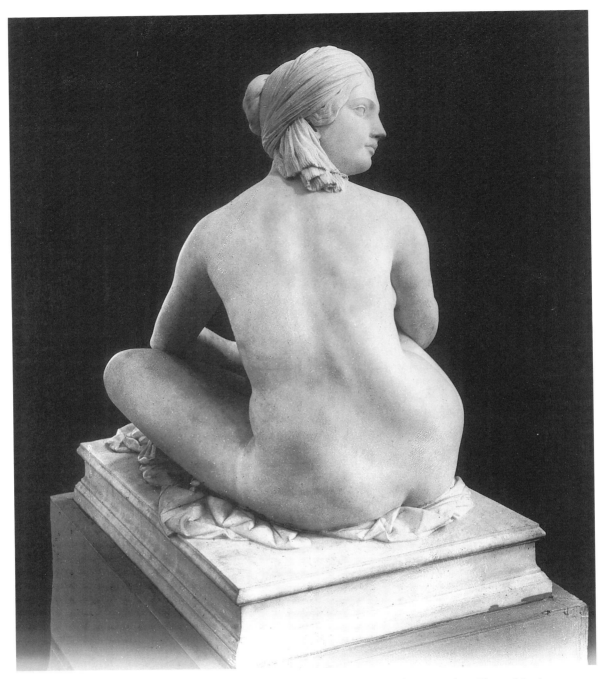

Figure 267. James Pradier. *Odalisque*, 1841. Marble. Lyon, Musée des Beaux-Arts. Photo: Musée des Beaux-Arts.

century Florentine composition. Because the domain of Pradier's innovations was sexual, however, and because he chose to continue within the sphere of marble goddesses and mythological figures, his impetus toward a liberating sculptural vocabulary (iconographically and figurally) gets lost in the titillation.

Like Bosio and his many well-trained colleagues,

Pradier remained perfectly capable of executing the sort of academically acceptable figures required of government commissions, witness his twelve solemn *Victories* for Napoleon's tomb. But in his private, self-commissioned work he continued to fan his sensual inclinations to the immense delight of his Parisian public.

In his later, sensuously affected *Chloris Caressed by Zephyr* (1849; Musée des Augustins, Toulouse), for example, he gave expression to the effect of a warm Mediterranean glow much as his friend and mentor Baron Gérard had done in his weirdly luminous painting of *Flora* (1802).[158] Pradier may even have intended the sexually laden sound of the name "Chloris" to titillate the viewer. But by this time, Clésinger's writhing *Woman Bitten by a Snake* (1847; Musée d'Orsay, Paris) had made its scandalous appearance. Pradier's orgasmic suggestions could hardly compete.

From his restrained first exercises Pradier systematically proceeded further afield, finally turning, in his private works, to enticing statuettes of women busied with the occupations of daily life and leaving the "utopia of transparency" far behind. In both Bosio's and Pradier's work, neoclassicism was less a yearning than a pleasant fait accompli and both were prepared to relinquish its language when it suited their purposes. Their apparent indifference to theoretical matters offers a perfect foil to the soul-searching, morally adamant and politically *engagé* person of David d'Angers, who carried the banner of neoclassical loftiness while relinquishing the form. He was a classicist à la Delacroix.

David d'Angers

David d'Angers,[159] a student of Roland and a prolific recorder of exalted ideas, aspired to the greatest nobility of his art founded upon classical precepts (even if the results were often at odds with pure academicism). He exclaimed, for example, "Nudity is the condition of sculpture, which is almost always miserable and vulgar without it!"[160] Yet he would be torn between seemingly contradictory views. While dramatizing his colossal *Condé* (1817–27; Fig. 43) in historical dress, he found a clumsy formula for his *Monument to Général Foy* (1827–31; Paris, Père Lachaise), who bunches up an ungainly toga at his side.[161] In spite of his adherence to classical principles, he did greater justice to Louis XIV's flamboyant general than to his nude figures. *Condé* surges like a tidal wave, a momentous romantic overture in sculpture, in which the freedom of the baroque (one notes Coysevox's superb busts of the Grand Condé) and the heroic grandeur of the neoclassical ideal come together. Like Delacroix, whom he admired greatly, David d'Angers must have seen himself as a classicist beyond the boundaries of an academic style, since his many utter-

ances on the nobility of sculpture, often far loftier than his actual work, carried academic theory to its most exalted pitch.

As a mature artist, David openly acknowledged his debt to his master Roland whom he equated with the "princes of sculpture, the Michelangelo's and the Puget's" for making the marble "tremble before him" as he worked on his own statue of the *Grand Condé*.[162] From Rome, in 1812, he would write to Roland, reassuring him about his diligence in following his master's precepts.[163]

The earliest testimony to Roland's teaching was David's competition entry for the 1810 Prix de Rome, the *Dying Othryades* (Fig. 268). It won him only second prize but it did gain him access, free of charge, to Jacques-Louis David's studio, so accomplished was it. The work combines elements from Sergel's *Othryades* (Fig. 90) and J.-B. Giraud's *Achilles* (Fig. 91) into a more compact whole, the shield establishing an eloquent resonance with the body's long curve. David d'Angers won the 1811 Prix de Rome competition with a *Death of Epaminondas* (Galerie David d'Angers, Angers), the formulaic quality of which is mitigated by an animation in the overall pattern and a general clutter pointing to his later relief style.

His academic drawings, weak for the most part, show no particular originality (cf. Fig. 269). Like Canova, he also reveals himself to have been a questionable anatomist in his drawings.[164] Other, later works, however, show off to better advantage the fruits of his contact with Canova. The *Mausoleum of the Duchess of Brissac* (1819) or the *Tomb of the Count of Bourke* (1823–26),[165] which Canova's *Funerary Stele of Giovanni Volpato* (1804–07) inspired, or his *Young Greek* (1827), all bear the trace of a delicate classicism learned in Rome, mingled with a graceful sense of natural movement in the last case. The young girl's face is particularly fresh and contemporary.

By this point, however, the relevance of Canova's art to David's in sheer figural terms had become irrelevant. Yet one point of interest remains, centered again on that noteworthy visit to the famous sculptor's studio at the end of the day.[166] The polemical nature of his recollections of Canova's statues becomes clear when one realizes that the entire anecdote belongs to his brief analysis of the career of *Thorvaldsen* whose sculpture, he claimed, struck him as cold and inert. Even if Canova's nymphs, on the other hand, seemed to lack moral grandeur, David carried a lingering sense of their lovely animation out into the night. While it

might be too much to say that the suggestion of life engendered by the spectral light was responsible, David nonetheless determined to create a "living" sculpture, and that at the outcome of this visit. Did he realize that the visit might have had something to do with it, even thought he rejected the sensual appeal of the dancing figures? Although he fell prey on occasion to an official ponderousness, David did bring a new animation to his sculpture at a remarkably early date. Indeed, one of his first major works, the *Grand Condé*, a commission he took over from his deceased master Roland (whose second Condé this was), bursts with life and energy.[167] Houdon's *Tourville* and Pradier's *Turenne* were the models (rather than Roland's earlier, less effectual *Condé*), and possibly Lemot's striking *Jean Bart* (Fig. 174), but the fiery mood, broader form and colossal scale belong to a new world.

Without a doubt, David admired Canova, as his comments on the *Magdalen* show, although almost every scholarly reference to this relationship is negative, prompted largely by a highly selective reading of the sculptor's notes.[168] Jacques-Louis David's well-known admonition against the famous sculptor accompanied his homonym and student to Rome (where he stayed from 1811 to 1816): "See the seductive worker of marble often, but beware of copying him, for his false and affected manner is of a kind to mislead a young man. Michelangelo is the same kind of artist, but with a very different physiognomy. He too is a dangerous master."[169] David d'Angers later added:

> I have often been led to admit the truth of this opinion. Yet I consider Canova to be the most original artist of the first part of this century. He is the Correggio of sculpture. Nonetheless, that M. David, with his pure and wholesome taste, should not have liked Canova's manner was to be expected. For my part, every evening, at dusk, I would go to Canova's studio. He was willing to speak with me at length. . . . I owe much to Canova's advice.[170]

The warm ties belie the view generally held that Canova and the French had only the most distant relations. On the one hand, there are those who claim Canova did little to advise the students at the academy as he had been urged to by Napoleon.[171] On the other, there are memories of his being a willing visitor there and a generous host to students in his studio.[172]

Canova's accessibility gave David d'Angers the chance to appreciate the Italian sculptor's integrity firsthand. He became a role model of sorts. For in spite of that visit to Canova's studio at dusk, during which David resolved to shun the seductiveness of the ghostly figures in favor of a virile art, he cannot have failed to be impressed by the decorum of Canova's life and the nobler aspects of his art. Nor can he have failed to hear of Canova's generous support of an entire series of busts of famous men for the Roman Pantheon commissioned from needy artists.[173] While Houdon prided himself on having modeled the busts of the great men of his day "pour la gloire," Canova's was a far more immediate and noteworthy action, exactly of a kind to spur David toward the creation of his own pantheon of genius. Thus he modeled himself in the image of a supranational figure, traveling abroad to collect the likenesses of European luminaries regardless of their nationality.[174] The cautious sculptor also sent back a plaster of his every work to his hometown, establishing a counterpart to Canova's Gipsoteca at Possagno. And if he never erected a Temple to God and the divine origin of his craft, he nonetheless exclaimed, "Oh, how sublime you are, great sculptor of the world!"[175]

Yet David d'Angers' fluctuating opinions about Canova yielded some particularly blunt appraisals. He held Canova's views on art (as recorded by Missirini)[176] "to be the valueless comments of an artist preoccupied with the mechanisms of art, with the superficial knowledge of man, and in no way anxious to discover fundamental causes."[177] To Flaxman, therefore, went the title of the "continuateur de l'antique," David finding Canova to be, in spite of everything, the Bernini of his time.[178]

Flaxman's outline drawings broadly influenced a number of undated drawings by David d'Angers (e.g., Fig. 269), which nonetheless can with some certainty be placed early in his career, perhaps even during his Roman days. Derivative and ineffectual (yet pointing to his future, radical relief style), they still provide indubitable examples of Flaxman's artistic hold on him as well as Ingres' presence at the Academy during those years, so tellingly reflected in David's *Nereid Bringing Back the Helmet of Achilles* (Fig. 74).

Flaxman, along with the Elgin Marbles, preoccupied the young French sculptor enough to induce him to travel to London after his Prix de Rome stay (1811–15).[179] That Flaxman's sculptures did not live up to his expectations comes as no surprise in view of the disparity between them and the line drawings. Yet David, sensitive to Flaxman's poetry, should at least

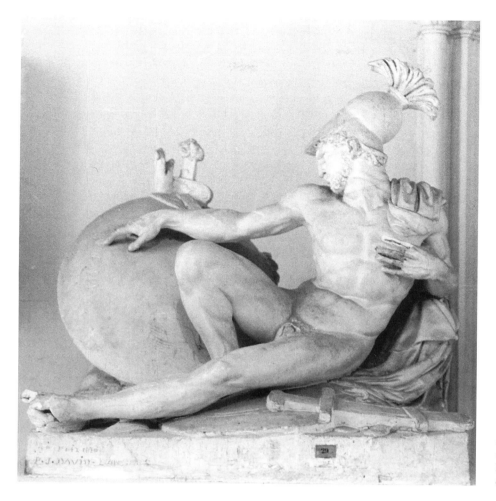

Figure 268. Pierre-Jean David d'Angers. *Dying Othryades,* 1810. Plaster. Angers, Galerie David d'Angers.

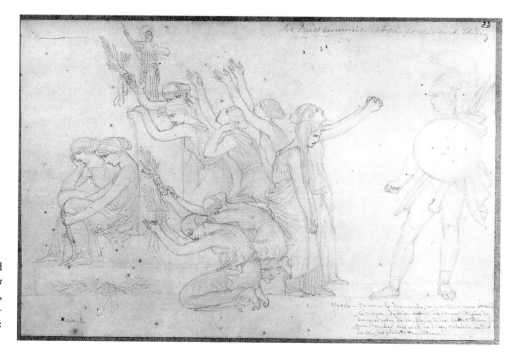

Figure 269. Pierre-Jean David d'Angers. *Scene from the Seven against Thebes* (Aeschylus), c. 1815. Drawing. Angers, Galerie David d'Angers. Photo: Musées d'Angers.

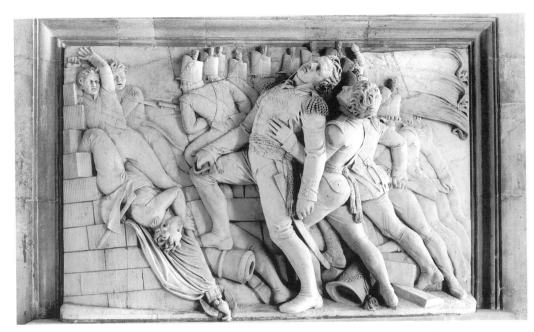

Figure 270. Francis Chantrey. *Monument to General Bowes*, c. 1811. Marble relief. London, St. Paul's Cathedral. Photo: Courtauld Institute.

Figure 272 a (below) and b (on opposite page). Pierre-Jean David d'Angers. *Aux Grands Hommes La Patrie Reconnaissanate*, 1830–37. Stone relief. Paris, Pantheon pediment.

Figure 271. Pierre-Jean David d'Angers. *Général Gobert Freeing Soldiers in Santo Domingo*, 1847. Marble relief on base of the Monument to Général Gobert, Paris, Cemetery of Père Lachaise.

have responded to the lyricism of Flaxman's funerary reliefs.[180] Evidently, he had gone in search of the author of the outline drawings alone.

Along with his disappointment in Flaxman, a revelation awaited David d'Angers in the art of Sir Francis Chantrey, the attractive simplicity of whose *Sleeping Children* (1811) he found congenial to his own inclinations.[181] He left no record of his impressions of Chantrey's other works, but he cannot have failed to examine his *Monument to General Bowes* (c. 1811, Fig. 271) in St. Paul's, along with all the other monuments there including Sir Richard Westmacott's *Monument to General Sir Ralph Abercromby* (1802–05) mentioned above.[182] The relief of the *Death of General Bowes* in particular seems to have struck a responsive

chord in David whose own novel relief style evolved from clarity toward a similarly crowded, repetitive, "primitive" format which he elaborated in a highly personal style of clearly incised, flat figures.[183] Flaxman's more delicate adumbration of this greater primitivism appears in scenes such as *Oath of the Seven against Thebes*. David, however, in his reliefs for the base of the dying *Général Gobert* (Fig. 270), realized scenes of a brazen ugliness and awkwardness unknown to Flaxman, and heightened by the utter flatness of the figures.[184] A strong line almost perpendicular to the surface marks off the silhouettes of the figures, as opposed to the more subtle passage from plane to plane of neoclassical reliefs.

David's surging masses vertically layered behind the

Figure 272 b (below)

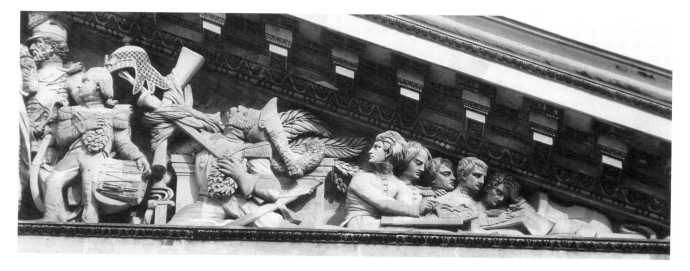

Figure 273. Carlo Marochetti. *Assumption of the Magdalen*, 1835–41. Marble group. Paris, Church of the Madeleine.

regimented battalions unite the sophisticated naïveté of modern archaism with the exuberant "horror vacui" of Roman sarcophagi completely at odds with Flaxman's transparent arrangements.[185] Not to be excluded either is the jarring influence of David's own student, Préault, who in his relief *Tuerie* (1834; Fig. 319) had already broken every law of classical relief style, indulging in a "horror vacui" of unprecedented congestion. Even in his pediment reliefs for the Pantheon (Fig. 272 a and b), David displayed a penchant for anatomical distortions and crowding.

The artists contributing to the Vendôme column had laid the groundwork for some of these changes in a milder form with rigidly layered groups of soldiers, for example (Fig. 138). Among his many spoils of war, Napoleon had also dispatched to the capital archaic and Egyptian reliefs. The latter in particular have always impressed their viewers with both the obvious stylization of the form and the particular shallowness and flatness of the raised relief surface, qualities which David seems to have taken some pains to preserve in the midst of seeming chaos. Finally, his particularly strong republicanism and his commitment to sculpture as a preeminently educational vehicle may also hold a clue to another stylistic point of departure, namely the popular *images d'épinal*.[186] That he might have found in these bold, accessible pictures yet another language suited to his own art would extend to the domain of sculpture what has long been noted in the domain of painting (notably in Courbet's work).[187] Destined to be "read" – and that is the key word – by the populace at large, his reliefs echoed the energetic, blunt narrative of the *images* and the vigorous, unrefined attitudes of the protagonists.[188] Thus, the admixtures to and the subversions of not only Flaxman's (and Canova's) original intentions but also of France's own linear heritage yielded a new brutalism. Relief as "écriture" became a mission for David d'Angers who saw in it the possibility of a direct dialogue with the people, a form of writing of an almost hieroglyphic, airless kind.[189] Did he know that Quatremère de Quincy saw reliefs as a kind of writing?

With remarkable ease, David appropriated and transformed whatever might enhance both the immediacy of his work and its moral impact. This flexibility also led him to share Flaxman's profound admiration for the Gothic, especially for its moral elevation.[190] He perceived the "preeminence of the soul over matter" as the essence of its spiritual grandeur, a quality which he was at pains to capture in his own sculpture. This is particularly evident in his portrait busts of great men. While Gall and Lavater's work provided the scientific basis for David's interpretation of the physiognomy of genius, the figural distortions of Romanesque and Gothic art also held the key to new expressive possibilities. But at no time did David directly copy the distortions and peculiarities of the Gothic style.

Very few artists actually tried to come to terms with the hip-shot poses and nonclassical shape of Gothic sculpture, Préault's model for *Jacques Coeur* (c. 1860; Musée Fabre, Montpellier) being a significant exception.[191] If anything, a more generalized, eclectic response to the past emerged in the 1830s.

On a large scale, Carlo Marochetti (1805–68) achieved a Flaxmanesque (rather than Gothic) lyricism in his astonishing *Assumption of the Magdalen* (1835–41; Fig. 273) for the altar of the Madeleine. Suggesting the traditional Gothic mandorla of the Virgin's Assumption and the diaphanous grace of Flaxman's funerary reliefs, the arabesque of wings surrounding the floating angels produces the effect of a sibilant prayer expanding in space. It is one of the most pre-Raphaelitic works in France, an entirely original (and technically daunting) conception for an altar group. The return to religious art allowed for a new fusion of belief and form to arise, capitalizing heavily on the growing taste for Florentine art in particular, to which Flaxman responded far more than Canova.

Flaxman's Drawings

Flaxman's drawings appear to have been particularly influential during the student years of the generation of artists coming to maturity in the first decades of the nineteenth century. A drawing by Louis Petitot, for example, *The Competition between Pan and Apollo* (Fig. 274), bears an inscription to "son ami Ingres. Petitot. Rome 1818,"[192] a telltale if superfluous indication of artistic allegiances to both Ingres and, through him, Flaxman. The busy, flattening details and angularities recur in Jean-Pierre Cortot's drawings

of amorous legends (Louvre), executed in all likelihood during this same period.[193] Petitot's drawings convey a mildly sculptural effect due to the heavier line contouring the figures for shadow effect. But the overall quality of the drawings of both sculptors is one of a pleasant, linear archaism lacking in originality, as were most of the sculptures by these convinced academicists who belonged to the same generation as Pradier, David d'Angers, Barye and Rude. The direct copying of Flaxman's drawings also occurred in unexpected quarters.

François Rude (1784–1855),[194] who had begun his studies in the highly academic atmosphere of Cartellier's studio, eventually turned to freer compositions and more politically audacious subjects. At the outset of his career, however, this friend of J.-L. David and partner in exile (1815–27) applied his knowledge of Flaxman to his designs of the reliefs (1823–24) of the Palace of Tervueren (destroyed in 1879).[195] Bénigne Gagneraux, whose tempered linearism stands as an early expression of the international style in France, may have encouraged Rude in his study of Flaxman when the latter worked with him in Dijon.[196] The surviving plasters in the Musée Rude at Dijon preserve Rude's debt. He allowed himself some liberty in the accessories and groupings, however, absolving himself from total plagiarism (e.g., Fig. 275).[197] But the wind has gone out of the sails. By then, modishness had cast its bland pall over the fire of real invention, which Rude would eventually revive in very different ways, even when distantly remembering Flaxman's *Odysseus* in the *Marseillaise*.[198]

More forthright in his emulation, Théodore Géricault (1791–1824) copied Flaxman's drawings with some precision and method. Yet his many sketches in the Zoubaloff sketchbook shift the emphasis from light to shade, introducing through bold washes a plasticity and dark psychological undertone absent from the original.[199] In fact, Géricault was forging a style of such plastic strength as to carry him far beyond the transparencies of Flaxman's ideal. Barye fell heir to these new developments.

A student of Bosio for sculpture and of Gros for painting, Antoine-Louis Barye (1796–1875),[200] in addition to having been a jeweler's apprentice, absorbed the entire classical education of the Ecole des Beaux-Arts without, however, culminating this program with a trip to Italy. Drawings of decorative motifs and classical urns, of which examples survive in the Louvre sketchbooks,[201] testify to the remarkable

Figure 274. Louis Petitot. *The Competition between Pan and Apollo*, 1818. Drawing. Paris, Louvre, Cabinet des Dessins. Photo: R. M. N.

Figure 275 (below). François Rude. *Achilles and Briseis*, 1823–24. Plaster relief. Dijon, Musée Rude.

sureness of his touch. The sketch for his 1823 competition relief, *Hector Reproving Paris* (Fig. 276), modeled after Flaxman (Fig. 277),[202] summarizes at a glance not only his education but also his gifts and ease within this academic framework. The figures are anatomically satisfying, graceful and well disposed, deriving their coherence from Barye's innate sense of harmony and form. To admire the expressive clarity of contour is to admire in its incipience one of Barye's essential artistic qualities evident in his drawings and sculpture alike.[203]

Barye called upon the vast resources of ancient vase painting, too, in preparation for his relief *Napoleon Crowned by History and the Fine Arts* for the New Louvre.[204] He eventually eliminated the idea of a standing Napoleon, but while toying with the idea, he copied the *Apollo Crowned*, illustrated in d'Hancarville's *Greek Vases in the Hamilton Collection*.[205] The

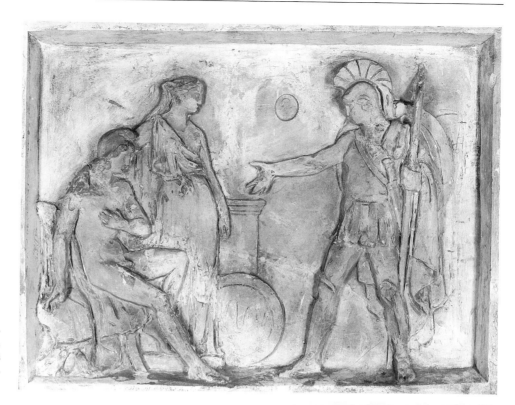

Figure 276. Antoine-Louis Barye. *Hector Reproving Paris*, 1823. Plaster relief. Paris, Ecole des Beaux-Arts. Photo: Ecole Nationale Supérieure des Beaux-Arts.

Figure 277. John Flaxman. *Hector Reproving Paris (Iliad)*, 1793. Engraving.

Figure 278 (right). Antoine-Louis Barye. Sketches after Flaxman's *Divine Comedy*. Drawing. Baltimore, Walters Art Gallery. Photo: Walters Art Gellery.

elegant, restrained attitudes correspond to the exigencies of tasteful public sculpture without in any way violating Barye's persistent feeling for classical form, which he could indulge in such commissions.[206] Barye drew after Flaxman's *Divine Comedy* as well, perhaps encouraged in this by Géricault whose opinion the sculptor valued.[207] The sketches are few (four quotations on one sheet; Fig. 278) and devoid of Géricault's more systematic approach. But these sketches bear witness to the Englishman's continuing presence – a presence to which Réveil's edition of the line drawings added new luster in 1833.[208]

Figure 279 (above). Alexandre François Desportes. *Study of Kittens*. Oil on paper. Cambridge, Fitzwilliam Museum. Photo: Fitzwilliam Museum.

Figure 280 (left). Denis-Antoine Chaudet. *Panther*, 1792–1810. Drawing. Paris, Louvre, Cabinet des Dessins. Photo: R. M. N.

Figure 281. Théodore Géricault. *Cats*, 1817–18. Drawing. Courtesy of the Fogg Art Museum, Harvard University Art Museums, Bequest of Grenville L. Winthrop.

In other drawings, especially of animals, the form and content achieve a new equilibrium divested of classical overtones yet predicated upon a lasting sense for linear strength and clarity instilled in Barye by his exacting academic training. To this he brought the microscopic observation of reality which lends such a gripping truth to his creations. But in the strength of the contour lies his power. Seen together, Alexandre François Desportes' (1661–1749) *Kittens* (Fig. 279),

Chauder's *Panther* (1792–1810; Fig. 280) Géricault's *Cats* (1817–18; Fig. 281) and Barye's almost Japanese *Leopard* (Fig. 282) detail the nature of the change. The elastic contours of Barye's *Leopard* swell and contract now to give birth, sprawled across the page, to a rampant jungle beast as remote and unalloyed as archaic antiquity, and seething with indomitable energy.[209] In a sense, one could say that animals allowed Barye to explore abstraction, or pure form, more freely.

Figure 282. Antoine-Louis Barye. *Leopard*, c. 1840–50 (?). Paris, Louvre, Cabinet des Dessins. Photo: R. M. N.

Figure 283. Antoine-Louis Barye. *Lion Crushing a Serpent*, 1831–33. Bronze. Paris, Louvre.

As Canova and Flaxman had applied antiquity and the primitives to their ends, so the artists of Barye's generation bent Canova and Flaxman to their needs, altering their goals in the process. Yet, like Canova, Barye ably exploited the potential of contour. For example, in the *Lion Crushing a Serpent* (1831–33; Fig. 283), the massive mountainlike shape speaks of power before the subject can penetrate the intellect, as is the case with the *Hercules and Lichas*. The silhouette remains as visually effective as Canova's, but the energy has become that of mass rather than "velocity" (or contour), the emphasis lying in a fully three-dimensional plasticity. Barye's model for the equestrian *Monument to Napoleon* (1861–64; Fig. 307) offers one of the paradigmatic statements of archaism, carrying Canova's, Flaxman's as well as Thorvaldsen's concerns far into the nineteenth century. At the root of this more monumental classicism lay the Elgin Marbles whose importance both as a direct inspiration and a stimulus for invention was incalculable.

The Elgin Marbles and the End of the International Style in France

Tout artiste puise dans le bel antique ce que
son génie lui prescrit d'y chercher.
Quatremère de Quincy, 1833[1]

THE HISTORY OF the Elgin Marbles is, up to a point, a familiar one. Though they did not go on public view until 1816 in London when the government finally bought them, they were brought to the city in installments beginning in 1802 and were available to visitors at Lord Elgin's residence at Park Lane from 1807 on. They had been known for centuries and were drawn with greater or lesser success by artists from the fifteenth century on, Richard Dalton being the first to publish his rather uninspired drawings in 1751–52. As early as 1795, the Comte Choiseul-Gouffier commissioned casts and was responsible for having a fragment of the frieze brought to the Louvre in 1801. Jean-Baptiste Giraud's casts, however, would actually be the first in Paris, arriving from London in 1818.[2] Indeed, casts were eventually dispatched all over Europe for the benefit of students, while in England, "even Flaxman, the Phidias of our times, and venerable President West, drew from them for weeks together."[3] Not surprisingly, this period saw a rash of artistic pilgrimages to London. Among others, David d'Angers crossed the Channel in 1816 to behold the marbles firsthand: Géricault availed himself of his London stay (1820) to study them carefully too. Lorenzo Bartolini, spearheading the Italian reaction against excessive academicism, exclaimed that, had he a son who desired to be a sculptor, he would send him not to Rome but to London for schooling in the company of the Elgin Marbles.[4]

The Greek sculptures served to fuel the academic debate about the relative merits of idealism and natu-

ralism, especially after the publication in 1805 of T. B. Emeric-David's *Recherches sur l'art statuaire*. Refreshing the eyes of those wearied by the *Apollo Belvedere*, the marbles gave both the neoclassical and the anti-academic movements a new impetus. After Winckelmann's enamored panegyric to the *Apollo Belvedere* – thought then to be of the fourth century B.C. – there appeared a more tempered appreciation founded upon the realization that the *Apollo Belvedere* merely reflected a lost Greek original. Admittedly, this was not an entirely new idea, having already surfaced by the late eighteenth century,[5] but the Elgin Marbles helped to thrust the point home.

The *Apollo Belvedere*'s stature mattered less in the more general arena of the public, which went on admiring the work anyway, than in artistic circles, where discovery of the Elgin Marbles initiated a violent controversy about their authorship and quality.[6] To help in its determination, the government called upon a substantial number of qualified witnesses including Flaxman and Canova, who played a major part in convincing the authorities of their artistic worth. When the dust finally settled, the marbles emerged as the supreme exemplars of Phidian genius.

One particular quality struck many of those viewing the marbles for the first time, Canova and Quatremère among them: the freedom of the surface, or the flesh texture.[7] Indeed, those who had emulated the style of the *Apollo Belvedere* on the grounds of its earlier excellence were compelled to reconsider their art. Canova felt that he had been justified at least in his

choice of greater warmth or sensuality rather than the "mathematic system of the others"[8] or of archaeological purists like Bertel Thorvaldsen. Curiously enough, in light of his progressive views, Emeric-David continued to favor the *Borghese Gladiator* or the *Laocoon* over the Elgin Marbles.[9]

Despite Quatremère's and Canova's feeling for the surface qualities, the former also found in the marbles his justification for the highest ideals of noble forms nobly expressed. In other words, he rejected them as a vindication of pure naturalism.[10] The anti-academicists or modernists, on the other hand, read in the textural freedom of the Elgin Marbles license for their exploration of a less academically deadened finish.[11] The debate was a heated one. In 1833, Gustave Planche showered scathing irony on the academicists and their attempts to throttle life out of art by emulating mere Roman copies while avoiding the lessons of the Greeks.[12] Like the peasant's wonder at the mystery of cooling soup or animating a fire by blowing on both, a witness to the controversy might marvel at the use made of the Elgin Marbles to reinforce diametrically opposite views.

With the deeper appreciation of Phidian greatness came a loss of innocence and a new hopelessness as well as a stylistic liberation. In a sense, the marbles shattered the belief in modern sculptural perfectibility while simultaneously goading classicists to follow in their path and radical modernists to forge a new language. Yet the climate in which the Elgin Marbles were received had in some sense been prepared by sculptors like Flaxman and Bertel Thorvaldsen (1770–1844) who had favored a vocabulary more primitive or sober than Canova's. Thorvaldsen's presence in Rome in particular already constituted a major challenge to Canova's artistic hegemony by virtue of his claims to a nobler manner. Even if few French sculptors appeared to respond directly to him,[13] the Dane set the agenda for an increasingly radical, Phidian style. His preoccupation with a purified archaeological exactitude (as handmaiden to a moral purism) reemerged in postrevolutionary France as a struggle to come to terms with the Elgin Marbles and lead to the innovative archaisms of Barye's sculpture.

Thorvaldsen

The year 1803 marked Thorvaldsen's ascent to fame when he electrified Rome with his paradigmatic statue of *Jason* (Fig. 284).[14] It was his answer to Canova's

Perseus.[15] The powerful musculature, the secure stance and the clear, contained contours of the statue deliberately offered a marked contrast to Canova's expansive Apollonian hero. With this work Thorvaldsen consolidated his position as Canova's new rival, earning Canova's own generous praise in the process.[16]

Brought up on the radical classicism of Abildgaard, Wiedewelt and Carstens in the north, Thorvaldsen had traveled to Rome in 1797, arriving there on March 8 (which he thereafter celebrated as his birthday). Immediately exposed to Canova's great achievements and fame, he had embarked on a campaign to equal

Figure 284. Bertel Thorvaldsen. *Jason*, 1803–28. Marble statue. Copenhagen, Thorvaldsen Museum.

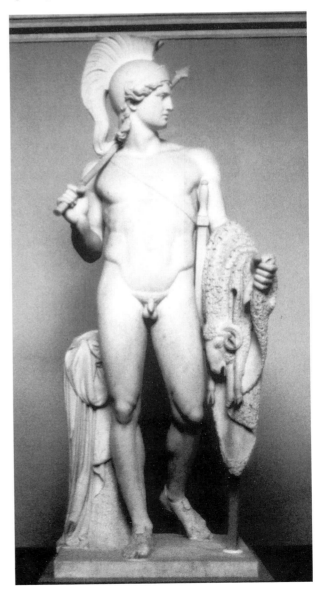

and, if possible, to surpass him. In his desire to realize a manner archaeologically, technically and morally more pure than Canova's, he used Canova's work as a foil for his own. Hence, not surprisingly, his adoption of innumerable Canovian themes, the better to reveal his artistic philosophy.[17]

No one had carried an investigation of the neoclassical ideal in theoretical terms further than Canova in his *Perseus*. Taking Winckelmann to heart, Canova had labored to forge the modern *Apollo Belvedere*, incorporating the incorporeal qualities of transparency and linear purity. Thorvaldsen arrived in Rome when these ideas had crystallized under the imaginative powers of both Canova and Flaxman. He himself brought from the north Carstens' equally radical, utopist conception of an art purged of illusiveness and sensuality, with strong ties to Trippel's art and Flaxman's own distrust of mere dexterity – a "high" mode as opposed to the "beautiful" mode of sensuality and grace.[18] Thorvaldsen discarded considerations of finish in the name of conceptuality. He set the Idea above and beyond matter, thus freeing himself to some degree from the technical cares so endemic to Canova's art. A friendship with Shick and the Riepenhausen brothers – the Lukasbrüder – blossomed during this period, giving him a family of like-minded purists.

Uninhibited by the *Apollo Belvedere*'s status, Thorvaldsen plundered a more remote past for the essence of his sculptural ideal. Pushing even further back to the Polyclitan simplicity of the *Doryphoros* (Fig. 108),[19] which had not yet been identified but of which copies existed, he elaborated a forceful masculinity in his hero and a profound tranquillity in all his art. The *Ares Borghese*, the *Mars* of the Villa Albani, even the *Horse Tamers* played a part in the work's genesis as well. But, in spite of Thorvaldsen's debts, a fugitive element of modernity, or energy, hovers about the figure, infuses the immoderate accretion of accoutrements with knowledgeable detail and dispels the meditative languor of the Greek athlete. These were the inevitable traces of Thorvaldsen's time to which he himself may have been blind. In one major respect, however, Thorvaldsen would deliberately ignore the fruits of archaeological research.

Color in Sculpture

Thorvaldsen's disapproval of Canova's sensual handling of marble had its counterpart in his refusal to color his sculptures. Yet it was known even then that the ancients painted and adorned a good number of their statues including the *Venus de Medici*. The internal logic of the quest for archaeological truth and archaic simplicity broke down under the splendor of the utopic vision of a sun-drenched world of shimmering white marble.[20] Thorvaldsen's attempts at archaeological precision served in matters of concrete form alone, the rest being a question of poetry. David d'Angers, who likened white to the light of the heavens, shared this bias, giving an extended view of his position in his *Pensées sur l'art*.[21] His words constitute the culminating apology for the neoclassical fetishism of white marble, which is not to say that David d'Angers limited himself to that medium. Canova, Thorvaldsen and especially David all had works cast in bronze. In the case of the former two, however, the highly finished models served in the same way as for a marble. For David, bronze implied new expressive possibilities which he was only too happy to explore. But this change in medium alters nothing in the argument against color, which was an argument in favor of the unity and purity of a medium. Falconet and Diderot had objected to color for reasons of formal considerations and possibly because they believed antique sculpture only to have been white. David, like Thorvaldsen, flew in the face of archaeological evidence for the sake of a vision.

Quatremère, on the other hand, painstakingly justified Canova's application of tinted waxes and washes and golden attributes to his statues with his important and well-illustrated volume *Le Jupiter Olympien* (Paris, 1817; Plate 5), documenting the history of color, both applied and toreutic, in ancient sculpture.[22] His own *Patrie* planned for the Pantheon was to have been a gigantic polychromed work.[23]

Emeric-David, supporting his theory of the imitation of Nature in Greek sculpture, spoke of the Greek's use of such means to render their statues all the more living.[24] Consequently, he held the myth of Pygmalion to be the illustration of the desire for imitation among the ancients,[25] a desire which yielded a considerable progeny in France.

David d'Angers, in casually referring to "figures painted in flesh tones in the gardens,"[26] implied the unexceptional existence of a number of colored statues in Paris of which no trace survives or which, like Augustin Alexandre Dumont's *Bacchus and Leucothea* (1829), lie buried inaccessibly in museum storage.[27] A varied critical reception awaited such works. Charles

Lenormant congratulated Dumont for having colored his figures; Charles Farcy complained of the tastlessness of staining the hair yellow and a little crown green, and of gilding the chalice: "It was taking a lot of trouble to spoil a good work."[28] Delécluze, the purist and biographer of J.-L. David, gave a surprisingly indulgent nod at Foyatier's variously colored *Little Girl Playing with a Goat* (1831),[29] while, in 1847, Clésinger seems to have taken it for granted that Delacroix, being a colorist, would like a work of his because it was colored.[30] Even Pradier was not averse on occasion to ornamenting the hem of a robe with pink or blue. The trend continued till the end of the century and Jean Léon Gérôme's *Tanagra* (1890), with a monumental detour to England and John Gibson's famous *Tinted Venus* (1850–51).[31]

Canova's use of wax tints was subtle enough not to betray the fundamental nature of his medium, while his application of gilded attributes had both an illusionistic and a decorative effect, opposing material to material, somewhat like Ingres' application of gold leaf to his painting *Venus Wounded by Diomedes*. The later transformation of these means into more overtly illusionistic devices converted an archaeological property into a para-baroque phenomenon.[32] On the whole, however, most sculptors clung to the tradition of uncolored marble, even if Canova's preference was more prophetic of certain twentieth-century developments.

Toward the Archaic

Thorvaldsen and Canova's rivalry spilled over into the domain of relief sculpture as well. Despite the latter's study of contour, Thorvaldsen's natural penchant for relief sculpture led him to evolve a lucid, sober idiom of considerable grace and feeling. So sure was his grasp of the significance of contour against a planar background that he quickly came to be considered the "Patriarca del Bassorilievo."[33] In this medium in particular, he availed himself of every opportunity for showing off his grasp of Phidian antiquity – well before the Elgin Marbles had received their final government accolade. His success earned him Napoleon's patronage in Rome, where he produced the extensive *Alexander Frieze* (*Alexander's Triumphal Entry into Babylon*, 1812) for the Quirinale Palace. This was to be his Panathenaic frieze, as a segment portraying sev-

eral "Phidian" horsemen (Fig. 285; cf. Fig. 286) so tellingly betrays. The frieze sheds the energy of Canova's mannered line in favor of a calm progression of forms enlivened here and there by an unexpected, anecdotal touch.[34]

A few years later, in his chaste and charming statue of *Hope* (plaster, 1817; marble, 1818–29), included in his *Self-Portrait* (Fig. 287), Thorvaldsen pushed his taste for the archaic to the limit. He completed his little statue after his restorations (now removed) of the Aegina marbles for Ludwig I of Bavaria in 1816. In these as well as in the *Hope* one detects certain "improvements" to which Thorvaldsen may again have been blind.[35] Still, the statue of *Hope* (cf. Fig. 288; Fig. 289) distinguished itself by being one of the most daringly archaic sculptures of its time. Others had "represented" more ancient styles but not quite recaptured them: for example, Clodion's *Antinous Osiris* (Roman period; private collection), a lively terra-cotta copy of the Roman marble in the Vatican.[36] Clodion's *Egyptian Girl with Naos* (c. 1770–71; Fig. 290)[37] as well as E. P. Gois' *Egyptian Woman* (1769)[38] antedate Thorvaldsen's efforts, belonging as they do to the modish Egyptian vogue of their time, but without the same severity.[39] In the second of Clodion's terracottas, the young, graceful figure, scantily clad in purportedly Egyptian dress, holds an Egyptian-looking statuette in a small portable temple (naos). Art and artifact play against each other as Clodion opposes his view of a living (eighteenth-century!) Egyptian girl to the unnatural stiffness and hierarchy of Egyptian art. To his "Egyptianism" may be compared Flaxman's *Supplicants* (1795; Fig. 291), in which he effectively contrasts the fluid, breathing lines of the pleading women with the rigidity of three archaic statues. The historic consciousness here displayed was purely intellectual, since neither artist ever pursued a fully archaizing mode on a large scale. In his Wedgwood reliefs, however, Flaxman had freely indulged his taste with scenes like the *Apotheosis of Homer* (1778; Fig. 292) which speak of a genuine feeling for the archaic style.[40] He could do this with a degree of impunity which the sphere of high art might not have accorded him. This was also true of Clodion whose terra-cotta statuette anticipates the later, mundane historicism of a Gérôme. It remained something of an anomaly if one disregards the few Egyptianizing fountains and imitations made during the Napoleonic period for decorative purposes. No other French sculptor embarked on

Figure 285. Bertel Thorvaldsen. *Alexander Frieze*, 1812. Plaster relief. Rome, Quirinale Palace.

Figure 286. Parthenon frieze. *Horsemen.* London, British Museum.

this kind of artistic play turned to serious pursuit by Thorvaldsen who, like Clodion, strove to re-create the archaic appealingly if more correctly. Others would eventually strike out on more original paths, imbued with a spirit akin to Thorvaldsen's but bent upon a more individual expression of their affinities for classicism.

Although archaizing in the draperies and firm frontal pose, the *Hope* is in every other respect softened into a well-formed and anatomically satisfying figure of the "truest" classical period, the neoclassical embodiment of a yearning for distant purity more intelligible today than the message of Canova's *Perseus*. A variety of ancient models existed [41] but one in particular stood out: the *Hope Dionysos* (Fig. 288) a Roman copy of a Greek original (395–55 B.C.) which includes a figure of Hope. The whole configuration recurs in the *Self-Portrait* which Thorvaldsen's assistant, Bissen, finished. For Dionysos, Thorvaldsen has substituted himself as a Phidian craftsman with his

Figure 287. Bertel Thorvaldsen. *Self-Portrait*, 1839, Marble statue. Copenhagen, Thorvaldsen Museum.

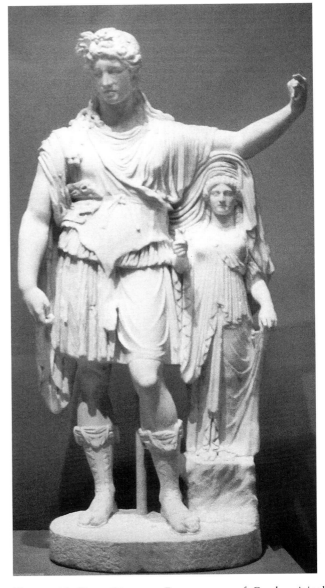

Figure 288. Hope Dionysos. Roman copy of Greek original (395–55 B.C.). New York, Metropolitan Museum of Art.

work in progress. Rough rasp marks still cover the entire surface of the little statue.

Regardless of Thorvaldsen's sustained interest in the archaic, it does not appear to have yielded the same depth of theoretical reasoning bound up with the development of the international style. Neither does the body of contemporary critical writing allude with any frequency to the merits of archaic sculpture, for which Quatremère had small liking. Lenormant's sympathetic

assessment of 1833, on the other hand, proves that a gradual assimilation of the qualities of a more remote antiquity was taking place.[42] But this tended to remain an acquired taste, like the Gothic and "Gothicism." The other component of Thorvaldsen's basic artistic outlook, his belief in the conceptual, or the "Idea," had a long Platonic tradition, but again only a limited presence in contemporary criticism. Delpech, for example, reminded his readers, when evaluating Bosio's *Hercules*

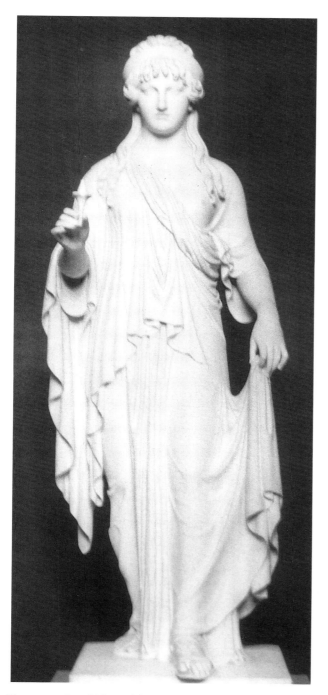

Figure 289. Bertel Thorvaldsen. *Hope,* 1817–29. Marble statue. Copenhagen, Thorvaldsen Museum.

Figure 290. Clodion. *Egyptian Girl with Naos,* c. 1770–71. Terra-cotta statuette. Paris, Louvre.

and Achelous, that "the execution, however perfect it might be, should never be thought of as anything but a secondary quality."[43] Judging by the appeal of Pradier's craftsmanship, however, a fully conceptualist approach could find little favor in France, especially with the

public. Instead of the inexpressive, flat surface of a plaster reflecting an ideal concept, the French would soon reinvent a freer technique to which they would add an unfinished surface quality in bronze, revealing more directly the act of conceiving in matter. In other

Figure 291. John Flaxman. *Supplicants*, 1795. Engraving.

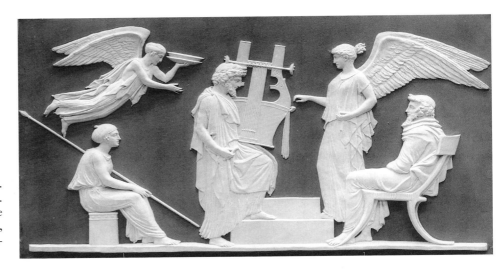

Figure 292. John Flaxman. *Apotheosis of Homer*, 1778. Wedgwood relief. Trustees of the Wedgwood Museum, Barlaston, Staffs. Photo: Courtauld Institute.

words, they would try to emulate the first, impressionistic idea of the bozzetto. These tendencies, however, did not entirely preclude an affinity for the direction in which Thorvaldsen had moved. His name crops up far less often than Canova's in contemporary criticism, he appears to have constituted much less of a threat to French artistic hegemony, and almost no one openly admitted to having espoused his manner. Yet his work pointed more clearly toward the period of the Elgin Marbles than anyone else's and was in fact of signal importance to several of the young French sculptors then studying in Rome. At the same time, it must be

remembered that the French themselves had precociously if perhaps unconsciously begun to grasp the lessons of fifth-century Greek sculpture, witness Houdon's *St. John the Baptist*.

Giraud de Luc

Among those looking for alternatives to the single-minded Winckelmannian past dominated by the *Apollo Belvedere*, Pierre-François-Grégoire Giraud (1783–1836), also known as Giraud de Luc,[44] remains an exceptional figure. Heir to both the theories and

Figure 293. Pierre-François-Grégoire Giraud (de Luc). *Phalanthus and Aethra,* 1808–14. Marble relief. Paris, Ecole des Beaux-Arts. Photo: Ecole Nationale Supérieure des Beaux-Arts.

fortune of his homonym, Jean-Baptiste Giraud, he found himself a Prix de Rome winner studying in Italy from 1806 to 1814.

As mentioned above, J.-B. Giraud had assisted Emeric-David in formulating the principal ideas contained in the *Recherches sur l'art statuaire* with its insistence upon a balanced study of Nature and the antique, signaling a reluctance to pursue excessive,

abstract idealism in opposition to Quatremère's dogma. He had brought together an excellent collection of antiquities and especially of casts after the antique in his *hôtel particulier* on the Place Vendôme. Thus the young Giraud had an opportunity to absorb their qualities early in life under the tutelage of a sensitive guide.

Giraud de Luc won the Prix de Rome with a

Figure 294. Joseph-Antoine Romagnési. *Minerva Protecting the King of Rome,* 1811. Painted plaster relief. New York, Metropolitan Museum of Art.

Philoctetes on Lemnos (1806) standing awkwardly in pain. A boldness in the stance, the athletic body bending into an inelegant pose, bears the imprint of a forceful personality, but Landon's line engraving[45] conveys little of the plastic nature of the sculpture. Fortunately, another of his earliest works survives.

The engaging wax relief of *Phalanthus and Aethra* (Fig. 293, sent from Rome in 1808; marble, 1814; École des Beaux-Arts), preserves a young artist's exploration of a more archaeologically pronounced classicism than usual. Pausanias recounts the legend of the young conqueror who, having failed to capture a single Tarentine city, sat despondently bemoaning his fate. The Delphic oracle had predicted victory when rain would fall from a cloudless sky, an impossible occurrence he now realized. In deep sympathy with his plight, Aethra (aithra = sky), his wife, fell to weeping upon his head, so realizing the prophecy. He then went on to great victory.[46] From this obscure event, Giraud fashioned his moving scene.

Figure 295. Giraud de Luc. *Dog*, 1827. Marble. Paris, Louvre. Photo: R. M. N.

The composition of the relief lends force to the emotions at play. Giraud distinguished himself particularly in the disposition of the full, round shield and spears. Phalanthus lives within the womb of his sorrow as if cut off from solace by his segregating weapons. To completely different ends, Ingres (who frequented J.-B. Giraud's house before his and Giraud de Luc's departure for Rome), had achieved dynastic grandeur for Napoleon in his imperial portrait of 1806 by isolating him from the world of common man with the eloquent circles of the throne and ermine collar, and a formidably trenchant, slim, diagonal staff. Giraud de Luc applied the same principles, on a modest scale, to his melancholy group. He may have borrowed the shield motif from ancient vase painting and no doubt drew inspiration both from late-fifth-century B.C. steles and the Capitoline *Sleeping Endymion*, but the significant arrangement was his.[47] For the other particulars, Giraud derived Aethra's draperies from Hellenistic models, while turning to the Aphrodite/Sappho type of the mid-fifth century B.C. for her profile and hairstyle which are even more daring in their stylization than Thorvaldsen's later *Hope*.[48]

Another young sculptor in Rome, Joseph-Antoine Romagnési (c. 1782–1852), sensed the promise of this direction and modeled an equally severe piece for Napoleon in honor of the king of Rome: *Minerva Pro-*

tecting the King of Rome (Fig. 294). But where Giraud was so successful in disposing the accessories to underline the mood, Athena's protective shield is skimpy and awkward. Nonetheless, the relief is an elegant work, more grave and graceful than many of its kind and, like Giraud's work, it reflects Thorvaldsen's presence in Rome more than Canova's.

Giraud bore out his early promise in two other surviving works, each hailed then or later as a masterpiece. The first, his *Dog* (1827; Fig. 295), also harks back to antiquity with its reference to the famed Vatican collection of Hellenistic animals. The other, Giraud's last, is his most accomplished: a wax model for a tomb for his wife and two children (1827; Fig. 296).[49] Executed toward the end of his life, this group evinces a growing concern for the truly monumental in modern terms as well as an interest in a medium to which Emeric-David referred as particularly favored by the Greeks for modeling.[50] Instinct with grace and free from lachrymose sentimentality, this homage to grief transposes the bonds of private affection into a universal statement on fecundity, maternity and death. The mother and child in Marin's prize-winning relief *Caius Gracchus Taking Leave of His Wife, Licinia* (Fig. 186) already testify to a steady interest in rich, full forms harmoniously grouped and imbued with tender sentiment.[51] In addition to this lineage, Giraud's group even touches upon the Renaissance and the

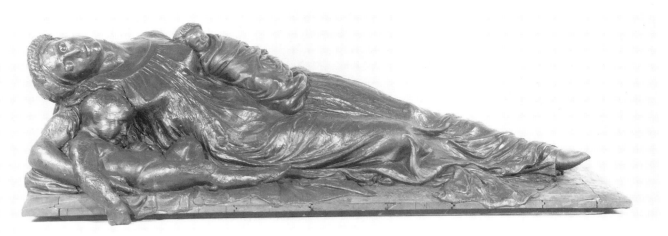

Figure 296. Giraud de Luc. *Tomb for the Artist's Wife and Two Children*, 1827. Wax model. Paris, Louvre. Photo: R. M. N.

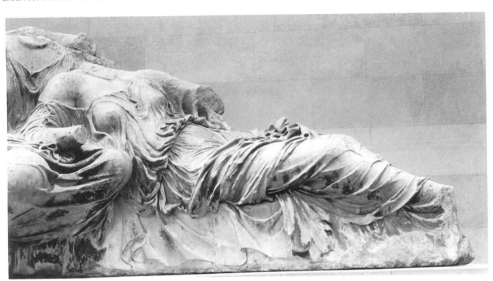

Figure 297. Aphrodite. From the east pediment of the Parthenon. London, British Museum.

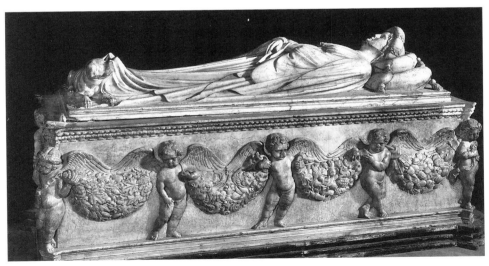

Figure 298. Jacopo della Quercia. *Ilaria Monument*, 1406. Lucca, Duomo. Photo: Alinare/Art Resources, N.Y.

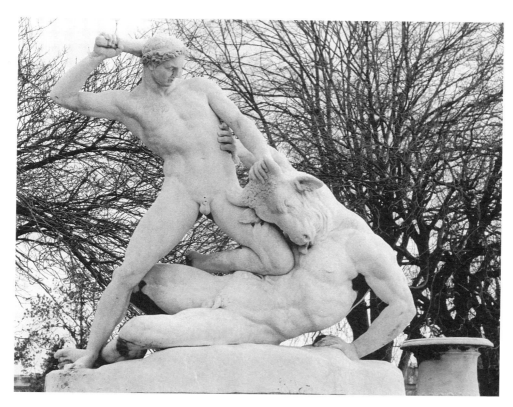

Figure 299. Claude Ramey. *Theseus and the Minotaur*, 1822–27. Marble group. Paris, Tuileries Gardens

Figure 300. Antoine-Louis Barye. *Lapith and Centaur*, 1850. Bronze group. Paris, Louvre. Photo: R. M. N.

Figure 301. Pierre-Jean David d'Angers. *Monument to Général Bonchamps*, 1822–25. Marble. St. Florent-le-Vieil, Church. Photo: Bruno Rousseau, Inventaire du Maine et Loire, France.

Figure 302. *Illisos* or *Hero*. Marble figure from the Parthenon, east pediment. London, British Museum.

Figure 303. James Pradier. *Monument to the Duc de Berry,* 1821–24. Marble group. Versailles, Church of St. Louis.

tranquility of the *Ilaria Monument* (1406; Fig. 298) by Jacopo della Quercia.[52] More than anything, the Elgin Marbles lie at the root of Giraud's conception, in particular *Aphrodite* from the east pediment (Fig. 297).[53] The clinging draperies and full, rounded forms of the Greek goddess unmistakably left their imprint upon the later work. Ultimately, however, Giraud de Luc's monument escapes the parameters of any particular debt. It was the fruit of a fully emancipated classicism beyond Canova and Thorvaldsen's "neoclassicisms," and beyond a merely literal emulation of the Elgin Marbles.

This last work indicates the degree to which Thorvaldsen's purifying, archaizing impetus was absorbed into the broader revisionary movement generated by the famous Greek sculptures. These struck the imagination of the French more vividly than the Dane's work and either directly inspired new works or

prompted sculptors to explore even more primitive styles.

On a very straightforward basis, for example, Claude Ramey cast his handsome *Theseus and the Minotaur* (1822–27; Fig. 299; cf. further discussion of Fig. 300 on p. 000) along the lines of the metopes composed of eloquent, clearly silhouetted groups. David d'Angers and Pradier experienced a comparable challenge when occupied with two equally important monuments, the *Monument to Général Bonchamps* (1822–25; Fig. 301) and the *Monument to the Duc de Berry* (1821–24; Fig. 303).[54] In both, the sculptors fashioned broad, powerful torsos with a clearly defined yet supple musculature inspired by the *Theseus* and the *Illisos* (Fig. 302), which remained major points of reference for the rest of the nineteenth century. But a close examination of Pradier's duc de Berry reveals a more searching attention to delicate anatomical fact than one finds in the Elgin Marbles, meaning that Pradier was carrying their lesson, as he saw it, to a logical conclusion – the imitation of Nature. Pradier, of course, was simultaneously availing himself of the *Venus de Milo* for the emphatic curves of his *Psyche* (1824), thus engaging in a Greek mode on all fronts.

The *Monument to the Duc de Berry* was Pradier's first important commission after his return from Rome, Deseine having been discarded after some consideration.[55] The duc de Berry's assassination in 1820 caused a great stir and his "martyrdom" is alluded to quite openly in the Christ-like wound on his right side. To keep the event within its historical period, Pradier carefully added a discernibly modern chemise under the classical drapery covering the duke's left hip and leg.

David went further afield than Pradier, casting the features of his noble hero, unusually solitary for an active tomb figure, along the lines of an Alexander.[56] Bonchamps, who insisted that his enemies (including David d'Angers' father) be spared, also takes on the character of the Redeemer. Neither sculptor responded as literally to the Elgin Marbles again.

Where David d'Angers is concerned, his Roman stay had in many ways prepared him for the combined richness and sobriety of the Greek works. Both Canova's sensualism and Thorvalden's restrained gravity could claim antecedents in the Phidian works. But in terms of chastity of tone, Thorvaldsen's work would have been of paramount importance for David's own manner. Despite the latter's unkind

Figure 304. The Departure and the Triumphant Return of the Armies of the Republic and the Empire, 1833–36. Stone frieze. Paris, Arc de Triomphe de l'Etoile.

words about the Danish sculptor,[57] and despite what may have been a sincere dislike for the quality of the work, he can hardly have failed to grasp either the high seriousness of Thorvaldsen's efforts or his means for achieving those ends: a lower center of gravity than that in Canova's statues, a fuller, more placid contour

and more severe features. David's *Nereid* aside, the tenor of his work would quickly fall into line with that of Thorvaldsen, witness his *Young Shepherd* (1816, Musée d'Angers) executed in Rome,[58] or the serene delicacy of his later *Young Greek* (1827; for the tomb of Marco Botzaris), an amalgam of Canova's and

Figure 305. Théodore Géricault. Horse and Rider, c. 1819? Wax relief. Private collection.

Thorvaldsen's language. Even the central figure of *Patrie* in David's Pantheon pediment shares with Lemaire's *Christ* for the Madeleine a characteristic, Thorvaldsenian severity. By this point, however, Thorvaldsen had easily taken second place to the Elgin Marbles.

The Elgin Marbles

Their influence penetrated government commissions with some swiftness for, in spite of its conservatism, the government left room for innovation in the larger commissions it handed out. From the relative shallowness of Lemot's pediment for the east facade of the Louvre, for example, Lemaire passed to the deep undercutting and three-dimensionality of his pediment for the Madeleine (Fig. 225), consciously striving to give the greatest possible depth to his figures in the competition relief (1830) in emulation of the Elgin Marbles.[59] He used the reduced space at either end of the pediment in an original way to suggest in this *Last Judgment* figures emerging from and sinking back into the ground, just as Chalgrin had projected in his sketch of *Hercules Against the Enemies of the Republic* (c. 1800) for a relief for the Salle des Séances Conservateurs at the Senate.[60]

In a sense, the depth of carving of Rude's *Marseillaise* belongs to this same current. Less remarkable was the creation of the "Louis-Philippe" frieze, *The Departure and the Triumphant Return of the Armies of the Republic and of the Empire* (1833–36; Fig. 304), for the Arc de Triomphe, loosely modeled upon the Panathenaic procession, horse upon horse and soldier upon soldier crowning the top of the edifice in a breathless, densely packed modern horde. For the first relief conceived in 1828, the "Charles X" frieze, the sculptors had been ordered to pattern themselves on the Parthenon metopes, which they had protested on the grounds of inappropriateness to a frieze.[61] The victory of the Elgin Marbles, however, is clear, even if their legacy was to be divided. Indeed, these more literal or fashionable adaptations of the Greek works would give way to increasingly original, independent extrapolations.

One of the first artists to take note of the new possibilities implied by the marbles, Théodore Géricault (1791–1824) used them as a starting point for lively ruminations on horses in action. At his death, he was carving a relief on his studio wall, of which nothing survives save the memory and great praise. Lenormant

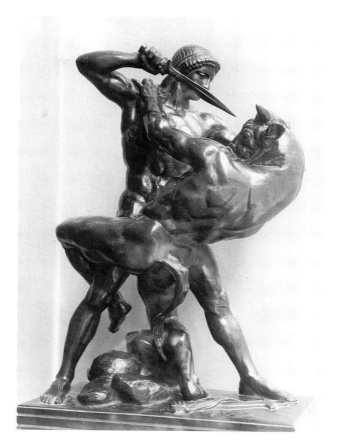

Figure 306. Antoine-Louis Barye. *Theseus and the Minotaur,* 1846. Bronze group. Paris, Louvre.

referred to "motifs worthy of the Parthenon frieze," while others remembered the appearance of the rider clad in ancient dress trying to restrain his mount.[62]

Tangible evidence of his admiration of the Elgin Marbles survives in another wax relief figure of a *Horse and Rider* (c. 1819?; Fig. 305)[63] in which Géricault is unquestionably practicing the lessons of antiquity, but with a livelier sense of modeling. He also created several smaller groups and the écorché of a horse which could be seen in any number of studios.[64] All these works speak of an innate sculptural sensibility which it may have been his intention to explore in a major way especially since he expressed his willingness to execute his lost wax model of an equestrian Emperor Alexander on a large scale.[65]

The opportunity, however, to develop these new possibilities fell to Barye, who went far beyond his sources in the formulation of a new, passionate classicism. It was he who became Thorvaldsen's unexpected heir to an ever more radical archaism.[66]

Barye, born in Paris in 1796, first studied with his

Figure 307. Antoine-Louis Barye. Monument to Napoleon, 1861–64. Plaster model. Paris, Musée d'Orsay. Photo: R. M. N.

father, a goldsmith. This early education in casting and chasing left an indelible mark on his finely textured bronze figures. Excluded from competition after several attempts to win the Prix de Rome, he pursued his studies on his own. His many silent hours at the zoo are legendary and yielded the innumerable and revolutionary animal studies on which his fame rests today. His human figures were just as remarkable.

Barye's bronze *Theseus and the Minotaur* (1846; Fig. 306), defined through bold shapes and hieratic poses, carried the radical in sculpture to its utmost degree, steering clear of archaeological pedantry.[67]

Compositionally brilliant, the group enacts a battle which pitches the writhing, serpentine, contrapuntal form of the vanquished against the powerful, static pyramid of the victor. This ritualistic dance translated into bronze brings to life the chthonic underworld of ancient myths and legends. To pass from the serenity of Canova's tranquil victor enshrined in "white silence" to this ritualistic vision is to leave the Elysian Fields for the River Styx.

In spite of the fact that this and other bronzes were not full-scale works, they still elicited comparisons to Phidias. Théophile Gautier, for example, waxed enthu-

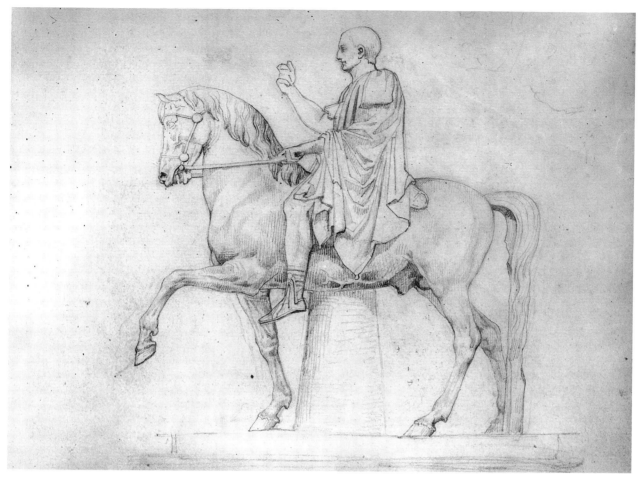

Figure 308. Théodore Géricault. *Balbus*, c. 1818. Drawing. Paris, Louvre, Cabinet des Dessins. Photo: R. M. N.

siastic over Barye's later *Lapith and Centaur* (1850 Salon; Fig. 300), seeing in it a work fit for the Pantheon pediment.[68] And, indeed, Barye's magisterial command of the language of form makes him one of the greatest sculptors and most progressive classicists of the century, something which the limited number of public commissions for full-scale figures sadly obscures.

Barye's equestrian model (Fig. 307) for the *Napoleon* at Ajaccio (1865) stems from the same archaistic sensibility evinced in the bronze groups. Canova and Thorvaldsen had both graced public squares with equestrians, among them the former's *Ferdinand I of Bourbon* (1820–22) in Naples and the latter's *Poniatowski* (1819) in Warsaw. But Barye's statue is more deliberately radical in its classicism than the equestrians of the two neoclassicists, an original transmutation into the ideal of a Roman ruler in pre-

Roman simplicity, even if strains of Arabian stallions shine through in the anatomically resplendent horse.[69]

Barye turned to the famous *Balbus* which Géricault had drawn during his Roman stay (Fig. 308) and to which Falconet's preference had gone in the Marcus Aurelius debate.[70] Yet a comparison shows to what degree Barye modified the ancient silhouette, shortening the emperor's legs so that the bare feet hardly interfere with the diagonal line running from the tail to the horse's raised leg, and arching both the neck and the tail more eloquently.[71] These changes result in a clear, forceful silhouette lending substance and grandeur to the small and notoriously inept horseman that Napoleon was.

The change in the direction of operations at the Louvre from Visconti to Lefuel occasioned the cancellation of another bronze equestrian by Barye,[72] though Lefuel kept Barye on for the four pedimental groups of

Figure 309. Antoine-Louis Barye. *Peace*, 1854–62. Plaster model. Paris, Musée d'Orsay.

Strength, Order, Peace (Fig. 309) and *War*, the two *River Gods* and pedimental reliefs (1854/5–62).

Barye cast all four groups in the same mold, combining a heroic nude figure with a child and an animal. He adhered to the physical type he devised for his Theseus, while also turning to Michelangelo's work for inspiration. The grace and force found in *Peace* must surely owe something to Michelangelo's *Bruges Madonna* (1504/5–06). Meanwhile, a thickening of the limbs and stylization of the musculature add their primitive accent to the *River Gods* (Plate 7) which typify the development of a personal and sophisticated archaism imbued with the knowledge of Michelangelo's tomb figures in the Medici Chapel.[73] Barye's figures, whose roles are essentially peaceful, project a mysterious sense of both tragedy and calm bound within the formal rigor of his magisterial classicism. As with all great art, the beauty of Barye's figural works brings the mind to both perfect stillness and to a state of passionate yearning for the source itself of creation.

Casting back into the annals of French sculpture, one finds several works which show that Barye, like Giraud de Luc, emerged not from a void but from a discrete school. Moitte's model for the *Monument to*

Jean-Jacques Rousseau, pleasing for its quiet strength and full forms, and touching in the portrayal of Rousseau's sympathetic observation of children, is one example. Barye favored a peaceful mood of this sort for each group, relinquishing, as he did in all his major public, figural works, the unbridled energy of the animal kingdom. Barye may also have known Boichot's *Hercules*[74] and certainly Giraud de Luc's *Tomb for the Artist's Wife* with its broad planes and full, rounded forms.

A rare strength and monumentality endow Barye's sculptures with lasting significance – the significance of perfectly felt form in harmony with its subject. It is with such works that the spirit of classical radicalism attains its summit in French nineteenth-century sculpture, not long before Carpeaux's exuberant *Dance* (1866) was to shock Paris. Yet one cannot speak of stylistic anachronism in Barye. His classicism, forsaking the delicacy of Canova's and Thorvaldsen's more innocent neoclassicisms, was as modern as his wildest beast. Barye's singular achievement was to have rejected all things academically sterile and to have cleared new ground for himself, the better to realize a modern epic style. And in this, he was encouraged by the revelations of the Elgin Marbles.

In a far more subtle way, the Elgin Marbles became the justification for Falconet's early advocacy of Puget, this on the basis of their surface treatment. Puget's name had retained its luster after the Revolution, occurring in various important texts, notably Emeric-David's *Recherches sur l'art statuaire* (1805) and Chaussard's *Pausanias français* (1806), who, for the period of Louis XIV, closely followed the *Recherches*.[75] Puget, the fiercely independent man, emerged as the "Phidias de Marseilles," while in 1805, Landon found his *Milo* worthy of Michelangelo.[76] In 1801, Alexandre Lenoir honored Puget with a cenotaph,[77] and Jean-Joseph Foucou (1730–1815) executed the first statue of the sculptor. By that point, Falconet's individual cause had swelled into a national one. Even for the Louvre vestibule, where the arts of Italy are represented by Michelangelo's *Moses*, Greece by the *Apollo Belvedere* and Egypt by the *Colossus of Memnon*, Puget's *Milo* stands for France in Jean-François Lorta's relief (1802–10). Later, Rude also used the *Milo* to symbolize sculpture in his relief of *Prometheus Animating the Arts* (1833–35) for the Palais Bourbon.[78] Finally, Quatremère, without finding Puget entirely to his taste, conceded the brilliance of his surface realism.[79] This constituted the most significant parallel in the critical

reception of Puget and the Elgin Marbles. By 1824, when the Salle Puget opened at the Louvre, his reputation was on a steady ascendant.

In the early phase of this revival, a curious blindness prevailed, which led Puget to be called the French Michelangelo at the expense of his patently baroque qualities.[80] In order to transform him into a national figure, he was artfully shorn of his baroque ties.[81] Michelangelo, while not orthodox, was at least an admired or tolerated example of an idiosyncratic genius to whom Puget could be favorably compared.

In the 1830s, critics situated Puget in contradictory positions vis-à-vis the ancients. For example, in 1831, Lenormant claimed that before the painter Léopold Robert, three artists only had followed in the footsteps of the ancients, namely, Michelangelo, Puget and Lesueur, to whom he was tempted to add Géricault's name as an afterthought.[82] Gustave Planche, mean-

while, took a very different position in his article on the sculptor in *L'Artiste* the same year. In his view, Puget's art spelled a radical rejection of everything Greek and Roman and a "heroic battle . . . between marble and nature."[83] Where Emeric-David had been compelled to say great, energetic, sublime "*but* irregular," Planche could later write "*and* irregular"[84] and deliver Puget from all academic bonds. Henry Jouin, France's leading historian of sculpture at the end of the nineteenth century, shared these views, adding another dimension to them. Equating Michelangelo and Puget, he saw them as not only having forged a language equal to that of antiquity, but as having established a Christian art as well.[85] In light of the prevalent notion that sculpture was a pagan medium, this was an important apology for the validity of this branch of art in the modern, "Christian" world.

Strong nationalist sentiment undoubtedly played a

Figure 310. Jehan Duseigneur. *Roland Furieux*, 1831–67. Bronze figure. Paris, Louvre.

Figure 311. Henri de Triqueti. *Thou Shalt Not Covet Thy Neighbor's House*, 1834–41. Bronze relief. Paris, Madeleine, door.

role in the resuscitation of Puget, fed perhaps by Cicognara's *Storia della Scultura*, which was essentially unsympathetic to the French and in which Cicognara quoted French verses mocking Pigalle.[86] Amused by their own witticisms, the French would have resented an Italian's turning their own barbs upon them. Around Puget, however, rather than Pigalle whom even the French continued largely to ignore, rallied the defense.

As one might expect, the taste for the Elgin Marbles and the Puget revival were accompanied by a revision of technique among sculptors spurred also by a rejection of Quatremère in favor of Emeric-David. Thus one finds David d'Angers infusing movement and fire into his *Grand Condé* directly upon his return from England. Ironically, the iconoclasm of his relief sculpture may also have been precipitated in part by his acquaintance with the marbles and their liberating

effect. Could one not also imagine that Jehan Duseigneur (1806–66) deliberately radicalized the *Illisos* in his notorious *Roland Furieux* (1831; bronze, 1867; Fig. 310) shown at the same, revolutionary salon which followed so closely upon the political upheavals of 1830. While choosing a thoroughly unclassical subject destined to be cast in bronze, Duseigneur nonetheless seems to have established a point of reference with the famous Greek work through the nudity and general pose, the better to show off his own more passionate approach in terms of both modeling and suggestion of explosive energy.

Baron Triqueti in turn stunned his contemporaries with a relief of *The Death of Charles of Burgundy* (1831), so rough and unchased as to draw comment on that score from everyone.[87] His consummate bronze reliefs (1834–38; Fig. 311) for the great doors of the church of the Madeleine show the sculptor reveling in

the possibilities of the medium. Clearly a commentary on the work of Ghiberti, Donatello and Jacopo della Quercia, the reliefs explore the language of Christian sculpture anew, for which a chaste classicism seemed inadequate. Inviting the eye to study bewitching details and distant perspectives, Triqueti then brings it back again and again to the central figures in high relief. Rough surfaces alternate here with the more fully modeled and polished forms of the protagonists in a flamboyant display of technical and compositional skill, while underlining the narrative and spiritual thrust of the commandments. Triqueti's originality made a deep impression on Préault, whose *Crucified Christ* may be seen to emerge directly from the murdered man in the foreground of *Thou Shalt Not Covet Thy Neighbor's House.*

While the smooth, white world of academicism was taking a beating, it must be remembered that this historical awareness of the Renaissance and its many phases high and low owed its existence to Winckelmann's development of an original concept of style and history. From antiquity to primitivism to all neo-primitivisms, the evolution of historical consciousness spreads out from that epochal moment.

At the same Salon of 1831 appeared, among others, Barye's paradigmatic virtuoso study of natural Nature, the *Tiger Devouring a Gavial* (Plate 8, Fig. 315) and Rude's *Neapolitan Fisherboy* so quickly followed by Francisque Duret's *Neapolitan Fisherboy Dancing a Tarantella* (1833 Salon). The mad, writing hero, the fisherboy and the beast dealt a permanent blow to academic tradition. Furious movement, insanity, long

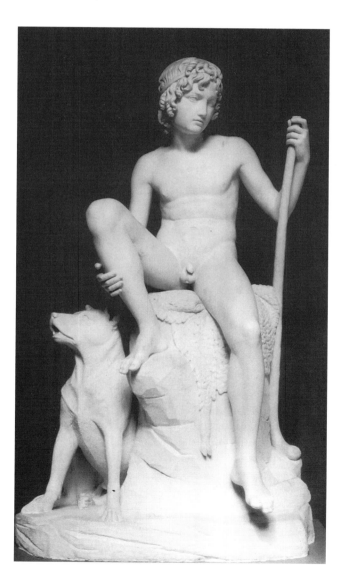

Figure 312 (left). Bertel Thorvaldsen. *Shepherd Boy*, 1817–26. Marble. Copenhagen, Thorvaldsen Museum.

Figure 313. François Rude. *Neapolitan Fisherboy*, 1813–33. Marble. Paris, Louvre. Photo: R. M. N.

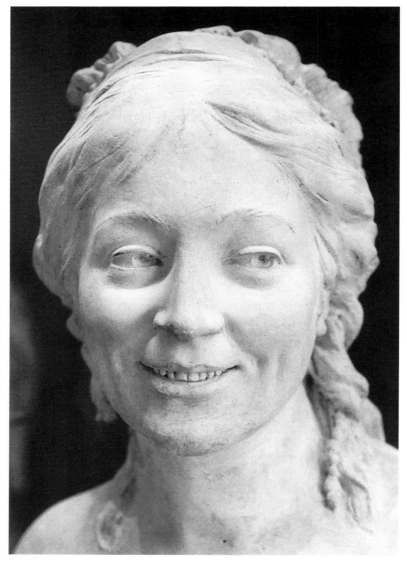

Figure 314. Antoine Houdon. *Madame Houdon*, detail, 1787. Plaster. Paris, Louvre.

hair, passion, untutored naturalism, the wild, all these elements shifted the parameters of artistic discourse. If to these one adds David d'Angers' inspired *Paganini* (1830–34; Fig. 217), so shocking to his contemporaries when it appeared in bronze in 1834, the shift becomes even more dramatic. The extravagantly free modeling and cranial distortions more vividly suggested "genius" and destiny than any bust since Canova's *Napoleon*. These works mark the beginning of an attitude to surface finish, composition and subject extending far beyond the surface refinements of the Elgin Marbles, even if the "modernists" had first invoked them to justify their departures.

François Rude, who had been absent from France until 1827, came back at the cresting of this new wave and plunged in with the plaster of his *Neapolitan Fisherboy* (Fig. 313; cf. Fig. 312). In this, his first major salon submission, he revealed his conversion to the naturalism which the modernists perceived in the Elgin Marbles. Gustave Planche at first irritably inquired why the lad was naked and, if Rude wanted nudity, why he had not stuck to mythology.[88] But Rude valued Emeric-David's *Recherches* and he evidently took to heart the emphasis upon naturalism, ignoring the subsequent principles of idealized form and decorous expression which he had practiced in his *Aris-*

Figure 315. Antoine-Louis Barye. *Tiger Devouring a Gavail*, 1831. Bronze. Paris, Louvre. Photo: R. M. N.

taeus Mourning the Loss of His Bees (1812, destroyed by Rude in 1842). The broad smile and polished teeth of his fisherboy also drew critical attention. They too spoke of a startling degree of liveliness, while pointing to the advent of the neorococo. The smile vividly recalls Houdon's exquisite portrait of his wife (1787; Fig. 314). Sketched with brilliant gaiety, she shows off perfect teeth, which must have been rare in those days of poor dentistry.

In his *Neapolitan Fisherboy*, Rude animated Thorvaldsen's *Shepherd Boy* (1817–26; Fig. 312),[89] exchanging the latter's introversion for the high spirits of youth. He was bringing into existence the modern idyll, the contemporary Daphnis of another trade, executed in the post – Elgin-Marble aura of romantic naturalism. Presenting his public with the naïve delights of a laughing fisherboy, he also presented it with one of the very inhabitants of those distant, sunny lands whose past had given rise to so many nostalgic dreams.

Exasperated by these very dreams, David d'Angers' alienated, quarrelsome pupil Auguste Préault gave in turn a bitter reply. To the salons he sent his *Pariahs* (1834),[90] his fat, ugly *Aulus Vitellius* (plaster, 1834; Toulouse, Musée des Augustins), his distraught *Hecuba* (1835) and, of course, the relief *Tuerie* (see Fig. 319). Proposing an idiosyncratic twist to the prolonged gaze upon antiquity, he created this shrill relief in the very year Quatremère published his monograph

on Canova. The plaster, cast in bronze only in 1850, found its way into the Salon of 1834 not on its merits but on its "faults." In fact, Cortot recommended that it be exhibited as a deterrent to other artists or as a species of "entartete Kunst."[91] Not only did the plaster defy every rule of relief composition,[92] which the sharp criticisms of Clodion's *Deluge* seem to anticipate so vividly, but it also veiled itself in an iconographic mystery that is only slowly being unraveled.[93]

The relief may well conflate the tragedy of three slaughters or deaths from three plays then being produced: to the left, Othello's murder of Desdemona, in the center, Dona Sol's suicide on the night of her wedding to Don Ruiz Comez de Silva (helmeted head) whom she was compelled to marry instead of Hernani,[94] and to the right, from the obscure *Chaius Caligula* by Charles T. F. d'Outrepont, Julia Drusilla, daughter of the murdered Caligula, escaping her assassin.[95] If these literary sources provided an iconographic impetus, it was Préault's gift to merge them into one major civil war with roots in other places as well.

Préault admired Puget whose moody independence he shared. Broad links extend between his work and, for example, the crushing proximity of faces and general confusion of the middle ground in Puget's relief of *Alexander and Diogenes* (1688; Fig. 317).[96] More recently, Canova had expressed extreme and unusual

Figure 316. Jean-Pierre Cortot. *Resistance*, 1833–36. Stone relief. Paris, Arc de Triomphe de l'Etoile.

violence in his *Hercules and Lichas* (the only work within recent sculptural history to take horror to such a pitch), and Rude's apocalyptic *Marseillaise* was underway. Préault could easily have known this before its public exhibition, as well as Cortot's *Resistance* (1833–36; Fig. 316). The unfortunate (and unusual) group of victimized people in the latter, recalling Delacroix's *Massacre at Chios* (1824), bears the clos-

est resemblance to the "mother," child and wounded man in *Tuerie*. But an even more telling proximity exists between the large bronze relief and Henri de Triqueti's life-size relief *Avenging Law* (Fig. 318) for the Salle Louis-Philippe at the Palais-Bourbon, Paris. Préault probably availed himself of the chance to see the work before its completion in Triqueti's studio. Commissioned in 1833 and finished by 1834, the relief

Figure 317. Henri de Triqueti. *Avenging Law*, 1834. Plaster relief. Paris, Palais Bourbon (Assemblée nationale), Salle Louis-Philippe.

with its violent action in the lower right departs from the standard cool collectedness of academic art as it so often appeared on government edifices before the 1830s or at least until Lemaire began to stir things up on the Madeleine pediment. Still, it stood for the July Monarchy's glorification of Law and Order (a theme quite deliberately espoused in the iconographic program of the Madeleine directly across the river)[97] which Préault debunks with his relief as much as he debunks academic formulae. For the "LEX" in Triqueti's relief he substitutes "TUERIE" (Fig. 319).

None of the works forming the background to Préault's reaches as far into the unconscious and brutal as does his gloomy vision. For their moral tone, Préault substituted the world of nightmares. The nigh-illegibility of the meaning perhaps constitutes part of its message: the stupidity, the cruelty and the wastefulness of all killing. It was the most radical work of its day.

Carefully defining its ruined state, Préault conceived the relief as a colossal fragment with colossal protagonists in a disastrous, darkening conflict – in

Figure 318. Pierre Puget. *Alexander and Diogenes*, detail, 1688. Marble relief. Paris, Louvre.

short, something sublime. But the figures artfully and daringly create their own space and limits, rather than imitating ruins in a literal way. Hair and body parts form the "frame," appearing three-dimensionally along the sides. The fragmentation seems real enough to suggest other unseen parts. A wide variety of textures, from the woman's seaweed hair to the blunt gash on the wounded man's chest, also contributes its excitement to the conflict heightened by the word "TUERIE." The vibrant, diagonal word seems to be the whole thought of the central figure, a scream impelled by violent inner contraction. The shrill character of this graphic intrusion departs from the more sober lettering in other works, including those proposed for David's colossal *Hercules* or Triqueti's *Law*. It even becomes a grotesque play on the delicate ribbons of words in earlier Flemish painting.

Préault's relief, even more than Barye's *Theseus and the Minotaur*, takes one "through the glass darkly" into a lurid world of vengeance and death, a deliberately created fragment refuting all earlier classical ruins, a statement about the nature of barbarism, a hysterical tabula rasa on a sublime scale going back to a primeval chaos at complete odds with the "Utopia of Transparency."[98]

By virtue of its being a piece of sculpture, *Tuerie* was all the more daring in its innovations, wresting contemporary art from the pieties of academic dogma more dramatically even than Delacroix's *Sardanapalus* (1827) and other paintings at the same, famous salon.[99] Préault no doubt consciously laid to rest the cliché of attributing the quality of antiquity to a modern work should it chance to be embedded in and dug out of the ground. He could be certain that this "fragment," if unearthed, would never be mistaken for a work of classical antiquity. In fact, Claude Vignon invented a scenario in his salon criticism of 1850 in which he used this very idea as the core of his comic, sarcastic six-page demolition of Préault's relief. Projecting himself into the year 2850, he imagined the confused horror of a group of wise men as they come upon the work and examine the "hideous, decomposed, fantastic and imprecise . . . faces."[100] One member of Vignon's learned council surmises the relief to be by the Visigoths or Vandals. Might Préault not have wished to suggest this himself?

A perverse product of the romantic longing for a remote past turned to Baudelaire's "nostalgie de la boue," *Tuerie* no longer bore the slightest relation to

Thorvaldsen's pure, measured world of neoclassical archaeology and archaism. Préault cut himself loose from that idyllic shore in quest of a brutal grandeur interpreted variously by David d'Angers in his monstrous craniums, by Barye in his animal kingdom, or by Rude in the *Marseillaise*.

The progress of the sublime from Falconet and Pigalle to Préault was not only that of a sculptural vocabulary but that of the notion of genius as well, with a direct repercussion upon the sculptor's reputation and his sense of what he might accomplish. Préault's refusal to relinquish his freedom to academic rigor had as its counterpart a megalomaniac iconoclasm and visionary cast (periodically brought to heel by the need for money!).

The growth of the sublime knew one, long, steadily ascendant course, while neoclassicism as a sustained programmatic movement tending toward the international style rose and fell within the same chronological parameters in both painting and sculpture. Canova's and Thorvaldsen's dominant position and fame continued to make theirs the officially accepted vocabulary well past its apogee. Before Canova had made his name, however, France showed herself to have been fertile ground for the early expression of a marked classical sensibility.

Houdon's precocious *St. John* and his *Morpheus*, Dupasquier's reliefs for Sens, Boichot's Goujonesque reliefs, Moitte's vigorous republican style, and J.-B. Giraud's *Achilles* all share in the establishment of a new order for which neither the critics nor the academy directors were entirely prepared. Meanwhile, the English in Rome gave Canova the encouragement which the French withheld from their own, in spite of their remarkable art schools and the Comte de Caylus' learned advocacy of classicism, a situation scarcely improved by Quatremère de Quincy's support of Canova. Eventually, the Canovians brought the Italian master's style to France, filtered through their individual personalities (or, perhaps, in the case of Bosio, creating his personality) and giving birth to the academicism against which less dogmatic sculptors would rebel. At the same time, Bouchardon's more naturalistic brand of classicism evolved into the "republican" style. Moitte, J.-B. Giraud, Giraud de Luc and Barye established a continuity with this tradition to which each subsequent generation brought its modifications. Thus Barye's sculpture wove together the strands of the remote past and of the "sublime," of

Figure 319. Auguste Préault. *Tuerie*, 1834–59. Bronze relief. Musée de Chartres.

Canova, Thorvaldsen and Flaxman's legacy, of the lessons of the Elgin Marbles and of France's own sculptural heritage into a deeply felt, personal classicism.

One of the supreme ironies of the neoclassical movement was that the foremost examples of Phidian accomplishment should help to bring about its demise. Yet the Elgin Marbles set into motion such a reappraisal of both contemporary and ancient sculpture, that no sculptor could escape their impact. The marbles vindicated those who were suspicious of an exclusively cold, neutral surface. (Thus Canova triumphed over Thorvaldsen on one front, while Thorvaldsen's greater archaism triumphed over Canova's work.) And Falconet's encomium to Puget received its ultimate justification from them.

It was Canova's fate, however, to stamp the period with his artistic vision and it was the fate of his contemporaries to labor in his shadow. French sculptors of real stature like Moitte, Clodion or Giraud de Luc have also left too few monumental works behind to compete with Canova's ubiquitousness. But the following generation, the generation of David d'Angers, Rude, Barye, Pradier, and later, Préault, bore witness to the presence of a thriving school deeply indebted to the new directions established by Falconet and Pigalle.

Notes

INTRODUCTION

1. The new arrangement of sculpture in the Denon wing of the Louvre solves some of the problems and creates new ones. The rooms devoted to the eighteenth and nineteenth centuries are so cramped and dark that the works vie uncomfortably for attention, crammed against wall ends and with busy perspectives for backdrops – witness Julien's *Gladiator* against a row of blindingly cleaned *morceaux de réception*. The dark green of the walls is carried over into the vitrines, turning their glass into strong mirrors, the works displayed competing with endless reflections. Michelangelo's slaves are finally on permanent display, but in an inglorious situation, on low bases at the end of a long, busy gallery where Canova's reclining *Cupid and Psyche*, once so magnificently displayed, is now backlit on a high pedestal in a corner. This breakup of a period in favor of national divisions has destroyed the sense of unity that characterized the presentation in the Pavillion de Flore with its exceptional natural light.

2. "The Musée d'Orsay: A Symposium," *Art in America*, vol. 76, Jan. 1988, 84–106, offers a particularly illuminating example of almost total indifference to sculpture. Among the ten contributors to the symposium, only the sculptor Alain Kirili devoted attention to the sculpture, albeit in terms critical of the display of some of the major works. Linda Nochlin's exhibition suggestions (88ff.) fail even to include sculpture, while Sarah Faunce (101) addresses herself to the paintings alone, describing a progress through the museum which excludes sculpture entirely.

3. Jean Chatelain, *Dominique Vivant-Denon et le Louvre de Napoléon*, Paris, 1973, "Rapport à l'empereur sur le Salon de 1810," 332.

4. Take Andrew McClellan's "Politics and Aesthetics of Display: Museums in Paris, 1750–1800," *Art History*, VII, 1984, 4, 438–64, which does not so much as mention the word "sculpture," even though the famous series of the "Grands Hommes" was destined for the new Louvre museum. In his discussion of the vicissitudes of taste, *Rediscoveries in Art*, Cornell University Press, New York, 1976, 5, Francis Haskell particularly notes the influence of possession and financial interest on collecting and taste.

5. While H. W. Janson's *Nineteenth-Century Sculpture* (New York, 1985) constitutes an important starting point for any study of sculpture of this period, its introductory character and traditional, monographic presentation leaves little room for the greater complexities characterizing the sculpture of the late eighteenth and early nineteenth centuries. It will rapidly become apparent that Robert Rosenblum's *The International Style of 1800* (Ph.D., 1956) and *Transformations in Late Eighteenth-Century Art* (1967; also devoted to architecture and sculpture to a lesser degree) were of fundamental importance to the overall concept of this undertaking. The exhibition catalogue, *The Age of Neo-Classicism* (Arts Council of Great Britain, London, 1972) remains an invaluable source of information, while Wend Graf Kalnein and Michael Levey's *Art and Achitecture of the Eighteenth Century in France*, Harmondsworth, 1972 (Painting and Sculpture revised, 1993, Yale), remains the only synthesis to date of prerevolutionary French sculpture. The series of exhibitions of "Art around 1800" organized by Werner Hofmann at the Hamburg Kunsthalle, including *Johan Tobias Sergel* (1975) and *John Flaxman – Mythologie und Industrie* (1979), and the Thorvaldsen exhibition at Cologne (1977) enlarge the body of information on the international circle in Rome, but add relatively little to what is known about French sculpture. (Several more recent Sergel and Thorvaldsen exhibitions expand the available documentation on the artists.) The one work which, in this respect, might have proved useful, Bo Wennberg's *French and Scandinavian Sculpture in the Nineteenth Century*

(1978), tends to juxtapose the art of two countries rather than to establish meaningful links. On the other hand, despite the general nature of both his *Neo-classicism* (1968) and *Romanticism* (1979), Hugh Honour brings into evidence the major problems confronting sculpture and has done more than anyone to give Canova his due. It is with great impatience, therefore, that one awaits his monograph on the Italian master.

Francis Haskell and Nicholas Penny's *Taste and the Antique* (1981) in particular and Karina Tür's *Zur Antikenrezeption in der französischen Skulptur des 19. und frühen 20. Jahrhunderts* (1979) are helpful guides to the changing perception of antiquity. Tür presents a thematic arrangement of subjects influenced by antiquity, but it is too fragmented to give a coherent picture of the century.

Of the works specifically devoted to art after the Revolution and during the Empire, François Benoît's *L'Art français sous la Révolution et l'Empire* (1897), Louis Hautecoeur's *Rome et la renaissance de l'antiquité à la fin du XVIIIème siècle* (1912), Jules Renouvier's *Histoire de l'art pendant la Révolution* (1863) and Spire Blondel's *L'Art pendant la Révolution* (1887), only Hautecoeur attempted to give some idea of both the quality of French sculpture and Canova's importance. Benoît managed not to mention Canova once in his entire book, which would be like writing the history of Italian neoclassical painting without mentioning Jacques-Louis David.

Paul Vitry's "La Sculpture en France de 1789 à 1850," in the *Histoire de l'art* edited by André Michel (VIII, 1925) and a number of other scattered French texts offer a standard fare of names and works, but these appear in a vacuum between the foregoing and subsequent periods. On the other hand, Gérard Hubert, in *La Sculpture dans l'Italie Napoléonienne* (1964) and in *Les Sculpteurs italiens en France sous la Révolution et l'Empire* (1964) and Antoinette Le Normand, in *La Tradition classique et l'esprit romantique: Les Sculpteurs de l'Académie de France à Rome de 1824 à 1840* (1981), offer substantial evidence of contact between French and Roman artists, although little is ultimately made of the complex nature of the artistic exchange or the answer of French sculptors to the international style. The works in question are particularly valuable for their documentation, Hubert's studies being the broadest to date and models of thoroughness.

Those works directed toward "romantic" sculpture, which are exceedingly few in number, bypass the issue of neoclassicism. Luc Benoist's *La Sculpture romantique* (1927) dwells briefly on the influence of the eighteenth century without touching upon neoclassicism, except to define romanticism as an anti-academic movement, and ignores anything but French sculpture. The ground-breaking *The Romantics to Rodin* exhibition (1980) purposefully omitted any work prior to 1820. The individual introductory essays in the catalogue, however, do address the preceding decades for the sake of organic coherence. The exhibition of *La Sculpture du XIXème siècle* actually begins within the neoclassical period and so inevitably touches upon some of the issues. But the scope is too narrow and the catalogue space too reduced for the brief section on "L'Art classique" to serve as a major revision. Most recently, *Skulptur aus dem Louvre* (*Sculptures françaises néo-classiques, 1760–1830*), Paris, 1990, offers a reworking of the usual themes with the benefit of some lesser-known works.

With the exception of the Sergel, Flaxman and Thorvaldsen exhibition catalogues, few monographs, recent or old, exist, meaning that little has been done to update the careers and contributions of the sculptors in question. Jean-René Gaborit's catalogue, *Jean-Baptiste Pigalle, 1714–1785*, Louvre, 1985, adds to our knowledge of the works in that collection. Fred Licht has enriched the bibliography with his *Canova* (1983), which offers the most elaborate and sensitive interpretation of that sculptor's work. Both the text and David Finn's photographs manifest the possibility of a deeply sensual approach to Canova's neoclassicism. Again, however, it adds little to what is known of his influence in France. More recent publications and glossy books have appeared as well, most significant of which is the catalogue for the exhibition *Antonio Canova*, Museo Correr, Venice, 1992. The excellent catalogue, *Clodion*, Louvre, Paris, 1992, updates the scholarship and reevaluates the Clodion attributions in an exemplary taxonomic study. However astonishing it may seem, no complete monograph has ever been published on either Joseph Chinard or Denis-Antoine Chaudet, the foremost French Napoleonic sculptors. Other, less well-known figures like François Maximilien Laboureur (1767–1831), who was considered one of Canova's great rivals in Italy during the Directoire and Empire, also deserve attention. (For a few comments on his standing in Rome, see Anatole de Montaiglon and Jules Guiffrey *Correspondance des directeurs de l'Académie de France à Rome avec les surintendants des bâtiments*, Paris, 1887–1912, XVII (1908), 320, 336 and 364 especially, and Hubert, *It. Nap.*, 161–8). Jacques de Caso's 1988 monograph on David d'Angers and Gisella Gramaccini's on Moitte (1993) both offer, in quite different ways, a wealth of information on each artist and his environment.

6. François Benoît, André Michel, Louis Gonse, Louis Réau and Gérard Hubert, among others.

7. Fred Licht, "Tomb Sculpture," *The Romantics to Rodin*, 96–108, presents a first overview. See also Licht, "Thorvaldsen and Continental Tombs of the Neoclassic

Period," *Bertel Thorvaldsen*, Cologne Kunsthalle, Cologne, 1977, II, 173–82, and Licht, *Canova*, 1983, 49–90, for an excellent summary. See also Antoinette Le Normand Romain, "De la mort paisible à la mort tragique," *La Sculpture au XIXème siècle* (or *XIXè*), 268ff.

8. James Holderbaum, "Portrait Sculpture," *The Romantics to Rodin*, 36–51, sketches the development of French portraiture from the late eighteenth century to the end of the nineteenth in a few dense, illuminating pages. See also H. Rostrup, *Franske Portraetbuster fra det XVIII Aarhundrede* (French summary), Copenhagen, 1932, for a survey of portraiture up to the Revolution.

9. See the Bibliography.

10. Siegfried Gohr, "Die Antike in der Kunsttheorie von J.J. Winckelmann bis Friedrich Schlegel," *Bertel Thorvaldsen*, I, 9–15, touches upon the problem as it arises in German literature.

11. David d'Angers, *Les Carnets de David d'Angers*, Paris, 1958, I, 30, was to write that "what gives sculpture such a high importance over painting is that it speaks to posterity through the durability of its materials which it uses to give form to an apotheosis." This was one of his attempts to express the superiority of sculpture which hinged on moral considerations.

12. Many of the same patterns as those in painting can be found especially in the drawings and reliefs of sculptors. H. W. Janson, "Historical and Literary Themes," *The Romantics to Rodin*, 70–82, addresses himself to one aspect of the issue but confines himself to the second decade of the nineteenth century on.

13. The first major text on this issue for painting is of course Thomas E. Crow's *Painters and Public Life in Eighteenth-Century Paris*, New Haven and London, 1985.

14. Meredith Shedd's dissertation, *T. B. Emeric-David and the Criticism of Ancient Sculpture in France, 1780–1839*, University of California, Berkeley, 1980, has not been made available through the Ann Arbor, Michigan, microfilm service. It undoubtedly touches upon contemporary sculpture theory, as this was so intimately bound up with the perception of ancient sculpture. Parts of Shedd's dissertation have appeared in the form of articles (see Bibliography). Karina Tür, 1979, provides a summary introduction to the changing perception of antiquity in the nineteenth century. A number of scholars, including Yvonne Luke and Alex Potts, are working on Quatremère de Quincy.

15. Marguerite-Julie Charpentier, born in 1770, is one such figure.

16. June Hargrove, *The Statues of Paris*, Antwerp, 1988, intro and chap.1, and Jacques de Caso, *David d'Angers: L'Avenir de la mémoire*, Paris, 1988, 26ff., both recapitulate some of the developments surrounding the shift from autocracy to democracy.

17. See Réau, 53, and Rocheblave, 57ff. See also Crow, 1985, 156ff. Crow mentions Bachaumont's distaste for militaristic royal portraits and the influences at work on Pigalle through the Abbé Gougenot.

18. The people of Reims themselves, in admiration of Pigalle's character and artistry, insisted that he give the Citizen his own features (Rocheblave, 62).

19. Réau, 56, and Rocheblave, 63.

20. See Alison Willow Yarrington, *The Commemoration of the Hero, 1800–1864: Monuments to the British Victors of the Napoleonic Wars* (Cambridge University, 1980), Garland, New York and London, 1988.

21. Page 13. See chap.1 for a discussion of Stendhal.

22. In 1843, Théodore Jouffroy, a professor of aesthetics at the Sorbonne, wrote that, "according to several schools of literature, and especially according to the French school, the sublime is merely the superlative of the beautiful, meaning that a passably beautiful object remains simply beautiful while a very beautiful object becomes sublime" (*Cours d'esthétique*, Paris, 1843, 314). Hugh Honour expresses a similar distinction in *Neo-classicism*, 145: "It generally signified an emotion of awe, bordering on terror inspired by natural phenomena. But it was also applied to works of art expressive of a superhuman grandeur which could not be accounted for by the normal critical criteria – though with emphasis, it must be noted, on the noble and lofty rather than the turbulent and supernatural." He goes on to give his own Burkean appraisal of the Sublime and the Beautiful characterized by the *Laocoon* and the *Apollo Belvedere* respectively.

Giulio Carlo Argan, *Antonio Canova* (Università degli Studi di Roma, Anno Academico, 1968–69), Rome, 1969, 63–64 and 75, adds another dimension to the word "sublime" as meaning objectified. He reasons that in the Burkean sublime, the spectator is subjectively awed by the external "otherness" or self-sufficiency of the object in question, leaving no possibility of identification with it. The sublime, therefore, becomes objective or independent; an object which can be identified with a geometric form becomes a sublimated object, Canova's *Perseus* and especially his *Hercules and Lichas* being examples of this. However interesting his arguments, we need only register "otherness" in relation to the following discussion. The context will clarify the word when it occurs.

23. Rosenblum, *Transformations*, 3ff, offers various terms ("neo-classic horrific," "-erotic," etc.) to help define some of the types of neoclassicism encountered in the late eighteenth and early nineteenth centuries.

24. See J. J. L. Whiteley, "The Origins of the Concept 'Classique' in French Art Criticism," *JWCI*, XXXIX, 1976,

268–75, for a review of the emergence of the critical vocabulary concerning this issue.

25. Edouard Pommier traces the interesting and unexpected course of Winckelmann's influence upon the French in "Winckelmann et la vision de l'antiquité classique dans la France des lumières et de la Révolution," *Revue de l'art*, 83, 1989, 9–20. His earlier essay, "La Théorie des arts," for *Aux armes et aux arts*, eds. Philippe Bordes and Régis Michel, Paris, 1988, 167–97, addresses in greater detail the role of French theoreticians. Régis Michel's catalogue for the exhibition *Le Beau Idéal ou l'art du concept*, Louvre, 1989, elaborates in a fragmented and disorganized way on the question of the real, "la belle nature," the ideal and its conceptual character, offering some useful syntheses of major theoretical positions. For an excellent interpretation of Winckelmann's writings, see Alex Potts, "Winckelmann's Construction of History," *Art History* 5, n. 4, Dec. 1982, 377–407.

26. René Schneider has, thus far, produced the two most useful accounts of Quatremère's life and aesthetics: *Quatremère de Quincy et son intervention dans les arts*, Paris, 1910, and *L'Esthéthique classique chez Quatremère de Quincy*, Paris, 1910. See also Yvonne Luke, "The Politics of Participation: Quatremère de Quincy and the Theory and Practice of 'Concours publiques' in Revolutionary France 1791–95," *The Oxford Art Journal*, 10, n. 1, 1987, and Joshua C. Taylor, *Nineteenth-Century Theories of Art*, University of California Press, Berkeley, Los Angeles, and London, 1987, 83ff.

27. Schneider, *Esthétique*, v–vii, gives a complete bibliography of the theoretical works.

28. Luke, "The Politics of Participation," is careful to point this out.

29. *Considérations*, 23 (all translations are mine unless otherwise noted).

30. Ibid., 71.

31. Pommier, 1989, II, 16–17

32. Luc Benoist, *La Sculpture romantique*, Paris, 1927, 35.

33. "C'est alors que le législateur de sa patrie et l'auteur d'un instrument utile, que le libérateur de son concitoyen et le vainqueur à la course, que l'orateur philosophe et l'inventeur d'une nouvelle sorte de tuiles, verront leurs statues placées dans les temples, et leurs personnes consacrées par l'art qui les vivifie, jouir d'une espèce d'avant goût d'immortalité" (*Considérations*, 35).

34. *Recherches*, 334.

35. This is clearly stated throughout his *Essai sur la nature, le but, et les moyens de l'imitation dans les beaux-arts*, Paris, 1823, and in *Essai sur l'idéal*, Paris, [1805] 1837, 13–19, where he writes that a sense of ideal beauty in the soul of the creator guides his hand and his appreciation of Nature.

36. See Pommier, *Revue de l'art*, 1989, for comments on institutions vs. liberty.

37. *Age of Neo-classicism*, lxxxiii.

38. "Les contrées du Nord ont leurs Alpes: elles peuvent enfanter un statuaire . . . la brillante et féconde Italie ne présente que des lignes ondoyantes; elle ne produira jamais que des peintres . . . son unique statuaire [Michel-Ange] fut un monstre sublime" (*Essai sur les signes inconditionnels dans l'art*, Leyden, 1827, quoted by Jacques de Caso, "Le Romantisme de David d'Angers," *Acts of the 24th International Congress of the History of Art* (Bologna, 1979), Bologna, 1984, VI, 96, fn.11.)

39. See Hugh Honour, *Neo-classicism*, xxiii, for a few comments on the concept of *belle nature*, and Régis Michel, 1989, *passim*.

40. The author did acknowledge his debt in the introduction. The letters were published and reveal a tone of angry rebuff on Emeric-David's part, signaling the end of the friendship.

41. See *Histoire de la sculpture française* (completed 1817), Paris, 1853, 199 (Pigalle) and 200 (Houdon).

42. Deloynes, XXVI, no. 692, "Salon de l'an IX," *Journal des Débats*, 1801, 498.

43. Page 463: "M. Pajou prouva dès lors qu'on ne pouvait rien faire qu'en étudiant la Nature, et il prouva qu'il l'avait étudiée."

44. See Charles W. Millard, "Sculpture and Theory in Nineteenth-Century France," *The Journal of Aesthetics and Art Criticism*, XXIV, 1975, no. 1, 15–20.

45. *Salon de 1808*, vol. II, 20.

46. Only a good deal more work on the nature of patronage during this period will yield solid information concerning the real freedoms and restrictions granted to the artist.

47. Whitley Papers, The British Museum, vol. II, 219, *Diary of Thomas More* (ed. Lord John Russell), vol. 3, Rome, Nov. 1819.

48. Ibid., vol. X, 1267, W. C. Brownell, *Daily Chronicle*, May 16, 1902.

CHAPTER 1

1. See Colton, *The "Parnasse Français": Titon du Tillet and the Origin of the Monument to Genius*, Yale, 1979, Introduction, which brings to the fore an important if largely neglected project and stepping-stone to the monument to genius, and Colton, *Monuments to Men of Genius: A Study of Eighteenth-Century English and French Sculptural Works*, Ph.D., New York University, 1974, 198ff. Yarrington, 1980, provides a continuation of this study in England, "examining the variations in style and patronage of British monuments . . . by means of a series of chronologically ordered case studies" (xii).

June Hargrove, *The Statues of Paris*, Antwerp, [1988, French] 1989, presents a general overview of Parisian statues to great men, summarizing in the first chapters the major issues relevant to these creations. Julius von Schlosser, "Vom modernen Denkmalkultus," *Vorträge der Bibliothek Warburg*, 6 (1926–27), 1–21, and Leopold Ettlinger, "Denkmal und Romantik: Bemerkungen zu Leo Von Klenzes Walhalla," *Festschrift für Herbert von Einem sum 16 Februar, 1965*, Berlin, 1965, 60–70, gather together some of the earliest examples of monuments to great men, notably to Erasmus of Rotterdam. Alois Riegl's *The Modern Cult of Monuments: Its Character and Its Origin* (1903), translated by Kurt W. Forster and Dianne Ghirardo in *Oppositions: Monument/Memory*, Fall 1982, 21ff, is not truly relevant within the context of this discussion, although, as its title implies, it analyzes the history of the cult of monuments (not necessarily the same thing as the celebration of great men) and provides a theoretical overview of what actually constitutes a monument, which may have begun as one intentionally, or have become one by the force of history and aesthetic interest.

2. Honour, *Neo-classicism*, 33.
3. Marie-Louise Biver, *Les Fêtes révolutionnaires*, Paris, 1979, 35.
4. Jacques de Caso, *David d'Angers: L'Avenir de la mémoire*, Paris, 1988, 30.
5. See Judith Colton, 1979, 26. An earlier project (1687) mentioned by Michael Preston Worley, *Pierre Julien and French Neoclassical Sculpture*, Ph.D., University of Chicago, 1986, 239, Nicodemus Tessin's *Temple of Apollo*, anticipates some of the elements of Titon du Tillet's program and scale. A Pantheon-like structure would have stood at the end of the Grand Canal at Versailles.
6. See below, Chap. 7.
7. The model is not accessible to the general public, nor are the statues of the "Grands Hommes."
8. Colton, 1979, 23.
9. Ibid., 23 and 48.
10. Ibid., 26.
11. Ibid., 36–37: "L'ouvrage est connu de toute l'Europe, et l'amateur a les suffrages de tous les esprits et de tous les coeurs" (1755).
12. Ibid., 11, 32. The 1732 and 1760 editions of the *Descriptions* show the monument in nature.
13. George Levitine's *The Sculpture of Falconet*, Greenwich, 1972, is the most recent monograph (without footnotes) on the artist, updating and condensing Louis Réau's standard monograph and invaluable reference source, *Falconet*, Paris, 1912. Levitine's is the first real attempt to put Falconet into perspective with some comparative material, though much remains to be done.
14. A line in his correspondence with Marigny reveals his true state: "J'ai bientôt cinquante ans et je n'ai rien fait encore qui mérite un nom" (Réau, 79).
15. In his *Réflexions* he had observed that "the most worthy aim of sculpture, if one looks at it from the moral point of view, is [therefore] . . . to perpetuate the memory of illustrious men and to give us models of virtue which are so much the more effective since the men who had these qualities can no longer be the objects of our envy" and, later: "A sculptor, as well as a writer, is . . . worthy of praise or criticism according to the wholesomeness or licentiousness of his subjects" (Levitine, 1972, 64). Hindsight lends a high degree of irony to the latter statement. Falconet never specifically relinquished this view in which he contemplates the glory of the great men portrayed rather than the artist's own fame, but the last few lines speak of personal concerns as does the letter to Marigny. Thus, his arguments against Diderot's belief in and cherishing of the judgment of posterity have a slightly hollow ring. See Yves Benot, *Diderot et Falconet: Le Pour et le contre*, Paris, 1958, for their exchange of views.
16. See Sergei Androssov and Robert Engass, "Peter the Great on Horseback: A Terra-cotta by Rusconi," *BM*, CXXXVI, Dec. 1994, no. 1101, 816–21.
17. Engravings of the monument showing these *Virtues* survive, notably at the Bibliothèque Nationale, Paris. Levey, 1993, 101, comments upon their iconographic importance.
18. See Rocheblave, 1919, and Réau, 1950, for the standard accounts of his life, and more recently, Gaborit, 1985.
19. See Réau, *Pigalle*, 96. Diderot had objections to the complex allegory (*Salons*, III, 326), and favored a more "human" Saxe. See Rocheblave, 199–220, and Réau, 60–67, for a history of the commission. Eduard Hüttinger, "Pigalles Grabmal des Marechal des Saxe," *Studi di Storia dell'Arte in Onore di Antonio Morassi*, Alfieri, [1971?], 357–65, offers a complete account of the monument's genesis. See too Gaborit, 1985, 13f and 62ff, for the most recent gathering of scholarly data.
20. The animals referred to represent defeated countries.
21. Le Soldat aux occasions
 Paroist comme du foudre de guerre.
 Ses généreuses actions
 Font trembler le ciel et la terre.

 Aux combats c'est un nouveau mars
 Un adonis auprès des dames.
 Venus qui chérit les soldats
 A pour luy de nouvelles flames.

 Etant aymé mesmes des Dieux
 Il ne craint ny destin ny Parque
 Dans les lieux les plus perilleux
 C'est ou la Valeur se remarque

Sy vous voulez savoir sur quoy
Son heur & sa valeur se fond
C'est (dit yl) que Je sers le Roy
Le plus Juste qui soit au monde.

Grégoire Huret (1606–70)

Le Soldat (Fig. 43)

Claus Elmar Stolpe, *Klassizismus und Krieg: über den Historienmaler Jacques-Louis David*, Frankfurt/New York, 1984, 100f, 145f, 176f, discusses the nature of the soldier as both hero and lover. Stolpe supports a deepened interpretation of the *Horatii* with material from texts on the military and customs and morality, establishing a parallel between the *Horatii* (and other works) and the "praxis" of contemporary military genius in this context.

22. Alison West, "The Sculptor's Self-Image," *Acts of the XXVIth International Congress for the History of Art*, Washington, D.C., 1986, 391ff, offers a brief discussion of this work. See Gaborit, 1985, 66f, for a recent account of the commission, and Rocheblave, 51ff.

23. See Rocheblave, 285–87, for the history of the statue and its critical reception, and Willibald Sauerländer, *Jean Antoine Houdon, 'Voltaire'*, Stuttgart, 1963, 5–9, for a discussion of the work in comparison to Houdon's *Voltaire* and the *Dying Seneca*.

24. Janson, *Sculpture*, 1985, 33. See Gaborit, 1985, 70ff, for the most recent account of the commission. The so-called *Dying Seneca* is now thought perhaps to be a fisherman.

25. H. H. Arnason, *The Sculpture of Houdon*, London, 1975, 49–53, gives the genesis of the work.

26. Hargrove, 1989, 20.

27. Henri Stein, *Augustin Pajou*, Paris, 1912, 171.

28. H. W. Janson quotes this familiar remark in "Observations on Nudity in Neoclassical Art," *Stil und über-lieferung*, 198–207. See Quatremère de Quincy, *Essai sur la Nature, le but, et les moyens de l'imitation dans les beaux-arts*, Paris, 1823, 409, for an extended view on the ideal and metamorphosis (taken up again in *Essai sur l'idéal*, Paris, 1837, 204), and 340 and 409 for his disapproval of Pigalle's *Maréchal de Saxe* and *Voltaire* respectively.

29. Kalnein and Levey, 97, comment upon this in discussing Pigalle's monument. Dowley, "D'Angiviller's 'Grands Hommes' and the Significant Moment," *AB*, XXXIX, 1957, 259–77, provides a thorough study of the background for the choice of this "significant moment." François Pupil, *Le Style troubadour*, Presse Universitaire de Nancy, 1985, 221–23, gives a broader literary background for the series. Guilhem Scherf, "La Galerie des 'Grands Hommes' au coeur des salles consacrées à la sculpture française du XVIIIè siècle," *Revue du Louvre*, 1993, 5/6, 58–67, gives some additional details about the commission and later inclusions in the series.

30. Samuel Taylor, "Artists and 'Philosophes' As Mirrored by Sèvres," *The Artist and Writer in France: Essays in Honour of Jean Seznec*, Oxford, 1974, 21 9, traces the impact of the "Grands Hommes" and their eventual failure as propaganda within the context of their Sèvres manufacturing. Quatremère, *Recueil de notices historiques* (Houdon), Paris, 1834, 396, found none of the statues in the series to be any good.

31. David Wildenstein and Guy Wildenstein, *Documents complémentaires au catalogue de l'oeuvre de Louis David*, Paris, 1973, 56, no. 477.

32. See Jean Locquin, *La Peinture d'histoire en France de 1747 à 1785* (Paris, 1912), Arthena, Paris, 1978, 163, or Honour, *Neo-classicism*, 44, for easily accessible quotations of J.-J. Rousseau's view.

33. For example, *Journal des artistes et des amateurs*, 1831, 323–26: "Mais que nos grands hommes remplacent tous ces dieux . . . etc."

34. Colton, 1979, 204–05.

35. See Lami, *Dictionnaire*, 18C, II, 373–82, and in particular 376–77. François Pupil, "La vogue des célébrités sculptées dans le contexte historiographique et littéraire," *Le Progrès des arts réunis, 1763–1815: Actes du colloque international d'histoire de l'art* [1989], Bordeaux-Toulouse, 1992, 317–37, gives some other examples.

36. Deloynes, VII, no. 101, *Lettres à madame sur les peintures, sculptures et gravures exposés dans le Salon du Louvre, 1763*, Letter IV, 210: "Il est difficile de faire à sa patrie un présent plus noble & plus digne d'elle, que celui que M. Grosley fait à la sienne. Il annonce un excellent Citoyen, & il est très-propre à en former d'autres. Les édifices les plus superbes ne décoreroient pas une Ville aussi-bien que les statues des grands hommes qu'elle a produits, et les honneurs qu'on rend à la vertu, réveillant dans toutes les âmes une émulation généreuse & sublime, qui peut produire les plus grandes choses."

37. For the life of Caffiéri, see Jules Guiffrèy, *Les Caffiéri*, Paris, 1877. See also Lami, 18C, I, 151–62, and especially 154–56.

38. Deloynes, VIII, no. 156: "Sçavez-vous, notre ancien, qu'ils sont destinés à orner le foyer de l'Opéra, & que c'est la reconnoissance de la Nation qui les y place. – Ma foi j'en suis ravie, les François commencent donc à honorer ces grands hommes qui ont vécu parmi eux; ils n'auroient point tant tardé s'ils avoient sçu combien la vue d'une pareille statue sert à enflammer et à féconder le génie des beaux arts."

39. Watelet, a friend of d'Angiviller, eventually commissioned a statue of the late d'Alembert (1786–1791, Louvre) which found its way to the Institut de France courtesy of Napoleon (Scherf, 1993, 64).

40. Deloynes, X, no. 191, *Exposition au Salon du Louvre des peintures, sculptures et autres ouvrages de messieurs de l'Académie royale en 1777*.

41. For example, Deloynes, X, no. 190, 1075–76, *Lettres pittoresques à l'occasion des tableaux exposés au Salon en 1777*, Paris, 1777; Deloynes, X, no. 178; Deloynes, XI, no. 212, 463, *Lettres d'un voyageur*, 1779; Deloynes, XI, no. 205, and XIII, 1783, no. 289; Deloynes, XIII, no. 312, *Lettres aux auteurs du Journal de Paris*, 1783.

42. See Stolpe, *Klassizismus*, chap. 2, "Mißstände," especially 32ff.

43. Taylor, 1974, 32, comes to this conclusion which can be verified by going over the available documents at the Sèvres manufactory proving the limited sales of the statuettes because of their extremely high prices. I am grateful to Madame Tamara Préau for her time and help in this regard. As concerns the function of the "Grands Hommes," Taylor, 21 and 34, endorses the view that they represented an aristocratic nostalgia for the age of Louis XIV as well as being propaganda for the monarchy and military honor, prompted by a sense of decadence, a view commonly held for a number of the paintings of the period. Both the military theoretician, Joseph Servan, *Le Soldat citoyen, ou vues patriotiques sur la manière la plus avantageuse de pourvoir à la défense du royaume, dans le pays de la liberté*, Neufchâtel, 1780, 225, and La Font de Saint-Yenne, 1754, 51–52, agreed that visual perception was more important than words in stimulating emulation (see Stolpe, *Klassizismus*, 76–77). Andrew McClellan, "D'Angiviller's 'Great Men' of France and the Politics of the Parlements," *Art History*, XIII, no. 2, June 1990, 174–92, delves into the political background for the choice of the famous magistrates forming part of the series. A fuller look could be taken at the impetus for commissioning other figures in the series.

44. Deloynes, X, no. 178, 864–65. The recorded reaction to most of the art of the period is highly rhetorical. It is difficult to know whether the authors meant seriously what they wrote. For example, Gorsas, *Troisième promenade de critès au salon*, London, 1785, 34–35, claimed that he too, upon seeing the *Horatii*, felt like drawing out his sword to participate in the oath (see Stolpe, *Klassizisimus*, 79). Montaiglon appears to have invented his young character for the sake of illustrating the anticipated effect of the "Grands Hommes" on a girl.

45. See Louis Bertrand, *La fin du classicisme et le retour à l'antique dans la seconde moitié du XVIIIè siècle et les premières années du XIXè siècle en France* (Paris, 1897), Slatkine reprints, Geneva, 1968, 32.

46. Ibid.

47. Elizabeth Holt, *The Triumph of Art for the Republic*, New York, 1979, 46 (Holt's translation): "Our warriors, following the example of the Athenians, come to the tombs of our heroes who have died for their country, and there sharpen the iron destined to avenge them.

Mothers shall bring their children, so that their hearts may early be formed by the sentiments of magnanimity and of courage, and like new Hannibals swear, from earliest infancy, an eternal hatred for the devastators of the world."

48. See Colton, 1979, 203ff, for Titon's legacy.

49. Ibid., 214ff. See also, *Projets et dessins pour la Place Royale du Peyrou à Montpellier*, Inventaire générale des Monuments et Richesses de la France, Grand Palais, Paris, 1980, Caisse des Monuments Historiques, Paris, 1983, and Gramaccini, 1993, 50ff, for a full, updated account of the commission and Moitte's part in it.

50. Ibid., 219.

51. Haskell and Penny, *Taste and the Antique*, New Haven and London, 1981, 288, give the history of the works' reception.

52. Only on a much smaller scale does one find comparable groups of an even livelier cast, notably among Paul Louis Cyfflé's (1724–1806) biscuit productions from his own manufacture of "terre de Lorraine." As had so many other artists, especially painters, Cyfflé turned to Gravelot's illustrations of the 1764 edition of P. Daniel's *Histoire de France*. Maurice Noël, "Sur quelques Biscuits en terre de Lorraine de P. L. Cyfflé," *Revue des arts*, 1959, no. 1, 31–36, provides a good account of the modest if varied career of this artist. See also Lami, 18C, I, 243–44.

53. Janson, "Observations on Nudity," 202–03, gives precedents of the dying-hero type in England.

54. See Lami, 18C, I, 129–34.

55. Ibid., 129.

56. The relief in question does not appear in Lami. Seznec, ibid., 154, rejects A. Chastel's dating of the work to the later period of Davidian classicism (*Nicolas Poussin*, Paris, 1958, 302). R. Verdi, "Poussin's Eudamidas, Eighteenth-Century Criticism and Copies," *BM*, CXIII, Sept. 1971, 513–24, discusses Breton (521–22) and Michael Rysbrack's reliefs after Poussin. See below, Chap. 2, "Falconet."

57. See Rosenblum, *Transformations*, 28ff, for a discussion of the deathbed scene.

58. Janson, "Observations on Nudity," 202–3, mentions this monument in relation to French developments.

59. See Arnason, *Houdon*, 42, and *The Age of Neoclassicism*, Arts Council of Great Britain, London, 1972, 255.

60. Jérémie Benoît, *Nouvelles acquisitions*, 1984, 66–67, and *Clodion*, 1992, 152–56.

61. Lami, 18C, I, 177. Model executed for Saint Louis, Toulon. The marble was never executed, but a stucco version by another artist was.

62. See Stein, *Pajou*, 263–64, for the history of the commission.

63. Canova, incidentally, refused Cardinal de Bernis' commission for a monument to Bayard, perhaps not only

because of his many other obligations (e.g., the *Monument to Clement XIII*) but also because of the implied historicism, which he could not have swept under a toga.

64. This work does not appear in Lami. The only mention of Desaix is a bust of 1808 (18C, I, 213). The general's death at the battle of Marengo was followed by a flurry of commissions to commemorate the hero. Isabelle Leroy-Jay Lemaistre, "Joseph Chinard," *Les Muses de Messidor: Peintres et sculpteurs Lyonnais de la Révolution à l'Empire*, Musée des Beaux-Arts, Lyon, 1989, 78, briefly discusses this terra-cotta and the unfinished marble (c. 1807, Clermont-Ferrand).

65. The only other work comparable to Chinard's in sculpture is the unusual *Duke of Enghien at the Battle of Sénef Assisting the Grand Condé from His Fallen Horse* (Dijon, Musée des Beaux Arts), a terra-cotta group by Nicolas Bornier (1762–1819) who won the Grand Prix de Sculpture des états de Bourgogne with it in 1787 (Lami, 18C, I, 97). There exists no precedent for such a prize subject in Paris and one can only attribute it to the idiosyncrasy of a provincial official. The scene is not actually one of death, but in its choice of a fallen hero, it may be likened to other images of imminent demise. It was given to Dijon in 1808.

66. Lami, 18C, II, 168. It is of interest to note that, when Broc painted his *Death of General Desaix* (1806), a salon critic compared it to West's painting (Deloynes, XXXVII, no. 1035, *Lettres impartialles sur les expositions de l'an 1806 par un amateur*, 1104).

67. See Janson, *Stil und überlieferung*, 194.

68. Réau, *Pigalle*, 87.

69. See Ferdinand Boyer, "Le Sculpteur Barthélémy Corneille à Rome et en Toscane (1787–1805)," *Le Monde des arts en Italie et la France de la Révolution et de l'Empire*, Turin, 1970, 52. This is the only extended discussion of the artist.

70. Gérard Hubert, *Sculpteurs Italiens en France*, Paris, 1964, 125–26 outlines his career.

71. See Caso, *David d'Angers*, 1988, 77.

72. Ibid., 204.

73. Deloynes, XIII, no. 311, 975, "Observations sur les ouvrages de peinture et de sculpture," *Année Littéraire*, 1783: "Les talents du même artiste se font reconnaître au Salon dans la petite figure de Caton d'Utique qui s'arrache les entrailles: mais je suis faché qu'on reproduise aux yeux des Spectateurs un spectacle aussi révoltant."

74. Anne Betty Weinschenker, *Falconet: His Writings and His Friend Diderot*, Geneva, 1966, 16.

75. A lost relief by Auguste-Félix Fortin (1763–1832, Lami, 18C, I, 347–49) presented at the Salon of 1789, for example, removes the spectator to a more delicately spine-chilling world of novels and gothic horror: two

travelers in Egyptian catacombs, having discovered the bodies of two men, one of whom holds a letter in which is described how their guides had robbed them and locked them in, hear their own guides closing the doors upon them (salon catalogue, no. 302). There is no title except for this long description which must apply to a relief. Janson, "Historical and Literary Themes," *Romantics to Rodin*, 76, mentions this relief as one of the possible examples of literary subjects in sculpture, although there is no given source. Le Comte's *Esclave accablé de douleur* (Salon 1769), now lost, clearly adumbrates this sort of thing. It is almost impossible, however, to gauge the expression from the Gabriel de Saint-Aubin sketch (see *Salons*, III, plate 55).

76. Lami, 18C, I, 258, 259.

77. See Stein, *Pajou*, 223. A few other examples among many include Pajou's "Camillus assiègeant la ville de Veyès en Toscane" (1771, no. 243) or several drawings by E. P. Gois depicting gruesome scenes: "Cambyse, Roi de Perse, ayant été informé que l'un des Juges Royaux (on les nomait ainsi) s'étoit laissé corrompre par des présens, le condamna à la mort, et fit étendre la peau sur le Tribunal ou il siègeoit" and "Cambyse, après avoir fait éxécuter les ordres envers ce Juge prévaricateur, ordonne à son fils, qui devait lui succéder, de s'asseoir sur la peau de son père" (1779, nos. 210, 211). In 1777, E. P. Gois (1731–1823), or Gois père, also submitted *Socrates Drinking the Hemlock* (along with *The Illness of Antiochus*).

78. Judging from Diderot's ultimately dissatisfied comments, another of Pajou's drawings, the *Death of Pelopidas* (1767), was modeled upon Poussin's deathbed scenes (*Salons*, IV, 1767, no. 203, 325–26).

79. Benoît, (1897) 1975, 368.

CHAPTER 2

1. Michael Levey, *Painting and Sculpture in France – 1700–1789*, Yale University Press, New Haven and London, 1993, 93ff, gives a broad account of Bouchardon's career within the larger context of French eighteenth-century sculpture, finding Bouchardon to have been overrated in his time. A number of monographs have been devoted to Bouchardon. See A. Roserot, *Edmé Bouchardon*, Paris, 1910, and O. Colin, *Edmé Bouchardon*, exhibition catalogue, Chaumont, 1962. This small catalogue makes no pretense at a new assessment of Bouchardon's work.

2. See Marc Jordan, "Edmé Bouchardon: A Sculptor, Draughtsman, and His Reputation in Eighteenth-Century France," *Apollo*, 121, June 1985, 388–94.

3. See Réau, *Pigalle*, 46, and Rocheblave, 161.

4. See Rocheblave, 297–300, who calls this attractive work one of the jewels of the Musée Jaquemart-André,

Paris (297). Réau, *Pigalle*, 45–46, finds the work only partially satisfying in spite of the great trouble Pigalle took over it because of its angular pose and weather-worn state.

5. The child is a portrait of Paris de Marmontel's one-year-old son (Réau, *Pigalle*, 107). The work was exceedingly popular in its time, Pigalle eventually buying it back for considerably more than he had sold it for. For the iconographic and stylistic origins, see Cecile Nemser, "Pigalle's 'Enfant à la Cage,'" M.A. thesis, New York University, 1966.

6. His *Oeuvres* is replete with references to Pliny's criticism and the monuments of antiquity which he characteristically evaluated for himself.

7. See Réau, *Falconet*, I, 216–24, for the genesis of the relief and 219 in particular for contemporary theatrical inspiration.

8. See Levitine, *The Sculpture of Falconet*, 33–38, for a discussion of classicism in Falconet. He lays perhaps too much emphasis on the classical qualities of the *Pygmalion and Galatea*. No discussion exists of Falconet's classicism within the broad context of neoclassicism. Réau's comparison (*Falconet*, 223) of the *Apelles and Kampaspe* to Puget's *Alexander and Diogenes*, while valid, also serves to underline the degree to which Falconet reduced Puget's overall busyness of texture in favor of a more lucid arrangement.

9. See Falconet's "Réflexions sur la sculpture," *Oeuvres*, Paris, 1808, III, 1ff and 28ff particularly. (Levitine, *Sculpture of Falconet*, 64–75, offers a translation of this text.) Jean Seznec, "Falconet, Diderot et le bas-relief," *Walter Friedlander zum 90*, Geburtstag, Berlin, 1965, 151–57, and Francis Dowley, "Falconet's Attitude towards Antiquity and His Theory of Reliefs," *AQ* XXXI, 1968, 185–204, offer a more comprehensive theoretical approach.

10. See Dowley, *AQ*, 1968, 186–87.

11. See Seznec, "*Falconet*," 154. Seznec, 156, also draws into consideration Diderot's enthusiasm for Poussin's *Testament of Eudamidas*. See Levitine, *Sculpture of Falconet*, 36–37, for Falconet's resentment of the inferiority ascribed to sculpture in the *Paragone*. Bos, Coypel, Caylus, d'Argenville, all agreed in placing painting foremost (see Jacques de Caso, "Sculpture et monument dans l'art français à l'époque néo-classique," *Stil und überlieferung in der Kunst des Abendlandes*, Berlin, 1967, vol. I, 191).

12. For the most recent information on Rysbrack, see *Michael Rysbrack Sculptor, 1694–1770*, Museum and Art Gallery, Bristol, Bristol, 1982, organized by Katherine Eustace. Malcolm Baker, "Sculpture for Palladian Interiors: Rysbrack's Reliefs and Their Setting," ibid., 35–41, gives the context for Rysbrack's commissions. The *Testament of Eudamidas* is not mentioned but it is of the same type of relief ornamenting the Palladian interiors. M.I. Webb, *Michael Rysbrack, Sculptor*, London, 1953, 288, documents the relief. See also Rupert Gunnis, *Dictionary of British Sculptors*, London, 1953, 333–38, and Margaret Whinney, *Sculpture in Britain from 1530 to 1830* (Pelican History of Art), Baltimore, 1964, 83–91, for introductions to the life of Rysbrack. Neither mentions the relief which appears in the photographic archives of the Courtauld Institute's Witt Library.

13. Even before Falconet's time there was opposition to a relief style such as he would advocate. See de Caso, *Stil und Uberlieferung*, 196–97. Mariette and Grimm, for example, favored a clearer, simpler composition. Caylus, in his *Parallèle de la peinture et de la sculpture*, 1759, 147, agreed that each medium could contribute to the other, though he was conscious of the limits of such an exercise.

14. *Oeuvres*, III, 95–96. Winckelmann's opinion changed between the publication of *Über die Nachahmung* (1756) and the *Geschichte der Kunst des Altertums* (1764).

15. The references to Winckelmann are too numerous to be listed here. The 1808 edition of Falconet's *Oeuvres* has the advantage of a complete index.

16. "Quelques idées sur le Beau dans l'Art occasionées par un passage de Pline," *Oeuvres*, II, 150: "Après avoir dit librement mon avis ailleurs sur quelques erreurs de M. Winckelmann, je dois avec la même candeur convenir que je n'ai rien lu de mieux sur le beau dans l'art, que ce qu'il en a écrit: il étoit fondé sur l'unique base qui étoit solide; soit qu'il dût cette vérité à quelques artistes, soit qu'il le tint de ses observations propres, il a touché le but."

17. See *Oeuvres*, II, 149ff, for Mengs' letter from Madrid to Russia, July 25, 1776. Falconet's "Réposne à Monsieur Mengs" follows, II, 208ff. See especially 221f for Puget's genius.

18. Lorenz Eitner, *Neoclassicism and Romanticism, 1750–1850: Sources and Documents in the History of Art*, New Jersey, 1970, vol. I, 27, speaks of Piranesi's *Della Magnificenza ed Archittetura de' Romani* as the first nationalistic rebuttal of Winckelmann's Grecophilia.

19. "Réflexions," *Oeuvres*, III, 23. Falconet was not alone in finding Puget to be at the summit of sculpture. L.P. de Bachaumont's *Essai sur la peinture, la sculpture et l'architecture* (1752), Slatkine reprint, Geneva, 1971, 29–47, dwells at great length on Puget's outstanding originality and genius, surpassing perhaps anything from "la meilleure antiquité."

20. *Oeuvres*, III, 5: "Le Beau lui-même qu'on appelle idéal en sculpture comme en peinture, doit-être un résumé du beau réel de la nature. Il existe un beau essentiel, mais

épars dans des différentes parties de l'univers." See Weinschenker, *Falconet*, 1966, 37ff, for a fuller discussion of Falconet's position.

21. Dowley, "Falconet's Attitude towards Antiquity," 185ff, examines Falconet's precocious historic sense.

22. "Réflexions," *Oeuvres*, III, 22.

23. See Honour, *Neo-classicism*, 27 and 193, for more details on this object. Réau, *Falconet*, 224, refers to Lalive de Jully's deceased wife in connection with the subject of melancholy, but he makes no comment on the possible reason for the stylistic evolution. He does compare the statuette to Tanagra figurines (56).

24. See Levitine, *Sculpture of Falconet*, 33–34, for a discussion of *Sweet Melancholy* and Falconet's adherence to fashionable themes. Like Réau, Levitine makes no mention of Lalive's possible influence.

25. Ibid., 38.

26. Ibid.

27. Ibid., 56. See also Réau, *Falconet*, 366.

28. See Levitine, *Sculpture of Falconet*, 56.

29. Deloynes, X, no. 191, 1108–09, "Expositions au Salon . . . 1777," *Mercure de France*. In addition to those works mentioned in the previous chapter, see René Schneider, *L'Esthéthique classique chez Quatremère de Quincy*, Paris, 1910, 51–52, fn. 3, for further references to the debate, including Nicolas Ponce's "Réflexions sur le nud et le costume en sculpture," *Moniteur*, Feb. 2, 1809, as well as Locquin, [1912] 1978, 165f, for the early, archaeological interest in costume. Diderot came down in favor of classical costume, though he admired successfully executed contemporary costumes – witness his praise of Houdon's *Tourville* (*Salons*, IV, 381). Hanna Hohl, "Sergel, Schadow und die Frage des Kostüms in der Denkmalplastik," *Johan Tobias Sergel*, Hamburg, 1975, 55ff, discusses the problem in northern countries, the same arguments applying everywhere, it would seem.

30. Deloynes, XII, no. 271, 471–72.

31. Ibid., X, no. 160, 1775.

32. One hesitates to ascribe the adjective rococo to wigs. It may have been the sitter's desire to appear without a wig in accordance with a personal philosophy. In this case, the sculptor would simply be transcribing realistically the sitter's more natural condition rather than making an artistic statement. His gifts of observation would be equally well applied to wig or balding head.

33. Deloynes, XI, no. 207, *Encore un rêve – suite de la Prêteresse*, Rome, Paris, 1779.

34. Ibid., XII, no. 299, *Observateur*, 60–61: "Je ne sais quelle fatalité semble attaché aux hommages que la Nation a voulu rendre, dans ces derniers temps, à ces Grands Hommes. Parmi les éloges qui leur ont été consacrés, il en est peu qui soient encore lus, et les autres ne le furent jamais. Aujourd'hui on leur élève des statues; & à l'ex-

ception de quelques-unes, de tous les Ouvrages de nos Sculpteurs, ce sont les plus médiocres . . . Convenons d'abord que rien n'est plus ingrat, pour la Sculpture surtout, que notre costume. Le génie de l'Artiste doit se glacer à la vue des formes bizarres de nos habillements." For a similar argument, see ibid., no. 312, 1773, 1006–07.

35. *Appel au public sur la formation d'un jury pour juger les ouvrages des artistes par un peintre dont les tableaux n'ont point été rejetés*, Paris, ibid., XIV, no. 526, 623.

36. R. G. Saisselin, "Neo-Classicism: Images of Public Virtue and Realities of Private Luxury," *Art History*, IV, no. 1, March 1981, 14–36, objects to the equation of neoclassicism with the bourgeoisie, tracing its rise to aristocratic patronage instead.

37. For a convenient reproduction, see Caso, *David d'Angers*, fig. 15.

38. Lami, 18C, I, 174.

39. Deloynes, XLVIII, no. 1283, *Ouvrage de sculpture de l'exposition du Louvre*, 258.

40. See Colton, *Monuments to Men of Genius*, 297–310, for the entire history of the monument and 299 in particular for the question of nudity. Colton enlarges upon the significance of Buffon's idealization and dialogue with Pigalle's *Voltaire* in "From Voltaire to Buffon: Further Observations on Nudity, Heroic or Otherwise," *Art the Ape*, 531ff. His nudity may be seen as that of the civilized man vs. the barbarity of the nakedness of the man of the desert.

41. See Marc Furcy-Reynaud, *Inventaire des sculptures exécutées au 18è siècle pour la direction des bâtiments du roi* (*Archives de l'Art Français*, Nouvelle Période, XIV, 1925–27), Paris, 1927, 77–78, and Henri Thirion, *Les Adams et Clodion*, Paris, 1885, 310–16, for the details of the commission.

42. See Janson, *Stil und überlieferung*, 201.

43. See Lami, 18C, II, 344–45, for Stouf and G. Scherf, *La Révolution française et l'Europe*, III, 891, and Scherf, "La Galerie des 'Grands Hommes,'" *Revue du Louvre*, 1993, 65f.

44. Réau, *Pigalle*, 67–68. In his physically idealized or heroicized *Jeanne d'Arc* (1804, Orléans), Edmé-Etienne Gois retained the garments of a French woman of the fourteenth century.

45. A sketch by Gabriel de Saint-Aubin in his salon catalogue preserves the appearance of the work.

46. Benoist, *Sculpture romantique*, 14.

47. *Salons*, IV, 381.

48. See Réau, *Falconet*, 369–71; Levitine, *Sculpture of Falconet*, 19.

49. See *Oeuvres*, XIII, 43, and Seznec, *Diderot et l'antiquité*, Oxford, 1957, 23–24.

50. *Oeuvres*, III, 3.

51. Francis Haskell and Nicolas Penny, *Taste and the Antique*, New Haven and London, 1981, 91.

CHAPTER 3

1. George Levitine, *The Sculpture of Falconet*, Greenwich, 1972, 31, speaks of a "voluptuously mannered elegance." Louis Réau, *Falconet*, Paris, 1912, 193, wrote: "Il semble que l'artiste ait retrouvé le secret de Jean Goujon qui donne au corps lisse de ces Nymphes la fluidité d'une eau courante."

2. Levitine, *Sculpture of Falconet*, 42, makes this comparison and sees in this statuette traces of a classicism demarcating her from the "Lucidity Louis XV" of the earlier *Bather*. For the meaning of the unfortunate phrase "Lucidity Louis XV," see ibid., 30–31.

3. See Réau, "Un Sculpteur oublié du XVIIIè siècle: Louis-Claude Vassé, 1716–1772," *GBA*, 6è période, IV, July 1930, 31–56, for a short survey of this artist.

4. *Les Salons de Diderot*, eds. Jean Seznec and Jean Adhémar, Oxford, 1957, II, 223.

5. Ibid. In 1763, Diderot wrote of a *Sleeping Bacchante* by Mignot: "Nos statuaires [la] placent d'une voix unanime aux rang des antiques" (*Salons*, I, 247). Ten years later one finds the same telling reproach directed at a *Pygmalion* by Boizot: "mais on est surpris de voir un Artiste jeune, et qui doit être encore dans le feu de l'âge, tombant dans une manière ronde, lisse et froide," which suggests that classical restraint implied a certain artistic or even emotional impotence (Collection de Pièces sur les Beaux-Arts imprimées et manuscrites, recueillies par Pierre-Jean Mariette, Charles Nicholas Cochin, et M. Deloynes, Bibliothèque Nationale, Paris, Vol. X, no. 169, *Observations sur les ouvrages de M. Le comte de XXX*, Paris, 1775).

6. For example, see Rudolph Zeitler, *Klassizismus und Utopia*, Stockholm, 1954, 42, and Janson, *Nineteenth-Century Art*, Englewood Cliffs and New York, 1984, 102.

7. H.H. Arnason, *The Sculpture of Houdon*, New York and London, 1975, 94.

8. The architect Claude Nicholas Ledoux (1736–1806) immediately followed Pajou's example by designing the gilded plaster reliefs for the Hotel de Montmorency (Paris, Musée Carnavalet) in 1770–71 in a more pronounced Goujon style, choosing gracefully twisted poses for several of the standing, life-size figures.

9. See *Clodion*, 1992, 193.

10. Ibid., 193–95. At times Anne Poulet (*Clodion Terra-Cottas*) stretches the comparisons, but the general point holds.

11. See Michèle Beaulieu, "Oeuvres inédites et procédés de travail d'un sculpteur de la seconde moitié du XVIIIè siècle: Augustin Pajou," *BSHAF*, 1979, 162–64. A pedestal or a spherical clock, signed and dated "Pajou 1776," at the gallery of Guy Ladrière (Paris), harks back to Germain Piton's *Three Graces*.

12. See Henri Stein, *Augustin Pajou*, Paris, 1912, 234, for Gilles Corozet's comments dating back to 1587. Stein, 234–39, gives a brief history of the monument and its restoration.

13. Ibid., 235.

14. *Clodion*, 44.

15. Stein, *Pajou*, 238.

16. Lami, 18C, II, 300.

17. Henri Jouin, *David d'Angers: Sa Vie, son oeuvre, ses écrits et ses contemporains*, Paris, 1878, II, 229: "Dans cet ouvrage, on peut remarquer combien, sans les copier, Roland s'était inspiré des beaux exemples de ses prédécesseurs. Les figures, d'un style grand et sévère, portaient bien le cachet du sentiment individuel de l'artiste. C'était une imitation libre, hardie et rivale à la fois des Cariatides dont Jean Goujon a embelli l'une des salles du Louvre."

18. Clodion's attenuation of his figures in the later phases of his career was in step with the gradual rise of mannerism within neoclassicism.

19. See Louis Armand Calliat, "Sculptures et dessins de Guillaume Boichot," *Revue des Arts*, 1958, no. 5, 229–34; Jean Guillemin, "Guillaume Boichot," *Mémoires de la Société d'Histoire et d'Archéologie de Chalon*, V, 3è partie, 1872, 1–74; *Autour de David: Dessins néo-classiques du Musée des Beaux-Arts de Lille*, 1983, 25–27; Lami, 18C, I, 75–81. Didier Lardy is currently finishing his thesis on Boichot for the Ecole du Louvre.

20. Calliat, "Boichot," 230.

21. *Autour de David*, 26. This frequentation of the English circle may explain his choice of *Agrippina with the Ashes of Germanicus at Brindisium* (Lille, M.B.A.) as the subject of an important drawing of around 1770. The stylistic eclecticism, combining echoes of the *Ara Pacis*, Poussin and Daniele da Volterra (see ibid., for these comparisons), serves as a concise introduction to his taste. For the subject, he may have drawn upon Benjamin West's *Agrippina* (1768), a more sedate and purified performance.

22. See, for example, a drawing of c. 1770 of the *Feast of Pan* (Chalon-sur-Saône, Musée Denon). Calliat, "Boichot," 230, implies this date though it is by no means certain.

23. The work was commissioned by the Boyelleau family in Chalon in memory of the death of a brother and sister.

24. Calliat, "Boichot," 230; Lami, 18C, I, 78.

25. See Henry Jouin, "Arc de Triomphe du Carrousel," *Inventaire Général des Richesses d'Art de la France. Paris. Monuments Civils*, Paris, 1880, I, 258–59 and Bo Wennberg, *French and Scandinavian Sculpture in the Nineteenth Century*, Stockholm, 1978, 11–12.

26. "Trompé par son imagination, Boichot, en cherchant le style antique, tomba dans la manière des Florentins; il

substitua la grâce des Primatices à celle de Praxitèle. Ce maître a tracé des dessins plus qu'il n'a exécuté des sculptures. Un bas-relief, placé dans la voûte de l'Arc de Triomphe du Carrousel, et représentant un fleuve, offre un exemple de son goût et de son élégance un peu recherché." *Histoire de la sculpture française*, Paris, 1853, 202.

27. As the examination of the period deepens, others will be found to share Boichot's taste, as revealed by the illustrations of the highly mannerist and refined work of Alexandre Renaud (1756–1817), a still obscure artist in Marseilles, in Philippe Bordes' article, "Sculpteur et Jacobin: Alexandre Renaud à Marseilles pendant la Révolution," *Le Progrès des Arts Réunis*, 1992, 363–71.

28. See David Lloyd Dowd, *Pageant-Master of the Republic: Jacques-Louis David and the French Revolution*, Lincoln, 1948, 45f, Marie-Louise Biver, *Les Fêtes révolutionnaires à Paris*, Paris, 1979, 111ff and Gisella Gramaccini, *Jean-Guillaume Moitte (1746–1810): Leben und Werk*, Berlin, 1993, 72ff. Moitte exhibited his drawings for the "reliefs" (they were actually grisaille paintings) at the Salon of 1791 (ibid., 75).

29. See below, Chap.5.

30. Gramaccini *Moitte*, 1993, 77, details the various identities attributed to this Hydra, including the Hydra of Despotism.

31. Ibid., 75.

32. Richard James Campbell, *Jean-Guillaume Moitte: The Sculpture and Graphic Art, 1785–99*, Ph.D., Brown University, 1982, 35f, first speaks of Moitte's 1:8 canon, without mentioning Goujon's possible influence. For Roman influences on the figures of the Triumphal Arch, see p.72. Gisella Gramaccini, "Jean Guillaume Moitte et la Révolution française," *Revue de l'art*, 1989, 64, and Gramaccini, *Moitte*, 1993, 79, proposes the *Ara Pacis* as a specific model. Goujon's name appears at various intervals throughout Gramaccini's monograph, but not in relation to this relief or the Pantheon pediment. From 1773 on, Moitte worked for Auguste, "orfèvre du Roi," bringing to goldsmithing his new ideas (Lami, 18C, II, 164). Armand Guérinet, *Décorations du XVIIè siècle. Vè série.*, figs. 118–35, and *Aspects of Neoclassicism: Drawings and Watercolours, 1760–1840*, Colnaghi, New York, 1982, offer a number of examples of Moitte's decorative schemes for Auguste. See Gramaccini, *Moitte*, 1993, for documentation of this aspect of Moitte's early career.

33. For an introduction to the complexities of historicism, classicism and modernism in relation to these reliefs, see William Olander, *Pour transmettre à la postérité: French Painting and Revolution 1774–1795*, Ph.D., New York University, 1983, 196 and 203ff.

34. J.J.L. Whiteley, "The Origins of the Concept 'Classique'

in French Art Criticism," *JWCI*, XXXIX, 1976, 271. My italics and translation.

35. Gramaccini, *Moitte*, 1993, 83ff, offers the most rounded discussion of the entire project. See also René Schneider, *Quatremère de Quincy et son intervention dans les arts*, Paris, 1910, 44ff; Marie-Louise Biver, *Le Panthéon à l'époque révolutionnaire*, Paris, 1982, 39ff and 53ff; Biver, *Fêtes*, 51 and 52; Philippe de Chenevière, "Les Décorations du Panthéon," *GBA*, 2è période, XXII, Oct. 1880, Part I, 296ff, Part II, 500ff.

36. Schneider, *Quatremère de Quincy*, 44.

37. Biver, *Panthéon*, 35.

38. Ibid., 53.

39. Gramaccini, *Moitte*, 1993, 85, finds Schneider's claim for Quatremère's hegemony overstated.

40. Jacques de Caso, "Sculpture et monument dans l'art français à l'époque néo-classique," *Stil und überlieferung*, 193ff, and Schneider, *Quatremère de Quincy*, 38.

41. Schneider, *Quatremère de Quincy*, 50.

42. Quatremère prepared a report on the Pantheon enriched with a complete description of his pedimental program which one must consult to understand the relief, and this in spite of Quatremère's aversion to recondite allegory: "C'est aussi la Patrie qui paraît, dans ce bas-relief, comme la divinité principale du temple. Des symboles caractéristiques de la France l'accompagnent. Un autel chargé de festons et de signes rémunératifs est à côté d'elle. Elle y a pris les couronnes de chêne qu'elle tient et que ses deux bras étendus présentaient à l'émulation publique. L'une d'elles vient de se poser sur la tête de la Vertu. A son air timide, à son maintien modeste, l'artiste a voulu faire entendre que la véritable vertu se contente de mériter les récompenses; qu'elle ne sait ni les solliciter ni les fuir, mais que la Patrie saura toujours la trouver et la prévenir.

Un caractère tout différent brille et se développe dans la figure opposée: c'est le Génie, personnifié sous la figure d'un beau jeune homme ailé; une massue, symbole de la force qui dompte tous les obstacles, est dans sa main gauche. Il ne faut que lui montrer la récompense; aussi sa main droite saisit la couronne que tient la Patrie. Son air, son attitude et toute l'expression de la figure, annoncent la hardiesse, et ce désir de gloire, et cette ambition des Récompenses, qui sont l'aliment du génie. Comme la vertu attend la couronne, le génie l'arrache: tels sont les principaux traits qui différencient ces deux figures.

Mais ce qui forme leur cortège, ou ce qui vient à leur suite, en prononce encore mieux le caractère. Derrière la Vertu plane en l'air le génie de la Liberté; il tient d'une main le *palladium* de la France; l'autre saisit par leurs crinières et conduit, comme en triomphe, deux lions attelés à un char rempli des principaux attributs des Vertus. Ce char a terrassé le Despotisme; on le reconnaît

à une figure renversée sur des ruines, à ses regrets et au poignard qui lui reste, et qu'il va tourner contre lui-même. Le triomphe du Génie est d'un autre genre. Ses vraies conquêtes sont sur l'Erreur; c'est à ce prix qu'il aura dorénavant accès dans le temple de la Patrie. Tel est le sens du groupe qui termine la partie à gauche du fronton: on y voit le génie de la Philosophie, armé du flambeau de la Vérité, qui combat l'Erreur et le Préjugé. L'artiste les a représentés sous la forme du griffon, animal chimérique qui, dans le langage de l'allégorie est devenu le symbole de l'Erreur; l'un d'eux recule à la lueur du flambeau qui détruit les prestiges, l'autre expire sous les pieds du Génie; le char auquel ils étaient attelés offre, renversé et culbutés, tous les emblêmes des diverses superstitions. Le *lituus*, les tables hiérogly-phiques, les instruments des mystères, le trépied sacré, tous ces signes qui ont si longtemps abusé l'imagination en trompant les sens, rendent, dans leur chute, hom-mage au génie de la Raison, et occupent la partie la plus rampante du fronton" (Chenevière, 1880, 503–4).

43. Gramaccini, *Moitte*, 1993, 90, speaks of an early "cubism" and of the Club Révolutionnaire des Arts' belief that the line and the circle were sufficient for the expressive needs of an artist.

44. The titles are *Patriotism Receiving the Crown and Expressing Gratitude, Patriotism Fighting for the Homeland, Patriotism Making an Offering to the Homeland* and *Patriotism Dying for the Homeland*, all at the Musée Carnavalet. Recent scholarship has wavered back and forth, now giving them to the sculptor, Simon-Louis Bocquet (1750? – 1814?), who collaborated on the Hôtel de Salm with Moitte and Roland in 1784 (*La Révolution Française, Le Premier Empire: Dessins du Musée Carnavalet*, Musée Carnavalet, Paris, 1982, 18–19), and back again to Moitte (Gramaccini, "Moitte," 1989, and *Moitte*, 1993, 85–86).

45. Michel Gallet, "Un Modèle du sculpteur Claude Ramey pour la décoration révolutionnaire du Panthéon," *Bulletin du Musée Carnavalet*, 1948–67, no. 1, June 1965, 18–19, traces the history of the relief.

46. See Biver, *Fêtes*, 103, for the original order of the reliefs for the peristyle. Chaudet's relief now occupies center stage.

47. T.B. Emeric-David, *Histoire de la sculpture française*, Paris, 1853, 204. Emeric-David, incidentally, discovered in both Goujon and Moitte rivals of Glycon, noting of the former that, "il lutte avec Phidias dans ses Caryatides, et avec Glycon dans ses frontons du vieux Louvre" (*Histoire*, 169) and of the latter, "L'énergie de Glycon était plus conforme à son naturel que la délicatesse de Cléomènes" (ibid., 202).

48. René Schneider, "L'Art Anachréontique et Alexandrin sous l'Empire," *Revue des études Napoléoniennes*, IX, no. 2, 1916, 257–71, explores the continuing erotic,

feminine facet of art in opposition to David's "virilism." Moitte's female allegory having been *Legislation*, he chose *Moses* as one of the first lawgivers. Napoleon's name appears on the tablet as a reference to him as legislator.

49. "Fontainebleau s'éleva, comme les jardins d'Armide, au sein des déserts: édifice superbe, qui renferme cinq Palais dans son enceinte! asile des plaisirs et de la gloire, où les Rois se disputèrent le luxe et les Artistes de talents! On vît sortir de l'école du Rosso et du Primatice, Simon Leroy, Dorigny, Lérambert, Charmoy, Dubreuil, Jean Cousin, homme étonant pour le siècle où il parut, Peintre, Architecte, Statuaire à l'exemple de Miche-lange, et Frémiet, qui, trop séduit par les Tableaux de ce dernier, força les attitudes de ses figures et s'écarta de la belle et simple Nature. On vit Jean Goujon porter la Sculpture du Bas-relief à un degrès qu'on n'a pas encore atteint depuis, et qu'on ne surpassera probablement jamais" (J.B. Chaussard, *Le Pausanias français* [1806], Paris, 1808, 30).

50. See Patricia Tanis-Sydney, *Monuments to Artists in France, 1800–1914*, Ph.D., University of Pennsylvania, 1982, 30 and 305: "Vous, Goujon et Cousin, dignes fondateurs de l'école Française, vous avez aussi agrandi les arts, et l'érection de vos tombeaux est une dette que j'ai voulu payer en faveur des siècles à venir."

51. Christiane Aulanier, *La Salle des Caryatides (Histoire du Palais et du Musée du Louvre)*, Paris, 1957, gives the history, as its title implies, of the room in question. See 111 for Lemot.

52. C. P. Landon, *Salon de 1810, Annales*, 1810, 92: "Ce bas-relief, dont l'auteur paraît avoir cherché le style de l'école florentine, ou plutôt du célèbre Jean Goujon, le premier des sculpteurs français, vient d'être exécuté en pierre."

53. The initiative to create these galleries dated back to 1816, with one gallery ready by 1817. See Louis Coura-jod, *Histoire du département de la sculpture moderne au Musée du Louvre*, Paris, 1894, 63.

54. G. Laviron and B. Galbaccio, *Le Salon de 1833*, Paris, 1833, 346, stated that the Caryatids were universally admired. In the same year, *L'Artiste* (V, 197) even compared the work of the delicate sculptor Antonin Moine (1796–1849) to Goujon's: "C'est au seizième siècle, à la cour de Louis XII ou de François Ier, qu'il devait naître et vivre, car entre tous les âges de l'histoire il n'a choisi ni la Grèce de Périclès et de Phidias, ni la Rome des Tra-jan et des Antonins, ni les hardies créations de cet autre Phidias de Marseilles, de Pierre Puget; il a choisi la France de Jean Goujon, du rénovateur de la sculpture française, de celui que nous pouvons sans crainte opposer à Ghiberti, à Michelange, à qui nous devons les cariatides du vieux Louvre, l'Hôtel Carnavalet, la fontaine des Innocens et la Diane." The comparison is

slightly off-key, however, since Moine's Goujonism was one of historicism or modishness (e.g., *Dame du XVIè siècle*) rather than one of profound stylistic identification. But this alters nothing in the relevance of the passage to the general taste for Goujon. In 1831, in *L'Artiste* (III, 50), the art of both Phidias and Sarrasin is mentioned in one breath as "éternellement un art antique." When François Benoît published *L'Art français sous la Révolution et l'Empire* (1897), 65, he fell in with the fashion: "Au XVIè siècle, nos sculpteurs ne surpassèrent-ils pas leurs rivaux transalpins? Jean Goujon, en particulier, 'n'a pas eu d'égal, au moins chez les modernes par l'application de la sculpture aux monuments de l'architecture'; jamais artiste 'ne fut plus près des chefs d'oeuvre de l'antique.'" Benoît gives no sources for his quotations.

55. *Galerie David d'Angers*, catalogue by Viviane Huchard, Angers, 1984, 100.

56. See Caso, *David d'Angers*, 1988, 85. In mitigated form, he would have the opportunity to re-create Ingresque women in the reliefs for the Arc de Triomphe of Marseilles inaugurated in 1835.

57. See *Statues de chair: Sculpture de James Pradier*, Geneva, 1986, 123, and Jacques de Caso, "Remarques sur l'invention de Pradier," *Zeitschrift für Schweizerische Archäologie und Kunstgeschichte*, v. 38, 1981, no. 2, 112.

58. *Statues de chair*, 123.

59. Ibid., 29.

60. David Mower, "Antoine Auguste Préault," *AB*, LXIII, June 1981, 299.

61. Charles Millard, to whom I am grateful for having allowed me to read his dissertation, mentions Préault's taste for Goujon in *The Life and Work of Auguste Préault*, Ph.D., Harvard, 1983, II, 92, in his catalogue entry for the *Ophelia*. He also notes the impact of David d'Angers' sketch of *Gilbert Mourant* (93) and Delacroix's *Ophelia* (94). *Skulptur aus dem Louvre*, 1990, 76, juxtaposes Louis Dupaty's *Biblis Changed into a Fountain* (1819–24) with the *Ophelia*.

62. Isabelle Leroy-Jay Lemaistre, "Romantisme," *La Sculpture française au XIXè siècle*, 320, compares the relief to funerary reliefs like that of André Blondel de Rocquencourt's in the Louvre.

CHAPTER 4

1. John B. Halsted, ed., *Romanticism*, London and Melbourne, 1969, 15, coined this phrase.

2. On the trying nature of copying, Chardin told Diderot, "Vous n'avez pas été témoin des larmes que ce Satyre, ce Gladiateur, cette Venus de Médicis, cet Antinoüs ont fait couler" (Seznec, "Hercule et Antinoüs," *Essais sur Diderot*, 34).

3. F. Benoît, [1897] 1975, 209–10, summarizes the prevailing curricular requirements. Le Normand, 1981, 42–43, summarizes the curricular requirements of the Academy according to the "Ordonnace du 26 janvier, 1821."

4. Canova did nonetheless execute a few small-scale copies in the period of his early training.

5. Licht, *History of Western Sculpture*, 21.

6. Haskell and Penny, 1981, 103.

7. Dec. 11, 1780. *Reynolds' Discourses on Art*, ed. Robert Wark, New Haven and London, 1974, 178.

8. See below, Chap. 9.

9. H.W. Janson, "The Autonomous Fragment," *James A. Mellon Lectures*, National Gallery, Washington, D.C., 1974, begins the study of this question. These lectures have not yet been published.

10. Seymour Howard, *Bartolommeo Cavaceppi, Eighteenth-Century Restorer* (Ph.D., University of Chicago 1958), Garland Press, New York and London, 1982, is the single most important documentary work on the sculptor. See also Howard, "Bartolomeo Cavaceppi and the Origins of Neo-classic Sculpture," *AQ*, XXXIII, 1970, 120–33, for a brief account of his significance and rise to prominence. The exhibition catalogue, *Cavaceppi*, Heim Gallery, London, 1983, adds to Howard's work. Orietta Rossi Pinelli, in "Artisti, falsari o filologhi? Da Cavaceppi a Canova, il restauro della scultura tra arte e scienza," *Il Neoclassicismo tra rivoluzione e restaurazione, Ricerche di Storia dell'arte*, XIII–XIV, 41–56, provides an overview of the changes in and guiding principles of restoration during this period. See also Carlos Picon, "Bartolommeo Cavaceppi: Eighteenth-Century Restorations of Ancient Marble Sculptures from English Private Collections," Clarendon Gallery, London, 1983.

11. Pinelli, "Artisti," 42, 47 and 52, discusses Cavaceppi's concern with stylistic integrity and the new guidelines for acquisitions under Canova, one of which was artistic "purity."

12. Honour, "Vincenzo Pacetti," *Connoisseur*, CXLVI, Nov. 1960, 174ff, gives a succinct biography (with catalogue and bibliography) of this artist. Pinelli, "Artisti," 43f, also analyzes his methods as a restorer. His success may be judged from contemporary criticism: for example, the *Giornale delle Belle Arte*, no. 22, June 4, 1985, 169, had very high praise for his *Calipygian Venus*. On the nature of decorative stuccos and their contribution to early neoclassicism, see Klaus Perlasca, "Motive antiker Stützfiguren an Kaminen des Frühklassizismus," *Zeitschrift für Kunstgeschichte*, XXXVII, no. 3–4, 1974, 269–83.

13. See Honour, "Vincenzo Pacetti," 174. The prize was for the Concorso Balestra at the Academy of St. Luke.

14. See Haskell and Penny, 1981, 295, "Pasquino." There is

some discussion over who influenced whom. Nancy L. Pressly, *The Fuseli Circle in Rome*, Yale Center for British Art, New Haven, 1979, 20, states that Sergel influenced Pacetti. In *John Tobias Sergel*, 1975, 33, Sergel's model is dated 1775, Pacetti having won the Concorso in 1773.

15. Count Leopoldo Cicognara, *Storia*, VII, 76.

16. John Thomas Smith's *Nollekens and His Times* (London, 1828), London, 1895, is the fullest, if negatively biased, account of his life. See Whinney, 1964, 165–70, Gunnis, 1953, 276–79.

17. Nollekens took elaborate measurements of the *Medici Venus* in 1770. David Irwin, *Winckelmann: Writings on Art*, London, 1972, 22, says of the drawing in the Walter Brandt Collection that preserves these measurements that it was "representative of many meticulous studies of antique sculpture made in the eighteenth century." Whinney, 1964, 159, mentions Florentine mannerism as another influence upon Nollekens' style. This is significant inasmuch as it points to an early interest in mannerism so visibly important to Fuseli and those around him.

18. Smith, *Nollekens*, does indeed portray a wretched, miserly spirit behind a considerable talent, though the portrait may have been accentuated through the ill will Smith bore Nollekens.

19. *Gentleman's Magazine*, Aug. 1823, 167 (from the Courtauld's Witt Library, press clipping, file VIII, 1083).

20. The *Arts*, "Sculpture," 1790 (Witt Library press clipping).

21. Sarah Symmons, "The Spirit of Despair: Patronage, Primitivism and the Art of John Flaxman," *BM*, CXVIII, Oct. 1975, 644.

22. See Pressly, *The Fuseli Circle*, passim.

23. A number of works exist on Wiedewelt's career, the most recent and accessible being Karl Wilhelm Tesdorpf's *Johannes Wiedewelt*, Hamburg, 1933. See also Frederick Julius Meier, *Efterretninger om Billedhuggern Johannes Wiedewelt og om Kunstakademiet paa Hans Tid*, Copenhagen, 1877; Theodor Oppermann, *Kunsten i Danmark under Frederick V og Christian VIII*, Copenhagen, 1906, 79ff; Karl Justi, *Winckelmann und seine Zeitgenossen*, Leipzig, 1923, II, 25ff, and Kamphausen, 1956, 51–53. Rosenblum, *Transformations*, 148, fn. 9, mentions him as a northern precursor of radical trends. H. W. Janson, *Nineteenth-Century Sculpture*, 1985, devotes several pages to him. Wiedewelt studied in Paris with Coustou from 1750 to 1754 before traveling to Rome. He was probably well acquainted with, for example, Girardon's *Tomb for Cardinal Richelieu* whose mood if not composition had some bearing on Wiedewelt's work.

24. Thorvaldsen returned to Copenhagen for a visit in 1819–20 and definitively in 1838.

25. *Alexander Trippel: Skulpturen und Zeichnungen*, Museum zu Allerheiligen, Schaffhausen, 1993, is the most recent work on the sculptor and tends to confirm H. W. Janson's assessment of his talent (*Nineteenth-Century Sculpture*, 59). But he remained an influential figure all the same. See also C. H. Vogler, "Der Bildhauer Alexander Trippel am Schaffhausen," *Schweizerisches Künstler Lexikon*, Frauenfeld, 1913, III, 330–32, and Thieme-Becker, *Allgemeines Lexikon*, XXXIII, 406. Hautecoeur, *Rome et la renaissance*, 169, 190–91, 206 and 231, mentions him in various contexts as a dominant personality, though his actual influence upon artistic developments remains vague. Hubert, *La Sculpture dans l'Italie Napoléonienne*, 46, mentions his studying with Pigalle, Houdon and Sally in Paris from 1771 to 1774, adding that he was considered Canova's great rival, but Hubert contributes little to our general knowledge of Trippel's real impact. He was, in any case, largely overshadowed by Canova in the eyes of the French.

26. Reproduced in *Alexander Trippel*, 1993, fig. 21.

27. Pressly, *The Fuseli Circle*, 17–27, offers the most contextual information on Sergel in Rome. The best relatively recent works on Sergel are *Johan Tobias Sergel*, Hamburg Kunsthalle, Hamburg, 1975, with an excellent bibliography (187ff) and *Sergel Tecknar*, Stockholm National Museum and Thorvaldsen Museum, Copenhagen, 1976. See also Ragnar Josephson's important *Sergel's Fantasi*, Stockholm, 1956. Elvy Setterquist O'Brien, *Johan Tobias Sergel (1740–1814) and Neoclassicism: Sculpture of Sergel's Years Abroad, 1767–1779*, Ph.D., University of Iowa, 1982, brings together useful information. The more recent catalogue, *Sergel*, Stockholm, Nationalmuseum, 1990, recapitulates the major facts of his career.

28. See, among others, Oskar Antonsson, "Johan Tobias Sergel," *BM*, LXXXIII, Dec. 1943, 293, and *Clodion*, 1992, 30.

29. See O'Brien, *Johan Tobias Sergel (1740–1814)*, 32–33, 37–38.

30. Cicognaria, *Storia*, VII, 76. He makes a few mistakes however: Sergel did not become a member of the French Academy and never presented his *Cupid and Psyche* to gain entrance.

31. Björnstahl, Sergel's close friend, wrote these words (Pressly, *The Fuseli Circle*, 19).

32. See *Age of Neo-classicism*, 281.

33. See Sergel, "Autobiography," *Johan Tobias Sergel* (1975), 81.

34. The *Altar of Pergamon* (ca. 180 B.C.) was not known at the time but the figure belongs to that tradition.

35. See Schiff, *Johann Heinrich Füssli*, 1973, 91 and fig. 372 cf.

36. See *Clodion*, 21–22 and 128, for a discussion of the date of creation either immediately before or after the begin-

ning of his Roman stay. The work was shown at the 1773 Salon. The French antecedents of the work are emphasized (13) in the catalogue, such as Dumont's *Titan Foudroyé* (1712) and N. S. Adam's *Prometheus* (1738). Deshays's *Hector exposé sur les rives du Scamandre* (1759) seems a little remote in spirit and form.

37. See most recently *Clodion*, 30.

38. Ibid., 28–29.

39. Sergel wrote of his sadness to his friend Nicolai Abildgaard, the painter (*Johan Tobias Sergel*, 104). He did return to Rome as cicerone to Gustavus III in 1783–84.

40. Deloynes, XI, no. 205, *Le Visionnaire*, 1777, 221.

41. He sketched the fencers he saw there while preparing for the *Diomedes*. Dyveke Helsted, "Sergel and Thorvaldsen," *The Age of Neo-classicism*, lxxxiv. See also 281.

42. Pressly, *The Fuseli Circle*, v.

43. Alfred Kamphausen, *Deutsche und Skandinavische Kunst, Begegnung und Wandlung* Schleswig, 1956, 47.

44. See *Johan Tobias Sergel*, 109, no. 12, for a drawing of *François André Vincent* by Sergel. Sergel included on the same sheet Jean Simon, J. Berthélémy, Le Bouteux and J. B. Suvée. He in turn was included in a caricature by J. B. Stouf (engraved by Francoville) which depicted many of the artists associated with the French Academy (see Pressly, *The Fuseli Circle*, 26).

45. See John Gage's review of the "Kunst um 1800" exhibitions, *Studies in Romanticism*, XV, Summer 1976, 484, for a few pertinent comments on Rome and Whilhelm Tischbein's *Aus Meinem Leben*, Berlin, 1922, 123f.

46. This was his nickname (Kamphausen, 1956, 46).

47. Charles Bell's *The Annals of Thomas Banks*, Cambridge, 1938, is the single most useful source for Banks, though it is limited to the presentation of documents relevant to his life. See also Whinney, 175–82, and Gunnis, 37–40. Pressly, *The Fuseli Circle*, 48–53, provides more recent observations on his development within the Fuseli circle.

48. As his earlier relief the *Death of Epaminondas* (1763) in Portland stone, and *The Redemption of the Body of Hector* (1765) have disappeared, it is impossible to gauge the extent of his progress before his arrival in Rome. The ground covered between the *Alcyone and Ceyx* and *Germanicus*, however, confirms that Banks arrived at his fully mature style while abroad. Rosenblum, *Transformations*, 30–31, sets Banks' *Germanicus* within the context of the "international" mourning scene (28ff), citing Gavin Hamilton's *Andromache Mourning Hector* (1764) as a chief precedent.

49. The relief, which was then thought to be ancient, is now thought perhaps to be a forgery (see Guido Mansuelli, *Galleria degli Uffizi – Le Sculture*, Rome, 1958, vol. 1, 178–79).

50. Drawing of *Samuel and the Witch of Endor* (1777; Schiff, 1973, I, 91, no. 372).

51. There was another English sculptor in Rome during a slightly later period (1783–98), John Deare (1759–98), whose excellent work is worthy of sustained attention. But what flagstone he laid on the path leading to the sculptural "tabula rasa" is as yet hard to determine. Though he explored Miltonic subjects as early as 1777, he seems not to have evolved a style as radical as Banks' or Flaxman's. His drawings reveal an intimacy with the more dramatic inclinations of the English circle, but his known sculptures never exceed the limits of a pleasant, well-formed neoclassicism however technically refined and appealing they are. Canova thought well of this scrupulous anatomist, testifying to the latter's significance in the artistic community. But, to my knowledge, no reference to him in available French documents exists illuminating an artistic bond between Deare and the French sculptors in Rome. See Gunnis, 123–24; Hubert, *La Sculpture dans l'Italie Napoléonienne*, 49.

CHAPTER 5

1. Michel N. Benisovich, "Drawings of the Sculptor Augustin Pajou in the United States," *AB*, XXXV, no. 4, Dec. 1953, 297.

2. Rosenblum, *Transformations*, 39ff, provides an extended discussion of the rise in popularity of the virtuous widow within the context of the "exempla virtutis."

3. See Lami, 18C, I, 308–09. After these reliefs, Dupasquier, a pupil of Bridan, disappears for about ten years, exhibiting again in 1791 and working on the Pantheon, Vendôme column, Arc de Triomphe and the Palais du Corps Législatif. Jacques de Caso, "Jacques-Louis David and the Style 'all'antica'," *BM*, CXIV, Oct. 1972, 690, revived Dupasquier's reputation with a discussion of these two reliefs.

4. Lami, 18C, I, 308.

5. Caso, "Jacques-Louis David," 690.

6. Conjugal Love was probably carved by Pierre Julien while an apprentice to Coustou (see Pascal, "Pierre Julien," 1903, 24). See also Kalnein and Levey, 79 and 365, fn. 11. Cochin and Diderot contributed ideas to the program.

7. Hargrove, 24, mentions that the work was roundly criticized for its extravagant detailing.

8. Dorothy Johnson, "Corporality and Communication: The Gestural Revolution of Diderot, David, and the *Oath of the Horatii*," *AB*, March 1989, LXXI, no. 1, 92–113, 109, offers this translation of Buffon's text. In this context, the word "carrée" does not exactly mean "square," though, as much as "broad and straight." She addresses the new interest in the expressiveness and

clarity of the body in painting in the 1780s, long advocated by Diderot.

9. See Stein, *Pajou*, 250ff.

10. Mechtild Schneider, "Verlassenwerden-Verlassensein. Zur Darstellung des Liebesschmerzen in der französischen Skulptur des späten Ancien Régime," *Pantheon*, XLVIII, 1990, 110–22, 204. She gives a variety of sources for the iconography and form.

11. Johnson, "Corporality and Communication," 1989, draws attention to the important exchange between Diderot and David on the communication of feeling through form, which reached such a peak in the *Oath* (1784).

12. Stein, *Pajou*, 206f, offers no date (Burat collection). The Metropolitan Museum in New York houses a beautiful terracotta version dated to 1768–70. The attribution of the Washington Gallery's *Calliope* is still in debate (see Ulrich Middeldorf, *Sculptures from the Samuel H. Kress Collection: European schools, XIV–XIX Century*, New York, 1976) and so I do not include her here as a work by Pajou, although she resembles the *Ceres* and other works in a number of ways.

13. H. H. Arnason's monograph, *The Sculpture of Houdon*, London, 1975, is the best up-to-date view of Houdon's art. Though much remains to be done to set Houdon within the broader context of French and European sculpture, Arnason outstrips Réau's *Houdon: Sa Vie et son oeuvre*, Paris, 1964 (2 volumes) in this respect. Though the latter's rich documentation, however, is indispensable, as is Georges Giacometti's *La Vie et l'oeuvre de Houdon*, Paris, 1928.

14. One example preserved at the Rhode Island School of Design Museum, Providence, shows an interest in gloomy tomb scenes with despondent women: *Project for a Tomb to Monsieur Guillard*, 1774 (reproduced by Arnason, *Houdon*). The composition is not particularly classical.

15. See Réau, *Houdon*, 482. According to André Michel, "Exposition Universelle de 1889," *GBA*, 3è période, II, 1889, 287, fn. 66, Legrelle and Delerot had access to a collection of letters which have disappeared.

16. Réau, *Houdon*, 498. The accomplishments of which he was most proud were his technical and anatomical advances, the *écorché* heading the list.

17. Natoire, still director of the Academy, obtained a copy of the *écorché* for the school. It subsequently became the standard art school anatomy model, though others had existed before it. Réau, *Houdon*, 204ff, gives a short history of *écorché*s while both Locquin [1912] 1978, 216ff, and Benoît [1897] 1975, 216ff, trace the history of the study of anatomy, underlining thereby the importance of Houdon's achievement. Arnason, *Houdon*, 14, compares the *écorché/St. John* to the ancient works mentioned above. He and others also compare it to Michelangelo's *Christ*. Réau, *Houdon*, 212, finds this to be an overrated idea. The classical examples, in any case, are more compelling.

18. The difficulties of bringing a manifestly pagan vocabulary to Christian subjects grew in proportion to its dogmatic application. Canova's *Lamentation* (1821, Gipsoteca, Possagno) remains problematic for that very reason. The question of Christian iconography and classical style is treated in part in *Christian Imagery in French Nineteenth-Century Art: 1789–1906*, eds. Martin L.H. Reymert and Robert J.F. Kashey, Shepherd Gallery, New York, 1980, 5f especially.

19. The drawing is preserved at the Museo Civico di Bassano which has the largest holding of drawings by Canova in the world. Canova confirmed his admiration of Houdon's work in a letter of Feb. 17, 1817, to his friend Cicognara, in which he specifically remembered the *Saint Bruno* and the *Ecorché* with its extended arm. See *Un amicizia di Antonio Canova: Lettere di Lui al Conte Leopoldo Cicognara*, ed. Vittorio Malamani, Citta di Castello, 1890, 86.

20. Hubert, *La Sculpture dans l'Italie Napoléonienne*, 269. The work was inaugurated in Venice in 1811 and removed by the Austrians in 1814.

21. See Réau, *Houdon*, 211–12.

22. Arnason, *Houdon*, 11, notes the classical source for the *Vestal*, the Capitoline *Psyche*. The latter is in fact a *Priestess Carrying a Vessel* (see H. Stuart Jones, *The Sculptures of the Museo Capitolino*, Rome, 1969, 345 and pl. 86). In the catalogue *Sculptures by Houdon*, Worcester Art Museum, Worcester, 1964, 22f, Arnason writes: "If there is any truth in the story that during the Revolution Houdon, inspired by his resourceful wife, transformed a statue of Saint Scholastica into a figure of Philosophy in order to escape suspicion of religious leanings, it can be understood when one examines the marble *Vestal*. She could serve equally well as a priestess of antiquity or a mediaeval saint." Arnason, *Houdon*, 14, also comments on Houdon's general classical sensibility, opposing his "classical idealism" to "neoclassicism."

23. See Anne Poulet, *Clodion Terra-cottas in North American Collections*, The Frick Collection, 1984, 12. The Piranesi-Clodion connection is made in ibid., 28–29.

24. Poulet, ibid., 10, also notes this, finding a very exact borrowing of the tripod from this painting by Clodion for his *Vestal Sacrificing*.

25. See *Clodion*, 1992, 94ff, 105ff, and 199ff.

26. Anne Poulet, *Clodion Terra-cottas*, 135, suggests a date either just before his departure for or his arrival in Rome and offers the *Mars Ludovisi*, the *Torso Belvedere* and Michelangelo's *Day* as sources, in addition to the *Perseus* (Senate, Palais du Luxembourg) restored by L.-S. Adam. See also 15–16.

27. Arnason, *Houdon*, 18, notes the model-like specificity of the hair. Réau, *Houdon*, 222–23, gives its critical reception. Among others, Diderot found it to be too academic, a sign of its novel accomplishment. Quatremère, *Recueuil de notices historiques*, 393, perceived in the *Morpheus* qualities prophetic of a regeneration of style – words of high praise.

28. As Bouchardon's pupil, he may have known his teacher's terra-cotta relief of a weeping woman "dans le goût de l'antique" belonging to Lalive de Jully (see Jordan, "Edmé Bouchardon," 1985, 390, for a reference to this work) executed for the monument to the young duchess de Lauragais in 1736.

29. Arnason, *Houdon*, 45 (fig. 67).

30. See ibid., 49–52, and Réau, *Houdon*, 55 and 272ff, for the complete history of the monument.

31. "On aurait dans Ephèse admiré ton ouvrage [*Diana*]/ Rival de Phidias, ingénieux Houdon / A moins que les dévots en voyant ton image / N'eussent craint le sort d'Actéon" (André Michel, 1889, 282).

32. Comments such as "one could take it for an antique" or "the majesty and style of Rome" appeared (*The Age of Neo-classicism*, 1972, 253–54).

33. *Clodion*, 348ff. Clodion's name was not among the first chosen; Pajou and Julien got first choice on the subjects.

34. See ibid., 352ff for ancient sources and comments on the iconography.

35. Quatremère, *Receuil de notices historiques*, 287. André Michel is quick to point out the biased nature of Quatremère's perception.

36. Joachim Le Breton, *Notice historique sur la vie et les ouvrages de Pierre Julien*, Paris, 1805, refers to him as "le rénovateur de la statuaire" while Julien's biographer, the Abbé Pascal, "Pierre Julien," *GBA*, 325, unjustly writes, "Caffiéri, Houdon, Pajou se contentent de bien rendre la vie dans toute sa vérité. . . . L'esprit antique n'a point embrassé l'oeuvre de ces artistes."

37. Most recently, the work has been discussed in *Skulptur aus dem Louvre*, 39, no. 6.

38. André Pascal's *Pierre Julien*, Paris, 1904, is the only published monograph to date on the sculptor. A characteristically useful tool, it lacks contextual perspective and offers no discussion of theoretical matters. More recently (1986), Michael Preston Worley has written a doctoral thesis on the sculptor. Worley offers some useful information, but the definitive work remains to be written. Hautecoeur, *Rome et la renaissance*, 188, believes Julien to derive more inspiration from antiquity than does Houdon. See also Kalnein and Levey, 80. The plaster fragments of his reliefs for Sainte Geneviève were discovered several years ago and published by Guilhem Scherf, "Pierre Julien et le décor sculpté de l'église Sainte Geneviève à Paris," *Revue du Louvre*, 38/2, 1988, 127–37.

39. *Funérailles de M. Moitte, le 3 mai, 1810*, Paris, 1810, 3. Gisella Gramaccini's *Jean-Guillaume Moitte – Leben und Werk*, Berlin, 1993, is the most recent and best account of his life. A short article derived from its contents appeared in *Revue de l'Art*, 1989, 61–70: "Jean-Guillaume Moitte et la Révolution française." Richard James Campbell's dissertation, 1982, is a first attempt to gather the available material on the sculptor during the height of his career. For basic information, see Lami, 18C, II, 164ff.

40. See Diderot, *Salons*, III, 1767, 342–45 and Rocheblave, *Pigalle*, 101–02.

41. In 1784, while in Rome, David reported dining with the Moittes (Wildenstein, 1973, 17, no. 132). A portrait drawing of Moitte by David is preserved at the Ecole des Beaux-Arts. See also Gramaccini, *Moitte*, 1993, throughout.

42. Lami, 18C, II, 167.

43. See Gramaccini, *Moitte*, 1993, 53–54.

44. Moitte actually used a cast of the astronomer's face for the portrait (Furcy-Reynaud, 1927, 215–17). Gramaccini, *Moitte*, 1993, 55ff, offers a full account of the commission.

45. Henri Thirion, *Le Palais de la Légion d' Honneur: Ancien Hotel de Salm*, Versailles, 1883, 76–77, gives the details of the commission. See Gramaccini, *Moitte*, 1993, 25ff and vol. II, 40, for a more extended discussion.

46. These statues, replaced in turn by recent replicas, are now at the Maison de l'éducation de la Légion d'Honneur at St. Denis. The catalogue, *Bicentennaire de l'Hôtel de Salm*, Musée National de la Légion d'Honneur, Paris, 1983, 170–73, offers further details on the Hotel.

47. See *Autour du néoclassicisme*, Galerie Cailleux, Paris, 1973, 82.

48. Gramaccini, *Moitte*, 1993, speaks unconvincingly of Moitte's stylistic changes, mentioning a distancing from Pigalle's so-called "thickset, muscular types" (25). The proportions do change (and even here there is room for discussion), but Moitte's predilection for heavily muscled figures never ceases.

49. See *Autour de David: Dessins néo-classiques*, 164–65. Gramaccini, *Moitte*, 1993, gives this new date, vol. II, 23.

50. See *Le Néo-classicisme français*, 1975, 98, and Gramaccini, *Moitte*, 1993, vol. II, 38, no. 78ff.

51. Gramaccini, *Moitte*, 1993, 102, vol. II, 83, identifies this as the subject.

52. For the available information on Sergel's friendship with the French, see his "Autobiography," *Johan Tobias Sergel*, 82. One knows that Suvée was a friend of Sergel from the drawing mentioned above. His name, however, fails to appear in the list of artists whom Sergel met abroad and whom he considered to be outstanding:

Julien de Parme, Mengs, Pompeo Battoni; in Paris, Gibelin (*sic*), David, Vien, Vernet, Hall, Roslin, Robert, Pajou, Clodion, Houdon, Algrin (Allegrain), Gondoin, Ledoux; in London, Reynolds, West, Bacon, Banks, and Chambers. As Fuseli's and Suvée's names do not appear, it may be inferred that Sergel had a larger group of acquaintances than that listed. Moitte may also have been among the unnamed. Ragnar Josephson's (*Sergel's Fantasi*, 1956, II, 546–47) comparison of a drawing (ca. 1800; fig. 131) in preparation for a monument by Sergel to one of Moitte's 1784 terra-cotta statuettes for the Hôtel de Salm is the only previous instance of a linking of these artists' names. In this case the similarity is of a generic rather than specific kind and the direction of the influence is reversed, going from Moitte to Sergel. According to Tornten Gunnarson, Nationalmuseum, Stockholm, there is no other mention in the Sergel literature, or documentation of an artistic bond. Gramaccini, *Moitte*, 1993, does not mention Sergel.

53. *La Henriade II, Studies on Voltaire and the Eighteenth Century*, XXXIX, Geneva, 1965, Chant X, lines 281–332.

54. Ibid., lines 179–234.

55. On the popularity of this sort of tenebrism see *De David à Delacroix*, 612–13.

56. See *Louis Boilly 1761–1845*, Musée des Beaux-Arts, Lille, 1988, 46, and Susan L. Siegfried, *The Art of Louis-Léopold Boilly*, Yale, New Haven, 1995, 45. Siegfried discusses the new and darker character of Boilly's work in light of the 1794 National Art Competition.

57. *Le Néo-classicisme français*, 1975, 98.

58. Gramaccini, *Moitte*, 1993, 102–03, and vol. II, 83–84. She notes that next to the drawing is inscribed the erroneous title of the subject with "Motte [*sic*], sculpteur du Roi." If this were a contemporary inscription, the drawing would at least have to antedate the death of Louis XVI.

59. Reproduced in Gramaccini, *Moitte*, 1993, vol. II, fig. 193.

60. Gramaccini, *Moitte*, 1993, fig. 291, private collection.

61. Ibid., vol. II, 84, suggests that the drawings represent War and Famine from the Four Plagues. This kind of apocalyptic, biblical reference might have appeared more readily before the anticlericalism of the Revolution.

62. Gramaccini, *Moitte*, 1993, 25, and vol. II, no. 118, dates the group to c. 1785–92, but the discussion of style leaves plenty of room for debate. The proportions of Love do not necessarily place this work later in his oeuvre. He used elongated proportions as early as the *Cephalus and Procris* of 1771–73, or the figures for a candelabra (1775) in the Moatti Collection (ibid., color plate 1). And the theme is one more likely to have been treated by Moitte before the Revolution than after. It emerges from the figural style of *Jupiter Receiving Venus* (1780).

63. C. F. Bell, "Sergel and Neoclassicism," *BM*, LXXXIII, April 1944, 293.

64. Houdon was vexed at not having automatically received the commission on the basis of the death mask he had taken. See Paul Vitry, "Les Monuments à J.-J. Rousseau de Houdon à Bartholomé," *GBA*, 4è période, VIII, Aug. 1912, 108–09. See also Gramaccini, *Moitte*, 1993, 115ff.

65. François Masson's (1745–1805) less successful model, lacking both breadth of conception or formal strength, was ultimately chosen.

66. Gramaccini, *Moitte*, 1993, 112, brings together this material for the first time, clarifying some of the less obvious forces at work in the fate of this commission.

67. Gramaccini, *Moitte*, 1993, 115ff, lists various influences.

68. Zeitler, 1954, 73, did not see Sergel as an influence anywhere. Indeed, very little of his impact has been recorded by anyone.

69. Jean-Baptiste Giraud and Pierre-François Giraud are occasionally mentioned in the literature on the period, but no one has yet undertaken a complete study of their work or influence. An article by Meredith Shedd, derived from her unpublished Ph.D. thesis (1980), "A Neo-classical Connoisseur and His Collection: J. B. Giraud's Museum of Casts at the Place Vendôme," *GBA*, 6è période, CIII, May–June 1984, offers valuable information on his plaster cast and marble collection.

70. Paul Vitry, "'L'Achille Blessé' du sculpteur J. B. Giraud," *Bulletin des Musées*, 1923, 182. Gérard Hubert, *Les Sculpteurs italiens*, 39, writes of this work that it is "dans le goût des oeuvres de Sergel."

71. E.J. Delécluze, *Jacques-Louis David: Son école et son temps* (Paris, 1855), ed. Jean-Pierre Mouilleseaux, Paris, 1983, 130.

72. Wildenstein, 1973, 29, no. 216, 17 Sept. 1789: Letter to Wicar. See Hautecoeur, *Rome et la renaissance*, 48–52, for a brief discussion of J. B. Giraud.

CHAPTER 6

1. Blondel, 1887, 66. Blondel advises his reader that "il nous a paru à propos de signaler ce mouvement extraordinaire dans l'histoire de la sculpture française, d'autant plus qu'il a été méconnu volontairement et passé sous silence par la plupart de nos historiens d'art" (69). He adds that even if few works were executed, they contributed to a sense of moral grandeur, concluding with Renouvier's view that in all the works he mentions, "il y a . . . une grandeur de conception si général et une correction de formes et d'ajustements si reconnue, qu'on

peut affirmer que les siècles de la monarchie, à qui les temps ni la fortune ne manquèrent pas, n'ont rien produit d'aussi grand" (82). This presents an early if exaggeratedly revisionist position weakened by an absence of critical judgment and contextual analysis, the discussion being more a listing of ephemera.

2. The commission, Napoleon's "Ponte Sant'Angelo," dated to 1810 but was only carried out under Charles X and inaugurated in 1827 only to be dismantled again. The colossal statues, of which David d'Angers' *Grand Condé* was the most popular, obstructed everyone's view and were soon dispatched to Versailles and other towns of France.

3. When this last series was announced, sculptors deluged the officials in charge with individual and collective pleas for work (Benoît, [1897] 1975, 249), although there appears to have been, on this occasion, enough for even foreigners to be employed (Hubert, *Les Sculpteurs italiens*, 9).

4. The work was executed in perishable materials. Benoît, [1897] 1975, 162–64, gives a list of works undertaken between 1800 and 1814.

5. Charles Corbet complained to the government about its lack of assistance to the arts and sculpture in particular in 1796 (Leith, 1965, 137), while, in 1798, a critic who was to praise Chaudet's *Cyparissus* lamented the general state of affairs: "Cet art qui travaille pour l'immortalité, qui confie à la postérité les traits des grands hommes et dont les compositions se marient si naturellement avec celles de l'Architecture, est un de ceux que la révolution devait le plus enrichir et de sujets et de secours. Mais il languit, parce qu'il ne peut fleurir que par le très grand luxe des particuliers, ou par la protection spéciale du Gouvernement" (Deloynes, XX, no. 540). In 1799, Lange had sent his plaster *Philopoemen* to the salon hoping to receive financial encouragement to realize the marble group, but he was unsuccessful.

6. For David's role, see the classic study, Dowd's *Pageant-Master of the Republic: Jacques-Louis David and the French Revolution*, University of Nebraska Studies, New Series, no.3, June 1948.

7. Hubert, *Les Sculpteurs italiens*, 20, writes of the post-Napoleonic rupture between Italy and France as a blow to Canova's prestige in France and a change of stylistic orientation. At the same time, the considerable list of sculptors he considers not to have been affected by Canova indicates a resistance to the international style (57). The change of stylistic orientation was not as abrupt nor was Canova's reputation dramatically altered, since there had always been resentment toward his French commissions. It is true, however, that he received no more commissions from the French. James Leith (1965, 154–55) gives another instance in which this national and international question yielded conflict:

"Both the demand for [revolutionary] didactic art and the desire for national prestige [which would spare artists of doubtful political orientation rather than damage France's reservoir of artistic ability,] were utilitarian attitudes, but they did not necessarily coincide."

8. See, among others, Biver, *Fêtes*, fig. 50.

9. Benoît, [1897] 1975, 118, fn. 2, cites Quatremère, Delécluze and Landon as sources.

10. Quatremère, *Canova*, 113.

11. See Rosenblum, *Transformations*, 86, for the counterpart in painting. Madame Pajou participated in this donation as well.

12. Rosenblum, ibid., discusses the espousal of an imperial style under Napoleon in terms of both painting (95ff) and of architecture (129ff).

13. These first reliefs were to have ceded their place to reliefs by David d'Angers, Pradier and others (see Ruth Butler-Mirolli, *Nineteenth-Century French Sculpture: Monuments for the Middle Class*, J. B. Speed Art Museum, Louisville, Kentucky, 1971, 11). These plasters were installed in 1828 but the sculptors involved failed to ready the marbles before the revolution of 1830 which preceded a régime favorable to the glorification of Napoleon. Louis-Philippe ordered that the original marbles be immediately reinstalled. Nothing was done, however, to restore the bronze effigy of Napoleon standing in the quadriga atop the Arc de Triomphe. The subject of the new reliefs was the participation of France in restoring a Bourbon monarchy to Spain. See *Inventaire*, 252–54, for a complete listing of the original reliefs and the plaster substitutes. Patricia Sands, "The Sculptural Program of the Arc de Triomphe de l'Etoile and the Arc de Triomphe du Carrousel," Seminar Report, New York University, Institute of Fine Arts, Spring 1981, has analyzed the iconography of both triumphal arches.

14. Biver, "La Statue de la Paix de Chaudet," *Revue de l'Institut Napoléon*, no. 110, Jan. 1969, 189–93, traces the history of the work.

15. See the *Inventaire général des richesses de l'art de la France*, Paris, 1879, I, 345, for the details of the commission and execution. Biver, *Paris de Napoléon*, 1963, 167f, records the displeasure of the old academicians at being subjugated this way, and the attempts of one of their number to work in his own style, regardless of Bergeret's drawings. His reliefs were destroyed and replaced by the work of a more compliant sculptor.

16. René Schneider's *Quatremère* is an exhaustive account of Quatremère's role. Dowd, *Pageant-Master*, 69, questions Quatremère's having overseen the 1792 Fête de la Loi.

17. Quatremère, *Considérations*, 52–55 and 163.

18. This was projected for 1800. See Benoît, [1897] 1975, 162. Turenne's tomb was moved to the Invalides in the

same year. See also Biver, *Panthéon*, 104. The church of the Madeleine was briefly intended as a monument to military glory.

19. "En 1791, l'Assemblée Constituante avoit décrété une somme de 100 000 Livres applicable à des travaux d'émulation, qui devoient devenir le prix des Artistes vainqeurs à l'Exposition publique. Une partie de cette somme fut répartie en modèles de sculpture, dont le sujet étoit au choix des Statuaires. Ces figures pouvoient ne devenir que des objets d'études inhabiles à toute destination publique. J'ai engagé ceux qui en étoient chargés à faire tourner leurs talens et leurs efforts au profit de la décoration du Panthéon, en choisissant des sujets correspondant au motif du Péristile. Ces Artistes ont saisi avec zèle l'occasion de donner à leurs modéles une place si intéressante; et se sont concertés avec moi sur le choix du sujet et sur la proportion convenable.

Le Directoire a approuvé dans le tems voulu une mesure dans laquelle les Artistes, le Panthéon et la Chose publique, sont déjà faites et j'en place ici la description, quoique la totalité ne soit pas achevé" (Biver, *Panthéon*, 104).

20. See Schneider, *Quatremère*, 58; Biver, *Fêtes*, 51; Biver, *Panthéon*, 29; Dowd, *Pageant-Master*, 67–77. Berthault's engraving after Prieur's drawing is at the Musée Carnavalet, Paris.

21. Dowd, *Pageant-Master*, 69.

22. Ibid., 76.

23. Ibid, 70.

24. Salon catalogue, 1797, p. 66, no. 1007, gives this dimension.

25. Quatremère's extended description of *La Patrie* is as follows: "Ce seroit sous les traits et dans une attitude semblables à ces Colosses que la Richesse de la Matière et la Magie de l'Art savoit animer dans les Sanctuaires de la Grèce que devroit, selon moi, apparoître au fonds de notre Monument, le simulacre de la Patrie, cette véritable idole d'un peuple libre, et la vraie divinité du Temple qu'elle s'est choisi. Assise sur un trône, ses deux Génies tutélaires lui servant d'appui, l'un seroit la Liberté portant d'une main la pique surmontée de son signe caractéristique et lui présentant de l'autre ce Monument qui, après avoir été le symbole de l'Esclavage, est devenu l'emblème de sa destruction. Le bras gauche de la Patrie s'appuyeroit sur le génie de l'égalité, et offriroit aux yeux le niveau, vainqueur des préjugés, tandis que sa main droite soutenue par la Liberté élèveroit et feroit briller la Palme qu'elle réserve aux vrais Amis de la Patrie.

L'autel de la Patrie, élevé sur cinq marches, seroit placé au milieu de la Coupole, de manière qu'en entrant, il paroîtroit arrivé aux pieds du Colosse. Quelques épreuves ont été faites de cette composition, plutôt pour completter l'ensemble et arrêter l'imagination du spec-

tateur que pour devenir le modèle de ce qu'on pourra faire" (Biver, *Panthéon*, 112).

26. Gramaccini, *Moitte*, 1993, 97, offers evidence that political disagreements played a significant part in preventing Quatremère's ideas from materializing.

27. Mona Ozouf, "Le Panthéon, L'Ecole Normale des morts," *Le Lieu de la mémoire*, ed. Pierre Nora, Paris, 1984, Part I, vol. 1, 139–66, addresses the fate of the Pantheon and the inability of the French to agree upon appropriate candidates for burial there.

28. Philippe Contamine, "Mourir pour la patrie," *Le Lieux de la mémoire*, Part II, vol. 3, 31ff, summarizes the views of the Chancelier d'Aguesseau, shared by Montesquieu, that true patriotism could flourish only in a republic. Montesquieu also specifically recommended "couronnes, triomphes, oraisons funèbres, inscription, tombeaux, enseignes et spectacles" (32) to assist in building this sense of patriotism in the citizenry.

29. Maurice Agulhon, *Marianne au combat: L'Imagerie et la symbolique républicaine de 1789 à 1880*, Paris, 1979, speaks of the lower-class origins of the name "Marianne" and investigates how the use of such imagery shaped the political views of the French.

30. Gramaccini, *Moitte*, 1993, 8 (see also 226ff)

31. Salon catalogue (1798), no. 523. My italics.

32. Salon catalogue (1802), no. 436. Lorta received a Prix d'encouragement.

33. Salon catalogue (1802), 70, no. 426. My italics.

34. See *La Révolution française* (1982), 126. The catalogue speaks of "strangely baroque accents."

35. Lynn Hunt, *Politics, Culture and Class in the French Revolution*, Berkeley and Los Angeles, University of California Press, 1984, enters into an extensive discussion of the "language of ritual and ritualized language" of the Revolution and examines it not as a reflection of the times, but as a rhetorical force actually shaping the social and political world (24). She speaks of the repeated oath taking as a continual re-creation of the Revolution and social contract in a "mythic present." See also 44–46. I have extended this argument to sculpture.

36. See ibid., "The Imagery of Radicalism," 87ff, for a discussion of the lack of a "fictional center" in the Revolution and the search for a figure/image to fill it, as well as the relative identities ascribed to Marianne and Hercules at this and later times (passim).

37. David and Guy Wildenstein, *Documents complémentaires au catalogue de l'oeuvre de Louis David*, 70, no. 666, 1793. Philippe Sorel, "*Le Peuple français* de Chinard. Précision et hypothèse," *Le Progrès des Arts Réunis*, 353–61, discusses Chinard's use of writing on certain terra-cottas (e.g., *Perseus and Andromeda*, 1791) and which may have directly influenced David. His statuette of *Le Peuple français* (1794, Carnavalet,

Paris) bears words on the forehead (Lumière), arm (Force) and hands (Travail).

38. Agulhon, 1979, 100, refers to these Herculeses as images of positive reinforcement for the French who saw themselves as heroic through them. Hunt, 1984, 98f, also addresses the importance of Hercules, although (100) she perceives the manipulative nature of the image: "even as the image proclaimed the supremacy of the people, it reintroduced the superiority of the people's representatives" since they decided on how to represent the people to themselves.

39. Campbell, *Moitte*, 1982, 143ff, identified Moitte's project. A number of other gouache drawings by Moitte of large female Equalities or Liberties at the Cabinet des Estampes reveal his interest in creating colossal, propagandistic images. Gramaccini, *Moitte*, 1993, 107ff, covers the entire competition as well as Moitte's project and its ancient sources.

40. Espercieux's figure held the scepter and symbols of peace and of war in his hands, "to indicate that he addressed the Senate only to inform that body of treaties of peace and declarations of war" (Salon catalogue, 1808, 100, no. 689).

41. Réau, *Houdon*, I, 71, 431–32, briefly mentions the evolution of the commission. Pierre Julien's *Nymph with the Goat* had found its way into the Galerie du Sénat as well by 1803, indicating that it was also a repository for well-known if inappropriate sculpture.

42. For this recently rediscovered plaster, Clodion drew upon the marble *Portrait of Augustus* in the Louvre for its overall composition (and almost identical size), but bared the chest (*Clodion*, 348).

43. Landon, *Annales*, 1803, VII, 132, pl. 71; 1805, VIII, 229, pl. 55 and 39, pl. 16.

44. For the multivalent relevance of Brutus to the interregnum see Robert L. Herbert's classic study, *David, Voltaire, "Brutus" and the French Revolution: An Essay in Art and Politics*, New York, 1972.

45. The other two works in the Salle des Quatre Colonnes are Lemot's *Lycurgus* and Ramey's *Solon*.

46. See Hunt, 1984, 44. Hunt discusses the nature of the changes in language and "plot" during this period from that of comedy to tragedy (34–37).

47. Pierre Victorin Vergniaud (1753–93), a Girondist, regicide and fierce opponent of Danton and Marat for their part in the great prison massacres, coined memorable lines such as: "La Révolution est comme Saturne; elle dévore ses enfants." Vergniaud deplored the extreme leftist views of the Jacobins, while at the same time advocating war against Austria in 1792. His views on war thus handily coincided with Napoleon's. His fall from grace ended at the scaffold on Oct. 31, 1793. (*Grand Dictionnaire universel du XIXème siècle* (1867), Slatkine Reprint, Geneva-Paris, 1982, II,

446–47). Another moderate, the Feuillant Antoine Barnave, who advocated constitutional monarchy, found his way into this company as well, helping to define the balanced image sought by Napoleon. Beauvallet's statue appeared in the Salon of 1804.

48. I have not followed up this idea, but it was forbidden to raise the arm over the head in the king's presence at least.

49. Hunt, 1984, 52ff, dwells upon the significance of dress during the Revolution, referring back to Serge Bianchi's study of the "politicization of everyday objects," *La Révolution culturelle de l'an II: élites et peuples (1789–1799)*, Paris, 1982.

50. Lami, 18, I, 321.

51. Hubert, *Sculpture dans l'Italie Napoléonienne*, 208, shares this point of view, writing: "éloignés de Paris, les deux artistes [Milhomme et Leclerc] se sentirent plus libres d'appliquer les conceptions de l'école ultra-classique dans la représentation de personages contemporains, sans même essayer de trouver un prétexte mythologique à leur nudité idéale. Canova devait les confirmer dans leurs idées. Le bon sens et les goûts traditionnels de Napoléon et des Parisiens s'opposèrent à l'exposition définitive de ces oeuvres." Cacault, the French ambassador to Rome, shared the Roman viewpoint, expressing his contempt for modern dress in a letter to Talleyrand in 1803 (March 30, *Correspondence*, XVII, 389, no. 995).

52. See Honour, "Canova's Napoleon," and Boyer, "Canova, sculpteur de Napoléon," 1970, 131–41, for complete details of the commission.

53. David d'Angers remembered seeing it at Apsley House in 1816, with the jackets of servants thrown over the shoulder (Jouin, *David d'Angers*, II, 156).

54. Fernow, *Über den Bildhauer, Antonio Canova*, 1806, 215–17. See also Hubert, *Sculpture dans l'Italie Napoléonienne*, 144.

55. The bust, modeled from life in Paris in Oct. 1802, included Napoleon's high-collared uniform, which Canova stripped off in his process of preparing the bust for the statue. See Honour, "Canova's Napoleon," *Apollo*, XCIX, Sept. 1973, 180–84, for a complete account of the posing sessions and progress on the work in Paris.

56. Boyer, "Canova Sculpteur de Napoléon," 1970, 133.

57. While there, Canova's every move received attention from the press, letting the public at large in on the reason for the visit.

58. Boyer, "Canova Sculpteur de Napoléon," 1970, 138–39.

59. Ibid., 134. David d'Angers, taking Roland's clothed statue of the emperor as his point of departure, later bemoaned the choice of a foreigner for a commission such as Canova's (Jouin, *David d'Angers*, II, 237).

60. Although the salon catalogue for 1810 lists Canova's statue, it was not exhibited.

61. Letizia Bonaparte commissioned the work from Canova in 1804 and sent it to her son with the hope that he would place it opposite his throne in the Tuileries. It was exhibited in 1808.
62. Gramaccini, *Moitte*, 1993, vol. II, no. 230, and fig. 291.
63. The correspondence is published in the *Revue universelle des arts*, IX, 1959, 410–25, by the editor under the title, "La Question du nu dans la Statuaire." The academic purist, Cartellier, having failed to find Chaudet at home, also wrote his friend a warm letter of encouragement. "Lettre Inédites d'Artistes Français du XIXè siècle," *Nouvelles Archives de l'Art Français*, 1900, XVI, 7: "Quoy que je sois persuadé que tu tiendra fortement au parti que tu as pris relativement à la statue de Bonaparte, je voulois te dire que j'adopte entièrement ton idée et que je repousserais de toutes mes forces toutes les criailleries d'une foule de raisonneurs denués de ce sentiment si nécessaire aux arts. Leur cohorte me paraît assez nombreuse et est malheureusement grossi par quelques confrères qui n'adopte pas ce principe du fond du coeur."
64. See *Inventaire*, I, 345.
65. The change of régime in 1814 saw the dismantling and melting down of the figure eventually replaced by Seurre's uniformed *Napoleon* in 1833. Finally, in 1863, a reedition of Chaudet's figure went up only to be toppled during the Commune.
66. "Ne croyez pourtant pas, mon ami, que j'entende bannir absolument le costume! Il est clair que des personnages qui ne se sont pas élevés jusqu'au sublime ne méritent pas l'honneur d'être idéalisés comme des dieux; qu'ils portent donc le costume de leur époque ajusté avec une certaine grandeur, et dissimulé dans ce qu'il peut avoir d'ingrat; mais si le sculpteur est en présence d'une de ces grandes figures qui n'apparaissent que de loin en loin, de Napoléon, par exemple, nul doute qu'il pourra s'élever jusqu'à l'apothéose, et alors, dépouillant son héros de ce qui le rattache plus particulièrement à telle époque ou à telle nation, la statuaire le représentera non plus comme Français, mais comme homme; elle en fera la plus haute expression de l'humanité" (Jouin, *David d'Angers*, II, 250). He was to complain elsewhere of Seurre's replacement: "Quand je vois la statue de Napoléon avec son petit chapeau et sa redingote, juchée sur la colonne, j'éprouve un sentiment pénible à décrire. J'ai toujours peur que cet homme ne tombe et pour m'expliquer cette statue, je suis obligé de me rappeler qu'une pensée politique a commandé ce choix. On voulait lui enlever toute idée de grandeur. L'Apothéose de l'Empereur l'eût élevé audessus du terre à terre de notre époque" (David d'Angers, *Carnets*, I, 31).
67. By 1840, the notion of a messianic Napoleon had taken firm root. See Frank Paul Bowman, *Le Christ romantique*, Geneva, 1973, chap.5, 172f, for a discussion of Napoleon as Christ and anti-Christ.
68. See Biver, *Paris de Napoléon*, Paris, 1963, 151ff. Benoît, [1897] 1975, 175, treats Vivant-Denon's preemption of the casting more dramatically. See also *La Place des Victoires et ses abords*, Délégation à l'Action Artistique de la Ville de Paris, Paris, 1983, 38ff, for a reedition of Biver's main points supplemented with additional visual material.
69. See Gramaccini, *Moitte*, 1993, 147–49.
70. He destroyed the first model, the second only measuring some six feet (*Correspondance des directeurs de l'Académie de France à Rome*, Nouvelle Série, ed. Georges Brunel, Rome, 1984, II/2, 651).
71. Ibid., 839, June 12, 1806.
72. Benoît, [1987] 1975, 52.
73. At almost every salon from this time on several works appeared honoring Bonaparte. Some were in the form of independent homages to the hero, others were commissioned. Still other major works appeared outside the salon, especially after 1804.
74. See Biver, *Paris de Napoléon*, 1963, 172, among other sources, for his protestations, and Hargrove, 1989, 43f. Lemot's statue is at Malmaison.
75. Uwe Westfahling, "Klassizismus und Reichsidee: Darstellungen Napoleons von Canova und Thorvaldsen," *Thorvaldsen*, II, 277–303, provides an overview of works commemorating Napoleon by these sculptors and a few other Napoleonic artists.
76. It was to have been the largest equestrian ever made. See Praz and Pavanello, *L'opera completa del Canova*, 120, no. 22, equestrian monument to Charles III, and Hubert, *Sculpture dans l'Italie Napoléonienne*, 141–42, 156–57, for the fate of Canova's equestrian. When Napoleon commissioned his standing portrait from Canova, Quatremère expressed the wish for a bronze equestrian, but, besides time and expense, there was doubt as to Canova's ability to do a horse (141–42). Other equestrians were suggested in Italy (see ibid., 235, 276), but either time ran out or the government balked at the cost.
77. See Gramaccini, *Moitte*, 1993, 156–58, and vol. II, no. 235, fig. 337. Gramaccini attributes to Moitte the bronze statuette sold at Christie's to an unknown collector. The horse is close to that in the relief of the *Dying Desaix*.
78. Lami, 18, I, 188. Who precisely the public may have been remains open to inquiry, as often the "public" stands for the authority's point of view in such matters.
79. Butler-Mirolli, *Nineteenth-Century French Sculpture*, 11, quotes these translated lines from an article in *L'Artiste* written on the Pantheon pediment.
80. His idea was to crown it with laurels and clothe Napoleon as a Roman consul. Hubert, *Sculpture dans l'Italie Napoléonienne*, 164 and 206. Benoît [1987] 1975, 131, mentions Comolli and Laboureur. Honour,

ibid., 102, mentions the busts supplied to Laboureur and Callamard. He adds, fn. 23, that Laboureur's statue is in Piazza Pata, Ajaccio.

81. Hubert, *Sculpture dans l'Italie Napoléonienne*, 206f, mentions Cacault as the moving force, which he probably was in that he was helping these young artists to find commissions, but Murat seems to have been the faulty patron who never financed the marble (*Correspondance*, 1984, II/2, 651).

82. Hubert, *Sculpture dans l'Italie Napoléonienne*, 200.

83. Ibid., 347, 362.

84. See ibid., 212, 213, 234, 244, 251ff, 269–70, 276, 347, 362 for a discussion of these other examples.

85. Lami, 18, I, 434. The statue was never actually placed on the column. The three busts are those of Napoleon in uniform at Versailles, the terra-cotta herm bust and Napoleon as First Consul, now lost.

86. L. Benoist, *Sculpture romantique*, 19; Paul Vitry, "La Sculpture en France," 1925, 53.

87. Napoleon gave the work to the City of Dunkerque in homage to her favorite son, famous for his daring raids and heroic actions under Louis XIV.

88. Hubert, "Houdon," *The Age of Neo-classicism*, London, 1972, 246.

89. Inexplicably, Hubert, ibid., 251, writes, "The glance and the expresssion of a domineering and super-human calm exert a strange power, and one can only wonder why such an ideal type was not disseminated in bronze, plaster and marble, as were the busts of Chaudet and Canova." It should be noted that the very size of Houdon's bust was smaller and less grand.

90. Ibid., 345. These numbers are not absolutely firm, but documents argue in their favor. Denon alone ordered 15 copies (86).

91. Gérard Hubert, "Un Buste du premier consul par Chinard," *La Revue du Louvre*, no.3, 1984, 189–92, dwells upon the circumstances of the bust's execution and a variety of possible sources.

92. Lagrange, "Simart," 1863, 113. For Simart's work on the tomb, see Philippe Durey in *La Sculpture au XIXè*, 176ff.

93. This statue has finally gone on permanent display at the Louvre.

94. See both J. Whiteley, "*Homer Abandoned*: A French Neo-classical Theme," *The Artist and Writer in France*, 40–51, and James Henry Rubin, "Oedipus, Antigone and Exiles in Post-Revolutionary French Painting," *AQ*, XXXVI, no. 3, Aug. 1973, 141–69. More recently, Helge Siefert, *Themen aus Homers Ilias in der französischen Kunst*, 1750–1831, Munich, 1988, details the history of the theme, although sculpture makes a small showing.

95. In 1789, a salon critic had written: "Troubles and injustice always stand in the way of genius; everything is refused them, even honours. Poussin, the most able painter of his century, was persecuted; Homer lived the life of a destitute vagabond; Tasso was the most unfortunate man of his time; Milton and hundreds of others who crowd the temple of memory were even less fortunate" (Whiteley, "*Homer Abandoned*," 46).

96. Jonathan P. Ribner, "*Le Peuple de Dieu*": Old Testament Motifs of Legislation, Prophecy and Exile in French Art between the Empires, Ph.D. diss., New York University, 1986, 10. Ribner offers new insight into the use of biblical imagery between the empires, emphasizing the "transvaluation of [an] ostensibly religious class of imagery under the pressure of a variety of new secular concerns" (1). Madame de Staël's *De l'Allemagne*, first published in 1811, extended the law-giving and prophetic qualities of biblical figures to creative genius (10). See also Paul Bénichou, *Le Sacre de l'écrivain, 1750–1830*, Paris, 1973, and *Le Temps des prophètes: Doctrines de l'âge romantique*, Paris, 1977, both mentioned by Ribner, and Bowman, *Le Christ romantique* (1973) for their discussions of the evolving messianic or prophetic role of the writer.

97. M. Schneider, 1977, 207–08, makes detailed comments on Roland's use of classical sources including observations on his willful changes (more pronounced features, parted lips). Landon, reflecting the ever-present self-consciousness about nudity, put it down to Homer's inspiration, his cloak slipping off unnoticed to leave him all but naked (Landon, *Annales*, 1802, III, 151).

98. M.S. Delpech, *Examen raisonné des ouvrages de peinture, sculpture et gravure exposés au Salon du Louvre in 1814* (Paris, 1814), 222, who had admired Milhomme's semi-nude *Hoche*, felt that Roland had failed to create an apotheosis by emphasizing the merely physical at the expense of his genius: "Sa statue devait être un monument élevé à sa gloire, une espèce d'apothéose; ce n'était pas la forme matérielle du corps, mais son génie qu'il fallait représenter. M. Roland n'a pas rempli cette tâche difficile; il est resté beaucoup au-desous de son sujet."

99. See D. Johnson, "Corporality and Communication: The Gestural Revolution of Diderot, David, and the *Oath of the Horatii*," *AB* (March 1989), LXXI, no. 1, 92–113, mentioned in relation to Pajou's *Psyche Abandoned*. Her discussion of Diderot's call for a "sublime" gestural quality could be studied with interesting consequences in the discussion of revolutionary sculpture. In painting before David, the body had acted principally as a support for the facial expression, so that the heroic animation of the body spelled a radical departure in that medium.

100. Landon, *Annales*, 1802, III, 96.

101. Rude had participated in the Vendôme column relief program, a reminder of his firsthand acquaintance not with the Revolution but with its glory which he sought to revive.

102. Alex Potts, *Flesh and the Ideal: Winckelmann and the Origins of Art History*, Yale University Press, New Haven and London, 1994, 113f, offers a synopsis of Winckelmann's definitions of the sublime and the beautiful, with the *Niobe* embodying the sublime and *Laocoon* the beautiful. This, he points out, was at odds with Burke's Male Sublime and Female Beautiful.

103. Duret had been his own model (Le Normand, 1981, 194).

104. Werner Hofmann (*Flaxman*, 1979, 17) draws this comparison.

105. John Pope-Hennessy, *Italian Renaissance Sculpture*, London and New York, 1971, 75.

106. He deprecated the extremity of a grimace engendered by "enthusiasm," as he put it: "La passion qui grimace aux heures les plus solennelles est ridicule. La laideur n'entraine pas, et le visage de la liberté, tel que Rude l'a rendu, est hideux. La douleur peut crier en sculpture, mais jamais l'enthousiasme qui doit éclectriser une nation" (Jouin, *David d'Angers*, II, 307).

107. Guilhem Scherf, "Homère mordu par les chiens," *Revue du Louvre*, June 1993, 54–60, traces the genesis of the work.

108. Moitte's 1789 bust is an example. Others also executed busts of small groups: Houdon (1773), J.B. Stouf, (1785), L. P. Deseine (1789), Beauvallet (1791) and Chaudet (terra-cotta, 1791; the Louvre has the plaster cast executed after the terra-cotta; cf. *Skulptur aus dem Louvre*, 62). As early as the late sixties, porcelains appeared. Cyfflé's *Belisarius Guided by a Child* (1769–80) and *Belisarius Receiving Charity* (1769–80) modeled after Gravelot and Van Dyck respectively, are examples. No full-scale *Belisarius* seems to have appeared at the salon.

109. Lami, 18, I, 78, gives no indication of size or material.

110. The sculptor exploited other such scenes, like the later, biblical *Agar and Ismael* (1814), a marble group for the banker Torlonia in Rome (salon catalogue, 1814, 110, no. 1099). The catalogue does not specify if the commission originated with Torlonia, or whether Marin collared the commission through an appealing plaster model. Ribner, 1986, chap. 5, 110ff, addresses the issue of the "Exile of the Chosen" within the context of the political situation between the empires. The translation of the Old Testament in its entirety only after 1814 dramatically affected its reception (3f). It came to be viewed as "a portentous record of sacred history rather than as a focus of religious devotion" (6), with a resulting politicization of its content (7f). The literature on Marin is extremely limited. See Maurice Quinquenet, *Un élève de Clodion, Joseph Charles Marin, 1759–1834*, Paris, 1948. More recently, a small catalogue, *Joseph-Charles Marin* (Paris, March 1992) has been produced by the Galerie Patrice Bellanger for an exhibition of small works. The dates are attributed to the figures in *The Age of Neo-classicism*, 260–61. Marin continued to exhibit works like a *Bacchante couchée avec des enfans*, for example (Salon of 1791 [no.50]).

111. For the history of this work, see Quinquenet, *Marin*, 56–57; Honour, *The European Vision of America*, National Gallery of Art, The Cleveland Museum of Art, Grand Palais, Cleveland, 1975, 217, no. 189.

112. They were only tentatively attributed to Marin by Quinquenet, *Marin*, 70. The Musée de Chaalis now firmly attributes them to his hand.

113. The inclination of the head and the straggly hair of the *Bather* bear a family resemblance to the *Pleureuses* which may have been executed earlier, perhaps even in Rome.

114. "M. Marin eut été nommé à juste titre le Fragonard de la sculpture; mais cette nouvelle statue doit ajouter à sa réputation; elle annonce un style plus élevé, un goût plus pur, des formes plus grandioses" (Landon, *Annales*, Salon de 1812, II, 40).

115. T. C. Bruun-Neergard remarked upon it favorably in *Sur la situation des beaux arts en France* (Paris, 1801), as did a number of other critics, finding it to be one of the most significant pieces on display: "Le plâtre des *Trois Horaces*, par *Gois* le fils, est un des morceaux qui étonne le plus les connaisseurs. Si l'éxecution en marbre répond à ce qu'on a droit d'attendre de ce sculpteur, ce morceau sera à coup sur un chef d'oeuvre. On trouve seulement qu'il a un peu manqué dans l'expression, en ne donnant qu'à une seule tête la fermeté qui, d'après l'histoire, appartenait aux deux autres" (p.78, Lettre V, Paris, le 2 Brumaire, an IX). Bruun-Neergard found the sculpture at the Salon of 1800 as weak as the engravings due to a lack of submissions. Justifiably or not, of some one hundred and ninety pages, he devoted only two to sculpture. The *Mercure de France* (Deloynes, XXII, no. 638, 766) also reviewed the group favorably as did Landon, *Annales*, An IX (1801), I, 129–30. There was no criticism of the group being composed of three figures, but as a rule, such groups met with little favor in the sphere of theory. One can exclude harmonious unions of Cupids and Psyches, Venuses and Marses or Castors and Polluxes from the general censure. This question crops up in Fernow's comments on Canova's *Creugas and Damoxenes*, which he considered to be a group in spite of their separate bases and in which he commended their "decided character" (*Canova*, 145). Throughout Canova's work one finds pendants communicating across open space, from his *Orpheus and Eurydice* (1775–76; 1773–75) to his *Hector and Ajax* (1808–16; 1811–12). Fernow even suggested that the *Creugas and Damoxenes* were to be viewed side by side like the

Tyrannicides, though there is nothing to justify this view (142). If anything, the psychological bridging of the figures resembles Algardi's *Beheading of St. John the Baptist* (1641–47, San Paolo, Bologna) which incorporates open space in the single-based composition. Of the problem of separate bases, Memes and other critics felt that this endangered the group. Memes (*Canova*, 427) saw in Canova's *Dancers* a continuity of action threatened by separation of place (Italy, England, Russia) just as Chauvin, in 1824, feared for de Bay père's *Mercure prenant son épée pour trancher la tête à Argus*: "Il ne s'agit pas ici d'un groupe, mais de deux figures bien distinctes et désunies à dessein. Hâtons-nous de remarquer à ce sujet que de tels *pendans* sont inadmissibles en sculpture, car les évènements peuvent un jour séparer les blocs, envoyer l'un à Rome et l'autre à Venise: alors que deviennent l'oeuvre et la pensée de l'artiste?" (*Salon de 1824*, Paris, 1824, 224). Gois' group falls somewhere between the collected, classical pairs on one base and the separated figures, since his group is united in only the most casual way. Their conversant, anecdotic tone is closer to the Place du Peyrou project than to most antique precedents.

116. See H. Thirion, *Les Adams et Clodion*, 351–62, and especially Anne Poulet, "Clodion's Sculpture of the *Deluge*," *Journal of the Museum of Fine Arts*, Boston, vol. 3, 1991, 51–76.

117. See ibid., 56–57, 59. In 1787, Dardel had also modeled a small group entitled *Aeneas Carrying His Father Anchises in the Middle of the Flames and Defending Him against the Enemy* (Lami, 18C, I, 250), and in 1798 Chaudet sent a painting of the same subject to the salon.

118. It should be noted that at the same salon, Clodion exhibited a scene from the "Thousand and One Nights," lest one assume that he had narrowed his focus to purely ennobling themes.

119. Landon, *Annales*, 1801, I, 99.

120. See James Rubin, "An Early Romantic Polemic: Girodet and Milton," *AQ*, 1972, 230.

121. The statement has also been attributed to his enemy Frederick the Great but has circulated more widely as being French.

122. See the *Livret du Salon de 1801*, 413.

123. "Ce groupe, où l'on a remarqué des parties bien dessinées et d'une belle exécution, fait d'autant plus honneur au C. Clodion, que cet estimable artiste, âgé de 66 ans, n'avait, jusqu'à ce jour, fondé sa réputation que sur de très-petits ouvrages, et c'est un des plus capitaux de l'exposition de cette année" (Landon, *Annales*, 1801, I, 100).

124. Deloynes, XXVI, no. 692, 494–96, "Salon de l'An IX," *Journal des Débats*. See also Deloynes, XXVII, no. 635, "Expositions du Salon du Musée," *Journal des Arts*, and "Ouverture du Salon," *Journal des Arts*, 1801.

125. Cavaceppi restored a version of the ancient work in Rome in 1780, but there is no figure at the base of that *Tyche* (see Tobias Dohrn, *Die Tyche von Antioch*, Berlin, 1960, 23, no. 17). Clodion may all the same have been familiar with the other type, although even that would not account entirely for the group's effect.

126. *Salon de 1814*, 230–31.

127. Delpech, Salon (Paris, 1914), 230–31.

128. Ruth Butler, "Long Live the Revolution, the Republic, and Especially the Emperor!: The Political Sculpture of Rude," *Art and Architecture in the Service of Politics*, eds. Henry A. Millon and Linda Nochlin, Cambridge, Mass., and London, 1978, assesses Rudes' position and the artistic expression of his political views.

129. A figure of Marat stood for a brief while in the Rue aux Ours (1793–94) (Rosenblum, *Transformations*, 84), and a life-size effigy on a deathbed was placed in Saint Eustache (Bowman, 1973, *Le Christ romantique*, 62). Jean-Joseph Espercieux (1857–40) created a *Mirabeau* for the Senate staircase (Lami, 18C, I, 322).

130. Jim Draper, "L'Art français au Metropolitan: Les terres-cuites néo-classiques," *Connaissance des Arts* 467, Jan. 1991, 96, does not refer to the woman as the child's mother.

CHAPTER 7

1. See Weinschenker, *Falconet*, 16, and chap. 1, 13ff, for a discussion of the sublime in France at the time, heavily based upon Samuel Monk, *The Sublime: A Study of Critical Theories in Eighteenth-Century England*, Michigan, 1962. In passing one might note that, in 1765, the critic Mathon de la Cour hit upon a quality of the sublime (awesome scale) in drawing attention to the faults of Nicolas Sébastien Adam's (1705–78) group of *Ulysses and Polyphemus*: "Une légère inattention de la part du Sculpteur, a privé ce morceau d'une grande partie de l'effet qu'il devoit produire. L'Auteur a proportionné son Bélier à la taille de Polyphème; par là ce géant ne paroît qu'un homme ordinaire, & Ulysse un Myrmidon. Si le bélier eût été proportionné à la taille d'Ulysse, le héros aurait paru ce qu'il devait être, les proportions de Polyphème auroient étonné." From Deloynes, VIII, no. 110, 511: *Lettre à un partisan de bon goût, Salon de 1765*. Adam was "agrée" in 1762 with a *Prometheus*.

2. Falconet, *Oeuvres*, I, 5. Of particular interest in Levesque's view, beyond its implication of a taste for a certain potency and grandeur during the imperial times, is the reappraisal of Falconet in the face of a Quatremère de Quincy and his distate for the rococo

school. A little earlier, Emeric-David's then famous *Recherches sur l'art statuaire* (1805) had also signaled a renewed interest in this period of French sculpture and especially in Pigalle whose *vérisme*, whose minute scientific observations, he considered to belong to the very foundations of art. See especially pp.197–99 of *L'Art statuaire*, Paris, 1863.

3. Deloynes, VI, no. 71, 303–05: *Lettre sur le Salon de 1755*, Amsterdam, 1755.
4. "Vie d'étienne Falconet," *Oeuvres*, III, 13.
5. "Du Moïse de Michelange et du Bacchus," *Oeuvres*, III, 146ff. Falconet, ibid., 147, mentions seeing engravings after Michelangelo.
6. "Quelle admiration, quel étonnement Michel-Ange ne nous doit-il pas causer! On le voit partir semblable à la foudre pour étonner la nature par ses miracles de grandeur, de proportion et de dessin terrible. Cette réflexion, qui paraît une digression, n'en est pas cependant une, quoique je ne vous propose pas ce grand homme comme un modèle d'harmonie mais en le citant comme le plus grand effort que la nature eut peut-être fait pour montrer ce qu'elle pouvait produire de plus grand, de plus fier et de plus austère. Je le donne comme un example frappant mais général de l'usage que tout génie peut faire de ce qu'il a vu" (Nov. 4, 1757). See Eugen Dörken, *Geschichte des französischen Michelangelobildes von der Renaissance bis zu Rodin*, inaugural diss. Bonn, 1936, 17, who quotes this. He covers the period up to 1780 in a few pages, giving more details for the subsequent decades leading up to high romanticism. He does not mention Falconet's taste for Michelangelo nor does he explore the relationship to England's own fascination with the latter. The work is useful for its quotations of contemporary views.
7. For example, Memes, *Canova*, 60: "Yet with much to be pardonned – with more to be admired – , the Moses will ever remain one of those anomalous productions, which criticism would condemn, – but which genius redeems."
8. "Though our judgement must, upon the whole, decide in favour of Raffaelle, yet he never takes such firm hold and entire possession of the mind as to make us desire nothing else, and to feel nothing wanting." See *Reynolds' Discourses on Art*, ed. Robert Wark, New Haven and London, 1974, 83. Reynolds delivered this lecture on Dec. 10, 1772. R. Schneider, *Esthétique*, 147f, comments on the mixed admiration and suspicion of Quatremère and others.
9. For example, Reynolds mentions Falconet's opinion of Timanthes' veiling of his face in the Eighth Discourse, Dec. 10, 1778 (*Reynolds' Discourses*, 164–65).
10. See Weinschenker, *Falconet*, 15. Levesque, Falconet's *Oeuvres*, 1808, 15, mentions this exchange. See also Réau, *Falconet*, 466ff. As Reynolds exhibited the *Ugolino* in 1773, it is likely that Pierre-Etienne was the bearer of the engraving sent in return for the cast of *Winter* which Falconet may have sent from Leningrad.

11. Réau, *Falconet*, 466; Algernon Graves, *The Royal Academy of Arts* (London, 1905), London, 1970, II.
12. "C'est cette traduction que je lis, où je ne trouve rien de remarquable que le sublime d'un grand mur nud. . . . M. Burke définit le sublime dans les objets matériels, tout ce qui imprime de la terreur. Ne résulterait-il pas de cette définition trop vague, que le gibet, qu'un roué, seroient sublimes? . . . Cependant, comme il y a des hommes qui, sans être stupides, envisagent froidement les dangers; qu'il y en a qui n'ont peur ni des revenant, ni des souris, ni des arraignées; il en résulte que la défintion n'est rien moins qu'exacte. Le vrai sublime est essentiel; il est réel, absolu, & n'est relatif que dans des cas particuliers. L'océan est sublime; l'habitude, la stupidité, la surdité, la cécité, peuvent seules en diminuer ou en empêcher l'effet sur notre *sensorium*. L'océan fait naître des idées que ne donne jamais un mur nud, de quelque hauteur et grandeur qu'on le suppose. J'ai éprouvé l'effet d'un grand mur nud; il est très propre à faire dormir debout, pour peut qu'on le regarde attentivement." See "Quelques Idées sur le Beau." Falconet *Oeuvres*, III, 146–47.
13. Dandré-Bardon, *Essai sur la peinture*, 150.
14. The heterogeneous grouping of Michelangelo's *Moses*, Puget's *Andromeda* and Girardon's *Bain d'Apollon* as illustrations of the sublime can only be understood on discovering the characteristics typifying the sublime in Dandré-Bardon's view: "élévation de la pensée, noblesse du sentiment, magnificience du spectacle, tournure ingénieuse des figures, vérité d'expression, force de pinceau et enfin . . . un coloris caractéristique" (ibid., 96).
15. In 1754, the Academy finally accepted him on the presentation of the *Milo* (Réau, *Falconet*, 64).
16. Levitine, *The Sculpture of Falconet*, 26, discusses the importance of Michelangelo for the *Allegory* and gives the work a more favorable appreciation than it has hitherto received and which it richly deserves.
17. See Rudolph Wittkower, *Sculpture: Processes and Principles*, London, 1977, 204–05.
18. See Réau, *Falconet*, 285–304, for the complete history of the chapels.
19. Levitine, *The Sculpture of Falconet*, 74, discusses the team. Coustou is mentioned by neither him nor Réau. The name crops up in Jean-Pierre Babelon, *L'Eglise St. Roch à Paris*, Paris, 1972, 34.
20. Réau, *Falconet*, 285–304, gives the complete history of the chapels. Falconet's friend, Charles Nicolas Cochin (1715–90), came to his defense with the entertaining, pointed *Les Misotechnites aux Enfers* (Paris, 1763), directed against the marquise de Pompadour's librarian, de la Garde (ibid., 293).

21. Ibid., 294–95. On several occasions, Falconet himself belittled his own work at St. Roch but one should perhaps take a guarded view of this. He may have chosen to fall in partly with its critical reception for practical reasons; he may also have chosen to flatter the patron of a new project – the *Peter the Great* – by diminishing his earlier achievements. Falconet sent Marigny a list of his works, referring to St. Roch as "cette besogne"; to Catherine the Great, in 1767, he wrote, "cet ouvrage est une babiole en comparaison de la statue de Pierre le Grand" (Réau, *Falconet*, 296).

22. Levitine, *The Sculpture of Falconet*, 50. He situates the Chapel of the Calvary somewhere between these two. Later, in 1820, Louis-Pierre Deseine, who was instrumental in recovering the *Christ in Agony*, devised a lighting scheme designed to magnify the chiaroscuro effects (Réau, *Falconet*, 292).

23. Levitine reproduces this drawing, figs. 79 and 85.

24. The painting was attributed originally and with good cause to de Machy by Levitine, *Sculpture of Falconet*, 49. In the *Age of Louis XV: French Painting from 1710 to 1774*, The Toledo Museum of Art, The Art Institute of Chicago, The National Gallery of Canada, Toledo, 1975, 85, no. 122, Pierre Rosenberg tentatively put forward the name of Hubert Robert. Shortly thereafter, the Louvre was able to purchase a portfolio of Lépicié's drawings which turned out to include a number of preparatory sketches for the painting, allowing Pierre Rosenberg to make the definitive attribution, published in the article "Une énigme résolue..," *Bulletin du Musée Carnavalet*, 31é année, 1978, no. 2, 22–28.

25. See Réau, *Falconet*, 291–93.

26. Ibid., 289.

27. Pascal de la Vaissière, Curator of the Musée Cognacq-Jay, Paris, raised this possibility in the course of a conversation in Paris, in June 1988. Rosenberg, *Age of Louis XV*, 1975, makes no mention of this discrepancy.

28. See *Salons*, II (1765), 211. Diderot felt that color in sculpture was not to be tolerated. See also Deloynes, XLVIII, no. 1283, 250–51, *Ouvrages de Sculpture de l'Exposition au Louvre en 1763*: "Nous avons cru au premier aspect apercevoir dans ce buste en terre cuite [Mme la Comtesse de Brionne], le secours étranger de la couleur, légèrement employée dans quelques parties, mais comme cet artifice est aujourd'hui décidément proscrit dans la sculpture, nous n'osons affirmer qu'un artiste aussi éclairé sur les vrais principes de son art ait employé ce moyen." The work in question was by Lemoyne.

29. Levitine, *Sculpture of Falconet*, 50.

30. "Vedrete la fantasia un po delirante di Mr. Falconet a S. Roco nella cappella della BV del Calvario," quoted from *Per le Nozze Papadopoli: Lettere familiari inedite di Antonio Canova e di Gianantonio Selva*, August 1802. Venice, 1853, 27.

31. "Queste strane invenzioni, ottime per feste pubbliche e teatrali spettacoli, erano un oggetto d'ammirazione in quell'età." Cicognara, *Storia*, VI, 321.

32. Hugh Honour, *Neo-classicism*, Harmondsworth (1968), 1975, 118, writes, "Disturbingly life-like *trompe-l'oeil* effects were avoided in sculpture as in painting. The nymph at Rambouillet provides an instance of this approach. Whereas a Rococo sculptor would certainly have decorated the grotto with a highly realistic figure, seeking to surprise the visitor by his virtuosity, Julien provided what was unmistakably a marble statue." Falconet, a "rococo" sculptor, shunned tricks of that kind too, though in neither the latter's nor the former's work could one speak of Olympian classical integrity, even if their illusionism is limited in comparison to more vividly baroque, provincial productions. Pascal, "Pierre Julien," 1903, 56, quite rightly points out the theatricality of Julien's group.

33. Philippe Sagnac and Jean Robiquet, *La Révolution de 1789*, Paris, 1934, II, 238.

34. "L'auteur du projet a désiré qu'il pût former avec les objets environnants un tableau qui rappellât les beaux paysages du Poussin. Le pied d'une montagne escarpée sur laquelle sont les ruines d'un ancien fort, nommé le Château Gaillard, une voie publique et les murs du Petit-Andelys, formeraient le plan antérieur. Un peu au-delà serait le *Sacellum* placé sous l'ombre silencieux d'une espèce de bois sacré. Le caractère sévère du monument, le ton ferme et soutenu qu'il aurait, n'étant frappé extérieurement d'aucun rayon du jour, la hauteur des arbres, l'étendue des ombres projetées sur les terrains, formeraient une masse tranquille qui contrasterait avec le ton brillant du plan suivant . . . On a cherché à produire *extérieurement* et intérieurement un effet de gloire: *extérieurement*, en dirigeant dans le porche les rayons du jour par une clairevoie ménagée dans les branches, et par une lanterne qui serait pratiquée dans la voûte; intérieurement, en dirigeant ces mêmes rayons sur la statue du Poussin, à travers un arc qui couronnerait le mur de refend, entre le porche et le *Sacellum*." Landon, *Annales*, 1803, II, 27–28 (it is illustrated, pls. 13 and 14). Jacques de Caso, *Stil und überlieferung*, 197f, discusses this monument within the broader context of the *Paragone* opposing architecture to sculpture. He cites it, therefore, as an example of a single sculptural figure achieving a new level of significance, independent of architectural support rather like a god within a temple. See also M. Schneider, 1977, 33–35.

35. Apparently Canova wished to portray Pauline Borghese as Diana, but was overruled in this by her (see Licht, *Canova*, 130ff). See Praz and Pavanello, *Canova*, 11–12, no. 165, for the details of its genesis. This kind of personal apotheosis of a naked, famous woman is

almost unique in sculpture, betraying a substantial audacity on the part of both creator and sitter, who later came to regret her choice and begged her husband to restrict the viewing of the statue (Hubert, *Sculpture dans l'Italie Napoléonienne*, 152). Italo Faldi, *Galleria Borghese: La Scultura dal Secolo XVI al XIX*, Rome, 1954, 46, notes that there were so many visits by day and by night that they had to be limited.

36. One recalls Canova's enthusiastic words in *I Quaderni di Viaggio*, ed. Elena Bassi, Venice and Rome, 1959, 103, for the *Apollo and Daphne* (Villa Borghese), for example: "Vidi poi il gruppo di Apollo e Dafne del Bernini, lavorato con tanta delicatezza che sembra impossibile, vi sono le foglie dell'aloro di meravigliosa lavoro, bello è ancora il nudo che non credevo tanto."

37. In his youthful travel notes, the *Quaderni*, recording his first trip to Rome in the winter of 1779–80, Canova passingly mentions recognized masterpieces (including works by Michelangelo) but yields to rapture only in front of Bernini.

38. See Rosenblum, *1800*, 184, and *Jean-Auguste-Dominique Ingres*, New York, 1967, 107, for the most penetrating analysis of this aspect of Ingres' style.

39. Bell, *Annals of Thomas Banks*, 1938, 17–18. Rather unappealingly, Canova occasionally used washes of dirty water too. Eventually, at some point between 1805 and 1811, he abandoned the practice of staining his marbles altogether. For details of this practice, see Honour, "Canova's Studio Practice I," 148. This was a relatively common thing to do.

40. Honour, ibid., mentions the practice as do most of Canova's earlier biographers. This was a common occurrence.

41. In a letter to Quatremère of Nov. 29, 1806, Canova asked his friend to tell him "schiettamente la verità, [si] mi avete fatta la grazia di considerare il Torso del mio genio, opera di sedici o diecisette anni addietro? . . . Datevi la pena di essaminar tutto ciò ben bene con un lume di notte, e radente per potere veder le più delicate avertenze" (Boyer, "Canova, sculpture," 1970, 145). The Genius is that on the *Monument to Clement XIV*. Later, Quatremère agreed that seeing the *Pauline* by torchlight accentuated both its qualities and its flaws (Quatremère de Quincy, *Canova*, 1834, 149).

42. Licht, *History of Western Sculpture*, 22, comments upon the custom of visiting Pompeii and Herculaneum by torchlight.

43. Canova, *Quaderni*, 113, 1 April 1780: "e vidimo poi con le torccie quello che non riesce di poter vedere al giorno per ragione che sono situate in posti che non possono avere bel giorno; Nella statua d'Apollo in particolare si vidi a meravigli." Napoleon visited the statue under the same circumstances in Paris (see J. J. L. Whiteley, "Light and Shade in French Neo-classicism," *BM*,

CXVII, Dec. 1975, 772). J. F. Reichhardt wrote that "in Italy, the statue was seen to best advantage by torchlight, a form of illumination which has not yet come into fashion in Paris" (quoted by Eitner, *Sources and Documents*, 1970, II, 11 from *Vertraute Briefe aus Paris geschrieben in den Jahren 1802 und 1803*, Hamburg 1805, I, 124f). Torchlight in general had a magical effect on the spectator at the time. In a darkened city, the sudden illumination of buildings was comparable to fireworks. Canova witnessed such an illumination of St. Peter's which lasted for three minutes and which he found to be a "cosa veramente sorprendente" (ibid., 109, 1 March 1780).

44. I am grateful to Dottoressa Sarah Stacciolli for her generous permission to view the statue by torchlight on a winter evening in December 1981. I am equally grateful to Brad Keach for photographing it for me.

45. J. J. L Whiteley, *BM*, 1975, 772.

46. "Corinne et Lord Nelvil terminèrent leur journée en allant voir l'atelier de Canova, du plus grand sculpteur moderne. Comme il était tard, ce fut aux flambeaux qu'ils se le firent montrer, et les statues gagnent beaucoup de cette manière d'être vues. Lea anciens en jugeaient ainsi, puisqu'ils les plaçaient souvent dans leurs thermes, où le jour ne pouvait pas pénétrer. A la lueur des flambeaux, l'ombre plus prononcée amortit la brillante uniformité du marbre, et les statues paraissent des figures pâles qui ont un caractère plus touchant et de grâce et de vie" (ibid.).

47. In his useful article (*BM*, 1975), Whiteley discusses the changing role of chiaroscuro in French painting principally.

48. Jouin, *David d'Angers*, I, 76, or II, 247–48 ("Thorvaldsen"). Elsewhere, the sculptor commented unfavorably upon the effect of moonlight on monuments like the Louvre which, because of the many surface incidences, looked to him like beehives (*Carnets*, I, 1830–31, 115; I am grateful to Suzanne Lindsay for signaling this particular passage to me). Since architecture is in question, however, David d'Angers' opinion does not necessarily contradict his feeling about sculpture.

49. *Carnets*, 1830, I, 89.

50. "A figure silhouetted against the sky seems larger than it is and, providing its contour is good, the poetic feeling will grow in intensity under such conditions. The clouds sailing through the air animate the statue by creating the illusion that it is moving. Immensity becomes the theatre of its actions. At night, the stars are its crown, and their distant glimmering on the horizon envelops the transfigured bronze or marble, which seems a fantastic apparition in the foreground of a superior world" (Jouin, *David d'Angers*, II, 61). David returned again and again to the same subjects with slightly different slants: "Pourquoi éprouvent-on de si

vives sensations à visiter des monuments antiques au clair de lune? C'est que ces monuments ne sont, comme la lune, que des reflets de ce qu'ils étaient dans les âges passés." (*Carnets*, I, 1835, 359). This was written while he was at Nîmes. Licht, *History of Western Sculpture*, 22, writing, "The spectral resurrection of buried cities has all the fascination of a ghost rising from the grave," expressed the intimate bonds between these various subjective experiences. David even executed a number of ghoulish graveyard scenes like that of a *Man Holding the Hand of a Cadaver* in which he explored the fashionable lugubriousness of the day. His *Young Inspired by the Muse* draws upon the same vein as Pierre-Auguste Vafflard's eerie painting of *Young and his Daughter* (1802), which epitomized this Gothic taste, though any number of other paintings, like Joseph Wright of Derby's *Virgil's Tomb by Moonlight* (1779) or Gros' *Sappho* (1801), illustrate these developments in their various phases just as well. David even executed several very poor drawings of a moonlit *Sappho* playing the lyre on Leucadia. All these drawings are preserved at the Musée d'Angers. G. Chesneau and C. Metzger published a catalogue, *Les Oeuvres de David d'Angers*, Musée des Beaux-Arts, Angers, in 1934, but a great deal remains to be done on the chronology. See nos. 908, 434 and 375 for the drawings above. The first two mentioned may be dated to the 1820s or later, showing David's more mature sketching style. The *Sappho* has the uninspired clumsiness of many of his youthful drawings.

51. Whiteley, *BM*, 1975, 772–73.

52. Benoist, *Sculpture romantique*, Paris, 1927, 70–71.

53. Wordsworth, *Prelude*, III, 58–63. Colton, *Monuments*, "The Monument in the Shrine and the University," 57ff, discusses the subjective pleasures felt in the gloominess of Westminster Abbey, for example.

54. Licht, *Canova*, 145.

55. During the exhibition *La Sculpture au XIXème siècle*, she was horizontally placed, but on such a high base that the point was again lost.

56. Réau, *Falconet*, 296, and Levitine, *Sculpture of Falconet*, 50, both see the Chapels as preparation for the equestrian which they certainly were. According to Kalnein and Levey, 88, Falconet's *St. Ambrose* was an early essay in the dramatic and heroic, but it is difficult to understand the reference to windswept drapery on looking at Gabriel de Saint-Aubin's 1765 drawing after the model at the salon (Levitine, fig. 33) which shows no such thing. For the history of the equestrian, see Réau, 329–403.

57. See Kalnein and Levey, 88 and 365, fn. 25, and Levitine, *Sculpture of Falconet*, 51–53.

58. "Montrez-leur, ainsi que vous l'avez projeté, votre héros sur un cheval fougueux, gravissant ce rocher escarpé qui lui sert de base et chassant la barbarie devant lui. Faites sortir des nappes d'un bassin rustique et sauvage; pourvoyez à l'utilité publique sans nuire à la poésie. Que je voie la *Barbarie*, les cheveux à demi-épars, à demi-nattés, le corps couvert d'une peau de bête, tournant ses yeux hagards et menaçant votre héros, effrayée et prête à être foulée sous les pieds de son coursier! Que je voie d'un côté l'*Amour des peuples*, les bras levés vers leur législateur, le suivre de l'oeil et le combler de bénédictions! Que de l'autre je voie le symbole de la *Nation*, couché à terre et jouissant tranquillement de l'aisance, du repos et de la sécurité! Que ces figures placées entre les masses escarpées qui borderont votre bassin forment un tout sublime et présentent de toutes parts un spectacle intéressant!" This letter was written in 1766 (Réau, *Falconet*, 339).

59. "Ce cheval respire-t-il? S'èlance-t-il fièrement vers les contrées barbares? Nous offrira-t-il bientôt l'image d'un des plus beaux monuments qu'il y ait dans la nature, un grand espace franchi d'un saut . . . Comme les obstacles disparaissent devant lui" (Diderot, *Lettres inédites*, 14, Letter V, July 1767).

60. See Réau, *Falconet*, 341ff, for precedents. Levitine, *Sculpture of Falconet*, 55, also briefly examines the rearing-horse type. Wittkower, *Sculpture*, 1977, 218, reproduces a drawing after Le Brun's project for an equestrian of Louis XIV for the Louvre as the closest antecedent.

61. See Colton, "*Parnasse français*," 1979, 148ff, for the "rococo sublime," a phrase coined by her. Titon knew Boileau's translation of Longinus.

62. Wittkower, *Sculpture*, 1977, 220, mentions the deliberate, identical 10-degree angle of the horse and the slant of the base to the ground.

63. Colton, "*Parnasse français*," 142ff, briefly discusses group composition preceding the *Parnasse*.

64. "ce beau désordre, . . . ce spectacle séduisant qui inspire le sublime" (*Essai sur la sculpture*, 6).

65. Luigi Vanvitelli's Great Cascade with the *Bath of Diana* (c. 1776) at Caserta is a case in point, being composed of marble figures set in a landscape. The difference consists in the figures having been conceived and sculpted for that very spot (as opposed to the *Niobids*, originally destined for a pediment, and *Apollo and the Nymphs* originally situated in a more lucid architectural framework). The entertaining baroque "play" is not too different, except in numbers, from the solitary *Hermit Guarinus* (1725–35) by Mathias Bernhard Braun von Braun (1683–1738) at the estate of Kuks near Prague. The originally polychromed hermit crawls upon the ground at the mouth of his cave in complete fusion with the natural environment. Eberhard Hempel, *Baroque Art and Architecture in Central Europe* (Pelican History of Art), Baltimore, 1965, 135–36, enumerates a number

of Braun von Braun's works for the estate of Kuks including a *Magdalen, St. Francis, St. Jerome* and another hermit, *Onufrius*, all originally polychrome.

66. Finally, "parfois un riche boiard se passait une couteuse fantaisie et chargeait un Francesco Righetti de réunir l'Apollon et les Muses du Vatican sur un Parnasse en marbre de Carrare, revêtu de bronze vert." See Hautecoeur, *Rome et la renaissance*, 74. The scale is not mentioned. The taste for such arrangements continued unabated in the nineteenth century, witness Hyppolyte Maindron's *Les Baigneurs* (1835) – essentially a family out boating and swimming – refused by the salon. As its intended size is unknown, its daring is difficult to judge but Maindron was obviously trying to break from academic tradition in every way. The universal trend reared its head in Sevilla too with Gloria de Becquer's *Group of Women* in the Park of Maria Luisa, seated in the shade of a magnificent real tree, and it traveled all the way north to Copenhagen where Edvard Eriksen's little bronze *Mermaid* (1913), perched on a rock, gazes out to sea. Any number of examples could be listed from John Cheere's *The Green Man* (1753, Biel, England), a gamekeeper shooting, to di Brazza's *Moses Saved from the Waters* (1820s?, Borghese Gardens, Rome), in which the group embedded in the landscape crouches and stands around the child. In France, especially in the second half of the nineteenth century, parks filled with figures and groups that appear like genii loci. Antoine Etex's *Naufragés* (1853–59) and other groups in the Parc de Montsouris show the importance of the trend. Even at the Chateau of Pierrefonds the little Gothic monsters, hybrids of pelicans, frogs and bats, straddle the balustrades as if "real" creatures. In the same way a classicizing *Venus and Mars* by Giuseppe di Maria (1762–1838) casually seated on either side of the staircase (upon a low ramp) of Palazzo Hercolani at Bologna distract the visitor with their "dialogue in time." This pupil of Canova in no way betrayed his own master's principles of illusionism (witness the *Paolina Borghese*) but for the explicit exchange between the figures. The occupation of "our" space proceeded apace, giving rise, by the end of the century, to the poet *Bigot* (1897) at Nîmes by Alexandre Charpentier (1856–1909) or, at the Conservatory of Music at Naples, a fierce *Beethoven* (author unknown, c. 1900), both leaning upon a podium of rough-hewn stone as though to address us in an outdoor lecture. The path leads straight to J. Steward Johnson, Jr.'s bronzed, colored figures (see, for example, *Time Magazine*, June 11, 1984, 77–78) and, more metaphorically, to George Segal's plasters.

67. Without wishing to avail themselves of the full extent of Falconet's means, both Canova and Thorvaldsen aspired to achieve something of the *Peter the Great*'s marriage with his surroundings by overcoming the psy-

chological barrier of the pedestal. Canova, in his first design for the equestrian statue for Napoleon (1806–07) showed the leader astride a pacing horse, turning back to urge his troops on more pointedly than in any previous baroque equestrian. In his correspondence with Quatremère, Canova specifically stressed the value of Napoleon's apparent communication with invisible troops but eventually gave in to Quatremère who categorically disagreed with the Berniniesque aim. See Quatremère de Quincy, *Canova*, 224 and 372–77, for Canova's letter (April 10, 1810) of agreement to Quatremère's suggestions. H. De Latouche (with Reveil), *Oeuvre de Canova*, 1825, 19, recorded this comment by Canova, though it may well be apocryphal: "Et lorsqu'on lui demanda pourquoi cette même figure de héros tournait le regard en arrière, dans la composition qu'il avait ébauché, il répondit: 'E prove che sta il primo di tutti.'" Incidentally, Count Leopoldo Cicognara found the horse to be even better than the *Marcus Aurelius* which Falconet himself had hoped to outshine (*Storia della Scultura*, Prato [1813–17], 1823, VII, 97–98). Quatremère agreed that the concept of Canova's equestrian was entirely new but, on that scale, lacking in nobility: "On admettra encore, disois-je, cette liberté de composition dans des ouvrages d'une petite dimension, et qui n'ont point à jouer un role public. J'en citrois ici un example qu'on trouve parmi les bronzes d'Herculaneum dans une très petite statue équestre d'Alexandre, dont le cheval au galop a les deux jambes en l'air: idée tolerable en petit, mais selon moi, fausse en grand, et surtout en grand colossal" (*Canova*, 226–27). This reads like a direct censure of Falconet's *Peter the Great* while the whole issue reveals to what degree Canova's natural inclinations in such an heroic monument moved in the direction of a certain immediacy of contact with the viewer or, at least, toward a suggestive theatricalism transcending the isolation of pure classicism. Others would take up where he left off. Froment-Meurice (1802–55) and H. Cordier (1827–1905) both executed equestrian statuettes of generals turning to their troops – though in radically different moods. These works date from after 1840 by which time their idiom would be entirely conventional on that scale. If the intention was to flood the viewer with a sense of valor, heroism or drama, the means had to be more fervent than the restrained pose of the *Marcus Aurelius* and even Thorvaldsen, the most dogmatic of the classicists, sensed this. In designing his *Equestrian of Poniatowski* (1826–27), he too attempted to break the barrier of isolation by suggesting an imminent leap into the waters of the Elster. David d'Angers found in this the object of one of the few positive things he had to say about Thorvaldsen, revealing to what degree the concept was different and significant in the Dane's oeuvre: "Une seule fois peut-

être Thorvaldsen s'est permis la fantaisie: c'est quand il a modelé la statue équestre de Poniatowski, statue qui devait surmonter une fontaine à Varsovie. Le cheval est représenté reculant effrayé devant les eaux de la fontaine, qui sont prises là pour les flots de l'Elster, tandis que Poniatowski, voulant mourir, enfonce l'éperon dans les flancs du cheval" (Henri Jouin, *David d'Angers: Sa Vie, son oeuvre, ses écrits et ses contemporains*, Paris, 1878, II, 251).

68. An *Eve in Paradise* in the Jardin des Plantes, Paris, by her very anecdotic qualities, fails to achieve the high symbolism of Rodin's works. Carefully integrated into the gardens, she brings her destiny down to the common level of everyday life.

69. See *Auguste Rodin: Le Monument des Bourgeois de Calais*, Musée des Beaux-Arts de Calais, Calais, 1977, 103. In 1893, Rodin expressed his intention simply: "J'avais pensé que placé très bas le groupe devenait plus familier et faisait entrer le public mieux dans l'aspect de la misère et du sacrifice, du drame, dis-je" (ibid., 96). A work such as Pierre Roche's (1855–1922) Rodinesque *L'Effort* (c. 1900) in the Luxembourg Gardens offers, through its theatrical effects, a perfect foil for the profoundly searching, burdened heroes of Calais.

70. Eventually Falconet dismissed the idea of an artificially constructed, naturalistic pedestal in favor of the engineer Carburi-Laskary's suggestion of floating the "Thunder-Stone" from the Karelian Swamp in the vicinity of the Gulf of Finland, an operation which took two years (1768–70) (Réau, *Falconet*, 372–79).

71. Falconet, *Oeuvres*, III, 347ff. Falconet is referring to M. Linguet mentioned in note 17. The event was so well-known that the *Memorie per le Belle Arti*, Rome, published an article, "Trasporto della Gran Base per la Statua di Pietro il Grande a Piterosburgo" in July 1785, I, 111–18.

72. Falconet, *Oeuvres*, 363–64; Falconet's italics.

73. The legend of Mount Athos never ceased to fascinate artists and critics. As early as 1721, J. B. Fischer von Erlach had reproduced his vision of *Mount Athos Carved into the Shape of Alexander the Great* in *Entwurf einer Historischen Architektur* (see Barbara Maria Stafford, "Rude Sublime: The Taste for Nature's Colossi during the Late Eighteenth and Early Nineteenth Centuries," *GBA*, 6è période, LXXXVII, 1976, 113–26). Adolphe Thiers quotes it again in 1822 (Benoist, *Sculpture romantique*, 21). In the same year as Valenciennes, Chancourtois executed his painting of the *Statue of Memnon* (see Henry Bardon, "Les Peintures à sujets antiques au XVIIIè siècle d'après les livres de salons," *GBA*, 6è période, LXI, April 1963, 217–49). For a lively study of Mount Athos in antiquity see Blanch R. Brown, "Novelty, Ingenuity, Self-aggrandisement, Ostentation, Extravagance, Gigan-

tism, and Kitsch in the Art of Alexander the Great and His Successors," *Art the Ape of Nature*, 1–13. Falconet also mentions the colossi of Egypt and Mount Athos in *Oeuvres*, I, 217–18.

74. Deloynes, LIV, no. 1628, *Monuments de l'héroïsme français*, 536, fn. 4.

75. Ibid., 536–38: "Faire du pont de Neuilly un pont triomphal, décorer la place de l'étoile, terminer ses rayons ou points de vue par autant d'acrs de triomphes en l'honneur des armées françaises.

Ériger au centre un rocher immense et à pic, représentant les Alpes; ce rocher serait percé à jour;

Élever sur la pointe la plus escarpée, la statue de l'héroïsme français, soutenant un faisceau de palmes, et debout sur un char antique, traîné par quatre chevaux aîlés;

Asseoir sur les flancs des rochers les Dieux des principaux fleuves, dont les urnes épancheraient des cascades

Diviser ces ondes en ruisseaux qui serpenteraient dans les Champs Elysées, les statues des héros morts au service de la patrie;

Disposer, sur toute la longueur de la route principale, des trophées d'armes, sur lesquels on graverait les prodiges de la gloire nationale;

Placer d'espace en espace des autels dédiés AUX VERTUES IGNORÉES;

Donner à cette route le nom de VOIE SACRÉE. (. . .)

Que s'il paraissait gigantesque à des esprits étroits, je leur rappellerais la *grandiosité* des monumens de l'antiquité, les pyramides et les canaux de l'Egypte, les prodiges de Dinocrates [Mount Athos], les merveilles de Rhodes et d'Alexandrie, le colysée des Romains, leurs amphithéâtres, leurs palais, leurs thermes, leurs grands chemins.

Et pour ne parler que des modernes, je citerais le Bernin, proposant à Louis XIV d'élever un rocher de cent pieds de haut, sur la place du Carrousel; *Falconet, déplaçant un quartier de roche, l'érigeant sur la route de Pétersbourg et plaçant sur cet escarpement la statue du créateur des Russies, de l'immortel Tsar Pierre-le-Grand, qui franchit à cheval ces hauteurs inaccessibles.* Je citerais Perrault, traçant le plan d'une rue prolongée depuis le pied de la colonnade du Louvre, jusqu'à la barrière du Trône; le Nôtre, projetant de former des eaux de la Seine, un canal au milieu des Tuileries." (My italics.)

76. "Proposition d'un monument à élever dans la capitale de la France, pour transmettre aux races futures l'époque de l'heureuse révolution qui la revivifiée sous le règne de Louis XVI, Paris, 1790, 14: ' . . . et il existe dans la vaste capitale [St. Petersburg] de ce vaste empire un monument qui transmettra en caractères intelligibles et ineffaçables la mémoire de ce grand changement; et ce sont des artistes français, appelés par cette nation

renaissante au fond du nord, qui l'ont composé et exe-
cuté.'"

77. Marvin Trachtenberg, *The Statue of Liberty*, New
York, 1976, 85, mentions David's project as part of the
trend toward the colossal.

78. See James Leith, *The Idea of Art As Propaganda in
France, 1750–1799*, Toronto, 1965, for more informa-
tion on this type of manifestation.

79. L. Benoist, *Sculpture romantique*, 72: "Sire, je pars pour
l'Auvergne. Vous me concédez un pic de montagne. Je
vais choisir un puy volcanique dominant le coeur de la
France pour le transformer en acropole de la civilisation
gauloise! Je ferais circuler de la base au sommet une voie
en spirale assez large pour donner passage à une armée,
ou à des flots de peuple . . . De distance en distance
seront espacées comme les sentinelles du sanctuaire des
statues de guerriers gaullois de dix mètres de haut. Sur
la crête de la montagne, un piédestal composé avec des
armures, ustensiles et objets symboliques de la vie de
nos aïeux, flanqué de quattre statues allégoriques; le
Druide, le Brenn, le Barde et Velléda (dix mètres de
haut). Et sur le piédestal une statue équestre de Ver-
cingétorix, les bras étendus criant l'appel aux armes.
Tout en airain, bronze, pierre, granit, ou matière sombre
et qui se rouille." Préault had communicated this project
to Théophile Thoré as something he would like to sug-
gest to Napoléon III. He had several megalomaniac pro-
jects in mind: carving a statue of Liberty out of the Butte
Montmartre in Paris, crowning the Arc de Triomphe
with a gigantic eagle ("dont les ailes de quatre-vingts
pieds d'envergure eussent enveloppé le monument dans
leur ombre") and a huge statue of Charlemagne which
he actually executed in plaster but which crumbled in
the studio (see David Mower, "Préault," *AB* LXIII, June
1981, 293–94).

80. Colton, "*Parnasse français*," 1979, 46, concludes that
the article did little to bring the *Parnasse* back to public
attention which is generally true. But Préault's plan
shows a possible response.

81. Licht, *History of Western Sculpture*, 308; Honour,
Romanticism, London, 1979, 133.

82. Leith, 1965, viii.

83. Paul Léon, *Les Invalides*, Paris, 1929, 398ff, gives a
complete description of the crypt. For the return of
Napoléon's ashes in 1840, the government commis-
sioned temporary statues of French heroes for the
Esplanade des Invalides and other figures for the
Champs élysées.

84. The sarcophagus measures 4,50 x 4,00 x 2,00 ms., the
Victories, 4,00 ms. The latter represent Napoléon's
greatest military campaigns. See ibid., 132–33.

85. See Honour, *Romanticism*, 222.

86. They represent Civil and Military Force and were origi-
nally conceived in marble but were altered in favor of
the black bronze. This in turn was gilded, but on fading,
was quickly rebronzed. Lami does not mention Duret's
execution of these figures.

87. The full project exists: *Projet de Tombeau de Napoléon*,
Paris, 1840, including the base (with four allegorical
reliefs) of black marble with gilded inscriptions. Yvon
Christ, *Paris des Utopies*, Paris, 1970, reproduces it
without the base.

88. See Furcy-Reynaud, *Inventaires*, 1879, I, 332.

89. "Malgrès mon admiration pour les anciens, je ne saurais
approuver dans eux ce goût assés bizarre pour les stat-
ues colossales; je pense, comme Watelet: 'l'orgueil des
hommes et l'exaltation ou l'exagération de leurs idées
ont une analogie sensible avec le colossal dans les arts:
aussi peut on penser que c'est à l'orgueil des hommes
puissans que l'on a du la plupars des figures ou statues
colossales dont ils nous restent des notions. Telle est
l'idée de la statue proposée à Alexandre, et que l'artiste
élevant son imagination au niveau de l'orgueil d'un
conquérant, avait proposé de former d'une montagne
entière'" (Deloynes, L, no. 1367, 891).

90. Flaxman, *Lectures*, 90. R. Schneider (*Quatremère*, 57
and 126) mentions *La Patrie* for its polychromy and
relationship to Quatremère's interest in colossal chryse-
lephantine works. See also p. 2 and fn. 104.

91. Trachtenberg, *Statue of Liberty*, 88, uses the term
"pseudo-colossus" to denote those works which, while
large in size, are scaled down by perspective (distance).
Where a single figure was concerned, colossal meant
varying sizes from seven to fifty feet or more, usually
applying to anything over life-size. Trachtenberg,
204–05 and fn. 13, quotes Cellini and Pomponius Gau-
ricus' estimate of the colossal as being three times life-
size. Benoît, [1897] 1975, 403, after discussing
gigantism in painting, wrote, "Le goût du gigantisme
affecta également la sculpture dans de moindres pro-
portions: il ne sévit que pendant la révolution et dis-
parut avec elle," which is true to some degree since the
government ceased to hand out commissions for colos-
sal works, but the nineteenth century was nonetheless a
century of megalomaniac projects and colossal statues.
See also Virginia Bush, *The Colossal Sculpture of the
Cinquecento*, Garland, New York and London, 1976,
Conclusion, 294ff, for a summary of the Renaissance
use of the colossal which prefigures its appearance dur-
ing the Revolution.

92. Biver, *Panthéon*, 92.

93. "Est-ce que nous ne prêtons pas naturellement au génie
des proportions grandioses? Et puisque la statuaire n'est
pas la représentation littérale de l'homme, mais une
sorte d'apothéose, et l'essence d'une âme divine, deve-
nue forme afin d'être saisie par le regard des gén-
érations, je maintiens que le colossal convient à
la représentation des grands hommes" (Jouin, *David*

d'Angers, II, 73) and "J'ai dit qu'une statue devait être beaucoup plus grande que les êtres vivants qui l'entourent journellement. Il faudrait que les statues eussent l'air de ne pas être faites pour entrer dans les maisons" (*Carnets*, I, [1828] 37).

94. Jouin, *David d'Angers*, II, 61.

95. Du Haut du temple ou du théatre,
 Colosse de bronze ou d'albâtre,
 Salue d'un peuple idolâtre,
 Je surgirais sur la cité,
 Comme un géant sentinelle,
 Couvrant la ville de mon aile,
 Dans quelque attitude éternelle
 De génie et de majesté! . . .

 "Va! que nos villes soient remplies
 De tes colosses radieux! . . . "

96. The grandeur of this vision lends substance to the idea of Piranesi as at least the equal of other men and as the author of an erased dedication to Lord Charlemont in the 1756 edition of *Le Antichità Romane*, following in the steps of Hogarth's "The No Dedication" in protest against subservience to aristocratic patronage. Eitner, *Sources and Documents*, 1970, I, 105, documents the quest for freedom from patronage, but as almost everywhere, sculptors are ignored, possibly because of the paucity of actual documents.

97. Hautecoeur, *Rome et la renaissance*, 206, specifies that his model was a recently unearthed head of Apollo. It looks like an Alexander.

98. This is the inscription on the monument as illustrated in the Fond Massiet, Bibliothèque du Musée des Arts Décoratifs, Paris, vol. 440–46, Germany. He originally wrote to Wolzogen in 1805, "Schiller muss colossal in der Bildhauerei leben, ich will eine Apotheose" (*Age of Neo-classicism*, 232, no. 238). The marble was completed in 1810 and became instantly famous, casts proliferating in great numbers. Dannecker wanted to place the bust, the original version of which he made in 1794, in a special temple.

99. Bindman, *Flaxman*, 1979, 36. Hayley, a poet and dilettante, was an invaluable friend to Flaxman in procuring him with commissions.

100. F. R. de Toreinx (Ronteix) indirectly justified David's inclination when, in his *Histoire du romantisme en France*, Paris, 1829, 132–33, he wrote: "Phidias veut donner à son *Jupiter* une intelligence surhumaine: il développe en lui à un degré gigantesque le front qui renferme toutes les facultés de l'intelligence. Voyez cette tête d'Homère, tête idéale, mais telle qu'il semble que l'artiste qui la sculptée en ait eu la révélation: les sinus frontaux, la partie supérieure des pariétaux ont une dilation extraordinaire: dessous, sont les organes de la mémoire, des images, de la méditation et de la versification; et ne sont-ce pas les trois facultés dont se compose le génie poétique?"

101. "Houdon faisait ses bustes de la grandeur du modèle. Il les moulait sur la nature. Il faut qu'elle soit moulée à travers le cerveau de l'artiste. Il faut aussi que le buste soit plus grand que la nature pour rendre l'expression que l'on ressent en voyant un grand homme. Comment rendre son animation sublime, sans l'illusion des traits vus en grandiose" (David d'Angers, *Carnets*, I, 49). He reiterated this view elsewhere (Jouin, *David d'Angers*, II, 49, and *Carnets*, I, 171–72) in almost identical terms.

102. Jouin, *David d'Angers*, II, 78.

103. Charles Lenormant, *Les Artistes contemporains*, Paris, 1833, 191, speaks of "une heureuse combinaison des hypothèses ingénieuses de Lavater avec les observations plus rigoureuses du docteur Gall."

104. Wennberg, 1978, 81, mentions the appearance of ugliness in one of the faces of Lemaire's Madeleine pediment relief.

105. David himself, in his 1794 *Self-Portrait*, refrained from idealizing his face by removing the evidence of the tumor which, at the time, was smaller. The idea of the ugly as being a necessary step on the way to the good and the beautiful had become a popular idea by the 1830s. Bowman, *Le Christ romantique*, 1973, 265ff, in the sections entitled "La Transcendance religieuse du laid" and "Le Laid et le progrès," addresses this question in the literature of the period.

106. See West, "The Sculptor's Self-Image." Whether the artists were aiming for government commissions through congenial subjects or truly expressing their deepest convictions, the independence conferred by working without commission was essential to the sculptor's slow evolution from mere workman to intellectual artist, although throughout the nineteenth century the humble origins of so many sculptors continued to bar the way to equality with painters. For a sustained discussion of the sculptor's condition in society in the nineteenth century, see Anne Middleton Wagner, *Jean Baptiste Carpeaux, Sculptor of the Second Empire*, New Haven and London, 1986.

107. Countless examples of artists donating their work to the state exist. On a very small scale, François Martin (? – 1804), who died in abject poverty in spite of his enterprising nature, prepared busts of notables for sale on a speculative basis (Lami, 18C, II, 115). The *Journal général de la cour et de la ville* of Nov. 9, 1789, announced: "Le Sieur Martin, sculpteur, déjà connu pour sa belle collection de bustes de nos grands hommes, a l'honneur de prévenir le public qu'il vient de mettre au jour les bustes en talc blanc, couleur de terre-cuite et bronzé, de M. Bailly, maire de Paris, et de M. le Marquis de La Fayette, commandant général de

la garde nationale parisienne. Ces bustes sont de la grandeur du quart de nature et servent de pendant l'un à l'autre. Il est inutile de dire qu'ils sont très bien exécutés. Le talent de M. Martin est assez connu pour qu'on en soit persuadé. On sait le grand honneur que lui ont fait son La Fontaine et son Rousseau. Le prix de chacun de ces bustes est de six livres." These can hardly compete with a full-scale salon plaster, resembling as they do porcelain tourist ware, but the Revolution stimulated artists at every level of ambition. Busts of Brutus apparently were to be found everywhere and statues of him stood "in every street." See Spire Blondel, *L'Art pendant la Révolution*, Paris, 1887, 69 and 77 (he devotes a mere seventeen pages to sculpture). In any event, this hyperbolic statement gives the climate of the times. Chaudet offered his *Bust of J.J. Rousseau* to the Assembly of 1790 (Vitry, "Les Monuments à J.J. Rousseau," 109). Claude-André Deseine, brother of the royalist Louis-Pierre, presented busts of Mirabeau and the Abbé de l'épée to the Assembly in 1791 and busts of Marat and Mucius Scaevola to the Conventions in 1793 and 1794 respectively, the latter accompanied by the notice: "La Cnne de Senne prie la Convention d'agréer le buste d'un ennemi intrépide des rois, Mucius Scaevola, modelé par son mari" (Lami, 18C, I, 274–75). Joseph Boiston, a sculptor lost to the present almost entirely, offered his copy of the *Capitoline Brutus* to the National Assembly on Sept. 1, 1792, to "thunderous applause." Robert Herbert, *David, Voltaire: "Brutus" and the French Revolution: An Essay in Art and Politics*, London, 1972, 90. Lami, 18C, I, 84, gives no dates for Boiston but he situates him in Rome in 1789. His serialized bust of Brutus went on the market in 1792. Pajou followed these examples, donating his bust of the *Conventionnel Beauvais, mort martyr de la liberté* to the Convention in 1794 (Lami, 18C, II, 222). The busts of Marat, Charlier and Lepelletier were highly popular, Beauvallet (1750–1818) giving his version to the Convention and producing an entire series for the "assemblées populaires" (Blondel, 1887, 77). Simon-Louis Boizot (in charge of sculpture at the Manufactory of Sèvres) patriotically presented *A Republican Maintaining Union and Equality* at the Salon of 1793 and, in the same year, modeled for Sèvres his biscuit group of a negro and a negress bearing the inscription in broken French: "Moi égal à toi, moi libre aussi" (Lami, 18C, I, 90 and 91; Kalnein and Levey, 169). And Chinard, to vindicate himself more than anything, had volunteered the pediment for the Hôtel de Ville of Lyon. With a different end in mind, Bernard Lange (1754–1839) sent the plaster for a *Philopoemen* to his first Salon of 1799, announcing that it was to serve as an element in a group of his own devising, providing

he could find the funds. Benoît, [1897] 1975, 248, mentions this. He gives no source for his information. See Lami, 18C, II, 77–78, for the scanty details of his life. The Italian sculptor, Giuseppe Ceracchi, working in France during the Revolution and executed there for his part in a plot to overthrow Napoleon, left for the United States in 1790 in the hope of securing a commission for his project of a monument to *Liberty* some one hundred feet high. Like Deinokrates addressing Alexander, he took the initiative but met with failure (Hubert, *Sculpture dans l'Italie Napoléonienne*, 27; Trachtenberg, *Statue of Liberty*, New York, 1976, 80–81), as did Canova's attempt to win acceptance for his projected colossal marble, *Religion*. The notion of the artist's emancipated status, held in the phrase "ils sont libres par essence" (salon cat., 1793) was itself a species of propaganda for the times. It dissimulated the artist's obligation to celebrate liberty, the new tyrant, in a situation similar to the freedoms and limitations imposed by a neoclassical vocabulary. Leith, 1965, 100, comments on this state of affairs, juxtaposing the new exhibition rights of artists and, more particularly, the freely conceived plan of erecting a monument commemorating the work of the Assembly with Beauharnais' reminder to artists that their duty lay in serving the state. Dowd, "Structure sociale et activité politique: Les Artistes engagés de la Révolution," *Actes du 86è Congrès National des Sociétés Savantes* (Montpellier, 1961), Paris, 1962, 513–29, and Dowd, *Pageant-Master of the Republic*, 78ff, offer useful discussions of the relationship of the artist to society. Benoît, [1897] 1975, 249, had already noted the marked change in the social condition of the artist, opening his book with comments on the fundamental rather than superficial relation of the arts to the social structure during the Revolution. See also "Utilité sociale et politique de l'art," 5, and 58ff. June Hargrove, "The Public Monument," *The Romantics to Rodin*, 21ff, thoughtfully analyzes the changes and contradictions between "immortalising the unique [individual talent] and the communal [liberty, etc.]" (22).

108. See Neil McWilliam, "David d'Angers and the Pantheon Commission: Politics and Public Works under the July Monarchy," *Art History*, V, no. 4, Dec. 1982, 429ff. Isabel Leroy-Jay Lemaistre returns to the politics of the relief's creation and unveiling in "Aux Grands Hommes – le ciseau et l'histoire," *Aux Grands Hommes, David d'Angers*, Fondation Coubertin, Saint-Rémy-les-Chevreuses, 1990, 22ff.

109. T. J. Clark, *The Absolute Bourgeois: Artists and Politics in France, 1848–51*, London, 1972, 58. The work could only be installed in 1857.

110. Agulhon, 1979, 10, from the *Revue Républicaine*.

111. David d'Angers, *Carnets*, II, 263.

112. See West, *From Pajou to Préault: The Development of Neoclassicism and the Sublime in French Sculpture, 1760–1830*, Ph.D., New York University, 1985, 388–404, and "The Sculptor's Self-Image." See also Ruth Butler, *Western Sculpture: Definitions of Man*, New York, 1975, 6–10, for a summary of the positions of sculpture vis-à-vis painting.

CHAPTER 8

1. Sarah Symmons, *Flaxman and Europe: The Outline Illustrations and Their Influence*, Ph.D., Courtauld, Garland, New York and London, 1984, offers a compendium of the major "benefactors" of Flaxman's legacy (see especially 127ff). Symmons also offers a very useful table of publication dates for Flaxman's works in Europe, 277ff.

2. Jacques Lamarie (1750–82), a sculptor and friend of J.-L. David, who had gone to Rome in 1778, apparently "had a mania for outline drawing" (Antoine Schnapper, *David*, New York, 1980, 47f), but his short career curtailed a sustained exploration of its possibilities and little is known about his work.

3. See Lami, 19C, IV, 77–82.

4. See Lami, 19C, I, 424–32; *The Romantics to Rodin*, 1980, 182.

5. Boyer, "Le Sculpteur Berthélémy Corneille à Rome et en Toscane (1787–1805)," 1970, 45ff, contains the only recent account of the sculptor's life, adding considerable material to Lami's entry (18C, I, 228–29) which gives his date of death as 1812. Boyer successfully argues for the earlier date of 1805.

6. Ménageot, director of the French Academy, approved of his work, but his Parisian counterparts dealt severely with the young sculptor's copies and "envois."

7. This is my translation of the text in M. Tinti's *Lorenzo Bartolini*, Rome, 1936, II, 129–30. Boyer, *Le Monde des arts*, 15–17, also quotes the entire passage. Symmons does not appear to be familiar with this source, nor does she discuss Corneille or Bartolini in relation to the influence of Flaxman.

8. The Canova bibliography is extensive, though still mostly restricted to a narrow monographic focus. Among fairly recent publications, Fred Licht, *Canova*, New York, 1983, is one of the most valuable. Though not intended as an exhaustive scholarly text (there are few footnotes), the book functions as the only broad study of his work to date pending Hugh Honour's long-awaited magnum opus. The latter's many articles form the truly solid foundation for subsequent work on Canova, including Mario Praz and Giuseppe Pavanello's excellent *L'opera completa del Canova*, Milano, 1976. Hubert, *Sculpture dans l'Italie Napoléonienne*, 63–81, 123–60, also gives a good if narrow account of Canova's achievements and an extensive bibliography (16–19). Hubert's thoroughness in his attention to individual artists (a few errors notwithstanding) in a work so broad in scope is always remarkable. Ottorino Stefani, *La Poetica e l'Arte del Canova, Tra Arcadia, Neoclassicismo e Romanticismo*, Treviso, 1980, attempts to come to terms with Canova's creation on a psychological level as well as to illumine its relation to contemporary literature (Ugo Foscolo). Curiously, Stefani omits several important works in the bibliography, such as Hans Ost's *Ein Skizzenbuch Antonio Canovas, 1796–1799*, Tübingen, 1970, in the section "Disegni," 174. The *Studi Canoviani*, Rome, 1973, presents one of the richest compendiums of essays on the sculptor. More recent exhibition catalogues, notably *Antonio Canova*, Museo Correr, Venice, 1992, add detailed information to various aspects of his life.

9. For example, the *Mercure de France*, Dec. 1784, carried an article on the gesso model of the *Monument to Pope Clement XIV* to be unveiled three years later.

10. Hubert, *Sculpture dans l'Italie Napoléonienne*, 78. As early as 1787, Canova was in a position to refuse the Cardinal de Bernis' commission for a monument to Bayard (ibid., 71).

11. Napoleon later wished to confer Vivant-Denon's position as Directeur Général des Musées upon Canova who refused (ibid., 90). Canova managed with exemplary courtesy to refuse most of Napoleon's invitations (see Hubert, *Sculpteurs italiens*, 39–42, 47–50).

12. Ippolito Pindemonte wrote to Costatino Zacca on April 10, 1823, "pur so che il presente secolo si deve chiamarlo, anzi che il secolo di Napoleone quel de Canova" (Francesca Romana Fratini, "Opere di scultura e plastica di Antonio Canova di Isabella Teotochi Albrizzi," *Studi*, 43). Cicognara had dedicated his first volumes of the *Storia* (1813) to the century of Napoleon. Upon the latter's downfall he dedicated the second edition (1823–24) of the work to the century of Canova.

13. Ugo Ojetti, "Canova e Stendhal," *Daedalo*, Anno III, vol. II, 1922–23, 307–40, gathers in one place Stendhal's comments on Canova (see 307 for the reference to the poet, sculptor and emperor). Stendhal met Canova in 1810, voicing this opinion in a letter to de Mareste, dated April 14, 1818.

14. In France, Reveil and De Latouche published their *Oeuvre de Canova* in 1825 and Lemercié his engravings of Canova's works, grouped dramatically and suggestively, from 1842 to 1846. Quatremère read his Eulogy of Canova in 1823 and published his monograph in 1834. In 1835, *L'Artiste* published an article entitled "Les Amours de Canova" followed shortly by a two-part account of his life by Saint-Chiron composed of standard material and prejudices (1ère série, IX, 1835, 80ff, and X, Part I, 149ff; Part II, 161ff). Books on the

life of Canova for children came out in the 1850s in Italy and Ludovico Muratori wrote his five-act play, *Antonio Canova*, in 1877 (Praz and Pavanello, 11). See ibid., 11ff, for excerpts from the literature defining the critical vicissitudes of Canova's reputation preceded by an essay, "Canova e la Bellezza," in which Praz gives a broad outline of Canova's critical reception. This is largely a reprint of his views published in "Canova and the Erotic Frigidaire," *Art News*, LVI, Nov. 1957, 24–27 and in *On Neoclassicism*, London, 1949, 142ff.

15. Stefani, *Canova 1980*, 72–73, appears to provide conclusive evidence that at its inception, Canova's *Hercules and Lichas* did have political overtones, Lichas representing "licenziosa libertà."

16. See Philip Fehl, "Canova's Tomb and the Cult of Genius," *Labyrinthos: Studi e ricerche sulle arti nei secoli XVIII e XIX*, 1/2, 1982, 46–66, for a full account of the events following his death and 61 and 66 for the references to Goethe and Lawrence. I am grateful to Mr. Sergio Romano for pointing this article out to me. A subscription letter (J.9157, 3) addressed to the Duke of Doudeauville, Ministère de la Maison, of May 4, 1825, from Venice is preserved in the Fritz Lugt Collection at the Fondation Custodia, Paris.

17. Cicognara, *Biografia di A. Canova*, 61.

18. Ibid., 65.

19. Quatremère, *Canova*, 354.

20. *Leopoldo Cicognara: Lettere ad Antonio Canova*, ed. Gianni Venturi, Urbino, 1973, 8, Letter 2.

21. Memes, *Canova*, 1823, 378. See also 127–28. The parallels with Michelangelo are contradictory, since Canova's reputation lay in having restored art to its ancient grandeur according to a set of classical rules. Michelangelo, on the other hand, elicited admiration for his rule-breaking individuality, the *Moses* especially standing for modern originality without precedent in Greek art. Quatremère in writing about Michelangelo in his *Dictionnaire d'Architecture*, Paris, 1832, I, 253, reiterated Vasari's assessment of Michelangelo as one who followed in no one's footsteps. Of Canova he said the same. Apart from "la partie grossière et purement mécanique du travail vulgaire de la matière, on sera toujours en droit d'affirmer que, pour ce qui regarde l'art véritablement dit du statuaire, il ne fut élève que de lui seul" (Quatremère, *Canova*, 4; see 8 too). This thought recurs persistently throughout his monograph which stands as a monument to Quatremère's neoclassical dogma expressed through the medium of Canova's art. For the relationship of Quatremère's monograph to the actuality of Canova's career, see Maria Grazia Messina, "L'Arte di Canova nella critica di Quatremère de Quincy," *Studi*, 119ff. Quatremère saw no contradiction in urging Canova to adhere to the rules of ancient sculpture while extolling his singular originality.

He thus lent the aura of exalted genius to what might have been an academic pursuit.

22. Quatremère, *Canova*, 71. He painted a fake Giorgione *Self-Portrait* which is supposed to have taken everyone in (ibid., 72), but this is hard to believe when one considers the mediocrity of so many of his paintings.

23. Praz and Pavanello, 87. Though hardly on the artistic or physical scale of St. Peter's, Canova's Tempio stands as a monument of sorts to his genius. It was the first structure of such importance raised by an artist on his own initiative. If he thought of it as a monument to himself or to his genius, he never admitted it. See West, "The Sculptor's Self-Image from Falconet to David d'Angers," *Acts of the XXVIth International Congress for the History of Art* (Washington, D.C., 1986), 1989, 391f, for more on the relevance of this monument to the artist's social standing.

24. Canova may have incorporated the pose of the *Dying Slave* into his highly polished *Sleeping Endymion* (1819–22) though Quatremère refers to it as the fruit of his exposure to the Elgin Marbles (Quatremère, *Canova*, 311). The arm raised behind the head is suggestive as is the high polish found also in Michelangelo's early works, but the stylistic bonds are tenuous. Vittorio Malamani, *Canova*, Milan, 1911, 262–63, juxtaposes illustrations of these works. Michele De Benedetti, *Michelangelo e Canova (Memoria premiata della R. Accademia di San Luca nel Concorso Poletti, scritto di Scultura, à 1924–II)*, Rome, 1933, XI, 9, sees in this comparison the only rapprochement between the two. He perceives Canova as the founder of nineteenth-century realism in sculpture, a position usually attributed to Bartolini, though there is much justification for De Benedetti's view.

25. Fernow found the group to fail because of its purely horror-inspiring character which could awaken only revulsion rather than interest in the subject (*Canova*, 1806, 138). He opposed what he considered to be the rhetorical bombast of many of Canova's male figures. Gianna Piantoni, "Le obiezioni della critica tedesca: Il saggio su Canova di C.L. Fernow," *Studi*, 33–34 and 59, speaks of "hyperbolic Michelangelism."

26. He found it to be the grandest project since Michelangelo's (Quatremère, *Canova*, 97). In his *Quaderni*, Canova often referred to Michelangelo and mentioned the *Moses* as something he knew to be famous, but it was in front of Bernini's *Apollo and Daphne* that he yielded to rapture.

27. Canova's larger than life-size *Self-Portrait* (1812) gives three-dimensional form to the essence of his role as the supreme artist of Europe. The work also ranks as one of the most remarkable instances of self-homage from the hand of a sculptor.

28. Welcomed in Rome by Gavin Hamilton and his pro-classical circle of friends, he was encouraged by them to

drop the naturalism of the *Daedalus and Icarus* nonetheless admired for its excellent observation of nature (Honour, "Canova's *Theseus*," 10). The group included Hewetson, Jenkins, Byres, Quarenghi, Batoni (later to criticize the *Monument to Clement XIV*), Volpato and Cades, the engravers, and the sculptor Angelini. For his early career in Rome, see Honour, "Canova and the Anglo-Romans, I," 241–95.

29. See Rosenblum, *1800*, 135, who establishes the *Sabines* as the climax of the international style in painting for its linear abstraction.

30. Even Fernow, *Canova*, 1806, 191–92, comments on the statue's great fame. See in particular Olga Raggio, "The Triumphant Perseus," *Connoisseur*, CLXXII, Nov. 1969, 204–12, for the complete history of the statue and its variant. Antonio Pinelli, "La sfida rispettosa di Antonio Canova. Genesi e peripezie del 'Perseo Triomphante,'" *Il Neoclassicismo tra rivoluzione e restaurazione, Ricerche di Storia dell'Arte*, 13–14, 1981, 21–40, enlarges upon Raggio's article without, it must be said, acknowledging it. He brings to bear Winckelmann's theories and Stendhal's opinions for a subtle interpretation of the work. See also Praz and Pavanello, 104–05 nos. 121–24.

31. Pinelli, "Antonio Canova," 1981, 40, fn.1.

32. See Raggio, "Triumphant Perseus," 1969, 208. If, in 1788, Guattani had deplored the departure of the *Theseus and the Dead Minotaur* from Rome "where someone could and ought to have bought it," the same mistake was not allowed to happen twice. See Honour, "Canova's *Theseus and the Dead Minotaur*" (*Victoria and Albert Museum Yearbook*, I, 1969), London, 1969, 5.

33. This newsworthy fact found its way into the correspondence of the French minister to Rome, François Cacault, with Talleyrand, in a letter of Oct. 18, 1801. See Anatole de Montaiglon et Jules Guiffrey, *Correspondance des directeurs de l'Académie de France à Rome avec les surintendants des bâtiments*, Paris, 1887–1912, XVII (1908), 320, no. 9880, 20 Vendémiaire, an 10. Canova had helped Cacault's younger brother in financial distress in Rome. Cacault also wrote to the same correspondent in December of the same year, that "la figure colossale de *Hercule* de Canova, dont le modèle en plâtre a été tant admiré dans son atelier, va être exécutée en marbre par ce grand artiste. C'est Monsieur Torlonia, banquier, le plus riche de Rome, qui fait faire ce grand ouvrage et qui fera la dépense nécessaire pour qu'il soit placé convenablement et *qu'il ne sorte pas de Rome*" (ibid., 338, no. 9894, Dec. 8, 1801; my italics). The *Hercules and Lichas* was commissioned by Onorato Gaetano in 1795 (Praz and Pavanello, 106f, no. 131). Canova's *Pugilists* (1795–1806) was purchased as well by Pope Pius VII in 1802 and also entered the inner

sanctum of art, the Vatican collections. Suvée, director of the Academy, also wrote to Talleyrand about the *Perseus*, and about Canova in general as one of the greatest artists in Rome (*Correspondance*, 1979, 305, no. 178).

34. Pinelli, "Antonio Canova," 1981, 21–22, discusses the portion of Winckelmann's aesthetic underlying the statue. Canova had been plotting a figure such as the *Perseus* for some time, the final impetus to realize it coming when he returned to a desolate Rome in 1799 and was spurred, in all due modesty, to do something to fill the vacant pedestals left by Napoleon (Raggio, "Triumphant Perseus," 1969, 206–07). When he had fled to Vienna and to Possagno in the north in 1798, unable to tolerate the French activities in the Eternal City, he had already elaborated a fairly complete model (1797) for the statue as it would eventually look. Canova had projected the *Perseus* without commission, Honoré Duveyriez only becoming its first but not final patron in 1798 (ibid., 208).

35. Raggio, "Triumphant Perseus," 206 (Fernow, 1806, mentions this). Licht, *Canova*, 185, speaks of the similarities to the *Apollo* as being merely an afterthought, which was definitely not the case.

36. Licht, *Canova*, 186 makes these valid comparisons. Canova drew the *Horse Tamers* and noted his admiration for them in his *Quaderni*.

37. This is Barbara Maria Stafford's more succinct translation of Winckelmann's thought in the "Beauty of the Invisible: Winckelmann and the Aesthetics of Imperceptibility," *ZfK*, XLIII, no. 1, 1980, 71. See 71–72 for her discussion of transparency.

38. Ibid., 70, fn. 70.

39. Ibid., 77, fn. 149 (Winckelmann, *Geschichte*, 218). In a letter addressed to Wiedewelt, Winckelmann uses the same image again (Justi, 1923, III, 221–22).

40. Pauli, 1925, 51, speaks of Canova's masterful transcendence of materials. Licht, *History of Western Sculpture*, 24, describes the way in which the *Paolina Borghese* first impresses the viewer as stone. In *Canova*, 138, he presents a balance between the illusion of flesh and the sense of stone. Indeed, she is so complex that one cannot claim precedence for either stoniness or fleshiness or perhaps even silhouette.

41. "Essendo poi l'esecuzione nelle opere dell'arte quello che è l'esecuzione nella poesia, dicea aggiustarsi perfettamente alla parte esecutiva quelle belle parole sulla locuzione, cioè, che l'elocuzione deve esser chiara e non bassa, perchè quando e composta solo di parole proprie e comuni, diventa chiarissima, ma pero bassa, e che per renderla nobile convien far uso di parole pellegrine, e di tutto cio che puo distinguerla dalla comune favella popolare: così l'arte debbe fare accoglienza solo alle fisionomie più elette, alle forme più belle, alle pieghe più

scelte, alla maniera più facile e nobile insieme, più pellegrina e vera" (Melchiore Missirini, *Antonio Canova*, Prato, 1824, 351, LX). This recalls, of course, Winckelmann's description of a beauty comparable to the transparency and tastelessness of water (*Geschichte*, 150). For an interpretation of this simile and its significance, see Martin Kemp, "Some Reflexions on Watery Metaphors in Winckelmann, David, Ingres," *BM*, CX, May 1968, 266ff.

42. Missirini, *Antonio Canova*, 319, IX. Canova used "sublime" here to describe an ineffable quality of "superhuman" distinction, nobility and grace, the sublime of a transcendent experience or vision. Argan, *Antonio Canova*, 1969, 55, takes exception to the phrase "esecuzione sublime" because he is under the mistaken impression that Canova did not care about surface finish, believing that he left that to assistants. This was not the case at all (see Honour, "Canova's Studio Practice," I and II).

43. Argan, *Canova, Cicognara, Foscolo* (with Giandomenico Romanelli and Giovanni Scarbello), Venice, 1979, 24, describes the passage from bozzetto to marble in these terms. Canova kept his bozzetti, aware of their own particular qualities but he and his contemporaries were sensitive to the all-important differences between the bozzetti, plaster models and polished marbles. Quatremère's momentary lapse when admiring the *Hercules and Lichas* in bozzetto form does not mean he secretly preferred the *non-finito* (Quatremère, *Canova*, 83–84). Hemsterhuis had earlier delved into the attraction of the sketch as an incitement to the imagination absent in the cool completeness of the finished work. See *Lettre sur la sculpture*, 8. The Comte de Caylus had voiced a similar opinion in a lecture in 1732 (E.G. Holt, *A Documentary History of Art*, New York, 1957, II, 323). See also Gage, 1976, 482–83. Thus, there was nothing original in Quatremère's thought nor does it invalidate the stronger position favoring a well-turned marble piece. Gaspare Landi wrote of the *Perseus* in 1801, "ma il modello non ha niente di commune colla perfezione della statue" (Honour, "Canova's Studio Practice II," 225, fn. 78).

44. Cesare Brandi felt that he "translates marble into cement" (Praz and Pavanello, 8).

45. "L'âme désiroit le plus, parmi les objets visibles, un point lumineux presque imperceptible par sa quantité visible" (Stafford, "Beauty of the Invisible," 1980, 73).

46. In relation to this, it is worth noting that D.P.G. Humbert de Superville's (1770–1849) *Projet d'un musée classique de la statuaire ancienne au moyen des jets de plâtres* (1825) justified a museum devoted to casts rather than to the originals on the following grounds: "Un beau plâtre est plus qu'une copie: c'est l'empreinte et l'image la plus naïve et la plus fidèle possible de son original et s'il ne rend ni le marbre ni le bronze, ce mar-

bre et ce bronze à leur tour ne constituent pas seuls toute la beauté de la sculpture ancienne, il leur a fallu, et il leur faut ce souffle divin, qui les dématérialise, le donne d'abord à l'argile qui leur servit de modelle [*sic*] et le transmet encore à leur fidèle empreinte." See Barbara Maria Stafford, "Arena of Virtue and Temple of Immortality: An Early Nineteenth-Century Museum Project," *Journal of the Society of Architectural Historians*, XXXV, March 1976, 22. This dematerialized beauty living within the plaster calls to mind the immaterial condition of sculpture defined by Hemsterhuis or Winckelmann. Not too surprisingly, Humbert de Superville's fascination with "transparency" lived on in his line drawings inspired by Flaxman (see Rosenblum, *Transformations*, 165, fn. 60 and 175). Humbert de Superville became the first director of the Museum of Plaster Casts in Leiden, the Prentenkabinet of the Rijksuniversiteit in 1825.

47. Hemsterhuis, *Lettre sur la sculpture*, 3 and 13, quickly asserts that sculpture is the principal art in seizing the all important contour as it exists materially and not illusionistically. He elaborates upon the need for simplicity in the *Lettre sur les désirs* (7–8, 49ff) and discusses the general desire of man to unite with whatever is about him, including art.

48. Stafford, "Beauty of the Invisible," 1980, 75, coins this phrase when mentioning Théodore Jouffroy's *Cours d'esthétiques*. They are particularly valuable for their early appreciation of the longing for transparency as a means to reach the inner being of the object expressed, according to him, in Greek sculpture and the painting of Raphael, J.-L. David and his followers. But it is a mistake to think he unreservedly admired David and his contemporaries. On the contrary, he felt that they had followed too stringent and hopeless a path. He discussed the nature of the invisible (185) in the three categories (the invisible free of any form, the invisible in natural form and the invisible in artificial form) quickly coming to a summary of Hemsterhuis' position without naming him: "Les uns ont pensées que puisqu'il était évident que dans les objets extérieurs, c'était l'invisible qui agissait sur nous, il fallait en conclure qu'en dépouillant l'invisible de ses formes extérieurs, cet invisible continuerait d'agir, et même agirait sur nous d'une manière plus énergique. D'après ce principe, ont procédé dans l'art un certain nombre d'artistes en tout genre; ces artistes composent l'école de l'idéal . . . Dans cette hypothèse . . . les formes sont un obstacle à l'émotion . . . Il s'ensuit qu'il faut effacer les formes le plus possible, ou les abstraire au point qu'elles expriment l'invisible le plus nettement possible; et si on ne peut pas s'en passer dans les arts plastiques, il faut au moins les rendre si transparents, qu'on les fasses oublier en quelque sorte, de manière que le fond seul et l'invisible paraissent agir

sur nous." With regard to sculpture, he concludes that "le principe de cette école n'a pas pu, dans les arts plastiques, être passé jusqu'à ses dernières conséquences. Le statuaire ne peut pas se passer des formes, des lignes, des signes par lesquels l'invisible se manifeste. Le statuaire idéaliste les simplifie, les rend aussi claire que possible, en ne laissant rien de vague dans le sentiment qu'il veut rendre; mais il ne peut pas les supprimer" (198). In an earlier lecture, Jouffroy dwells upon the morality of significant form and its "invisible" message: "Deux formes ou deux lignes ne sont donc pas seulement deux formes ou deux lignes, ce sont encore deux expressions de quelque chose que nous ne voyons pas. Après leur sens immédiat et physique, il y a de plus leur sens intérieur et caché" (163).

49. Canova carried his criticism of the *Apollo* and of his own Vatican *Perseus* further in the Tarnowska version (Metropolitan Museum of Art, New York), commissioned in 1804 and executed between 1804 and 1806 in which he attenuated and softened the figure even more. Raggio, "Triumphant Perseus," 1969, 210, discusses the Tarnowska *Perseus* and the refinements of its conception.

50. "The greatest fault of the 'divine Perseus' as we have often heard him called, is precisely this, that he is 'divine,' when he should only be a hero" (*Dublin University Magazine*, Aug. 1844, XXIV, no. 10, Part II, 296, translation of Fernow, *Canova*, 1806, 196). Pinelli, "Antonio Canova," 1981, 29, quotes Forsyth as an example of protest against this "divinisation" and, 31, refers to Winckelmann's position.

51. Quatremère dwelled upon this in describing Canova's *Mars* and *Venus*: "Les noms de *Mars* et *Venus* ne sont plus à nos yeux la désignation de deux divinités, que leurs images ne sont des simulacres réputés réellement divins. Ce sont uniquement deux idées morales ou poétiques, auxquelles l'artiste est libre de donner, toujours cependant avec la vraisemblable de la fiction qui a continué de leur rester attaché, plus ou moins d'action, de mouvement et d'expression" (*Canova*, 128). This is an admittedly bold claim, though on further consideration, it is apparent that the indifference to subject was relative. Canova's random choice of names remained a random choice amongst the gods and heroes of antiquity. Licht, *History of Western Sculpture*, 24, sees in the favoring of form over subject in neoclassicism the first development of modern sculpture leading to Brancusi.

52. Pinelli, "Antonio Canova," 1981, 32.

53. Ibid.

54. Memes, *Canova*, 1823, 564–65.

55. In terms of iconography, Canova had no antique precedent on which to draw for inspiration, a matter of some advantage to him as it gave him greater leeway in defining the character. The winged, flapped Phrygian cap, for example, is his own inventive solution to the various descriptions of Perseus' headgear while conforming in general shape to the silhouette of the *Apollo*'s hairstyle (Raggio, "Triumphant Perseus," 1969, 207 and 208).

56. "Canova ayant été romantique, c'est à dire ayant fait de la sculpture qui convenait à ses contemporains (et qui leur faisait le plus de plaisir, parceque elle était à leur mesure), ses ouvrages sont compris et sentis bien longtemps avant ceux de Phidias" (Pinelli, "La afida rispettosa di Antonio Canova," 1981, 37 and fn. 47). Stendhal adds, "Pourquoi se faire un devoir d'admirer l'*Apollon*? Pourquoi ne pas avouer que le *Persée* de Canova fait beaucoup plus plaisir?" (ibid., 38 and fn. 55).

57. Symmons, *BM*, CXV, 595.

58. "Ma sono antichi; e cio basta per far loro [the critics] cader la penna di mano, anzi impegnarli ad esaltare come vere bellezze quelle a un moderno sarano veri difetti" (Ferdinand Boyer, "Canova, sculpteur de Napoléon," 1970, 145: Letter from Canova to Quatremère, Nov. 26, 1806).

59. Licht, *History of Western Sculpture*, 21.

60. August von Kotzebue, visiting Canova's studio in 1805, had commented favorably upon the Venus: "It may be said that the artist has to a certain degree imitated the position of the Medici Venus; but I think his performance in this respect far superior to the latter, for this Venus cannot be charged with that counfoundedly stiff position of the arms which the other appears to have learnt from a dancing master" (Honour, "Canova's Statue of Venus," *BM*, CXIV, Oct. 1972, 662).

61. "Il riflesso deliberamente elusiva di una bellezza che gli antichi, e solo gli antichi, avevano reso eterna" (Pinelli, "Antonio Canova," 1981, 28).

62. For accounts of this visit, see Hubert, *La Sculpture dans l'Italie Napoléonienne*, 141ff and *Les Sculpteurs italiens*, 42f. Ferdinand Boyer, "Canova et les Français avant les commande de Napoléon," *Le Monde des Arts*, 1970, 119ff, documents Canova's earlier commissions and acquaintances. In "Canova, sculpteur de Napoléon," ibid., 131ff, he adds further details to the history of the Napoleonic commissions.

63. Hubert, *Les Sculpteurs italiens*, 42.

64. Quatremère published a *Notice sur M. Canova: Sur sa réputation, ses ouvrages et statue du Pugilateur* in 1804, devoted to the general praise of the sculptor.

65. For the Louvre version, see Praz and Pavanello, 102–03, no. 101. It was commissioned by John Campbell and bought by Joachim Murat in 1801. No. 102. also commissioned by Campbell, went to Josephine de Beauharnais and eventually (in 1815), like most of the works in her collection, to Czar Alexander, which explains the rich holdings of the Hermitage.

66. Ibid., 102, no. 100.

67. Ibid., 110, no. 147.

68. Ibid., 101, no. 87. A second version (1805–09; ibid., 117, no. 198) in the Hermitage was commissioned by Eugène de Beauharnais. There are actually two versions at the Hermitage, the second a rather less refined copy, is kept in the sculpture reserves.

69. Ibid., 112, no. 113. The *Dancer* met with great success at the salon after having been reluctantly lent by Josephine on the insistence of both artists and amateurs. She refused to lend the *Paris*, then considered to be one of Canova's finest achievements (Hubert, *Sculpteurs italiens*, 18 and fn.7).

70. Praz and Pavanello, 112–13, no. 172. This statue, begun as a portrait of Alexandrine Bleschamps, wife of Lucien Bonaparte, princess of Canino, was completed for Sommariva who lent it to the Paris salon where it arrived in the closing days. The drapery drew high praise, but its success was limited. See H.H. Hawley, "Antonio Canova's *Terpsichore*," *Cleveland Museum Bulletin*, LVI, Oct. 1969, 287–305, for an extended discussion of the work.

71. Canova himself is said to have disparaged her (Boyer, *Le Monde des arts*, 1970, 145). For a complete history of the work, see Franco Boggero, "Una rilettura critica del Canova: La *Maddalena Penitente*," *Civiltà Neoclassica nella Provincia de Como (Arte Lombarde)*, 1980, 386–92.

72. "L'anxiété était à son comble," wrote the *Moniteur* of Feb. 24, 1839. See René Schneider, *Quatremère*, 385, fn. 5. and Francis Haskell, *An Italian Patron*, 10.

73. Hubert, *Sculpteurs italiens*, 44.

74. Haskell, *An Italian Patron*, 15. Haskell goes on to say of this arrangement: "an appropriate decor, we may feel, for a figure which so ingeniously combines pietism and worldliness." It should be noted that Fernow, *Canova*, 1806, 127–28, found the *Magdalen* to be a consistent work: "A penitent Magdalen, in life size, is one of the few of Canova's works which possesses at least the merit of appropriate and pervading individuality, in which the figure is in harmony with itself, and the expression with the character. In this respect, therefore, it is entitled to our praise, even if we find the character of a Magdalen has not been correctly conveyed" (translation, *Dublin*, 1844, II, 171).

75. Clodion had produced several small terra-cottas of quite attractive *Penitent Magdalen*s while in Rome (see *Clodion*, 115ff for Louvre terra-cotta, 1767, and 119f for Agen Musée des Beaux-Arts terra-cotta, 1768). These and Canova's works are so different from Donatello's famously ugly standing *Magdalen* that they are not really comparable.

76. Hubert, *Sculpteurs italiens*, 44–45, lists many of the sources for contemporary criticism.

77. "une vraie création de son génie et de son ciseau" (*Canova*, 68). The same grounds for approbation appear in an 1808 criticism (Deloynes, XLIV, no. 1144). Quatremère also mentioned its pictorial qualities. Gustave Planche, *Salon de 1831*, Paris, 1831, claimed that it would be better as a painting.

78. Chauvin, *Salon de 1824*, Paris, 1825, 241–42. The full passage reads as follows: "A ce joli groupe de *Grâces*, je préférerais cependant encore une figure sublime, la *Madeleine Pénitente*, que j'ai vue réunir tant de suffrages mérités.

Dans cette création singulière, étonnante, l'artiste a su profiter avec art des vives lumières de la religion et des beautés mâles dont la grandeur et l'élévation des écritures ont si magnifiquement doté les peuples modernes. Les Grecs et les Romains ne se formaient pas l'idée d'une douleur semblable à celle dont le poids accable et terrasse Madeleine. Dans les statues antiques, on ne retrouve guère, quant à l'expression, au delà des souffrances purement physiques, plus ou moins ennoblies. La *Niobé* seule présente un caractère approchant de l'affection morale; mais cette exception douteuse fut-elle admise, viendrait encore fortifier la règle générale.

Gardons-nous de répéter, avec des juges peu réfléchis, que la *Madeleine Pénitente* n'est autre chose qu'une *statue romantique*: ce serait bien légèrement abuser des mots. Une oeuvre expressive, pathétique, touchée largement et simplement, n'a rien de commun avec le genre appelé romantique, genre essentiellement froid, parce qu'il est radicalement faux."

79. De Latouche, 1825, "Madeleine Pénitente." This comment sets the standard assessment of the Laocoon, usually perceived as the foremost example of noble suffering (an expression of the soul), on its head. The full passage is as follows: "Cette figure est l'ouvrage le plus généralement connu, la composition la plus populaire qui soit échappée au ciseau de Canova. Tous les hommes qui sont réservés à une longue renommée rencontrent dans le cours de leur carrière une pensée qui fait une fortune inattendue. Tout était neuf dans cette entreprise. Le génie des Grecs et l'appui des modèles est totalement oublié. Le marbre, si pathéthique, n'a point de rivaux chez les anciens; car l'admirable Laocoon ne reproduit que des douleurs physique; et Niobé, qui voit succomber ses enfants, est plutôt en révolte contre le ciel, que résignée à sa puissance. La Madeleine pénitente est une statue qu'on pourrait appeler romantique: et c'est peut-être là le secret de son triomphe."

80. Hubert, *Sculpteurs italiens*, 60, fn. 1. "Je me souviens d'avoir dit un jour à notre célèbre et ingénieux sculpteur, M. Pierre Jean David [d'Angers], que la statue de la *Madeleine* me paraissait la *statue dogme du Christianisme*, c'est à dire de la religion de pardon et de clémence, et qu'il me parut partager entièrement cette opinion."

81. "Il y avait des jeunes gens qui entouraient cette bière. J'éprouvai un sentiment de jalousie. J'étudiai leur regard, et j'éprouvai un peu de soulagement, quand je ne vis sur leur visage que ce sentiment que l'on éprouve quand on voit ravir à la terre un être si beau. Ils éprouvaient ce sentiment que l'on éprouverait si tout d'un coup on voyait un monceau des débris de la Madeleine de Canova" (David d'Angers, *Carnets*, I, 246, 1833).

82. Lapauze, *Histoire de l'Académie de France à Rome*, Paris, 1924, II, 56, 1805.

83. Delpech, *Examen raisonné des ouvrages de peinture, sculpture et gravure exposés au Salon du Louvre en 1814*, Paris, 1814. My italics.

84. "Les artistes français se sont empressés dans tous les tems, de rendre justice à leurs rivaux, et ce sont eux, qui pleins d'estime pour la personne de Canova, ont premiers fait connoître son nom dans toute l'Europe. Ils se plaignent seulement, ou plutôt, il s'affligent de n'avoir pas trouvé depuis longtemps d'aussi belles occasions de se faire connoître; car depuis la statue elevée a Louis Quinze et le mausolée du maréchal de Saxe, aucun monument de quelqu'importance et digne de porter ce nom n'a été entrepris. Cependant les progrès de l'école française, depuis cette époque, sont incontestables" (Deloynes, XXX, no. 850, 482–83).

85. Jouin, *David d'Angers*, I, 157.

86. Georges le Chatellier, *Louis-Pierre Deseine, 1749–1822: Sa Vie et ses oeuvres*, Paris, 1926, 9, quotes the letter.

87. Ibid., 75–76.

88. Réau, *Falconet*, 292.

89. Ibid., 302. Though invisible to the public, who are usually forbidden to enter the now walled-off space of the chapel, the two later groups still survive, flanking a mournful niche in which Anguier's *Crucifixion* has again been raised on a very narrow bed of rocky protuberances painted black.

90. Deseine had admired Canova's *Monument for Clement XIV* while studying in Rome as a Prix de Rome winner in 1779. His letter describing the monument is preserved at the Cabinet des Dessins.

91. See Mario Praz and Giuseppe Pavanello, *L'opera completa del Canova*, Milano, 1976, 107–08, no. 134, for the genesis of the monument.

92. This concept is first expressed by Hugh Honour in "Canova and David," *Apollo*, XLVI, Oct. 1972, 312–17, and reiterated in Honour, *Neo-classicism*, 36 and 42. See also 156–58 for the *Monument to Maria Christina*. Fred Licht, *History of Western Sculpture: 19th and 20th Centuries*, Greenwich, 1967, 22 and 31, elaborates on the notion of dissociation or juxtaposition within the context of later sculptural developments. See also Licht, *Canova*, New York, 1984, 69ff, for a sensitive appraisal of the monument in question. Argan, *Antonio Canova*, 1969, 63ff, in speaking of Canova's reliefs of the life of Socrates, employs the words "syntactic" and "paratactic" to express the same idea of juxta- and com-position.

93. "Jusqu'à un certain point, en effet, il y a dans la conception de cet ensemble, dans ses variétés de distribution, de masses et d'actions réparties sur plus d'un espace, quelquechose qui paroîtrait pouvoir appartenir au génie de la peinture, et qui indiqueroit une sorte de conquête de la part de la sculpture de sa rivale" (Quatremère, *Canova*, Paris, 1834, 134).

94. "Canova," *Dublin*, 1844, 294 (Fernow, *Canova*, 1806, I, 181–82).

95. See Elena Bassi, *Canova*, Milano-Bergamo-Rome, 1943, 26. Bassi herself finds the monument very difficult to like because of its excessive theatrical rhetoric – uncongenial, she feels, to contemporary taste.

96. See Ottorino Stefani, *La Poetica e l'Arte del Canova*, Treviso, 1980, 83ff, for a comparison of the monument to Ugo Foscolo's poetry and 85f and 90, fn. 6, for further comments on its illumination by torchlight and the poetic effect of this.

97. For details, see Le Chatellier, *Deseine*, 1926, 73ff and 90ff, and *Skulptur aus dem Louvre*, 1990, 98, no. 30.

98. "La force de courage soutient le prince jusqu'à son heure dernière; il marche avec calme à la mort; le Crime, qui se cache, l'attend pour le frapper, la France enchaînée par la tyrannie est accablée par cet horrible assassinat. Le bas-relief represente l'instant où l'illustre victime montre à ses assassins la place où ils doivent frapper.

Sur le sarcophage, sont placées deux couronnes de chêne, emblème de la force et de la valeur. Elles sont enlacèes de deux branches de cyprès.

Le brisement des balances et du glaive de Themis, placés aux pieds de la France, signifie que sous la tyrannie la Justice est sans force.

La France tient dans sa main son sceptre renversé, ce qui indique qu'elle était alors sans force pour commander." See Le Chatellier, *Deseine*, 73 (from the salon catalogue).

99. The figure of Religion is a later substitution for Courage carved by Deseine's nephew, Amédée Durand, who completed the tomb in 1822. See ibid., 74, for the vicissitudes of the execution.

100. No study exists of Canova's full impact upon France. One of the most recent examinations of French neo-classicism, Philippe Durey's "Le Néo-classicisme" (288–302) for *La Sculpture française au XIXème siècle*, Grand Palais, Paris, 1986, touches briefly on the subject (292ff), suggesting that it has largely been exhausted by Hubert's methodical *Sculpteurs italiens*, 57ff. Hubert does indeed trace Canova's influence in France in ways useful for gathering factual information even if, for example, he denies any link between

Canova and Pajou. But the discussion leaves out certain aspects of the critical reception of Canova's work, and the more complex position of Canova as role model and how this in turn might influence a young sculptor like David d'Angers. Going back in time, François Benoît, [1897] 1975, omits any mention of the sculptor's name whatsoever, writing the history of French sculpture as though it were taking place in a vacuum. Gonse, 1895, 259, mentions Chaudet, Cortot, Cartellier, Lemot, Seurre and Bosio as imitators of antiquity with no mention of Canova. Vitry, "La Sculpture en France de 1789 à 1850," *Histoire de l'Art (L'Art en Europe et en Amérique au XIXè siècle et au début du XXè)*, Paris, 1925, VIII, 45ff, mentions Canova's influence generally (along with Dannecker and Thorvaldsen), 53, without elaboration. He writes, 54, of the international group, "On a presque peine à distinguer l'une des autres les productions du Suédois *Sergell*, du Danois *Thorvaldsen*, de l'Allemand *Dannecker*, du Belge *Kessel*, ou de l'Anglais *Flaxman*." This insensitivity to the individuality of style of these sculptors explains in part the dismissive approach to the period in question, lumped together as an unfortunate episode in French art. Antoinette Le Normand, 1981, scrupulously notes any borrowings from Canova in the works of the sculptors with whom she concerns herself, but by 1820–40 the significance of such borrowings was greatly diminished because of their ubiquitousness and more important developments. *Skulptur aus dem Louvre*, the 1990 exhibition catalogue of the Louvre holdings in sculpture from 1760–1830, offers an excellent sampling of works but still lacks a comprehensive overview.

101. There exists as yet no full monograph on the work of this sculptor. The best sources are *L'Oeuvre de Joseph Chinard*, Lyons, 1978, a small exhibition catalogue of the sculptor's work (which, however, does not give the location of the works borrowed) written by Madeleine Rocher-Jauneau whose "Chinard and the Empire Style," *Apollo*, LXXX, Sept. 1964, 220–25, provides a useful account of his Roman stay and subsequent career. See also Paul Vitry, *L'Exposition des oeuvres du sculpteur Chinard de Lyon*, Paris, 1909, Kalnein and Levey, 170–72, and Lami, 18C, I, 194–218 (bibliography, 218) for summaries of his career. For his portraiture, see Günther Schwark, *Die Portätwerke Chinards*, Ph.D., Freiburg, 1936. This chronologically organized compendium is divided into three groups: the Naturalistic, Classical and Classicizing Chinard. Chinard's elusive style makes such categorizing artificial, but the book remains a valuable tool. More recently, Isabelle Leroy-Jay Lemaistre has provided a general essay for *Les Muses de Messidor*, 72–89, offering some useful updating of the available material.

102. Rocher-Jauneau, "*Chinard*," 1964, 220.

103. Mme Rocher-Jauneau, Curator Emeritus of the Musée des Beaux Arts de Lyon, was kind enough to share her information about Chinard's Roman stay and his personality gleaned from the manuscript of his autobiography.

104. See Madeleine Rocher-Jauneau, "Les Dieux de Olympes: Quatre Sculptures de Chinard retrouvées," *L'Oeil*, June 1989, n. 407, 50–55, for the documentation.

105. The actual date of the bust is, in fact, uncertain. Janson, *Nineteenth-Century Sculpture*, 47, discusses the problem of dating in relation to the possible influence of Canova's *Venus Italica*, the plaster of which was ready by 1805 and achieved instant fame.

106. For a complete description of this bust, see *Seven Centuries of European Sculpture*, Heim Gallery, London, 1982, no. 38, and *Musée du Louvre: Nouvelles acquisitions du département des sculptures (1980–83)*, Paris, 1984, 70f. J.-L. David refused to allow his portrait of *Madame de Verninac* to be exhibited next to Chinard's bust (ibid.).

107. Deloynes, XX, 540, *Exposition des ouvrages de peinture, sculpture, architecture, gravure*, Paris, 1798. Chinard also devised some particularly personal solutions to the bust form which keep his work fresh and original. His *Fanny Perrin As Psyche Playing with a Wreath of Flowers* which she holds up around her face (1808; Musée Bargoin, Clermont-Ferrand), for example, and *Madame Gauldrée-Boileau with Her Deceased Son's Head* (Musée des Arts Décoratifs, Paris) introduce playful or quasi-surreal elements akin to those characterizing his small terra-cotta groups.

108. This bust is labeled *Madame Récamier* in *La Collection de M. le Comte de Penha-Longa: Sculpture par Joseph Chinard de Lyon*, Paris, 1911.

109. J.H. Rubin, "La Sépulture romantique de Christine Boyer et son portrait par Antoine-Jean Gros," *Revue du Louvre*, XXV, no. 1, 1975, 17–22, traces the complete history of the work within the context of the vogue for melancholy.

110. They are indebted to both the 'Marbury Hall' *Bacchus and Ariadne* (Museum of Fine Arts, Boston) and the 'San Idelfonso' *Castor and Pollux* (Prado, Madrid). See Honour, *Romanticism*, 326.

111. See *Skulptur aus dem Louvre*, 1990, 216, no. 76, for the commission.

112. This work does not appear in Lami. Milhomme won the Prix de Rome with Joseph-Charles Marin in 1800, at the age of forty-three. Isabelle Leroy-Jay Lemaistre, *La Sculpture au Louvre*, 1984, dates the work to 1800 and refers to it as *tête d'expression*, a suggestion endorsed by Philippe Durey, *La Sculpture française au XIXème siècle*, 291. See also *Skulptur aus dem Louvre*, 1990, 46, no. 10 (which suggests that it may have

113. Mme Lévi-Godechot, who wrote her dissertation on Prud'hon for the Ecole du Louvre, was kind enough to elaborate upon Prud'hon's relationship with Canova in conversation.

114. Fuseli's sketch of the mythological couple (1778; British Museum, London) adumbrates the composition.

115. Clodion's influence can be seen to better advantage in his little groups of *Enfant et Amour* or *Amours Endormis*, or in a relief like the *Leçon de Danse*, all in Lyons.

116. On the base of the larger and later terra-cotta group in the Musée des Beaux-Arts, Lyons, the relief includes a passionate, maenadlike woman with long, wild hair.

117. The subject is taken from Ovid's *Metamorphoses*, book XII, "The Combat of the Lapiths and the Centaurs."

118. See Guilhem Scherf, *La Révolution française et l'Europe, 1789–99*, vol. III, 619.

119. Rocher-Jauneau, *Chinard*, 30–31. In 1810, the plaster was removed and eventually replaced by a statue of *Henry IV* by Legendre-Héral.

120. Janson, *Nineteenth-Century Sculpture*, 46–47, adds that the lions he had carved for one of the city gates looked too peaceful. Their tails should have been defiantly raised "like trumpets."

121. Licht, *History of Western Sculpture*, 310. Chinard was also capable of strangely surrealistic groups, such as that dedicated to Jean-Baptiste Dumas and bearing the words, "Le Creuset du Malheur éprouvant l'amitié fait de l'homme sensible une divinité." The children depicted apparently lost their mother and were, it seems, saved by Dumas, their tutelary guide, who extends welcoming arms to the orphans emerging from a bizarre cocoon (butterfly – psyche – saved souls?). See Rocher-Jauneau *Chinard*, 33. This elaborate conception may have its root in the allegories of friendship of the eighteenth century. In his portrait of Madame Gauldrée-Boileau (Musée des Arts Décoratifs, Paris), he also incorporated her deceased son as a cupid head with wings.

122. Lami, 18C, I, 196 and 202.

123. Benoist, *Sculpture romantique*, 14.

124. Biver, *Paris de Napoléon*, 83.

125. *Age of Neo-classicism*, 35–40.

126. Rocher-Jauneau, *Chinard*, 3 and 66. See West, *"The Sculptor's Self-Image,"* 1989, 393, for its place within the context of the sculptor's self-image and for the possible conditions of its execution.

127. Bartolini, along with his friend Ingres, did take an interest in the activities of the Barbus, but nothing came of it (*Lorenzo Bartolini*, Palazzo Pretorio, Prato, Florence, 1978, 100).

128. Another *Self-Portrait* of Chinard, an undated medallion, c. 1808 (see Rocher-Jauneau, *Chinard*, 66), exhibits the same classicism enlivened by a cap of fiercely active hair.

129. Chinard left behind him a bronze medallion, posthumously cast in 1827, inscribed "Antonius Canovus," and dedicated "au prince des sculpteurs de son pays" (*Madame Récamier*, Musée Historique de Lyon, Lyons, 1977, no. 108). As its purpose remains unknown, it is impossible to say whether it was commissioned at an earlier time by a person in power, whether it was to have been used as a means of self-serving flattery, or whether it was indeed a testament of his deep appreciation of the Italian master.

130. Like the Chinard bibliography, Chaudet's is very limited. See Kalnein and Levey, 169ff. Hubert, *Sculpture dans l'Italie Napoléonienne*, 40, mentioned years ago "une importante monographie en cours" which has unfortunately not materialized. Lami, 18C, I, 184–90, gives the most information.

131. Lise Duclaux, *Dessins de sculpteurs de Pajou à Rodin*, Paris, 1964, no. 4, quotes Vitry's opinion that Chaudet's drawings, by virtue of their freedom from academic classicism, placed him among the "precursors of Romanticism." Even if this resurrects neoclassicism and romanticism as clear polarities, it also points to the freer, lyric side of Chaudet's imagination. Nonetheless, he collaborated with Moitte, Gérard, and Girodet on the highly academic project of illustrating Didot's edition of Racine, for example.

132. Bo Wennberg, *French and Scandinavian Sculpture in the Nineteenth Century*, Stockholm, 1978, 12, makes this observation.

133. Chaussard, who had called Chinard a poet, praised Chaudet in similar terms when writing about his *Cyparissus*: "Cyparisse tient dans ses bras un jeune cerf qu'il a tué par méprise et qu'il pleure. Image naïve et délicieuse. L'Artiste, qui est un homme de génie, ne s'est pas contenté de d'avoir présenté le plus beaux des hommes: il a rendu sensible" (Deloynes, XX, no. 540 [1798], 187). This favorable opinion comes as a marked contrast to an earlier one of 1791, charged with revolutionary fervor, directed against the *Nest of Love*: "Vous savez sans doute où est le cabinet épuratoire?" (Deloynes, XVII, no. 439, 503, *Seconde et dernière promenade an III de la liberté*). The various extant plasters are cast from the old mold. The marble is in the Hermitage, St. Petersburg.

134. It is now on deposit at Lamalou, minus its head and some other parts. Jacques de Caso, "La Sculpture en Crise: Aspects d'une révision," *Le Progrès des Arts Réunis*, 1992, 311–16, mentions and reproduces this statue while discussing how much remains to be rediscovered and worked on.

135. The Cabinet des Dessins of the Louvre houses a good collection.

136. For recent information, see *Skulptur aus dem Louvre*, 1990, 66, no. 17.

137. Like Roland's *Homer*, this work remained for many years in the basement reserves of the Louvre. Durey, *La Sculpture française*, 1986, 297, considers it to be one of the major works of this period. Chaudet's beautiful small group of *Belisarius* (terra-cotta, 1791; plaster a little later, Louvre) foretells an interest in these subjects (*Skulptur aus dem Louvre*, 1990, 42, no. 15).

138. See *Skulptur aus dem Louvre*, 1990, 62–63, 280–81, for a recent account of the work.

139. Gérard Hubert's thesis on Cartellier is summarized in *Musées de France*, Oct. 1950, no. 8, 222–24. Since then, he has written several articles on the life and work of the sculptor: "Pierre Cartellier, Statuaire. Oeuvres et Documents Inédits. Ancien Régime, Révolution, Consulat," *BSHAF*, 1976, 313–29; "Pierre Cartellier," *GBA*, 6è période, XCVI, July-Aug. 1980, 1–44. For a brief synopsis of his life, see Lami, 19C, I, 295–300. Hubert, *Musées de France*, 222, ranked him with Chinard and Chaudet as one of the three great French neoclassicists. Emeric-David remembered Cartellier as "l'un des statuaires qui ont le plus contribué à introduire et à maintenir l'amour du vrai beau dans notre école" (*Vie des artistes anciens et modernes*, Paris, 1853, 210).

140. Hubert, *GBA*, 1980, 222, writes: "Partisan convaincu de l'Antiquité grecque, il fut heureusement contraint par les commandes officielles ou privées à tempérer son exigeant dogmatisme par un réalisme de bon aloi qui le rattache à la tradition française des siècles précédents et le protège des influences ultramontaines de Canova et de Thorvaldsen."

141. Jacques de Caso, *Stil und überlieferung*, 195, establishes this parallel, though the scope of Hemsterhuis' application is much broader. See above, Chap. 8, "Canova's *Triumphant Perseus*."

142. The cameo entered the Louvre in 1800. It is reproduced in Bernard de Montfaucon's *L'Antiquité expliquée et représentée en Images*, Paris, 1719, I, part 2, 156. Caso, *Stil und überlieferung*, mentions this cameo in conjunction with Cartellier's relief.

143. Caso, *Stil und überlieferung*, explores the relationship of sculpture to architecture between the years 1770 and 1810 in an attempt to come to terms with the shifting relation of the two and the identity of sculptors during this period.

144. For an appraisal of these works within the context of the international linear style, see Rosenblum, *Transformations*, 187–89.

145. Lami, 19C, I, 147–60. Hubert, *Sculpteurs italiens*, 82–119, gives a good account of his life.

146. Lami, 19C, I, 148ff, documents his fickleness in passing from imperial to royal patrons.

147. He apparently also attempted to free himself from Roman and Greek prototypes in his first French commission (1808) for several segments of the Vendôme column frieze (Barbarin, *étude sur Bosio*, 1910, 29). As drawings for the reliefs were provided to each sculptor, however, it remains to be seen to what degree he was able to bring out his individual character.

148. Several years ago, this work was stolen and has never been recovered.

149. The most recent and easily the best publication on Pradier is the exhibition catalogue, *Statues de chair: Sculpture de James Pradier*, Geneva, Musée des Beaux Arts, and Paris, Musée du Luxembourg, 1986, referred to as *Pradier*. Pradier's *Correspondance*, vol. I, 1790–1833, edited by Douglas Siler, also appeared in Geneva in 1984. Unfortunately, Pradier spoke little of his work or his views of art. Guillaume Garnier has written a dissertation on Pradier for the Ecole des Chartes, Paris, which I have not seen, but which was made available to the organizers of the exhibition. Garnier himself also contributed an essay. The main sources until this exhibition had been L. Gielly, "Les Pradiers du Musée de Genève," *Geneva*, III, 1925, 347–57 and "Les Dessins de James Pradier au Musée de Genève," *Geneva*, VII, 1929, 242–50, who amplifies considerably on Lami with a good catalogue of the museum's holdings. See also *The Romantics to Rodin*, 313–23, and P. Lièvre, "Pradier," *Revue de Paris*, 15 Aug. 1932, 807–27, and 1 Sept. 1932, 172–201.

150. Douglas Siler, "Les années d'apprentissage," *Pradier*, 56ff, attempts to clear up the matter of dates concerning his arrival and apprenticeship to Lemot.

151. For further details, see *Pradier*, 119ff. His major source of inspiration lay in an ancient relief in the Villa Albani (120).

152. For a discussion of the iconography and inspiration of this work, see ibid., 73 and 114ff. The *Pauline Borghese* is not mentioned.

153. Hubert, *Sculpteurs italiens*, 11, mentions this departure from Lemot's usual academic manner, as touched by a shadow of "romanticism."

154. Lenormant discovered "une chaleur d'exécution que le statuaire moderne avait complètement oubliée, enfin une sculpture profondément *amoureuse*, ce qui est pour nous, dans un pareil sujet, le comble de l'art, et ce qui nous suffit à nous expliquer la supériorité des écoles d'Italie sur toutes les autres" (*Le Salon de 1831*, Paris, 1833, 139) – an indirect avowal of Bernini and Canova.

155. *Pradier*, 33f and 126f, offers excerpts from contemporary criticism which details the generally unfavorable

156. Ibid., 32ff and 124ff, details the creation of the work and its unusual iconography, inasmuch as a Bacchante and a Satyr were not usually drawn together this way.

157. Ibid., 282ff. Pradier wrote of a *Premier pas de Bacchus* which he was working on during his second visit to Rome in 1824. He then thought of executing the work on a large scale as a pendant to the *Satyr and Bacchante*.

158. The sculptor's nigh-plagiarization of the painter's work extends even to the subject. Chloris and Flora, both affiliated with nature and vegetation, were often thought of as interchangeable. *Pradier*, 149ff, gives the genesis of the work, but does not specifically mention this painting.

159. Jacques de Caso's *David d'Angers: L'Avenire de la mémoire*, Paris, 1988, is the best relatively recent scholarly work on the sculptor. It begins to put the sculptor within the context of his time, paying attention both to his critical reception and political affiliations, but almost nothing is made of the sculptor's contact with Canova. Suzanne Linday reviews the book, *AB*, Sept. 1989, vol. 71, no. 3, 525–28. Viviane Huchard's catalogue of the David collection, *Galerie David d'Angers*, Angers, 1984, offers a rich source of images and information. *Aux Grands Hommes: David d'Angers*, 1990, offers a compendium of essays on various topics about the sculptor. Both Hugh Honour, *Romanticism*, 1979, and *The Romantics to Rodin*, 211ff, situate the sculptor within a broader if mainly French context. Paul Emile Schlagmann, *David d'Angers: Profiles de l'Europe*, Geneva, 1973, 17, makes only passing mention of Canova – as a nonfigurant in David's life – but gives a good historical background for the sculptor's many medallions. The single most important source work on the sculptor remains Henri Jouin's *David d'Angers*, Paris, 1878, I and II, which incorporates David's "Vies des Artistes," his recollections and views of his predecessors and contemporaries. *Les Carnets de David d'Angers*, I and II, Paris, 1958, is one of the most useful private documents available. Finally, the name of David's hometown was appended to his own to distinguish him from the painter.

160. Jouin, *David d'Angers*, II, 87.

161. See Caso, *David*, 109ff, for a fuller discussion of nudity in David's art. The sculptor saw a difference between a "sculpted portrait" and a "statue" or apotheosis. Differing degrees of genius and national import yielded different degrees of idealization.

162. Jouin, *David d'Angers*, II, 228.

163. Thus, every evening, he drew models posed after the antique, in accordance with Roland's view that the study of antiquity led to the perception of beauty in nature – obviously, a commonly held view. See letter of May 13, 1812, Cabinet des Dessins, Louvre, Paris.

164. Though Canova valued anatomy highly (see Massimo Pantaleoni, *Disegni Anatomici di Antonio Canova*, Milano, 1949, 6) he often failed in it or willfully altered the form. Missirini, *Antonio Canova*, 1824, 321, XI, notes the artistic liberties taken by the artist for expressive ends: "Questo ardimento alloro non è più una infrazione delle regole, la quale nasce dalla ignoranza, ma è la scienza dell'arte nel conoscere il punto di vista e l'effetto, ciò che nasce dalla filosofia nel giudizio dell'artefice." Ragghianti, "Studi sul Canova," *Critica d'Arte*, XXII, July–Aug. 1957, 22–23, comments on Canova's abandoning of the least anatomical plausibility to seize a motif, turning ineptitude into a gift. Many of Canova's drawings show an alarmingly poor grasp of the human figure with no redeeming artistic purpose.

165. Hubert, *Sculpteurs italiens*, 59, mentions David as having borrowed more than a few details from Canova's funerary monuments.

166. See above, Chap. 7, "Canova and the Mystery of Light." The rest of the passage reads: "Mais quand je fus sorti de cet atelier et que je m'en revins par les rues tranquilles de Rome; quand j'eus respiré l'air du soir et que ma tête se fut un peu calmée, il se fit en moi une réaction puissante. L'austère souvenir de Poussin, de ce génie français qui avait erré parmi ces ruines, me commandait un retour sur moi-même. Je fus bientôt en proie à un autre genre d'exaltation. Je sentais mon âme s'élever dans les régions de la pensée, je me rappelais les préceptes de Platon. Les statues que je rencontrais ça et là sur ma route, et qui forment, pour ainsi dire, un autre peuple dans Rome, redoublaient en moi la vénération des héros. Elles me révélaient toute la grandeur de la sculpture destinée à perpétuer les mâles vertus, les nobles dévouements, à faire vivre les traits de l'homme de génie quatre mille ans aprés qu'il n'est plus. Je dis faire *vivre*, car je rêvais, dans mon enthousiasme, d'animer le marbre et le bronze, je voulais poursuivre le mouvement et la vie; ma plus grande ambition d'artiste était de faire disparaître ces mots: *la froide sculpture*" (Jouin, *David d'Angers*, I, 76 or II, 247–48).

167. In addition to Dardel's bronze statuette of *Condé* (1782), Roland's original *Condé* (1785–87) may also have influenced David who inherited Roland's second commission for a statue of the hero. The terra-cotta at the Wadsworth Atheneum, Hartford, however, suggests that Roland's statue would have been a far more sober figure, firmly planted on both feet.

168. Caso, *David*, 46, barely touches upon the question and comes up with the same general dismissal of Canova.

See also Jouin, *David d'Angers*, II, 75ff and Hubert, *Sculpture dans l'Italie Napoléonienne*, 212, and *Sculpteurs italiens*, 58.

169. Jouin, *David d'Angers*, I, 75.
170. Ibid. See also II, 148 and 155. He mentions the *Monument to Maria Christina*, the *Monument to Clement XIII*, the *Hercules and Lichas* and the *Magdalen* as examples of this originality. He also ignores David's less than pure and wholesome erotic paintings. A letter of David d'Angers to the painter, Abel de Pujol, written from Rome on Feb. 6, 1812, reinforces the image of a friendly dialogue between the two sculptors (Fritz Lugt Collection, Fondation Custodia, Paris, 1979, A 354–1812) while another to his master Roland, dated April 13, 1816, proves the friendship to have been a lasting one and shows Canova to have been on good terms with a number of French sculptors: "Monsieur Canova qui sort de chez moi il y à une heure, m'a chargé de vous saluer de sa part" (Bibliothèque Doucet, box 38).
171. Hubert, *Sculpture dans l'Italie Napoléonienne*, 131, states that Canova never corrected at the Academy and that Parisian teachers were hostile to him, which one might expect. See Antoinette Le Normand, 1981, 19, for more on Canova's relevance to the artists at the Villa Medici and their borrowings.
172. Lapauze, 1924, 106, 1812. His participation in a picnic held in honor of the Fête de la Paix in 1801 further substantiates a friendlier involvement than hitherto allowed (*Correspondance*, XVII, 328–29: Letter from Cacault to Talleyrand, 11 November 1801.
173. These busts were later moved to the Promoteca Capitolina.
174. *Galerie David*, 34. This event, which David witnessed, took place in 1793.
175. David d'Angers, *Carnets*, II, 13: "Oh! que tu es sublime, grand statuaire du monde!"
176. Stefani, *Canova*, 1980, 90, fn. 4, quoting from d'Este, says there is reason to doubt the accuracy of Missirini's text.
177. Jouin, *David d'Angers*, II, 27. He also called Canova's *Dancers* mannered (II, 246). Other negative comments crop up in the *Carnets* (I, 347; II, 47ff, 148–49, 150, 151).
178. Jouin, *David d'Angers*, II, 153–54.
179. "Two powerful reasons drew me to London, the bas-reliefs of the Pantheon and Flaxman, the most poetic sculptor of our time. I already knew his admirable compositions; I wanted to see his sculpture which did not live up to my expectations. Canova had given me a letter of introduction to Flaxman" (Jouin, *David d'Angers*, I, 111). The British sculptor, under the impression that he had the regicide painter at his door, apparently refused to see David d'Angers.

180. He did once lean toward a Flaxmanesque delicacy in his *Angel Bearing Off a Child* (1841), a cross with a design etched in the marble. It brought to France a touch of the Gothic lyricism of Flaxman's funerary reliefs (see *Galerie David*, 91).
181. Jouin, *David d'Angers*, II, 190. For his appreciation of sentiment in English art, see *Carnets*, I, 6–7.
182. See Chap. 1, "A Hero's Death."
183. Caso, *David*, 1988, 84ff and passim, dwells at some length on David's particularly flat relief style immune to changing light conditions.
184. See, for example, his reliefs for the Arc de Triomphe of Marseilles, 1836 (*Galerie David*, 92–95).
185. June Hargrove, *The Romantics to Rodin*, 1980, 212, refers to David d'Angers' "private archaism," but says nothing of its genesis.
186. Jacques de Caso hinted at this possibility in the course of a conversation in Paris during the summer of 1986, which he again briefly alludes to in his monograph *David*, 1988, 137, 142 and especially 151.
187. This area of study is entirely open to investigation.
188. Caso, *David*, 136, quotes David's defiant words about the Pantheon reliefs: "C'est pour le peuple que j'ai fait cet ouvrage et non pour le Pouvoir."
189. Caso, *David*, 1988, dwells at length on this aspect of his art. See 151–52, or 162ff, for example, dealing also with the various other relief styles that he might have admired. Michael Paul Driskel's assessment of the political significance of David's *Monument to Gutenberg* ("Et la lumière fut: The Meanings of David d'Angers' 'Monument to Gutenberg,'"*AB*, Sept. 1991, LXXIII 3, 359–80) is especially relevant to this aspect of his creation (for example, the printing press as a republican symbol, 362–63).
190. "L'art convaincu par excellence, c'est l'art gothique. Toutes les figures, chez les gothiques, respirent ce sentiment élevé de la prééminence de l'âme sur la matière, principe du culte chrétien. Ainsi les artistes modernes ont-ils le devoir de s'initier au sentiment moral de l'art chrétien chez les gothiques." See Jouin, *David d'Angers*, II, 11 and 20.
191. Indeed, the patrons of the civic work refused it in its most daring form. Préault in turn refused to be identified with the stone sculpture which was executed on the basis of his model and now stands in Bourges.
192. See Duclaux, 1964, 24–25.
193. See ibid., 18 and 25. He traveled to Rome in 1809 as a Prix de Rome winner.
194. The standard monograph on Rude is L. de Fourcaud's *François Rude, sculpteur: Ses Oeuvres et son temps (1784–1855)*, Paris, 1904, updated but not significantly enlarged by J. Calmette's *François Rude*, Paris, 1920. *The Romantics to Rodin*, 351–57, offers a useful summary of his career and recent insights into the exhibited works.

195. Vitry, "Les Dessins de Rude du Musée de Dijon," *GBA*, 6è période, IV, Aug. 1930, 117, lists the subjects.

196. For Gagneraux's place in the history of the development of the international style, see Rosenblum, *1800*, 83, and *Transformations*, 179–80. For details on the early history of Rude's career, see Pierre Quarré, "François Rude et le milieu artistique dijonnais," *Le Dessin*, XI [1948], 6.

197. See Symmons, "Flaxman and the Continent," *Flaxman*, 166 (fig. 131), 152–55; "French Copies after Flaxman," *BM*, CXV, Sept. 1973, 591–99, and Rosenblum, *1800*, 219–20, for Rude's borrowings from Flaxman.

198. Werner Hofmann, "The Death of the Gods," *Flaxman*, 17, juxtaposes these two works.

199. See Symmons, *Flaxman*, 154–55; "Géricault, Flaxman and Ugolino," *BM*, CXV, Oct. 1973, 671–72; "French Copies after Flaxman," 1973. For the chronology of these drawings, see Joanna Szczepinska-Tramer, "Notes on Géricault's Early Chronology," *Master Drawings*, XX, no. 2, 1982, 135–48. Lorenz Eitner, *Géricault: His Life and Work*, London, 1983, 78f, mentions Flaxman's contributions.

200. Glenn Franklin Benge's *Antoine-Louis Barye: Sculptor of Romantic Realism*, Pennsylvania State University Press, University Park and London, 1984, provides the most recent survey of Barye's work. It follows closely the author's dissertation, *The Sculpture of Antoine-Louis Barye in American Collections with a Catalogue Raisonné*, University of Iowa, 1969, in which Benge attempts to set the work of Barye in perspective. The thesis and the book contain problematic stylistic categories (Barye's monumental pedimental groups for the Louvre are called "miniaturistic," for example), but they remain the most valuable body of scholarship to date with a very complete bibliography. Benge also provided the Barye entries for *The Romantics to Rodin*, 124–41. See also Frédéric Chappey, "Antoine-Louis Barye à l'Ecole des Beaux Arts (1818–1825)," *The Journal of the Walters Art Gallery*, vol. 49/50, 1991/92, 119–29, for his early career.

201. For example, RF4661, 8–9.

202. Benge, 1984, 17–18, engages in a lengthy description of all the Flaxman sources for this relief and Barye's problem in adapting the anatomy of Hector in a different pose. In fact, there does not seem to be a real problem, the shift in position looking entirely natural.

203. Like Flaxman, Barye also drew after Attic vases, stimulated perhaps by the touching oddity of some of the poses which he fully conserves. See an "Introduction to the Sketchbook from the Institute's Collection," *Minneapolis Institute of Arts Bulletin*, LIX, 1970, 59–63.

204. Benge, "Barye's Apotheosis Pediment for the New Louvre: Napoleon I Crowned by History and the Fine Arts," *Art and the Ape*, 607–30.

205. Ibid., 619.

206. Benge, ibid., 607, calls these later works his "late classical style," although Barye never abandoned his classicism.

207. Benge, "Barye's Uses of Some Géricault Drawings," *Walters Art Gallery Journal*, XXI–XXII, 1968–69 (1971), 13–27.

208. *L'Artiste* acclaimed them with high praise when they appeared: "Flaxman, dont les compositions si pures, si naïves, si sublimes, n'avaient eu cours long-temps que dans un cercle étroit, Flaxman devient populaire aujourd'hui" ([1833], V, 259ff and VI, 209).

209. His contemporaries never relinquished the view that animal sculpture constituted an inferior genre. Jouin wrote "Le statuaire qui néglige l'homme pour l'animal, s'appelait-il Barye, peut donner la mesure de son talent, mais il inflige à son art le sceau d'une infériorité consentie" (*David d'Angers*, I, 140).

CHAPTER 9

1. *Raphael*, Paris, 1833, 70–71.

2. Jacob Rothenberg's dissertation for Columbia, completed in 1967, *Descensus ad Terram: The Acquisition and Reception of the Elgin Marbles*, is an excellent source for information about their uneasy history and contemporary aesthetics in England.

3. *Gentleman's Magazine*, 1816.

4. Whitley Papers, British Museum, IV, 191, Diary of Thomas Moore, Florence, Oct. 1819.

5. See Haskell and Penny, 1981, 106, and A. Potts, "Greek Sculpture and Roman Copies, I: Anton Raphael Mengs and the Eighteenth Century," *JWCI*, v. 43, 1980, 150ff. Anton Raphael Mengs, among others, shared the opinion that the *Apollo* was a mere copy.

6. See A. Michaelis, *Ancient Marbles in Great Britain*, Cambridge, 1852, and Massimiliano Pavan, "Antonio Canova e la Discussione sugli 'Elgin Marbles,'" *Rivista dell'Istituto Nazionale d'Archaeologia e Storia dell'-Arte*, Nuova Serie, XX–XXII, 1974–75, Rome, 1976, 219–344.

7. L. Benoist, *Sculpture romantique*, 101, mentions that critics were astounded by the freedom of technique. See also Eitner, *Sources and Documents*, 1970, II, 3ff. Canova lamented his tardy acquaintance with the marbles, lauding their "vera carne" as a belated confirmation of his aspirations to which he might have given fuller expression. See Quatremère, *Canova*, 288; Letter from Canova to Quatremère, London, Nov. 9, 1815, and Michaelis, *Ancient Marbles in Great Britain*, London, 1882, 144–45, for Canova's change in style. He responded with his *Endymion*, after turning down an offer to restore the marbles. Quatremère, *Canova*, 313, states that it was executed under the influence of the

marbles and the *Ilyssus* in particular, to which it owes its "ondoyance de contours." Canova's *Theseus and the Centaur* also recalls the metope groups. Hubert, *La Sculpture dans l'Italie Napoléonienne*, 162, writes that the marbles dealt a blow to Canova's reputation though, in France, Napoleon's fall had been sufficient to put an end to government commissions if not to his influence there.

8. Pavan, "Antonio Canova," 256. Ivanoff, 1957, 40, interprets Canova's praise of the marbles as a polemic stand in favor of the picturesque Venetian school and against the purists. See also Pavan, "Antonio Canova," 254, for more of Canova's comments on the marbles. David d'Angers, *Carnets*, I, 5, recalled Canova's enthusiasm upon the latter's return and before his own departure in 1816: "Il était fou de ce qu'il avait vu des fragments du fronton du Parthénon. Il me dit: 'J'apporte ces plâtres-ci afin de faire voir aux Italiens jusqu'à quel point les Grecs ont fait la nature, et qu'ils ne dédaignaient point de copier toutes les naïvetés de la nature, de rendre la flexibilité de la chair avec la plus grande naïveté.'"

9. Philippe Durey, "Le Néo-classicisme" ("Héllénisme"), *La Sculpture française au XIXè siècle*, 298.

10. R. Schneider, *Esthétique classique*, established the Elgin Marbles as a watershed for Quatremère's theories and for sculpture in general, but he gives almost no concrete examples.

11. See ibid., 20, for Quatremère's double use of the Elgin Marbles as a lesson both to frigid academicists and to extravagant "romantics."

12. Gustave Planche, *L'Artiste*, 1ère série, IV, [1833], 62: "Il y a dans les galeries italiennes des marbres d'un goût bien hasardé; il y a des bas-reliefs grecs et romains qui se rapprochent singulièrement des idées nouvelles, et dont le spectacle habituel doit être scrupuleusement interdit aux jeunes gens. Fort heureusement les fragments achetés par Lord Elgin sont au musée de Londres, et les plâtres qui se voient chez Jacquet ne sont guère connus que des curieux et des rêveurs. L'Italie au moins ne les possède pas. . . .

A Rome on est toujours d'avis que les chefs d'oeuvres de la sculpture antique sont l'Apollon et la Vénus de Médicis . . . En général la sculpture romaine est volontiers préférée à la grècque . . . Elle se prête plus facilement à l'imitation. La sculpture grècque, au contraire, témoigne trop souvent la sève et l'énergie de sa jeunesse, elle serre de trop près la nature qu'elle a sous les yeux." He does not mention J. B. Giraud's collection of plasters which had passed to Giraud de Luc in 1830.

13. Le Normand, 1981, 58–59, discusses the relative absence of Thorvaldsen's influence upon the students at the Academy, but his impact upon French sculpture is still in need of further exploration.

14. The bibliography is extensive, the best modern works beginning with *Bertel Thorvaldsen (Skulptur, Modelle, Bozzetti, Handzeichnungen)*, Cologne Kunsthalle, Cologne, 1977, and its companion volume, *Bertel Thorvaldsen (Untersuchungen zum seinen Werk un zur Kunst seiner Zeit)*, or volumes I and II, followed more recently by *Bertel Thorvaldsen, 1770–1844, scultore danese a Roma*, Galleria Nazionale d'arte Moderna, Rome, 1989, and another companion study, *Thorvaldsen: l'ambiente, l'influsso, il mito*, ed. Patrick Kragelund and Mogens Nykjaer, Rome, 1991, from the congress at the end of the exhibition (January 1990). J.B. Hartmann, *Antike Motive bei Thorvaldsen*, Tübingen, 1979, 48–54, discusses the *Jason* at length. See also Antonio Pinelli, "Il *Perseo* di Canova e il *Giasone* di Thorvaldsen: due modelli di 'nudo eroico' a confronto," *Thorvaldsen*, 1991, 21ff.

15. It has also been seen as a response to Carstens, to whose *The Argonauts with Chiron* (1792), for example, he does distant homage. Herbert von Einem, *Thorvaldsen's "Jason": Versuch einer Historischen Würdigung* (Bayerische Akademie der Wissenschaften – Philosophische – Historische Klasse, 1974, III), Munich, 1974, devotes considerable effort to tracing the legend of the Argonauts in art before Thorvaldsen's *Jason*, quickly narrowing in upon Carstens' cycle as the immediate source. The latter turned not to Ovid's *Metamorphoses* but to Pindar's *Pythian Odes* for his narrative sequence (24). See also Hubertus Froning, "Thorvaldsen und Carstens," *Thorvaldsen*, I, 41–45. He compares the statue to Carstens' *Oedipus with Theseus*.

16. Herbert von Einem, *Thorvaldsen's "Jason,"* 1974, 4: "Quest' opera di quel giovane danese è fatta in un stilo nuovo e grandioso." Astonishingly, the marble took some twenty-five years to come into existence, leaving a mere plaster cast to establish the reputation of the Danish sculptor. Thorvaldsen had little regard later in life for the *Jason*.

17. A number of comparative studies of Canova and Thorvaldsen have been published, notably by Hartmann. See also, among others, Emma Salling, "Canova and Thorvaldsen: A Study in Contrasts," *Apollo*, XCVI, Sept. 1972, 214–19, and Antonio Pinelli, "Il *Perseo* di Canova e il *Giasone* di Thorvaldsen: due modelli di 'nudo eroico' a confronto," *Thorvaldsen*, 1991, 21ff.

18. See Rosenblum, *1800*, 89–94, for the elements of Carstens' style within the context of international neo-classicism and Alex Potts, *Flesh and the Ideal*, 1994, 68ff, for a discussion of Winckelmann's analysis of the beautiful.

19. Hartmann, *Antike Motive bei Thorvaldsen*, 1979, 19–20, and *Thorvaldsen*, 1989, 62–63.

20. Honour, *Romanticism*, 212, briefly compares Winckelmann's poetic antiquity to that of strict historicists.

21. Jouin, *David d'Angers*, II, 95–96. The last line reads: "aussi convient-il que la blancheur du marbre soit à l'oeuvre plastique comme un vêtement d'immortalité."

22. R. Schneider, *Quatremère*, 127ff, gives a useful introduction to color in sculpture at the time. He also discusses, 57 and 126, Quatremère's *Patrie* in light of its polychromy. Surprisingly, Katerina Tür fails to mention Quatremère's fundamental study of polychromy in her brief discussion of color in sculpture (170ff). M. M. Knoch has written a study of polychromed sculpture, *Farbige Plastik*, Cologne, 1975 (Tür cites it in her bibliography). Maria Cecilia Parra, "Letture del colore antico tra i 'Savans' del primo Ottocento," *Ricerche di Storia dell'Arte*, 1989, vol. 38, 5–21, details the debate between the likes of Quatremère and Baron Hittorf on the subject of color in its architectural use.

23. Canova had contemplated a toreutic *Religion* for St. Peter's.

24. Emeric-David, *Recherches*, 155: "C'était ce désir de produire une agréable illusion, qui avait fait dorer les cheveux de le Vénus de Médicis, qui l'avait ornée de pendants d'oreille, ainsi que celle de Praxitèle, et qui avait fait imaginer de mêler de l'argent dans le bronze pour représenter avec plus de vérité la pâleur d'un homme mort."

25. Ibid., 154.

26. Jouin, *David d'Angers*, II, 96. He added that they were "unpleasant to behold when such encounters [were] unexpected."

27. See Le Normand, 1981, 206.

28. Charles Farcy, *Journal des Artistes et des Amateurs*, 1831, 365.

29. Délecluze, *Journal des Débats*, 1831.

30. Eugène Delacroix, *Journal: 1822–1863*, ed. Répis Labourdette, Paris, 1980; March 13, 1847. Clésinger continued to color his works throughout his career (e.g., *Sappho victorieuse dans la lutte de poésie*, 1858).

31. Jeremy Cooper, "John Gibson and his *Tinted Venus*," *Connoisseur*, LXXVII, Oct. 1971, 84–96, calls this "romantic rather than heroic idealisation." For the subject in general, see Elisabeth Darby, "John Gibson, Queen Victoria and the Ideal of Sculptural Polychromy," *Art History*, XX, 1981, 37–52.

32. Karina Tür, *Zur Antikenrezeption in der französischen Skulptur des 19. und frühen 20. Jahrhunderts* (1979), 170, refers to Pradier's use of color as harking back to the decorative empire style rather than to an archaeological principle. Indeed, he was probably availing himself of the archaeological justification for other ends, as Tür believes Canova was too. But the latter's *Religion* would have been a pronounced toreutic statement. Jehan Duseigneur applied gilding to his *Larme pour une goutte d'eau: Esmeralda et Quasimodo*, a plaster group of 1833 illustrating Victor Hugo's *Notre Dame de Paris*.

Its whereabouts are unknown. This example seems to denote another departure in the use of color with a return to medieval polychromy. Following Canova's and Quatremère's lead, Simart made a reduced, fully reconstructed ivory and gold *Minerva* (1846–55) for the Château of Dampierre where it stands directly in front of Ingres' *Golden Age*. The colorful piece elicited a negative reaction from Lagrange, "Simart," 1863, 115–16, who scoffed at the rapprochement made between Simart and Phidias. The small scale (life-size) of the work and its coloring do divest it of grandeur. Almost no one else would undertake such radical reconstructions.

33. Hartmann, *Bertel Thorvaldsen, Scultore Danese, Romano d'Adozione*, Quaderni di storia dell'arte, XIX, Città di Castello, 1971, 14. Karlheinz Hemmeter's 1983 dissertation, *Studien zu Reliefs von Thorvaldsen. Auftraggeber – Künstler – Werkgenese. Idee und Ausführung*, Munich, 1984, is the first sustained look at Thorvaldsen's reliefs. See also Bjarne Joarnes, "Thorvaldsen's 'Triumph of Alexander' in the Palazzo del Quirinale," *Thorvaldsen*, 1991, 35–41.

34. Another frieze for the Quirinale Palace shows that there did exist a marked if sporadic taste for the archaic or primitive in Rome, which no one else pursued to the same extent. José Alvarez de Perrera y Cubero (1768–1827; see Hubert, *Sculpure dans l'Italie Napoléonienne*, 215–17) produced four reliefs for the emperor's chambers of which the scene of *Leonidas at Thermopylae* (1812; reproduced by Hubert) illustrates particularly well the deliberate archaism of his work. The bodily proportions, the stylized features and beards and the hieratic poses constitute an original approach too bold, or too crude, perhaps, for the French Academy or even for Thorvaldsen.

35. See L.O. Larsson, "Thorvaldsens Restaurierung der Aegina-Skulpturen im Lichte zeitgenössisches Kunstkritik und Antikenauffassung," *Konsthist. Tids.*, XXXVIII, no. 1–2, May 1969, 23–46, and Orietta Rossi Pinelli, "Il frontone di Aegina e la cultura del restauro dell'antico a Roma intorno al 1816," *Thorvaldsen*, 1991, 123ff.

36. See *Clodion*, 316–18.

37. Ibid., 319–22. Anne Poulet suggests a date immediately before or after Clodion's departure from Rome in 1771.

38. See *Salons*, IV, fig. 57, for Gabriel de Saint-Aubin's sketch.

39. Hautecoeur, *Rome et la renaissance*, 102ff, devotes some attention to early Egyptianism noted especially in architecture and decorative motifs rather than in sculpture.

40. Flaxman derived the design from plate 31 in Sir William Hamilton's *Collection of Etruscan, Greek and Roman Antiquities*.

41. See Hartmann, *Thorvaldsen*, 1990, 68–69.

42. Lenormant, *Les Artistes contemporains*, 28: "Toutes les fois que les arts ont long-temps vécu chez un peuple,

après que l'habitude, la satiété et le besoin d'innover ont produit tous les excès de la routine de l'affectation, il se manifeste chez certains esprits un retour passionné vers les premiers essais de l'art: on sent le besoin de reculer jusqu' à la naïveté de l'ignorance pour retrouver quelque chose de naturel et de spontané. C'est ce besoin qui a produit chez les Grecs le goût archaïque, c'est-à-dire l'imitation des oeuvres de l'art le plus ancien. A cette recherche nous devons quelques unes des plus charmantes productions de l'art antique, entr'autres la *Minerve de style éginétique* du Musée de Naples."

43. Delpech, 1814, 221.

44. Very little has been written on either J.-B. or P. F. Giraud, though mention is made of them here and there. Lami, 18C, I, 375–77, and 19C, III, 63–65, gives the details of their lives. Meredith Shedd's recent article, "A Neo-classical Connoisseur and His Collection: J.-B. Giraud's Museum of Casts at the Place Vendôme," *GBA*, 6è période, CIII, May–June 1984, 198–206, brings to light more information on the collection of plaster casts assembled in J. F. Giraud's *hôtel particulier* on the Place Vendôme.

45. Landon, *Annales*, 1806, XII, pl. 68.

46. *Description of Greece*, J. G. Frazer translation, New York, 1965, X, 10, 514.

47. Giraud may also have studied the Spada reliefs (see the *Wounded Adonis*, for example).

48. I am grateful to the late Charles M. Edwards for his help in pinpointing these ancient sources. Hubert, *Sculpture dans l'Italie Napoléonienne*, 211, speaks of Giraud's copy (Musée de Nantes) of the *Paris* in the Museo Nazionale in Naples as being better than most copies executed by students at the Academy.

49. Their date is recorded nowhere in the available literature, nor is there an exact date for the creation of this wax model. Licht, *History of Western Sculpture*, 309, speaks of the artist's attempt to preserve a native French classicism.

50. Emeric-David, *Recherches*, 134–35.

51. See also his *Canadian Indians at Their Child's Grave* and Moitte's project for a *Monument to J.J. Rousseau*.

52. Sir Francis Chantrey also executed a tomb with a configuration similar to Giraud's – a reclining woman holding her child to her breast – in 1823 (Chevening, Kent).

53. Vitry, "La Sculpture romantique," *Le Romantisme et l'art* (ed. Hautecoeur) Paris, 1928, 53, writes that J.-B. and P.F. Giraud were ardent admirers of the Elgin Marbles and that the latter's tomb for his wife was "à la fois la plus antique et la plus sensible de toute cette génération." Jérémie Benoît, "Deux Parques," *Musée du Louvre: Nouvelles acquisitions du Département des Sculptures (1980–83)*, Paris, 1984, 98f, discusses the continuing fascination exerted by the group of goddesses upon French sculptors as late as the 1860s.

54. Caso, in *David d'Angers*, 84, alludes to the impact of the *Illysos* as well as in "Remarques sur l'invention de Pradier," *Zeitschrift für Schweizerische Archäologie und Kunstgeschichte*, vol. 38/2, 114, in which he brackets these two monuments as examples of the impact of the Elgin Marbles. Durey, "Héllénisme," *La Sculpture française au XIXè siècle*, 1986, 298, recapitulates these remarks in his brief summary of the response to Greek sculpture.

55. See *Statues de chair*, 1986, 370ff, for further details.

56. See Suzanne Lindsay, *David d'Angers' Monument to Bonchamps: A Tomb Project in Context*, University Microfilms, Ann Arbor, Michigan, 1987, for the complete history of the monument, and Caso, *David d'Angers*, 1988, 76ff, for a brief but insightful analysis of the political quandary the work implied for David. See also *La Sculpture française au XIXè siècle*, 278–80.

57. For example, "cet artiste aux nerfs de fils de fer" (David d'Angers' *Carnets*, II, 347–48). Caso, *David d'Angers*, 1988, 46, alludes to the sculptor's negative views of both Canova and Thorvaldsen, without, however, going beyond David's tendencies as a polemicist and fierce nationalist to measure what Thorvaldsen's actual impact might have been.

58. Caso, *David d'Angers*, 1988, 46, notes this.

59. See Charles Lenormant, *Beaux Arts et voyages*, Paris, 1861, 403. Isabelle Leroy-Jay Lemaistre, "L'Eglise de la Madeleine," *La Sculpture française au XIXè siècle*, 196ff, gives an account of the commission.

60. The figures to the far left of the relief are tumbling and falling, one "below" the lintel. The drawing is reproduced in *Le Sénat, Palais et Jardins du Luxembourg*, Imprimerie Nationale, Paris, 1994, 70–71. Philippe Martial, ibid., wrote the essay, "Chalgrin, architecte du Palais."

61. Louis de Fourcaud, *Rude*, 1904, 177–78. Rude, Seurre and Cailhouet worked on the "Louis-Philippe" frieze. Millard, "Sculpture and Theory," 18–19, comments upon the dilemma confronting sculptors in the 1830s, leery of using a language either associated with the political overtones of the Empire or one recalling the excesses of the aristocracy (rococo/baroque).

62. *Salon de 1831*, 1833, 107. See J. A. Schmoll, "Géricault sculpteur, à propos de la découverte d'une statuette en plâtre d'un moribond," *BSHAF*, 1973, 319–33, and especially 321. Clément, *Géricault*, Paris, 1879, 325, describes the relief of a *Horse Stopped by a Man* (1819) as "un homme en costume de l'Antiquité [qui] s'efforce de retenir des deux mains un cheval déporté vers la gauche, tandis qu'un autre homme nu est renversé sous les jambes du cheval."

63. Maurice Rheims, *Nineteenth-Century Sculpture* (Paris, 1972), New York, 1977, 296, reproduces the work but gives no date. No mention is made of this work in

Lorenz Eitner's *Géricault: His Life and Work*, London, 1983. However, Mr. Eitner believes there is good circumstantial evidence speaking for Géricault's authorship. The work is mentioned in Philippe Grunchec's *Toute l'oeuvre peinte de Géricault*, 148. Charles Blanc refers to it in *Histoire des peintres français au XIXè siècle*, Paris, 1845, 434, as one of two works in the collection of General Brack. These two references were kindly supplied by Mr. Eitner.

64. Schmoll, "Géricault," 1973, 320–21.

65. Ibid., 322.

66. Seymour Howard, "Archaisms and Attitudes in Ialianate Neo-classic Sculpture," *Acts of the 24th International Congress of the History of Art*, Bologna, 1984, 9–16, sketches the line from Thorvaldsen to Barye, though the brevity of the paper did not allow for elaboration. Glenn F. Benge, "Barye, Flaxman and Phidias," ibid., 103–10, raises the issue of Barye's all-pervasive classicism, which is a new development in his consideration of the sculptor. Walter Pach had already alluded to Barye's Phidian debt and to his innate classicism in "Le Classicisme de Barye," *Amour de l'Art*, XIII, 1932, 319–20.

67. Barye probably borrowed the essence of the poses from Géricault's *Boxers*, 1819, as well as the hairstyle of the *Apollo Piombino* (Benge, *Barye*, 1984, 117–18). It may even be that Barye was familiar with Edmé Dumont's *Milo of Crotona* (1752–68; Musée des Beaux-Arts, Dijon). The hairstyle and anatomy bear a strong resemblance to Barye's later work.

68. "Le centaur dompté par un Lapithe montre que ce Romantique proscrit par le jury était le statuaire moderne qui se rapprochait le plus de Phidias et de la sculpture Grècque. Ce Lapithe aurait pu figurer dans le fronton du Parthénon à côté de l'Ilissos et le Centaure se meler aux cavalcades des métopes" (Louis Réau, *Sculpture romantique*, 1930, 191). Others shared his delight, Fizelière, *Salon de 1850*, 97, contributing the following to the tide of praise: "Je termine par le plus beau morceau de l'exposition, le plus complet, le plus important: le *Combat du Centaure*, de M. Barye. Cette oeuvre a la largeur et l'énergie de l'antique. Le torse du Centaure, celui du Lapithe, les expressions violentes des têtes, montrent le sentiment de la nature dans ce qu'il a de plus grandiose. Je ne vois rien de plus fort au Salon, si ce n'est cependant le *Jaguar et la Lièvre* du même auteur."

69. The bronze has been removed from its original location and is now in what looks like a large storage area or garage. Licht, *History of Western Sculpture*, 315, refers to its originality as comparable to the equestrians of the Quattrocento. I am grateful to Marie-Dominique Roche, Conservateur Départemental des Antiquités et Objets d'Art de la Corse du Sud, for a photograph of the bronze equestrian.

70. See Haskell and Penny, 1981, 160.

71. Other sculptors had called upon the Elgin Marbles or the Horses of San Marco to guide them in the creation of equestrian monuments. L. Dupaty's (1771–1825) *Louis XIII* (1816–21, plaster) for the Place des Vosges, completed by Cortot (1821–29) and replacing Martin Desjardin's statue destroyed in the Revolution, signaled the advent of this interest. The figure of the king is one of the more neoclassically defined of its kind if least successful. Lemot intensified the emulation of an Elgin-Marbles – styled horse in his equestrian of *Louis XIV* (1820–25) for the Place Bellecour in Lyons. The cleaner silhouette also echoes the Horses of San Marco which had adorned Paris in Napoleon's time. Again, though, Barye's *Napoleon* strikes a note of greater originality and sensibility.

72. See Benge, "Barye's Apotheosis Pediment," *Art the Ape*, 607–30, for details of Barye's involvement with the Louvre program.

73. Paul Vitry, "Les Musées de France: La Salle Barye au Musée du Louvre," *Bulletin des Musées de France*, 1912, 96, extolled the River Gods in these terms: "Le *Flot*, la *Rivière*, ainsi les désignent les notes de Barye lui-même et les descriptions officielles, sont . . . deux académies, deux corps nus superbes et décoratifs comme les ignudi de Michel-Ange à la Sixtine, ou comme telle création plastique de la statuaire grècque à laquelle ces morceaux, plus que les précédents encore, nous font penser, non certes à cette sculpture gréco-romaine toute de formule et d'habileté, pas même aux souples éphèbes de Praxitèle ou de Phidias, mais à ces nus héroïques que les fouilles d'Olympe par exemple nous on révélés et que Barye pourtant ne pouvait connaître sauf par quelques rares échantillons."

74. Benge, *Barye*, 53, cites Boichot's *Hercules* as the precise antecedent for these groups but that attributes too much importance to one work. And in that event, Puget's *Hercules Gaulois* would have been much more accessible. Neither shows the stylization of the body characterizing Barye's figures. On the other hand, Benge is correct in pointing out the marked naturalism common to both works in spite of Barye's overall stylization.

75. "Il n'existait plus en Sculpture ni de Jean Goujon ni de Germain Pilon; mais un homme plus étonnant encore s'élevait et croissait dans la retraite et l'indépendance; c'étoit le Pujet [sic], qui n'eut point de rival dans l'art de l'expression. Il produisait des chefs d'oeuvres; mais comme il étoit trop grand et trop fier pour ramper aux pieds de le Brun, il fut écarté par d'indignes rivaux" (Chaussard, *Pausanias français* [1806], 36).

76. *Salons*, An XIV, 139. Of Michelangelo, he wrote, "Il est peu d'ouvrages modernes qui ne paraissent froids et mesquins auprés des productions de son ciseau" (*Salons*, An VII, 109; on p. 151, he discusses the slaves). The glory thereby reflected on Puget was considerable.

77. Tanis-Sydney, 1982, 306. He had unsuccessfully tried to have the *Hercules Gaulois* moved from Sceaux, where it was deteriorating outdoors, to the Musée des Monuments Historiques in 1797 (Reff, 1967, 276).

78. See de Fourcaud, *Rude*, 1904, 467.

79. Reff, 1967, 275.

80. Reff, 1967, 274–75, attributes Puget's popularity to the new vogue for Rubens who remained popular even when Bernini fell from favor, but he makes no mention of the act of mental contortion needed to evaluate Puget without acknowledging the Italian baroque.

81. Emeric-David, in the posthumous *Vie des artistes anciens et modernes*, Paris, 1853, 183ff and 265ff, gives two lives of Puget. In the second, he juxtaposes Bernini, the corrupter of taste (270) with Puget, the lover of truth (276), as two very different types. Eventually, by the 1870s, Puget would come to be seen as Berniniesque again (Reff, 1967, 280).

82. Lenormant, *Les Artistes contemporains*, p. 107.

83. "Il faut le dire hautement, la sculpture de Puget est une formelle insurrection contre l'art grec et romain. C'est un art nouveau, étrange aux deux autres, mais aussi haut que les deux autres, plus profond et plus difficile peut-être. C'est la lutte corps à corps du marbre et de la nature" (II, 1831, 105).

84. Reff, 1967, 280.

85. "Michel-Ange et Puget, hommes nouveaux, s'appuyant sur des principes ignorés des maîtres d'Ionie, ont fait parler la pierre dans des oeuvres rivales des marbres antiques. Ils ont reculé les frontières de la sculpture. Au style égyptien, au style grec, au style romain, ces fiers génies ont fait succéder l'art chrétien" (Jouin, *David d'Angers*, I, 92).

86. Pigal au naturel représente Voltaire
 Le squelette à la fois offre l'homme et l'auteur
 L'oeil qui le voit sans parure étrangère,
 Est effrayé de sa maigreur.
 Cicognara, *Storia* (VI, 318–19)

87. For example, "Cependant le caractère volontairement inachevé de toutes les parties, l'absence complète de modelé, l'exclusive prédilection vouée aux indications même indécises, rappellent plus volontiers les chapiteaux romans de plusieurs églises, et, par example, de Saint Germain des Prés" (Planche, Salon de 1831, 56–57).

88. "Où M. Rude a-t-il vu de pareils pêcheurs, si simplement vêtus? Un bonnet, sans chemise, plaisant accoutrement! Pourquoi pas de haillons? Pour Dieu, si vous voulez à toute force du nu, et rien que nu, restez dans la mythologie, vivez sur les héros, et ne touchez pas à l'humanité!" (ibid., 151). By the next time Rude exhibited the marble, Planche had come around to the work, giving it high marks.

89. Honour, *Romanticism*, 136, tellingly compares J.

Schnorr von Carolsfeld's *Seated Boy* (1822) to Thorvaldsen's statue, commenting upon the proximity of appearance in spite of the discrepancy of their traditional classification as romantic and neoclassical.

90. These are known through the lithograph published in *L'Artiste*.

91. See Millard, *Préault*, chap. 2, 4.

92. David Mower, "Préault," 1981, 292–93, mentions its point-by-point rejection of Griffoul Dorval's essay on classical relief form (*Essai sur la sculpture en relief*, Toulouse, 1821). When one reads rule 7 (p. 13), "enfin, remplir le fond autant qu'il est possible," one wonders whether Préault was not maliciously extending the rule to its breaking point. Griffoul Dorval's essay depended heavily upon Emeric-David's *Recherches* and Cartellier's lessons at the école des Beaux Arts, both of whom he acknowledges.

93. In the eighteenth century the notion of the "illiterate monument" sprang up, based upon the illegibility of certain primitive ruins. Barbara Maria Stafford addressed herself to this issue in a talk given at a symposium on *The French Academy: Classicism and Its Antagonists* (University of Maryland and Walters Art Gallery, 1984) entitled "'Illiterate' Monuments: The Ruin As Dialect or Broken Classic." Stafford examined the opposing attitudes toward the classical, literate monument and the barbaric, illiterate or unintelligible one and the opposing interpretations of given ruins and runes. Inigo Jones, for example, saw in Stonehenge the beautiful remains of a stately, round Tholos. Charlton, on the other hand, restored the monument to its "barbaric" appearance and maintained that its language was no longer intelligible. Even if Préault was not abreast of this scholarship, his sense of dialectic – he was a fiery polemicist – might well have pushed him to be as unintelligible, and therefore even more barbaric, as possible, in simulation of the "illiteracy," for example, of Stonehenge.

94. Préault's enthusiasm for Victor Hugo's play is famous.

95. Nancy Davenport, "Sources for Préault's 'Tuerie,'" *Notes in the History of Art*, Fall 1991, XI, no. 1, °22–30, is the first to note this fascinating possibility.

96. Millard, *Préault*, II, 14, sees Puget as an influence second to Goujon and apparent in the Ternes *Crucifixion* or the relief of *Dante and Virgil in Hell* (Musée de Chartres) but not in *Tuerie*. He compares the relief to Hieronymous Bosch and Louis-Léopold Boilly's *The Grimaces* (34ff) and refers to a relief by Klagmann, *The Giants* of 1831 (39), which I do not know.

97. Jonathan Ribner, "Henri de Triqueti, Auguste Préault, and the Glorification of Law under the July Monarchy," *AB*, Sept. 1988, LXX, no. 3, 486–501, paints a complex image of the interweaving of politics, art and urban planning in this excellent article arising from his 1986

dissertation. He is the first to suggest Triqueti's *Avenging Law* as a trigger for Préault's *Tuerie*.

98. Stafford, "The Beauty of the Invisible," 75, fn. 25, referring to Rose Macaulay's *The Pleasure of Ruins* (1953), New York, 1966, concludes: "The beauty of the invisible and the rude sublime represent the Apollonian and the chthonic Dionysian polarities of the 18th century." The polarity continued well into the nineteenth century.

99. Honour, *Romanticism*, 143, notes its particularly iconoclastic value as a piece of sculpture.

100. "Nous sommes en 2850. Dans une grande ville située sur les bords du Don, dans l'empire tartare, alors roi du monde civilisé, un conseil de savants est assemblé; les membres de ce congrès scientifique sont profondément absorbés; au milieu d'eux une masse carrée verte et fruste semble captiver toute leur attention. Cette masse ressemble à du métal grossier; elle n'a l'apparence, d'abord, que de quelque chose d'informe; mais peu à peu l'oeil attentif de l'observateur y découvre comme des traits, comme des manières de visages même, visages affreux, décomposés, fantastiques et indécis, comme ceux qui apparaissent parfois en songe aux mortels quand Smarra visite leurs alcôves" (*Salon de 1850*, Paris, 1850, 25). I am grateful to Suzanne Lindsay for drawing my attention to this material.

Bibliography

This bibliography is arranged in two parts, a selected general bibliography and an arrangement by sculptor. Monographic exhibition catalogues on painters appear under the last name of the artist in question in the bibliography. It should be noted that individual articles from the Collection Deloynes are listed in the relevant footnotes. An asterisk signals unpublished works which have not been consulted but are of potential utility to others.

The Age of Neo-classicism, The Arts Council of Great Britain, London, 1972

Agulhon, Maurice, *Marianne au combat: L'Imagerie et la symbolique républicaine de 1789 à 1880*, Paris, 1979

Antal, Frédérick, *Classicism and Romanticism*, London, 1966

Argan, Giulio Carlo, *Il Neoclassicismo* (Università degli Studi di Roma, Anno Academico, 1967–68), Rome, 1968

Arnaud, Jean, *L'Académie de St. Luc*, Rome, 1886

Art the Ape of Nature: Studies in Honor of H. W. Janson, eds. Mosche Barasch and Lucy Freeman Sandler, New York, 1981

Arte Neoclassica, Atti del Convegno, 12–14 Ottobre 1957, Fondazione Giorgio Cini, Venice-Rome, 1964

Aspects of Neo-classicism: Drawings and Watercolours, 1760–1840, Colnaghi, New York, 1982

Assunto, Rosario, *L'Antichità come Futuro, Studio sull'Estetica del Neoclassicismo Europeo*, Milan, 1973

Aulanier, Christiane, *La Salle des Caryatides (Histoire du Palais et du Musée du Louvre)*, Paris, 1957

Autour de David: Dessins néo-classiques du Musée des Beaux-Arts de Lille, Musée des Beaux-Arts, Lille, 1983

Autour du néoclassicisme, Galerie Cailleux, Paris, 1973

Babelon, Jean-Pierre, *L'Eglise St. Roch à Paris*, Paris, 1972

Bachaumont, Louis Petit de, *Essai sur la peinture, la sculpture et l'architecture* (1752), Slatkine reprint, Geneva, 1971

Bardon, Henry, "Les Peintures à sujets antiques au XVIIIè siècle d'aprés les livres de salon," *GBA*, 6è période, LXI, April 1963, 217–49

Benoît, François, *L'Art français sous la Révolution et l'Empire* (Paris, 1897), Paris, 1975

Benoist, Luc, *La Sculpture romantique*, Paris, 1927

Bertrand, Louis, *La Fin du classicisme et le retour à l'antique dans la seconde moitié du XVIIIè siècle et les premières années du XIXè en France* (Paris, 1897), Slatkine reprints, Geneva, 1968

Bialostocki, Jan, "Das Modusproblem in der Bildenden Kunst zur Vorgeschichte und Nachleben des 'Modusbriefes' von Nicolas Poussin," *ZfK*, XXIV, no. 2, 1961, 128–41

Bicentenaire de l'Hôtel de Salm, Musée Nationale de la Légion. d'Honneur, Paris, 1983

Bieber, Margaret, *Laocoon: The Influence of the Group since Its Rediscovery*, Detroit, 1967

*Biver, Marie-Louise, *La Sculpture officielle du Ier Empire*, école du Louvre, 1937 (published in part in *Le Paris de Napoléon*)

 Le Paris de Napoléon, Paris, 1963

 Les Fêtes révolutionnaires à Paris, Paris, 1979

 Le Panthéon à l'époque révolutionnaire, Paris, 1982

Blackmur, Richard Palmer, *The Artist As Hero, the Lion and the Honeycomb: Essays in Solicitude and Critique*, New York, 1955

Blondel, Spire, *L'Art pendant la Révolution*, Paris, 1887

Boilly: *Louis Boilly 1761–1845*, Musée des Beaux-Arts, Lille, 1988

Boime, Albert, *Hollow Icons: The Politics of Sculpture in Nineteenth-Century France*, Kent State University, Ohio, 1987

Bottari, G., and S. Turazzi, *Racolta di lettere sulla pittura, scultura e architettura scritta da' più celebri personagi dei secoli XV, XVI e XVII*, Milan, 1822–25

Boyer, Ferdinand, *Le Monde des arts en Italie et la France de la Révolution et de l'Empire*, Turin, 1970

Bresc-Bautier, *Sculpture française du XVIIIè siècle (école du Louvre. Notice d'Histoire de l'Art, 3)*, Paris, 1980

British Artists in Rome, Greater London Council, Kenwood House, London, 1974

Brown, Blanch R., "Novelty, Ingenuity, Self-aggrandisement, Ostentation, Extravagance, Gigantism, and Kitsch in the Art of Alexander the Great and His Successors," *Art the Ape of Nature*, New York, 1981, 1ff

Bruun-Neergard, T.C., *Sur la situation des beaux-arts en France*, Paris, 1801

Bukdahl, Else Marie, *Diderot, critique d'art*, Copenhagen, 1980

Burke, Edmund, *A Philosophical Enquiry into the Origins of Our Ideas on the Sublime and the Beautiful* (1757), London, 1961

Bush, Virginia, *Colossal Sculpture of the Cinquecento* (Ph.D., Columbia, 1967) Garland, New York and London, 1976

Carr, J.L., "Pygmalion and the 'Philosophes.' The Animated Statue in Eighteenth-Century France," *JWCI*, XXIII, nos. 3 and 4, 1960, 239–55

Caso, Jacques de, "Jacques-Louis David and the Style 'all'antica' ", *BM*, CXIV, Oct. 1972, 686–90

"Sculpture et monument dans l'art français à l'époque néo-classique," *Stil und überlieferung in der Kunst des Abendlandes*, I, *Acts of the 21st International Congress of Art History* (Bonn, 1964), Berlin, 1967, 190–98

"Bibliographie de la Sculpture en France – 1770–1900," *Information culturelle artistique* (after 1968, *L'Information d'histoire de l'art*), VII, 1963, 151–59

Chaussard, J.B., *Le Pausanias français* (1806), Paris, 1808

Chenevière, Philippe de, "Les Décorations du Panthéon," *GBA*, 2è période, XXII, Oct. 1880, Part I, 296ff, Part II, 500ff

Christ, Yvon, *Paris des Utopies*, Paris, 1970

Christian Imagery in French Nineteenth-Century Art 1789–1906, eds. Martin L. H. Reymert and Robert J. F. Kashey, Shepherd Gallery, New York, 1980

Cicognara, Count Leopoldo, *Storia della scultura dal suo risorgimento in Italia al Secolo di Canova* (1813–18), Prato, 1823–24

Clarac, Count de, *Descriptions du Musée Royale des Antiques du Louvre*, Paris, 1830

Musée de Sculpture Antique et Moderne, Paris, 1826–27

Clark, T. J., *Image of the People, the Absolute Bourgeois: Artists and Politics in France, 1848–51*, London, 1972

Clement, N. H., *Romanticism in France* (1939), Krauss reprint, New York, 1966

Cochin, Charles Nicolas, *Les Misotechnites aux enfers*, Paris, 1763

Coletti, L., "L'Arte dal Neoclassicismo al Romantico," *La civiltà Veneziana nell'età romantica*, Florence, 1961, 131–54

Collection de pièces sur les beaux-arts imprimées et manuscrites, recueillies par Pierre-Jean Mariette, Charles Nicolas Cochin, et M. Deloynes. 63 volumes. Bibliothèque Nationale, Paris.

Colton, Judith, *Monuments to Men of Genius: A Study of Eighteenth-Century English and French Sculptural Works*, Ph.D., New York University, 1974

The "Parnasse français": Titon du Tillet and the Origins of the Monument to Genius, New Haven and London, 1979

Cooper, Jeremy, "John Gibson and His *Tinted Venus*," *Connoisseur*, LXXVII, Oct. 1971, 84–96

Nineteenth-Century Romantic Bronzes: French, English and American Bronzes – 1830–1915, Newton Abbot, c. 1975

Correspondance des directeurs de l'Académie de France à Rome avec les surintendants des bâtiments, eds. Anatole de Montaiglon and Jules Guiffrey, Paris, 1887–1912, XVII (1908)

Correspondance des directeurs de l'Académie de France à Rome, Nouvelle Série, ed. George Brunel, II, Rome, 1984

Courajod, Louis, *Histoire du département de la sculpture moderne au Musée du Louvre*, Paris, 1984

Cummings, Fred, "The Selection of 'Style' in Neo-Classical Art," *Stil und überlieferung der Kunst des Abendlandes*, I, *Acts of the 21st International Congress of Art History* (Bonn, 1964), Berlin, 1967, 232–35

Dacier, Emile, ed., *Catalogue de ventes et livrets de salon illustrés par Gabriel de Saint-Aubin*, Paris, 1909–54

Dandré-Bardon, *Essai sur la peinture* (includes *Essai sur la sculpture*), Paris, 1765

De David à Delacroix: La Peinture française de 1774 à 1830, Grand Palais, Paris, 1975

Delécluze, E.J., *Jacques-Louis David: Son école et son temps* (Paris, 1855), ed. Jean-Pierre Mouilleseaux, Paris, 1983

Delpech, M.S. *Examen raisonné des ouvrages de peinture, sculpture et gravure exposés au Salon du Louvre en 1814*, Paris, 1814

Diderot, Denis: *Les Salons de Diderot*, eds. Jean Seznec and Jean Adhémar, Oxford, 1957

Diderot, Denis, "Observations sur la sculpture et sur Bouchardon" (1763), *Oeuvres*, ed. Maurice Assézat, Paris, 1876, XIII, 40ff

Dohrn, Tobias, *Die Tyche von Antioch*, Berlin, 1960

Dörken, Eugen, *Geschichte des französischen Michelangelo-*

bildes von der Renaissance bis zu Rodin (Ph.D., Bonn, 1933), Bonn, 1936

Dowd, David Lloyd, *Pageant-Master of the Republic: Jacques-Louis David and the French Revolution*, Lincoln, 1948

"Structure sociale et activité politique: Les Artistes engagés de la Révolution," *Actes du 68è Congrès National des Sociétés Savantes* (Montpellier 1961), Paris, 1962

Dowley, Francis H., "D'Angiviller's 'Grands Hommes' and the Significant Moment," *AB*, XXXIX, 1957, 259–77

Draper, James, "Fortunes of Two Napoleonic Sculptural Projects," *Journal of the Metropolitan Museum of Art*, XIV, 1979, 173–84

Duclaux, Lise, *Dessins de sculpteurs de Pajou à Rodin*, Cabinet des Dessins, Louvre, Paris, 1964

Eitner, Lorenz, *Neoclassicism and Romanticism, 1750–1850: Sources and Documents in the History of Art*, New Jersey, 1970, I–II

Emeric-David, T. B., *Vie des artistes anciens et modernes*, Paris, 1853

Histoire de la sculpture française, Paris, 1853

Recherches sur l'art statuaire considéré chez les anciens et chez les modernes (1805), Paris, 1863

Ettlinger, L. D., "Winckelmann or Marble Boys Are Better," *Art the Ape of Nature: Studies in Honor of H. W. Janson*, New York, 1981, 505–11

Faldi, Italo, *Galleria Borghese: La Scultura dal Secolo XVI al XIX*, Rome, 1954

Farrington Diaries, typescript, Print Room, British Museum, London

Ferrara, Luciana, "La 'Stanza di Elena e Paride' nella galleria Borghese," *Rivista dell'Istituto Nazionale d'Archaeologia e Storia dell'Arte*, Nuova Serie A, III, 1954

Frémy, J. N. M., *Notice historique sur les douze statues élevées sur le Pont Louis XVI*, Paris, 1828

The Frick Collection. Volume IV. Sculpture, by John Pope-Hennessy assisted by Anthony Radcliffe, Princeton University Press, 1970

Furcy-Reynaud, Marc, *Inventaire des sculptures exécutées au 18è siècle pour la direction des bâtiments du roi* (*Archives de l'Art Français*, Nouvelle Période, XIV, 1925–27), Paris, 1927

The Fuseli Circle in Rome, catalogue by Nancy L. Pressly, Yale Center for British Art, New Haven, 1979

Gage, John, "Kunst um 1800: Book Review," *Studies in Romanticism*, XV, no. 3, Summer 1976, 482–89

Gohr, Siegfried, "Die Antike in der Kunsttheorie von J. J. Winckelmann bis Friedrich Schlegel," *Thorvaldsen*, Cologne Kunsthalle, Cologne, 1977, I, 9–15

Goldscheider, Ludwig, *Fünfhundert Selbstporträts von der Antike bis zur Gegenwart*, Vienna, 1936

Gonse, Louis, *La Sculpture française depuis le 14è siècle*, Paris, 1895

Griffoul, Dorval, *Essai sur la sculpture en bas-relief*, Toulouse, 1821

Gunnis, Rupert, *Dictionary of British Sculptors*, London, 1953

Halsted, John B., *Romanticism*, London and Melbourne, 1969

Hargrove, June, *The Statues of Paris, An Open-Air Pantheon: The History of Statues to Great Men*, Antwerp, 1988

Hartmann, Jörgen Birkedal, "Die Genien des Lebens und des Todes," *Römisches Jahrbuch für Kunstgeschichte*, XII, 1969, 1–37

Haskell, Francis, "The Old Master in Nineteenth-Century French Painting," *AQ*, XXXIV, 1971, 55–85

An Italian Patron of French Neo-classical Art, Oxford, 1972

Haskell, Francis, and Nicolas Penny, *Taste and the Antique*, New Haven and London, 1981

Hautecoeur, Louis, *Rome et la renaissance de l'antiquité à la fin du XVIIIème siècle*, Paris, 1912

L'Art sous la Révolution et l'Empire, Le Prat, 1953

Hawley, H., *Neo-Classicism: Style and Motif*, Cleveland Museum of Art, Cleveland, 1964

Hemsterhuis, François, *Lettre sur la sculpture*, Amsterdam, 1769

Lettre sur les désirs, Amsterdam, 1770

Herbert, Robert, *David, Voltaire: "Brutus" and the French Revolution: An Essay in Art and Politics*, London, 1972

Hirth, Georg, *Kulturgeschichte Bilderbuch*, Munich, 1882

Holt, Elizabeth, *The Triumph of Art for the Republic*, New York, 1979

Honour, Hugh, *Neo-classicism*, Harmondsworth, 1968

"After the Antique: Some Italian Bronzes of the Eighteenth Century," *Apollo*, LXXVII, March 1973, 194–200

Romanticism, London, 1979

Howard, Seymour, "Archaisms and Attitudes in Italianate Neo-classic Sculpture," *Acts of the 24th International Congress of the History of Art* (Bologna, 1979), Bologna, 1984, VI, 9–16

Hubert, Gérard, *La Sculpture dans l'Italie Napoléonienne*, Paris, 1964

Les Sculpteurs italiens en France sous la Révolution, l'Empire et la Restauration, 1790–1830, Paris, 1964

Hunt, Lynn, *Politics, Culture and Class in the French Revolution*, Berkeley, 1984

Inventaire général des richesses de l'art de la France. Paris. Monuments Civils, Paris, 1879, I

Irwin, David, *Neoclassical Art*, Greenwich, 1966

Winckelmann: Writings on Art, London, 1972

"Unclassical Neo-classicism: Sentiment and Gothic," *Connoisseur*, CLXXXI, Sept. 1972, 18–24

Ivanoff, Nicolo, "Leopoldo Cicognara ed il gusto dei primitivi," *Critica d'Arte*, XIX, Jan. – Feb. 1957, 32–46

Jacoubet, Henri, *Le Genre troubadour et les origines françaises du romantisme*, Paris, 1929

Janson, H. W., "Observations on Nudity in Neoclassical Art," *Stil und überlieferung in der Kunst des Abendlandes, Acts of the 21st International Congress of Art History* (Bonn, 1964), Berlin, 1967, 198–207

"Correlations between German and Non-German Art in the Nineteenth Century," *German Neoclassic Sculpture in International Perspective, Yale University Art Gallery Bulletin*, XXXIII, no. 3, Oct. 1972, 4–22

Nineteenth-Century Sculpture, New York, 1985

Janson, H. W., and Robert Rosenblum, *Nineteenth-Century Art*, New York, 1984

Japy, André, *L'Opéra royal de Versailles*, Paris, 1958

Johnson, Dorothy, "Corporality and Communication: The Gestural Revolution of Diderot, David, and the *Oath of the Horatii, AB*, March 1989, LXXI, no. 1

Jones: "Memoirs of Thomas Jones," *The Walpole Society Journal*, XXXII, 1946–48

Jouffroy, Théodore, *Cours d'esthétiques*, Paris, 1843

Jouin, Henry, *La Sculpture dans les cimetières de Paris* (Nouvelles Archives de l'Art), Paris, 1847

Justi, Karl, *Winckelmann und seine Zeitgenossen* (1898) Leipzig, 1923

Kalnein, Wend Graf, and Michael Levey, *Art and Architecture of the Eighteenth Century in France* (Pelican History of Art), Harmondsworth, 1972

Kamphausen, Alfred, *Deutsche und Skandinavische Kunst, Begegnung und Wandlung*, Schleswig, 1956

Kemp, Martin, "Some Reflexions on Watery Metaphors in Winckelmann, David, Ingres," *BM*, CX, May 1968, 266–70

Kirstein, Lincoln, "The Taste of Napoleon," *The Nelson Gallery and Atkins Museum Bulletin*, IV, no. 10, 1969

Kjellberg, Pierre, *Le Guide des statues de Paris*, Paris, 1973

Kris, Ernst, and Otto Kurz, *Legend, Myth and Magic in the Image of the Artist* (Vienna, 1934), New Haven and London, 1979

Kryger, Karin, *Allegori og Borgerdyd. Studier i det nylassicistsike gravemale i Danmark 1760–1820*, Copenhagen, 1985

Kunst um 1800, Hamburg Kunsthalle, Hamburg, 1974

Kuspit, Donald, "The Self-Portrait As a Clue to the Artist's Being-in-the-World," *Proceedings of the 6th International Congress of Aesthetics*, Uppsala, 1968, 237ff

Lami, Eugène, *Dictionnaire de la sculpture du 18è siècle* (Paris, 1914), Kraus reprint, Neideln/Liechtenstein, 1970

Dictionnaire de la sculpture du 19è siècle (Paris, 1918), Kraus reprint, Neideln/Liechtenstein, 1970

Landon, C. P., *Annales du Musée et de l'école Moderne des Beaux Arts*, Paris, 1801–1833

Lankheit, Klaus, *Révolution et Restauration* (Baden-Baden, 1965), Paris, 1966

Lapauze, Henri, *Histoire de l'Académie de France à Rome* (I: 1666–1801; II: 1802–1910), Paris, 1924

La Place des Victoires et ses abords, Délégation à l'Action Artistique de la Ville de Paris, Paris, 1983

"La Question du nu dans la statuaire," *Revue universelle des arts* (editor's note), 1959, IX, 410–25

La Révolution française et l'Europe, 1789–1799, Grand Palais, Paris, 1989

La Révolution française. Le Premier Empire. Dessins du Musée Carnavalet, Musée Carnavalet, Paris, 1982

"La Scultura nel XIX secolo," *Acts of the 24th International Congress of the History of Art* (Bologna, 1979), ed. H. W. Janson, Bologna, 1984, VI.

Laviron, G., and B. Galbaccio, *Le Salon de 1833*, Paris, 1833

Le Breton, Joachim, *Rapport à l'empereur et roi sur les beaux-arts depuis les vingt dernières années*, Paris, 1808

Leith, James, *The Idea of Art as Propaganda in France, 1750–1799*, Toronto, 1965

Le Lieux de la mémoire, ed. Pierre Nora, Paris, 1984

Lemaistre, Isabelle Leroy-Jay, "Romantisme," *La Sculpture française au XIXè siècle*, Grand Palais, Paris, 1986

Lemoine, Jean-Gabriel, "Les idées de Diderot sur la sculpture" (Résumé de thèse), *Bulletin des Musées de France*, VIII, 1936, 140f

Le Néo-classicisme français: Dessins des Musées de Province, Grand Palais, Paris, 1975

Le Normand, Antoinette, "De Lemaire à Rodin: Dessins de sculpteurs du XIXè siècle," *Etudes de la Revue du Louvre*, 1980, no. 1, 152–59

La Tradition classique et l'esprit romantique: Les Sculpteurs de l'Académie de France à Rome de 1824 à 1840, Rome, 1981

Lenormant, Charles, *Les Artistes contemporains: Salons de 1831 et 1833*, Paris, 1833

Beaux-Arts et voyages, Paris, 1861

Léon, Paul, *Les Invalides*, Paris, 1929

Léopold Boilly, Musée Marmottan, Paris, 1984

Le Panthéon: Symbole des révolutions, Paris, Hôtel de Sully, 1989

"Le Progrès des arte réunis, 1763–1815: Mythe culturel des origines de la Révolution à la fin de l'Empire," *Actes du Colloque Internationale d'Histoire de l'Art, Bordeaux-Toulouse, 1989, 1992*

Les Muses de messidor: Peintres et sculpteurs Lyonnais de la Révolution à l'Empire, Lyon, Musée des Beaux-Arts, 1989

Lethève, Jacques, *La Vie quotidienne des artistes français au XIXè siècle*, Paris, 1968

Levey, Michael, *Painting and Sculpture in France, 1700–1789*, Yale University Press, New Haven and London, 1993 [revised edition of Kalnein and Levey's 1972 Pelican History of Art volume]

Levitine, George, "The Primitifs and Their Critics in the Year 1800," *Studies in Romanticism*, I, no. 4, Summer 1962, 209–19

The Dawn of Bohemianism, Pennsylvania, 1978

Girodet-Trioson: An Iconographic Study, (Ph.D., Harvard, 1952), Garland, New York and London, 1978

Licht, Fred, *History of Western Sculpture: 19th and 20th Centuries*, Greenwich, 1967

　"Friendship," *Art the Ape of Nature: Studies in Honour of H. W. Janson*, New York, 1981, 559–68

Lindsay, Jack, *Death of the Hero: David to Delacroix*, London, 1960

Locquin, Jean, *La Peinture d'histoire en France de 1747 à 1785* (Paris, 1912), Arthena, Paris, 1978

Luke, Yvonne, "The Politics of Participation: Quatremère de Quincy and the Theory and Practice of 'Concours publiques' in Revolutionary France 1791–95," *The Oxford Art Journal*, 10, n. 1, 1987, 36ff

Macon, G., *Les Arts dans la maison de Condé*, Paris, 1903

Messerer, Wilhelm, "Zu extremen Gedanken über Bestattung und Grabmal um 1800," *Probleme der Kunstwissenschaft*, I, *Kunstgeschichte und Kunsttheorien des 19. Jahrhunderts*, Berlin, 1963

Metamorphoses in Nineteenth-Century Sculpture, Fogg Art Museum, Cambridge, Mass., 1975

Michel, André, "Exposition Universelle de 1889," *GBA*, 3è période, II, 1889, 57–66, 281–309, 389–406

Michel, Régis, *Le Beau Idéal ou l'art du concept*, Louvre, Paris, 1989

Middeldorf, Ulrich. *Sculpture from the Samuel H. Kress Collection, European Schools XIV–XIX Centuries*, London, 1976

Millard, Charles W., "Sculpture and Theory in Nineteenth-Century France," *The Journal of Aesthetics and Art Criticism*, XXIV, 1975, no. 1, 15–20

Monk, Samuel, *The Sublime: A Study of Critical Theories in Eighteenth-Century England* (1935), Michigan, 1962

Montaiglon, Anatole de, *Procès verbaux de l'Académie Royale*, VIII, Paris, 1888

Montfaucon, Bernard de, *L'Antiquité expliquée et représentée en figures*, Paris, 1719

Mopinot de la Chapotte, le Chevalier de, *Proposition d'un monument à élever dans la capitale de la France, pour transmettre aux races futures l'époque de l'heureuse révolution qui l'a revivifiée sous le règne de Louis XVI*, Paris, 1790

Musée du Louvre: Nouvelles acquisitions du département des sculpture (1980–83), Musée du Louvre, Paris, 1984

Newton, Eric, *The Romantic Rebellion*, Longman, Great Britain, 1962

Nineteenth-Century French Sculpture: Monuments for the Middle Class, catalogue by Ruth Butler Mirolli, J. B. Speed Art Museum, Louisville, Kentucky, 1971

Oechslin, Werner, "Pyramide et sphère: Notes sur l'architecture révolutionnaire du XVIIIè siècle et ses sources italiennes," *GBA*, 6è période, LXXVII, April 1971, 201–38

Olander, William, *Pour transmettre à la postérité: French Painting and Revolution 1774–1795*, Ph.D., New York University, 1983

Ollé-Laprune, Léon, *Théodore Jouffroy*, Paris, 1899

Oppermann, Theodor, *Kunsten i Danmark under Frederik V og Christian VIII*, Copenhagen, 1906

Ozouf, Mona, *La Fête révolutionnaire 1789–1799*, Paris, 1976

Parlasca, Klaus, "Motive Antiker Stützfiguren an Kaminen des Frühklassizmus," *ZfK*, XXXVII, nos. 3–4, 1974, 269–83

Parra, Maria Cecilia, "Letture del colore antico tra i 'Savans' del primo Ottocento," *Ricerche di Storia dell'Arte*, 1989, v. 38, 5–21

Pauli, Gustav, *Die Kunst des Klassizismus und der Romantik* (Propyläen Kunstgeschichte), Berlin, 1925

Paulson, Ronald, *Representations of Revolution, 1789–1820*, Yale University Press, New Haven and London, 1983

Penny, Nicholas, *Church Monuments in Romantic England*, New Haven and London, 1977

Perrier, François, *Segmentum nobilium signorum et statuarii quae temporis dentem inuidium eausure urbis aeternae ruinis erepta*, Rome, 1638

Planche, Gustave, *Le Salon de 1831*, Paris, 1831

　Études sur l'école Française, Paris, 1855

Pommier, Edouard, "Winckelmann et la vision de l'antiquité classique dans la France des lumières et de la Révolution," *Revue de l'art*, 83, 1989, 9–20

Ponce, Nicolas, "Réflexions sur le nud et le costume en sculpture," *Le Moniteur universel*, Feb. 2, 1809, no. 33, 129f

Potts, Alex, "Greek Sculpture and Roman Copies: Anton Raphael Mengs and the Eighteenth Century," *JWCI*, 1980, v. 43, 150–73

　"Winckelmann's Construction of History," *Art History*, 5, n. 4, Dec. 1982, 377–407

　Flesh and the Ideal: Winckelmann and the Origins of Art History, Yale, New Haven and London, 1994

Previtali, Giovanni, *La Fortuna dei Primitivi dal Vasari ai Neoclassici*, Turin, 1964

Projets et dessins pour la Place Royale du Peyrou à Montpellier, Inventaire générale des Monuments et Richesses de la France, Grand Palais, Paris, 1980, and Caisse des Monuments Historiques, Paris, 1983

Quatremère de Quincy, Antoine Chrysostome, *Considérations sur les arts du dessin en France*, Paris, 1791

　Considérations morales sur la destination des ouvrages de l'art, Paris, 1815

　Essai sur la Nature, le but, et les moyens de l'imitation dans les beaux-arts, Paris, 1823

　Dictionnaire d'architecture, 1832

　Receuil de notices historiques, Paris, 1834

　Histoire de la vie et des ouvrages de Michel-Ange Buonarotti, Paris, 1835

　Lettres sur l'enlèvement des ouvrages de l'art antique

à Athènes et à Rome, écrites les unes au célèbre Canova, les autres au général Miranda (Rome, 1818), Paris, 1836

Raggio, Olga, "The Myth of Prometheus: Its Survival and Metamorphoses up to the Eighteenth Century," *JWCI*, XXI, 1958, nos. 1–2, 44–62

Réau, Louis, *Les Sculpteurs français en Italie*, Paris, 1945

Reff, Theodor, "Puget's Fortunes in France," *Essays in the History of Art Presented to Rudolf Wittkower*, London, 1967, 274–84

Renouvier, Jules, *Histoire de l'art pendant la Révolution*, Paris, 1863

Reynolds' Discourses on Art, ed. Robert Wark, New Haven and London, 1974

Rheims, Maurice, *La Sculpture au 19è siècle*, Paris, 1972

Ribner, Jonathan, *"Le Peuple de Dieu": Old Testament Motifs of Legislation, Prophecy and Exile in French Art between the Empires*, Ph.D., New York University, 1986

Riegl, Alois, *The Modern Cult of Monuments: Its Character and Its Origin*, translated by Kurt W. Forster and Diane Ghirardo, published in *Oppositions: Monument/Memory*, ed. Kurt W. Forster, Fall 1982

Rocheblave, Samuel, *Essai sur le Comte de Caylus*, Paris, 1889

The Romantic Movement, Arts Council of Great Britain, London, 1959

The Romantics to Rodin, catalogue by Peter Fusco and H. W. Janson, Los Angeles County Museum of Art, Los Angeles, 1980

Rosenblum, Robert, "The Origins of Painting: A Problem in the Iconography of Romantic Classicism," *AB*, XXXIX, Dec. 1957, 279–90

 Jean-Auguste-Dominique Ingres, New York, 1967

 Transformations in Late Eighteenth-Century Art, Princeton (1967), 1974

 The International Style of 1800: A Study in Linear Absraction (Ph.D., New York University, 1956), Garland, New York and London, 1976

Rosenthal, Gertrude, "The Basic Theories of French Classic Sculpture," *Journal of Aesthetics and Art Crticism*, I, no. 6, 1942, 42–53

Rossi Pinelli, Orietta, "Artisti, falsari o filologhi? Da Cavaceppi a Canova, il restauro della scultura tra arte e scienza," *Il Neoclassicismo tra rivoluzione e restaurazione. Ricerche di Storia dell'arte*, XIII–XIV, 41–56

Rostrup, H., *Franske Portraetbuster fra det XVIII Aarhundrede* (French summary), Copenhagen, 1932

Rubin, James Henry, "Oedipus, Antigone and Exiles in Post-Revolutionary French Painting," *AQ*, XXXVI, no. 3, Aug. 1973, 141–71

 "La Sépulture romantique de Christine Boyer et son portrait par Antoine-Jean Gros," *Revue du Louvre*, XXV, no. 1, 1975, 17–22

Rupprecht, Bernhard, "Plastisches Ideal und Symbol in der Bilderwelt der Goethezeit," *Kunstgeschichte und Kunst-theorie im 19. Jahrhundert*, ed. Hermann Bauer, Berlin, 1963, 195–223

Sagnac, Philippe, and Jean Robiquet, *La Révolution de 1789*, Paris, 1934

Saisselin, R. G., "Neo-Classicism: Images of Public Virtue and Realities of Private Luxury," *Art History*, IV, no. 1, March 1981, 14–36

Scherf, Guilhem, "La Galerie des 'Grands Hommes' au coeur des salles consacrées à la sculpture française du XVIIIè siècle," *Revue du Louvre*, 1993, 5/6, 58–67

Schiff, Gert, *Johann Heinrich Füssli, 1741–1825*, Zurich, 1973

 "The Sculpture of the 'Style Toubadour,'" *Arts*, LVIII, no. 16, Summer 1984, 102–10

Schneider, Mechtild, *Künstler Denkmäler in Frankreich: Ein Thema der Auftragsplastik im 19 Jarhhundert*, Frankfurt-am-Main, 1977

 "Verlassenwerden-Verlassensein. Zur Darstellung des Liebesschmerzen in der französischen Skulptur des späten Ancien Régime," *Pantheon*, XLVIII, 1990, 110–22

Schneider, René, *Quatremère de Quincy et son intervention dans les arts*, Paris, 1910

 L'Esthétique classique chez Quatremère de Quincy, Paris, 1910

 "L'Art Anacréontique et Alexandrin sous l'Empire," *Revue des études Napoléoniennes*, IX, no. 2, 1916, 257–71

Schroder, Maurice, *Icarus: The Image of the Artist in French Romanticism*, Harvard, 1961

Seven Centuries of European Sculpture, Heim Gallery, London, 1982

Seznec, Jean, *Essais sur Diderot et l'antiquité*, Oxford, 1957

*Shedd, Meredith, *T. B. Emeric-David and the Criticism of Ancient Sculpture in France, 1780–1839*, University of California, Berkeley, 1980

 "Emeric-David's 'Anatomical Vision': A French Response to the Elgin Marbles," *GBA*, 6è période, CII, Nov. 1983, 158–64 (material from the dissertation)

Skulptur aus dem Louvre: Sculptures françaises néo-classiques 1760–1830, Louvre, Paris, 1990.

Stafford, Barbara Maria, "Arena of Virtue and Temple of Immortality: An Early Nineteenth-Century Museum Project," *Journal of the Society of Architectural Historians*, XXXV, March 1976, 21–34

 "Rude Sublime: The Taste for Nature's Colossi during the Late Eighteenth and Early Nineteenth Centuries," *GBA*, 6è période, LXXXVII, April 1976, 113–26

 "Beauty of the Invisible: Winckelmann and the Aesthetics of Imperceptibility," *Zfk*, XLIII, no. 1, 1980, 65–78

Stolpe, Claus Elmar, *Jacques-Louis David: 'Der Schwur der Horatier' oder von der Nützlichkeit der Tugend*, Inaugural diss., Munich, 1984

Tanis-Sydney, Patricia, *Monuments to Artists in France, 1800–1914*, Ph.D., University of Pennsylvania, 1982

Taylor, Joshua C., *Nineteenth-Century Theories of Art*, University of California Press, Berkeley, Los Angeles and London, 1987

Taylor, Samuel, "Artists and 'Philosophes' As Mirrored by Sèvres," *The Artist and Writer in France: Essays in Honour of Jean Seznec*, Oxford, 1974, 21–39

Thiery, J. B., *L'Arc de Triomphe de l'étoile*, Paris, 1845

Thirion, Henri, *Le Palais de la Légion d'Honneur: Ancien Hôtel de Salm*, Versailles, 1883

Tischbein, H. W., *Aus Meinem Leben*, Berlin, 1922

Toreinx, F. R. de, *Histoire du romantisme en France*, Paris, 1829

Tourneux, Maurice, *Salons et expositions d'art à Paris (1801–1870)*, Paris, 1919

Tür, Karina, *Zur Antiken rezeption in der französischen Skulptur des 19 und frühen 20 Jahrhunderts*, Berlin, 1979

Trachtenberg, Marvin, *The Statue of Liberty*, New York, 1976

Verdi, R., "Poussin's Eudamidas, Eighteenth-Century Criticism and Copies," *BM*, CXIII, Sept. 1971, 513–24

Vermeule, Cornelius, *European Art and the Classical Past*, Cambridge, Mass., 1964

Vitry, Paul, "Les Monuments à J.-J. Rousseau de Houdon à Bartholomé," *GBA*, 4è période, VIII, Aug. 1912, 97–117

 Musée National du Louvre: Catalogue des Sculptures, Part II, "Temps modernes," Paris, 1922

 "La Sculpture en France de 1789 à 1850," *Histoire de l'art (L'Art en Europe et en Amérique au XIXè siècle et au début du XXè)*, ed. André Michel, Paris, 1925, VIII, 45ff

 "La Sculpture romantique," *Le Romantisme et l'art* (ed. Hautecoeur), Paris, 1928, 49–73

 La Sculpture française classique de Jean Goujon à Rodin, Paris, 1934

Vitry, Paul, and Luc Benoist, "Liste des bustes d'artistes commandés pour la Grande Galerie et les salles peinture du Louvre," *BSHAF*, 1930, 37–42

Wakefield, David, *Stendhal and the Arts*, London, 1973

Walker, Dean, *The Early Career of François Girardon (1628–1696)*, Ph.D., New York University, 1982

Wennberg, Bo, *French and Scandinavian Sculpture in the Nineteenth Century*, Stockholm, 1978

West, Alison, *From Pajou to Préault: The Development of Neoclassicism and the Sublime in French Sculpture, 1760–1840*, Ph.D., New York University, 1985

 "The Sculptor's Self-Image," *Acts of the XXVIth International Congress of the History of Art*, Washington, D.C., 1986, 391ff

Western European Bronzes of the Nineteenth Century, Shepherd Gallery, New York, 1973

Whinney, Margaret, *Sculpture in Britain from 1530 to 1830* (Pelican History of Art), Harmondsworth, 1964

Whiteley, J. J. L., "*Homer Abandoned*: A French Neo-classical Theme," *The Artist and Writer in France: Essays in Honour of Jean Seznec*, Oxford, 1974, 40–51

 "Light and Shade in French Neo-classicism," *BM*, CXVII, Dec. 1975, 768–73

 "The Origins of the Concept 'Classique' in French Art Criticism," *JWCI*, XXXIX, 1976, 268–75

Whitley Papers, Print Room, British Museum, London

Winckelmann, J.J., *Geschichte der Kunst des Altertums*, Vienna, 1934

Wildenstein, David, and Guy Wildenstein, *Documents complémentaires au catalogue de l'oeuvre de Louis David*, Paris, 1973

Yarrington, Alison Willow, *The Commemoration of the Hero 1800–1864: Monuments to the British Victors of Napoleonic Wars* (Cambridge University, 1980), Garland Press, New York and London, 1988

Zeitler, Rudolph, *Klassizismus und Utopia*, Stockholm, 1954

Individual Artists

BANKS

Bell, Charles, *The Annals of Thomas Banks*, Cambridge, 1938

Stainton, Lindsay, "A Rediscovered Bas-Relief by Thomas Banks," *BM*, CXVI, June 1974, 327–29

BARTOLINI

Il Genio di Lorenzo Bartolini, ed. Carlo del Bravo, Palazzo Pretorio, Prato, Florence, 1978

Tinti, Mario, *Lorenzo Bartolini*, Reale Academia d'Italia, XV, Rome, 1936

BARYE

Barye: "An Introduction to the Sketchbook from the Institute's Collection," *Minneapolis Institute of Arts Bulletin*, LIX, 1970, 59–63

Benge, Glenn Franklin, *The Sculpture of Antoine-Louis Barye in American Collections with a Catalogue Raisonné*, Ph.D., University of Iowa, 1969

 "Barye's Uses of Some Géricault Drawings," *Walters Art Gallery Journal*, XXI–XXII, 1968–69 (1971), 13–27

 "Barye's Apotheosis Pediment for the New Louvre: Napoleon I Crowned by History and the Fine Arts," *Art and the Ape*, 1981, 607–29

 Antoine-Louis Barye: Sculptor of Romantic Realism, Pennsylvania State University Press, University Park and London, 1984

"Barye, Flaxman and Phidias," *Acts of the 24th International Congress of the History of Art* (Bologna, 1979), Bologna, 1984, VI, 103–10

Chappey, Frédéric, "Antoine-Louis Barye à l'Ecole des Beaux-Arts (1818–1825)," *Journal of the Walters Art Gallery*, 49/50, 1991–92, 119–29

Hubert, Gérard, "Barye et la critique de son temps," *Revue des Arts*, VI, 1956, 223–30

Pivar, Stuart, *The Barye Bronzes: A Catalogue Raisonné*, Woodbridge, Suffolk, 1974

BOICHOT

Calliat, Louis Armand, "Sculptures et dessins de Guillaume Boichot," *Revue des Arts*, 1958, no. 5, 229–34

Dowley, Francis H., "A Neo-Classic Hercules," *AQ*, Spring 1952, 73–76

Guillemin, Jean, "Guillaume Boichot," *Mémoires de la Société d'Histoire et d'Archéologie de Chalon*, V, 3é partie, 1872, 1–74

BOSIO

Barbarin, L., *Etude sur Bosio, sa vie et son oeuvre*, Monaco, 1910

*Selz, Germaine, *François-Joseph Bosio, 1768–1845*, unpublished thesis, Ecole du Louvre, 1931 (summary in *Bulletin des Musées de France*, 1932, no. 8, 131–32)

BOUCHARDON

Edmé Bouchardon, catalogue by O. Colin, Chaumont Museum, Chaumont, 1962

Diderot, Denis, "Observations sur la sculpture et sur Bouchardon" (1763), *Oeuvres*, ed. Maurice Assézat, Paris, XIII, 40ff

Jordan, Marc, "Edmé Bouchardon: A Sculptor, Draughtsman, and His Reputation in Eighteenth-Century France," *Apollo*, 121, June 1985, 388–94

Roserot, A., *Edmé Bouchardon*, Paris, 1910

BRETON

*Cornillot, Marie-Lucie, *Le Sculpteur bisontin Luc Breton, 1731–1800*, Ecole du Louvre thesis, Paris, 1937 or 1938.

CAFFIÉRI

Guiffrey, Jules, *Les Caffiéri*, Paris, 1877

CANOVA

Albrizzi-Teotochi, Isabella, *Opera di scultura e di plastica di A. Canova*, Pisa, 1821

Antonio Canova, Museo Correr, Venice, 1992

Argan, G.C., *Antonio Canova* (Università degli Studi di Roma, Anno Academico, 1968–69), Rome, 1969

Argan, G.C., Giandomenico Romanelli, and Giovanni Scarabello, *Canova, Cicognara, Foscolo*, Venice, 1979

Bassi, Elena, *Canova*, Milano-Bergamo-Rome, 1943

Boggero, Franco, "Una rilettura critica del Canova: La *Maddalena Penitente*," *Civiltà Neoclassica nella Provincia de Como (Arte Lombarde)*, 1980, 386–92

Boyer, Ferdinand, "Canova, sculpteur de Napoléon," *Le Monde des arts en Italie et la France de la Révolution et de l'Empire*, Turin, 1970, 131–45

Canova, Antonio, 110 Letters to Quatremère de Quincy, Bibliothèque Nationale, Paris, Mss Italiens, 65
 I Quaderni di Viaggio, ed. Elena Bassi, Venice and Rome, 1959

Cicognara, Count Leopoldo, *Biografia di A. Canova*, Venice, 1823

Leopoldo Cicognara: Lettere ad Antonio Canova, ed. Gianni Venturi, Urbino, 1973

De Benedetti, Michele, *Michelangelo e Canova (Memoria premiata della R. Accademia di San Luca nel Concorso Poletti, scritto di Scultura, à 1924–II)*, Rome, 1933, XI

Disegni di Canova del Museo di Bassano, Castello Sforzesco, Milano, 1982

Fehl, Philip, "The Placement of Canova's *Hercules and Lichas* in the Palazzo Torlonia," *North Carolina Museum of Art Bulletin*, 1971–73, no. 3, 15–27
 "Canova's Tomb and the Cult of Genius," *Labyrinthos: Studi e ricerche sulle arti nei secoli XVIII e XIX*, 1/2, 1982, 46–66

Fernow, Carl Ludwig, *Über den Bildhauer, Antonio Canova: Römische Studien*, Zurich, 1806

Honour, Hugh, "Antonio Canova and the Anglo-Romans. Part I: First Visit to Rome" and "Part II: The First Years in Rome," *Connoisseur*, CXLIII, June 1959, 241–95 and CXLIV, Jan. 1960, 225–31
 "Canova's *Theseus and the Dead Minotaur*" (*Victoria and Albert Museum Yearbook*, I, 1969), London, 1969
 "Canova's Studio Practice I" and "Canova's Studio Practice II," *BM*, CXIV, March 1972, 147–59 and April 1972, 214–29
 "Canova and David," *Apollo*, XLVI, Oct. 1972, 312–17
 "Canova's Napoleon," *Apollo*, XCIX, Sept. 1973, 180–84
 "Eight Letters from Antonio Canova," *Apollo*, CIV, Oct. 1976, 290–97

Licht, Fred, *Canova*, New York, 1983

Malamani, Vittorio, ed., "Un amicizia di Antonio Canova: Lettere di Lui al Conte Leopoldo Cigconara, Città di Castello, 1890
 Canova, Milan, 1911

Memes, J. S., *Canova*, Edinburgh, 1823

Missirini, Melchiore, *Della Vita di Antonio Canova*, Prato, 1824

Ojetti, Ugo, "Canova e Stendhal," *Daedalo*, Anno III, vol. II, 1922–23, 307–40

Ost, Hans, *Ein Skizzenbuch Antonio Canovas, 1796–1799*, Tübingen, 1970

Pantaleoni, Massimo, *Disegni Anatomici di Antonio Canova*, Milano, 1949

Pavan, M., "Antonio Canova e la discussione sugli Elgin Marble," *Rivista dell'Istituto d'Archeologia e Storia dell'Arte*, N.S. XXI–XXII, 1974/5, 219–344

Per le Nozze Papadopoli: Lettere familiari inedite di Antonio Canova e di Gianantonio Selva, August 1802, Venice, 1853

Pinelli, Antonio, "La sfida rispettosa di Antonio Canova. Genesi e peripezie del 'Perseo Trionfante,'" *Il Neoclassicismo tra rivoluzione e restaurazione, Ricerche di Storia dell'Arte*, 13–14, 1981, 21–40

Praz, Mario, and Giuseppe Pavanello, *L'opera completa del Canova*, Milano, 1976

Quatremère de Quincy, *Notice sur M. Canova: Sur sa réputation, ses ouvrages et sa statue du Pugilateur*, Paris, 1804
 Canova et ses ouvrages, Paris 1834

Ragghianti, "Studi sul Canova," *Critica d'Arte*, XXII, July – August, 1957

Raggio, Olga, "The Triumphant Perseus," *Connoisseur*, CLXXII, Nov. 1969, 204–12

Reveil and H. de Latouche, *Oeuvre de Canova*, Paris, 1825

Stefani, Ottorino, *La Poetica e l'Arte del Canova, Tra Arcadia, Neoclassicismo e Romanticismo*, Treviso, 1980

Studi Canoviani (Quaderni sul Neoclassico), ed. Elisa Debendetti, Rome, 1973

Wischermann, Heinfried, "Canova's Pantheon – überlegungen zum Tempio Canoviano von Possagno," *Architectura*, X, no. 2, 1980, 134–63

CARTELLIER

*Hubert, Gérard, *Pierre Cartellier*, unpublished thesis, Ecole du Louvre, 1949 ("Résumé de thèse," *Musées de France*, Oct. 1950, no. 8, 222–24)
 "Pierre Cartellier, Statuaire. Oeuvres et Documents Inédits. Ancien Régime, Révolution, Consulat," *BSHAF*, 1976, 313–29
 "Pierre Cartellier," *GBA*, 6è période, XCVI, July – Aug. 1980, 1–44

CAVACEPPI

Cavaceppi, Heim Gallery, London, 1983

Howard, Seymour, "Bartolomeo Cavaceppi and the Origins of Neo-classic Sculpture," *AQ*, XXXIII, 1970, 120–33

Bartolommeo Cavaceppi, Eighteenth-Century Restorer (Ph.D., University of Chicago, 1958), Garland, New York and London, 1982

CHAUDET

Biver, Marie Louise, "La Statue de la Paix de Chaudet," *Revue de l'Institut Napoléon*, no. 110, Jan. 1969, 189–93

Hubert, Gérard, "Notes sur deux œuvres retrouvées du sculpteur Chaudet," *Nouvelles Archives de l'Art Français*, viii, 22, 1950–57 (1959), 287–89

Vitry, Paul, "Un Album de dessin du sculpteur Chaudet," *BSHAF*, 1924, 27 (this is no more than a lecture announcement)

CHINARD

Exposition d'oeuvres du sculpteur Chinard de Lyon, 1756–1813, catalogue by Paul Vitry, Union Centrale des Arts Décoratifs, Paris, 1909

Hubert, Gérard, "Un Buste du premier consul par Chinard," *La Revue du Louvre*, no. 3, 1984, 189–92

La Collection de M. le Comte de Penha-Longa: Sculpture par Joseph Chinard de Lyon, Paris, 1911

L'Oeuvre de Joseph Chinard, catalogue by Madeleine Rocher-Jauneau, Lyon, Musée des Beaux-Arts, Lyon, 1978

Rocher-Jauneau, Madeleine, "Chinard and the Empire Style," *Apollo*, LXXX, Sept. 1964, 220–25
 "Les Dieux de l'Olympe: Quatre Sculptures de Chinard retrouvées," *Oeil*, 407, June 1989, 50–55

Saunier, Charles, *Joseph Chinard et le style empire à l'exposition du musée des arts décoratifs*," *GBA*, 4è période, III, Jan. 1910, 23–42

Schwark, Günther, *Die Portätwerke Chinards*, Ph.D., Freiburg, 1937

CLODION

Clodion, Louvre, Paris, 1992

Poulet, Anne, *Clodion Terra-cottas in North American Collections*, The Frick Collection, New York, 1984

Scherf, Guilhem, "Autour de Clodion: Variations, imitations, répétitions," *Revue de l'art*, 1991, 47–49

Thirion, Henri, *Les Adams et Clodion*, Paris, 1885

CORNEILLE

Boyer, Ferdinand, "Le Sculpteur Barthélémy Corneille à Rome et en Toscane (1787–1805)," *Le Monde des arts en Italie et le France de la Révolution et de l'Empire*, Turin, 1970, 45–54

CYFFLÉ

Noël, Maurice, "Sur quelques Biscuits en terre de Lorraine de P. L. Cyfflé," *Revue des arts*, 1959, no. 1, 31–36

DAVID D'ANGERS

Aux Grande Hommes, David d'Angers, Fondation de Coubertin, 1990, Saint-Rémy-les-Chevreuses

Caso, Jacques de, "David d'Angers: L'Inventaire après décès," *GBA*, 6è période, XCVI, Sept. 1980, 85–97

"Le Romantisme de David d'Angers," *Acts of the 24th International Congress of the History of Art* (Bologna, 1979), Bologna, 1984, VI, 87–102

David d'Angers: L'Avenir de la mémoire, Paris, 1988 (English translation: *David d'Angers: Sculptural Communication in the Age of Romanticism*, Princeton University Press, 1992)

Driskel, Michael Paul, "'Et la lumière fut': The Meanings of David d'Angers's Monument to Gutenberg," *AB*, LXXIII/3, Sept. 1991, 359–80

Galerie David d'Angers, catalogue by Viviane Huchard, Angers, 1984

Jouin, Henri, *David d'Angers: Sa Vie, son oeuvre, ses écrits et ses contemporains*, Paris, 1878

Les Carnets de David d'Angers, Paris, 1958

McWilliam, Neil, "David d'Angers and the Pantheon Commission: Politics and Public Works under the July Monarchy," *Art History*, V, no. 4, Dec. 1982, 426–46

Schlagmann, Paul Émile, *David d'Angers: Profils de l'Europe*, Geneva, 1973

DESEINE

Le Chatellier, Georges, *Louis-Pierre Deseine, 1749–1822: Sa Vie et ses oeuvres*, Paris, 1926

ETEX

Etex, Antoine, *Projet de tombeau de Napoléon*, Paris, 1840
Les Souvenirs d'un artiste, Paris, 1877

FALCONET

Benot, Yves, *Diderot et Falconet: Le Pour et le contre: Correspondance polémique sur le respect de la postérité. Pline et les Anciens*, Paris, 1958

Correspondance de Falconet avec Catherine II, 1767–1779, Paris, 1921

Diderot et Falconet, Frankfurt, 1959

Dieckmann, H., and Jean Seznec, *Diderot et Falconet: Correspondance. Les six premières lettres.* (*Analecta Romanica, Beihefte zu den Romanischen Forschungen*, VII, ed. Fritz Schalk), Frankfurt-am-Main, 1959

Dowley, Francis H., "Falconet's Attitude towards Antiquity and His Theory of Reliefs," *AQ*, XXXI, 1968, 185–204

Falconet, Maurice-Etienne, *Oeuvres*, Paris, 1808 (Slatkine Reprint, Geneva, 1970)

Lettres inédites de Diderot au statuaire Falconet, St. Germain, 1867 (extract from the *Revue moderne*, 1866–67)

Levitine, George, *The Sculpture of Falconet*, Greenwich, 1972

Réau, Louis, *Falconet*, Paris, 1912

Seznec, Jean, "Falconet, Diderot et le bas-relief," *Walter Friedlaender zum 90 Geburtstag*, Berlin, 1965, 151–57

Weinschenker, Anne Betty, *Falconet: His Writings and His Friend Diderot*, Geneva, 1966

FLAXMAN

Bindman, David, ed., *Flaxman*, Royal Academy of Art, London, 1979

Flaxman, John, *Lectures on Sculpture* (first published, 1828), London, 1839

Irwin, David, *John Flaxman, 1755–1826*, New York and London, c. 1979

Symmons, Sarah, "French Copies after Flaxman," *BM*, CXV, Sept. 1973, 591–99

Flaxman, 154–55; "Géricault, Flaxman and Ugolino," *BM*, CXV, Oct. 1973, 671–72

"The Spirit of Despair: Patronage, Primitivism and the Art of John Flaxman," *BM*, CXVIII, Oct. 1975, 644–50

Flaxman and Europe: The Outline Illustrations and Their Influence, Ph.D., Courtauld, Garland, New York and London, 1984

GÉRICAULT

Berger, Klaus, *Géricault: Drawings and Watercolors*, New York, 1946

Clément, C., *Géricault: étude biographique et critique avec le catalogue raisonné de l'oeuvre du maître*, Paris, 1879 (New York, 1974)

Eitner, Lorenz, *Géricault: His Life and Work*, London, 1983

Schmoll, J. A., "Géricault sculpteur, à propos de la découverte d'une statuette en plâtre d'un moribond," *BSHAF*, 1973, 319–33

Szczepinska-Tramer, Joanna, "Notes on Géricault's Early Chronology," *Master Drawings*, XX, no. 2, 1982, 135–48

GIBSON

Cooper, Jeremy, "John Gibson and His Tinted Venus," *Connoisseur*, LXXVII, Oct. 1971, 84–96

Darby, Elisabeth. "John Gibson, Queen Victoria and the Ideal of Sculptural Polychromy," *Art History*, XX, 1981, 37–52

J. B. GIRAUD

Shedd, Meredith, "A Neo-classical Connoisseur and His Collection: J. B. Giraud's Museum of Casts at the Place Vendôme," *GBA*, 6è période, CIII, May – June 1984, 198–206 (material from Shedd's dissertation)
Vitry, Paul, " 'L'Achille Blessé' du sculpteur J. B. Giraud," *Bulletin des Musées*, 1923, 66

GIRAUD DE LUC

Courajod, Louis, "Le Groupe en cire de Pierre-François-Grégoire Giraud," *GBA*, 3è période, V, 1891, 307–15

GUIARD

Roserot, Alphonse, *Laurent Guiard*, Paris, 1901

HEWETSON

Hodgkinson, Terence, "Christopher Hewetson, an Irish Sculptor in Rome," *Walpole Society Journal*, XXXIV, 1952–54, 42ff
Romallo, Germán, "Christopher Hewetson, Tre Ovras suyas en Espana," *Archivo Espanol de Arte*, XLVI, no. 182, 1973, 181–87

HOUDON

Arnason, H.H., *The Sculpture of Houdon*, New York and London, 1975
Giacometti, Georges, *La Vie et l'oeuvre de Houdon*, Paris, 1928
Réau, Louis, *Houdon: Sa Vie et son oeuvre*, Paris, 1964
Sauerländer, Willibald, *Jean Antoine Houdon*, 'Voltaire,' Stuttgart, 1963

JULIEN

Le Breton, Joachim, *Notice historique sur la vie et les ouvrages de Pierre Julien*, Paris, 1805
Pascal, Abbé André, "Pierre Julien," *GBA*, 3è période, XXIX, 1903, 326–42 and 407–14
 Pierre Julien, sculpteur, 1731–1804: Sa Vie et son oeuvre, Paris, 1904
Scherf, Guilhem, "Pierre Julien et le décor sculpté de l'église Sainte Geneviève à Paris," *Revue du Louvre*, 38/2, 1988, 127–37
Worley, Michael Preston, *Pierre Julien and French Neoclassical Sculpture*, Ph.D., University of Chicago, 1986

LEMOT

*Moulin, Monique, *François Frédéric Lemot et son élève, Charles Dupaty*, unpublished thesis, Ecole du Louvre, 1960

MARIN

Joseph-Charles Marin, Galerie Patrice Bellanger, Paris, 1992
Quinquenet, Maurice, *Un élève de Clodion, Joseph Charles Marin*, Paris, 1948

MOITTE

Campbell, Richard James, *Jean-Guillaume Moitte: The Sculpture and Graphic Art, 1785–99*, Ph.D., Brown University, 1982
Gramaccini, Gisella, "Jean-Guillaume Moitte et la Révolution française," *Revue de l'art*, 83, 1989, 61–70
 Jean-Guillaume Moitte (1746–1810): Leben und Werk, Berlin, 1993 [reviewed by G. Scherf, *BM*, v. 136, n.1092, March 1994, 182–83]
Madame Moitte, *Un Ménage d'artistes sous le 1er Empire: Journal inédit de Mme Moitte 1805–07*, ed. Paul Cottin, Paris, 1932

NOLLEKENS

Smith, John Thomas, *Nollekens and His Times* (London, 1828), London, 1895

PACETTI

Honour, Hugh, "Vincenzo Pacetti," *Connoisseur*, CXLVI, Nov. 1960, 174–81
 "The Rome of Vincenzo Pacetti," *Apollo*, Nov. 1963, 368ff

PAJOU

Beaulieu, Michèle, "Oeuvres inédites et procédés de travail d'un sculpteur de la seconde moitié du XVIIIè siècle: Augustin Pajou," *BSHAF*, 1979, 159–65
Benisovich, Michel N., "Drawings of the Sculptor Augustin Pajou in the United States," *AB*, XXXV, no. 4, Dec. 1953, 295–98
Stein, Henri, *Augustin Pajou*, Paris, 1912

PIGALLE

Gaborit, Jean-René, *Jean-Baptiste Pigalle, 1714–85: Sculptures du Musée du Louvre*, Paris, 1985
Hüttinger, Eduard, "Pigalles Grabmal des Marechal des

Saxe," *Studi di Storia dell'Arte in Onore di Antonio Morassi*, Alfieri, [1971?;cb, 357ff
Réau, Louis, *Jean-Baptiste Pigalle*, Paris, 1950
Rocheblave, Samuel, *Jean-Baptiste Pigalle*, Paris, 1919

PRADIER

Avenier, L., "J.-J. Pradier," *Pages d'art*, 1922, 97–114, 125–40, 153–78
*Garnier, Guillaume, *James Pradier*, unpublished thesis, Ecole des Chartes, 1979?
Gielly, L., "Les Pradiers du Musée de Genève," *Geneva*, III, 1925, 347–57
 "Les Dessins de James Pradier au Musée de Genève," *Geneva*, VII, 1929, 242–50
Lièvre, P., "Pradier," *Revue de Paris*, Aug. 1932, 807–27, and Sept. 1932, 172–201
Pradier, James, *Correspondence*, ed. Douglas Siler, Geneva, 1984
Statues de chair: Sculpture de James Pradier (1790–1852), Musée d'Art et d'Histoire, Geneva, 1985.

PRÉAULT

Millard, Charles W., *The Life and Work of Auguste Préault*, Ph.D., Harvard, 1983
 "Préault's Commissions for the New Louvre: Patronage and Politics in the Second Empire," *BM*, 131, Sept. 1989, 625–30
Mower, David, "Antoine Auguste Préault," *AB*, LXIII, June 1981, 288–307
Ribner, Jonathan, "Henri de Triqueti, Auguste Préault, and the Glorification of Law under the July Monarchy," *AB*, Sept. 1988, LXX, no. 3, 486–50

RAMEY

Gallet, Michel, "Un Modèle du sculpteur Claude Ramey pour la décoration révolutionnaire du Panthéon," *Bulletin du Musée Carnavalet*, 1948–67, no. 1, June 1965, 18–19

RODIN

Auguste Rodin: Le Monument des bourgeois de Calais, Musée des Beaux-Arts de Calais, Calais, 1977
Caso, Jacques de, and Patricia Sanders, *Rodin's Sculpture: A Critical Study of the Spreckels Collection, California Palace of the Legion of Honour*, Rutland, Vermont, 1972
Elsen, Albert, and Kirk T. Varnedoe, *The Drawings of Rodin*, New York and Washington, 1971
Rodin Rediscovered, catalogue edited by Albert Elsen, National Gallery of Art, Washington, D.C., and Baltimore, 1981

ROLAND

Draper, James David, "Philippe-Laurent Roland in the Metropolitan Museum of Art," *Journal of the Metropolitan Museum of Art*, v. 27, 1992, 129–47
*Genoux, Denise, *P.-L. Roland*, unpublished thesis of the Ecole du Louvre, 1963

RUDE

Butler, Ruth, "Long Live the Revolution, the Republic, and Especially the Emperor!: The Political Sculpture of Rude," *Art and Architecture in the Service of Politics*, ed. H. Millon and L. Nochlin, Cambridge, Mass., and London, 1978, 92–107
Calmette, J., *François Rude*, Paris, 1920
Drouot, Henri, *Une Carrière: François Rude*, Paris, 1958
Fourcaud, L. de, *François Rude, sculpteur: Ses Oeuvres et son temps (1784–1855)*, Paris, 1904
Legrand, Dr. Maximilien, *Rude, sa vie, ses oeuvres, son enseignement: Considérations sur la sculpture*, Paris, 1856
Quarré, Pierre, "François Rude et le milieu artistique dijonnais," *Le Dessin*, XI [1948], 6ff
Vitry, Paul, "Les Dessins de Rude du Musée de Dijon," offprint of the *GBA*, 6è période, IV, Aug. 1930, 113–27

SERGEL

Antonsson, Oskar, "Johan Tobias Sergel," *BM*, LXXXIII, Dec. 1943, 290–96
Bell, C. F., "Sergel and Neoclassicism," *BM*, LXXXIV, April 1944, 97
The Drawings of Johan Tobias Sergel, catalogue by Per Bjürström, National Museum, Stockholm, Chicago, 1979
Josephson, Ragnar, *Sergel's Fantasi*, Stockholm, 1956
Johan Tobias Sergel, Hamburg Kunsthalle, Hamburg, 1975
Sergel, Stockholm, Nationalmuseum, 1990
Sergel Tecknar, Stockholm National Museum and Thorvaldsen Museum, Copenhagen, 1976
Setterquist O'Brien, Elvy, *Johan Tobias Sergel (1740–1814) and Neoclassicism: Sculpture of Sergel's Years Abroad, 1767–1779*, Ph.D., University of Iowa, 1982, Ann Arbor Michigan, University Microfilm International

SIMART

Eyriès, Gustave, *Simart*, Paris, 1860
Lagrange, Léon, "Simart," *GBA*, 1ère période, XIV, 1863, 98–123

THORVALDSEN

Bertel Thorvaldsen, 1770–1844, scultore danese a Roma, Galleria Nazionale d'arte Moderna, Rome, 1989

Einem, Herbert von, *Thorvaldsen's "Jason": Versuch einer Historischen Würdigung*, (Bayerische Akademie der Wissenschaften – Philosophische – Historische Klasse, 1974, III), Munich, 1974

Hartmann, Jørgen Birkedal, *Antike Motive bei Thorvaldsen*, Tübingen, 1979

*Hemmeter, Karlheinz, *Studien zu Reliefs von Thorvaldsen. Auftraggeber – Künstler – Werkgenese. Idee un Ausführung* (Ph.D., Munich, 1983), Munich, 1984

Larsson, L. O., "Thorvaldsens Restaurierung der Aegina-Skulpturen im Lichte zeitgenössicher Kunstkritik und Antikenauffassung," *Konsthistorisk Tidskrift*, XXXVIII, May 1969, no. 1–2, 23–40

Licht, Fred, "Thorvaldsen and Continental Tombs of the Neoclassic Period," *Bertel Thorvaldsen*, Cologne Kunsthalle, Cologne, 1977, II, 173–82

> *Bertel Thorvaldsen I (Skulptur, Modelle, Bozzetti, Handzeichnungen)*, Cologne Kunsthalle, Cologne, 1977

> *Bertel Thorvaldsen II (Untersuchungen zum seinen Werk un zur Kunst seiner Zeit)*, Cologne, 1977

Opperman, Theodor, *Thorvaldsen*, Copenhagen, 1927–30

Plon, Eugène, *Thorvaldsen: Sa Vie et son oeuvre*, Paris, 1874

Rave, Paul Ortwin, *Thorvaldsen*, Berlin, 1949

Sass, Else Kai, *Thorvaldsen Portraetbuster*, Copenhagen, 1963–65

Thiele, J. M., *Den danske Billedhugger Bertel Thorvaldsen og Hans Voerker*, Copenhagen, 1831–32

Thiele, J. M., *Thorvaldsen*, Copenhagen, I–IV, 1851–56

Thorvaldsen: Drawings and Bozzetti, Heim Gallery, London, 1973

Thorvaldsen, Galleria d'Arte Modern, Rome, 1990

Thorvaldsen: L'ambiente, l'influsso, il mito, ed. Patrick Kragelund and Mogens Nykjaer, Rome, 1991

TRIPPEL

Alexander Trippel (1744–1793): Skulpturen und Zeichnungen, Museum zu Allerheiligen, Schaffhausen, 1993

Vogler, C. H., "Der Bildhauer Alexander Trippel am Schaffhausen," *Schweizerisches Künstler Lexikon*, Frauenfeld, 1913, III, 330–32

VASSÉ

Réau, Louis, "Un Sculpteur oublié du XVIIIè siècle: Louis-Claude Vassé, 1716–1772," *GBA*, 6è période, IV, July 1930, 31–56

WIEDEWELT

Meier, Frederick Julius, *Efterretninger om Billedhuggern Johannes Wiedewelt og om Kunstakademiet paa Hans Tid*, Copenhagen, 1877

Tesdorpf, Karl Wilhelm, *Johannes Wiedewelt*, Hamburg, 1933

Index

Illustrations are represented by italics; main discussions of a sculptor are indicated by bold type